EyeMinded

EyeMinded

KELLIE JONES

LIVING AND WRITING
CONTEMPORARY ART

WITH CONTRIBUTIONS BY
AMIRI BARAKA,
HETTIE JONES,
LISA JONES, AND
GUTHRIE P. RAMSEY JR.

Duke University Press
Durham and London 2011

© 2011 Duke University Press

All rights reserved

Printed in the United States of America on acid-free paper ∞

Designed by Heather Hensley

Typeset in Scala by Tseng Information Systems, Inc.

Library of Congress Cataloging-in-Publication Data appear
on the last printed page of this book.

For my parents

—

Hettie Jones
and
Amiri Baraka

—

The first writers
I ever met

CONTENTS

ACKNOWLEDGMENTS

There are twenty-five years of people and places to thank here. The cultural institutions that have supported my work and employed me over this time: The Studio Museum in Harlem, the Jamaica Arts Center, and the Walker Art Center. In my scholarly life, the gifted faculties and departments of history of art and African American studies, as well as the Griswold Fund at Yale University; the department of art history and archaeology and the Institute for Research in African American Studies at Columbia University. The generous sponsorship of the Alphonse Fletcher Sr. Fellowship at Harvard University; the David C. Driskell Prize in African American Art and Art History, High Museum of Art, Atlanta; and the Peter Norton Family Foundation. All are greatly appreciated.

There would be no book without many, many wonderful artists I've had a chance to work with over the years whose art you will find in these pages. I have much gratitude for all the fantastic students who keep asking questions. Many colleagues in the academy, the museum, and other parts of the art world have supported me along the way, including: Rasheed Araeen, David A. Bailey, Emma Bedford, Camille Billops, Rashida Bumbray, David Cabrera, Luis Camnitzer, Hazel Carby, Lisa Gail Collins, Margo Crawford, Olivier DeBroise, Okwui Enwezor, Tom Finkelpearl, Jean Fisher, Coco Fusco, Paul Gilroy, Thelma Golden, Alexander Gray, Farah Jasmine Griffin, Kathy Halbreich, Deidre Hamlar, Anna Harding, halley k. harrisburg, Salah Hassan, James Hatch, Jurgen Heinriches, Anne Higonnet, Kurt Hollander, Robin D. G. Kelley, Thomas Lawson, Arnold Lehman, Susana

Torrella Leval, Kobena Mercer, Mary Miller, William P. Miller, Susan Morgan, Donna Mungen, James Oles, Robert O'Meally, Richard J. Powell, C. T. Woods-Powell, Michael Rosenfeld, Oswaldo Sanchez, Alicia Schmidt Camacho, Joan Simon, Lowery Sims, Lorna Simpson, Franklin Sirmans, Robert Storr, Zoe Strother, Robert Farris Thompson, Jack Tilton, Michael Veal, Rachel Weiss, Fred Wilson, and Mimi Yiengsprakawan.

I owe a debt of gratitude to wonderful people who assisted with research on a number of these essays: Danielle Elliott, Ava Grumberg, Brandi Hughes, Jonathan Kidd, Jerlina Love, Emma Ross, Elizabeth Thorpe, and Regina Woods. Scholarly resources are ever important, and many thanks go to Columbia University Libraries, and particularly Michael Ryan; Yale University Art and Architecture Library, and all the librarians there, particularly Beverly Lett; the Getty Research Institute, Research Library, Special Collections and Visual Resources; New York University, Bobst Library and the Fales Library and Special Collections; the library at the Whitney Museum of American Art; and University of California, Los Angeles, Department of Special Collections, Charles E. Young Research Library, and particularly the librarians Jeffrey Rankin and Octavio Olvera.

This book came together with the aid of some more great folks. Denise Murrell did the thankless job of compiling all that I had written. Dasha Chapman tirelessly followed up on every permission and image with painstaking detail. The Columbia University staff Caleb Smith and Josh Sakolsky also provided key assistance with images and permissions. Many thanks to Ken Wissoker, editorial director, and Duke University Press for taking on this project. I have enjoyed working with Leigh Barnwell, Courtney Berger, Heather Hensley, and Neal McTighe, too.

Great friends have kept me on track: Deborah Willis, Elizabeth Alexander, Cheryl Finley, Alondra Nelson, Saritha Clements, Alicia Loving Cortes, C. Ian White, and Fatimah Tobing Rony. I continue to be inspired by amazing family members, particularly my great-aunts. Ninety-three-year-old Elise Martin, before retiring as a poll watcher in 2008, sat in for one last round in the South Carolina primary where she met and was photographed with Barack Obama. I was able to celebrate her sister Gottlieb Harvest's one hundredth birthday with them both. The Baraka family of Newark continues to inspire with art and activism, especially Amina Baraka. I married into the fabulous and ubiquitous Ramsey clan of Chicago; special thanks to mother-in-love Celia Ramsey Wynn for her embrace and great recipes for food and many other things. To the Browns of Baltimore, brother-in-law Ken, who makes everything tick like an expensive watch, Dr. Margaret Brown, PhD, and the most amazing niece ever, Zoe MHC Brown.

The ones who have brought their words to bear here have made the writing and structure of the book real. The best sister ever, Lisa Jones Brown; my father, Amiri Baraka—who has given so much to many people; Hettie Jones—a most incredible woman and mother; my husband, Guthrie Ramsey, who keeps the music, words, and fun going.

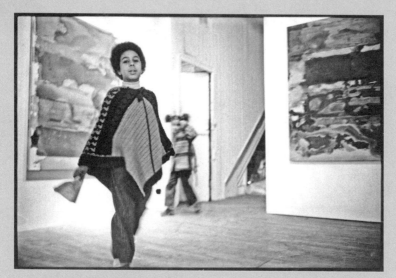

Kellie Jones (foreground) and Lisa Jones, Paula Cooper Gallery, New York, 1969. Paintings are by Ed Ruda. Courtesy Kellie Jones.

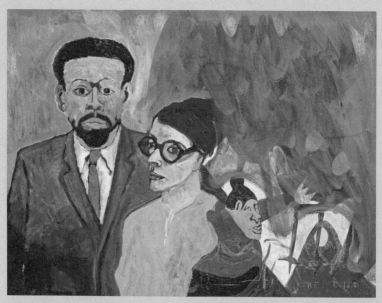

Bob Thompson, *LeRoi Jones and His Family*, 1964. Oil on canvas, 36 3/8 x 48 1/2 inches. Hirshhorn Museum and Sculpture Garden, Smithsonian Institution, Washington, D.C. Gift of Joseph H. Hirshhorn, 1966.

Art in the Family

On Tuesday February 17, 2009, a drawing by Charles White (*Move On Up a Little Higher*, 1961) and a painting by Al Loving (*Cube 27*, 1970) were sold by Swann Galleries in New York. Swann is known for its auctions of art by African Americans as well as ephemera, documents, and material culture relating to black life. Prices were solid, only beginning to show the effects of the current economic downturn.

For me these two pieces signified something somewhat outside the strict register of monetary gain or notable historical fact. These were works of art made by my friends' parents, people I grew up with, hung out with, learned about life with. They signal the parameters of the community in which I was born, raised, and became an intellectual. In my world, art is not only part of history—even a living history—it is part of and makes community, it is part of and makes family.

What I want to think about here is how art objects, and the activities around their making and display—in exhibitions, homes, studios—as well as their materiality and life, are integral to forming relationships, connections, and kinship among sometimes diverse constituencies. How is art a connective force, a glue between people, creating the sense of community whole but also of family and affiliation? Indeed how does the circulation of art forms in public and private arenas create dialogues and sites of collectivity, personal and communal meaning, and how are these formations part of how we craft individual and larger social and political involvements? How do objects coalesce a public, create a life for artists and audiences and a circle of friendships from the particular to the collective? In what ways does

art become a catalyst for the invention of forms of and places for modes of familial and civic recognition and representation?[1]

Trying to think through concepts of family and community and how these might intersect with and inflect notions of art, I picked up Barack Obama's book *Dreams from My Father* (1995). Inspired by his missives from the campaign trail, I turned to the president's writing because of our generational link and similar biographies. We were both born and raised in the United States in the urban, multiracial settings of Honolulu and New York City respectively. We had mixed ethnic backgrounds with one black and one white parent, though his was certainly the more complex transnational context with Kenya, Kansas, and Indonesia as part of the picture, as opposed to my Newark, New Jersey, and Brooklyn, New York, roots. Our histories (and perhaps those of our generation) led us to ideas of politics and community in different valences. (Plus we both married cool people from Chicago!)

For Obama, navigating what he identifies as separate black and white realms leads him to continually recast and reimagine structures of kinship and society. He describes slipping back and forth between worlds, hoping that they would eventually cohere without the pain and tragedy of confrontation which often marks the American story. He asks, "What is family? . . . a genetic chain . . . a social construct [or] economic unit . . . shared memories. . . . An ambit of love? A reach across the void? . . . The insistent pleasure of other people's company, the joy of human warmth[?] . . . And how does one reconcile blood family with the larger idea of human association"?[2] In one scenario Obama imagines a series of ever-widening circles around himself, expanding from an inner core to a loop embracing the planet. Within this framework, commitments to a larger world are also commitments to self.

Paul Gilroy has cast this pursuit of common ground as a search for a "planetary humanism" devoted to a certain "conviviality," which he explains as "the processes of cohabitation and interaction that have made multiculture an ordinary feature of social life in Britain's urban areas and in postcolonial cities elsewhere."[3] It looks for solidarity across boundaries real and imagined, seeing differences whether national, ethnic, or religious, neither absolute nor unbridgeable.

It is Obama's active and perpetual visualizing of the reaches of family that eventually translates into political organizing. He searches for collectivity and common ground, looking for commonalities and intersections between communities and constituencies which allow room for people to come together with greater ease. Interestingly, he observes it is when we escape from what we know, placing ourselves in a liminal or marginal situa-

tion, that we find more room for union with others. Gilroy, too, calls for a certain distancing or estrangement from the familiarities of one's own situation, culture, and history, a repositioning that is both "anthropological and indeed ethical method."[4] It is a space that can be unsettling and agonistic yet which allows us to move toward others with greater equanimity, the minor conflicts of difference as a pedagogical opening, a route to knowledge rather than a reason to turn away. In the words of poet Adrienne Rich our divergences should not be determinative, causing us to reject the other and "flee from our alikeness."[5]

Gilroy's conviviality is an expansion of activist or critical multiculturalism that is forward looking, political, and antiracist, and that intercedes in institutional structures of power relations and domination. It is the notion that the twenty-first century (Western) societies in which we live are not just recognized superficially as multiple but reflect an egalitarian notion of polis. It is based on the idea that intellectual culture reflects the realities of multiculture (one, as Gilroy points out, lived daily as mundane proximity in friendship and vernacular practices) rather than as a monoculture that fashions itself as core values to a plural periphery. Even the use of the term conviviality itself is meant to move discourse away from the pitfalls of so-called identity politics toward a cosmopolitan and political, or "cosmopolitical," interculture, one that is tolerant and humane.[6]

The location where uneasy agonisms are yet productive, jostling to form bonds and coherence across boundaries and through difference, this is the place for the type of flexible and active relations Obama values as well. According to his first boss, Obama becomes a community organizer because he is angry. "Well-adjusted people," the man quips, "find more relaxing work."[7] I would say the same about some of the intellectual work I do; it is not always relaxing, but it is in my mind a necessity, an ongoing and ever-present commitment to notions of equality, multiculture, and activism that is "aesthetic, cultural and scholarly."[8]

I was born in the years soon after the 1954 *Brown v. Board of Education* case that outlawed de jure segregation in the nation. Still even in that postdesegregation moment it remained illegal, in fact a felony in the majority of the United States, for my African American father and Jewish mother to marry. It was not until 1967 with *Loving v. Virginia* that miscegenation laws were dismantled by the federal government. Raised by poets, a larger community, and a world committed to justice and social change, I have been marked in my creative output as a writer and curator by the hopes and dreams of the *Brown* decision. I was born into a world bent on change, and I took my job quite seriously.

Coming into consciousness as a person in the 1960s and 1970s was an amazing experience, as many books today tell us. Growing up as a colored child in New York's East Village—the Lower East Side or Loisaida as we called it then, using the name that our Latino neighbors gave our home—was a great gift. It was filled with neighbors of all kinds—hippies, a variety of black folk, Ukrainians, Puerto Ricans, and above all, creative people of every stripe and creed—musicians, writers, visual artists, and dancers. The notion that people lived their dreams and possibilities was just a given; they had gathered in this neighborhood to do just that. These were my mentors, the adults in my life. The four-story tenement building at Cooper Square where I lived from about three years of age until going off to college presented this landscape in microcosm. Not only did it face Cooper Union, one of the country's oldest art schools (so prestigious that if you were talented enough to get in you paid no tuition), but over the years that building was home to many, many creative souls, beginning at least with my parents, the poets Amiri Baraka (then LeRoi Jones) and Hettie Jones. The jazz saxophonist Archie Shepp (along with his wife, Garth, and their four children) lived there for a while with bands rehearsing all the time. The cover photograph of Shepp's *Attica Blues* (1972) shows him in his studio, perhaps composing songs that form his response to New York's Attica Prison massacre the year before. Free jazz became my lullaby and comfort music. The painter Elizabeth Murray with her first husband, Don Sunseri (my elementary school art and woodshop teachers respectively), resided there with their son when they first arrived in New York from Chicago. Through them I eventually met the painters Martha Diamond and Jennifer Barlett and the sculptor Joel Shapiro, who all contributed to creating a revitalized space for figuration as the 1970s headed toward the 1980s. The jazz bassist Sirone later became a resident of the building on Cooper Square as well as the artist, scholar, and curator C. Daniel Dawson. The painter George Mingo called the place home and his partner, the photographer Coreen Simpson, came by often.

From my multicultural preschool aptly called the Church of All Nations to the independent Downtown Community School several blocks away, my full world continued to be shaped. My sister, Lisa, and I attended the latter together, along with Shepp's sons Pavel and Accra. In my six years there I came to know many kids whose parents were making art happen in New York and who themselves would do so in their own time: Sidonia Gross, whose mother, Sally, was a member of Judson Dance Theater; Sara Kirschenbaum, whose parents were both artists—her father, Bernard, a sculptor who

showed with the early experimental cooperative Park Place, and her mother, Susan Weil, a painter first married to Robert Rauschenberg; Cicely Khan, daughter to the painter Wolf who grew up to be a successful one in her own right. And I made lifelong friends: Saritha Clements whose father, Millard, was an early environmentalist at New York University, and Alicia and Ann Loving Cortes, stepdaughters of Al Loving.

The Lovings had arrived in New York and into my world from Ann Arbor, Michigan, in January 1969. By December Al would become the first African American to have a solo exhibition in the thirty-eight-year history of the Whitney Museum of American Art, inaugurating an unprecedented twelve-show series of works by black artists. Two essays in this collection discuss Loving and his generation of abstractionists, "It's Not Enough to Say 'Black is Beautiful': Abstraction at the Whitney 1969–1974" (2006) and "To The Max: Energy and Experimentation," from my exhibition "Energy/Experimentation: Black Artists and Abstraction, 1964–1980," which opened at the Studio Museum in Harlem in 2006. I dedicated the latter essay, really the show itself, to Loving, who had passed on a year before in the midst of my organizing the project. It was only when I got to college that I had realized not everyone knew artists, watched or listened to their magic unfold. When I spoke to Al about participating in "Energy/Experimentation" he was excited and said he would help in any way he could. He also thanked me. Not for doing the show per se but for joining their special club, signing up for the work of organizer, writer, interpreter. He thanked me for continuing on this journey with him.

Along with Al, the painter and designer Wyn Loving was a part of a generation that stepped out of its comfort zone, intent on demolishing pat orthodoxies and challenging the United States to live up to its creed of equality and justice for all. Both were graduate students with children when they met at the University of Michigan. At that time Ann Arbor was the home of various activist movements—in art, education, and politics and seen in the presence of the Ann Arbor Film Festival, Children's Community School, and Students for a Democratic Society. Al and Wyn both took jobs after graduation at nearby Eastern Michigan State University. When their friendship developed into a serious relationship, Al was fired from his position and Wyn resigned very publicly in protest. Think of this taking place in the context of urban rebellions that swept Detroit in 1967 as well as the country during that time, in addition to the new legality of interracial unions that had been handed down that same year. Their radical perspectives and friendships continued in New York where Wyn was the anchor of

a very lively community of artists and political activists on the Bowery from the 1960s onward.[9]

With Alicia I spent many hours in this Bowery loft where Al and Wyn also made paintings. And perhaps through them my connection to the world of visual artists grew and began to captivate me. In that building at 262 Bowery alone there was Kenneth Noland, who gained recognition for color and staining that defined some new directions for painting as the 1950s made room for the 1960s—he was father to Cady Noland, who would make important sculptural statements a few decades later—and the dancer Batya Zamir, who pioneered her own suspension dances in the 1960s and 1970s (Al Loving danced with her for some time), and her husband, the sculptor Richard Van Buren, who also showed with the Park Place group.[10] I met the abstract painters Jack Whitten and William T. Williams and babysat for their children. In many ways I learned about looking at and making art with this generation of artists. I came to understand what was inspiration, what was at stake, and certainly that creativity was not the exclusive province of specific types of people, as most art history books professed.

I took my first trip to Europe with Jack Whitten and his family as an au pair for his daughter. That summer the painter Norman Lewis and his wife, Ouida, joined us in Greece. Knowing the paintings he made as a result of that trip, such as *Blue Seascape*, 1978, or *Seascape XIV*, 1976, remind me of the time we shared there. I remember his great talent, wisdom, and commitment to making a place and leaving a legacy for young black artists, as well as his amiably cantankerous nature. Some of my earliest curatorial and critical projects collected here—the essay "Norman Lewis: The Black Paintings" (1985) and the exhibition "Abstract Expressionism: The Missing Link" (1989)—were inspired by thinking about and contextualizing his art and legacy.

The sculptor Melvin Edwards and his wife, the poet Jayne Cortez, were always very clear about their politics as well as the aesthetics of their work; later I would find their practice ever more intriguing when I discovered their roots in the Los Angeles art scene. The sculptor, filmmaker, and archivist Camille Billops and her husband, the theater historian James Hatch, gave me an appreciation for the notion of archive, visualized in the words of the playwright Suzan-Lori Parks, "You should write it down and you should hide it under a rock."[11] For decades they have interviewed writers and performing and visual artists of all walks of life, from the recognizable to the lesser known. Every year a portion of these are published in their journal *Artist and Influence*. Their mentorship led to several collaborations, one of

which—"Interview with Howardena Pindell" (1990)—appears here. Pindell was another important figure for me who insisted on both aesthetic and political freedom with a feminist edge. These were some of the people in my life and some of the people who made SoHo.

However, along with this great rainbow of New York's downtown culture there was another equally important if very different experience that had a great impact on me during those years. It was the Black Arts Movement and black culture generally that I found in Newark in the lives of my father and grandparents.

Unlike Obama's narrative where he sees black and white as exclusive and exclusionary universes that often meet in distress and misery, my worlds were not so clearly delineated in that way. There were creative people of color that were major fixtures in my New York life, so much so that in my later study of art history I was baffled and angered by a body of literature that left out all the fullness and diversity I had known to exist. What differentiated the two realms was the fact of Black Cultural Nationalism, a political program that while seeking human rights and social justice, designed a plan of self-fashioning, and self-respect, and whose structures and emotional power also resulted in a certain insularity.[12]

Many volumes have been written, including by my father himself, of his cultivation of a Black Cultural Nationalist program in Newark at this moment, and its influence not only on that community but also on the nation and the world during that time.[13] In Newark my sister and I were part of a larger, very purposeful reality, one about politics and liberation, "freeing black people from intellectual chains." We studied Africa and learned some Kiswahili. We celebrated Kwanzaa, learned African dance, marched in African Liberation Day parades, even performed in the play *Slave Ship, 1969* as voices of screaming children.[14] We learned about culture as a powerful tool. At my grandparents' home in Newark it was a different thing. Fun and backyard parties, plenty of "play cousins," aunts, and uncles. Music, drinking, and popular dance of people who worked hard and enjoyed their weekends and who were part of "the cause" in their own way.

Marianne Hirsch has written eloquently about photography, memory and the circulation of meaning through the configurations of family. She speaks of generational transmission, how experience and remembrance are passed along via creative form, through stories and images as well as gesture. Family photographs in particular also become a site for a nexus of mul-

tiple gazes, among families but also with viewers. There is also a conceptual interface between such visual mementos and the larger world of media images, and representations of family as well as family mythologies.[15]

The structure of *EyeMinded* engages Hirsch's concepts in a number of ways. I pondered how notions of family are constructed and transmitted through acts of art, thinking about the creative work of four family members: my parents, the poets Amiri Baraka and Hettie Jones; my sister, the writer and filmmaker Lisa Jones; and my husband, the scholar and musician Guthrie Ramsey.[16] I was interested not only in how creativity is learned and passed on, but in understanding it as a place where we speak to and from each other; where our discussions intersect and diverge. However, if these exchanges are personal and familial to a certain extent, they are very much public, addressed to a wider creative community and the world at large.

Hirsch has discussed family or group memory as many times embodied in behavior, gesture, conversation, or tales, while cultural and archival memory is known through the circulation of symbolic forms and systems. However, in considering notions of cultural transmission and expression in the case of survivors of the Holocaust and the subsequent generation, she notes that the dearth of personal and family images or keepsakes are addressed by the adoption of public images as part of an ancestral trove or archive. Thus the "familial gaze" is mediated through the remnants found in the public record. It is there that mutual recognition as ascribed to the circle of kin is found. In this way family stories and histories become at once private and personal as well as public and archival. One thinks of family photos as unique with no meaning outside the context of a specific clan or lineage. Yet in many ways these images are interchangeable, mining poses and gestures that emanate feeling and affiliation. These ideas are transmitted between families but also to a wider community of viewers who recognize there structures of feeling that are available to them as well. So it is with cultural forms, like writing, that are addressed to a general audience but that in doing so also speak back to the collective/family, the place writing and cultural meaning was learned.

The writings in *EyeMinded* also bear witness to the notion of the personal and family archive, one created in and through our writings across space and time. *Archive Fever* is the term Jacques Derrida uses to explain the notion of archivization, as both public or state and more private and personal functions. These actions and techniques are a consignation—a unification, classification, and ordering—we use to forestall the breakdown of memory and evade death. These perpetual and repetitious actions move us

into the future. In this way the notion of archive is always transgenerational, moving from one period to the next. But the archive's assemblage also anticipates the glance backward. It opens toward "historicity and with the obligation of memory."[17] To the lacuna of the official archive language speaks. Specifically, as Giorgio Agamben has outlined, spoken communication addresses the archive in the form of the testimony and speech of the witness/ subject.[18] Thus the pages of *EyeMinded* are at once a family archive, a collection of documents that map the trajectory of these intimate relationships across time, but they also speak back to the official record, to the histories that would ignore, erase, or rewrite our existence and interconnection, creatively or otherwise.

How has my existence, in the embrace of the arts, developed and shared in childhood, and continued as an avocation and a life journey, shaped what I write and how I write about it? Since birth and perhaps before, I feel I have been in a constant dialogue about culture with my family. Learning about art and life from a community of artists in the New York of the 1960s and 1970s, now labeled a neo-avant-garde, and absorbing art's instrumental uses from Black Nationalists in another universe across the river in New Jersey. This was the way we lived whether on the Lower East Side or in Newark. To look back and see that I myself have generated two decades of cultural commentary is amazing and humbling. It is a testament to my family no matter how unorthodox my reality seemed to others or looks like in retrospect. Like all stories of human existence it is an account both unique and universal.

In a sense these pages reveal the "obligation of the archive" as a personal, familial, or community structure and as it is assessed in documents, images, language, stories, and material culture.[19] I also want to think about such transmission through art. One artist who works through objects in this way is Vivan Sundaram. Using the format of installation as well as family photographs and letters, Sundaram illuminates and weaves histories of her relatives through three generations. In it are accounts of modernity and culture that maps Anglo-Indian connections across the twentieth century. It begins with the marriage of the artist's grandfather, the Sanskrit scholar Umrao Singh Sher-Gil, and her Hungarian grandmother, Marie Antoinette, and their voluminous collection of family photographs, and it persists in the important paintings by Amrita Sher-Gil, Sundaram's aunt, that navigate Indian modernism; this legacy is maintained in the body of work of Sundaram herself.[20] More recently the exhibition "Progeny" held in Miami, New York, and Sacramento featured individual photographs and objects by

Deborah Willis and her son Hank Willis Thomas. The show also highlighted collaborative pieces that engaged memory and the forward motion of its generational inscription.[21]

These examples, as well as my own history lived among artists and many creative people, compel me toward narration not only through texts—mine and a familial assembly—but to consider how some artworks (such as the pieces by Loving and White), like family photographs, hold similar associations, private but also lived in public. How do these notions—both of transgenerational creativity and visual art's role in narrating life's meaning—empower and energize my notion of art and writing? Stories, Obama tells us, and, thinking expansively, I would hazard art in general, become ways for people to explain themselves, give themselves a sense of place and a sense of purpose. In the fabric of the tale we find the "the messy, contradictory details of our existence."[22] Indeed, how might such cultural forms help us navigate our existence and its "messy details"? As painting, sculpture, mixed-media assemblies, and so on move from studio to exhibition to home or museum, in these diremptions and cycles, how do they create narratives of their own histories but also generate communities of artists, families, friends, supporters, viewers who are linked across space and time and in doing so find and create common ground, and a platform for new and advanced forms of affiliation?

ON MUSEUM ROW

Multiculturalism flourished in the space and time of the postmodern museum. Poststructuralist critics offered us a postwar landscape that rejected History as a grand and singular narrative for a more general concept of mundane planetary chronicle composed of various and competing as well as overlapping stories. Such talk confirmed the presence of a multiplicity of artists and aesthetics, viewpoints that were continuing to find greater visibility in museums and other exhibition spaces.[23] Ideas of heterogeneity made space for multiculturalism on an intellectual level. In theory, a wide range of American art, made by a variety of practitioners, should exist. However, as Chon Noriega points out, oftentimes these inclusions operated on the level of theoretical construct rather than real integration of museum spaces. Sometimes even when the museum demographic was enlarged there was a sense of the restriction of the type of art and representation that was allowed, one where "minorities never [got] to represent more than their marginality."[24] In other instances diversity became a code word for internationalism rather than forcing a look inside the United States and outside the confines of culturally dominant trend.

What theory many times did not acknowledge was the politics and struggles on the ground that forced actual inclusion rather than just its understanding as an intellectual construct. Rights movements of the 1960s and 1970s were battles for equity and visibility in social and cultural spheres. Protests by artists against the museum status quo led to the unlocking of these cultural citadels. This same energy also led to the development of alternative nonprofit galleries and ethnically specific museums.[25]

Such social action opened up places for a wide array of artists to exist, show, and develop. At the same time there was the insistence on equivalent curatorial and critical voices, an understanding of the need to expand what constituted expertise to frame an emerging discourse, which is where I felt my contribution lay. I was drawn to museums and curatorial and critical practices as a way to support artists and culture generally. There was a role for cultural workers. Yet in retrospect it was also transgenerational inheritance: seeing art and culture as activist, as modes in which to move society forward.[26]

I was and continue to be interested in museums as locales where people can come in contact with visual and intellectual thought, consider public culture and discourse. If the concept of the museum as strictly a playground for the elite is in ruins, the institution has been reconfigured, to a certain degree, to provide for different constituencies, in part by showing things to serve and develop new audiences. My "Basquiat" exhibition—represented here with the catalogue essay "Lost in Translation: Jean-Michel in the (Re) Mix" (2005)—for instance, produced record-breaking attendance everywhere it toured.[27] The museum remains a site to expand viewers, for the works of African American artists and others, and not just for the sake of African American viewers alone. It is still a spot in the public sphere for conversation but also a space to carry on a "discourse of recognition," a setting for performances of acknowledgment and worth.[28] As we learned from Frantz Fanon, the revision of preconceived cultural images is also part of the fight for equity and freedom.[29] Museums are locales where evidence of such shifts of visual meaning can be collected and found. They are places to see art by a diverse range of practitioners as emblematic of the flows of culture in general.

My writing speaks to family ties but also to the many relationships I built as an adult, the world I created with my peers and with my sister Lisa. Though I fancied that I would work in the United Nations when I left college, that I wanted to be a Romance language major and a translator, instead I picked the next best thing: art historian. In this field one needs to know languages and in some ways translates what is going on in the work of art for

a broader population. I came to art also through the High School of Music and Art (now the Fiorello H. LaGuardia School of the Arts), another public multicultural community where my buddies were the impeccable drafts-man Whitfield Lovell, the singer-actress Alva Rogers, and the writer Hilton Als. In the early 1980s I worked first at the Studio Museum in Harlem, in its initial incarnation at 2033 Fifth Avenue and later when it made its move to 125th Street where Mary Schmidt Campbell—now dean of Tisch School of the Arts at New York University—was the director, and C. Daniel Daw-son worked as a curator. I also came to know the scholar Leslie King Ham-mond—who had already started her long career as dean of graduate studies at the Maryland Institute College of Art—while working on one of her exhi-bitions, "Ritual and Myth," which opened the Studio Museum's new 125th Street space in 1982. The photographer and filmmaker Lorna Simpson and the painter Glenn Ligon, like me, began as interns at the Studio Museum in Harlem, as did Thelma Golden, who later worked with me at the Jamaica Arts Center before continuing her career at the Whitney Museum and then moving to run the museum at which she once interned.

A commitment to living artists had always been at the core of the Studio Museum in Harlem's existence. Working in the curatorial department there I interacted with the famed artist-in-residence program and the prolific painter Candida Alvarez, and the sculptors Tyrone Mitchell, Alison Saar, and Terry Adkins, who were exploring various approaches to notions of accumulation and construction. The multimedia artists David Hammons, Charles Abramson, and Jorge Rodriguez were still around having finished their residencies right before the museum's move from Fifth Avenue to 125th Street.

I gained mentors and friends: Lowery Sims, whose long tenure as a cura-tor in the department of twentieth-century art at the Metropolitan Museum of Art was ever valuable, and Deborah Willis, then a photography specialist at the Schomburg Center for Research in Black Culture. I hung around Linda Goode Bryant's Just Above Midtown Gallery (JAM) in Tribeca, the first to commit to artists like Hammons, Houston Conwill, Senga Nengudi, and Maren Hassinger, whose postminimalist practices muddied the East Coast's more puritanical categorizations. Goode Bryant's support of this vein of abstraction by black artists was bold and exciting for its time. At JAM I met the sculptor Fred Wilson, who was working there before moving on to PS 39/Longwood Arts Project in the Bronx as director and hiring me for one of my first curated shows.

"In the Tropics" tackled the notion of the "tropical" world—the carto-

graphic expanse between latitudes of the Tropic of Cancer and the Tropic of Capricorn, also known as the Torrid Zone. Covering five continents and countries from Cuba to Thailand, this nebulous area was a site of shifting and multiple definitions, from tourist fantasies to war-torn lands, from non-aligned or "third world" nations to home; places lived in as well as imagined. The exhibition featured eighteen artists, and on the final night Lisa's performance piece "Carmella and King Kong" had its premiere.[30] The show was on view during the spring of 1986, a year before Wilson's own groundbreaking project "Rooms with a View" appeared there. At that moment he began to blur the lines between curator and artist and move toward an art practice that would take as its central force the explosion of antediluvian museum frameworks, from the taxonomies of display to the logics of collecting. Through an increasingly installation-based practice Wilson addressed not only viewers but also people working inside such cultural institutions.[31] This was the lure of the museum space for me as well. It was a place to interrogate how "truth" was produced and think about power relations: who was allowed to speak, and to and for whom. It was a place of address: to get a casual viewer thinking or touch like-minded souls who too were intervening in other arenas, seeing them with new eyes and giving them new life. Through curatorial action one could fill in historical and archival gaps in our understanding of the world.

From the Studio Museum I moved to the fledgling Broida Museum, the collector Edward R. Broida's personal museum which never did open to the public.[32] Nevertheless, as it tried to come into existence in the mid-1980s, I worked as an assistant curator there with founding director Joan Simon, who came to the institution from her job as managing editor of Art in America. I came to know Robert Storr and Charles Stuckey, who had both written for the magazine and would also eventually transition to the museum field, and came in contact with artists like the painters Susan Rothenberg and Anselm Kiefer and the conceptualist Bruce Nauman. When Broida decided after three years not to go ahead with the project I moved on to the Jamaica Arts Center, a community art center in southeast Queens, founded in the early 1970s as part of the decentralization of culture from "Museum Row" to urban neighborhoods.[33] Besides offering historical, local and contemporary exhibitions, it became the launching pad for my international work. In the fall of 1989, from this small arts center, I sent one show to London and another to Brazil. I presented the sculpture of Martin Puryear as the commissioner from the United States to the São Paulo Bienal; it is the essay for that catalogue from which this book takes its name.[34] Weeks

after the Puryear project opened and we won the prize for best individual exhibition, I headed to London to install "US-UK Photography Exchange" at the Camerawork Gallery in London.[35]

The appeal of photography grew as I realized the potential for exchange: one could carry a whole exhibition around the world in a three-by-four-foot portfolio.[36] And artists were using the medium in more and more exciting and critical ways, combining images with text and as the fulcrum for larger installations. My interest in photo practice is revealed in the many essays on it in this book, writings on Dawoud Bey, Lorna Simpson, and Pat Ward Williams from the United States and the Mexican neoconceptualist Silvia Gruner. The expanded scale artists were working in was the subject of an early exhibition as well, "Large As Life: Contemporary Photography" (1987). In photography I also remarked on transnational and feminist practice that I found in the dialogue between black British and American artists in "In Their Own Image" (1990).

During the 1980s critic and artist Coco Fusco and I both became fascinated with black British culture. Here was a transnational practice—and a generation—that mirrored so much of our own, in its formulation of broader platforms for creative and intellectual work. In that moment the use of the term "black" by nonwhite as well as immigrant artists in England had a political valence and signified an oppositional aesthetics; as scholar Courtney J. Martin explains, "*black* was not simply what one was, but rather, how one made art."[37] We were impressed by how these practitioners manipulated traditional and new media to reveal the rapid, if uneasy, development of a multiracial Europe. Fusco connected with the filmmakers, like Isaac Julien, John Akomfrah, and Martina Attille. I engaged with the painters, sculptors, and photographers, Ingrid Pollard, Rotimi Fani-Kayode, Sonia Boyce, Keith Piper, Roshini Kempadoo, and others who were curators and critics as well as artists like Maud Sulter, Lubaina Himid, and David A. Bailey. In this moment I also met Paul Gilroy and Vron Ware and family along with Kobena Mercer. It was Lisa who had first introduced me to this community, when she lived in Europe for a year after graduating from college early in the decade.[38]

As young critics, curators, artists, actors, directors, filmmakers, and musicians we were excited about the world we were making then. Lisa was part of the "make black film movement," collaborating with Spike Lee on his films and books. She was also a journalist at *The Village Voice* with Greg Tate, Nelson George, and Harry Allen. Tate and writer Trey Ellis both remarked at the time on the way our generation was making what Trey nominated as

the "New Black Aesthetic," one that appreciated the beauty of art and the nationalist object but felt confident enough to leave strict dogma behind.[39] And we knew black wasn't the only thing on the block, working with critics and curators like Coco Fusco; Margo Machida—an expert on Asian American artists; Yasmin Ramirez, who wrote for the East Village Eye and Art in America; and Geno Rodriguez, who ran SoHo's Alternative Museum; and with the artist Papo Colo, who along with his partner Jeanette Ingberman founded Exit Art; and artists like the painters Candida Alvarez, Juan Sanchez, Martin Wong, and the multimedia artist Yong Soon Min; the list goes on.

The 1990s of course brought greater professionalism and more exciting opportunities: deciding to go for a doctorate in art history and studying with the amazing Robert Farris Thompson at Yale University, who named the Afro-Atlantic cultural world that we now know as the African diaspora; serving as an adjunct curator at the Walker Art Center in Minneapolis with the visionary director Kathy Halbreich for most of the decade; curating a show for the Second Johannesburg Biennale in 1997 and working with Okwui Enwezor, the biennale's artistic director, were some of the highlights. My time at the Walker, one of the beacons of contemporary art and experimentation in this country and worldwide, is framed by an interview with one of Cuba's important sculptors, Kcho (Alexis Leyva Machado), and essays on the photographer Dawoud Bey and the performer Bill T. Jones, who has contributed to our changing notions of dance over the last three decades. The experience in South Africa was far briefer but in ways more influential.

As someone who had grown up thinking about and studying aspects of African culture and who had been schooled in the evils of apartheid since childhood, it was an amazing opportunity. It was also my first visit to the continent. I held onto the honor even while experiencing the difficulty of producing an international exhibition without the comparative comfort of the type of official United States support that I had in Brazil, and in a place where white supremacy was the rule of law until three years prior. Visiting the infamous prison at Robben Island at the end of the project put everything into perspective. Only recently reopened as a museum, here I was able to see the "president's cell," the space hardly larger than a king-sized bed where Nelson Mandela had spent eighteen of his twenty-seven years of imprisonment. From here nothing I had gone through with my exhibition appeared to have the level of difficulty I had initially imagined. Even Mandela himself had seen museums as places where new democratic ideals could

be worked out, opening the Robben Island space several weeks before the biennale with the call for such institutions to "reflect history in a way that respects the heritage of all our citizens."[40]

The exhibition I conceived, "Life's Little Necessities: Installation by Women in the 1990s," focused on women artists as bearers of the complexities of the global. In addition to the catalogue essay, my time spent there sparked two other writing projects on aspects of feminism, transnationalism, and art, "A.K.A. Saartjie: The Hottentot Venus in Context (Some Reflections and a Dialogue)" (2004) and "Tracey Rose: Postapartheid Playground" (2003).

In the 1990s and the new millennium my writing matured. But the themes and interests remained colored by the life and world I wanted to make and continue to work toward today. While I might approach a few of these topics somewhat differently now, I remained impressed by my directness and the confidence I had in my young voice.

WRITING/ART

"This was it, I thought to myself. My inheritance. I rearranged the letters in a neat stack and set them under the registry book."[41] In this passage Obama muses on letters and documents from his father and grandfather that he is given in Kenya, which both enhance and detract from the family narratives he has imbibed throughout the years. How do these items, objects invested with their own official and state meanings, augment or contradict the inheritance of oral histories that have lived in Obama's head as cultural patrimony for years? How do these papers displace or erase his memories, even those acquired as tales, and lived with, almost as myth?

Story and art do live as trace or fragment that destabilizes the notion of archive as an ordered document of state and official history. Artistic practices have often involved practices of countermemory, and visual artists have worked against the regulation of the archive by using its formations — film, photography, media, documents — in ways that trouble the recall of these official histories and, as Okwui Enwezor points out, "in their inconsistency perforate the membrane of private and public memory."[42] Some of these are antimonuments, particularly sculpture which wonders about history and performs as modest remains, antiheroic and unmonumental elements conceptualized as pieces of the world which narrate their own journeys. They are sometimes raw in formal presentation, testing the limits of what is acceptable, and in doing so "deliberately situate themselves in a minor place in an attempt to restore the power of opacity, difficulty and doubt."[43] They do not narrate holistic, sanctioned, or hegemonic history; in-

stead they live in the interstices and the caesuras of the standard record, in "the messy, contradictory details of our existence," as Obama has observed.

Their fragmentedness makes them enigmatic, pieces whose meaning oscillates. They mirror the trajectory of memory and postmemory pieced together through stories, images, materials that themselves are on their second, third, or nth iteration. There is also gesture, where memory becomes emanation, an "embodied living connection," an indexical performance shaped by the artist's and "the viewer's needs and desires."[44] Such is the remnant as a site or "machine" of redemption. These speculatory forms are posited against amnesia, toward preservation of local personal knowledge, and toward remembering and renewal. And artists mining this sense of the archival often create alternative utopic spaces, sites of countermemory beyond the empirical and the manifest.[45]

Giorgio Agamben has analyzed Michel Foucault's discussion of archive as a "system of relations between the unsaid and the said," the inside and outside of language. Agamben amplifies this concept to embrace the "possibility and impossibility of speech," and inserts into this liminal space between the two positions—in the interstices and caesuras—the notion of testimony.[46] Along the trajectory between imminent and achievable notions of evidence and its remoteness or unattainability resides the musings and substantiations of the witness/subject. These thoughts and objects, oral or otherwise, are mobile remnants, defined by Agamben in their most concise form as the poetic word; he imagines the mobility and power of the single word, the simple self-contained fragment, the "redemptive machine." Obama concurs. In human accounts, at once inimitable and common, "There was poetry as well—a luminous world always present beneath the surface, a world that people might offer up as a gift to me, if I only remembered to ask."[47] These chronicles, words, traces, and fragments also suggest and point to something larger. If people make sense of their existence through stories and art generally, it is not done necessarily in isolation (though it can be) but often with and through community, in whatever way one chooses to define it.

Organizing my own essays spurred me to think about how art makes community and how that was manifest in my own life of writing. How the art object's movements from studio to museum or gallery in the twists and turns from public to private accumulates and draws community over time. I wondered how my practice might have performed the same action: both reflecting family traditions (if intellectual ones) and coalescing and building a new world, understanding writing and culture generally as a vocation, intellectual voyage, and political charge. These thoughts brought me to the

notion of community archives: theorizing how artistic communities—be they families of origin, groups, movements, neighborhoods, and so on—create and theorize their pasts, illuminating the dialogic among individuals and the collectives to which they belong, and in which artistic meaning is derived. And seeing this idea of community archives posited in opposition to the official text or document, positioning the notion of the fragmentary versus holistic monuments, as well as the conceptions of multiculture against that of a single calcified monoculture. Pieces written into and from the world, carrying knowledge of that time and moment embedded in them and in this way narrating the story of their migration, their history, and time in the world in form as well as content.[48]

The four-chapter structure of *EyeMinded* seeks to both illuminate and honor the familial dialogues that have shaped my creative output over two decades, as a writer and curator. While my writing is not poetry or plays, personal or social essays of my parents, Hettie Jones and Amiri Baraka, their love of both objects as well as the people who create art, and the appreciation of culture generally, was something I learned early on. My most constant fellow traveler in this world of culture, however, has been my multitalented sister Lisa Jones, a writer and filmmaker. We collaborated as sisters, friends, creative women, and feminists; we made the world in our own image and in the image of each other, from birth. I have also been blessed to meet another cultural traveler in this lifetime, my husband, Guthrie P. Ramsey Jr., a music historian and piano player from Chicago. We started out with a writing collaboration and have been doing things together ever since.

Poems or essays by family members frame the sections of EyeMinded and I have selected my own writings that I feel are in dialogue with the person's work. Another interchange is then created when each family member reads the section and responds to the pairings I have created, offering an introduction to that segment. The more indirect conversations we have as writers are made front and center here. They reflect the writing life and the circulation of ideas, aesthetics, and the creation of meaning, the intersection of voices, as well as the outlines and reaches of each of our own creative concerns. Here the themes that have compelled me again and again—chronicles of African American, contemporary, and women artists, and the communities that form around these creators and their works; sensibilities and ways of making that remain outside mainstream and canonical histories—are found too in the pages of these other family productions.

The collection opens with Part I, "On Diaspora," and my father's poem "Preface to a Twenty Volume Suicide Note" (1957), written before I was born, but dedicated to me upon my arrival. This section includes the essays

that grew out of my experience as a curator for the Johannesburg Biennale and focuses primarily on notions of diaspora and the work of women artists.

Here diaspora is considered in both concrete and abstract valences. On the one hand it is the act of African global dispersion and the subsequent will to reconnection. These linkages are forged across national boundaries, are not bound by the fixities of the nation-state, and attest to the transnationalism of political consciousness and black cultural and political work. However, such black internationalism, as Brent Hayes Edwards points out, also comes with certain risks, embodied in the inadequacies of translation.[49] Yet the fact of translation itself—even that which is putatively "unhappy"—also suggests the substitution of exactitude for flexibility, and notions of suppleness and accommodation, cooperation and forgiveness in the work of transnational process. Diaspora in its more conceptual mode takes as fulcrum the restoration of origins, with migration as exodus, and return as redemption and the promise of new possibilities. Here, Saidiya Hartman tells us, desire for kinship and a sense of place for the dispersed are worked out in the symbolic mirror of the African motherland.[50]

Like me, Amiri too has thought about "America" in its hemispheric equation, the fullness of its linguistic and cultural reach. This impacts what the United States is. As he writes, "it is simply that we want to include the real lives of the people of our world, the whole world. American culture is the creation, for instance, of all Americans. It is the combining of all the nationalities and cultures here that makes up the national character of American culture."[51] In his introductory essay for this volume, which he also calls "EyeMinded," Amiri finds in his assignment the challenge of responding to issues of art in the postnationalist era. He wades through the realities of gender as well as the ambivalent voice of conceptualism and a visual arena that resists didacticism, a singularity of voice, location, and purpose. Baraka dives into it also as an experiential maneuver, and as always finds his place in the new world.

The poem "Eye of the Beholder" by my mother provides the framing for Part II, "In Visioning." Written in the 1970s, it muses on my sense of vision even at that moment, and is what Hettie extrapolates on in her introduction, "Seeing Through." It is an idea of seeing that Jonathan Crary has described as embedded in changes in knowledge and its systems, and elucidated by an "observer" who is inextricably part of the era. The action of observation for Crary takes place intellectually as well as bodily, and demonstrates a body demarcated by "the operation of social power."[52] This too is what I saw and what my mother saw in me. For Hettie, it is the joining of vision in this expanded computation with the "precise language [that] was

important in our house" which was key, along with my notion that there existed an audience for art made up of all manner of intelligent witnesses; these parameters, she insists, molded my writing voice.

In this part of the book the selections reflect on artistic periods and styles through the imagery and profiles of individual artists. It includes writings on Dawoud Bey, Silvia Gruner, and Pat Ward Williams, my well-known interview with David Hammons from 1986, and the essay "Eye-Minded" on Martin Puryear.

"How I Invented Multiculturalism," one of my favorite essays from my sister's collection *Bulletproof Diva: Tales of Race, Sex, and Hair* (1994), introduces Part III, "Making Multiculturalism." I am fascinated by how she so eloquently sums up so much of what we lived through in just a few pages. And I love her humor, her "lip and nerve" as she calls it.[53] She found her language in the genre of satire, yet still in her discussions of contemporary life and culture (popular and otherwise) her investment in the multiracial is always critical and political. Her audacity and self-possession reveal a woman charged and charged up with defining the world she saw and letting the rest of us in on what things looked like now, how landscapes had changed, and where our generation would take it. Hers is a voice resolutely feminist, compelled by the culture of women, but energized as we were by the lessons and textures of African American life and art, living Ntozake Shange's feisty words, "I am a daughter of the black arts movement (even though they didn't know they were going to have a girl!)."[54]

For us art was an actant; there was always a correlation between all manner of cultural productions and their actions in the world. Art allowed us to boldly fly the political flag we knew. "Welcome to my America," Lisa writes, where "cultural pluralism was more than a performance piece for well-heeled art house patrons, but an everyday life led by thousands of Americans, black, yellow, brown, red, and yes, even white."[55] In her essay for this book, "Excuse Me While I Kiss the Sky & Then Fly and Touch Down," she elaborates further on the perspective we share as sisters and collaborators — co-conspirators really — in this grand universe of letters, art, and culture. While I have most often couched my observations in the so-called "objective" voice of scholar and art historian, she has always been the more bold and fearless writer. With a journalist's eye for detail and a novelist's ear for language, Lisa's voice remains distinctly her own, a clear-eyed chronicle (politically astute and hilarious) which shows us how issues of power, race, and gender are lived on a daily basis. My writing in Part III, as the title of her earlier essay suggests, explores the notion of multiculture, along with issues

of transnationalism and postcolonialism, and include pieces on Jean-Michel Basquiat, Pepón Osorio, Cuban artists, and black British artists.

I commissioned my husband Guthrie Ramsey to write "Free Jazz and the Price of Black Musical Abstraction" for my exhibition "Energy/Experimentation: Black Artists and Abstraction, 1964–1980." The artists of the generation who were the focus of the show looked to jazz for directions in their own practice, and particularly to the "free jazz" experimentation that developed in the 1960s.

Guthrie's essay opens the fourth section, which focuses on African American artists' pursuit of "Abstract Truths," their desire to escape the expectation to constantly perform representation. It is an aspiration instantiated, to a certain extent, by the relative newness of their ability to actually control their own images after many centuries of enforced sublimation to others' portrayals; it is a power concomitant with the very notion of the ownership of the body itself. The desire for a utopic imaginary has been an important overarching factor for African American modern artists, one based in the charge to present a narrative that captures their significant and unique perspective. Yet it has also been a burden, a constraint at times on visual creativity. Ann Gibson, among others, has written of the pull toward figuration for African American practitioners occasioned by factors both external and internal.[56] This ambivalence and the movement between the space of bodily representation and the site of total nonobjective ground can be observed in the works of painters like Hale Woodruff, Norman Lewis, Al Loving, and Howardena Pindell. The momentum toward visualization of the recognizable, the knowable, fights the historical loss of the black body, one that has been disappeared by violence and social forces as much as through visual erasure. Another explanation may also be simply the context of American art, for Yve-Alain Bois the "ambiguity of the figure/ground relationship as the very theme of American painting."[57]

Bois's interest in thought that is pictorial and anti-illustrative, whose theorems lie within the technics and phenomenology of the matter/acts/ knowledge that is painting, is something the artists in this section attest to. Yet I would also not limit such notions of art's intellectual perceptions or truth to painting alone for each medium or material assembly has its own way of telling us about the world. As Guthrie points out in his piece opening this section—"Them There Eyes: On Connections and the Visual"—the lessons and models of art's knowledge have circulated easily among us as thought, information, almost as "family gossip." Of course there is meaning in art outside of its life in the social world, knowledge that is made there,

then made available to us. Art is thought and art is history, sometimes the only reliable idea or evidence. The truth telling of art's making offers intellectual formations, ones that can, among other things, give us models of community. The partnership between Guthrie and myself indeed began with our shared wonder at the historical diremptions of things visual as well as musical.

In this final section of *EyeMinded* my writing concerns the Black Arts Movement and its legacy, issues for African American artists choosing to work in abstract styles, and notions of artistic freedom. It includes my essay for the "Energy/Experimentation" catalogue, a piece on abstract shows by black artists at the Whitney Museum in the 1970s, and writing on California conceptualists.

In the pages of *EyeMinded*, myself and others perform our conversations. This book makes public the dialogues that one has with family, friends, mentors, but also with the world one writes from and to. Here the writing life is revealed and celebrated. One may write alone, but it seems to always be in concert.

INTO THE ARCHIVE

In 2008 Columbia University acquired Amiri Baraka's archive, two hundred boxes of manuscripts, audio- and videotapes, correspondence, photographs, and other ephemera.

Recently I visited this material now housed in the Rare Books and Manuscripts Department at Butler Library. Given the format of my essay collection I thought I needed to take at least one initial glance to get some sense of it. Was there anything there of use to me? Was this too my inheritance of manuscripts, letters, pictures, and sounds—much like the letters and registry book Obama accepted with expectations as well as not a little trepidation? Or was this something whose meaning lay elsewhere?

What fascinated me was the raw, unprocessed nature of its elements at that moment—rickety bankers boxes, still covered with the "patina of time"—new to Columbia, as well as new to the official archive. In these containers I witnessed things moving from being part of the fabric of life, along the trajectory toward official knowledge. Yet all told, what they revealed are the materials and the business of being a writer and activist. They show the wear, tear, and use. They narrate their movement through the world.

The artist Renee Green, whose own art has mined and mimed archival practices, has written: "How does one return? To a country, to a place of birth? To a location which reeks of remembered sensations? But what are these sensations? Is it possible to trace how they are triggered and why they

are accompanied with as much dread as anticipation? . . . What does an archive allow?"[58] Indeed, I do see myself passing through these boxes at Butler Library, I remember these times and places written and talked about; find myself too in the images, sounds, and pages and pages and pages. I am there in these pages, and these pages are there in my memory.

In the place of a single linear history with distinct lines of antecedents and succession, the theorist Michel Foucault thinks instead about the synchrony of manifold and coincident universes of knowledge and meaning.[59] This was and is a boon to those of us who study so-called alternative histories—diasporic, planetary—that appear different from canonical narrations, that are modern in ways distinct from a singular Western hegemonic model. We thrive in the multiplicity of synchronic worlds which are finally recognized as existing with their own logic and power, embracing the concept of multiculture as a reality that is quotidian, mundane. In Foucault's schema such discursive formations are multiple, and they are repetitive in their construction. But this repetition is not progression or advance in a hierarchical or linear formulation, it is not a return, it is "not tradition."[60] The density of these practices creates the archive according to Foucault, that which is:

> at once close to us, and different from our present existence, it is the border of time that surrounds our presence, which overhangs it, and which indicates it in its otherness; it is that which, outside ourselves, delimits us. The description of the archive deploys its possibilities (and the mastery of its possibilities) on the basis of the discourses that have just ceased to be ours; its threshold of existence is established by the discontinuity that separates us from what we can no longer say, and from that which falls outside our discursive practice; it begins with the outside of our own language.[61]

The archive is what becomes past as we move toward the future, and its boundaries "deprive . . . us of our continuities."[62] The way we access the archival past, Foucault tells us, is through motions that are at their base archeological—sifting and combing through things already left behind.

Foucault's paradigm for archive is in some ways best thought of on the order of a metaschema, and addresses the notion of archival practice as a fixture of historical and national constructs. In some ways it is a more uncomfortable fit for those microcommunities of users—those creating what I am referring to as community archives—those leaving traces of their existence through material, oral, written, performative cultures that belie their erasure by larger institutional formations. For these users the dismissal of

tradition in Foucault's framework is problematic. The logic of the community archive is on the one hand a site of dialogic relations through cultural formations and the creation and maintenance of cultural meanings. Here "tradition" becomes a way to mark and explain difference, a method to in fact signal that it is one of many discursive units. The rubric of diasporic dispersion embodies migration across the boundaries of space and time. Yet hand in hand with this mobility is the grounding in remembrance: that while one cannot necessarily go back to live in the past as it was lived, one can and does return, revisits. And in doing so one brings a piece, a fragment, forward, making it new, refiguring and re-forming a continuity.[63]

Similarly concerned with dismantling the hierarchy and hegemony of the authorial mode, Foucault and others empty the author function as a regulator of meaning and history. Yet Agamben sees testimony as an authorial role which creates a bridge between the inside and outside of language, a witness who speaks back to the archive, forming a connection between the lived realm and that of the past, the place of community archives. Figures found in the cracks, crevices, breaches, and breaks in the archive, in the shards that prod and prick, and emerge. "It is because there is testimony only where there is an impossibility of speaking, because there is a witness only where there has been desubjectification," as Agamben reminds us.[64] Testimony through trace, sometimes voluminous, is where communities of users—unaccounted for and sublimated by the prescribed boundaries of larger institutional formations and its official archive—inscribe, create, and enjoy meaning.

Thinking through these ideas in the face of my family's capacious archive I ask myself is it really ever over, really ever done with? How is one's mission as an intellectual and citizen of the world, learned from birth, with social justice at the center, how is this life, a move back and forth, not always excavating but actually living this charge to bring histories (one's own?) to light? The histories of African American and diaspora cultures, of American culture lived in its full glory, its untidy inconsistency and ambiguities. Is this past or past lived in the present brought forward made new; is it legacy; is it life?

And does my relationship to the archive at Columbia (as well as others) suggest or frame an approach to my own intellectual work?[65] The constant mining back into the history of art; reconsidering and seeing more fully that which has been erased or denied even when it lives in the archive, lives in the works of art, lives in the stories of those who made these things? How does this activity not only reconstruct history but community and family? Does the archive ever indeed have the final word? Isn't it always being re-

framed and interpreted, seen by new eyes with different information and contexts? In that sense does this discourse indeed "cease to be ours" as Foucault suggests? Or in the exhortations of the talmudic text, "Is it possible that the antonym of 'forgetting' is not 'remembering' but justice?"[66]

How do our actions as historians, intellectuals, people who walk the streets of the metropolis and the countryside intersect with larger global formations of progress? In the manner of Obama's schematic, I want to see my bond to family and community through art as part of a pact with the planet linked through a network of ever-growing circles where planetary commitments are also obligations to self. Is it the place where archives, and my family archives, including literature and art, as documents both private and public, offer a site for mutual recognition, a mediatory interval informed and expanded from the familial gaze, in the oscillating space of engaged tensions, in the area between memory and its future tense, "between continuity and rupture," that moves us forward?[67]

To quote Obama once more: "What is our community, and how might that community be reconciled with our freedom? How far do our obligations reach? How do we transform mere power into justice, mere sentiment into love?"[68]

Toward the end of *Dreams from My Father*, Obama has an epiphany about his search for making family and community while viewing an album of photographs. With his Kenyan sister Auma, he visits the comfortable Nairobi home of his father's third wife, the white American Ruth, who returned with Obama Senior to Africa and raised a family together, until they too split. While leafing through Ruth's family album he sees an "alternate universe"—the places where black and white come together as harmonious, and whole—"fantasies" he'd "kept secret" even from himself. After what he describes as an uncomfortable and tense family encounter, he returns with Auma to her apartment, only to now recognize on her wall one of the same happy family portraits from Ruth's collection.[69]

This visit allows Obama to understand and honor his personal narrative. One that is part of, but not wholly defined by, this situation and from which he creates something new: in Kenya but also within the rest of his family and world. He realizes the history that the photo album represents is not the only story but a partial tale, something that in its materiality is yet unfinished and incomplete. This contextualizes his own interest and investment in countermemory, and universes of microcommunities that contribute to a larger whole.

Sometime in the early 1960s Joseph Hirshhorn purchased the canvas *LeRoi Jones and Family* (1964) from the artist Bob Thompson. It was un-

finished. My mother and father are painted in; my sister and I are only outlines, sketched out in chalk. Thompson painted over another work and a single gnome-like figure shows through, in some ways a substitute for us children. Standing before this painting, as I have on numerous occasions, I am confronted perhaps with some of the same feelings that Obama acknowledges opening the Kenyan photo album: loss, craving the happy, holistic notions of the nuclear family; wishing away the stigma of America's problematic history and inability to accept or acknowledge its own life of multiculture, where "to have mixed is to have been party to a great civilizational betrayal;"[70] seeing in miscegenation a word "humpbacked, ugly, portending a monstrous outcome."[71] A notion perhaps even inscribed in this very painting; in the place where beautiful babies are replaced by a strange deformed creature.

But then there is life! My own memories of a life lived in worlds different but exciting, full of things to learn, understand, enjoy, dance and listen to, see, and live for. Life as fun but life as mission. To tell it, to make people see, know, and accept all of it at whatever cost; a responsibility to the past but also to the present and to the future. To write oneself back into history, as a continual action, as a responsibility not just to oneself but also to community. And in doing so making claims to a notion of community—national and outernational—one where we choose the better parts of our histories and ourselves. To live a conviviality that is spontaneous and organic, an intermixture that is at once banal and subversive in its ordinariness. To contribute to, in Gilroy's words, "contemporary cosmopolitics . . . in the service of planetary humanism and global multiculture . . . openness and undifferentiated love."[72]

In the lower right hand corner of Bob Thompson's LeRoi Jones and Family, ghostly chalk letters hover over the unfinished portion of the painting; ever more faded, a blocky signature emerges. KELLIE, I signed, and in doing so claimed what was partial and provisional, emerged where I was never supposed to, declared this space and my liminality not as a failure but as a site of layering, multiplicity, and possibility, a space even utopic.

Art, like family photography, "is not just about how the family looks in the pictures: it's also about how the pictures look in the family."[73] That is, the manner in which sculpture, painting, and other forms mediate the intersection of human gazes and needs. It is how we recognize the power, desire, and possibilities as well as the uncertainties and vulnerabilities that settle on objects and the methods and actions we find to maintain the emotional connection that flows between us there. It is thinking about the contexts in which art can "reactivate and rembody more distant social/national

and archival/cultural memorial structures by reinvesting them with resonant individual and familial forms of mediation and aesthetic expression," its role in communal life, tradition, and patterns of remembrance.[74] These are among art's gifts, its ability to provide a manner for people to see, know, and understand themselves in the world.

Wilmington, Del. | July 2009

NOTES TO INTRODUCTION

1. For a discussion of some of these ideas see Marianne Hirsch, "Introduction: Familial Looking," in Marianne Hirsch, ed., *The Familial Gaze* (Hanover, N.H.: University Press of New England, 1999).

2. Barack Obama, *Dreams from My Father: A Story of Race and Inheritance* (New York: Random House, 2004, originally 1995), 327, 329, 331.

3. Paul Gilroy, *Postcolonial Melancholia* (New York: Columbia University Press, 2005), xv.

4. Ibid., 70. Other recent writings on communities as collectives of uncommonness include Elizabeth Grosz, "Architectures of Excess," in *Architecture from the Outside, Essays on Virtual and Real Space* (Cambridge: MIT Press, 2001), Kwame Anthony Appiah, *Cosmopolitanism: Ethics in a World of Strangers* (New York: W. W. Norton, 2006), and Kobena Mercer, ed., *Exiles, Diasporas and Strangers* (Cambridge: MIT Press, 2006).

5. Adrienne Rich, "Disloyal to Civilization," in *On Lies, Secrets, and Silence: Selected Prose, 1966–1978* (1979), quoted in Gilroy, *Postcolonial Melancholia*, 71 n. 9. The structure of interculture defined by "teaching the conflicts" is from Gerald Graff, "'Teach the Conflicts': An Alternative to Educational Fundamentalism," in Betty Jean Craig, ed., *Literature, Language and Politics* (1988), quoted in David Theo Goldberg, "Introduction: Multicultural Conditions," in *Multiculturalism: A Critical Reader* (Cambridge, Mass.: Blackwell, 1994), 19.

6. Theories of multiculturalism abounded in the 1990s. Largely addressing the experience in the United States, it was seen as the outcome of the civil rights struggles of the 1960s and the expansion of identity formation emerging in structures of late capitalism and postmodernism. Among many useful texts see Goldberg, *Multiculturalism*; Avery F. Gordon and Christopher Newfield, eds., *Mapping Multiculturalism* (Minneapolis: University of Minnesota Press, 1996); and Hazel V. Carby, *Cultures in Babylon, Black Britain and African America* (New York: Verso, 1999), particularly "Dispatches from the Multicultural Wars." Like Paul Gilroy, Vijay Prashad has created another term—polycultural—to replace "multicultural" as a way to talk about multiracial societies in a global world. See Vijay Prashad, *Everybody Was Kung Fu Fighting: Afro-Asian Connections and the Myth of Cultural Purity* (Boston: Beacon Press, 2001).

7. Obama, *Dreams from My Father*, 141.

8. Gilroy, *Postcolonial Melancholia*, 99.

9. Some of this information and more can be found on the New Museum of Contem-

porary Art's website (www.newmuseum.org), as part of the Bowery Artist Tribute, a continuing project documenting artists' development of the Bowery area of SoHo, the museum's new home. I provided content for the Wyn Loving entry as well as that of my own.

10. The Park Place group championed sculpture, painting, and music whose versions of illusionism and minimalism have only recently made it into canonical accounts of art making in that period. Paula Cooper was an integral force in the gallery aspect of the group's project and with its shuttering in 1967 she opened her own space. See Linda Dalrymple Henderson, *Reimagining Space: The Park Place Gallery Group in 1960s New York* (Austin, Tex.: Blanton Museum of Art, 2008).

11. Suzan-Lori Parks, *The Death of the Last Black Man in the Whole Entire World* (1989).

12. The embrace of Black Nationalism generally and the rise in organizing along racial lines in the 1950s and 1960s was a response to continuing segregation and unrelenting discrimination in the United States. As a strategic political stance it became a model of organizing that energized others throughout the country—youth, Latinos, Native and Asian Americans—and which would be adopted for a time to gain greater footholds into U.S. institutional structures. From 1974 on Amiri increasingly eschewed this form of political organization for one that embraced multiracial coalitions and a greater critique of class, based on international socialism. These changes over time by my father framed my understanding of multicultural politics as well. See Komozi Woodard, "It's Nation Time in NewArk: Amiri Baraka and the Black Power Experiment in Newark, New Jersey," Jeanne F. Theoharis and Komozi Woodard, eds., *Freedom North: Black Freedom Struggles Outside the South, 1940–1980* (New York: Palgrave MacMillan, 2003), and Prashad, *Everybody Was Kung Fu Fighting*, 136.

13. Amiri Baraka, *The Autobiography of LeRoi Jones / Amiri Baraka* (Chicago: Lawrence Hill, 1997); James Edward Smethurst, *The Black Arts Movement: Literary Nationalism in the 1960s and 1970s* (Chapel Hill: University of North Carolina Press, 2005); and Komozi Woodard, *A Nation within a Nation: Amiri Baraka (LeRoi Jones) and Black Power Politics* (Chapel Hill: University of North Carolina Press, 1999).

14. For a compelling reading of Slave Ship as environmental theater see the chapter entitled "1969: Black Art and the Aesthetics of Memory," in Cheryl Finley's forthcoming *Committed to Memory: The Slave Ship Icon in the Black Atlantic Imagination* (Princeton: Princeton University Press).

15. Hirsch, "Introduction: Familial Looking," in Hirsch, *The Familial Gaze*; and Marianne Hirsch, "The Generation of Postmemory," *Poetics Today* 29 (1) (2008): 103–28.

16. I chose these four family members to structure the dialogic approach to this book. However, there are other creative kin to acknowledge that remain a part of this conversation: in the literary realm there is my brother Ras Baraka and my cousin Loretta Green, a journalist for many years with the *San Jose Mercury News* [California]. In the worlds of writing, music, and media there is my stepmother Amina Baraka; and of media production my brother Amiri Baraka Jr. and sister Dominique DiPrima along with her husband Guillermo Cespedes. There are, of course, younger generations, poised to step into the public realm very soon.

17. Jacques Derrida, *Archive Fever: A Freudian Impression*, trans. Eric Prenowitz (Chicago: University of Chicago Press, 1995), 75.

18. Giorgio Agamben, *Remnants of Auschwitz: The Witness and the Archive* (New York: Zone Books, 2002).

19. Derrida, *Archive Fever*, 75.

20. For a discussion of this project see Okwui Enwezor, "Archive Fever: Photography between History and the Monument," in *Archive Fever: The Uses of the Document in Contemporary Art* (New York: International Center of Photography, 2008), 45–46.

21. "Progeny" traveled to Bernice Steinbaum Gallery in Miami, Florida, the Miriam and Ira D. Wallach Art Gallery at Columbia University in New York, and Forty Acres and a Mule Gallery in Sacramento, California, during 2008–2009. The exhibition was curated by Kalia Brooks, Deborah Willis's niece. Artist and scholar Deborah Willis has also addressed similar ideas of family creativity and transmission in her own writings. See Deborah Willis, *Family History Memory: Recording African American Life* (New York: Hylas, 2005); and Deborah Willis, ed., *Picturing Us: African American Identity in Photography* (New York: New Press, 1994).

22. Obama, *Dreams from My Father*, 204.

23. This acceptance of heterogeneity was accompanied by ideas of institutional critique, with the notions that museums, historically, had been spaces whose coherence depended on the homogeneity of viewpoints and practitioners, and frameworks that coalesced the power of the elite and nation-state. See Douglas Crimp, *On the Museum's Ruins* (Cambridge: MIT Press, 1997). Jennifer Gonzalez offers a new appraisal of "institutional critique" in *Subject to Display: Reframing Race in Contemporary Installation Art* (Cambridge: MIT Press, 2008), 67–68; see also John C. Welchman, ed., *Institutional Critique and After* (Zurich: JRP/Ringier, 2006), and Alex Alberro and Blake Stimson, eds., *Institutional Critique: An Anthology of Artists' Writings* (Cambridge: MIT Press, 2009).

24. Chon Noriega, "On Museum Row: Aesthetics and the Politics of Style," *Daedalus* 128 (3), "America's Museum" (1999): 59. See also Jennifer Gonzalez, *Subject to Display*, 11. For more on the concept of the representation of "marginality" within the museum see Jan Nederveen Pieterse, *Ethnicities and Global Multiculture* (Lanham, Md.: Rowman and Littlefield, 2007), particularly "Multiculturalism and Museums."

25. See Noriega, "On Museum Row," Julie Ault, ed., *Alternative Art New York, 1965–1985* (Minneapolis: University of Minnesota Press, 2002); Francis Frascina, *Art, Politics and Dissent: Aspects of the Art Left in Sixties America* (Manchester, U.K.: Manchester University Press, 1999); and Kellie Jones, "To the Max: Energy and Experimentation," and "It's Not Enough to Say 'Black Is Beautiful': Abstraction at the Whitney 1969–1974," in this book.

26. Indeed, Obama becomes a community organizer in 1983 to create change in the government and the country from the grass roots.

27. This is not to discount the intersection of desires on the part of everyday viewing audiences interested in Basquiat's art and life and those of powerful collectors with a strong financial stake in the work. See Noriega, "On Museum Row"; and Ivan Karp, Corinne A. Kratz, Lynn Szwaja, and Tomás Ybarra-Frausto, eds., *Museum*

Frictions: Public Cultures/Global Transformations (Durham: Duke University Press, 2006).

28. Charles Taylor, *Multiculturalism and "The Politics of Recognition"* (Princeton: Princeton University Press, 1992).

29. Frantz Fanon, *The Wretched of the Earth* (New York: Grove Press, 1963).

30. "In the Tropics" was shown at PS 39/Longwood Arts Project in the Bronx, March 22 — April 19, 1986. It included Charles Abramson, Terry Adkins, Roger Anthony, Keiko Bonk, Robert Colescott, Papo Colo, Thom Corn, Marina Gutierrez, Skoman Hastanan, Janet Henry, Kate Kennedy, Marilyn Lerner, Manuel Macarrulla, Pepón Osorio, Catalina Parra, Lorna Simpson, Vincent Smith, and David Wojnarowicz. For a detailed description of "Carmella and King Kong" see Lisa Jones, "She Came with the Rodeo," in *Bulletproof Diva: Tales of Race, Sex, and Hair* (New York: Doubleday, 1994).

Housed in a former elementary school, PS 39/Longwood Arts Project had both gallery and artist studio spaces. It formed part of the activities of the Bronx Council on the Arts then run by Bill Aguado, who in that position supported the arts in the Bronx for thirty years. See David Gonzalez, "Arts Leader Who Gave Bronx Culture Respect and Renaissance," *New York Times*, July 10, 2009, A19–A20.

31. For a wonderful account of Wilson's artistic development see Jennifer Gonzalez, *Subject to Display*, chapter 2.

32. Broida eventually donated his collection to the Museum of Modern Art. See Carol Vogel, "The Modern Gets a Sizable Gift of Contemporary Art," *New York Times*, October 12, 2005, E1.

33. The Jamaica Arts Center, now known as the Jamaica Center for Arts and Learning, is still in existence.

34. My ability to organize a major international exhibition from the precincts of an urban community art center was occasioned by major funding in place just for this purpose. In 1988 the National Endowment for the Arts, Rockefeller Foundation, and the Pew Charitable Trusts joined with the United States Information Agency to support the Fund for U.S. Artists at International Festivals and Exhibitions. Administered by the Institute of International Education (which manages the Fulbright awards), the fund was set up to provide greater exposure for U.S. artists abroad. Given that it was the late 1980s, one prominent goal was to have the United States represented by a diversity of artists, not the just the status quo. This funding enabled smaller organizations like the Jamaica Arts Center to apply to participate on the international stage. After fifteen years the fund was disbanded in 2003 for financial reasons. Unfortunately this allowed selection for major international exhibitions to default to large institutions with bigger budgets which had been the previous model for all but that decade and a half. Case in point: the 2009 participation at the Venice Biennale was organized by the Philadelphia Museum of Art. See Nan Robertson, "U.S. Agencies and Foundation Join to Aid Artists," *New York Times*, February 24, 1988, C19.

35. "US-UK Photography Exchange" had been my summer show at the Jamaica Arts Center and I managed to bring all the artists to the openings in New York as well as London. The exhibition was on view in Queens July 12 — September 1, 1989. It

opened in London sometime in November of that year and toured England for eighteen months. The photographers included Dawoud Bey, Mikki Ferrell, and Charles Biasiny-Rivera from the United States and Rotimi Fani-Kayode, Maxine Walker, and Ingrid Pollard from England. David A. Bailey was the guest essayist.

36. This was the case with two of the exhibitions I did in London. "US-UK Photography Exchange" was done in this manner. It was in the previous year, however, that I first worked this way. "TransAtlantic Traditions: Women Photographers from the USA and Puerto Rico" went to Camerawork Gallery from September 13 to October 15, 1988. It was part of the Spectrum Women's Photography Festival and included works by Lorna Simpson, Coreen Simpson, Nina Kuo, and Freda Medin. The British photographer Ingrid Pollard helped me make the original contact and championed the project for the festival, attesting to the strong feminist connections that we were also building during this time.

37. My emphasis. Courtney J. Martin, "Cyclones in the Metropole: British Artists, 1968–1989," Ph.D. dissertation, Yale University, 2009, 7. See also Coco Fusco, "A Black Avant-Garde? Notes on Black Audio Film Collective and Sankofa," in *English is Broken Here: Notes on Cultural Fusion in the Americas* (New York: The New Press, 1995).

38. My last large project dealing with Black Britain in this period was the exhibition "Interrogating Identity." The show considered the notion of what we would now call the African diaspora through an interrogation of the designation "black" in the United States, England, and Canada. I was co-curator of the exhibition with Thomas Sokolowski, then director of the Grey Art Gallery and Study Center at New York University. "Interrogating Identity" was on view in New York March 12– May 18, 1991. The show's extensive tour included the Museum of Fine Arts, Boston; Walker Art Center, Minneapolis; Madison Art Center, Wisconsin; Center for the Fine Arts, Miami; Oberlin College Gallery, Ohio; Duke University Museum of Art, Durham, N.C. It was among the first museum exhibitions to present these artists in the United States. It paralleled the exposure of this work in the mainstream of Britain itself with the exhibition "The Other Story" at London's Hayward Gallery in 1989, and the subsequent mainstreaming of black British artists. The artists who participated in "Interrogating Identity" were Rasheed Araeen, Rebecca Belmore, Nadine Chan, Albert Chong, Allan deSouza, Jamelie Hassan, Mona Hatoum, Roshini Kempadoo, Glenn Ligon, Whitfield Lovell, Lani Maestro, Lillian Mulero, Ming Mur-Ray, Keith Piper, Ingrid Pollard, Donald Rodney, Yinka Shonibare, and Gary Simmons. From 1990 to 1993 I was also a board member of the London-based journal *Third Text*.

39. Trey Ellis, "The New Black Aesthetic," *Callaloo* 12 (1) (1989): 233–43; and Greg Tate, "Nobody Loves a Genius Child: Jean Michel Basquiat, Flyboy in the Buttermilk" (1989), as well as his earlier "Cult-Nats Meet Freaky Deke" (1986), both originally published in *The Village Voice* and collected in Greg Tate, *Flyboy in the Buttermilk* (New York: Fireside, 1992). For a feminist perspective see Lisa Jones, "She Came with the Rodeo."

40. Nelson Mandela quoted in Jovial Rantao, "Museums Must Rewrite History, Says Mandela," *Cape Argus*, September 25, 1997; see also Leslie Witz, "Transforming

Museums on Postapartheid Tourist Routes," in Karp, Kratz, Szwaja, and Ybarra-Frausto, *Museum Frictions.*

41. Obama, *Dreams from My Father*, 427.

42. Enwezor, "Archive Fever," 30.

43. Trevor Smith, "Sculpture: A Minor Place," in *Unmonumental: The Object in the 21st Century* (New York: New Museum of Contemporary Art, 2007), 190. Hal Foster has labeled these unexpected constructions "bad combinations," at once "preposterous [and] tendentious" as well as utopic. Hal Foster, "An Archival Impulse," *October* 110 (fall 2004): 20–21.

44. Hirsch, "The Generation of Postmemory," 111, 124.

45. The notion of remnant as "redemptive machine" comes from Agamben, *Remnants of Auschwitz*, 163. It also parallels Foster's concept of the utopic found in the uneasy amalgamations of some contemporary art practices.

46. Agamben, *Remnants of Auschwitz*, 144–45.

47. Obama, *Dreams from My Father*, 191.

48. Thanks to Guthrie P. Ramsey Jr. for helping me think through the idea of community archives, which shares similarities with his concept of "community theaters." See Guthrie P. Ramsey Jr., *Race Music: Black Cultures from Bebop to Hip-hop* (Berkeley: University of California Press, 2003).

49. Brent Hayes Edwards, *The Practice of Diaspora: Literature, Translation, and the Rise of Black Internationalism* (Cambridge: Harvard University Press, 2003); and Brent Hayes Edwards, "The Uses of Diaspora," *Social Text* 66 (spring 2001): 45–73. See also the special issue of *Radical History Review*—"Reconceptualizations of the African Diaspora" 103 (winter 2009).

50. Saidiya Hartman, "The Time of Slavery," *South Atlantic Quarterly* 101 (4) (2002): 757–77; and Saidiya Hartman, *Lose Your Mother: A Journey along the Atlantic Slave Route* (New York: Farrar, Straus and Giroux, 2007).

51. Amiri Baraka, "Multinational, Multicultural America versus White Supremacy," in Ismael Reed, ed., *MultiAmerica: Essays on Cultural Wars and Cultural Peace* (New York: Viking, 1997), 393.

52. Jonathan Crary, *Techniques of the Observer: On Vision and Modernity in the Nineteenth Century* (Cambridge: MIT Press, 1990), 3.

53. Lisa Jones, *Bulletproof Diva*, 3.

54. Ntozake Shange cited in Alan Read, ed., *The Fact of Blackness: Frantz Fanon and Visual Representation* (Seattle: Bay Press, 1996), 159.

55. Lisa Jones, *Bulletproof Diva*, 4, 10.

56. Ann Gibson, "Recasting the Canon: Norman Lewis and Jackson Pollock," *Artforum* 30 (March 1992): 66–72. See also Paul Gilroy, "Cruciality and the Frog's Perspective," *Third Text* 5 (winter 1988–1989), 33–44; and Kobena Mercer, "Black Art and the Burden of Representation," *Third Text* 10 (Spring 1990), 61–78.

57. Yve-Alain Bois, *Painting as Model* (Cambridge: MIT Press, 1990), 249.

58. Renee Green, "Survival: Ruminations on Archival Lacunae," in Beatrice von Bismarck et al., *Interarchive: Archival Practices and Sites in the Contemporary Art Field* (Cologne: Konig, 2002), 149, 150.

59. Michel Foucault, *The Archaeology of Knowledge*, trans. A. M. Sheridan Smith (New York: Pantheon Books, 1972), 167.

60. Ibid., 130.

61. Ibid., 130–31.

62. Ibid., 131.

63. On art and structures of remembrance see Pierre Nora, "Between Memory and History: Les Lieux de Memoire," in Geneviève Fabre and Robert O'Meally, eds., *History and Memory in African American Culture* (New York: Oxford University Press, 1994); and Cheryl Finley, "Committed to Memory: The Slave-Ship Icon and the Black-Atlantic Imagination," *Chicago Art Journal* 9 (1999): 2–21.

 Chon Noriega has discussed the material formations of memory in the paintings of Carmen Lomas Garza. As he points out, remembrance of the Chicano presence in Texas does not dwell on exterminating violence but on the linkage of culture and tradition. Similarly, African American artists, especially in the nineteenth century and early twentieth, focus on compositions of lush beauty and captivating figures as elements that are forward and progressive. They are more concerned with sketching a utopic imaginary than outlining the contours of a more brutal reality. Noriega, "On Museum Row," 65.

64. Agamben, *Remnants of Auschwitz*, 158.

65. Hettie Jones's archive was acquired by Columbia University in 2009. A baby picture of mine was recently discovered in the Charles Olson Archive at the University of Connecticut, Storrs. Thanks to Hettie Jones and Fred Buck for this information.

66. Talmud Yerushalmi quoted in Derrida, *Archive Fever*, 77.

67. Hirsch, "The Generation of Postmemory," 106.

68. Obama, *Dreams from My Father*, 438.

69. Ibid., 342–43, 345.

70. Gilroy, *Postcolonial Melancholia*, 125.

71. Obama, *Dreams from My Father*, 9.

72. Gilroy, *Postcolonial Melancholia*, 80; on intermixture see also 124 and 150.

73. Jane Gallop and Dick Blau, "Observations of a Mother," in Hirseh, *The Familial Gaze*, 82.

74. Hirsch, "The Generation of Postmemory," 111.

On Diaspora

PART ONE

EyeMinded

Is also obviously I minded, as Ms. Kellie shows herself to be. What it is she wants to see but also what it is, who it is, she wants to be. For reasons many could speculate about she has given me a large clutch of writings mostly about women artists and performers, save for the Cuban artist Kcho, and David Hammons, an artist whose work I knew and respected back in the 1960s in New York, when the BAM (Black Arts Movement) exploded. His work then was about what much of the most loudly registered work of Black artists of that period concerned, a newly focused outburst of intensity on the liberation of the Afro American people from national oppression, racism, as well as from the exploitation shared with most of the American people, though our work during those years was sharply Black Nationalist. His work has now grown much more subtle.

But most of the art in this part of Kellie's book is in fact post– or un–Black Nationalist in theme. Some of it has revolution only as an implied perspective given the normal aesthetic hence social order of the United States and its sister imperialist thralldoms.

Most of it is "conceptual art," which I have always thought of as related to newspaper puzzles and word games. Whose content consisted mostly of people trying to tell you how much smarter than you they are. Usually they ain't!

So I must confess to being daunted by what I, from jump, didn't claim to dig too much. Plus the mountain of this paper work that I actually did read, amidst mountains of other paper work to which I am still pledged to read, made this a task of iron will based, of course, on sibling insistence and some portion of curiosity.

First, according to my own ideological aesthetic, how and where would this work or these works she was presenting to me to comment on sit in my own measure and

understanding? The contradictory discourses that shuffle back and forth hiding or obscuring each from the other are whether I was writing about Kellie's writing about the works or whether I was writing about the works themselves.

Reading any work of criticism or analysis, our concern must first be with how much of the work that is the focus of the critical work can actually be understood from what the author has said about it. Hence, there is no doubt that Kellie has achieved, in each case, a clarity about these artists and their work that I knew little of. A function of this fundamental clarity is the added clarity afforded a whole area of contemporary art, at least for me.

The question remained, remains, what is it that art does if it does not openly try to smash what aspects of bourgeois, racist society it confronts? From this is what was intriguingly opened wider for me in this reading. Specifically, What and Where are you in this hell created by slavery and capital (which includes colonialism and imperialism)? What has it done to you and how are you reacting or acting toward it? It is the specificity of that sensitivity and response that must be measured. In other words, as this Happy Shoe Year passes, we cannot merely measure resistance to evil by the flying shoe! But if not by the Shoe itself, there must be a parable for and analogy to that paean of open rebellion against the Bush'it. Or so my deepest measure of the use of art, the functional utilitarian mode of revolutionary art.

But what of music, where the musicians are not openly chanting "throw that shoe, brother, sister, make sure it whacks him squarely on the knot!" Its effectiveness could be diluted if the piece is dull or uninspired. The words all but wasted as it were. And then music, the grandest of "abstractions," does not even need words to mean. That is why there are happy songs and sad songs, songs of repose and songs of excitement, songs of longing and songs of satisfaction. With no lyrics at all.

There are songs of signification as there are words of signification; Africans diasporically, likewise black Americans, have mastered this historic art in all its disciplines exquisitely. "Everybody talking about heaven ain't going there," they sang in their masters' faces even while slaves. There must also be images of signification! So in these works that are discussed we must see the work discussed clearly, as well as what are its proportions and pretensions. And what exactly is it signifying?

What do these works aspire to do? Prof. Jones does her best to deliver some aspects of the artists' conception to us. It is called conceptual art, therefore we want to know, through the work itself, what is the concept we are being exposed to, but also as my old friend Morris Hines used to say, "and then, so what?"

Using my space limitations as an excuse I will only comment directly on the first two exhibitions Prof. Jones has written about, though after reading her commentary I am now at least aware of the evolving work of Lorna Simpson and the Cuban artist Kcho, in an interview done by Prof. Jones when he was in New York that I

found very interesting, especially since Miami is in the hands of "Gusanos" (anti-Castro Cubans)!

In the piece "A.K.A. Saartjie: The Hottentot Venus in Context (Some Recollections and a Dialogue)," the dialogue between black feminist artists — the proxy of feminism as an ideology representing whomever — and the world in which they are wrapped and the self which wraps that world inside them, Prof. Jones says, "Since the late 1980s, African American women artists in particular have begun to reclaim Saartjie Baartman as a heroine." This is interesting especially in light of the fact that Barack Obama's inaugural poet, Elizabeth Alexander, called her first book *The Venus Hottentot*. Her words seem to confirm what Prof. Jones had drawn from these South African women's take on the vH, a black South African woman taken to Europe where she thought she was "the family entrepreneur" only to find that she was displayed as some kind of freak. Her buttocks and labia until recently (2002) still on exhibit at the "muse / de l'Homme on a shelf / above Broca's brain." She goes further in the poem: "Since my own genitals are public / I have made other parts private."

Prof. Jones was rejected in her first attempt to put together an exhibit which would, in her words, "recuperate Saartjie: write her the most beautiful poems, make the most exquisite art in her name, tell her centuries later that we dug where she was coming from, let her know that we recognized her beauty *and* her pain, whisper that she had not died in vain," but she discovers that even in South Africa there is a resistance to this reclamation, that there are people who resist this sentiment or more properly are closer to the European colonial attitude toward this abused and exploited black woman who have that same attitude even toward Themselves.

The second trip (Second Johannesburg Biennale) of this "colored looking" curator, the show "Life's Little Necessities: Installations by Women in the 1990s" was allowed. The intercontinental dialogue with the participating artists about the vH which followed the show, which the curator includes in these writings, shows a more diverse reaction to the "tail" of the vH than the curator's initial perception from across the water. This would be one way to understand the diversity of perception of Anything which exists naturally among the Pan-African peoples. Words or Works. But the fundamental address was still to racial and gender oppression.

The entire smog of reception can be reduced to Commerce, where the folk wisdom about Negroes and the pig applies: that the only part of said beast they don't consume is its oink. This relates to the question of the oppressor white or male chauvinist that women, doubly oppressed by class and gender, and women of color who are triply oppressed, not just by class and gender but also by "race," can be completely consumed and that if we put the oink in a book it is consumed as well. Though, usually, we are lucky (or un) if we are paid attention, never much coin.

What is important that Prof. Jones has done with her roundtable is flesh out (really) a depth of concerns by which the Imprisonment by money, by nationality ("race"), by class, and by gender makes us "consent" to be slaves. Though the installation presents various eyes on gender exploitation, its deeper vibe is to let us understand that the entire social system with its economic and political packaging is designed so our bodies, minds, and futures are inferior, actually by limitation and abuse or with the lies of racist description. The idea that Saartjie Baartman "consented" to become the VH is itself obscene distortion. As if black people across the world volunteered to be enslaved, or dragged across the world and made chattel, or colonized or live in a dangerous housing project in the Newarks of the world and be uneducated and unemployed.

The "Little Necessities" exhibit moved these bold concerns into the area of "sexual agency" and the curator explains how these artists' work demonstrates sexuality as an exploited property of women whether the still obvious fact that whatever the corporation wants to advertise it will use a (white) woman. But even with other nationalities sexual exploitation is what is doing the selling. Jones complains that "a performer like Madonna receives kudos for her stunning self-representation, evocative creative fictions, and salacious ironies . . . [but] women of color are rarely allowed as much aesthetic freedom in the realm of the erotic." But freedom is freedom, unfreedom is un. No matter the discussion.

Jones quotes women rappers whose aggressive decision "to speak their mind" she equates with artists in this show. The question remains by what means can these minds be filled with the world's real meanings and meanwhile how do we do something about the fact that as one of the artists, Tracey Rose, after telling us about receiving obscene phone calls regularly, says that there is a rape every eighty-four seconds. Too often, as artists, we are limited by our idea that we have no limitations.

The most important characteristic of these essays is that they can introduce you to a range of specific artists, but also monitor how a philosophical grounding can produce an aesthetic that is itself as radical in some ways as the ideas it is trying to project.

Newark, N.J. | December 31, 2008

Preface to a Twenty Volume Suicide Note

For Kellie Jones, born 16 May 1959

Lately, I've become accustomed to the way
The ground opens up and envelopes me
Each time I go out to walk the dog.
Or the broad edged silly music the wind
Makes when I run for a bus . . .

Things have come to that.

And now, each night I count the stars,
And each night I get the same number.
And when they will not come to be counted,
I count the holes they leave.

Nobody sings anymore.

And then last night, I tiptoed up
To my daughter's room and heard her
Talking to someone, and when I opened
The door, there was no one there . . .
Only she on her knees, peeking into

Her own clasped hands.

Originally published in *Preface to a Twenty Volume Suicide Note*.
New York: Totem Press in Association with Corinth Books, 1961.

3

A.K.A. Saartjie

The Hottentot Venus in Context
(Some Recollections and a Dialogue)
1998/2004

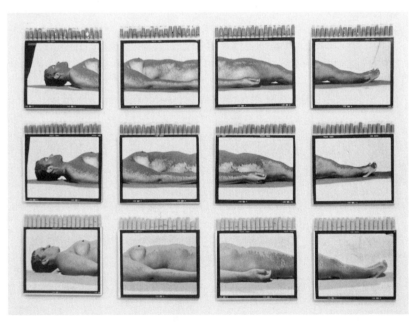

Berni Searle, *Girl*, from the "Colour Me" series, 1999. Mounted photographs, jars, spices, twelve photographs 21.26 x 17.72 inches each. Photo credit: Jean Brundrit.

A decade ago I put together a proposal for an exhibition on the image of the Hottentot Venus. Titled "Reclaiming Venus," the show was motivated by numerous African American women cultural practitioners who began to take up the theme in the late twentieth century. My first inspirations were visual artists, Renee Green, Tana Hargest, Lorna Simpson, Carla Williams, and Deborah Willis, and writers Elizabeth Alexander, Lisa Jones, and Suzan-Lori Parks. As one version of my prospectus read:

Reclaiming Venus

Curator—Kellie Jones

In the early nineteenth century, Saartjie Baartman, a Khoi-San woman of southern Africa, was displayed publicly throughout Europe as the "Hottentot Venus." Exhibited as a live anthropological specimen, European fascination with her buttocks and genitalia was the cause for such spectacle. Upon her death, Saartjie's labia were dissected and installed in the Musée de l'Homme where the famous "Hottentot Apron" remains to this day.

Since the late 1980s, African American women artists in particular have begun to reclaim Saartjie Baartman as a heroine. They have created work that considers her objectification in light of contemporary ideals of beauty and racial and gender stratifications. This show would explore such work but also more broadly examine issues of female agency, how women claim and control their bodies and sexuality in the 1990s.

In addition to art objects, video plays an important role in the show. In collaboration with scholar Fatimah Tobing Rony, I would like to create a video/film component that looks at misogyny and female objectification in the genre of music video, but also includes video makers who are not afraid to affirm and contemplate the power of the body—sensual, erotic or otherwise.

I am especially interested in addressing young women about feminist aspiration and action, concepts which seem to have been eclipsed in the last twenty years particularly in the realm of popular culture.

Over the years I was unsuccessful in finding a home for the show in the United States. When Okwui Enwezor invited me to contribute an exhibi-

tion to the Second Johannesburg Biennale in 1997, I just knew this was my chance to finally see "Reclaiming Venus" come to fruition. I was wrong. For one thing Okwui was dead set against the idea. I had not yet read his now classic essay "Reframing the Black Subject: Ideology and Fantasy in Contemporary South African Representation," in which he states:

> The Hottentot Venus, whose supposedly horrendous-looking vagina is now preserved in formaldehyde in a museum in France, and the black man on the auction block, as objects of denigration, become props of . . . ideological fantasy, the degenerative sketch from which whiteness stages its purity. These two historical scenes, in which the black body has been tendered as display, reproduce the abject as a sign of black identification.[1]

Of course I was miffed to have the show rejected once again. But I rallied to produce the exhibition "Life's Little Necessities: Installations by Women in the 1990s."[2] At the Johannesburg Biennale I was able to explore some of the same ideas of women's agency, power, and sexuality for which the Hottentot Venus was an emblematic figure. The context of the Biennale and South Africa also focused the show more centrally around concepts of the global, transnational, and postcolonial. Okwui's action had also saved me from stepping smack into the midst of a controversy in the post-apartheid milieu surrounding race, gender, authority, and nudity, and more specifically the seeming appropriation of the nude black female body by others. The responsibilities of artists, critics, and curators, notions of censorship, issues of historical trace in new images, and themes such as "representational violence" were debated over email, in the press, on panels, as well as in books and essays printed somewhat later.[3]

Undeterred I decided to stage a dialogue on the subject of the Hottentot Venus as a way to tackle ideas of the body on display, women and agency, creativity and embodiment. What does the body say? Does gesture function as its own language? Are terror and pain inscribed in the body then "written" by the corporeal form? Re-membered there? If Saartjie Baartman's body is initially conceived by the West as a monstrous one, evincing a grotesque and "hyperbolic sexuality,"[4] what does that infer about the intersection of race and gender in theories of the monstrous? As Rosi Braidotti has insightfully noted, the cipher of the monster organizes difference. Over time it has located otherness as geographical, theological, anatomical, and cybernetic.

> The monster is neither a total stranger nor completely familiar; s/he exists in an in-between zone. . . . The monstrous body, more than an object, is a shifter, a vehicle that constructs a web of interconnected and

yet potentially contradictory discourses about his or her embodied self. Gender and race are primary operators in this process. . . . The monster is a process without a stable object. It makes knowledge happen by circulating sometimes as the most irrational non-object. . . . It will never be known what the next monster is going to look like; nor will it be possible to guess where it will come from. And because we *cannot* know, the monster is always going to get us.[5]

By embracing this body deemed in the West as monstrous, excess, or as folks say, just "extra" (that's what's up!), we acknowledge the authority that our physical presence holds. In staging this dialogue on the Hottentot Venus I wanted to continue discussions on power, diversity, and solidarity among women in the South African context. Perhaps I also assumed it might be the closest I would ever get to bringing my former concept into view.

SOME RECOLLECTIONS/1998

A.K.A. Also Known As. One of Saartjie (now more frequently Sarah)[6] Baartman's aliases (stage names? noms de guerre?) was Hottentot Venus. We may never know the name she was born with, how she was called by the Khoi or San that identified her as one of their own.[7] Did these words signify beauty, star, quick-wit, lover? Did their sonorous clicks (too difficult for the Dutch to master) wrap her in the safe space of community?

Writing as an African American woman, for me, Saartjie as the Hottentot Venus, represented an image of sexualized black femininity. The emotions of disgust/longing that her corporeality raised among some is not unknown to black women, especially those who recognize Saartjie's stunning form as their own.

In that body I didn't see the abject, but a sister who thought she would use what she had to get what she wanted (to paraphrase 1970s soul singer Lyn Collins). Showing off your body, which did not carry the same taboo as it did in Western society, might have seemed a bit easier than working the *kraal* of one's *Baas*. In any case it was supposed to be a short gig with a big paycheck. But like most of the misinterpretations advanced under the colonial state, no one mentioned anything about cages, zoo animals, the cold, isolation, groping, stares, what it meant to be the freak of the week; and even after death, not to be allowed to rest in peace but to be further cut, cast and displayed for eternity.

Like other African American women, I wanted to recuperate Saartjie: write her the most beautiful poems, make the most exquisite art in her name, tell her centuries later that we dug where she was coming from, let

her know that we recognized her beauty *and* her pain, whisper that she had not died in vain. But after visiting South Africa for the first time, I began to question *my* appropriation of Saartjie's black femininity, when I discovered that in her own country the Hottentot Venus was a contested symbol.

First of all "Hottentot"—the misidentification of the Khoi people—was a slur, not anything you would use to anybody's face. The imaging of the Khoi as "others" went back to the eighteenth century. The Hottentot became a vessel of difference, the foil of the natural savage to the colonizer's unwavering civilization. Their itinerant, pastoral lifestyle was equated with instability and vagrancy. They were vilified, much like European gypsies, driven from the land, and even shot at will.[8]

The issue of Saartjie's "consent"—a term most loved by Western women living in the late twentieth century; we know we've got it and we like to think that we would kill any MF who imagines he can take it from us—also became murky. What does "consent" mean for a Khoi-San woman and farmworker, when it is being translated through Dutch documents, "Dutch" language,[9] and patriarchal systems in the early nineteenth century? Do/Can we ever hear Saartjie's voice in this decision? And how does the issue of "consent" play out again for South African women in the 1990s, when one of them is physically violated perhaps every other minute?

As in the United States, where the issue of use/misuse of black stereotypes constantly raises its profile, the image of the Hottentot Venus brings out a myriad of questions for cultural producers:

—Are artists identifying with racist/sexist imagery?
—What roles do myth and fantasy play in South African art-making?
—Can we distinguish the blurry demarcations between appropriation and speaking/creating on behalf of others (and under what circumstances), and "ownership" of images?
—If there is differentiation between these positions, how do we recognize it?
—How do questions of access to resources impact on the discussions of such ideas?

My visits to South Africa during 1997, as part of the curatorial team for the Second Johannesburg Biennale, were my first to the African continent. For an African American child of the 1960s and 1970s, and a keen observer of the anti-apartheid struggle, this journey represented the fulfillment of many wishes. But as they say, reality bites. As I wrote to some of the artists

who would be in the show after returning from my first trip, "South Africa is a truly amazing place, both intense and inspiring at the same time."

Politically, a new country can appear quite rapidly. But the process of developing a fresh civic life is constructed slowly, in fits and starts. That exercise was fascinating as well as painful to observe, and to participate in, in some small way. My notion of "service" as a cultural worker (caressing the conflicted edges of the term as it has been described by Bill T. Jones)[10] kept, and keeps, me looking forward to returning to the continent to do just that.

In my show for the Biennale, "Life's Little Necessities: Installations by Women in the 1990s," I chose to use women's art and the issues of identity construction as the context for viewing globalism. Five out of the thirteen women included in the exhibition were African. The two from South Africa, Veliswa Gwintsa and Berni Searle, have graciously agreed to participate in this dialogue.

The struggles and joys of putting up that exhibition is a topic I know I will write on in the future. Suffice it to say for now that the obstacles were substantially difficult—three years after the *de jure* fall of apartheid with the first democratic elections—for an American curator who also happened to be a small black, "colored"-looking woman.

The fact that the site of "Life's Little Necessities"—the Castle of Good Hope in Cape Town—was a former fort, built in 1666 and the oldest (Western style) structure in the country was pretty straightforward. What I only discovered after finishing the project was that a Khoi woman was actually buried on the grounds.

During the seventeenth century Krotoa (a.k.a. Eva) was one of the earliest interpreters for the Dutch settlers. Very much like her Mexican counterpart La Malinche (a.k.a. Malintzin and Marina), she married a settler and eventually was repudiated by both the colonists and the Khoi. Krotoa was banished for a time to Robben Island (used as a prison from the beginning of colonial settlement) before being returned in death and interred under this foundation of the South African republic.

During the installation process, a television interviewer asked me why I thought to put a "women's show" in such a male stratified space. Though I hadn't ever conceived it in those terms, having seen the galleries months after finalizing the idea, it seemed particularly appropriate, and even more so after finding Krotoa.

A DIALOGUE

Given the opportunity to meet many South African women artists in preparation for "Life's Little Necessities," I thought it would be interesting and important to get their input for this project. Saartjie Baartman is after all their ancestor. All of the artists included participated in the Second Johannesburg Biennale. Most exhibited in one of the Biennale's six exhibitions. Bongi Dhlomo-Mautloa, however, was the director of the Africus Institute for Contemporary Art, the organization that administered the Biennale.

My approach to a discussion of the Hottentot Venus was to create a forum for diverse opinions, something I hoped would illuminate what a variety of women artists were thinking in South Africa today. To this end I staged a transatlantic roundtable, asking for submissions via traditional, telephonic and electronic mail, rather than setting myself up as the translator of their ideas. The results were wide ranging, touching on the figure and perception of their (in)famous countrywoman, the implications of her image for the performative body and the body on display, and the impact of Saartjie's history, if any, on their own production.

Opinions varied between seeing Saartjie as a truly international figure, embodying the intersection of gender and race on a symbolic level, to considering her grounded in the South African milieu. She was at once a pawn, the personification of the myth of black women's perversion, a reflection of Europeans' own values, a vessel of women's pain, an emblem of the vulnerability of female sexuality, and a person whose much defiled form could be redeemed as a site of strength.

The Artists

BONGI DHLOMO-MAUTLOA is a painter, printmaker, and respected arts administrator. In addition to being a part of the directorate of both the 1995 and 1997 versions of the Johannesburg Biennale, she has been a pivotal figure in the management of cultural institutions and workshops in South Africa since the 1980s.

PENNY SIOPIS began her career as a painter, and recently has explored photography, installation and film. She has exhibited prodigiously both inside and outside of South Africa. She is an associate professor and chair of the Department of Fine Arts, University of the Witwatersrand in Johannesburg.

As an artist **VELISWA GWINTSA** has worked most recently with multimedia installations. She holds a master's degree in the history of art from the University of the Witwatersrand, and is currently curator of the Historical Section at the Johannesburg Art Gallery.

Multimedia artist **BERNI SEARLE** completed her undergraduate and post-graduate studies in fine arts at the University of Cape Town. In 2001 she participated in the Forty-ninth Venice Biennale. She was also the winner of South Africa's Standard Bank Young Artist Award in 2002.

MARLAINE TOSONI primarily works with photography and film. She has exhibited throughout South Africa and was included in the Johannesburg Biennale in 1995 and 1997.

TRACEY ROSE is a multimedia artist from Johannesburg whose works include video and performance. She also participated in the Forty-ninth Venice Biennale in 2001 and shows regularly with The Project in New York and Los Angeles.

As a South African and an artist, how do you feel about the attention being paid, largely by foreign women, to the Hottentot Venus?

PENNY SIOPIS: It seems understandable for foreign women artists to pay attention to the Hottentot Venus as her image and story are emblematic of concerns beyond the "local." Saartjie Baartman typifies so many things about racial and gender oppression, colonialism, Western scientific conceits and "gaze" etc. In fact she represents the West's use of Africa. She is almost something legendary, so visualizing her story does not rely on being South African. Anyway I don't believe cultural images are owned, if this is the implication of the question. It's a bit like images of slavery or the holocaust. I don't consider these images the preserve of descendents of slaves or holocaust survivors, however sensitive these images might be.

Art seems to me to be a good place to explore the complexity of the issues raised by the Hottentot Venus. As an overdetermined practice, art can elaborate rather than reduce the issues. Thus the more attention given to Saartjie's story through art, the better.

The way foreign visual artists seem to have referenced Saartjie's story is as "generic black women"—as victim or heroine or both. From the little I have seen, the work seems to have very little reference to the specifics of Saartjie's life—her origin, culture, location, etc. Since there could be little or no other identification on the part of these artists with Saartjie's descendents—or her cultural context—her story understandably floats rather without context, or rather, I would suggest, the context becomes that of the "race" discourse, as articulated for example, within recent black diasporic culture.

South African artists are of course more likely to be familiar with the actual cultural, geographical and political contexts of Saartjie Baartman.

This fact might have its own bearing on race discourses in the future. But interestingly, not many South African artists have referred directly to Saartjie's story. More have explored "Bushmen" culture in a general sense. But there have been theatrical productions about Saartjie, and quite a lot of poetry and prose in which very specific reference is made to her time and place and its relation to present concerns of identity.

BERNI SEARLE: The tendency to use Saartjie Baartman as a rallying point around black solidarity is comprehensible in the context of theories of anti-colonialism and racial liberation in Africa and the African diaspora. While it is understandable that African American women have claimed Saartjie Baartman as a heroine, there is a tendency on the part of African Americans generally to romanticize Africa and to superficially identify with what they see as being their African brothers and sisters. However, this approach often reinforces romantic and timeless notions of Africa untouched by Western materialism and technology.

MARLAINE TOSONI: I think that the amount of attention being paid to the Hottentot Venus by foreign women is almost expected. During Saartjie Baartman's time, as it is now, the Hottentot Venus is still seen as "foreign." The fact that today foreign women are paying attention to what the Hottentot Venus represents is testimony to that which is familiar to women irrespective of nationality or religion.

VELISWA GWINTSA: The Hottentot Venus will remain present in the history of South Africa for a number of reasons, the most important of these being that she provides an opportunity to talk openly about the reality of the past as far as the history of race and politics in this country are concerned. The matter of Saartjie Baartman became an international issue the moment she was moved from her original context. And therefore no one group, nationally or internationally, can claim to have the exclusive right to this history.

However, in the process Saartjie Baartman has been dehumanized. Moral laws that govern and determine fundamental respect for the body and for human remains—and that are exercised variably by all peoples on earth—have in this case been sidestepped. Hence even today Saartjie Baartman is still being referred to as the Hottentot Venus. Over time she has become not a person but more an object of discussion.

BONGI DHLOMO-MAUTLOA: Issues that surround art production in South Africa now, at the end of the century and the end of the millennium, produce a myriad of unanswered, sometimes unanswerable, questions. The

black people involved in art to start off enter any of these debates at very different levels than their white counterparts. There are many issues at stake and it is a fact that black women enter these debates and discussions from the most disadvantaged point.

As a South African woman and an artist I react to ways that have been used to display and dehumanize the body and the remains of Saartjie Baartman differently from my black male counterparts. I also react differently from my white female counterparts, I even react differently from my fellow black female counterparts. The reason for this is that we all enter the terrain with different assumptions and levels of understanding.

The reference to the present-day depiction and usage of the black female body as a commodity for the "other's" curiosity and enjoyment takes us back to the Hottentot Venus. Saartjie Baartman's displacement from her country and resettlement in Europe could have been done, as we are told, with her consent. Consent in this case could be argued on different levels. But it is the same "consent" that has allowed commercial photographers in this country to include black female subjects as part of the flora and fauna that end up on South African tourist postcards. I don't believe these subjects are made aware of what they are consenting to, that is if any "consent" is ever sought at all. Saartjie Baartman could not have known better. The present day Ndebele women in traditional attire and the Zulu maidens baring their breasts are not given the "low-down" on what will eventually happen to the photographs.

When foreign women enter the debate around the displacement and eventual display of Saartjie Baartman, the issue ceases to be a South African women's issue. It removes the discussion from national context to gender context first and gender/race context in particular, and opens up a dialogue on the female body and the black female body as icons. In such an inclusive forum, debate revolves around not only who and what determined these images, but what makes them acceptable to some and completely unacceptable to others.

The Hottentot Venus allows us to discuss present-day icons, their origins, and their future. It is therefore important to understand the context of the nineteenth century's use/abuse of Saartjie Baartman. Is the use of the black female bodies in present day commercial and artistic representations a formulation of new icons, or the perpetuation of the same old stereotype?

TRACEY ROSE: Before I actively engaged with the issues presented in this discussion, I took a mental diary of my experiences over several days:

- —Yesterday I received an "obscene" cell call; I receive them often and look forward to the attention. The caller, who claimed to be anybody I named, commented on my large arse. (While writing this Michael Bolton howls, "Can I touch you there?")
- —Within the same time frame I read through what I hoped would be an informative article in a reputable newspaper, entitled "Germany's Shame"; dominating the cover page was a large photograph of five Namibian Herero women who, standing in profile (save for one), display their bodies for a 1990s audience one hundred years later.[11]
- —I recall an interview with South African deejay Mark Gillman and Felicia Mabuza-Suttle (talk-show host, advocate for plastic surgery, local Oprah Wannabe, and self-appointed savior). Mark declares white women's envy toward black women as the former unlike the latter get both their arses and their faces done.

On my way out of my sometime job, I stopped and asked a large and beautiful black woman what she thought about Saartjie Baartman / The Hottentot Venus. Confronted by her look of confusion, I explained Saartjie, expanding on the following cues: hottentot, woman, buttocks, genitalia, London, Paris, jar. "Oh! She is the one with the . . ." a hand gesture elaborating on her own rather generous buttocks established that she was *au fait* with Saartjie. She then kindly proceeded to jot down the contact numbers of several male colleagues of her husband's who have more information on the subject.

Do you feel the Hottentot Venus is a sign of South African women's artistry, especially in terms of the performative body?

ROSE: No.

GWINTSA: Everyone needs to define for themselves what identity as a South African woman is and stands for, perhaps even to the point of questioning if there is such a thing. Yes, there are different and individual efforts being made by women in South Africa that aim toward asserting the power and emancipation of women as such; these efforts, however, should once again be interpreted as specific not universal. Oppression in other words must begin to be seen as individually and subjectively felt. In this regard then the use of Saartjie Baartman as a symbol of objectification is a projection of conceived beliefs about what oppression of black women in general stands for.

TOSONI: I don't consider the Hottentot Venus necessarily a sign of South African women's artistry, though as regards the performative body, she is a sign of the fine line between predator and prey, the insatiable desire to possess and dispossess.

DHLOMO-MAUTLOA: The assumed consent:

—by Saartjie Baartman to be displayed as a public spectacle,
—by female slaves to perform sexual favors for their masters,
—by rural black women to be used as subjects for touristic postcards and in contemporary art production,

and in the many other areas in which black women's subjectivity is at issue is not a sign of the women's artistry and cannot be assumed as fully representative of how black South African women see themselves or want to be seen.

There is a particular way in which we see others and in which we are seen by them; this is across any divide, it could be language, culture, dress, class, race, etc. When these perceptions are further supported by a social and political system it becomes difficult to undo them without resorting to long debates as to whose perception is right and whose is wrong. The South African system of government in the past instilled in the white population the belief that it had the right (by virtue of assumed superiority) to speak on behalf of the black population. It comes as no surprise to see this belief filter down generation after generation.

The "Hottentot Venus," "the servant," "the maid," "the prostitute" are all representations of the black woman not only as subject but also as an object for the "other's" use/abuse. The body of the subject/object "performs" not for itself, but always outward and for the satisfaction of the other. All these stereotypes (that exist in the "developed" world as well) in South Africa tend to be perpetuated under the old guise of talking on behalf of "our blacks." Of course now everyone is supposedly mumbling in what seems to be the same voice. But even now the voices of those who have always believed they have the right to speak outshout the others with the same authority of "we know what is good for them." Old habits die hard!

SIOPIS: The Hottentot Venus could be read in this way if performativity entails real or imagined bodily display. In terms of her representing something for South African women artists, yes, she would represent the obvious intersection of race and gender. Her female gender would provide the opportunity for identification to women (black or white). Saartjie could be seen in some sense to represent, for all African women, a body bearing out

desire. Doing this in a sense could be compared to the way Dora signified for European women in relation to the discourse of hysteria. Dora, or Freud's famous case "A Fragment of an Analysis of a Case of Hysteria," was reread by certain European feminists as a sexual politics of resistance—a challenge to patriarchal domination and to the pathologizing of female sexuality. The phenomenon of the hystericized body—performing or "acting-out" quite literally in sexually explicit gestures inner psychic states—is interesting in how it has been reclaimed as woman's (the other's) dis-ease under patriarchy. There is something about this performativity—this spectacle—that, for me, could connect with Saartjie.

The Hottentot Venus raises issues of the female/African body on display. Do you feel such concerns impact you, 1) as an artist displaying her work (or the type of work you do), 2) as a female artist in a male dominated field?

DHLOMO-MAUTLOA: If I am true to my "calling" as an artist then issues of the female/African body on display should and do impact me and my work. The question "Who has the right to present the female/African body?" confronts me and I ask myself if, as a female/African artist, I have the right to present, to talk for or on behalf of these "bodies" through my own work. In a sense black women artists in South Africa, by their mere entry into the arena of art production, are making statements and are giving voice to the "used" bodies. The voice-giving ritual is performed simply in the act of being an artist, or it can sometimes be found in the subject matter that black women artists produce.

I would not like to see a counterstatement simply for the sake of counterstatement to what we have seen recently from white women artists using black female bodies in their work, where there is further dehumanization and voicelessness of the black subject. I would not like to see the white female body used in a similar degrading manner by anybody. Neither would I like to see black Amazonian icons as homage to struggling and oppressed black women. The Hottentot Venus is that and much more. I would like to draw my strengths from the lived experiences of all members of society and, in the process, be able to give voice to those who need to have it.

SIOPIS: As an artist showing my work, the idea of the female body on display has been fundamental to my practice. It is difficult to comment on the "African body" now in South Africa as this could mean a white or a black body. This question often arises of late, but I assume in this context though you mean a black body. Either way (and I have used images of both black and white bodies) I am interested in the potential for the body on display

for positive enactment of desire, rather than the negative cast it receives under patriarchy. I see this "making positive" what is commonly considered negative, as in some way akin to the manner in which hysteria has been read positively from certain feminist perspectives. I have made this connection in many of my works intertwining the stories of Saartjie and Dora (Freud's famous hysteric). In these and other works I have used my own body, either directly or as a reference for other images. More recently I have made photographs of my own body as kind of static performances, as well as videos. I have also used body casts of black women as "found" museum objects in some of my installations, as well as having my face cast in the same "primitive" way human subjects were cast in nineteenth century scientific endeavors. But in all my works there has always been a very strong personal identification.

This personal aspect has proved to be a doubled edged phenomenon when it comes to the reception of the work in a male dominated field. My work is all too often read in reductive terms, the connection with women and biology being typical. There seems little license to explore complex female/sexual subjectivity in this country without being classified in one way or another.

GWINTSA: The female African body on display is a very historically specific concept that has to do with the politics of power and the imposed perversion of a particular white society that are (hopefully) past. This belief in the exaggerated body to be reflective of the African body is something that is a myth and should have no reflection on how individual African women should either see themselves or be seen by others. To see myself as a female artist and not as an artist and an individual in my own right first and foremost is to perpetuate and impose perceptions that are not natural. I see, think, create, react as an individual who has a personal past that I consider specific to my place in history.

TOSONI: Regarding the female African body on display: of course it impacts me. These issues often become the references others use when looking at my work simply because I am female, Caucasian, South African. As retaliation, I play with sociology and ethics, instead of biology and politics (they're there anyway), and this complicates the way I look at my work. Such generalizations are understandable though not plausible.

ROSE: What fundamentally concerns me about this question is that there appears to be an underlying assumption that Saartjie Baartman—posing as the symbolic Hottentot Venus—is a primary, or rather, an effective model

of the manner in which the Female/African body is displayed. It assumes that the displayed female is an individual placed (although willingly and consciously, still somehow naively) in a position where she does not or cannot comprehend the broader implications and issues of her context. Surely as artists we should ideally be well aware of the varying dynamics and power plays within the art arena and take these into account when producing and presenting a work of art?

SEARLE: While there is no doubt that Saartjie Baartman is a powerful symbol of our struggle against various forms of oppression, the process of claiming her cannot be a simplistic one. It is understandable that in terms of her suffering and humiliation she has become a symbol of the plight of indigenous people, but it is equally important to consider to what extent she has become a pawn.

Given that there is a strong tendency for various groups to identify with the original inhabitants of southern Africa and the need to be able to claim a particular history which has by and large been ignored this tendency can be seen as problematic when the links are made superficially to reinforce "ethnic minorities." One has to acknowledge that Cape Aboriginal heritage has been brutally interrupted and broken and that if there is any attempt to identify with that heritage, it has to be by way of enactment/performance/ritual rather than asserting it as part of a lived culture.

The emergence of "colored" political movements with an appropriately ethnic "colored" consciousness has increasingly gained ground in the Western Cape since the 1994 elections. I use the term "colored" in this particular way since it is not a term that I would use to describe myself, unable to see it as anything but an imposed label. Despite my reservations and the fact that it is difficult to speak of any cohesive "colored" identity, i.e., language, class, or religion, there are tendencies within communities previously classified as "colored" under apartheid legislation to foster a kind of ethnic consciousness. This tendency is bound to a number of complex factors, which extends beyond the parameters of this discussion. Similar tendencies can be observed in the Inkatha Freedom Party, the far right Afrikaner Weerstands Beweging [Afrikaner Resistance Movement] and the "colored" counterpart, the Kleurling Weerstands Beweging [Colored Resistance Movement], all of which focus on how they are exclusively different to any other groups in the broader South African context.

Such assertions and claims to an exclusive ethnic identity reinforce and perpetuate racism, especially when they become paramount and protected at any cost. In this context I would support Benedict Anderson's view that

all ethnicities are dangerous, breeding the politics of war and xenophobia. The growing pride in having indigenous roots has to be viewed, therefore, both in terms of its benefits and limitations.

Can you discuss some of the issues surrounding the Hottentot Venus in South Africa today or concerns around the female body and its display?

GWINTSA: What is more interesting for me, and that I also try to explore in my productions, is the way in which individuals may choose to represent themselves and others. This reveals a lot more about the person and the surrounding social system. Hence for me the issue of Saartjie Baartman reveals as much about those who portrayed her and their social constructs.

Right now, the issues of equality and power occupy the center of discussion in the new South Africa, i.e., who has the right to represent whom? What the agenda might be in the act of representing the other? How different or genuine is an image from that of the apartheid past? Does a particular representation do justice to the subject, and is it demeaning in any way? Who is the target audience?

SIOPIS: Most of the discussions of the Hottentot Venus in South Africa today are centered on debates around the repatriation of her body, burial rites, and the rights over cultural property. These debates are highly politicized and polarized with some people feeling that she should remain in Europe as a reminder to the West of the horrific consequences of the enterprise—a kind of symbolic retribution if you like, a bit like the Germans having to look at the victims of Nazi concentration camps. Others feel that Saartjie should be laid to rest in her own country, as a sign of respect for her descendents, and black South Africans more generally. These issues are openly discussed in South Africa today as part of the complex ethos created by the Truth and Reconciliation Commission. In Pippa Skotnes's exhibition "Miscast: Negotiating the Presence of the Bushmen" (South African National Gallery, Cape Town, 1996), there was some discussion of Saartjie's "sexuality," mostly on account of one of the illustrations (of female "Bushmen" genitalia) reproduced as part of a tiled floor "representing" Bushmen history. But the discussion did not really compare to the intensity raised by other issues of the exhibition. I believe at the opening one of the guests, a "Bushmen" woman, arrived bare-breasted. Whilst this too caused a stir in the press, it was no more sensational than any topless visitor to the South African National Gallery might be. But what it did do was to raise other issues concerning the female body on display—particularly bare-breastedness—as articulated within local cultural values. Bare-breastedness is often acceptable in tradi-

tional rural communities but in urban metropolitan areas where "Western" values dominate it is considered problematic. There is much debate about this at present in the country, debate which is part of a larger interrogation of questions around gender and rights, whether these concern reproductive rights, polygamy, or whatever.

SEARLE: It is hard in the South African context to ignore the ways in which the African body has been and continues to be displayed. It seems ludicrous that four years after the first democratic elections, the pre-colonial hunter-gatherers of southern Africa are still housed in Cape Town's natural history museum—the South African Museum—while the white colonialists are housed separately in the Cultural History Museum. An article in the *Cape Times* (September 14, 1994) quotes K. Hudson as saying the following as early as 1975:

> There is no essential difference between presenting a butterfly and a bushman to the world in this fashion. Both are the white man's specimens, symbols of his power and freedom to collect what pleases him. There are, in South African museums, no dioramas which illustrate the life of white men and women.

The three boxes suspended in front of the window in the installation at the Castle of Good Hope as part of the exhibition "Life's Little Necessities," entitled *Re:Present*, is a comment on this "bones and stones" regard for the country's first inhabitants. When visiting the South African Museum to look at the diorama, I was struck by the reactions of groups of mainly black school children. Some giggled embarrassingly, others mockingly referred to the casts as being each other's uncles or aunts. Aware on the one hand of some connection, this was certainly not a heritage that they identified with. Rather it is a heritage that is associated with the negative connotations of Afrikaans words "Hotnot" [Hottentot] and "Boesman" [Bushmen] words that they would have grown up with. The diorama remains the museum's biggest attraction.

TOSONI: The female body is displayed in the show window as a "must have" sexual entity, marketed as a "must be" sexual entity, and most women end up selling themselves or being sold simply as sex. As an archetype this does not bode well, though there are women who have made lots of money buying into this market.

ROSE: Page 4 opposite a full-frontal pic of two Herero women "Town lives in fear of child rapist" almost passes my attention.

"Crime in Chinatown: 'He pulled down his trousers, raped the child
 and sent her off with bananas, sweets & biscuits'"
"R100,000 Bail!"
"Two years later
still no trial."

DHLOMO-MAUTLOA: South Africa carries many problems deep in her bowels and on her shoulders. Just as she recovers from the nightmare of the apartheid government and many others before, she finds herself in the throes of a worse crisis: the use/abuse/discarding of female bodies. South Africa is said to be the "leading" country for rape—indiscriminate rape of babies, children, teenagers, young mothers, middle-aged mothers and grandmothers. This represents disregard for the human body, the person who occupies it, and the number of other people who share that person's life.

Hottentot Venus in South Africa today is every woman. The bodies of women are constantly on display—advertising this or that and looking sometimes more interesting than the product—dead women's bodies found in the veld where a serial killer is lurking in daylight waiting to pounce on unsuspecting women, and especially young and innocent school children. Saartjie Baartman may have left the shores of South Africa during the nineteenth century, but the legacy of her dehumanization in Europe has been brought back to the country of her birth. Young and old women of all races are on their own. Saartjie Baartman was on her own.

Are there any other concerns around your work that intersect with issues raised by the Hottentot Venus?

SIOPIS: A large number of my works have involved the Hottentot Venus directly. These were produced in the late 1980s and early 1990s. Probably the most well known of these are *Dora and the Other Woman* (1988) and *Exhibit: Ex Africa* (1990). In 1988 I took a series of photographs of Saartjie's body cast in the Musée de l'Homme in Paris, which I only exhibited in 1995. I was prompted to show a selection of these photographs, re-presented as juxtaposed with her baptismal and death certificates, in a photographic exhibition on race and representation titled "Black Looks, White Myths" [curated by Octavio Zaya and Tumelo Mosaka for the First Johannesburg Biennale, 1995]. These photos show the whole cast and details of the body presented in a travel crate. I chose the images which revealed something of the artifact quality of the cast and which emphasized the packing materials and museum setting. My interest in the Hottentot Venus was always based on a strong identification. Looking at her cast in the museum and the wax

molds of her genitals made me experience a very *contradictory sense of self*. As a woman I identified with her. As a white person, this is more fraught. While African, I am marked by my European descent, whether I like this or not. This connects me—discursively at least—to "the colonizer," the settler position. But I am not easily a settler, a European. I am South African. As a South African, race visibly defines me. But so does being a woman. I thus experience a feeling of being both insider and outsider. Saartjie's image hammered this predicament home to me and this is a large part of why I developed such a deep interest in her. She pictures my ambivalence and challenges my composure.

ROSE: Somewhere throughout these x-periences I became suspicious of the vulnerability projected onto female sexuality both within and outside of the "sisterhood." As I pulled my car into the driveway I picked up the Bible which poses in her doorless cubbyhole—it is an act I seldom perform—I open it fingering two sections . . .

> the 1st titled: second vespers of holy women.
> the 2nd: the Lord's Prayer with a second version that prays through the intercession of the Virgin Mary.

The vespers being the evening prayers dedicated to specific saints, martyrs, and in this case holy women, and virgin women. Nowhere else within "The Good Book" does it specify virgin male martyrs/men, etc. Why is it that we do not allow ourselves to celebrate female sexuality? Perhaps more than a victim and an exploited figure, we should see Saartjie Baartman for what she now is: an icon to the power of the pussy, as we all stand in awe of her well preserved genitalia. Her relevance is situated not in and among the woman that she would or should ideologically represent for she is a figure specific in time, place, and history who holds but little significance to many except those who choose to theorize and give pertinence to her issue (whatever that may mean to whomever); it is a position which is opportunistic as well as superficial.

In a country with high rape statistics—last time I checked one every eighty-four seconds—Saartjie Baartman holds no significance, preserved and protected in a sanctified museum space in the confines of a jar. Neither she nor her genitalia can change the position of women, nor make a change to the very real problems that confront us today in 1998. Historically she is displaced—time and context have almost nullified her relevance in her native country as we confront here and now more pertinent issues than that of pickled pussy.

As an artist human being woman (classifiably) colored South African recovering Catholic, these are thoughts made for a redundant argument/purpose as I reflect on the past (BC–1998).

In 2002, four years after the dialogue above took place, Saartjie Baartman's remains were returned to South Africa with much fanfare.[12] Requests for such action had intensified with the election of Nelson Mandela in 1994 particularly from South Africa's indigenous or First Nations peoples including the Khoi and the Griqua.[13] Introducing his petition with a poem by Khoi descendent Diana Ferrus, in December 2001 Senator Nicholas About brought a bill before the French Senate to have these relics repatriated.[14] After close to two hundred years of languishing in its museums Saartjie's body parts had become part of France's cultural patrimony thus requiring special legislation for their release. While President François Mitterand had apparently "made a personal promise" to his counterpart Mandela to resolve the issue, it took years for the French parliament to overcome "objections about the precedent it would set for countries seeking the return of artefacts."[15] Indeed as recently as 1998 the Musée de l'Homme had even denied that the vestiges of Saartjie Baartman were in its holdings.[16]

Nevertheless, these relics were released with great ceremony and bountiful media attention in April 2002. The "handover" took place at the South African embassy in Paris and was accompanied by music, the singing of a choir, and Ms. Ferrus reading her poem over two wooden coffins, one holding the actual traces of Saartjie's corporeality, and the other containing the painted plaster cast of her body. The historic event was attended by French Research Minister Roger-Gerard Schwarzenberg and Bernard Chevassus-au-Louis, director of France's Museum of Natural History, along with South Africa's ambassador to France, Thuthukile E. Skweyiya, as well as the South African Deputy Arts, Culture, Science, and Technology Minister Bridgette Mabandla, who heralded the occasion as a "'strong symbol' of solidarity between Paris and Pretoria."[17] Media tracked the repatriating plane trip on a South African Airlines Boeing 767 and arrival in early May to Cape Town. There Saartjie was received on a "carpet of antelope and zebra skins . . . since officials believed a red carpet would have colonial connotations"[18] and remembered by a Griqua Choir, Khoi and naval bands, and government officials as well as ordinary people who turned out to welcome a lost ancestor home.[19] After spending three months in a military mortuary, Saartjie's remains were formally buried on August 9, 2002, in rural Hankey, some 470

miles east of Cape Town. The date also marked the celebration of national Women's Day.

Throughout the years-long odyssey of return the figure of Saartjie Baartman had come to symbolize the fight for the rights of indigenous peoples as well as women. In 1999, three years before the traces of her body came to rest, the Saartjie Baartman Centre for Women and Children opened in Manenburg near Cape Town, providing services such a shelter, rape and HIV counseling, and legal advice. The Centre is perhaps indicative of the will to change the legacy of hardship for and brutality against women that is a specter in South Africa and the rest of the world, which I alluded to in my initial essay for the "Life's Little Necessities" exhibition. In 2004 rape is still a major issue and in tandem is now the rising AIDS rate; perhaps three-quarters of its young victims in Southern Africa are women.[20] Recognized in almost two hundred countries around the world, this year the international "16 Days of Activism against Gender Violence" took as its theme "For the Health of Women, for the Health of the World: No More Violence." In South Africa the period was commemorated in events from marches to plays, religious services to exhibitions of photography, and soccer matches as well as lectures, acknowledging "gender-based violence as a major global public health issue," particularly the "intersection of violence against women and HIV/AIDS";[21] this campaign also coincided with celebrations marking the tenth year of South African democracy. At Saartjie Baartman's Hankey funeral, President Thabo Mbeki called on South Africans "to work together to build a nonracial society and a land of gender equality. 'When that is done, then it will be possible to say that Sarah Baartman has truly come home.'"[22] Clearly there are still things that Saartjie can still tell us about politics, diplomacy, the global and transnational lives of women, and the circulation of bodies in the twenty-first century.

For the artists. Thank you for your poise and patience.

NOTES

Originally published in Deborah Willis, ed., *Venus 2010: They Called Her Hottentot*. Philadelphia: Temple University Press, 2010. (c) Kellie Jones and the artists 1998/2004.

1. This essay first appeared in the exhibition catalogue *Contemporary Art from South Africa* (Oslo: Riksutstillinger) in 1997. I read it when it appeared later that year in *Third Text* 40 (autumn 1997): 21–40. The piece was subsequently published in Okwui Enwezor and Olu Oguibe, eds., *Reading the Contemporary: African Art from Theory to Marketplace* (Cambridge: MIT Press, 1999), 376–99. The quote above is from this last version, page 381.

2. The artists were Zarina Bhimji (Uganda), Maria Magdalena Campos-Pons (Cuba), Silvia Gruner (Mexico), Veliswa Gwintsa (South Africa), Glenda Heyliger (Aruba), Wangechi Mutu (Kenya), Berni Searle (South Africa), Lorna Simpson (United States), Melanie Smith (United Kingdom), Valeska Soares (Brazil), Jocelyn Taylor (United States), Fatimah Tuggar (Nigeria), and Pat Ward Williams (United States). See Kellie Jones, "Life's Little Necessities: Installations by Women in the 1990s," in Okwui Enwezor, *Trade Routes, History and Geography: 2nd Johannesburg Biennale 1997* (Johannesburg: Greater Johannesburg Metropolitan Council, 1997), 286–315. Related articles include Kellie Jones, "Life's Little Necessities: Installations by Women in the 1990s," *Atlantica*, winter 1998, 165–71 (same title as the catalogue essay but a different essay); and "Johannesburg Biennale," interview with Franklin Sirmans, *Flash Art* 30 (October 1997): 78–82.

3. Briefly, artists such as Candice Breitz, Penny Siopis, Kaolin Thompson, and Minnette Vari, all white South African women, were chastised for the use of the black body in their work. These artists objected primarily to criticism from Okwui Enwezor, in the essay cited above, and Olu Oguibe, "Beyond Visual Pleasures: A Brief Reflection on the Work of Contemporary African Women Artists," in Salah Hassan, ed., *Gendered Visions: The Art of Contemporary Africana Women Artists* (Trenton, N.J.: Africa World Press, 1997), although commentary by artist Kendell Geers (in his guise as critic) and Deputy Speaker of Parliament Baleka Kgositsile (specifically on the Thompson piece *Useful Objects*, 1996, an ashtray in the shape of a black vagina) also featured in the mix. In 1999 *Grey Areas: Representation, Identity, and Politics in Contemporary South African Art*, ed. Brenda Atkinson and Candice Breitz (Johannesburg: Chalkham Hill Press), was published. Although clearly an attempt by editors Atkinson and Breitz to consider issues of visuality and power in the postapartheid world, one can't help noticing that most of the texts read as attacks on the black male critics (Enwezor and Oguibe). Bongi Dhlomo-Mautloa, Veliswa Gwintsa, Tracey Rose, and Penny Siopis all contributed to this book. Enwezor and Oguibe's *Reading the Contemporary: African Art from Theory to Marketplace* was also published in 1999.

Even earlier the video piece *Uku Hamba 'Ze—To Walk Naked* (1995)—documenting a 1990 incident in which black women, contesting the removal of their dwellings, faced down bulldozers by stripping naked in protest—caused a stir regarding appropriation since it too was made by a collective of white women, including Jacqueline Maingard, Heather Thompson, and Sheila Meintjes. They seemed aware of the concerns the piece would raise. See Jacqueline Maingard's statement in *Panoramas of Passage: Changing Landscapes of South Africa* (Johannesburg: University of the Witwatersrand, 1995), 58.

Two other art world incidents also speak to the contested visual landscape in the postapartheid state and the intersection of race, gender, and power. The exhibition "Miscast: Negotiating the Presence of the Bushmen" (South African National Gallery, Cape Town, 1996), organized by artist Pippa Skotnes as a meditation on the horrors of South African colonial history, seemed to misfire. Besides having no black contributors (out of fifteen) to the exhibition catalogue, Skotnes "neglected to take into account that her voice as the authority of history might indeed be con-

tested by the very people she was attempting to recuperate" (Enwezor, *Trade Routes, History and Geography*, 393). "Bushmen" invitees to the exhibition were apparently disgusted, refusing to recognize any cultural bond with body casts and a linoleum floor printed with their likeness (on which viewers were meant to tread!).

As a bid to prove "reverse" gender and racial discrimination, in 1991 Beezy Bailey, a white man, submitted work to an exhibition under the name Joyce Ntobe. Excitement had built about this new black woman on the scene, when Bailey revealed himself, castigating current art world politics. Amazingly, "he continues to exhibit work by Joyce Ntobe, whom he now claims as his alter ego." Marion Arnold, *Women and Art in South Africa* (New York: St. Martin's Press, 1996), 8.

All of these examples point to the black body, in particular, as a continued site of contention and trauma in the new South Africa. This is surely due in part to its historical role under apartheid and colonialism and the continuing trace of past histories borne by bodily form. There is also the need to develop artists, audiences, and criticism in a place where censorship was the rule for decades. For some interesting discussions of these ideas see Lola Frost, "Checking One Another's Credentials," Ernst van Alphen, "Colonialism as Historical Trauma," and Sue Williamson, "Out of Line: When Do Artists and Critics Go Too Far?" all in Atkinson and Breitz, *Grey Areas*. The figure of the Hottentot Venus is certainly part of this conflicted terrain.

4. Bibi Bakare-Yusuf, "The Economy of Violence: Black Bodies and the Unspeakable Terror," in Janet Price and Margrit Shildrick, eds., *Feminist Theory and the Body* (New York: Routledge, 1999), 313.

5. Rosi Braidotti, "Signs of Wonder and Traces of Doubt: On Teratology and Embodied Differences," in Price and Shildrick, *Feminist Theory and the Body*, 292, 300.

6. The name Sarah often replaces Saartjie since the "tjie" suffix, a diminutive, can be deemed patronizing. From southafrica.info website, December 28, 2004.

7. The San, the original inhabitants of the Cape of Southern Africa, were nomadic hunter-gatherers. Even before the arrival of the Dutch, they were intermarrying with and being replaced by the Khoi, semi-nomadic pastoralists. Thus the early denizens of this area are sometimes referred to as Khoi-San, as in the case of Saartjie Baartman.

The Dutch colonial designations are, of course, the ones that are most familiar: San became *Boesman* (Bushman); Khoi became *Getotterer*, "which was anglicized into 'Hottentot'," according to D. R. Morris. This appellation, like so many other colonial monikers, was based on a slur as well as mistaken identity (think "Eskimo" meaning "raw fish eater" for Inuit). As Morris notes, "the Dutch, bewildered by the tongue clicks and a grammatical structure totally alien to the Indo-European languages, initially assumed that all suffered from a hereditary speech impediment and referred to them as *Getotterer* ('hay-totterer' or 'the stutterers')." Donald R. Morris, "South Africa: The Politics of Racial Terminology," *Political Communication* 9 (1992): 112.

However, Khoi and San are somewhat unstable designations as well. These philological terms were applied in the second half of the twentieth century as substitutes for the offensive "Hottentot" and "Bushman" respectively. "Bushman," how-

ever, unlike "Hottentot" still seems to have current accepted usage (though often in quotation marks). See Morris, "South Africa," 111–21.

8. Arnold, chapter 2, "My Own and 'the Other,'" and Obed Zilwa, "South Africa Buries Remains of Indigenous Woman Who Was Displayed as Oddity in Europe," Reuters, BC cycle, August 9, 2002.

9. According to Morris, Afrikaans—a "pidgin Dutch" composed from Khoi, Malay, French, and Dutch—was spoken within a few generations after colonization. It was an oral language known only as *die Taal* (the language) until being written down at the end of the nineteenth century. Morris, "South Africa," 114.

10. Bill T. Jones has discussed his concept of reinscribing notions of compassion into art, as a way of seeing cultural production as "service" (bringing out the preacher in him). However, there was a part of him that rejected the equation of compassion with "service" (that was the slave in him). My notes from a lecture at the Museum of Fine Arts, Boston (May 31, 1998).

11. This comment refers to the recent request by the Herero people of Namibia for reparations from Germany, as atonement for an "extermination order" given by the colonial power that wiped out close to 80 percent of the population between 1904 and 1907. Many surviving Herero women were made virtual sex slaves following the massacre.

12. These included her skeleton, labia, and brain, and the casts made of her face and body upon her death.

13. John Yeld, "South Africa: Plea to Return 'Hottentot Venus' to South Africa," *Africa News*, January 13, 1999.

14. Titled "A Poem for Sarah Baartman," Ferrus wrote the piece while studying in Utrecht, the Netherlands. Homesick, she began imagining the feelings of her famous ancestor. "Poem the Key to Baartman Return?" *South African Press Association*, January 31, 2002, and December 28, 2004.

15. David Hearst, "Colonial Shame: African Woman Going Home after 200 Years," *Guardian* (London), April 30, 2002. All over the world indigenous people are calling for the return and burial of bodies displayed as "specimens" in Western cultural institutions. In 2000 Spain returned a Khoisan man to Botswana who had been exhibited in museums there for a century; see Yeld, "South Africa"; and Rachel L. Swarns, "Mocked in Europe of Old, African Is Embraced at Home at Last," *New York Times*, May 4, 2002, A3.

16. Andre Langenay, then head of the museum, made this assertion in Zola Maseko's 1998 documentary *The Life and Times of Sarah Baartman*. Gail Smith, "Fetching Saartjie," *Mail and Guardian* (South Africa), May 17, 2002.

17. Susan Stumme, "France Returns 'Hottentot Venus' Remains to South African Ambassador," *Agence France Presse* (English), April 29, 2002.

18. Ken Daniels, "Return of South African Woman's Remains Closes Painful Colonial Chapter," Reuters, BC cycle, May 3, 2002.

19. Swarns, "Mocked in Europe of Old."

20. BuaNews, "Princess Ann Commends Saartjie Baartman Centre for Its Work," *Africa News*, July 15, 2003; "The New Face of AIDS; Women and HIV," *Economist*, Novem-

ber 27, 2004; and "Setting Women Free from Fear," *Sunday Times* (South Africa), November 21, 2004, 36.

21. Quoted on capegateway.gov website, December 29, 2004. See the website for additional information. For information on United States participation in the "16 Days of Activism against Gender Violence" see the website of the Center for Women's Global Leadership at Rutgers, the State University of New Jersey.

22. Zilwa, "South Africa Buries Remains."

Tracey Rose

Postapartheid Playground

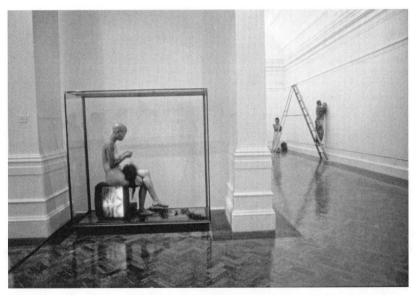

Tracey Rose, *Span II*, 1997. Performance installation, South African National Gallery, Cape Town, Second Johannesburg Biennale. Vitrine, television monitor, human hair, body; dimensions variable. Courtesy of the artist.

Nonetheless, most of the exhibitions and publications are dedicated to traditional and so-called "classic" African art forms, for example the journal *African Arts* in which just four years ago [1991], the editor John Pove asked, "What are we going to do about contemporary African art?" It was not an ironic query, it was a serious problem for him and reflects the general anxiety in the face of the challenge posed by modern art manifested by Africans. It neglects to include the modern African artists as part of the universal art movement. How can modern art be excluded from the general art tendencies simply on the basis of its origin? Why is this nihilistic attitude on the part of Western critics towards modern art produced by Africans, leading to the creation of a ghetto or segregation for them depending on their geographic background?
RASHID DIAB

To primitivise is to make me more tolerable, more containable, less competitive, less threatening. Its purpose, ultimately, is to freeze all those whose origins lie in the former colonies of Europe in the precise historical moment of their defeat.
OLU OGUIBE

Here's another paradox. In a recent issue of the art magazine, *Art in America*, [one] American critic implied in hardly uncertain terms that there is no such thing as an African avant-garde. A few months hence, a rival American art magazine, *Artnews*, had a startling and contradicting cover: "Contemporary African Artists, The Newest Avant-garde!" What a perfect note on which to rest the case.
OLU OGUIBE

Modern African art has been mapped out in a flurry of publications and exhibitions in the last decade. After almost thirty years of cultural boycott the West has now turned with keen fascination and curiosity to South Africa and its artists. Indeed, with the ending of apartheid, South African culture has entered a new phase of florescence, one not stymied by stagnant and repressive social and political systems.

In publication after publication it has been shown that modernism and Africa go hand in hand, and that, in fact, key phases in the development of Western culture—enlightenment, industrialization, modern life—were all fueled by the colonial exploitation of Africa (as well as other parts of the world). Such domination and oppression created a dark age against which to contrast the West's light.[1] But rather than simply putting a negative spin on African civilizations over such a broad swath of modern history, it is impor-

tant to expand our view, to contemplate how amazing culture was created even under such circumstances. Indeed, as Thomas McEvilley has pointed out, in Western art history:

> We are not accustomed to looking at artistic or other cultural phenomena with a very wide view of history. In our art history departments and related institutions we are trained to regard artworks as autonomous objects in themselves, which do not need a cultural or historical context to be meaningful, or as objects to be viewed within a very limited and highly defined thread of cultural history rather than within the whole weave of history's fabric.[2]

We need to retool how we look at and comprehend art and its meanings, not only in the twenty-first century but as we review and revise the full gamut of activities of the past, not just a narrow white Western story. In doing so one of the things we might be able to acknowledge is that postmodernism in the form of conceptualism is integrally linked to Africa and its arts as well.

In *Authentic/Ex-Centric*, the catalogue marking the major presence of African artists at the forty-ninth Venice Biennale in 2001, Okwui Enwezor, Salah Hassan, and Olu Oguibe all make a case for Africa as a generative source for conceptual art practice. As Hassan and Oguibe write, "First, it is obvious, that certain strategies adopted by the Western conceptualists be it in performance art, installation, text-based art, use of the found object and the ephemeral, were already evident in non-western artistic, philosophical, and spiritual practices, be they African, Asian, or Middle Eastern." If we trace the rumblings of the conceptual back to Duchamp and the notion of nominating something as art making it so, we can also see this sense of "non-art" materials already at work in the traditional practices of the cultures mentioned above. Yet again in the 1960s Western artists looked to places outside their boundaries for inspiration, stimulated by the material heritage as well as anti-imperialist struggles in Africa, Latin America, and Asia.[3]

As Enwezor explains the proclivity that has entranced Western minds, "African objects were never ends in themselves," there always existed "the work and the idea of the work." Art does not stand apart as a visual and material object but is tethered to philosophy, a process of "interpellation of the object and language."[4] Outside the generative force that African art has had on modern Western practices, these authors chart specific acts of African conceptualism from the 1970s on, in the works of Muhammad Hamid Shaddad (Sudan), Laboratoire Agit-Art (Senegal), and Malcolm Payne (South Africa). In most cases, as in much conceptual art from Latin America, such

activities were marshaled as a "critique of institutional power."[5] As Enwezor points out, however, conceptualism takes hold in Africa of the postcolony after the euphoria of independence has worn thin.

Tracey Rose makes art that is clearly born of this conceptualist pedigree. Her materials are ephemeral: paper, yarn, wall drawings, and video. Text is integral. She is not contained by one medium. Performance, a connection to body, is a major component.

In *Authenticity I* (1996), Rose plays with the idea of what "real" African art must look like, an acknowledgment of the intellectual forces of cultural determinism, primitivism, and exoticism that surround these works, and the will by Western art connoisseurs to freeze African artistic development in the colonial past. The pairing of object and text here mirrors strategies of ethnographic museum display; yet the piece also adopts the conceptual voice in its cool, honed down pragmatism. It presents a sculptural work by an African artist, yet the presentation does not live up to how one usually envisions African sculpture; it is bronze (not wood), in fact it is a miniature reproduction of Rodin's *The Thinker* (1879–1889), a found, not a handmade, piece. Not only is this a pun on African authenticity, as the work's title makes clear, but it also reveals the anxiety of influence, the apprehension that Africans are destined always to copy Western "masters" (a dominion to which all non-Western modern and contemporary artists are banished). The text of *Authenticity I* does not describe the artist's tribal affiliation but instead offers a story involving materials (ornamental bronze souvenir and stolen merchandise) and use (employed as a weapon in a domestic dispute and bearing the signs of struggle in its chipped plaster base). None of the narrative is what is expected from a work of African sculpture, not its non-wood, found object status or even the fact that it is made by a woman.

Even though we see Rose's satirical treatment of legitimacy or "realness" in pieces such as *Authenticity I*, her work is often discussed in terms of its relationship to her identity as a "classifiably colored" person in South Africa's racial landscape.[6] And she herself has mentioned it, particularly with regard to some of her earlier pieces on the theme of hair, that ever-present subject in the art (and life) of women of color. These include the photographic series *Hare* (1996), the video *Roots* (1996), and an untitled text piece (*Ongetititeldl*, 1997).

However, other works even from around the same moment let go of the one-to-one relationship between autobiography and artistic statement. Like David Hammons before her Rose has discovered a material that is culturally specific yet which opens on to a range of meanings; it is also a fiber that is incredible to work with.[7] Rose's pieces remain more personal than

Hammons's, particularly because they involve her own body. In the video *Ongetititeldl* (1996), we see the artist in a cramped bathroom shaving all the hair from her person and letting it drop to the floor. In *Span II*, a performance created for the second Johannesburg Biennale of 1997, Rose in all her shaved glory sat inside of a large glass display case. She perched on a television set which exhibited that staple of classical Western art history, the reclining nude, the odalisque. Rather than being gainfully unemployed as a passive object of desire, Rose methodically knotted lengths of her discarded hair. It was a meditation and a penance, an action familiar to the Catholic-raised Rose. However, it also signified the black laboring body, that fulcrum of colonial and modern affluence.

Shown in the exhibition "Graft" curated by Colin Richards, *Span II* was accompanied by *Span I*, a tandem performance in which a paroled prisoner carves the artist's childhood memories into a nearby wall of the South African National Gallery, underlining further the conflation of labor, coercion, and polite cultural pursuits. While having specific significance in the South African context, these performances by Rose also connect with others of similar facture and intent that have taken place in other parts of the globe. One that immediately comes to mind is Coco Fusco's and Guillermo Gómez-Peña's *The Couple in the Cage (Two Undiscovered Amerindians)* (1992), in which the artists visited parks and museums worldwide to mark the quincentenary of Columbus's "discovery" of the New World. Traveling as modern primitives, their gilded cage (at once home and prison) was filled with all the latest contemporary accoutrements (laptop, TV, boom box, etc.).[8]

Perhaps even closer in spirit are early works by Adrian Piper where the performative body and written memories come together to create lyrical works of incredible power. Yet Piper has adamantly insisted that while works such as *Food for the Spirit* and the "Mythic Being" series from the 1970s are personal, they are not autobiographical. They offer up intimacy but are not attached to a singular, specific, and individual history. Seeing them as strictly autobiographical, she feels, restricts their reception, keeps them in that colored girl box, walled away from more universal reception.[9]

Besides resonating on an international level, Rose's works are also fully part of visual culture in the postapartheid era. For Rose and her generation (she was born in Durban in 1974 and graduated from University of the Witswatersrand), being able to explore different aspects of identity as they find it—black, white, colored, their own as well those in the larger cultural landscape—is a given aspect of the art process, not necessarily something that is a hard-won right. Artists such as Candice Breitz and Moshekwa Langa also

take on the South African context in ways that evince a certain irreverence and recklessness, a sense of grappling with a postapartheid and larger post-colonial sense of what the world might look like now.[10]

If African photographers of the mid-twentieth century used the framing devices of the modern portrait and portrait studio as ways to construct visual narratives counter to those of the body as ethnographic icon, Tracey Rose has a similar relationship to video and to a certain extent performance. In *Span II* Rose reenacts the scopic regimes of the colony. She places her live body on view in a nod to the display of non-Western peoples in parks, zoos, museums, and royal courts, the playgrounds of European power, a practice dating back to the fifteenth century.[11] As with Fusco and Gómez-Peña, it is the willful agency that the artists bring to this form, along with their intent of ensnaring viewers in conscious acts of voyeurism, that reverses the disempowering results that such actions have had in the past.

But it is perhaps with video that such reversals are more recognizable and clear-cut, if only because of our familiarity with such contemporary ways of seeing. In *Ongetititeldl* (1996), viewers look down on Rose from above; it is not the bird's-eye view taken from nature that art history so admires but one from a surveillance camera. Similarly the video piece тко (2000) provides a murky recording of Rose boxing a heavy bag. Both cameras and audio equipment are embedded within the punching bag resulting in a picture that is grainy and filled with wild motion. The coarse, out-of-focus, self-image has much in common with earlier feminist experiments, as Jan Avgikos has keenly observed.[12] Rose's attack of her inanimate opponent, done gloveless and in the nude, builds to a breathy and screaming orgasmic climax. In both *Ongetititeldl* (1996) and тко, the culture of surveillance points to scopic desire. Indeed these works in their conflation of yearning and visuality point back to the ethnographic object. At the same time they reference the larger photographic archive whether it be passbook pictures and other scientific or government imagery, bourgeois studio photography, or the photojournalism of the struggle against apartheid.[13]

In "appropriating the tools of surveillance,"[14] Rose joins other South African practitioners from Malcolm Payne in the 1970s to the more recent work of Kendell Geers. Indeed for *Documenta 11* of 2002, Geers showed color photographs from 1999, depictions of the security apparatuses used to guard private residences in Johannesburg, "where people protect themselves by creating jails in which they willingly sentence themselves to a lifetime of imprisonment and call it freedom."[15] Such willful detentions are also linked to metaphorical prisons, calcified notions of boundaries

and identities; as Michel Foucault has written, "we are told not only who we are but who we must remember having been."[16] In one of her most complex pieces to date, *Ciao Bella*, 2001, created for the forty-ninth Venice Biennale, Rose uses kaleidoscopic color, roving operatic narrative, a mix of cartoon-like and human bodies, in a vivid three channel DVD projection. It is a piece that in a complex, insanely comic way, a veritable psychedelic surrealism, "directs attention away from the issue of origins and towards the vectors of traveling modern culture . . . culture's routine and irreverent translocation."[17]

Rose plays all the roles in this multiple character piece. The range spans a gamut of female imagery, adding some unexpected mixes into the brew. A sweet red-haired Lolita with matching apple cheeks and a sensual mermaid both sport dildos; a schoolgirl reads verse while Marie Antoinette serves chocolate cake; Saartjie Baartman a.k.a. the Hottentot Venus who is hung by a tie, rises to heaven, becomes a winged angel, then is transformed again into labia in a jar; a pugilistic figure (recalling *TKO*) and a squatting, self-flagellating porn star (after Ciccolina) with an enormous crepe paper labia; along with Mami the proper matron who opens and closes the show.

There is an interesting relationship between Rose's hybrid figures and similar creations by her contemporary, the Kenyan artist Wangechi Mutu. Mutu's recent mixed media collages privilege a sexual female body which morphs with animals and monsters in ways that are sensual, frightening, and also blazing with color. Rose and Mutu both share a theatricalized take on feminist imagery. Yet ultimately, even in these fantastical scenarios women are also seen as agents in the formation of global culture.[18]

Rose's insertion of her own figure into the work presses an insistent subjectivity, replacing the objectified ethnographic figure. This is a surrogate presence which, Salah Hassan has noted, "allows the artist's body image to transcend the conventional boundaries of verisimilitude" and become a source of inspiration and new meanings.[19] The human form here opens up a space of mediation. This is the opposite of the action that occurs in African photographic modernism. As Lauri Firstenberg has noted in pieces by the Malian photographer Seydou Keïta, the body melds with the high affect pattern of the background, is engulfed by the fluid design, and is in effect camouflaged. Viewers are given no access to the corporeal form; instead commodities are used as signs of "aspirations and types."[20] In this work which follows the period of ethnographic exploitation, the occluded, controlled body, the body that is unavailable to the probing eye is power. In Tracey Rose's postapartheid playground, the sense of personal freedom and

authority that is now owned by the social and political body allows the artistic one to explore all possibilities, to reinvent, reconsider, review everything before us.[21]

Indeed, this DVD projection, and to a certain extent the film stills of selected characters that accompany it, embody Jean Fisher's statement that "art does not in any straightforward way represent an indexical real."[22] Instead it manifests culture as the "interzone" in Octavio Zaya's parlance, a place of discovery and translocation, a space where we explore who we are and consider afresh what our passage through history might actually mean; it is a recontextualization of imagery and of the past.[23] The hyperreal color of *Ciao Bella* alone can be seen as "eclipsing the ethnographic eye,"[24] and removing it from the starkness of social science and documentary modes. Even Madiba, hero of the apartheid struggle, first postapartheid president, and now budding artist, has contrasted the bleak monotones of imprisonment—grays, khakis, black and white—with the exuberance of color that signifies liberty, "then came freedom, the lifting of the dark hood from my eyes. . . . I could not get enough of this looking at, feeling, touching, and experiencing, this new recovery of the experience of color."[25]

What is perhaps the most interesting aspect of *Ciao Bella* from an arthistorical point of view is how many of the characters Rose performs in whiteface. Of course she also performs in blackface (the mermaid) and in her natural "classifiably colored" face (as the khoisan woman Saartjie Baartman, and the matron Mami). While this makeup can be viewed as just another aspect of the work's larger theatricality, what is particularly fascinating about the whiteface is how it again reverses received strategies and images. A number of scholars have remarked on characteristics of apartheid-era art production. On the one hand in the 1970s and 1980s works by black artists found a market. Labeled "township" art this work apparently depicted "authentic black life." Here folklore mixed with sentimentalism and suffering, though the cause of such pain was conveniently elided. The sale of this work was of course largely to whites, yet they were hardly ever the subjects of the imagery. In fact black artists across the board rarely depicted whites at all. This fact is even more compelling when we take into account the ethnographic imperative of visual culture and social science throughout the age of imperialism. Colonizers took for granted their access to the black body and the control of its representation. With her simple donning of white powder and wigs Rose takes it upon herself to overturn centuries of visual iconography and cultural authority. In an interesting parallel, Mutu also explores the white female body in her collages to the same effect. Both artists reverse the scopic gaze, a process that we see begin to proliferate with mod-

ernist photographers like Keita and his willingness to block appropriative vision.[26]

Ciao Bella is deployed against boundaries, against the endless systems of classification erected under apartheid. Rose's figures are positioned on, under, behind a long banquet table. Are all in the country finally meta-phorically "seated" together, able to partake equally of the national bounty? Or is it simply the last supper in which a machine-gun-toting bunny blows everyone away (save Mami who is on hand to clean up the mess)? Somehow the horizontality of that long draped table reminded me of a landscape. In South Africa, as in so many places, landscape painting from the seventeenth through the nineteenth centuries signified the conquest of territory. In one sense then, being at the table for these characters means claiming and own-ing a piece of the rock. However, the tableau of *Ciao Bella* puts fluidity and ambiguity into a landscape from which such sensibilities were drained dur-ing the apartheid era.

Ciao Bella and other works by Tracey Rose address what Firstenberg has aptly nominated "the psychocultural politics of postcolonial representa-tion."[27] Rose uses the space of the "interzone" to explore cultural practices previously shut down and turned off and to contest boundaries and contain-ment as ways of both making and perceiving culture. Her practice and that of others working in the postapartheid visual landscape asks, is multicultur-alism enough, is pluralism enough, is hybridity enough, for new forms that are being brought into existence? Do these categories keep us locked inside of certain expected formations still? Are they addressed only to "the butter-fly collectors of alterity"? Do we instead need practices that, in the words of Paul Gilroy, are "cosmo-political" and "outer-national"; new words for new times to speak of cultures that are relational and ever in motion?[28]

NOTES

Originally published in Kellie Jones, FRESH: *7 Young South African Artists at the South African National Gallery*, Emma Bedford, ed. (Cape Town: South African National Gal-lery, 2003). The epigraphs are from Rashid Diab, "Different Values—Universal Art: The State of Modern African Art," in *Africus: Johannesburg Biennale* (Johannesburg: Transitional Metropolitan Council, 1995); Olu Oguibe, "A Brief Note on International-ism," in *Global Visions: Towards a New Internationalism in the Visual Arts* (London: Kala Press, 1994); and Olu Oguibe, "Strangers and Citizens," in Salah M. Hassan and Olu Oguibe, eds., *Authentic/Ex-Centric: Conceptualism in Contemporary African Art* (Ithaca, N.Y.: Forum for African Art, 2001).

 1. See Marilyn Martin, "Art in the *Now* South Africa: Facing Truth and Transforma-tion," in Kendell Geers, ed., *Contemporary South African Art: The Gencor Collection* (Johannesburg: Jonathan Ball, 1997), 131–49, 163–64; Okwui Enwezor, "Travel Notes:

Living, Working, and Travelling in a Restless World," in Okwui Enwezor, *Trade Routes, History and Geography, 2nd Johannesburg Biennale 1997* (Johannesburg: Greater Johannesburg Metropolitan Council, 1997), 7–12; and Paul Gilroy, *The Black Atlantic: Modernity and Double Consciousness* (Cambridge: Harvard University Press, 1993).

2. Thomas McEvilley, "Here Comes Everybody," in *Africus: Johannesburg Biennale*: 53.

3. Salah M. Hassan and Olu Oguibe, "Authentic/Ex–Centric: Conceptualism in Contemporary African Art," in Hassan and Oguibe, *Authentic/Ex-Centric*, 14; and Joseph Kosuth and Seth Siegelaub, "Replies to Benjamin Buchloh on Conceptual Art," *October* 57 (summer 1991): 152–57.

4. Okwui Enwezor, "Where, What, Who, When: A Few Notes on 'African' Conceptualism," in Hassan and Oguibe, *Authentic/Ex-Centric*, 73.

5. Ibid., 74. For information on Latin American conceptualism see Mari Carmen Ramírez, "Blueprint Circuits: Conceptual Art and Politics in Latin America," in Waldo Rasmussen, ed., *Latin American Artists of the Twentieth Century* (New York: Museum of Modern Art, 1993).

6. Clive Kellner, "A History of Invention," *co.@rtnews*, February 1999; coartnews. co.za; and Jan Avgikos, "Tracey Rose," *Artforum* 41 (October 2002): 152.

7. For more on Hammons and hair see Kellie Jones, "In the Thick of It: David Hammons and Hair Culture in the 1970s," *Third Text* 44 (autumn 1998): 17–24.

8. For a discussion of Fusco and Gómez-Peña's piece see Coco Fusco, "The Other History of Intercultural Performance," in *English Is Broken Here* (New York: New Press, 1995), 37–63, 197–98; and the film by Coco Fusco and Paula Heredia, *The Couple in the Cage: A Guatinaui Odyssey* (New York: Third World Newsreel, 1993).

9. Adrian Piper, "Xenophobia and the Indexical Present," in Mark O'Brien and Craig Little, eds., *Reimaging America: The Arts of Social Change* (Philadelphia: New Society, 1990), 285–95. For a further discussion of some of these works by Rose see Sue Williamson, "A Feature on an Artist in the Public Eye: Tracey Rose," *Art Throb*, March 2001.

10. On postcolonial and postapartheid identity formation and artists see McEvilley, "Here Comes Everybody," 55; and Sue Williamson, "Looking Back, Looking Forward: An Overview of South African Art," in Frank Herreman and Mark D'Amato, eds., *Liberated Voices, Contemporary Art From South Africa* (New York: Museum for African Art, 1999), 39.

There are, of course, times when such freewheeling tactics become complicated by the continuing residue of unequal power. This has particularly been the case with white women artists who use the black female body in their oeuvre. See the following works for part of the ongoing debates on such power relations in South African visual culture: Ruth Kerkham, "A Deadly Explosive on Her Tongue: White Artists/Black Bodies," *Third Text* 50 (spring 2000): 45–60; Okwui Enwezor, "Reframing the Black Subject: Ideology and Fantasy in Contemporary South African Representation," *Third Text* 40 (autumn 1997): 21–40; and Brenda Atkinson and Candice Breitz, eds., *Grey Areas: Representation, Identity and Politics in Contemporary South African Art* (Johannesburg: Chalkham Hill Press, 1999).

11. For more on this history see Fusco, "The Other History."

12. Avgikos, "Tracey Rose."

13. *TKO* was created in a residency at the ArtPace Foundation of San Antonio, Texas. See Judith Russi Kirshner, "Tracey Rose," in *Tracey Rose 00.1* (San Antonio: ArtPace, 2000). For a discussion of the concept of archive in South African photography see Lauri Firstenberg, "Representing the Body Archivally in South African Photography," *Art Journal* 61 (spring 2002): 58–67.

14. Okwui Enwezor, "Where, What, Who, When: A Few Notes on 'African' Conceptualism," in Hassan and Oguibe, *Authentic/Ex-Centric*, 81.

15. Kendell Geers quoted in Christian Rattemeyer, "Kendell Geers," in *Documenta 11_ Platform 5: Exhibition, Short Guide* (Kassel, Germany: Hatje Cantz, 2002): 86.

16. Michel Foucault quoted in Jean Fisher, "The Work between Us," in Enwezor, *Trade Routes, History and Geography*, 20.

17. Paul Gilroy, "For the Transcultural Record," in Enwezor, *Trade Routes, History and Geography*, 23.

18. There is an interesting relationship between Wangechi Mutu's collages and those of modern German photomontagist Hannah Höch, particularly her series "From an Ethnographic Museum" (1925–1929). Unlike Mutu's pieces these combine images of African sculpture with the female body. See Maud Lavin, *Cut with the Kitchen Knife: The Weimar Photomontages of Hannah Höch* (New Haven: Yale University Press, 1993). Mutu's solo show "Creatures" appeared at the Jamaica Center for Arts and Learning in Queens, New York, from February 1 to April 12, 2003; it was curated by Heng-Gil Han. For a discussion on women artists as emblems of globalization see Kellie Jones, "Life's Little Necessities: Installations by Women in the 1990s," *Atlantica*, winter 1998, 165–71.

19. Salah M. Hassan, "<Insertions>: Self and Other in Contemporary African Art," in Hassan and Oguibe, *Authentic/Ex-Centric*, 26.

20. Lauri Firstenberg, "Postcoloniality, Performance, and Photographic Portraiture," in Okwui Enwezor, *The Short Century, Independence and Liberation Movements in Africa 1945–1994* (Munich: Presel, 2001), 176–77.

21. An interesting comparison in this regard both to Rose's work and that of modern African photographers is that of the African American photographer and filmmaker Lorna Simpson. In her classic early photographs from the 1980s the black female protagonists assumed positions of refusal, their backs turned and faces out of the frame. In Simpson's most recent films the women are seen whole, sexual, and powerful, as if to say, "shit, we don't care who's looking." See Kellie Jones, "(Un)Seen and Overheard: Pictures by Lorna Simpson," in *Lorna Simpson* (London: Phaidon Press, 2002), 26–103.

22. Fisher, "The Work between Us," 20.

23. Octavio Zaya and Anders Michelson, *Interzones: A Work in Progress* (Madrid: Tabapress, 1996), 13.

24. Firstenberg, "Postcoloniality," 178.

25. Nelson Mandela quoted in Rachel L. Swarns, "With Vivid Palette, Mandela Depicts the Jailhouse Years," *New York Times*, February 12, 2003, A1, A4. An exhibition of Mandela's drawings took place at the Robben Island prison where he was held for eighteen of his twenty-seven years of incarceration. It is now a historical site and museum.

26. For some discussions on apartheid-era visual culture see Bongi Dhlomo, "Emerging from the Margins," in *Africus: Johannesburg Biennale*; David Kolane, "Walking the Tightrope," and Ivor Powell, "The Pale and Beyond: Rethinking Art in a Reconstructed Society," both in Enwezor, *Trade Routes, History and Geography*; and David Kolane, "Postapartheid Expression and a New Voice," in Herreman and D'Amato, *Liberated Voices.*

27. Firstenberg, "Postcoloniality," 175.

28. Gilroy, "For the Transcultural Record," 23–24. See also Martin, "Art in the *Now* South Africa."

(Un)Seen and Overheard

Pictures by Lorna Simpson

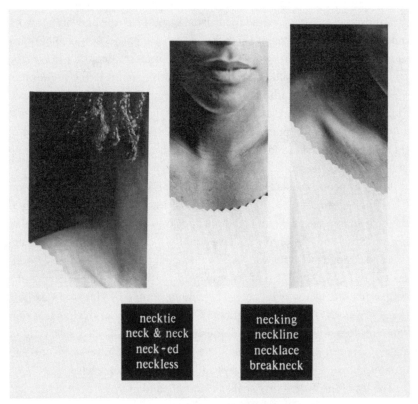

Lorna Simpson, *Necklines*, 1989. Three gelatin silver prints, two engraved; plastic plaques; 68 1/2 x 70 inches. Collection, the Museum of Contemporary Art, Chicago. Copyright Lorna Simpson.

THE WOMEN

We all know a classic Lorna Simpson photograph when we see one: those elegant black female figures, their backs to us, rejecting any familiarity yet communicating with us feverishly in accompanying written messages located just beyond the borders of the image.

When these works first appeared in the early 1980s they held up the medium of photography for intensive interrogation. Using the traditional format of the silver print, Simpson questioned the authority of realism that defined the photographic project. Particularly at issue were the tropes of documentary practice (perhaps best known through the angst-laden pictures of the New Deal era), which in their illumination of human suffering mostly framed such realities as natural, inevitable occurrences, the political causes behind the events remaining invisible and unexamined.

Simpson often provided detailed visual accounts of the body in her work but denied the strategies of the portrait and the particulars of biography thought to reside in the countenance. She also undermined the vision of the erotic female body as subject by never presenting nudes in the tradition of Western art, instead clothing her models in light, white shifts that covered the sensual form. As artist Coco Fusco reminds us: "Those enigmatic and alluring black female figures with their backs turned or their faces out of the frame came to stand for a generation's mode of looking and questioning photographic representation."[1]

Like her peers, artists Carrie Mae Weems and Barbara Kruger, Simpson used language to chart an alternative pathway into photographic meaning. If the body in Simpson's pictures did not appear to be the customary vessel of beauty and sensuality onto which we could project our fantasies, a connection and dialogue with the viewer was sustained through the text. However, the written exclamations that accompanied these photographs disrupted a simple reading of their imagery. The woman in one of Simpson's earliest images, *Waterbearer* (1986), might once have been seen as the handmaiden common to many of Vermeer's domestic dramas or as a classic caryatid of ancient Greece. But the addition of language meant that the work spoke to us simultaneously in different ways and on a number of levels.

The figure in *Waterbearer* strikes a delicate and graceful pose. She holds a pitcher in each outstretched hand. These paired vessels—one silver and

the other plastic—seem to mark the endpoints of the economic spectrum. Women of all classes, it appears, face regulation and impediments to expression and power. The text gives voice to women's language and memory, even while revealing how this speech is stifled and controlled:

She saw him disappear by the river
They asked her to tell what happened only to discount her memory.

What Simpson does in *Waterbearer* and in other works from this period is to comment on the lived truth of women in general and black women in particular. Yet embedded in the very structure of the work itself, in this case in the confrontation between the specificity of individual vision and the need of social forces to control what is recorded, is the action of the artist prying into the history of photographic practice, questioning what we see and how we see it. What are the coded gestures of beauty, the marks of timelessness, the signals by which we comprehend the "universal"? How is what we see conditioned by history, our specific place in the world, and what we think we know for sure? Simpson offers us answers that are open, disjunctive, and somehow not really answers at all. In the tradition of photomontage artists of the 1930s (John Heartfield, Hannah Höch), she works against a seamless, naturalized view of the universe. The (photographic) truth lies somewhere in the space between the image, the text, and our responses to it.

In these pieces from the 1980s, Simpson reacted against the historical image of woman: as sexually available, as an object of surveillance. She not so much countered as blocked traditional readings by presenting the renunciatory back, the noneretic fragment, as a form for contemplation. With this simple maneuver she also rejected the array of often contradictory stereotypes that haunted black women. In Western (visual) rhetoric, the black female body was seen as alternately pathological, criminal, pornographic, and reproductive, but it could also take the shape of the desexualized and faithful "mammy." Such effigies were used not only to justify oppression but also as the control against which white womanhood was set.

Of course, many of these concepts/images had their basis in a history of slavery, which miltitated against the cultivation of black individuals and families. Under this system black women produced children who ultimately did not "belong" to them, for according to the law they were allowed no parental rights. Instead, their offspring were the "property" of another. As chattel, slaves could not make contracts, thus neither marriage nor adultery applied to them in the legal sense. Though we know in reality many (white) masters sired slave children, legally "the father of the slave was 'unknown' to the law,"[2] and as literary critic and theorist Hortense Spillers reminds us,

this "denied genetic link [became] the chief strategy of undenied owner-ship."[3] Other legislation, such as anti-miscegenation statutes and restrictions on masters willing property or freedom to slaves, was further impediment to African Americans being incorporated into the fabric of the larger American family; they were rendered orphans in an undefined state of social relations. The result was that slaves, former slaves, and their progeny did not enjoy the yields of patrimony in either a local or general sense. They were not the recipients of any direct or immediately tangible benefits that could be inherited in a patriarchial society, such as wealth or land. Neither were they deemed as having any rights to the more symbolic and abstract form of birthright, any claims to the cultural riches that their labor had brought into being.[4]

Consider the impact that such antecedents had on concepts of creativity. In the United States, enslaved African Americans contributed to every aspect of building the country, from making the nails and timbers from which its edifices were constructed, to birthing the laborers that built them. Yet as Patricia Williams has commented, the law sets up a situation in which a "master-cloaked white manhood" usurps the fundamental act of creation as well as the "generative source" of culture.[5] African Americans are not only systematically denied all but rudimentary connections to the creative act, but are also blocked from enjoying the fruits of their own labor. In law and in art, the "universal" and the "transcendent" are terms that erupt from this violent disenfranchisement. These words cover the tracks of historical specificity and the painful places out of which American (and Western) culture developed.

Simpson's pieces from the 1980s seemed to take their visual clues from such history. However, they also appeared against the backdrop of the recent past: feminist art of the 1970s. Much of that work, as scholar Amelia Jones relates, "explore[d] stereotypical feminine identities so as to produce new, positive images and experiences of femininity."[6] However, if in the 1970s feminist artists saw femininity as a trap, by the 1980s the stance was one of bemusement, and the feminine was seen as an identity that was performed rather than as a collection of essential traits. Kruger's work of the 1980s, for instance, entered into a dialogue with the latter concept by choosing to "burlesque the construction of femininity," particularly woman as fantasy portrayed in the mass media.[7]

African American artists working in the postwar period had a more difficult time redeploying stereotypes. For the most part, the slurs and false imagery were still too much in current circulation to pass as distant objects of derision. Additionally, the Black Arts Movement, which took hold of the

cultural imagination in the 1960s and 1970s, placed a premium on certain formulations of "positive" imagery—black heroes, black queens, black (heterosexual) families, black warriors. With few exceptions, for African Americans who had only relatively recently been afforded the opportunity on a large scale to control their own images, "positivity" was the watchword.[8]

Simpson's approach to photographic practice was clearly cognizant of the weighted history of the black image and the pain that caricature and mockery might generate in African American audiences. In their postures of refusal, her figures denied the hungry gaze of the viewer and the possession that it entailed. They rejected our desire for intimacy. Those white shifts became shields, jealous guardians of individuality and sexuality. As the scholar bell hooks has written of the woman in *Waterbearer*: "By turning her back on those who cannot hear her subjugated knowledge speak, she creates by her own gaze an alternative space where she is both self-defining and self-determining."[9] These works, then, did not simply offer a critique of contemporary articulations of the black body. Instead the artist sought to create new paradigms for looking at the human form, new ways of considering photographs and meaning, other paths to convey both pain and pleasure.

Simpson managed to push at the boundaries of what could constitute an "acceptable" black image; she complicated the positive/negative binary that in many ways continued to hold the black body fast. These pictures cut to the heart of the framing narratives used by photography and other visual media to maintain control over such representations. Her texts added specificity to what we saw. However, in using these techniques she also insisted on leaving meaning open and available to the imaginings of the viewer.

Simpson's photographs were flexible enough to contain both images that were resistant to the covetous scrutiny of outside forces and those that revealed the methods of photographic evaluation and classification used over decades to define and subjugate black women. These latter practices were linked to photography's birth as a mechanical process. Indeed, because it was a mechanized apparatus, photography was seen as embodying neutrality, the perfect tool for scientific observation; it allowed humans to see things previously undetectable with the naked eye (Eadweard Muybridge's time/motion studies come to mind). The medium contributed to the growth of various sciences in the nineteenth century, among them budding fields of social categorization and control such as anthropology and criminology.

With her works of the 1980s, Simpson stripped away photography's picturesque vistas and embedded narratives. She revealed its fabricated nature, separating the image from easy notions of photography as a tool of the real,

an objective witness. In its place she offered the photograph pared down, exposing itself as an industrial object that circulated through our lives and consciousness on various levels, in scientific laboratories and galleries, in newspapers and magazines of pornography, anthropology and art.

You're Fine (1988) is a work that gives us a sense of floating between these various categories of photography. Here the figure reclines in the classic pose of the odalisque. We recognize the sinuous line of the body, the softly bent knees and delicate feet, the right hand lifted over the head in a graceful arabesque. But instead of the smiling and receptive countenance, and the demure yet available posture inviting our gaze, our visual advances are denied by the simple, yet resolute, turn of the back. The nature of the Polaroid printing process places the figure close to the surface and provides us with exquisite detail; it is as if she could get up and walk into our world at any moment. Yet she floats in an airtight, white-on-white photographic space. The feeling is somewhat clinical: she seems to lie on an operating table; the classic white shift is transformed into a hospital gown. The body is arrayed over four panels, the breaks between them almost suggesting where the dissection will commence: the head and shoulders separated from the torso, the legs separated from the feet. The language of medicalization that the artist accesses here delivers us again to history's doorstep and the use of slaves in medical research—not the able-bodied but the ill and the maimed who no longer had other roles in the system of production. Yet if we consider how this medical discourse intersects with issues of gender we will find not only the regulation of black women's reproductive capacities under slavery (as laboring machines that produced more laborers) but the continuation of such structures of control in the specter of the forced sterilizations that took place into the latter part of the twentieth century.[10]

The woman in *You're Fine* is further circumscribed by text. To the left and right, legends are etched on faux-brass plaques, reminiscent of upscale corporate logos or the antique labels affixed to picture frames and specimen cases. At the left, various tests are outlined, presumably taken by the woman in the photograph to secure the job indicated on the right, that of secretary. White ceramic lettering above and below the photograph gives us the final diagnosis (as well as the work's title): "You're Fine, You're Hired."

In works like *You're Fine* the artist offers us an object that is multivalent and ambiguous. It draws on the imagery of medicine and industry, the art-historical nude and the enslaved body. The figure denies the gaze yet remains caught in its sights. Throughout her work Simpson calls our attention to photography as an apparatus of discipline, as a way in which we contain and control our visions of the world. In this sense she takes us again

to the beginnings of the medium, where the discourses of tourism and imperialism were intertwined, and "imaginative geographies" of possession began to be constructed through the photographic lens.[11]

In comparing *You're Fine* with *Waterbearer* we are struck by the difference of approach. The space between the two images marks the artist's shift from a holistic statement—paired text and photograph—to one where multiple layers of meaning are inscribed into the photographic surface. Increasingly in the work from the 1980s into the 1990s, frames and the photographic edge become devices to accentuate the splintering of the human form. This activity appears in several ways. In *You're Fine*, the frame is used as the severing device. At other times discrete parts are repeated in serial fashion, as with the rhythmic torsos of *Five Day Forecast* (1988). With this action Simpson alludes to the commodification of people and their bodies through the photographic process, whether in formats defined earlier, such as police photography, or in more contemporary commercial advertising and packaging. Yet the other side of this serialization and fragmentation of the body is the artist's rejection of the singular, cohesive narrative as a defining vision for the present.

Art historian Rosalind Krauss has referred to the visual fragment as a "part-object," designating these elements as "desiring machines," which because of their partial nature fail in their quest for narrative completeness.[12] Rather than producing solid meaning or representation, the part-object always suggests that unfulfilled desire; it is "flow," it is process, but never finality. In Krauss's scenario, synecdoche—the part referring to the whole—does not exist, for that would complete the thought, the representation. Using Krauss's model, Simpson's incomplete and patched-together bodies do not stand in for an elusive whole existing somewhere outside the picture frame. If we consider the artist's nonerotic body fragments as part-objects, rather than offering up slices of (black) life, they instead point to the processes of seeing and thinking that make up the photographic experience.

This interpretation, however, exists in tandem with that of bell hooks, who offers a more caustic view of the part-object concept. Considering the condition of black American servitude before as well as after 1865, hooks emphasizes the idea of blacks reduced to a collection of parts, aspects of the laboring body, by the whites whom they served. She quotes Kentucky newspaper heiress Sallie Bingham's descriptions of her (black) servants' total invisibility and nonexistence except as "a pair of hands offering a drink on a silver tray."[13] Krauss's part-object theory accesses this interpretation of the body reduced to mechanized components, especially as it grows out of modern artists' reactions to the expansion of industrialism (and the realities of

war) in the early twentieth century. However, in the case of African Americans (and black people throughout the colonial world) this was their sole role during the past five centuries of Western history, as human machines.

If the part-object does not produce narrative it is itself a sign of modern Western life. Each desiring machine keeps generating "a flow for the next machine to process" in an endless cycle of production.[14] This is the story of the West. Simpson acknowledges such history in her work, then takes the process elsewhere.

Like the work of Simpson's peers from this period, *You're Fine* calls attention to the gaze and its trajectory. Kruger similarly arrests the traditional viewing process, alerting us to its implicit mechanisms of domination. Yet, the two artists differ in their use of popular visual imagery. Kruger, for instance, in *Untitled (You have received orders not to move)* (1982), recycles these visions, pointing out the alignment between devalued mass culture and the status of women.[15] Simpson rejects the use of such stock characterizations, and the psychological violence that they represent in the black imagination.

Cindy Sherman's *Untitled #96* (1981), like *You're Fine*, appropriates the pose of the odalisque. However, in Sherman's photograph the erotic nature of the image comes to us already overdetermined. Again, the accessibility of mass cultural imagery is conflated with the sexual availability of woman. As Amelia Jones has pointed out, here the flatness and openness of the body mimics the sheen of the centrefold; the figure's hand points directly to the pubis, which, when the image first appeared as a project in *Artforum*, was the actual "gutter (of the magazine)."[16] With this composition Sherman also calls attention to the photograph's role as fetish.

The work of all three artists places viewers in a compromised situation, making them complicit with voyeurism and dominance; it relies on scopophilia, the pleasure humans derive from viewing one another. But while Simpson carefully details for us the structures of visual domination, her work differs from that of Kruger and Sherman in its refusal to engage with popular, received notions of the black body. Simpson instead attempts to sever "the connection between woman and spectacle."[17]

SPEECH

Language became Simpson's primary tool to question and short-circuit the role of photography in the construction of black woman as erotic curiosity. The textual enunciation of these early works disrupted the simple reading of the images. On the one hand, the pairing of text and photograph appeared to ground the meaning of these pieces, arresting free-floating signification by attaching another layer to the process of contemplation and thus un-

doing their "own seeming innocence."[18] On the other hand, it often had the effect of adding ambiguity to rudimentary visual signification, for the two parts were rarely meant to mesh easily. What the artist's oeuvre, in fact, increasingly pointed out was "language's slipperiness" and its ability to slide "across the range of meanings suggested by an image or word."[19]

Language was an important device in much United States art of the 1980s, particularly that with a feminist edge. Kruger became well known for texts that were both declarative and ambiguous. Revolving around the paired pronominal shifters "you" and "I," her work created a site of instability by imbricating "each [subject] position within the other."[20] Jenny Holzer used a variety of surfaces (posters, stone, electronic signs) as vehicles for her explorations of words as art. In early work in particular—such as *Truisms* (1977–1979)—we are struck not only by the incongruous ideological positions that each phrase maps out, but the anarchism that such juxtaposition suggests.

Language in Simpson's work from this period creates a similar sense of disorientation. In *Necklines* (1989), arrayed across three photographic fragments are differing views of a woman's neck. On the left, dangling braids call our attention to the curve of the neck as it meets the shoulder. At the right, lighting brings focus to the delicacy of a clavicle and the parallel slope of the chin. The central image, photographed straight on, captures the figure's soft lips as well as the very tip of her nose, but leaves the rest of the face out of the frame. The woman's white shift, edged with a jagged pattern, offers a sharp counterpoint to the gentle surfaces of the skin and features displayed in all three images.

In two plastic plaques underlining the photographs, Simpson plays with the imagery created by the word "neck." "Necking," "neckline," and "necklace" reinforce the sensual, feminine readings found in the images we see. The masculine-identified "necktie," perhaps as a counterpoint to "necklace," seems somewhat incongruous here. However, what Simpson accomplishes with this simple word-out-of-place is to begin creating a wedge between signifier and signified, and with this action reveals the space of meaning as a large and complex terrain.

"Neck & neck" and "breakneck" are terms that bring to mind speed and racing; might this refer to competition between the figures depicted, or their haste to retreat from an oppressive situation? The sense of velocity also conjures notions of violence in "breakneck." Indeed, brutality lurks as a shadowy lexicon behind the face value of Simpson's text. "Necklace" seems to find its dark reflection in the homonym "neckless," until we recall how the necks of political traitors were encircled with flaming rubber tires dur-

ing South Africa's struggle against apartheid, a practice known in the 1980s as "the necklace." Neckties have also been indicated in violent acts. Necklines provides us with a primer on the artist's methodological approach to language. As with her handling of photographs, there is a sense that each word is not chosen for what it discloses, but neither is it meant to obfuscate. These ambiguous sounds and phrases are at once familiar and unsettling.

In the "slipperiness" of language, the artist found that not only did meaning migrate, often imbricating one word with its apparent opposite, but that the position of subject, object, and viewer could also change. While most mainstream critics writing on Simpson's works throughout the 1980s read the black women depicted as victims, others saw them as sentinels, standing guard over that "alternative space" identified by hooks as "both self-defining and self-determining."[21] These pictures and their written annotation pointed to the historical role played by photography in the surveillance of the black body. Yet the same works also mounted a guerrilla attack against such subjugation, refusing to be circumscribed by that institutional gaze, and in the process turning the tables on photography's documentary mode.

Artists' use of language in the 1980s was ascribed to the heritage of conceptual art of the previous decades. Forefathers such as Joseph Kosuth, Lawrence Weiner, Douglas Huebler, and John Baldessari were given credit for launching the image/text movement. Indeed, Baldessari was a force in Southern California during the time that Simpson attended graduate school at University of California, San Diego (UCSD). She was also exposed, firsthand, to the work of the conceptualists David and Eleanor Antin who taught there.

Eleanor Antin was among the first wave of feminist artists using conceptual strategies, combining photography, video, performance, and writing. Pieces such as *100 Boots* (1971–1973) and *Carving: A Traditional Sculpture* (1972) rely on photography as a mechanical process to record fugitive, private actions as art. In the latter work, daily documentation of Antin's weight loss is equated with a typical act of Western art-making. The commentary here on the construction of the ideal body is clearly something that could have had an impact on Simpson's own photographic conceptualization of the female form. In earlier pieces by the older artist, such as *California Lives* (1969) or *Portraits of New York Women* (1970), objects paired with elliptical texts give us an even greater sense of where some of Simpson's thinking may have started.[22]

Though he was a poet, the example of David Antin for Simpson should not be overlooked either, particularly regarding the linguistic aspect of her work. His method engaged poetry as a conceptual practice in both its oral

and written forms. Stream-of-consciousness writings emphasize the prosaic; public speech is cast as site-specific performance art. Language is revealed as a "common knowing" (Antin's term), emphasizing the act of collective creation.[23]

Like Carrie Mae Weems, her classmate at UCSD, Simpson used language in a way that evoked the spoken word in its "spontaneity . . . intimacy [and] immediacy," as well as its implicit reference to the idiom of African American life.[24] Thus *You're Fine* not only denotes the figure's health but, in vernacular parlance, comments on her attractiveness; "neck-ed" in *Necklines* is a bad spelling of "naked," a phonetic rendering of how some black folks refer to nudity. These shrewd details of speech remind us of the sophistication of Simpson's work, and how she subtly guides us to consider issues of history, race, and gender through visual form and language.

The feminist and literary scholar Barbara Christian has pointed out the importance of the word as a dynamic force in the history of African American theoretical formations. A vast array of verbal expression has been used to create this alternative epistemology, much of it in the service of physical, political, social, or spiritual liberation. African American philosophical theorizing might come through riddles, language play, proverbs, narration of any kind that is mutable.[25] The most renowned aspect of this oral tradition is, of course, song.

With song, mutability is found in the characteristics of indirection or double entendre present in the early heritage of work songs and spirituals. From the beginning, African American music functioned as a coded language, on the surface appearing earnest, sorrowful, and pious, yet containing occluded messages of escape, retribution, joy, and strength. If music was "central to the meaning of a culture of resistance during slavery," as Angela Davis has argued, then a form such as the blues was heir to this tradition of protest, continuing it into the twentieth century.[26]

Trained also as a folklorist, Carrie Mae Weems has often directly engaged what scholar Henry Louis Gates Jr. has called this "speakerly" tradition, whether signifying on racist jokes or incorporating traditional wisdom or song. Her language runs from the vernacular—the series *Untitled (Sea Islands)* (1990) and *Untitled (Africa)* (1991)—to the poetic—*The Hampton Project* (2000). Both Weems and Simpson have used sound as an ambient aspect of photographic installation, but in Weems's oeuvre this translates more often into a lyrical vocalization closer to song.

For the most part, Simpson's approach to vernacular language is more subtle. She is clearly aware of and inspired by the spoken/sung word in the African American tradition but does not necessarily translate its lyricism.

Simpson's shorter snippets of text do not have the poetic meanderings of song; they are not fluid narratives linking photographs into series, as we find in Weems's work. Rather they are like place marks, references; and in that way they seem to take measure of narrative as well as the passage of time.

This ability to mark both time and the trappings of African American language is particularly evident in several pieces made around 1990 that take hair as their focal point. As Kobena Mercer has pointed out, hair is the ultimate signifier of black difference.[27] Outside of visualizing a separation from the white "norm," for African Americans it also represents an internal dialogue on beauty and desire.[28] In works such as *1978–1988* (1990) and *Counting* (1991), the lexicon of hair—twists, locks, weave, braids, tangle, knot—almost imperceptibly signifies African American culture. Actions described in both pieces become methods to acknowledge the passage of time and denote the course of history. In the former piece, ropes of braids are roads leading us from one decade into another; in the latter a large coil of braided hair repeats the pattern of bricks in the image of a circular slave quarters above it, at once marking the distance and proximity of the past. The counting and labelling in each work has a quasi-scientific aspect in which the vocabulary of photography is embedded. But these seemingly matter-of-fact delineations also remind us of similar mundane language used by conceptual artists in the 1960s and 1970s, on whose example Simpson also draws.

Critic and curator Okwui Enwezor has written eloquently about the relationship of Simpson's work to minimalism, her reiteration of the grid, her (re)imposition of a speaking subject on its hulking, silent, primary forms.[29] However, it is perhaps not so much the configurations of minimalism per se, but conceptualism's adaptation of its parlance that Simpson embraces. There is that aspect of conceptualism, what some might call its "classic" form, that is spare, clean, repetitive formula, often based on investigations of closed "systems." It is the object vanished into language, honed down to its generating concept, and presented, in Judith Wilson's words, as "the melted down . . . status of evidence."[30] Indeed, the textual style of first-generation conceptualism was often characterized as pseudo-scientific or "pedantic . . . didactic . . . dogmatic."[31] Language was employed in much the same way as photography: for the corroboration of art as event or experience. Together these two poles of understanding—the visual and the linguistic—comprised the fundamental lexicon of conceptual art.

What the photographic and language-based documents of early conceptualism revealed, unlike minimalism, was "the process leading to form."[32]

Repetition in conceptual art encapsulated action and time in a way that its sculptural predecessor never did. It is this sense of progression based on daily, lived rhythms or "real time" that forms the basis of Simpson's work both visually and verbally. She does not so much detail African American speech but the processes through which conceptual code and indirection in forms like the blues are created.

F2M

By the early 1990s Simpson's imagery had become more complex, with multiple photographs and plaques, the use of color, and variation in the costumed figures. *Bio* (1992), a perfect example of the growth and maturity of Simpson's work at this point, is composed of eighteen large Polaroid prints and nine panels of text arrayed across an eight-by-thirteen-foot stretch of wall space. Three words frame its bottom edge—"Biopsy," "Biography," "Biology"—giving us both title and meaning. Using these three words that begin with life ("bio," from the Greek *bios*, meaning mode of life) Simpson elegantly describes key constructs that impact on and regulate individuals and bodies, from the clinical control and dismemberment implicit in Biopsy, to the performance of race that signals Biography, and the gestures of living gender that surround Biology. The figures that Simpson depicts balance on these sites of identity formation and power.

At the upper boundary of *Bio*, mirroring yet posited against the three building blocks of social structure, are six written fragments that move us closer to private constructions of agency and history. These texts lead us down a road where the discourses of medicine, race, and gender converge. "Bled to death inside hospital last year" wouldn't necessarily signal a racialized medical discourse, until it is paired with a panel that states "bled to death outside hospital 60 years ago," recalling the heyday of segregated facilities, medical and otherwise, public and private. African American bodies may come to mind with "tendency to keloid," but coupling this statement with "tendency to be prescribed anti depressants" decenters race, filling our minds with images of (black?!) housewives popping Prozac. The other two texts remind us that as we get nearer to individualized histories, we get closer to personal recollections:

> choose general and you might lose a shelf of memory
> choose local and you'll remember too much

Here the action of selecting anesthesia relates back to how much one wants to forget or how little one needs to remember. Medical discourse moves out to the social arena, whether we are talking about anaesthetization against

some of the pain of being black in the United States, or the way the well-to-do and/or white citizens of the same country "choose not to know what they know," to paraphrase artist Adrian Piper.

These two bands of text frame three sets of images with their public/private conversations. Directly beneath the narrative fragments are six identical black boxes. Arrayed above the bottom row of text and literally standing on them are six Polaroids of black oxford shoes. A pair graces each photograph except on the far left, where a single shoe floats above the word "Biopsy." The central focal points, sandwiched between these horizontal arrangements of words and pictures, are once again the backs of bodies. Six torsos are draped not with Simpson's familiar white shifts but with crisp, broad-shouldered, grey suits.

The three types of images taken together seem to stand in for the body in its entirety. A black box sits on top of each torso. It is the head, the command center, the container of experience and memory, much like its counterpart on an airplane; the thing always ardently sought in times of distress. The connection between the shoes and the torso is palpable. One can feel the support, invisible legs like pylons holding the figure up. Yet if the black box is the residence of the mind, its color and horizontality also suggest a coffin, the final resting place of the flesh. In size and detail, however, each carton is a shoe box matched perfectly to the footwear below. With the shoe/box Simpson links the psyche to the feet in a classic psychoanalytic pose. The shoe: the ultimate fetish and substitute for the missing sexual organ. Like the institutional formations invoked by Simpson in *Bio*, psychoanalysis is a medical discourse, a framework on which to hang our desires.

The medicalization of sexual longing that is subtly suggested in this large work is placed front and center by the artist in Landscape/Body Parts III (1992) made the same year. A two-panel piece, it is as simple as *Bio* is complex. Both share a flaming red background, setting a bloody scene, or one of passion. A single headless figure stands (facing us?) at center in a black cat suit and sensible boots. On each hand she sports a strappy red sandal, unpolished fingernails like toes peeking through the front. Her arms are crossed at the wrists, demurely, as one might otherwise do with one's ankles. Written across the bottom of the photograph—in fact across the ankles—Simpson's text reads:

Seated on a train she
realized she had been
given a
"Mississippi Appendectomy"

Sex, science, love, the knife: the place where these things intertwine has been explored by African American women artists in particular through the figure of the Hottentot Venus.[33] Here was a woman (of southern Africa, née Saartjie Baartman) whose genitalia were the toast of Europe in the early nineteenth century, so much so that her private parts were put on public display upon her death (in no less a cultural bastion than Paris's Musée de l'Homme).[34] And similar reproductive organs removed in the United States in countless "Mississippi Appendectomies," where might they have ended up?[35]

In *Bio* (and to a certain extent in *Landscape/Body Parts III*), however, the figure, for the first time, is not obviously female. The feminine white shift is replaced with the masculinizing power suit. At best the human form is androgynous, leaving viewers to choose its identity.[36] Racial signifiers are also more subtle: traces of skin make only the briefest of appearance, quietly at the top of each torso. If Simpson's classic statement, in some sense, never seemed clearer—revealing the social body as circumscribed by institutional formations—in other ways she was moving into new territory; or as one observer suggested, her photographs were "at once more pointed and more evasive" than ever.[37]

Foreshadowed by works such as *Necklines*, where a field of female-identified items is problematized by the word "necktie"—a sartorial symbol of male power—the gender indeterminacy of *Bio* opens Simpson's art more fully to interpretations of hybridity. The artist does not focus on the ostensibly competing claims of the term, understood as cultural syncretism or as more fraught scientific theory, where biological purity and posthuman concepts of the body seem again to lock us into taxonomies of power. Instead, as in so much of Simpson's oeuvre, *Bio* and other images from this period make a case against "the fetishism of boundaries."[38]

Simpson's figures of the early 1990s appear as transgendered bodies living in spaces marked by transformation. Like the butches and F2MS (females-to-males)[39] from whom these images seem to take their inspiration, Simpson's photographic protagonists give the impression of being intent on both demolishing the traditional understanding of gender normativity and examining the myriad ways in which women make their way in the world. In *Bio*, and a whole suite of works created in 1992, it is clear that while Simpson's figures may not play a "feminine role," the artist remains focused on the experiences of women.

Two pieces from the period are specifically concerned with the place of clothing in the construction of identity. They make the case for gender theorist Judith Halberstam's suggestion that we consider "a modern notion of

sexual identity as not organically emanating from the flesh but as a complex act of self-creation in which the dressed body, not the undressed body, represents one's desire."[40] In *Suit* (1992) a lone figure, seen from the back, is again androgynous. Stretching across three panels, about six feet tall, in a business suit and short-cropped hair, it stands erect, a symbol of phallic power. This vertical axis of authority, however, is disturbed by a slight shift in the shoulders, the resting of hand on hip. Here is another classic pose: that of a black woman ready to give someone the business. As the plaque at right (the same side as the raised hand) states, she is: "An average size woman in an average suit with illsuited thoughts."

Shoe Lover (1992) takes up the discourse of the fetish seen in *Landscape/ Body Parts III*. The relationship between sexual fantasy and the mind/body is revealed again in the shoe/box pairing. To the left, the phrase "female attraction" appears above the image of a black shoe box, a container of the sexual, be it the body or the mind. On the right we read "attract females" over a picture of elaborate mules. Rhinestone encrusted heels confronting us, the shoes are placed a foot and a half apart, toes pointed away, either miming a stance of sexual bravado or mimicking Simpson's familiar back-turned women. Again the androgynous suited figure makes its ambiguous appearance in the center panel; it is the body as both mediator and vessel, as both aggressor and pursued.

Halberstam has argued for equating "the clothed self with the construction of gender itself,"[41] citing compelling examples throughout Western history; this is more than masquerade. There was, for example, the eighteenth-century "female husband," a woman involved emotionally and sexually with other women, at once "a kind of folk hero who lived a daring life of subterfuge and dissimulation, and a rebellious figure who usurped male power."[42] She also describes "Aristocratic gentlemen inverts" (masculine-identified women) of the nineteenth and early twentieth centuries, who wore "proper" female attire on the street; their "manhood was a private identity rather than a public self."[43]

Not included in Halberstam's survey but equally creative in imaging gender at an earlier point in history is the figure of the African American female blues singer. The blues was initially recorded and made popular by African American women. A musical form known for its vivid, worldly, and explicit lyrics, it represented an arena in which they could offer forthright expressions of female autonomy and desire. Where the lyrics themselves might not be altogether critical, artists would rely on their own powers of suggestion, creating a sense of irony or a mocking stance that could be gleaned from their presentation. The crossdressing and bawdy songs of Gladys Bent-

ley were part of the fabric of Renaissance-era Harlem. Lesbian life and love were also subjects of the blues. A number of female blues singers maintained relationships with other women and sang about them too.[44]

While one may not wish to commit to the idea that "race" can be constructed through sartorial or performative identity, the masculine-identified woman of Halberstam's analysis can be compared, in certain ways, to the African American who "passes," who exchanges the identity she was born with (black) for one more suited to her aspirations and desires (white). Both states can be transitive (or not). In Wesley Brown's novel *Darktown Strutters* (1994), for instance, African American minstrels often dressed the part of domestic laborers while off duty and in town. No need to upset the (white) residents with their changeable, performative, magical,[45] uppity selves. Such comportment allowed the townspeople to continue believing that stratifications by race were fixed, and that the place of blackness remained safely on the lowest possible rung of the ladder. Meanwhile, the minstrels were able to walk the streets without fearing (as much) for their lives. Considering this example, could we venture to say (as with certain turn-of-the-century masculine-identified women) that some aspects of "blackness" were only found in the concealed private self? This is the question that Simpson seems to ask through her photographs over and over again.

In her pieces from 1992, Simpson problematized what "woman" looked like, and who she was, particularly with regard to issues of sexuality and gender. The increasing complexity of the photographic work was not solely the result of adding more panels, texts, and techniques, but due to the range of questions asked and the variety of notions of black womanhood and black identity—often competing—that the artist chose to explore. Among other things, these images affirmed that "one axis of identification [was] a luxury most people [could not] afford."[46]

Interestingly, masculinity and masculine privilege as inflected by race was the subject of what is considered the artist's first mature work, *Gestures/Reenactments* (1985). The multiple silver prints and text panels have the recognizable (if rudimentary) stylistic flair of her later work; the crushed-paper background of the studio is more in evidence, the words a touch more obtuse and nonlinear; bodies remain fragmentary and countenances unseen. The stark contrasts of skin (black) and clothing (white), which Simpson would carry forward for half a decade, are initially seen here.[47] In retrospect, the male body that is the focus of the piece is a prototype, a test model for all that would come later.

Observers have read *Gestures/Reenactments* as a paean to the formulation of identity as it unfolds within a human community: how each personal

connection offers another opportunity to rediscover the self in the presence of the other.[48] The players are Larry, Calvin, Mr. Johnson, Sam, and "his runnin buddy." Because the details of environment have been exiled from the picture plane along with the modes of straight and documentary photography, the locale is defined not by the particulars of a physical setting but by gesture. The freeze-frame images catch a variety of actions, or body language: "how his runnin buddy was standing when they thought he had a gun . . . how Larry was standing when he found out." Yet as always we are not so sure of what we see; for what we have here are not so much the motions of masculinity, but poses that call them into question, that decenter and indeed pry the concept away from that of maleness. The posture of the figure in *Suit* (1992) may have even been germinated here, in the text panel that reads: "Cecile with hands on hips got angry & told him about himself in the kitchen"; over it the man in the photograph assumes the same stance.

In opposition to femininity's apparent culture of masquerade, Halberstam has pointed out the seemingly "nonperformative nature of masculinity."[49] Masculinity is anti-theatrical. If the artifice of femininity is parodied in drag, masculine performativity (as enacted by women in what Halberstam terms "kinging") is defined by constraint. "If the drag queen gesticulates, the drag king learns to convey volumes in a shrug or a raised eyebrow."[50] What such performances point to is the sense we have of masculinity's naturalness, its inseparability from the male body. Masculinity's anti-theatricality and reliance on gestures of "realness" render it invisible, a given. And the standard-bearer of this concept is, of course, the straight, white, middle-class man. There is implicit power in nominating such bodies authentic and thus dominant: all other masculinities are rendered imperfect, mere pretenders to the throne.

Besides problematizing the concept of (black) women in 1992, Simpson also pushed further at the definitions of photography, moving beyond prints linked with text into the arena of site-specific installation. One of her initial pieces in this format was *Hypothetical?* (1992), created in the wake of the Los Angeles rebellions. In the project space of New York's Josh Baer Gallery, Simpson embedded about one hundred trumpet mouthpieces into a wall. On the other side of the little room, facing them, was a small black-and-white photo of a mouth with lips tightly shut. A low throbbing emanated from overhead filling the area: the reverb from distant and muted horns, their sounds seeming to empty into the building's structure, or just outside the confines of the gallery. To a third and adjacent wall she affixed a tiny square of Plexiglas on which the word "hypothetical?" was engraved. This

served as a frame for an even tinier snippet, cut, almost randomly, from a newspaper. It read:

> Asked whether he would now be
> afraid to be a black man in Los Angeles
> if he were not the Mayor, Mr. Bradley
> paused, then said: "No. I would not be
> scared. I would be angry."

In the pause between the journalist's question and Bradley's answer the raiments of masculinity are revealed. Though African American, Bradley has been (temporarily) made an honorary white man, joining the ranks of true (white) masculinity by virtue of his position as mayor of the second largest city in the country. As a minority politician in the United States political system for decades, this idea is certainly not lost on him. Yet hearing it spoken so plainly in the light of day sets him off guard momentarily. Using the conditional "would" in his response he continues the exchange in the subjunctive tense (would that I were a black man I would be angry), going along with the program and keeping his blackness hypothetical and thus in the mode of fantasy.

In illuminating Bradley's balancing act, Simpson also comments on the tension between community and individual. The one hundred mouthpieces blowing their collective sound appear to be set in opposition to the singular, silent mouth across from them. The person is separate, seemingly isolated, the jaw set against the communal reverberations. But listen again to Bradley, wading into the shallows of the pause, navigating the eddies of hypothetical blackness. He does manage to link himself back to his constituents on the shores of L.A. and speak with them: "I would not be scared. I would be angry." Bradley like Simpson knows the power of the statement that comes to you at an angle, the one that hits you upside the head.[51]

Simpson, master of indirection, takes us to the river and drops us off into a debate on masculinity and the L.A. rebellions. But we should know by now that women are lurking there. If the sound bite features Tom Bradley, hizzoner, mayor of Los Angeles in the year of our Lord 1992, the mouth that fills the lone photograph is not Bradley's at all, though it may speak with him. The single set of sensuous lips belongs to a woman. Writer and music journalist Greg Tate, in offering up an imaginary subtitle for *Hypothetical?*—"Starring the Lips of Alva Rogers"—reveals the layers of ideas and imagery that Simpson loads into each work, exposing, if momentarily and still partially, her process.[52] Tate's comment also shows us that the piece is grap-

pling with some of the same ideas as *Bio* or *Suit* though visually they may seem quite different. This specter of civil unrest offered an opportunity for the artist to make allusions to the strata of power, brutality, and oppression that masculinity often comes with. Is the woman's voice mute in the face of violence? No, it is a singer's mouth, humming with the trumpets through clenched teeth. Simpson reminds us through her images that make difference familiar (and not) that we must change old habits of thinking if we are to reach new paradigms.

OFF THE WALL AND (BACK) INTO THE WORLD

After 1992 the artist slowly began to disappear the figure from her photographs. In works such as *Five Candles* (1993) and *Twenty-Five Candles* (1993), we are left only with extremities, hands and not feet but shoes. In these two pieces even language has fled. *Stack of Diaries* (1993) continues the artist's move into installation. Here the recognizable body and its parts vanish altogether, in its place leaving only the physical suggestion of text. Simpson pairs a large photograph of a listing tower of spiral notebooks with a standing steel shelf supporting etched glass tablets. These discrete volumes— bodies of words—lead us back to corporeal space, back to gender. The ephemeral and elusive world of the private diary is the realm of women's writing. The glass-and-steel structure has the presence of modernist architecture, its language male, public, modern, new. Yet the engraved surface is somehow also very old, as ancient as the Rosetta Stone.

Installation is the new place in which Simpson gathers our contradictions; and again she hands them back to us altered. It is a genre that permits her to manipulate context in a way the monotone, planar backgrounds of the photographs never allowed. The constructed environment expands the space of interpretation; in and through it Simpson is able to juxtapose and display the physical evidence of multiple truths. Installation's construction is transparent, self-conscious, deliberate, clearly inviting the activation/participation of viewers.

In *Standing in the Water* (1994)—first shown at the Whitney Museum of American Art at Philip Morris—the artist refocused our eyes resolutely from the wall to the floor. The focal points were wide expanses of felt printed with images of the sea, and embedded with slabs of glass, this time etched with pictures of shoes, toned lighter or darker to mimic various levels of submersion. The soundtrack was not the rush of waves but a cacophony of water sounds such as flushing toilets, spraying fire hoses, or drops filling a bucket. Two miniature video screens, stacked one above the other, emerged from a far wall, each holding a single image and a text that scrolled across

it. Simpson described their content as follows: "The top monitor, with the image of the pitcher, carries the descriptions of things that occur in water, and the bottom monitor's texts, over the ocean image, are literal descriptions of the soundtrack."[53]

Standing in the Water was clearly a space of otherworldliness. One entered it through a billow of white cloth, which shut out the corporate entryway and muted the noises of midtown New York. The stilled waves, the floating shoes, the strange sounds transported one elsewhere. But it was not necessarily a site of the ethereal. All the watery connotations did not add up to purification, or other religious implications of rebirth. One was not "walking on water" but standing in it. One was not lulled into a meditative state by the echoes of waves but brought back to real time with the din of showers, hoses, and ships in motion. The human bodies leaving their footprints in the sand may indeed have moved on to a spiritual plane, but this was not necessarily due to any quest for eternal redemption. Rather, what Simpson suggested was the link between disappeared bodies, "political crisis and water." In an interview with exhibition curator Thelma Golden the artist describes such scenarios, connecting them with the video's moving texts:

> "Flooding the rice fields on purpose" . . . Reference to the acts of insurrection by enslaved Africans . . . "The promise of showers" . . . World War II concentration camps.[54]

The water's motion was also emblematic of the momentum in the work itself. The most perceptible change was, of course, the willful banishment of the figure and even, at times, the text. The reference to movement, already embedded in the seriality of Simpson's photographs, was taken to the next level with the incorporation of video. The three-dimensionality of installation, the further involvement of the viewer—and bodies in motion—in making meaning through the circumnavigation of the site were portents of moving pictures, films to come. On the way there, though, the artist was to go a little further with felt and with the specter of the absent body.

SEEN/HEARD/FELT

Between 1991 and 1994 the artist created six room-scale installations in addition to continuing with the phototext works that had become her métier.[55] These shared some common materials: increasingly smaller fragments of "traditional" photography, a sound component, video, glass, and silkscreened or lithographed felt. By 1995 the artist had moved away from the full three-dimensionality of multimedia installation. Instead she began

to focus almost exclusively on photographic impressions on felt. Multi-panel and larger in scale than any of her previous two-dimensional work, these were also environments. In the manner of much American painting from the 1950s on, their luxurious expanses presented themselves as sensory fields of contemplation. The declarative plaques become absorbed into this new material. And the body disappeared altogether, surviving only in the fullness of textual narrative.

As Enwezor wrote of these works, Simpson's "new reorientation to a more sublime and poetic realm moves her from a contestatory and interrogative social discourse to one of private contemplation, where she is able to explore the inner dwellings of unguarded desire."[56] Simpson's turn to felt was a brilliant one, for it spoke to issues of sensuality on a number of levels. As a fabric it was incredibly tactile, calling out for our touch. Even the process of its creation recalled sexual performance: felt is made by adding moisture to hair and compressing it. Finally, the word itself conjured bodily contact.[57]

In the series in felt called *Public Sex* from 1995, the relationships between the private and the social body, self and other, image and meaning are played out as encounters with sex and desire. Yet, we see no flesh, no signs of star-crossed lovers, no real intimations of the human form anywhere, except in the shadows. In *The Bed* for instance, we sense the ghostly imprints of figures in rumpled sheets. But most of the pictures in this group depict scenes that are outdoors and urban: the elegant, echoing archways of an antique building with a lone car parked off to the side (*The Car*); the grand vertical lines of the city embodied in the classic clock tower (*The Clocktower*); finding an oasis of green stillness among the bright lights of the concrete jungle (*The Park*). Each work documents intercourse that is public but unseen. The push and pull between photograph and text—now joined together in one extended plane of felt—foregrounds the ebb and flow of longing. The body's absence only heightens our yearning to see it again.

Simpson lets her material make tangible what her images render only palpable. Taking a cue from Joseph Beuys, felt becomes a sign of the curative and transformational powers of human society. It is comfort found in intimacy. Yet the urge to form community, the desire for union and kinship, also speaks to a passion for the journey that creates change within the individual, the movement from a place of solitude to that of (an)other unity.

Because the image of the black woman's body was integral to Simpson's more overtly politicized commentary, it had to be exiled from the picture plane in order for her to focus elsewhere. Interestingly, this action followed

the tradition of African American art history. For decades artists found it difficult to describe the nude black female visually. After centuries of rape and abuse under slavery, even the erotics of personal pleasure were hard to image. Given this historical trajectory, it is not surprising that Simpson would choose to isolate explorations of sexuality from the presence of the physical body.[58]

If (unseen) sexual liaisons were sites where human connection and community developed in these works, they were also places where seduction might turn sinister. While these black-and-white images appeared to be more or less straightforward depictions of urban environments, it was their texts that described both sexual union and its underside. Whispers and breathlessness in a fading, felt twilight opened onto mystery, danger, and voyeurism. The unseen were being watched, watching others, or were concerned about being watched. In *The Park*, for instance, a lone sociologist spends years collecting "data" in a public lavatory, while in a high-rise nearby a couple unpack a new telescope; the twosome "getting busy" in *The Car* overhear an argument between another pair who pass by. *The Bed*, however, takes us beyond sex and vision, beyond observance and desire. The "before and after" photos show us both a clean, crisp setting and the disarray that signals activity and enjoyment. As in *Untitled* (1991) by Felix Gonzalez Torres, the rumpled sheets record traces of action, signs of humanity. There is also an undercurrent of loss and melancholy that can be read into these vestiges of shared movement and love. To this sting Simpson adds the discomfort of surveillance, racial profiling that takes place in public space or even the semiprivate realm of the hotel, where the "too-many-dark-people-in-the-room" code is broken.

Most noticeable in the felt works (particularly in *Public Sex*) is something the artist has done all along in various ways: to make familiar objects, places, and images seem unfamiliar. A mundane landscape becomes the ideal setting for forbidden sex; a tableau recalling sexual intimacy sets the stage for a scene of discrimination. What this process of defamiliarization does is offer us understanding in bits and pieces and furtive snatches; gathering together meaning becomes our process, and one that we must own.

(WHITE) CRITICS

From early in her career, Simpson had always been well received by the art press. It was the 1980s; tolerance for "multiculturalism" and its diversity of voices was high. Her work, with its visualization of race and gender, could be held up as both socially savvy and formally complex. But like many suc-

cessful artists of color, she often found it reviewed in a mainstream press that appeared at once wholly ignorant about issues of race and yet complicit in upholding its formations. As Fusco has written of art caught in the cross-fire of the 1980s culture wars: "The wave of criticism of these works was bound by its reliance [on] notions of instrumentality, literalism in relation to artmaking (i.e., an image of something can only be what it appears to be and will only be interpreted that way), and a peculiar assumption that black speech is somehow more likely to be linked to action than to remain within the aesthetic domain."[59]

Such an idea of "literalism" constructs art by African Americans as socially descriptive, be it representational or abstract. Art depicting black women can only possibly be about that actual experience; somehow there seems to be no room for wider or "universal" interpretations, no place for "others" to imagine themselves in that picture, in that skin, though we are always asked to buy into the "universality" of figures or language that has issued from a white and/or male perspective.

If we consider some reviews in art publications, we can see how such critical activity plays out, how interpretations of Simpson's photographs revolve around the elucidation of "the black (female) experience," and particularly her life as victim. Though many critics appeared to be supportive, their preconceptions about and reactions to "race" revealed their ambivalence in the face of these images.

In "Bankers' Daughters," an article in *Artscribe* in 1990, artist and critic Ronald Jones homes in on Simpson's critique of documentary photography and even on how pictures of and by people of color are generally received as "forever social and political analogies." But for much of the piece he also laments the lost radicalism of work by these artists: "The art of the socio-political Other is no longer empowered to confront, and abruptly incite responses as it once was." The demise of this activist position, in Jones's eyes, is due to the appropriation of such imagery by an omnivorous media industry. But this statement begs the question, when was this work radical, and which artists did he really have in mind?[60] Such confrontation was the province of African, Asian, and Latin American artists at an earlier historical moment—not on a social but a formal plane—as their cultural products circulated in the world of European and American modernism, causing visual mayhem and radical transformation of Western art modes. However, art with a social/political message has not only been the territory of artists of color; and flat-footed didacticism is sometimes not particularly interesting in its formal range.

For Jones, Simpson's work is an ongoing lament for a passing civil rights era. Its focus is the wrongheadedness of stereotypes. Nothing else seems to matter, not method, construction, materials, nor gesture, except as an inverted mirror image of documentary practice. Writing two years later in *Artforum*, the critic Jan Avgikos similarly saw Simpson's photographs as "defined through lack." They were theaters for the display of "cataleptic drama" performed by passive victims. Distinguished only by the racism that consumed them, the pieces were peopled by indoctrinated and subjugated figures that existed solely "to elicit sympathy."[61]

This correlation between the reality of racism and the spaces of art imagined by African Americans bespeaks the "literalism" that Fusco identifies. Would Simpson, then, have to stop interpreting issues of race and gender in order to have her pieces discussed for their aesthetic merit? To preclude a strictly biographical reading of the photographs would she have to excise the black women from them, to counteract what the critic Jean Fisher called an "excessive visibility—a reading of cultural difference that [was] too easily marketable"?[62] What would it take to ensure that a meditation on experience was not continually seen as a didactic message or the illumination of black victimhood?

The gender-neutral hybrid of *Bio* was Simpson's escape route from such overdetermination. On the one hand, the indeterminacy of the figures was a generous act, a way to invite other readings not based on black female positionality, but it was also defiant. With this subtle change in imagery the artist insisted that her work would not be pigeonholed. Ironically, it seemed that the fickle, hybrid body of *Bio* also opened up a safer space in which to explore a more individualized sense of the portrait. Though unknown, the human protagonists claim their individuality in the variety of modulated gestures, the apparent antithesis of earlier serial images in pieces such as *Guarded Conditions* (1989). The explosion of pictures and language, signalling multiplicity, inclusivity, along with uncategorizable bodies, led eventually to the felt work with the flexibility of form now incorporated into the pliable nature of the material itself.

Interestingly though, the artist's eventual banishment of the figure was not well received by certain critics either. From the pages of a 1994 *Artforum* issue, critic Joshua Decter seems almost belligerent in his discussions of the body in Simpson's photographs. He insists on casting the work as both autobiographical and narcissistic, and remains incensed by what he sees as the artist's willful disregard of the camera lens. In his eyes, the subject/artist has caused her own alienation by refusing the possessive gaze, and through

her unwillingness "to complete the gesture of (self)portraiture." The partial nature of Simpson's narratives, their ambiguity, irritate him; as the pictures move away from bodies and toward conjunctions of objects, landscapes, and words, for him they fall into a "dank sentimentality and barely sublimated nostalgia."[63]

In these examples of critical response to Simpson's art in the first half of the 1990s we find a variety of positions all leading to the same impasse. If the artist shows a body that is black and/or female she presents a victim. By withdrawing the figure, the artist is seen as somehow not being true to herself. With twists and turns of encouragement and antagonism disguised as support, the institutional pillars of the art world (critics, curators, museums, galleries) enforce authenticity in the production of artists of color. Difference is entertaining, it breaks up the monotonous visual replication of the status quo but leaves the foundation intact.

When critics took Simpson to task for sidelining her "familiar subjects" (and her apparently direct political statements) particularly in the felt work, they were equally bothered by what she replaced them with: a delicate new lyricism that sketched the outlines of the sexual. Never mind that it was unseen, sex as transgression was too easy, too commercial, and oh so *Cosmopolitan* (and *Playboy*) magazine.[64] Thus, not only was the racial subject prescribed, but the need to evacuate the sensual conditions of art—and Simpson's terms of eroticism—was important too. The reviews cited all exemplify a will to restrict the artist's voice, requiring her to adhere to a vision of politicized "minority" art. Such critical approaches insist that African American artists play an agreed role as conscience to the dominant culture and not explore different trajectories, romantic, erotic, or otherwise.

The focus on black-artist-as-conscience enforces ideological purity and leaves space only for "literalism" in the interpretation of the work, as noted by Fusco. Toni Morrison has spoken of this same critical fixation as the need for "sociological accuracy" in African American art. Such a requirement has led to its "incipient orphanization" from the larger (read: formalist) narrative of the history of art. However, the eventual distancing and step away from this work is usually taken with the real intent "to issue its adoption papers."[65] In the modern period there was no need to understand the aesthetic philosophy of African, Asian, or Latin American art if the surfaces and forms were all that mattered to Western connoisseurs. Whatever the spiritual and/or emotional expression that formed the basis of the work, westerners were uniquely situated, as first-world citizens, to better perform distillations of meaning. If somehow it is made to seem that Lorna Simpson has not lived up to her role as an artist of political conscience, it is because

someone is waiting in the wings—with more of a handle on the construction of artistic rhetoric—to take up this very space.

Negative critical response to the pictures in felt was also a reaction to Simpson's defamiliarization of images thought to be standard or common. The fact that an African American artist of her activist practice was making what appeared to be straightforward cityscapes seemed to presuppose that politics or race were somewhere contained in the photographs. This ambiguity of the visible signalled discomfort for some: there was a possibility that blackness might be moving into the neighborhood, subtly, silently, and undetected.

The earlier, by now familiar, pieces were more easily defined and could be restricted to a specific territory of "political art" from which they were not meant to stray. Ultimately, confining this work to a "bounded environment"[66] where the specifics of "political art" or "black art" were not only known but tried and true allowed outside forces to set the tone, to decide that Simpson's work might not be living up to certain arbitrarily imposed "standards." Stepping out of this space and away from such definitions, Simpson placed herself beyond both easy control and superficial understanding. In doing so she rejected constrictive notions of what her practice could or should be.

The felt pieces were tactile, lush objects; their surfaces were porous and absorbent, holding hazy, gritty reproductions of shadowy spaces; their themes appeared uncertain. This new medium and direction provided the ideal locale for the birth of Simpson's film noir. The influence of this genre can be seen in the moods permeating the felt pictures, as well as in the approach to her own films that would follow. What is fascinating about this period in Simpson's work is the way in which the tropes of classic noir are able to serve as a mirror of the anxiety of (white) critics over "the fact of blackness"[67] in her changing practice.

Drawing on structures of American literary thrillers and the atmospheres of German Expressionism, film noir came of age in the United States during World War II. The dark, discomforting scenarios, often visualized in stories of underworld violence, were excuses to explore the underside of the American psyche. Classic noir addressed the unease of wartime and the immediate postwar period, stabilizing patriarchy at a time when foreigners, women, and people of color were challenging the status quo. Indeed, early critics often treated this type of film "as if it were an existential allegory of the white male condition."[68] Scholar Eric Lott has argued that film noir's trope of darkness or night was a means to contain societal apprehension about the encroaching "other." Marginal locales and characters

were metaphors for the subaltern; as he has observed: "Film noir is in this sense a sort of whiteface dream-work of social anxieties with explicitly racial sources."[69]

In Simpson's felt pieces similar feelings of dread surface. With the celluloid classics, however, the "racial sources" are not only integrated into the landscape but are "condensed on film into the criminal undertakings of abjected whites."[70] As Lott suggests, anxiety about the changing nature of society is transferred to dark, violent, and racially charged tableau, and yet in the same motion is removed to white people who are objectionable; "Film noir rescues with racial idioms the whites whose moral and social boundaries seem so much in doubt."[71] Clearly whites are stigmatized by this "othering" process, this descent into the dark shadows of "black film," an action that also unquestionably reinscribes race as taint. However, it also has the effect of supplanting black figures altogether or shuffling them off to all but the very margins of the film. Discourse about the role of race in United States society, then, is deposed to a site outside the filmic frame.

In photographs on felt we know to be created by Simpson, the absence of black people comes as a surprise and as a certain disappointment. There are no colored bodies to play the role of "victim" in somebody else's movie. But the lack of white people, even of a miserable sort, in these types of noir-like scenarios is also startling. Instead of stories told through figures there is the larger-than-life presence of the brooding cityscape filled with the pleasures and dangers of its shadowy spaces.

From one perspective the paucity of figures in these works acknowledges the manner in which images depicting people of color have been used to signal the abject within cultural discourses, to register difficulties or fractures in civic covenants and social lives. It is a withdrawal of the body that has been used to benefit so many situations other than its own. Yet these pictures also comment on the missing corporeal form that is white. Looking at a photograph like *The Clocktower*, even considering its text, one wants to see Barbara Stanwyck– or Robert Mitchum–like protagonists; the setting, the standard (universal?) narrative demands it. But because it is a work by Simpson the assumption is that there should be black people within the frame.

The *Public Sex* series leads us to an impasse; anxiety heightens as we face the conundrum head on. We imagine the vanished bodies and admit our desire to fill in the picture with ourselves. These works point up how viewers' expectations are bounded by their own lives, experiences, and capacities for vision. Simultaneously we experience the processes, both intellectual and physical, by which Simpson incites us to create meaning.

A number of factors seem to explain Simpson's move away from the successes of her photography and toward the challenges of the moving image in the late 1990s. Easier access to and dropping costs of the technology has recently influenced scores of artists to try their hands at filmmaking. No stranger to film or to film theory, in graduate school Simpson had studied with Jean-Pierre Gorin, a member of France's Dziga Vertov group of the 1960s and 1970s, which also included Jean-Luc Godard. The switch to another medium allowed Simpson the freedom to start afresh and to alter the composition of her work; we see this in the return of the figure (after a five-year hiatus), and the layers of complexity and depth that are added to the figural form as well as narrative structure.

Like so many of her contemporaries, Simpson used room-scale film projection. This combined the all-encompassing environment of earlier sculptural installation with the suture of viewer and image that occurs in commercial cinema to further involve the audience in the work and in the creation of meaning. Place was foregrounded in these new pieces. Figures were shown in recognizable life settings, the antithesis of the amorphous space of ideology carved out by language and bodies in the artist's photographs.

There were, of course, links to the work that came before. An early series from 1986 called "Screen" showed Simpson experimenting with photographs and three-dimensionality. In these pieces she attached large, black-and-white pictures to six-foot-high free-standing wooden constructions. These were folding screens, like the ones used to create a temporary sense of privacy; the title, however, also conjured visions of the filmic. Images of Simpson's classic women are underscored by red text that moves across the sections like the running subtitles of a film. In some works the words wrap the pieces, enticing viewers' circumnavigation. This is the case in *Screen 1* where three interlocking sections depict a seated figure, naturally in a white shift. Scrolling underneath is the caption: "Marie said she was from Montreal although." It is only on the back that we get to finish the sentence: "she was from Haiti."

With their three-dimensionality and free-standing qualities, the pieces in "Screen" demanded we move beyond readings that took into account only flat reproductions as photographic practice. They anticipated Simpson's installation work and incorporated qualities—a room-scale presence, running narrative, shifting, consecutive imagery—that eventually characterized her films. Yet particularly in *Screen 1* the issue of a malleable identity,

the specter of dissimulation, was a nod to the role-playing that formed the actor's trade; it was an exercise in how that activity could be translated into both gesture and language.

Though, as curator Sarah J. Rogers observes, Simpson takes visual clues from early twentieth-century melodrama, film noir, and soap opera,[72] her main focus is not necessarily the "idiomatic languages of media" that characterize works by artists such as Stan Douglas or Douglas Gordon.[73] More often, she lets the progression and syntax of the actors lead the way. She is fascinated by methods of performance: how actors build character, their ability to switch between personae from moment to moment. Simpson's writings are the starting point of the performers' dialogue, but throughout rehearsals and filming, words and their significance change, modulated by delivery, mood, and demeanor. This reinscription of language and movement by the actor—in the journey from printed page to line delivered— is what captivates Simpson: how her texts, loosely based on conversations overheard, are then transformed back into speech; how on the way to the finished product this work is altered and realtered by human process. Given this way of working the artist finds that "the films are even more about language" than her earlier photography.[74]

In many respects it is still the idiom of women that inspires her. Overall there are fewer men in the six short films she has made so far.[75] At times even when on screen they pose as silent sentinels with limited speaking parts. Just as often they may be referenced as off-camera protagonists. It is not only the discourse of women that sparks Simpson's imagination, but the vernacular of the body as well. For example, the noir-esque sections of the film *Call Waiting* (1997) were inspired by the glamour of black actresses in the 1940s and 1950s: Dorothy Dandridge, Lena Horne. Though the roles they were given may have been constricting, their efforts to transform these characters were palpable; it was an attitude, a delivery, a simple motion that spelled insouciance and power, regardless of destiny.

Each film is composed of a delicate collection of fragments. In the briefest of vignettes, character and setting come together to create moments of significance, where every subtle bodily gesture shoulders a load of meaning, carrying the narrative forward in fits and starts. It is this momentum that drives Simpson's filmic work. However, like Gordon or Douglas, she is also enthralled by "the seam or suture between . . . elements," the jump-cut that creates the appearance of disjunction, that sliver of the netherworld that opens onto the place of ideology. The loop, that continually recycled clip that renders action "both inescapable and inconclusive," is another device that she favors.[76]

Simpson's first film project, *Interior/Exterior, Full/Empty* (1997), lays bare the mechanics and progression of cognition by surrounding viewers with seven moving images. All of these emanate from projectors suspended from the ceiling, their hardware exposed, a homage to the experimental practices that popularized film among artists in the 1960s and 1970s. In many ways there is much continuity with the photographs. Simpson's fragmentary vignettes in film continue her earlier seriality. As in prior pieces she leaves things purposely vague; relationships between characters often remain unexplained. The expansion of narrative and language in her oeuvre at this point seems to require the filmic: the images must move, they cannot be held still. But there is also an increased sense of ephemerality, figures materialize and evaporate on one screen and then another in *Interior/ Exterior, Full/Empty*.

What does become clearer here is that the work's pleasure comes from "teasing out" the occluded stories and conversations, from putting our own imaginations to work.[77] How and why can a seemingly serious conversation about racism or unemployment be held by two women in a bathtub, one wearing sunglasses? Here Simpson revels in the obscurity she creates, delights in not being weighted down by the heaviness of her content. She again plays with binaries and specifics, in this case of race: not all of the characters are black, though they may be people of color. There is mischievousness to *Interior/Exterior, Full/Empty*, a certain amount of subtle satire. Can an interlude with an African American and an Asian woman, drinking whiskey in a noir-like setting and discussing a failed murder plot, really be a comment on race relations?

For her second work in film, *Call Waiting*, Simpson traded in the physical structuring device of multiple monitors for the editorial process of montage, moving to a single, large-scale projection. The telephone is the mechanism that drives the disconnected narrative structure. While Simpson creates a sense of indeterminacy within the piece, it seems clear that sex is on the line. The characters are linked as erotic partners, whether in the flesh or other electronically coded ways.

Duet (2000) has the most contemporary look of all Simpson's film projects. Perhaps because it was shot in color it seems to draw on visual models of modern melodrama and soap opera. Here she moves to create a larger dialogue with the language of film by using a split screen, allowing two distinct scenes to play before our eyes and in our heads at the same time. The growing complexity of Simpson's filmic vernacular is driven by her ever-present need to speak in ways that embrace multiplicity. As an artist and a woman who matured in the late twentieth century she feels com-

fortable with, not distracted by, the simultaneous and at times competing images and voices from which she pieces together her art. As critic Leslie Camhi points out, in the films as in the photographs we find Simpson "tripping up our narrative aspirations and thwarting our longing for closure; this slippery and enigmatic work remains continually engaging, precisely because it never really delivers," or rather because it refuses to offer itself as a single, definitive, or final statement on the world.[78]

CAMEO

A comment once made by author Ntozake Shange sheds light on the core of Lorna Simpson's work: "I'm a daughter of the black arts movement (even though they didn't know they were going to have a girl!)."[79] This remark brings us to a pair of issues at the heart of Simpson's photography and film: the centrality of images of/by black people that have a liberatory focus, and the way in which gender (and sexuality) fragments that chronicle of liberation, questioning the sense of a singular and holistic vision of what black agency/politics/art can and should look like, putting certainties on uncertain, unmarked, unfixed ground.

Yet the idea of liberation also brings us to the question: "Release or deliverance from what?" With this artist, as we have seen, the goal is a release from common understandings of how to read pictures, a release from set meanings embedded in set images, and an interrogation of how visual imagery extends trajectories of economic, political, physical, and psychic oppression, particularly the oppression wrought by white supremacy. In Simpson's work there is a fascination with the scopic aspect of the visual, how the gaze marks, fixes, and transforms the body. This is also true of her colleagues—artists of the African diaspora such as Carrie Mae Weems, Glenn Ligon, and Renée Green from the United States, or Keith Piper, Isaac Julien, and Ingrid Pollard of Britain—who matured in the 1980s and 1990s and chose as their métier photo- (and film- and video-) derived objects combined with text. Through their work each has asked the questions: What can the trajectory of the gaze tell us about how we see ourselves? What can it tell us about race and racism in society? What does it say about binary relationships that have been set up between apparently dominant white bodies and those of color? What does it reveal about structures of power and domination that encompass economic, physical, and visual points of control?

As we have seen, with Simpson (and the critical reception of her oeuvre) the topic of the gaze seems automatically to reference webs of authority and control that have historical as well as contemporary roots. Cultural theorist Stuart Hall has observed that "this body of work, then, assumes that 'the

look' can be subverted, displaced, resisted. But can it be refused, destroyed, abandoned?"[80] Such an understanding of scopic power presupposes a human figure that is caught in its sights, and indeed all the artists mentioned above engage the black body (or its substitutes, ghosts and ephemeralities) in their work. However, in looking for new ways to approach and problematize the visual in relation to the black corporeal form, are the previous legends, based on "bodily insignia,"[81] that make up the cornerstones of racial discourse ever truly forsaken? Is this knowledge so embedded as to perpetually reinscribe roles (some constituted in fantasy) that privilege strength (and labor) and hypersexuality (and procreation) among others?

In art by all these practitioners it is the supplement of words that acts as a counterforce against the continuation of such prevailing and well-worn narratives. In the same way that details of gender and sexuality recast the heroic (male) monolithic progression of black liberation, so language intercedes in images to alter our comprehension of bodies that we think we already know and understand. Yet the act of linguistic intercession is also inclusive; it sets up a rereading (as Kobena Mercer has posited) that contains the trace of the earlier history and the new reality. Such activity gives credence to Hall's query as to whether full destruction of earlier modes is ever really accomplished. One could argue that it is precisely because these artists do leave traces of past visual apparatuses that a case is made for the new. We become privy to the mechanics of it all, shown the methods/processes (the difficulties) and the manner in which their work moves us to another level. We are made conscious. Similarly, because objects by Simpson and others "affirm while they protest,"[82] they imagine a place no longer circumscribed by a dominant and/or white gaze.

As the art history of the last third of the twentieth century is written, covering styles ranging from conceptualism and postminimalism to neo-figuration and neo-conceptualism, we already know that, as usual, there will be an attempt to marginalize artists of color, that the process of "orphanization" described by Morrison will kick into gear. We have seen an inkling of this in certain dismissive criticism in relation to Simpson's work. Similarly, bell hooks has described how the figure of the woman is usually exiled from discourses both serious and forward-looking: "Not only is the female body, black or white, always a sexualized body, always not the body that 'thinks', but it also appears to be a body that never longs for freedom."[83] In the same fashion, artists of color are not normally considered part of the cadre offering innovation or avant-garde strategies. What is different seems awkward or incomplete, not forward-thinking, not revealing enough, not sophisticated enough, too easy, too plain, too decorative, too personal.

Never right. This could describe Simpson's relationship to the general view of late twentieth-century conceptualism, with her more speakerly texts, images that often focus on colored bodies, which are somehow not neutral enough for the dispassionate formulas thought to constitute conceptual practice. Yet Simpson's conjunction of words and images remains provocative and perplexing, "unsettling the identity of meaning and [the] speaking/writing subject."[84] The artist's rereadings of pictorial standards and of language change the photographic and filmic landscape, still. As the cultural theorist Trinh T. Minh-ha notes, "Words empty out with age. Die and rise again, accordingly invested with new meanings, and always equipped with a secondhand memory."[85] And this is where Simpson comes in: to recast easily consumed notions of pictures and text, and art by African Americans.

And it is also why the artist's recent work, though a return to photography (and pictures of black women) after four years of concentrating on film, is not necessarily a repeat of earlier imagery. Created a decade after her signature figures turned their backs on us, these pieces place even more emphasis on process, play, and intuitive markings. Simpson speaks of how her experience with film has encouraged her to use a more open and flexible method, not so tightly planning every image, every shot, or every word. The subjects are different as well. They are seen in headshots, cameos, not full bodies. They are not wrapped in the anonymity of white shifts but dressed stylishly in black, having been touched by the artist's recent foray into cinematic glamour. Yet even though she seems to focus on the classic portrait bust, the sitters still don't give us a full face or a smile. The glimpse of expression we do see is pensive and thoughtful. Once in a great while they lean toward us, but then . . . the faces move out of view. The trace of filmic influence is evident here too, in the repeated poses that scroll up and down the picture plane frame by frame like flickering celluloid.

In these new works both textual and pictorial structure call attention to periodization. For instance, we notice that the framing devices on each small portrait are usually either oval or square.[86] They subtly move us through Western visual history, from the delicate eighteenth-century vision of the cameo to that of the twentieth-century grid. Sometimes these forms are mixed in one work, such as *Untitled (impedimenta)* (2001), where the squares and ovals vie for ascendancy. Other pieces, like *Untitled (yellow hat)* (2001), are meditations solely on the grid, whose aggressive progression is extended by the organized march of female silhouettes. In *Untitled (guess who's coming to dinner)* (2001), the effect is more like a lively evening supper with each guest nicely contained in her oval setting.

Moving away from more speakerly language toward that which reveals

intellectual roots, Simpson's texts in this work are lifted from titles of paintings and films, which are delivered either whole or in snippets. These other media are endpoints of cultural practice that frame as well as impact on photography. The objects she cites were made anywhere between the 1790s and 1970s; they are by or about black people, and were selected for their loaded references. They form a closed set that is reused throughout the more than dozen pieces in the series. These photographs become vehicles for chronicling history, though the effect is partial. They name works but not authors, actors, directors, or years. Similarly, the framing devices don't really operate as they should. The cameos are not bursting with exquisite minutiae but offer us only general outlines, a countenance sketched in fuzzy detail. The perfect grid seems to fall apart or fade into the superimposed layers of Plexiglas.

Like Simpson's familiar concoctions of word and image, these new pieces also problematize and interrupt the creation of traditional meaning, perhaps to greater effect given their scrolling, staccato repetitions, narratives, and figures which are even more brief and partial. Rather than alluding to or making a space solely for the cognitive and physical processes of viewers, these same actions are more fully incorporated into the work itself. The specter of film looms large in these pictures that are neither animated nor digitally manipulated but integrate the almost shimmering pulsation of moving film frames.

The ghostly sense of motion is what causes defamiliarization in Simpson's new photographic work. It is kin to the seriality of earlier pieces that had a similar program and effect: repeat until pictures, words, the object become almost unrecognizable. In the early 1990s the female body was defamiliarized to create the transgendered body. In the felt work this same revisitation with a difference produced a sense of mystery, foreboding, and anxiety.

Theorist Homi Bhabha has described anxiety as a transitional place or moment "where strangeness and contradiction cannot be negated, but have to be continually negotiated and 'worked through.'"[87] This is the environment that Simpson fashions, perhaps most obviously in the felt work, but it remains the underlying schema of her entire oeuvre. Over two decades we have been witness to the artist's cultivation of defamiliarization, her creation of situations and/or objects that are recognizable but not, her fostering of disquiet and unsettling scenarios—where one instant we are confident in our knowledge then suddenly unsure of anything at all. As viewers we crave mastery, but perfect comprehension remains just out of reach. It is in this mediatory space of anxiety that we become cognizant of our quest for

understanding, our own physical and intellectual mechanics. But it is also where we "question the boundary of a we" and realize that "strangenesses are more oblique and shaded, less easily set off."[88]

Quoting anthropologist Clifford Geertz, Bhabha discusses anxiety as the (frightening?) recognition of diversity, the realization that we are immersed in and inextricably part of a world of "irremovable strangeness," surrounded by "foreignness [that] does not start at the water's edge but at the skin's."[89] Bhabha, however, goes further, proclaiming the skin itself as a "watery" medium and one not particularly suited to "cultural containment."[90] As we know all too well, driven by, among other things, engagement, respect, curiosity, fascination, desire, sex, and love, a corporeal boundary may be the easiest to breach.

It is this sense of diversity — the reality of the nearness of difference, the proximity of self and other — that Simpson draws on in one of her most recent films, *Easy to Remember* (2001). The minimalist grid returns again here, more obviously "violated" (Enwezor's term) by the subject, the human form, and the movement of fifteen mouths. On the surface the work seems to be an uncomplicated paean to multiculturalism. Each section is filled with a pair of lips that contrasts with the set next door. But their cropping in this black-and-white projection allows details of race and gender to blur and recede. Ironically, Simpson inserts some true self-portraiture here, acknowledging that one of the mouths is hers. Which one? Amazingly, the self-portrait remains unidentified and in a sense unseen.

The film, which runs for a minute and a half, consists of the fifteen mouths humming in unison John Coltrane's rendition of the Rodgers and Hart song "Easy to Remember." The melody of this constructed choir is comforting, something that the artist heard in her household growing up. But the complexity of Coltrane's jazz version renders the pop tune neither easy to remember nor to perform. From Rodgers and Hart to Coltrane to this hummed and filmed version, the sound is altered over and over again by the shifting circumstances of the recording and the remove of memory.

Easy to Remember also looks back at Simpson's own work. Created almost a decade earlier, *Hypothetical?* incorporated sound and, in various ways, the mouths that produced it. Contained behind a wall, the tune was muffled, changed, yet there was still the allusion to the players coming together in their difference to create something entirely new. While *Hypothetical?* was inspired by the rebellions in Los Angeles, strangely, and certainly unintentionally, *Easy to Remember* is now linked (perhaps just in this writer's mind) to a very different but somehow similar event where diversity, race, and col-

lisions of unequal power blow sky high. The film debuted four days after the disaster at the World Trade Center. Its wall of partial faces recalls both the endless posters of "missing" people plastered around New York, and the unimaginable human destruction at the site. Nothing about that will be easy to remember. Instead, Simpson tries to hold us together, tenuously, through our imperfect, wordless song.

In *Untitled (Music Box)* (2001) the interstices of difference reconfigure themselves into transformation. Simpson, always a thrift-store aficionado, has used the form of an old-style humidor as the prototype for a motorized music box. It plays the hummed soundtrack of *Easy to Remember* while slowly, magically opening, swiveling around, and then closing. The black box of a decade earlier, the site of the mind/body in photographic pieces, has been made tangible and infinitely interesting. Perhaps Paul Gilroy is right in interpreting "screams, wails, grunts, scatting, and wordless singing . . . as both indicative of a struggle to extend communication beyond words, and as a commentary on the inadequacy of language as a means for expressing certain truths."[91] What is important, however, in this work (and the companion film) is that the connection to the human voice is never lost. Simpson has created an object that holds the diversity of our almost unintelligible songs, yet, it is in continual motion, forever reconstituting, recomposing, and reinventing itself.

In memory of Beryl J. Wright

NOTES

Originally published in *Lorna Simpson* (London: Phaidon Press, 2002).

1. Coco Fusco, "Lorna Simpson," *Bomb* 61 (fall 1997): 51.
2. Patricia A. Williams, *The Alchemy of Race and Rights* (Cambridge: Harvard University Press, 1991), 163.
3. Hortense J. Spillers, "Mama's Baby, Papa's Maybe: An American Grammar Book," in Joy James and T. Dennean Sharpley-Whiting, eds., *The Black Feminist Reader* (Malden, Mass.: Blackwell, 2000), 77 (originally published in *Diacritics* in 1987).
4. See ibid.; and Williams, *The Alchemy of Race*, 8–9.
5. Williams, *The Alchemy of Race*, 163.
6. Amelia Jones, "Tracing the Subject with Cindy Sherman," in *Cindy Sherman Retrospective* (Chicago: Museum of Contemporary Art, 1997), 38.
7. Mignon Nixon, "You Thrive on Mistaken Identity," *October* 60 (spring 1992): 58–61.
8. Some artists connected with the Black Arts Movement of the 1960s and 1970s attempted to take on stereotypes on a limited basis. Betty Saar, Jeff Donaldson, and Murray DePillars, for instance, all refashioned the prototypical mammy as a guerilla warrior. But for the most part such reversals were isolated experiments and did

not form a major part of these artists' oeuvres. Adrian Piper's "Mythic Being" was a male alter ego, explored in print works and performance in the mid-1970s. Part of the goal of the piece was to make racist fantasy real, to "embody everything you most hate and fear," to quote one of the pieces from the series. However, though working within the period of the Black Arts Movement, Piper is not often considered part of it. Since the 1980s numerous African American artists have used satire more fluidly in their work; these include Carrie Mae Weems, Robert Colescott (who actually began using his colorful cartoonlike figures in the 1970s), Michael Ray Charles, and Kara Walker.

9. bell hooks, "Lorna Simpson, Waterbearer," *Artforum* 32 (September 1993): 137.

10. For a discussion of such practices during slavery see Spillers, "Mama's Baby," 62–63. For a revealing discussion of the regulation of black women's reproduction in both antebellum and contemporary periods see Dorothy Roberts, *Killing the Black Body: Race, Reproduction, and the Meaning of Liberty* (New York: Pantheon, 1997).

11. Derrick Price, "Surveyors and Surveyed: Photography Out and About," in Liz Wells, ed., *Photography: A Critical Introduction*, 2nd edition (London: Routledge, 2000), 69.

12. Rosalind Krauss, *Bachelors* (Cambridge: MIT Press, 1999). Krauss's use of the terms "part-object" and "desiring machines" comes from Gilles Deleuze and Félix Guattari, *Anti-Oedipus*, trans. Robert Hurley, Mark Seem, and Helen R. Lane (Paris: Éditions de Minuit, 1972).

13. Sallie Bingham, *Passion and Prejudice: A Family Memoir* (1991), quoted in bell hooks, *Black Looks* (Boston: South End Press, 1992), 168.

14. Krauss, *Bachelors*, 73.

15. See Nixon, "You Thrive on Mistaken Identity."

16. See Jones, "Tracing the Subject," 42.

17. Saidiya V. Hartman, "Excisions of the Flesh," in *Lorna Simpson: For the Sake of the Viewer* (Chicago: Museum of Contemporary Art, 1992), 56.

18. hooks, "Lorna Simpson," 137.

19. Coco Fusco, "Uncanny Dissonance, The Work of Lorna Simpson," *Third Text* 22 (spring 1993): 28.

20. Nixon, "You Thrive on Mistaken Identity," 71.

21. For a discussion of these works as guardian images see Beryl J. Wright, "Back Talk: Recoding the Body," in *Lorna Simpson: For the Sake of the Viewer*, 11–24. On Simpson and victimology see Andrew Wilkes, "Lorna Simpson," *Aperture* 133 (fall 1993): 14–23; and Lenore Malen, "The Real Politics of Lorna Simpson," *Women Artists News* 8 (3) (1988): 4–8.

22. Howard N. Fox and Lisa Bloom, *Eleanor Antin* (Los Angeles: Los Angeles County Museum of Art, 1999). Another interesting aspect regarding Eleanor Antin's example for Simpson is her use of black characters, particularly in her performance work. In 1974 she devised a figure called the "Black Movie Star." This was later transformed into "Eleanora Antinova," a fictitious black ballerina with Diaghilev's Ballet Russes, for which the artist created performances, videos, and a memoir.

23. William Spurlock, "Notes on the Exhibition," in *Dialogue/Discourse/Research* (Santa Barbara: Santa Barbara Museum of Art, 1979), 4.

24. Ernest Larsen, "Between Worlds," *Art in America* 87 (5) (1999): 125.

25. Barbara Christian, "The Race for Theory," *Cultural Critique* (spring 1987): 51–63.

26. Angela Y. Davis, *Blues Legacies and Black Feminism* (New York: Pantheon Books, 1998), 120.

27. Kobena Mercer, "Black Hair/Style Politics," in *Welcome to the Jungle* (New York: Routledge, 1994), 97–128.

28. Recent literary offerings on the topic of black hair include Ima Ebong et al., *Black Hair* (New York: Universe, 2001); and Pamela Johnson et al., *Tenderheaded: A Comb-bending Collection of Hair Stories* (New York: Pocket Books, 2001).

29. Okwui Enwezor, "Social Grace: The Work of Lorna Simpson," *Third Text* 35 (summer 1996): 49.

30. Judith Wilson, "In Memory of the News of Ourselves: The Art of Adrian Piper," *Third Text* 16/17 (autumn/winter 1991): 39.

31. John Chandler and Lucy R. Lippard, "The Dematerialization of Art," *Art International* 12 (2) (1968): 35.

32. Spurlock, "Notes on the Exhibition," 4.

33. Such artists include Lorna Simpson, Renée Green, Tana Hargest, Renée Cox (in collaboration with Lyle Ashton Harris), and Deborah Willis. For a discussion of the "Hottentot Venus" as woman and symbol see Partha Mitter, "The Hottentot Venus and Western Man: Reflections on the Construction of Beauty in the West," in Elizabeth Hallam and Brian V. Street, eds., *Cultural Encounters: Representing "Otherness"* (London: Routledge, 2000), 35–50; Lisa Gail Collins, "Historic Retrievals," in *The Art of History: African American Women Artists Engage the Past* (New Brunswick: Rutgers University Press, 2002), 11–36; *The Life and Times of Sara Baartman*, a film by Zola Maseko, 1998; and Kellie Jones, "A.K.A. Saartjie: The 'Hottentot Venus' in Context (Some Recollections and a Dialogue)," in Deborah Willis ed., *Black Venus, 2010: They Called Her "Hotentot"* (Philadelphia: Temple University Press, 2010).

34. France has recently returned Saartjie Baartman's remains to her South African home for a proper burial after almost two centuries. Ceding to decades-long requests for her return, French officials noted that Baartman's remains "were removed from public display in 1976" because they were "no longer deemed to serve any scientific purpose." Susan Daley, "Exploited in Life and Death, South African to Go Home," *New York Times*, January 30, 2002: A4. See also Rachel L. Swarns, "Mocked in Europe of Old, African Is Embraced at Home at Last," *New York Times*, May 4, 2002, A3.

35. "Mississippi Appendectomy" became a vernacular term for a hysterectomy because of its frequent and abusive use against African Americans in the latter half of the twentieth century. During the 1960s and 1970s in particular, sterilization became the fastest growing method of birth control in the United States and countless unauthorized operations were performed on African American, Native American, Puerto Rican, and poor white women. Many hospitals not only in the South but throughout the country performed unnecessary hysterectomies on these populations as a way to "get experience" of the procedure. The well-known civil rights activist Fanny Lou Hammer was one of the victims of such medical abuse. Often sterilization was the only form of birth control covered by Medicaid and available to poor women. For more on the issues of sterilization and the regulation of black

women's reproduction see Roberts; and Joann Rodgers, "Rush to Surgery," *New York Times Magazine*, September 21, 1975, 24.

36. These reviews reveal more about the position from which the critics write than anything else. See Ken Johnson, "Lorna Simpson at Josh Baer," *Art in America*, November 1992, 143; and Karen Jones, "(Re) Vision: Image/Text," *Tema Celeste* 39 (winter 1993): 61–63. Johnson identifies the figures as men while Jones calls them "androgynous female torsos."

37. Alice R. Gray, "Lorna Simpson, Josh Baer," *Art News*, October 1992, 125–26.

38. Jan Nederveen Pieterse, "Hybridity, So What? The Anti-Hybridity Backlash and the Riddles of History," unpublished manuscript, 2000. For more on the debates surrounding hybridity see María Fernández, "Postcolonial Media Theory," *Art Journal*, fall 1999, 59–73; Jennifer Gonzalez, "Envisioning Cyborg Bodies: Notes from Current Research," in Chris Hables Gray, ed., *The Cyborg Handbook* (New York: Routledge, 1995); and Pnina Werbner and Tariq Modood, eds., *Debating Cultural Hybridity* (London: Zed Books, 1997). My brief discussion of hybridity here was originally formed during a panel called "Whatever Happened to Hybridity?" organized by Kobena Mercer and including me, Jan Nederveen Pieterse, and Dan Cameron, held in April 2000 at the New School University, New York.

39. Judith Halberstam, *Female Masculinity* (Durham: Duke University Press, 1998), 173. In her book Halberstam uses the acronym "FTM" to signify transgendered bodies that have made the move from female-to-male. In an earlier essay in which she discussed the subject ("F2M: The Making of Female Masculinity," in Laura Doan, ed., *The Lesbian Postmodern* [New York: Columbia University Press, 1994]), she used the shorthand F2M, which I adopt here because of its intersection with the codes of black popular music, specifically the work of Prince.

40. Halberstam, *Female Masculinity*, 106.

41. Ibid., 99.

42. Ibid., 67.

43. Ibid., 90.

44. An oft-cited example is Ma Rainey's "Prove it on Me Blues," which is entirely about the singer's female liaisons. Lucille Bogan penned "B.D. Woman's Blues" in 1935 as a homage to the butch or "bull dagger." See Eric Garber, "Gladys Bentley: The Bulldagger Who Sang the Blues," *Outweek* 1 (spring 1988): 52–61. Simpson references Bentley specifically in the piece *Wigs* (1994). Both Hazel Carby and Angela Y. Davis have posited that themes of sex and love in the blues concealed a modern discourse on power, and served as vehicles of feminist consciousness. See Davis, *Blues Legacies and Black Feminism*; and Carby, "It Jus Be's Dat Way Sometime: The Sexual Politics of Women's Blues," in Robert G. O'Meally, ed., *The Jazz Cadence of American Culture* (New York: Columbia University Press, 1998), 469–82 (originally published in *Radical America* in 1986).

45. In the book a black minstrel performer is able to incite a slave insurrection simply by dancing. Wesley Brown, *Darktown Strutters* (New York: Cane Hill Press, 1994).

46. Halberstam, *Female Masculinity*, 159.

47. The man's white "uniform" was inspired, at least in part, by Simpson's residence in San Diego, where the Navy had a strong presence.

48. See Thelma Golden, "My Brother," in the catalogue of her exhibition *Black Male: Representations of Masculinity in Contemporary American Art* (New York: Whitney Museum of American Art, 1994), 36–37; and Linda Nochlin, "Learning From 'Black Male'," *Art in America*, March 1995, 91.

49. Halberstam, *Female Masculinity*, 235.

50. Ibid., 259.

51. Greg Tate, "Seeing for Miles," *Artforum*, May 1993, 12.

52. Ibid. Alva Rogers is a performer based in New York. A singer, songwriter, and play-wright, she is best known to the general public for her acting work in the films *School Daze* (Spike Lee, 1988) and *Daughters of the Dust* (Julie Dash, 1991). She was the model in many of Lorna Simpson's early photographs, and also collaborated with Simpson on the artist's very first installation work, a site-specific piece entitled *5 Rooms*, created for the exhibition "Places with a Past," curated for the 1991 Spoleto Festival in Charleston, South Carolina, by Mary Jane Jacob. Rogers composed and performed the sound component.

53. Lorna Simpson interviewed by Thelma Golden in *Lorna Simpson: Standing in the Water* (New York: Whitney Museum of American Art at Philip Morris, 1994), un-paginated. While I visited the exhibition numerous times when it was on view seven years ago, I owe much of my description here to this brochure.

54. Ibid.

55. The six installations were *5 Rooms* (1991), *Hypothetical?* (1992), *Group Dynamic* (1993), *Transparent Wishes* (1993), *Standing in the Water* (1994), and *Wigs* (1994, which first appeared as a three-dimensional piece). A seventh installation, *Avant Garde Walk a Venezia* (1995), never came to fruition.

56. Enwezor, "Social Grace," 56.

57. Information about felt found in Kristen Brooke Schleifer, "Taking a Fall: Lorna Simpson's New 'Do,'" *Print Collector's Newsletter* 25 (3) (1994): 92–93.

58. Some of the artists who were able to portray sexuality prior to the 1960s were William H. Johnson, Archibald Motley, and Eldzier Cortor. With the sexual revolu-tion of the 1960s the topic became more acceptable among African American art-ists. Romare Bearden was the first to work consistently with the nude, which has been a standard theme of Western (and I would argue African) art for centuries. Many of his collages portraying the black female body were created out of clippings from porn magazines, a topic that has yet to be thoroughly interrogated. See Judith Wilson, "Getting Down to Get Over: Romare Bearden's Use of Pornography and the Problem of the Black Female Body in Afro-US Art," in Michele Wallace and Gina Dent, eds., *Black Popular Culture* (Seattle: Bay Press, 1992), 112–23; Paula Giddings, "The Last Taboo," in Toni Morrison, ed., *Race-ing Justice, En-gendering Power* (New York: Pantheon, 1992), 441–65; Lisa Gail Collins, "Economies of the Flesh," in *The Art of History: African American Women Artists Engage the Past*, 37–63; and Deborah Willis and Carla Williams, *The Black Female Body, A Photographic History* (Philadel-phia: Temple University Press, 2002). It should be mentioned that images of black male nudity were equally rare.

59. Coco Fusco, "The Bodies That Were Not Ours: Black Performers, Black Perfor-mance," *NKA* 5 (fall 1996): 29.

60. Ronald Jones, "Bankers' Daughters: Lorna Simpson's Documentary Photography," *Artscribe* 80 (March–April 1990): 52–53.

61. Jan Avgikos, "Lorna Simpson, Josh Baer Gallery," *Artforum*, October 1992, 104.

62. Jean Fisher, "The Syncretic Turn: Cross-Cultural Practices in the Age of Multiculturalism," in *New Histories* (Boston: Institute of Contemporary Art, 1996), 35.

63. Joshua Decter, "Lorna Simpson, Josh Baer Gallery," *Artforum*, January 1994, 90–91.

64. Ronald Jones, "Lorna Simpson, Sean Kelly, New York," *frieze*, January–February 1996, 67–68.

65. Toni Morrison, "Unspeakable Things Unspoken: The Afro-American Presence in American Literature," in James and Sharpley-Whiting, *The Black Feminist Reader*, 32–33 (originally presented as a Tanner Lecture on Human Values at the University of Michigan, October 7, 1988).

66. Adrian Piper has used this term to refer to her early minimalist-inspired sculpture. See *Adrian Piper: Reflections, 1967–1987* (New York: Alternative Museum, 1987), 18.

67. This phrase is taken from a text entitled *The Fact of Blackness: Frantz Fanon and Visual Representation*, Alan Read, ed. (Seattle: Bay Press, 1996), and itself is drawn from a key chapter in Fanon's *Peau Noire, Masques Blancs* (*Black Skin, White Masks*, 1952). The 1996 text documented discussions surrounding the exhibition "Mirage: Enigmas of Race, Difference and Desire," which was held in London a year earlier.

68. James Naremore, *More Than Night: Film Noir and Its Contexts* (Berkeley: University of California Press, 1998), 26.

69. Eric Lott, "The Whiteness of Film Noir," *American Literary History* 9 (3) (1997): 551.

70. Ibid.

71. Ibid., 546.

72. Sarah J. Rogers, "Between Takes," in *Lorna Simpson: Interior/Exterior, Full/Empty* (Columbus, Ohio: Wexner Center for the Arts, 1997).

73. Scott Watson, "Against the Habitual," in *Stan Douglas* (New York: Phaidon, 1998), 66.

74. Lorna Simpson interviewed by Siri Engberg and Sarah Cook in *Scenarios: Recent Work by Lorna Simpson* (Minneapolis: Walker Art Center, 1999), unpaginated.

75. The films are *Interior/Exterior, Full/Empty* (1997), *Call Waiting* (1997), *Recollection* (1998), *Duet* (2000), *Easy to Remember* (2001), and *31* (2002).

76. Watson, "Against the Habitual," 45.

77. Leslie Camhi, "Clue," *Village Voice*, October 7, 1997, 87.

78. Ibid.

79. Ntozake Shange in "Artists' Dialogue" in Read, *The Fact of Blackness*, 159. This final section of the chapter owes much to my readings of texts in *The Fact of Blackness*, particularly those by Stuart Hall, Kobena Mercer, Isaac Julien, bell hooks, Homi Bhabha, and Raoul Peck. It was also informed by a personal conversation with Lorna Simpson that took place at the Sean Kelly Gallery on October 13, 2001, while her exhibition was on view. Further inspiration came from our public dialogue at the Wadsworth Atheneum Museum of Art in Hartford, Conn., on November 18, 2001. Special thanks to Deirdre Bibby and the Amistad Foundation.

80. Stuart Hall, "The After-life of Frantz Fanon: Why Fanon? Why Now? Why *Black Skin, White Masks*? in Read, *The Fact of Blackness*, 24.

81. Ibid., 21.

82. Paul Gilroy, *There Ain't No Black in the Union Jack* (London: Hutchinson, 1987), 155.

83. bell hooks, "Feminism as a Persistent Critique of History: What's Love Got to Do with It?" in Read, *The Fact of Blackness*, 84. See also Kellie Jones, "Life's Little Necessities: Installations by Women in the 1990s," *Atlantica* (winter 1998): 165–71.

84. Trinh T. Minh-ha, *Woman, Native, Other: Writing Postcoloniality and Feminism* (Bloomington: Indiana University Press, 1989), 76.

85. Ibid., 79.

86. The one exception on view during fall 2001 was *Untitled (man on bench)* (2001), where the framing devices were round rather than oval or square.

87. Homi Bhabha, "Day by Day . . . With Frantz Fanon," in Read, *The Fact of Blackness*, 192.

88. Ibid., 193.

89. Clifford Geertz, "The Uses of Diversity" (1986), quoted by Bhabha in Read, *The Fact of Blackness*, 193.

90. Bhabha, "Day by Day," 193.

91. Gilroy, *There Ain't No Black*, 212.

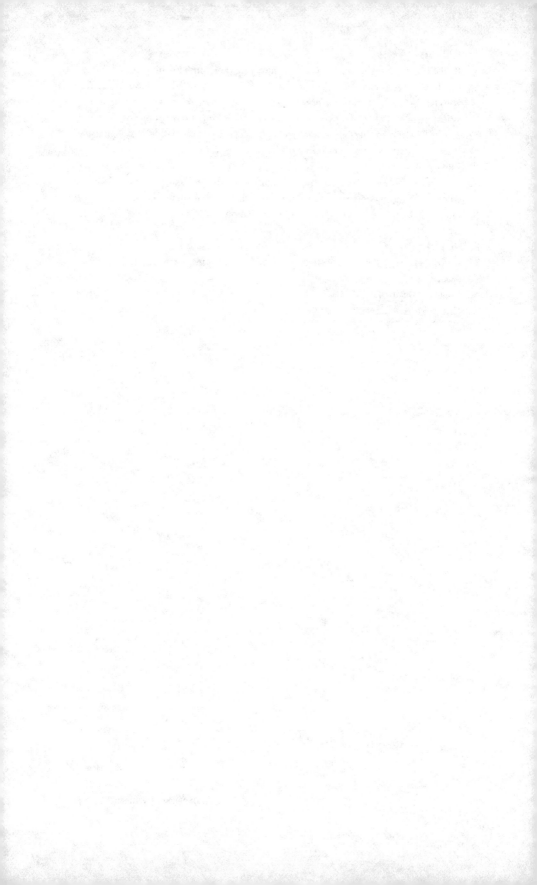

Life's Little Necessities

Installations by Women in the 1990s

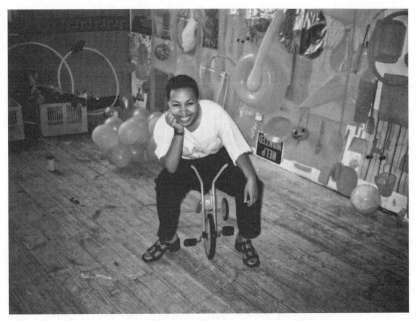

Kellie Jones, during the installation of: Melanie Smith, *Orange Lush VI*, 1997. Mixed-media installation, dimensions variable. Second Johannesburg Biennale, 1997. Courtesy Kellie Jones.

NECESSITY IS THE MOTHER OF INVENTION
What's in a Name?

An early title for this exhibition was "Material Girl." It was an appellation I had toyed with over the years, along with plans for an exhibition of women sculptors. I loved the play of meaning, the conjuring of the three-dimensional material of the artists, and the nod toward and twisting of the cliché of acquisitiveness and materialism that was particularly female. The way the designation "Material Girl" opened onto pop cultural sensibilities also intrigued me. From Madonna in the 1980s to Lil' Kim today, women performers had tried to take the image of woman as covetous-by-any-means-necessary (or as hip hoppers might say, the "gold-digging skeezer") and read it as a stance of empowerment. (After all, why should male-identified corporate raiders be the only ones congratulated for successful mergers and acquisitions?)

This self-definition and invention (to which pages have been devoted in the case of Madonna) could be deciphered as well in sculptural terms: a work's physical construction had a metaphorical and spiritual counterpart in women's everchanging assembling of a gendered identity. The accumulation (of knowledge) and the redefinition (of one's person) afforded by lived experience, the slippage between individual interpretations of self and the array of women's experiences worldwide, seemed to reflect the built environment of the sculptural artist. It later became clear to me that, in fact, installation was the prime genre through which one could discuss such ideas.

If we meditate on an immediate history of installation art (one dating from the 1970s) we find that its activation of "place," on both the cerebral and corporeal planes, was an activation of context. Through installation, artists could create a space of intentionality. Contingency, or the calculated process of spatial arrangement, "the act and consequences of placing something in a certain position,"[1] to evoke meaning and interpretation was revealed as such.

The artists in "Life's Little Necessities" all use installation's ability to display and imply a variety of truths as an active component. They may bring together an assortment of disparate things, silverware and video, perfume and rags. However, the material itself is not nearly as important as the result of the juxtaposition, and that potential for meaning. The capacity to signify becomes another tool, just like paint or wood.

The work of these artists most often represents some mix of straightforward feminist (political) practice, with referential fluidity. While the former presents an instance of installation's deconstructive impulse, taking apart societal, institutional, and cultural formations and exposing them to critique—the latter model tries to build toward a new paradigm that has yet to come into existence. Installation reminds us of art's peripatetic movement between solid referents in the world of experience, and the expansive playing fields of abstract signification.

ENTER EROS

The erotic is a measure between the beginnings of our sense of self and the chaos of our strongest feelings. It is an internal sense of satisfaction to which, once we have experienced it, we know we can aspire. . . . For as we begin to recognise our deepest feelings, we begin to give up, of necessity, being satisfied with suffering and self-negation, and with the numbness which so often seems like their only alternative in our society.
AUDRE LORD

If there is movement, constant back and forth migration between representation and abstraction, subtle moduations of meaning afforded by context and viewer, that the artists gathered here apply to their installation work, we should also consider how a changing/differing sense of womanhood might affect these very formulations.

On the one hand, there is the biological reality of the "female," on the other, the historical and cultural construct of "woman."[2] While early feminist art from the 1970s might have more readily conflated these positions, women working with installation in the 1990s are cognizant of the potential of the distinctions. It is not the clinical but the sexually/intellectually empowered body that is in control.

And if we take a cue from Luce Irigary, even female biology is not of a piece, but rather dispersed all over the body in shards. Like installation, it is not the phallic monument but the scattered/spread lips of vaginal reciprocity, or as Irigary writes, "[s]he herself enters into a ceaseless exchange of herself with the other without any possibility of identifying either."[3] In her now-classic essay, "Uses of the Erotic: The Erotic as Power," Audre Lorde reminds us of the potency and strength of the libidinal. The deep stirrings of erotic pleasure were the gauge not only of a personal physical bliss, but signaled a profound sense of satisfaction and self-realization beyond the sexual. It is this notion of the carnal that a number of artists in "Life's Little Necessities" draw on.

Valeska Soares uses objects as vessels of the sensorial. In her work, texture and aroma condition our understanding of her space, affecting as well our perceptions of time and memory. The materials themselves—wax, roses, swings, pedestal-like sculptures anointed with perfume—are charged things, embodying pleasure/pain/desire in their tactile and olfactory seduction. Soares's installations are visceral, simultaneously underlining emptiness and density and "the erotic charge of the forbidden."[4]

During the early 1990s Lorna Simpson moved her practice aggressively from a two-dimensional photographic format into the spacial terrain of installation. Recently she began working with projections. *Call Waiting* (1997) is a work for one projector that explores the sexual links between various protagonists. Speaking in Punjabi, Spanish, Chinese, and English, on an assortment of cellular and other equipment, from bedrooms, bars, and offices, characters named Jaia, Kimberly, Kaizad, and Chris play out their own international version of *Six Degrees of Separation*. Not only is everyone in the world connected at the remove of a handful of other people, but we all are erotic partners too, whether in the flesh or other electronically coded ways.

Jocelyn Taylor began her career as a maven of media through her work as an AIDS activist with ACT-UP. She has produced numerous short films as well as installation projects. *Alien at Rest* (1996) is a piece for three projectors. In the central image, the artist strides through the city sporting sunglasses and a pair of heavy shoes. Flanking this portrait are frames of Taylor in a bathtub, descending into its depths then bobbing suddenly to the surface. In all three projections she is very large and quite nude. As Yasmin Ramirez has pointed out, Taylor's nudity and overt sexuality is meant to intrude into the viewer's space of contemplation.[5] For the artist, to walk naked is not just a performance but a "political demonstration. . . . [W]ith every elegant stride, Taylor reclaims if not all black female subjectivity—a symbolic portion of it."[6]

The works of Soares, Simpson, and Taylor tap into the growing visibility and acknowledgment of feminine agency in the sexual arena. However, while a performer like Madonna receives kudos for her stunning self-representation, evocative creative fictions, and salacious irony, women of color are rarely allowed as much aesthetic freedom in the realm of the erotic.

As bell hooks has noted, the black female body is itself already a sign of sexual experience,[7] and so these women express their sensual independence at a price. For those whose persons throughout history have been treated as collections of salable parts, not whole conscious beings, projecting the corporeal/carnal figure as a work of art is a hard role to recover.[8] The sense of the burlesque, of performative exaggeration, is also lost. So that the

new wave of sexually explicit female rappers, for instance, like Foxy Brown and Lil'Kim, can be accused of "trickin' [as] a way of leveling the playing field."[9]

This spring in the United States press, a debate raged around black erotica in particular, almost exclusively focusing on female performers rather than their male counterparts.[10] Did the appearance of libidinousness play into the mythology of the oversexed woman, should they "selectively ration their erotic power,"[11] or, as we approach the twenty-first century, was it finally all right for (black) women to speak openly of and demonstrate freely both the joy and potency of the sensual?

For all intents and purposes, it would seem that much of the world is still not ready to acknowledge the force of women, either in private or public arenas. In fact, the display of self-contained sexual vitality becomes dangerous, and signals the need for (male) societal repression. Paradoxically, in openly expressing their own pleasure and satisfaction, the majority of the world's women make themselves vulnerable to brutality.

Statistics are grim. The United Nations has documented "a global epidemic of violence against women."[12] Most go through life living a patently burdened and unequal existence as compared to men. In a United Nations report from 1980, "women, half the world's population, did two thirds of the world's work, earned one tenth of the world's income and owned one hundredth of the world's property."[13] While at the end of the twentieth century we have more female elected officials than ever before, they still comprise only 10 percent of the legislators worldwide.[14] At the end of the day, the United Nations concluded that "there is still no country that treats its women as well as its men."[15]

The bonds between women, their work, and families are examined by a number of artists in "Life's Little Necessities." Using found objects arranged in discrete spaces for a recent installation in Johannesburg, Veliswa Gwintsa took on the issue of Lobola, or "bride price," the traditional dowry payment made by a South African bride's family to her husband.

The sculptural amalgamations of Fatimah Tuggar are inspired by the implements of women's domestic labor. Fans and brooms made of woven grasses and meant to operate on human brawn are "updated" using electricity. As Tuggar writes:

> I use traditional tools to point out the toggling that goes on in a contemporary city kitchen in a developing country. For example, housewives use the electric mixer in conjunction with the traditional stick whisk due to the inefficiency of the power system. My attempt is to dispel the media

stereotype of the poverty or purity, and yet remain honest to the short-comings of modernisation.[16]

The work of Glenda Heyliger comes from a very personal space. In *Auto-biographical Self-Portrait* (1996), the artist attempted to bring order to her chaotic life, folding about seventy thousand newspapers and forming a chamber from them that could contain "her most impressionable recollec-tions."[17] Included in three hollowed-out spaces were a broken teddy bear, a family portrait, a scrub brush in a bucket of soapy water, and a small cactus. Like the prickly plant which, if broken, can take root elsewhere, Heyliger moves forward, leaving a metaphorical piece of herself in one place, while anticipating the adventures to come.

Maria Magdalena Campos-Pons's search for self, the ongoing construc-tion of images of identity, is carved from a global sense of family and be-longing. Though she was born in Cuba, Campos-Pons's work often deals with the West African heritage that is found throughout the Caribbean. In the installation *The Seven Powers Came by Sea* (1993), for example, the his-tory of slavery is evoked through wooden tablets carved after images of the holds of slave ships, surrounded by small photo portraits. *The Seven Powers*, of course, refers to the Yoruba deities who are honored in Santería, a New World religion that is part of Africa's cultural bequest to the Americas.

The photography and installations of Pat Ward Williams touch on both the public and private aspects of life using historical and autobiographical voices. These become fused in a manner that blurs categories of knowledge while demystifying (personal/political) events.

With the necklace, Silvia Gruner has found a form and metaphor that allows her to move effortlessly and continuously from an intimate, personal, bodily space to a public, sculptural, universal one. Each bead, whether as sculptural or photographic object, becomes a morphological clone, a small but crucial segment in a freshly created, yet somehow perpetual, string-ing together of histories. The fragment is writ large in Gruner's jewelry-as-billboard. A different segment of one necklace is displayed over a series of huge panels. They do not necessarily form a complete piece; instead the idea is to make one see them as partial, as sections of a gigantic jewel (only visible at intervals) that surrounds the entire world. The idea is also to rec-ognize the impossibility of an essential wholeness, and to play with that con-cept at the same time.

By many standards the new South Africa has supported the strivings of its female population in ways beyond the global norm. As of last year women comprised 25 percent of the Parliament, and there were two women

on the Constitutional Court.[18] But along with Lobola, there are a few traditional African practices—including polygamy and denial of property inheritance—at loggerheads with modern (Western) concepts of feminism. This is delicate and complex ground. One source acknowledges that black feminists in South Africa are often equivocal about condemning certain customary practices, given the historical characterization, by whites, of things African as barbaric.[19] According to Baleka Mbete-Kgositsile, deputy speaker of Parliament and former secretary general of the African National Congress Women's League, "you can't be high and mighty and educated about it. In your Western marriage, is there fidelity and equality? At least these women [in polygamous marriages] know where they are. We shouldn't approach this just from a viewpoint of Western feminism."[20] One chilling statistic, however, stops us cold: South Africa has one of the highest rates of rape on the planet.[21]

TALKING BACK

One ought to consider the futility of a political program which seeks radically to transform the social situation of women without first determining whether the category of women is socially constructed in such a way that to be a woman is, by definition, to be in an oppressed situation.

JUDITH BUTLER

Given the scenarios of oppression that affect women on a global scale, we shouldn't be surprised to find collateral images that emphasize toughness and perseverance. And so it makes sense that the most successful female rap artist to date is Da Brat, whose persona is more tomboy and brazen adolescent than erotic temptress. Brat is a sister with a voice and an attitude. How can we not admire the strident posture of a woman with a second project called "Anuthatantrum" and a company named Throwin' Tantrums, Inc.?

While Brat's success might also be attributed to her self-styling after the macho male rapper image,[22] the performer herself acknowledges the difficulties of the position of women and the need for sisterhood. In her judgment, all the female rappers out there "get credit for even trying, 'cause we don't get it like the niggas. . . . But we coming up in the world. It's only a handful of us, so we can't start bickering yet."[23] Perhaps some of the most positive aspects of Brat's music are her loudness and her ability "to exercise her right to speak her mind. Nobody can take that power away from her."[24]

The individualism and self-determination of (black) women is often read as aggression, and is something that the world has trouble finding a place for. It is a characteristic, perceived of course as masculine, that many

times has to be combined with the sensual or erotic (designated as feminine) in order to be understood. So, for example, in the initial work of the performer Mary J. Blige, we get "the hat back, combat booted" female figure who is "both femme and butch, bitch and requisite nigga."[25] The impetus to unite these parts of the whole finds strange parallels in the places where the erogenous abuts the violent. And it is this in-between place that catches the imaginations of another group of artists in "Life's Little Necessities."

Melanie Smith's "Orange Lush," a series that began in 1994, can almost be read as a travelogue: with each small plastic object added to the ever expanding assemblage, a place, situation, or time is registered. The monochrome drama of the work is quite painterly, with subtle tones (rendered in found objects) making themselves known on closer inspection. Sensuous tactility, however, is undermined by its effervescent orange hue—a symbol of societal authority, whether in road signs or the attention-grabbing (and controlling) language of advertising. This color and authority both "attracts and repels."[26] By attaching her discoveries to board, Smith further broaches questions of surface versus interior.[27] In these shallow arenas, she probes issues of "consumerism, materialism, and artificiality."[28]

Zarina Bhimji's light boxes and installations perhaps most consciously interpolate the space between pleasure and pain. In these works, simple, familiar elements are imbued with a stronger emotional weight. Lush images of soft and yielding flesh and fabric, for instance, are transformed into signifiers of violence. These works as well examine patterns of classification (racial, biological, textural) and how such systems of display are tied up with colonial histories.

In creating objects that appear to be "genuine" archeological artifacts, Wangechi Mutu uses the language of ethnography to address the postcolonial time in which she lives. In *Maria* (1995) the devotional figure of a virgin crowned by the bloodied head of a black doll is completed with cowrie shell eyes. Recent pieces combine doll parts in unexpected ways with televisions, feathers, and picture frames. Her project for the second Johannesburg Biennale begins with a personal parable of cultural survival. While visiting her parents in Kenya, it is revealed that Mutu's mother refuses to serve lake fish, since they have been feeding on massacred villagers escaping the turmoil in Rwanda and Burundi. Writes the artist:

> The population of fish, even the size of them, had increased relative to the enormity of the tragedy. . . . The people who have "disappeared" (and are still disappearing) because of the Central African Holocaust have reemerged and are being redistributed amongst the living.[29]

Cape Town sculptor Berni Searle will also be creating an installation that forestalls loss and historical amnesia, a situation of mediation, where fresh approaches to the South African past can be invented. The artist works with resin screens, which suggest the ability to embed objects and layer visual possibilities; they are opaque and transparent, sculptural and ephemeral. Floating in and among the three dimensional is an audio track with recordings of a Bushman/San dialect, Khomani, which was spoken for twenty-five thousand years before it became extinct in the 1970s.

If we understand installation as the locale of the theatrical—a place of self-conscious construction, where the very deliberate placement of certain objects in relation to others is performed to bring forth a cascade of (sometime conflicting) meaning—we can see it, after Irigary's model, as a feminist site of origination. In a subversion of Plato's allegory of the cave, Irigary rereads this space as womb and the original location of theater. By linking the "illusionistic theatre apparatus—its mirrors, fetishes, lights, voices, the whole 'stage setup'—to matter, earth, body," she recasts this site of production as an arena of spectacle rather than a place of "maternity and nurturance."[30]

Indeed, as a setting for the activation of creative relationships, installation as artistic form foregrounds the prospect of actually empowering its audience by placing viewers at the center of art's "action" and meaning. In acknowledging that a work remains unfinished without the participation of the spectator, or putting forth "the notion of an artwork as a surface upon which viewers [can] project their own history,"[31] artists invite their audience to share in the creation of signification. This collaborative situation and site can then become a place of power. Installations thus have the potential to be cast as arenas in which a sense of personal agency can be formed.

A sense of self, the control of one's being, these are a few of life's little necessities that the generative energy of women's installation in the '90s wills into existence.

NOTES

Originally published in *Trade Routes: History and Geography. Second Johannesburg Biennale*; Kellie Jones, curator, "Life's Little Necessities: Installations by Women in the 1990s," October 12, 1997–January 18, 1998.

1. Chantal Boulanger, "Installation: Beyond In Situ," *Parachute* 42 (March–April–May 1986): 53.
2. See Judith Butler, "Performative Acts and Gender Constitution: An Essay in Phenomenology and Feminist Theory," in Katie Conboy, Nadia Medina, and Sarah Stanbury, eds., *Writing on the Body: Female Embodiment and Feminist Theory* (New York: Columbia University Press, 1997), 401–17.

3. Luce Irigary, "The Sex Which is Not One," in Conboy, Medina, and Stanbury, 254.

4. Charles Merewether, "Into the Void," Valeska Soares (brochure) (São Paulo: Galeria Camargo Vilaca, 1994).

5. Yasmin Ramirez, "Jocelyn Taylor at Dietch Projects," *Art in America* (April 1996), 114.

6. Martha Schwedener, "Jocelyn Taylor, Alien at Rest," *Time Out New York* (February 1996), 14–21.

7. bell hooks, "Madonna: Plantation Mistress or Soul Sister?" in Adam Sexton, ed., *Desperately Seeking Madonna* (New York: Delta, 1993).

8. bell hooks, "Selling Hot Pussy: Representations of Black Female Sexuality in the Cultural Marketplace," in Conboy, Medina, and Stanbury, 113–28.

9. Joan Morgan, "The Bad Girls of HIPHOP," *Essence* (March 1997), 77.

10. In addition to Morgan's article cited above, see bell hooks, "Platinum Pussy," an interview with Lil' Kim, *Paper* (April 1997); *VIBE* 5, 4 (May 1997) the sex issue; Michael A. Gonzalez, "Toni's Secret," *VIBE* 5, 5 (June–July 1997), 90–94, a suggestive pictorial accompanies this article on Toni Braxton; *VIBE* 5, 6 (August 1997), letters responding to the previous two issues; Michael Marriott, "Black Erotica vs. Black Tradition," *New York Times* (June 2, 1997), B1–B2.

11. Morgan, 134.

12. Emily MacFarquhar, "The War Against Women," *U.S. News and World Report* (March 1994), 44.

13. Ibid., 42.

14. Ibid., 44.

15. Ibid.

16. Fatimah Tuggar, "Proposal for the 2nd Johannesburg Biennale 1997."

17. Evelino Fingal, "Preserving Memories," Glenda Heyliger catalogue published on the occasion of the sixth Biennial of Havana Cuba, Instituto di Cultura Aruba, 1997.

18. "South African Wimmin," *Economist* (October 5, 1996), 79.

19. "South African Wimmin," 80.

20. Baleka Mbete-Kgositsile cited in ibid.

21. *McClean's* (Canada) (March 31, 1997), 41.

22. Morgan, 77.

23. Da Brat cited in Tracii McGregor, "Sittin' on Top of the World," *Source* (October 1996), 102.

24. Ibid., 104.

25. Karen R. Good, "Miss Mary Mack," *Village Voice* (April 1997), 59.

26. Melanie Smith, artist statement.

27. Yishai Jusidman, "Las Nuevas Majas," *Art Issues* (September–October 1994).

28. Smith, artist statement.

29. Wangechi Mutu, "Proposal for the 2nd Johannesburg Biennale 1997."

30. Elin Diamond, "Mimesis, mimicry, and the 'true-real,'" in *Acting Out: Feminist Performances*, Lynda Hart and Peggy Phelan, eds. (Ann Arbor: University of Michigan Press, 1993), 371–72.

31. Benjamin Weil, "Remark on Installations and Changes in Time Dimensions," *Flash Art* (January–February 1992), 105.

Interview with Kcho

Kcho, *Obras Escogidas* (*Selected Works*), 1994. Books, metal frame, wood table, newspaper, twine;
51 x 100 x 37 1/4 inches. Collection Walker Art Center, Minneapolis. Clinton and Della Walker Acquisition
Fund, 1996.

Kcho's almost obsessive reconstruction of the boat form in his installations appears to address the processes and problems of migration that particularly affect Cuba—a nation that fights a daily battle against its increasing economic, political, and cultural estrangement from the rest of the world. Boats have become a recurrent and a charged symbol in contemporary work by Cuban and Cuban-American artists, inspired in craft and spirit by the imaginatively fabricated "balsas" or rafts used by those who make the perilous, and usually illegal, ninety-mile journey from the island to the United States.

Yet Kcho insists on a much broader reading of his work. It speaks to the more general lived experience of island dwellers all over the world: the perennial confrontation with what he terms the "watery barrier" or the "liquid limit," the natural phenomenon that contains and defines one's existence. The image of the ship is also connected to memories of the artist's childhood—paper toys floated by little ones on lazy afternoons, the carpentry practices of his father. There is playfulness but at the same time a nostalgia for the warm safety of a (not so) long ago youth, the security of the real and metaphorical homeplace. This interview was conducted in Spanish and took place at the Barbara Gladstone Gallery in New York, shortly after the close of Kcho's solo show.

KCHO: My name is Kcho. Some people call me Alexis Leyva, but everybody has always called me Kcho.[1] It was my father's doing. I was born on the Isla de la Juventud, an island that is south of Havana, on February 12, 1970. I have been in New York for four months.

KELLIE JONES: How do you like New York?

KCHO: I like it very much. I've visited various places in the United States and this is a special city. You can't measure the United States by this city; it's very different from the rest. It's like a way of life.

KJ: Let's begin with the obvious: the rafts. Is this an idea that you share with other Cuban artists of your generation?

KCHO: Yes. However, to talk about this I should talk a little about history, my relationship with traveling, and with objects that are related to travel.

My fascination with this idea began with the body of work prior to this one, in which the fundamental concept had to do with the shape of the island of Cuba; that is to say, life on an island, meaning that everything evolved around it. In 1992, I made my first voyage out of Cuba. A work which resulted from that trip was called *Siempre fue Verde (It Was Always Green)*. In it I used a symbol that I have used on other occasions, a paddle tree. It is a plant that has a paddle instead of roots. And like you say, the theme is migration. It is a theme that concerns many artists in many parts of the world. However, the first work in which I used the element of a boat, ship, or raft, or however you call it, is related to one thing, my childhood. I completed *La Regatta (Regatta)* during 1993–1994. The implication was of a child's game. Later I began to take this concept in different directions; I began not only to construct objects but to utilize real objects. I manipulated these found things; my hand would either repair them or distribute them in space. They were works that depended a lot on energy. When objects already have a use, a prior history, that forms part of a work.

KJ: So, in the beginning your work drew on the idea of youth, and now it is about something different.

KCHO: Not really; the idea of youth is still present, the links to my childhood still hold. It was important to me that the work had the characteristics of a game, if a macabre game. These little ships have common, everyday meaning, referring to the migratory mentality of a person that lives on an island. To have a liquid medium as a limit always makes you think differently. A person that was born and raised on an island recognizes that he/she is on an island even if that limit does not really exist. For example, if you are on a continental mass and if you see the horizon, you know that you can continue walking. But the ocean produces something strange, a limit, like a barrier. You don't know what is beyond the horizon and you become a faithful believer that on the horizon there is something, even though you can't see it. There is a daily desire to evade or go beyond this limit that separates you from other things. This is the mentality of the isle.

KJ: So life is not about struggling against a barrier, but conquering it?

KCHO: It is the struggle to conquer or to eliminate a barrier. Let's take the example of a Cuban my age, born and raised with that existing limit, never knowing whether or not this limit can be surpassed. Some people are born and die on the island; they have never left Cuba. They know that beyond the blue horizon there is something, but they have never seen it. This is something very intense, and it always makes you think that you want to evade

that limit. The mentality of migration is similar to this notion, and it is a mentality that is becoming stronger each day in various parts of the world, as if every day that passes people want to move to better themselves, and so on. This is the only issue that is a constant in Cuba. Cuba is not always going to be socialist or communist; the only thing that is permanent is that Cuba is always going to be an island, and always the ocean will be the limit. This is what interests me, the daily confrontation with the liquid limit that forces you to think in a certain way.

KJ: In your work the rafts do not float, they don't function as methods of physical transportation. Is this a sign of failure?

KCHO: No, I wouldn't say it is a failure, but I enjoy the illusion or concept of the works floating or functioning. They are recognizable forms in whatever material they are made of, and they should float, but they can't. I like the illusion that they should float more than the fact that they do float. The work is more about that than the idea of failure. It's like a manipulation.

KJ: More like an illusion, just as art is an illusion?

KCHO: Exactly, art is an illusion, so I'm not as interested in the ability of the object to function as I am in its ability to function as pure illusion.

KJ: Critics say a lot of the time, regarding your work, that it signifies the failure of Cuban society.

KCHO: A work of mine that has generated that type of comment is the work just purchased by the Walker, *Obras Escogidas (Selected Works)*. It is a ship constructed with some of the schoolbooks that I used, books that could have been used by any Cuban of my generation or the generation before mine. That is to say, a Cuban formed in the revolution received the type of information contained in these books. And what *Obras Escogidas* tries to make visible is the idea of social structure which always remains hidden. It is like putting skin on something that doesn't have skin. Many people look at this work and only see books on Marxism and say the piece is about politics. But there are also natural science books, math, and geography books. It is a work that talks about universal literature and the mix of ideas in formation.

KJ: What is the theme of the work called *A los Ojos de la Historia (To the Eyes of History)*?

KCHO: I like to use a lot of indeterminate figures in my work. Any person with an art background can identify the Tatlin spiral [Vladimir Tatlin's *The*

Monument to the Third International, 1919–1920]; those without art knowledge can conclude that it is the Tower of Babel. Both are like an idea of a dream, the Titlin spiral as well as the Tower of Babel. Tatlin's spiral is the utopian dream of an artist. It was impossible to build it at the time, and it is impossible to build it now. Tatlin's concept constituted a utopia in that sense, then it became the symbol of a society that was supposed to change the world. And all of a sudden, this other content that was given by history also failed, when the socialist camp disappeared and that ideology failed. So it's not a symbol anymore, it's just one more utopia. This is how I see it. My dream is to find a way to make Tatlin's spiral work. What about making a drainer? It didn't function as one thing, so why not another? So a utopia is given function. It's something sarcastic too . . . how do you filter coffee in Tatlin's spiral?

KJ: Going back to the rafts, why aren't there any passengers in them?

KCHO: It is because, to me, the objects are the people themselves; they are not ships, they are people. I don't think that there is an invention of human transportation that throughout history has had a significance that is so determined by the condition of that person. You can find small boats, made by Indians from the Amazon, all the way up to those cruise ships that you see in Miami that look like palaces. I think these vessels really define people. That's why I think ships are beings, beings with a life of their own, an idea, a path.

KJ: You mean it is not a human being, but a being.

KCHO: A being with its own life and determination. To me, each floating object is such. And I don't call them boats or ships or rafts. I like to call them floating objects, because for me it is a floating object. They are things that are part of everyday life. So this table between us can also be like a floating object.

KJ: In another metaphoric way, these boats can transport people that look at them, and in another sense you have traveled with these works, to show them. So though the ships cannot float, they are means of mental transportation, and they *have* allowed you to travel, to come to the United States, to Europe. . .

KCHO: Yes, these works move all over the world. Let's say they are my company. They come with me wherever I go—to Korea, London, New York, Milan. They are like my family.

KJ: What other forms or artists influence you in your work? For example, people like Tatlin, poetry, music. . .

KCHO: Well, music is very necessary when I work. It is super important; it complements my process. I need music. Basically, what I listen to is jazz in its most traditional form and Afro-Caribbean music. I like Duke Ellington. Another favorite is Miles Davis. I have a lot of their music. I am constantly working with this type of music. In the context of art, let's say culture or specifically plastic or visual arts, a lot of things interest me. Russian avant-garde art, in its totality, interests me. At one time I was very interested in Italian art—Futurism and Arte Povera. It's like a process of apprehension and of utilization of things. For me a fundamental thing is to know history and to use it. When you don't have a knowledge of history, history uses you. When you don't know something, that something uses you, so it is important to know many things. The path you are going to take is clearer because you then begin to invent, to create, to grab the strings of the puppet and have everything under control.

KJ: Are there any specific artists that you like?

KCHO: For me art has a division, like stairs; there are two people that I consider gods—Picasso and Duchamp. These two people are very important. They gave us the possibility of thinking in another way. They gave us the opportunity to see in another way. To me, this is a god. Then there are the semi-gods; there are a lot of people in that group, people whose art I like a lot. And we are the mortals. We are here trying to do something. But in this world there have been many brilliant artists. We have Brancusi, for instance.

KJ: And Cuban artists, contemporary or historical?

KCHO: Wifredo Lam is known as the most important Cuban artist in history. I like the universality I find in his works. And there are a lot of interesting artists in Cuba, artists of my generation and the generation before mine.

KJ: I do know some of the Cuban artists of the 1980s, such as Glexis Novoa, Tomás Esson, Marta María Pérez Bravo, José Bedia, Carlos Rodríguez Cárdenas, and Ruben Torres Llorca.

KCHO: I met a lot of these artists in Mexico when they lived there. When I arrived in Mexico there was a sense that in Cuba there weren't any more artists, that they had all left. It was an exaggeration of the 1980s, that all the artists were living in the United States and in Mexico. This was not true; in Cuba there are still many artists working. There's a variety of interesting

work being done. Unfortunately, in the 1980s, that generation was very intense and complex but was left truncated. I hope it doesn't happen to this generation.

Something strange happened to me here in New York. I met a Cuban artist that I had never met before—right now I don't remember his name. I was with another Cuban artist named Carlos Garaicoa who had had an exhibition here. I asked this guy, "Are you also from Cuba?" He said, "No, no, I am from here." And I said, "Oh, you were born here?" He said, "No, I was born in Cuba." So then he *is* from Cuba; Cuban living outside Cuba. I say this because I also have a lot of family living outside of Cuba. Sometimes these people create mechanisms, very strange relationships with their motherland. Cuba is not Fidel lying on the ocean, Cuba is the land that gave birth to you, the land, the water, the plants, the animals, the garbage that you came out of. Cuba is not Fidel lying on the Caribbean. Cuba is something made by nature, and I am happy to have been born in Cuba, I love Cuba. It is my birthplace. For me, denying that is like rejecting your own mother. This is something that the land does not forgive. It is absurd to deny the land, especially when Cuba is so beautiful.

KJ: What about the artist group of your generation, called *Los Carpinteros* (The Carpenters)? Do they deal with the same questions and issues? And is this separate from artists of the 1980s generation? Are issues different for them?

KCHO: Well, I would say yes, it is possible that things are different. The relationship is different. In Cuba I have a lot of friends who are artists. Two artist friends who are particularly important to me are Israel Miranda (he lived and worked in Mexico with me) and Osvaldo Yiero. I just recently met him, because he just started to be known as an artist. We have common worries. For now, I get along with all the artists in Cuba. They are my friends. I hope there won't be any hate; that can be a byproduct of the field we are in. I was talking about it here with *Los Carpinteros*. I told them that I hope it never happens to us. If there are any problems, I hope we can talk about them, whether they concern a gallery, the collectors, etc. But my generation right now is quite busy, and there is a certain harmony in the relationships and ideas . . . this is really nice.

My thinking process is similar to the ideas of other artists that I have a relationship with. I think that my generation has different thoughts from those of prior generations—different ideas and relationships with art and life. And the generation after mine will have a different one; I think it is evolution or invention, I don't know what to call it. For example, I was raised

with the idea of studying art; I never thought of the future necessity of sell-ing my art to survive. I never thought when I was twenty years old that I would be sitting here in front of you. I made objects for the love of art, pure pleasure. But today, at the Institute of Arts in Havana, the artists seem to have a concern with selling their work in a way that people from my gen-eration or the generation before mine didn't have. They ask you, "Did you sell? Oh yes? And who bought it? And how much?" In other words, there is a concern with the art market. And Cuba is a place where the art market does not exist; people have no idea what comprises an art market. Instead, they have this paradisal illusion; they still maintain an admiration for the world of art, for artists, for international figures. It is really funny when I go to Cuba, students see catalogues of the exhibitions I was in, and they ask, "Did you meet that artist? Did you talk to that person?"

This goes back to the idea of the liquid barrier and seeing what is on the other side, because a lot of Cuban artists that have left Cuba have never come back. This is an issue that Cubans drag with them. You are born and raised, become a man, and you never know if you will be able to cross that barrier, and there are people who, once they cross it, don't know if they are going to come back. They feel they can't leave the road open for a return. It is something that life has forced people to do. It is very sad. It's terrible to feel compelled to think that if you leave your country you are not going to be able to return. Such is the pressure that many Cubans who live elsewhere feel. They have a desire to go to Cuba, but they know they can't, because they left, and so there is something sour about their return.

I don't like to be in one place. I don't like to feel that I can't walk where I want to. I don't think anybody likes it. My mom passed away, and if I wanted to go to visit the cemetery at five o'clock in the morning and sit on top of my mother's grave to talk to her, I want to be able to do it. I wouldn't like to spend twenty years suffering, thinking that I couldn't visit her. And there are things that are a lot more intense than this, things that make you step over that barrier many times. Here people worry about what is going to hap-pen when they return to Cuba: will they be able to leave once they go? What is going to be the relationship with the island? Nobody knows. The only way to find out is to go to Cuba.

KJ: Is there a difference between constructing one of your pieces here in New York with new materials and making one with used materials?

KCHO: I don't think that way. My work has followed two paths, constructions with found objects and new constructions that I have created. They each have a different type of energy. There is an energy from use, from prior his-

tory that found objects possess, or the type that comes from my own hands. Basically this work here [*la Columna Infinita II*], the manner in which it was constructed, relates to many things. First of all, I am using C-clamps and raw wood. My father was a carpenter, so these materials are fundamental to me. It is work that is constructed with pressure. The fact that it exists because of pressure is like a game or a play on words. Life is full of pressures; we feel pressured by many things. For instance, there are a lot of people here, especially in the United States, that are waiting for me to make a political statement. Many people wanted me to start a political scandal. But this does not interest me. So pressure is very important. My work exists because of the pressure. There aren't any nails or glue, it is wood and everyday pressure. People are surprised, because I use C-clamps or because the wood is new. They say, "Why didn't you use old wood?" But it is wood with its own life, and it will eventually change color with time. And like my other works, it will have a life of its own.

KJ: This is my last question, and you may have already answered it, I don't know. Do you think your work deals with the idea of Cubania or of nationalism?

KCHO: You can say *Cubania* or *Cubanidad*. It is something that theorists have defined in Cuba—Fernando Ortiz and Nicolás Guillén, for example.

KJ: Is it something natural for all Cuban artists or is it something that is constructed? Is *Cubania* a theory that one imposes upon a work of art, or is it something that is already present? For example, because the artists are Cuban, then automatically the work will have an aspect of *Cubania*?

KCHO: I guess it can be natural or it can be implanted. My work from about five years ago had a lot to do with that; it was very evident that I was a Cuban. I constructed Cuba many times; I used images such as the palm tree and other patriotic symbols. The island was a lot more evident as a metaphor. But later on, well, I think now things can be from anywhere, because they speak of a phenomenon that is universal. This world is made up of immigration. People will continue to move everywhere. This is a universal phenomenon.

Funny things have happened to me. For example, the exhibition *Cocido y Crudo* (*The Cooked and the Raw*) in Madrid that was organized by Dan Cameron. At the museum, the people who helped me mount my work asked me if I was Moroccan. Why Moroccan? Because of the *pateras*, they explained to me. Apparently Moroccans use a type of boat they call *pateras* to cross the Strait of Gibraltar. So they are referring to that issue, of Moroccans

crossing the Strait of Gibraltar to go to Spain; it was a familiar idea. I said, "Do I look like a Moroccan?" They said, "Well, there are a lot of Moroccans in Spain." This is something that had never happened to me. I realized that anyone can be from anywhere, because if you saw the work I did in Korea called *Para Olvidar (To Forget)*, the ship is Korean. The materials are all from Korea. The idea was to construct this work with materials from that place. It has all these Korean texts. If you look at it and don't read the name of the artist, you may think that it was made by anyone, even someone from Korea, because commentary has universal application.

In Cuba there is a lot of talk among artists directed toward this *Cubania*. They make reference to geography. This was used a lot in the 1980s, and it is still being used a lot now. They make reference to the shape of the island, the symbols of *Cubania*, things that identify Cubans. It is one tendency or path used by Cuban artists. It became more visible in the 1980s, but in reality it began earlier. It is a road that Cuban art has taken for a long time, and refers often to the island itself, to the geography, to life on the island.

KJ: So are Cuban artists in the 1990s no longer working in this manner? Is the work metaphoric and less direct?

KCHO: It is less direct. In December when I attended an exhibition in Havana, I was impressed at how a number of artists relied on the geography of the island. This is very Cuban, that the island be present in every work as a formal element. In some it is very evident and in others it is just a metaphor. For example, in Garaicoa's work, he makes reference to the architecture, the disintegration of the city of Havana. *Los Carpinteros* have many works that refer to the island itself, and others that are more allegorical—if you look at them, you could not make the assumption that the works were made by Cuban artists. However, in other works they speak about being Cuban; and then the idea of *Cubania* is a lot more direct. You can find many things in Cuba. At this moment it is very diverse.

NOTES

This interview took place May 5, 1996. It was first published in the exhibition catalogue *No Place (Like Home)* © 1997 Walker Art Center.
1. Kcho is a pseudonym for Alexis Leyva Machado.

The Structure of Myth and the Potency of Magic

I can't stand art actually. I've never ever liked art, ever.
DAVID HAMMONS, 1986

I like the kind of things people will say to me when I'm nailing my bottle caps or when I'm selling my shoes. Sometimes one of them sees the little rubber shoes all in patterns and says, "You should make art." And I say, "Oh I never thought of that."
DAVID HAMMONS, 1986

Many claim never to have seen David Hammons's work in the vacant lots or traffic islands of New York City—flags hung outside palazzos or bags and chains hanging from five-hundred-year-old Venus figures in Italy. Can it be art if he makes it from things we throw away, not just odd ends of metal and wood but barbecue ribs, chicken feet, wine bottles, fried chicken parts, grease, dirt, hair cuttings, bottle caps, fan blades, coal, and other common materials strewn over the places Hammons happens to pass through. Is he a "real artist" if after his first great successes, in his twenties, he rejected the art form which had given him fame, and instead, began making objects from used, greasy paper bags and bones, objects which had no hope of being sold?

Maybe, as Calvin Reid has written, David Hammons is just a "hip junk dealer,"[1] who specializes in the exotic, such as doll shoes, snowballs, and elephant dung. Maybe his being an artist is a myth, perpetuated by journalists hot for an intriguing story. But this irreverence is also advanced by Hammons, for while his work may or may not exist in liminal sites, over the years he has had no qualms about speaking to interviewers, in the process weaving tales about who he is and what he does.

They ask me all kinds of crazy things. "Is it art?" "Are you a gardener?" A cop came up to me one day and said, "Do you have a permit?" I looked at him. What would I be doing over here with 40,000 bottle caps and three telephone poles without a permit?[2]

As an artist, David Hammons expands our definition of the term with his varied and evolving practice. He is a "hip junk dealer," sculptor, performer, conceptual artist, environmental sculptor, magician, philosopher, social commentator, draftsman, and griot who positions himself "somewhere between Marcel Duchamp, Outsider art and *Arte Povera*."[3] Like Duchamp and the Dadaists he much admires, his art takes "a subordinate place in the supreme movement measured only in terms of life."[4] Indeed, Hammons's work not only comments on a specifically African American version of life, it is physically composed from the material elements of this experience.

Walk through Harlem any given day and you will see David Hammons' work. The work he does for people who cannot go to SoHo and gallery-hop. The people that he knows. The people he comes from. Bottles stuck on top of bare branches protruding from the ground. From vacant lots and cracks and crevices in the sidewalk. Hammons transforms them. Creates visual music and something to smile about in an environment that doesn't offer a lot in the way of jokes. But those cheap wine bottles have touched Black lips. Lips looking for a cheap way out of a predicament whose ultimate cost is very high. So Hammons knows this and gives our travails a new context—art. In very public spaces. The ultimate alternative space, if you will.[5]

The story goes that David Hammons was born forty-seven years ago in Springfield, Illinois, somewhere "on the other side of the tracks," one of ten children. At the age of twenty he left Springfield for Los Angeles. He attended Los Angeles City College for a year, then Los Angeles Trade Technical College, where he studied advertising. While going to LATT he also took evening and weekend classes at Otis Art Institute and eventually went on to Chouinard Art Institute. While at Otis, Hammons sought out Charles White, a superior draftsman and printmaker, who was a veteran of the 1930s and the WPA era. Hammons had initially found out about White through exhibitions and reproductions and eventually studied privately with him. At that time the idea that there were African Americans who had been practicing artists for thirty or forty years was a shock to Hammons and other black artists.[6]

The example of Charles White, whose socially committed work was for

and about African Americans and their struggles, and the climate of Black Power and black cultural nationalism of the late 1960s were certainly influences on the young artist. Some of his earliest works were prints, many of which used the American flag as a symbol of America's unkept promises to, and violence against, African Americans.[7] These were not ordinary prints, although silkscreen was involved. Called body prints, Hammons used his body as the printing plate, smearing it, as well as his clothes and hair, with margarine or other grease. Then, he pressed himself against a board and, finally to set the impression, dusted the board with fine chalk or other pigment. In these pieces Hammons became "both the creator of the object and the object of meaning."[8]

Hammons worked with body prints into the early 1970s. For the most part these were traditional, two-dimensional, frameable and salable objects, and they did very well in the art marketplace. But from the beginning, the artist experimented with participatory formats, moving beyond the picture frame. In *Black Boy's Window* (1968), he silkscreened a body print onto a windowpane which included a shade that could be pulled up or down by the viewer. An early description of *Injustice Case* (1970)—a piece inspired by the Chicago Eight trial at which defendant Bobby Seale was bound and gagged—reveals that the print was originally shown as part of a larger three-dimensional construction.[9] Even when the body prints began to formally disintegrate, leaving only facial features as in *Ragged Spirits* (1974), Hammons's images remained meditations on African American existence. Not so much descriptions, these works increasingly became reflections in which black viewers could find a vision of self.

The early 1970s proved to be a period of change for Hammons. Although he continued to do body prints until about 1975, he experimented more and more with objects. His "Spade" series was particularly transitional, encompassing two-dimensional and three-dimensional works as well as performance. As with his pieces which incorporated the American flag, Hammons again engaged a symbol, exploring both its connotations and physicality:

> I was trying to figure out why black people were called spades, as opposed to clubs. Because I remember being called a spade once, and I didn't know what it meant; nigger I knew but spade I still don't. So, I just took the shape, and started painting it. I started dealing with the spade the way Jim Dine was using the heart. . . . Then I started getting shovels (spades); I got all of these shovels and made masks out of them. It was just like a chain reaction. . . . I was running my car over these spades and

then photographing them. I was hanging them from trees. Some were made out of leather (they were skins).[10]

The "Spade" series led Hammons into the realm of the metaphoric, the allusional, into abstract art. He began to realize more fully the power of the symbolic, its cultural significance and potential for recognition and understanding by a broad audience. It was amazing that a discarded shovel could be transformed, so very simply, to carry another meaning.

Hammons eventually gave up the body print format altogether, rejecting the concept of framed works, which he felt put a barrier between object and viewer. A growing interest in the work of Duchamp and California artists such as Noah Purifoy, along with Hammons's own experiments, led him away from traditional artists' materials. Found substances became more alluring; they were easily obtained and cost nothing, thus, Hammons was freed from a reliance on money. Each component was activated, charged with energy by past use; it contained a spirit.

Pieces created from the mid-1970s onward—about the time Hammons transplanted himself to New York City—have an "anti-art" thrust. They are concerned with process and gesture and are often fugitive, difficult to find. They question formal methods of art-making as well as the concept of art as saleable merchandise. As Lowery S. Sims points out, "Hammons confronts our commodity-predicated notion of the dear, the beautiful, and transforms our perception of and reception to the humble detritus of our urban society."[11] Like the dadaists, there is a political and philosophic stance behind rejecting conventional forms which seem "incapable of acting—or even commenting—upon a world sorely in need of change."[12]

Hammons's *Greasy Bags and Barbecue Bones* were shown in New York at Just Above Midtown Gallery in 1975. These works were composed of discarded brown paper bags and sparerib bones, glitter, hair, and grease. Like the canvases of Helen Frankenthaler or Romare Bearden's paintings from the late 1950s, Hammons's bags were stained methodically with grease, the saturation controlled. Using the same materials, he also created mobiles. The ephemeral nature of these materials was matched by their implicative gestures. The bones, sans the missing/consumed barbecue, type of hair, and grease, all things known to and used by African Americans, were employed by Hammons specifically as intimate and personal comments on the culture. Illuminating this idea, Gylbert Coker has commented on Hammons's treatment of grease—actually a holdover from the body prints: "Much more subtle in their identifiable element, the prints nonetheless grew from a black object—grease. How many times has your Momma told you to get yourself

some grease 'cause your legs are ashy?"[13] Hair, which had been purely decorative in the "Greasy Bags and Barbecue Bones" series, was the next element to take on a life of its own. Hammons worked with this natural fiber for half a decade, collecting what he needed from black barber shops in any part of the country he happened to be in. He created objects such as *Untitled (Hair Pyramids)* (1977), in which each form is distinguished by a different color and texture and which also plays with the image of the famous Egyptian structures. In the "Dreadlock" series, shown at Just Above Midtown in 1976, Hammons made "quilts" by stuffing hair into metal screens, their designs seemingly ersatz "Rainbow Box" or "Diamond in Square," the patterns found in batted cotton versions made by black southerners. Many of these had dangling "locks," constructed by threading the hair onto wire.[14]

Through the hair pieces Hammons more fully developed the idea of environmental installations, creating three-dimensional spaces activated by artwork which encapsulated the viewer. Hair encrusted wires which were attached to walls and ceilings incorporated other materials like feathers, egg shells, and record album shards, as in *Gray Skies over Harlem* (1977) and *Victory over Sin* (1980). A room created for the exhibition "Afro-American Abstraction" at P.S.1 Museum in 1980 used hair as a recurring wallpaper pattern. An untitled early outdoor piece is particularly sensuous and lyrical. Installed on a beach in 1977, the hair is threaded on free-standing vertical wires of human scale which sway in the breeze like strange, hybrid dune grass. The lapping waves create a reflective surface on the sand, and the small field of hair plants is doubled and elongated.

Hammons's first major commission for Atlanta International Airport is made from a variety of hair constructions. Located over an escalator that connects Concourse C with the intra-airport transportation system, he installed different configurations in each of four overhead bays. Glittering brown bags with hair tassels; a linear, automatist scrawl of hair strung wire; swooping bird-like forms of dowels, feathers, hair balls, and 45-rpm records that conjure up the work's title, *Flight Fantasies* (1980).[15]

During the last decade, Hammons has continued to make art with similar materials, extending his repertoire to bottles, chicken parts, bricks, trees, cereal boxes, gold chains, and even Louis Vuitton handbags—reproductions, of course. He has completed five major commissions in addition to his usually ephemeral though pervasive public works. For Hammons, these types of exterior pieces are important because they reach a greater number and variety of people. A piece like *Flight Fantasies* can be seen by approximately fifty million people per year, "roughly fifteen times the annual attendance of the Metropolitan Museum."[16]

The art audience is the worst audience in the world. It's overly educated, it's conservative, it's out to criticize not to understand and it never has any fun. Why should I spend my time playing to that audience? That's like going into a lion's den. So I refuse to deal with that audience, and I'll play with the street audience. That audience is much more human, and their opinion is from the heart. They don't have any reason to play games; there's nothing gained or lost.[17]

Higher Goals (1986) is a commission Hammons assembled as artist-in-residence for the Public Art Fund. The piece was on view from April through October, on a small strip of green—part of the larger Cadman Plaza Park—facing the court buildings in downtown Brooklyn, New York. It consisted of five, twenty- to thirty-foot-high telephone poles topped with basketball hoops complete with backboards and blanketed with thousands of—mostly beer—bottle caps. Some of these regal obelisks carried diamond, zigzag, and chevron designs on their mosaic-like surfaces, their tight configurations reminiscent of snakeskin, Islamic decoration, African textiles, or even the patterns on Hammons's earlier hair quilts. Other poles seemed to sprout wiry lengths of caps, as if these replanted timbers had sent forth new growth. Hammons constructed the piece in situ for the first six weeks, methodically nailing and stringing thousands of bottle caps. The process was an integral part of the piece, as was the interaction with the judges, lawyers, clerks, downtown shoppers, residents, and even police who contributed to and redefined the work's meaning. Once again, Hammons wove various stories around a work, adding to the layering of cultural motifs from African to Islamic to southern black to northern urban basketball.

The issue is, I was deprived of a basketball career by being too short.[18]
It's an anti-basketball sculpture. Basketball has become a problem in the black community because kids aren't getting an education. They're pawns in someone else's game. That's why it's called *Higher Goals*. It means you should have higher goals in life than basketball.[19]

Like his extensive investigations of nappy hair, Hammons began exploring the basketball theme as early as 1982 in a performance called *Human Pegs/Pole Dreams*. In this work, seven masked participants ritually erected one highly ornamented pole, topped with a transfigured bicycle wheel resembling a Native American feathered shield. A later and physically somewhat different incarnation stood in Harlem for several years beginning in 1985; it was located on 125th Street and Lenox Avenue (now Malcolm X Boulevard), the same block where Malcolm X conducted his early street orations.

The project Pole Drems grew from Hammons' wanderings through Harlem. One day he happened to notice a basket made with two U-clamps and a two-by-four on a pole in the middle of his block. It was set-up for a basketball game. From that point on Hammons began to notice basket-ball set-ups hooked to something everywhere. They were made out of paper bags, cardboard boxes, wooden crates and more.[20]

African American folk construction and Outsider art is fascinating for Hammons because it points to an aesthetic, a way of using and doing things, of creating something beautiful from the nothing that is given, from the leftovers. By making art from detritus and found materials, Hammons attempts to put himself on the same plane as the historically marginal and opens himself up to their canons of beauty and perseverance that some-times translates as transformational magic.

Part of the Art on the Beach project sponsored by Creative Time, *Delta Spirit* (1985), was Hammons's ode to southern shanty construction. On a landfill at the southern tip of Manhattan, he created his own shack from wood scavenged in Harlem, embellished with bottle caps and flattened tin cans, complete with porch, curtains, and a clothesline. Though *Delta Spirit* was meant to be temporary and site specific, Hammons refused to dismantle it.[21] For him it was a public sculpture, significant for the human community, and like many of his other pieces, a "calling card."

> Everybody knows about *Higher Goals* . . . up there in Harlem. If I'm on the street up there I say, "I'm the guy who put that pole up there." I'll be on 116th or 110th and Amsterdam and talk to anybody, and they'll say, "You're the one who did that. Yeah, I know where that is, I know you. Brother, come here, this is the cat who did the pole, yeah." So sometimes I'll just say that to talk to somebody on the street, at three or four in the morning or something, it's like a calling card.[22]

Outdoor work is functional in Hammons's philosophy, though it is not necessarily didactic. In its poetry, it becomes something to consider and contemplate. Yet like calling or business cards, these pieces also identify the artist and act as a form of mediation and greeting.

Besides placing objects in the great outdoors, known also as the urban jungle, Hammons has done performances on the streets, actions seen fleet-ingly on the way to art galleries. Following his early "Spade" actions in Los Angeles—*Spade Run Over by a Volkswagen, Spade Covered with Sand*—he performed in New York in the late 1970s before doing *Human Pegs/Pole Dreams* in 1982.[23] In 1983 and again in 1985–1986, he engaged in a series

of acts that transformed the ritually derived motions of performance into consumer transactions, and in the process, compared the marketability of art and culture with other objects.

Bliz-aard Ball Sale was performed intermittently during the winter of 1983 on Cooper Square at the edge of Manhattan's East Village, the site of a new gallery/new art boom during that period. It is also where the prestigious art school Cooper Union is located and where a variety of vendors ply their mostly used products. Hammons seemed like just any other salesman standing on the sidewalk. But approaching his "stand," a simple cloth placed on the ground, one found he was selling snowballs! Lined up in neat rows from small, pebble-like pellets to large, palm-size spheres, there was indeed something for everyone (priced accordingly), and they sold. *Doll Shoe Salesman*, performed some two years later, was a similar action. Snowballs were replaced by rubber doll shoes which were arranged and rearranged in patterns on the street. These, too, were consumed by passersby, snatched up vigorously at fifty cents a foot, though they were of even less use than the snowballs.

> Selling the shoes and other things on the street I think is my personal best. . . . It's like having an opening for me when I do that piece, because I interact with people. . . . If you have an item between you and other people, then they can relate to you. If you don't have an item, you're enemy number one. But if you have an item between you, then it cools them out and they can deal with you.[24]

Perhaps Hammons's other calling card is his manipulation of wine bottles, another material he has probed over the years. For a long time he only worked with the Night Train and Thunderbird varieties. Some of the least expensive alcohols available over the counter, they were, of course, the most pervasive. He fashioned them into arches and circles. Sometimes the curves of seagreen glass were interrupted by one or two bottles still contained in their brown paper bags; sometimes the forms held candles.

As a tale-teller and a mythmaker, Hammons is enamored of puns, both the visual and the spoken kind (like doll shoes at fifty cents a foot), and his bottles are ripe with allusions. The train figures prominently in African American culture and lore: there's the underground railroad (the network by which slaves escaped to freedom); Freedom train (metaphorically "ridden" by "freedom riders" during the 1960s); train porters (this was a respectable job for African American men in the twentieth century). The blues is full of train metaphors, which are also used in jazz and rhythm and blues. The "A train" (the song by Duke Ellington about the subway line that

goes to Harlem); "Night Train" (in addition to being a cheap high, popular with those down on their luck, is an early piece by James Brown); John Coltrane (the legendary jazz saxophonist is often referred to as Trane). Finally, there is the idea of African Americans "living on the other side of the tracks" in a segregated society.

In addition to the circular and semicircular structures, the artist also used Night Train and Thunderbird bottles to make "bottle trees." These are, in effect, found sculptures or ones created by the power of designation, a device made famous by Duchamp. The action was modest: Hammons would take bottles from the ground and upend them on the branches of a nearby tree. Though he was activating form through process, the nomination of this object as "art" was outside of himself; he was merely finding objects and putting them together. Hammons could make these pieces almost anywhere. Mostly, he worked with Ailanthus, also known as "poverty trees," ubiquitous in the backyards and vacant lots of New York City or anyplace there happens to be a piece of urban dirt. Sometimes he would strip off the finer branches, working with the spindly trunks that recalled the flexible wires and dowels of his earlier hair sculptures. Other times he would make a piece in the fall or winter, when the tree was bare; by the spring and summer the work would be changed with leaves growing in and around the bottles. Hammons has also created objects with standard issue table wine bottles in which he has placed elements from crosses and Georgia clay on miniature hands, dolls, and feathers.[25]

> The thing about these bottles I love is that people have to ask how you got those things in there. It's like a trick. It's like they're saying, "how'd you do that trick?" . . . Visually it's hard now to mess with people, because everybody is so hip on what's happening. I like when people ask how I do these things, because that means they don't know. Whereas in painting everybody knows, or thinks they know.[26]

A wall installation entitled *Spring Chicken*, shown at the American Academy in Rome in 1990, further expands the concept of what a bottle or vessel can be. In addition to various Night Train and wine bottles, Hammons filled Budweiser cans, Scope and Coke bottles, and a lady's rubber "raindeer" boot, with water and placed a calla lily in each one. Here, Hammons drew on his own tradition and engaged the Italian culture around him.

> There's nothing negative about our images, it all depends on who's seeing it, and we've been depending on someone else's sight. . . . We need to look again and decide.[27]

Throughout most of his career, David Hammons has disarmed and deconstructed symbols and stereotypes through constant reuse. He has recycled images, ideas, and materials, employing them first one way and then another. By seeing them over and over again, recontextualized in a plethora of postures, meaning is not emptied but becomes more fluid. A spade is a form; hair is a fiber. These can mean everything or simply be constitutive elements in a work. His modus operandi has to do with the pun, with the "Now you see it now you don't" stance of the trickster. There are gestures for both the initiates and non-initiates of African American culture; there is visual stimulation for different levels of cognition, something for everyone.

The artist's fixation on the public arena, on creating incursions into our collective spaces, is a natural extension and integral part of his interest in the meaning of symbols in a society. These pieces must be in every unexpected nook and cranny and in our consciousness, "one of those objects that is in the path of your everyday existence,"[28] to be affective, to truly speak. By using our discards, our remains, things that we still recognize for the most part, Hammons draws us into a tale and weaves it around us. But the stories remain his.

Through his selections and juxtapositions Hammons provides an interpretation, albeit a heavily layered one. He communicates; he gives form; he names. There is power in such designation, in naming, in calling and claiming some thing as your own. By identifying and repossessing particularly negative, stereotyped, dirty, rejected symbols and signs through reconstituted objects, the artist retools judgments concerning beauty and, in a sense, refigures aesthetics.

NOTES

Originally published in *David Hammons: Rousing the Rubble* (Cambridge: MIT Press, 1991). The title comes from a line in Jane Addams Allen's essay for *Awards in the Visual Arts 8* (Winston-Salem, N.C.: Southeastern Center for Contemporary Art, 1989), 12. The epigraphs are from Hammons interviewed by Kellie Jones, *Real Life* 16 (autumn 1986): 2; Hammons quoted by Guy Trebay, "Pole Vault," *Village Voice*, May 13, 1986, 73.

1. Calvin Reid, "Chasing the Blue Train," *Art in America*, September 1989, 196–97.
2. Hammons quoted by Trebay, "Pole Vault," 73.
3. "David Hammons," in *Casino Fantasma* (New York: Institute for Contemporary Art, 1990), unpaginated.
4. William S. Rubin, *Dada, Surrealism and Their Heritage* (New York: Museum of Modern Art, 1968), 11, n. 2.
5. Dawoud Bey, "David Hammons: Purely an Artist," *Uptown* 2 no. 3, 1982, unpaginated.

6. David Hammons interviewed by Joseph E. Young, *Art International*, October 1970, 74.

7. Many African Americans were making art using the image or actual remnants of the American flag during this period including Betty Saar, Faith Ringgold, Clifford Joseph, John Outerbridge, and Timothy Washington. For further discussion of this trend see Dr. Mary Schmidt Campbell, *Tradition and Conflict: Image of a Turbulent Decade, 1963–1973* (New York: Studio Museum in Harlem, 1965), 60–61; and Lizetta Lefalle-Collins, *19Sixties: A Cultural Awakening Re-Evaluated, 1965–1975* (Los Angeles: California Afro-American Museum, 1989), 42.

8. Campbell, *Tradition and Conflict*, 61.

9. "This picture, however, is only part of a larger setting which consists of a seven-foot tall lighted case which has been lined with black velvet and which acts as a setting for the framed image. On a slightly elevated section in front of the picture rests a gavel, presumably the sort a judge would use to call a court to order. Possibly to create an 'aesthetic distance' for the viewer, the case has two sliding glass doors, complete with a lock. The total ensemble appears at the very least to equal some of the tableaux by Edward Kienholz." Young, 74.

10. Hammons interviewed by Jones, 4.

11. Lowery S. Sims, "Art as a Verb: Issues of Technique and Content," in *Art as a Verb* (Baltimore: Institute College of Art, 1988), unpaginated.

12. Rubin, *Dada, Surrealism and Their Heritage*, 15.

13. Gylbert Coker, "Human Pegs/Pole Dreams," *Village Voice*, September 28, 1982, 79.

14. In 1976 dreadlocks were not as well known or as widely worn among the population of the United States as they are today. Thus, the press release from Hammons's exhibition explains this visual reference: "The Dreadlock Series (taken from the hairstyles of Rastafarians)."

15. Although this work by Hammons and those of the thirteen other artists commissioned by Atlanta International Airport are still extant, they were all in bad disrepair when I last visited in September 1989. It seems there was never any provision made for the upkeep and conservation of this collection.

16. Peter Morrin, "Air in Public Places," in *Atlanta International Airport Art Collection First Commemorative Catalog* (Atlanta, 1981), unpaginated.

17. Hammons interviewed by Jones, 8.

18. Hammons quoted by Trebay, "Pole Vault," 73.

19. Hammons quoted by Douglas C. McGill, "Hammons' Visual Music," *New York Times*, July 18, 1986, section 3, 15.

20. Coker, "Human Pegs/Pole Dreams," 75.

21. The piece was eventually vandalized.

22. Hammons interviewed by Jones, 9.

23. There are surely a number of undocumented performances; see ibid., 7.

24. Ibid.

25. Both the bottle trees and objects in the bottles were inspired by folk art forms. Hammons saw examples of the latter in Robert Farris Thompson, *Flash of the Spirit* (New York: Vintage Books, 1984), 183, plate 117—see Hammons interviewed by Jones, 9.

It is also possible that he got his ideas for the bottle tree from that source as well; see Thompson, *Flash of the Spirit*, 142–45.

26. Hammons interviewed by Jones, 8.
27. Hammons quoted in Linda Goode-Bryant and Marcy S. Phillips, "Contextures" (New York: Just Above Midtown, 1978), 41.
28. Hammons interviewed by Jones, 4.

In Visioning

———

PART TWO

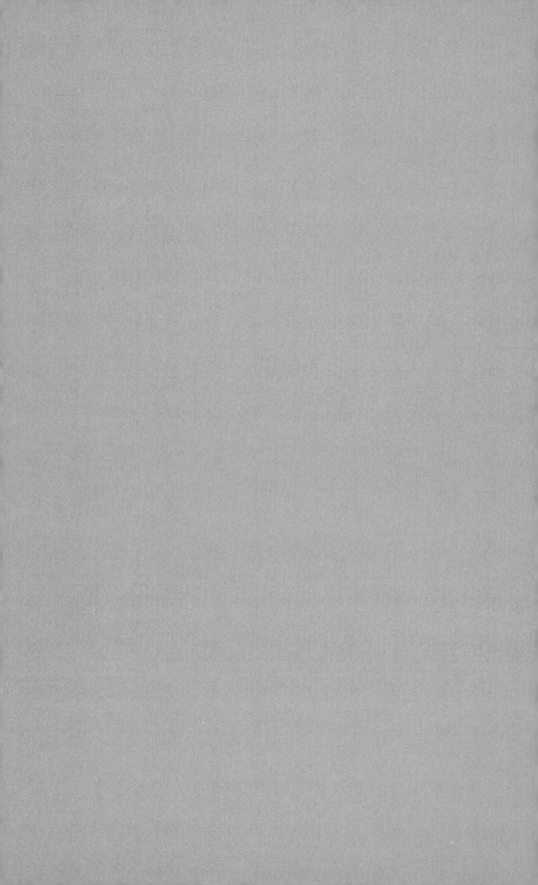

Seeing Through

Language—precise language—was important in our house; still I was startled the day Kellie called to tell me the title of her essay on Martin Puryear. "Eye-minded?" I asked. "Is that really a word?" "Look it up," she said, and of course I did before calling her back. "That explains everything!" I exulted. What I meant was that it described her as well, and put in plain words why I—being not "eye" but "ear-minded"—had always relied on her to show me what I couldn't see, or, to be precise, to offer ways of seeing, roads—inroads—along which I could never have traveled myself.

This facility of hers—to see and offer to others ways of seeing—is at the core of the following essays. I began to notice it even before the 1970s when she was in high school and I wrote the poem that introduces this section, when as a small girl she'd take an object I was puzzling over how to either open or assemble, and very kindly turn it around, or upside down, and show left-handed me the way. That kindness—by which I mean lack of fault-finding or criticism, and probably mean patience as well—comes through, I believe, in her writing. Her respect for the reader's intelligent witness leads her to clarity but never condescension or obfuscation. She doesn't need, ever, to tell you how much she knows about someone or something, but simply asks you to do as she does: to "see . . . through / her shining / black eyes."

I would emphasize here the idea of "seeing through," which to me is of primary importance, and has always been Kellie's approach to art, and to life itself. There is a very important reason for that phrase in my poem, having been given its own stanza. We know what we mean when we use it to imply understanding that permeates surface to reveal essence. Thus her interest in Betye Saar's use of "problematic figures" such as Aunt Jemima to "consume their power . . . drain their negative

magic," and her mention of Sylvia Gruner's sculptural acts as partly "a tangible way to reconnect and reconfigure the link of family and heredity."

I also wish to take up the idea of Kellie's "black eyes," and the reason they, too, have their own space in the poem. There is, without doubt, the literal: as her mother I treasure their shining revelation of her spirit, the willingness of her direct gaze. Of equal importance is that they are black, else I wouldn't have bothered, and "black," the descriptive redeemed from its eighteenth-century past and incorporated into late twentieth-century forthrightness, has come to us in this century signifying pride. More than an adjective, it carries on the idea of "tell it like it is."

This does not mean that in work such as that of Dawoud Bey there no longer remains "the challenge of describing African American lives in the face of continuing racist mythologies." There is no question that there is much work still to be done in that direction. But the idea of "seeing through" directs us to the personal, as Kellie writes about the photographic work of Pat Ward Williams containing "both history and autobiography." The personal, however, need not be figurative, need not follow a formulaic view of what African American art ought to look like. The abstract work of Howardena Pindell, for example, which as Kellie points out in her 1989 interview, follows an experimental arc in terms of both pattern and material. The same holds true for that of the sculptor Martin Puryear, lately the subject of a retrospective at the Museum of Modern Art, whose work Kellie chose to represent the United States in the 1989 São Paulo Bienal, where it was subsequently awarded the Grand Prize. As Kellie wrote in the essay to accompany her exhibit, his work "reflects a new sense of wholeness and balance, a contemporary American sculpture that benefits from pluralism and internationalism."

In her essay to accompany the exhibition "Large as Life: Contemporary Photography," Kellie mentions that large-scale photographs "not only make us perceive images in a different manner but also challenge us to consider them differently." This refers again to the idea of the African American artist redefining the image of the self, overriding the stereotypical, often boldly. Which reminds me that a title Kellie was once unable to use—"In Your Face"—is one that I hope will someday have its turn when applied to large-scale photography.

Coming to the work of David Hammons, who begins his interview here by proclaiming, "I can't stand art," a person can be, I suppose, either flummoxed or bowled over. I often stand with David in his position re "art," but have invariably been impressed by everything he has made, from his "bottle trees" to his *Higher Goals* piece, made with telephone poles embossed with bottle caps and topped by basketball hoops. But it takes someone like Kellie to ask the questions that elicit the answers from an artist like David, someone far too original to be considered within the usual "art" parameters.

I'm often asked questions about Kellie's career—when she expressed an inter-

est, when she began, etc.—and find these questions difficult to answer, even though there were early signs that she had the kind of eyes necessary to accomplish what she has done. Sometimes an art historian begins, as Kellie did, by making art as well as studying it. I have in my house two very precious objects, the first a clay necklace she made in "shop class" with Don Sunseri. She might have been eight, and I don't know how many examples of African art she'd seen, but the "beads" in their shape and articulation strongly resemble photos of African crafts. The second object is a self-portrait she painted at sixteen. In it her eyes are thoughtful but wide open. To me, this is the way she was and the way she remains.

Cape May, N.J. | August 2008

In the Eye of the Beholder

Tonight she brings
 eaters!
 little black boys with purple tongues
 in the City College mulberry trees

 in Times Square a Muslim woman
 munching a Mars bar under her veil

These are Kellie's pictures you see

 she sees
 through

 her shining
 black eyes

Originally published in Hettie Jones, *Drive*. Brooklyn, N.Y.:
Hanging Loose Press, 1998.

To/From Los Angeles with Betye Saar

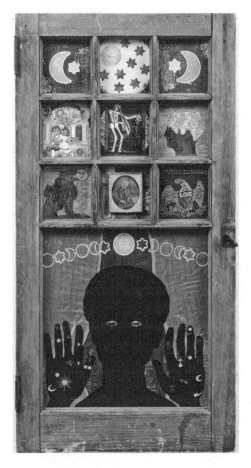

Betye Saar, *Black Girl's Window*,
1969. Mixed-media assemblage,
35 3/4 x 18 x 1 1/2 inches.
Collection of the artist. Courtesy
of Michael Rosenfeld Gallery, LLC,
New York.

What does a woman need in order to become an artist?

FAITH WILDING

In 1972 Betye Saar created what has become perhaps her most iconic work of art, *The Liberation of Aunt Jemima*. The central figure is a stereotypical mammy, black woman as nurturing symbol of white America, who, since the late nineteenth century, has offered comfort and sustenance from the safe space of a box of pancake mix. Yet here she has been transformed into a warrior, armed with guns and the strong fist of Black Power.[1]

Saar's engagement with exploding African American stereotypes in this moment was a practice clearly connected to the Black Arts Movement. Succinctly described as the "aesthetic and spiritual sister of the Black Power concept,"[2] it championed the aesthetic pleasures of blackness and focused on reception by black audiences. It was art with African American specificity. In the realm of visual art there was an emphasis on representational imagery, graphic style, bold color, and embedded words which clarified message and content. Important themes were African heritage, black heroes, and black families. Mary Schmidt Campbell has also identified works which dismantled "icons of racism" (including the American flag) and thus fulfilled their role as "weapons" of the black cultural revolution.[3]

Confronting black stereotypes allowed African American artists of this period to create figurative, representational work which was recognizable and thus available "to the masses" yet at the same time demonstrated art's role as weapon by enacting the destruction of negative imagery. By incorporating these problematic figures, artists sought to consume their power, enact physical and artistic cannibalization, and thus drain their negative magic. Saar made a number of pieces between 1970 and 1972 which function in this way, including *Whitey's Way* (1970), *Sambo's Banjo* (1971–1972), and *Black Crows in the White Section Only* (1972). Other artists creating work in this vein included Murray DePillars, Jeff Donaldson, and Joe Overstreet. As Jane Carpenter and Betye Saar argue, however, Saar was the first to integrate *actual* historical objects, so-called black collectibles into her pieces.[4]

If the Black Arts Movement seemed to represent the tenets of Black Power it also more broadly reflected the climate of the times. By the 1960s Betye Saar's Los Angeles was just one of many United States municipalities that contained black urban ghettos marked by raging unemployment; sub-

standard housing, schools, and municipal services; and the destruction of a legitimate black commercial sector; as well as a level of police brutality that assumed the proportions of an occupying army. And it was usually abuse by police that ignited the rebellions that marked the inner cities during this moment. According to Robin D. G. Kelley,

> Between 1964 and 1972, riots erupted in some 300 cities, involving close to a half-million African Americans and resulting in 250 deaths, about 10,000 serious injuries, and millions of dollars in property damage. Police and the National Guard turned black neighborhoods into war zones, arresting at least 60,000 people and employing tanks, machine guns, and tear gas to pacify the community.[5]

Los Angeles, though a sunshine paradise and land of economic opportunity in the twentieth century, was also home to one the largest riots by African Americans of the era. Initiated by a driving infraction turned brutal on August 11, 1965, the eruption came to an end six days later, after the deployment of the National Guard. The result: 34 dead, more than 1,000 injured, 3,952 arrested.[6] Because of their size and scope the Watts rebellions seemed cataclysmic; they took on symbolic, and almost mythical affect. The rebellions announced in a big way and in no uncertain terms African American anger and disgust at abuse, discrimination, and inequality that had lasted for centuries. They became a touchstone of change, the sign of a shifting and radical approach to subjectivity and to art.

The Watts neighborhood's iconic landmark, the Watts Towers—a series of fantasy structures created from a mosaic of refuse—was a fount of inspiration for Betye Saar's practice as an artist.[7] In the post–World War II United States art scene, mixed media quietly began to take hold, in the neo-dada of Jasper Johns and Robert Rauschenberg and the junk sculpture of Mark diSuvero and John Chamberlain, and on the West Coast in the parallel development of assemblage by Edward Kienholz, Bruce Conner, and others. While all these styles used the detritus of American consumerism to make art, California assemblage more famously privileged narrative and metaphor, and exploited a surrealist edge, offering a critique of materialism and societal repression. Such strategies found a comfortable home with Los Angeles artists working within Black Arts Movement rubric such as Noah Purifoy, John Otterbridge, John Riddle, and Saar. These artists (and others) engaged with bits and pieces of their environment, in particular the remnants of the Watts rebellions, through which they could refer to African American culture and life without relying on simplistic painted representations of the black figure. In this way African American artists working in

Los Angeles also provided an alternative to the standard visual formulas of the Black Arts Movement. Their take on black heroes, affirmations of cultural identity, and links with the African past followed different routes. Their visions were not particularly two-dimensional or graphic, colorful, or solely representational.

In his book *Freedom Dreams, The Black Radical Imagination*, Robin D. G. Kelley asks us to remember the driving visions with which radicalism begins, reminding us of the influence that liberation struggles in Africa, Asia, and Latin America have had on those of the United States. Importantly, he also claims that the energy we usually associate with the Black Power Movement after 1965 occurred as early as the 1950s. Inspired by Kelley's example I began thinking about the roots/routes of the Black Arts Movement in Southern California. While so many had spoken of the palpable change in the emotional, social, and political climate after Watts rebellion, as always with African American culture I knew there was more there than originally met the eye.

In its "Speaking of People" column, *Ebony* magazine offered brief snapshots of African Americans with interesting vocations. Featured in the October 1951 issue were artists Curtis Tann and Betye Brown (soon to be Saar) who created jewelry and other fine crafts under the moniker "Brown and Tann." The piece explains how enamelware is made and how the work is marketed and distributed "in gift shops and interior decorator studios." These outlets, in addition to state fairs and local competitions and exhibitions in homes and churches, served Brown and Tann and other African American artists throughout the 1950s. The *Ebony* article confirms such working methods and informal networks: "[The] couple uses Tann's garage as a workshop, and his living room as a display room for prospective buyers."[8] With the expansion of the African American population in Los Angeles after World War II, we also find a growth in the community of artists and creation of structures to support their work. Curtis Tann recalls that Brown and Tann exhibitions were extremely popular, particularly those in homes; they would clear out all the furniture, set the place up like a gallery, and often sell out.[9]

Unlike those in New York, artists in Southern California had space: the beach, the desert, the sky, but also homes, backyards, and garages easily converted into studios and temporary exhibition spaces. This space of the home is interesting not so much because of the possibilities that size seems to suggest but because it was identified with "hobbyists," "amateurs," and "homemakers," labels attached to black women and men struggling to make a living and to support their predilection for art-making. If they were

lucky they found work as graphic or window designers. As the art historian Judith Wilson points out, craft, applied, or functional arts have been the space where women thrived, often creating in the sites of homes or clubs, the antithesis of the male "fine" artist brooding in the garret.[10] However, African American women *and* men have also flourished in the crafts, a fact that almost certainly reflects the "usefulness" that such functional art had under slavery and in the postbellum period for people trying to survive economically in this country.[11] Wilson also cites modernism's predilection for incorporating traditions from outside the Western fine art canon, whether these were the arts of Africa, Asia, or Latin America, or the characteristics of the functional world, such as the Bauhaus. In California the line between fine and applied art has been more permeable, not only, it seems, for African Americans. This was evident in the 1950s and 1960s with the huge popularity of Peter Voulkos, an artist working with ceramics on a monumental scale.

Personal domestic space is a place where African Americans have traditionally been able to dream and thus to create. In a world where labor and the public environment often meant inequities of tasks, advancement, and services, or flat-out violence, the home and spiritual side of life was the place where you could, to paraphrase bell hooks, come back to yourself, make yourself whole. That art along with visions and dreams of radicalism would be nurtured in such spaces is thus no surprise.

In the 1950s, what indeed did it take for a woman to become an artist, especially in a postwar environment in which more women than ever before were trained in the profession, yet were denied access to careers and professorships?[12] Betye Saar began the decade as a social worker doing small interior design jobs and creating posters. However, it was her work in enamel, her association with Tann, and contact with an integrated community of artists (largely based in Pasadena), that opened her eyes to art as a vocation. Like a number of her colleagues, she started out by designing greeting cards during this period. Known as studio cards, they were based on artists' individual sketches, and then sold by agents to small boutiques. But by the late 1950s Saar felt herself being pulled increasingly toward the fine arts—she returned to college to get a teaching credential and to study printmaking. By then she was married with a family and often took one of her children to class. As she recalled, "in 1956 I had two children, so it wasn't as easy to work as an artist, but I still did my greeting cards."[13]

Saar began to focus primarily on printmaking around 1960. Already visible in her early work was the development of a number of thematic threads and strategies that she would continue to explore throughout her

career. Among these were the centrality of images of women, alternative spiritual practices and cosmologies, and the collision of textures. All this is evident in the serigraph *Anticipation* (1961) with its play of patterns, and focus on a pregnant black woman (perhaps Saar herself) in a meditative state.[14] Saar's focus on the female body a full decade before the preeminence of feminist art-making in the 1970s speaks to her force as a member of the vanguard and a visionary, similar in a sense to the groundbreaking work of Carolee Schneemann, and her move from straight painting to multimedia practice, also in the early 1960s.[15]

By 1966 Saar had largely replaced full figures with symbols, drawn primarily from astrology, tarot, and palmistry. The prints were meshed with found window frames which provided a new kind of support but also set up a fresh narrative structure, which, like a film, storyboard allowed the action of the picture plane to unfold incrementally, as in *Mystic Window for Leo* (1966). In works from 1966 through 1967 the hand becomes the marker of identity, whether the schematic of the palm reader's trade or an impression of the artist's own. These alternate with images of lions for the zodiac sign of Leo—Saar's birth sign. As has been argued elsewhere, the mystical arena evoked by Saar and others, like Sun Ra, during this period represented a surrogate space of liberation, and for Saar one that pointed back to the self.[16] *Black Girl's Window* (1969) is perhaps a turning point in this regard, where we see Saar reembrace the black body and make the connection between the black female form and her surrogate, the lion. Yet in a piece from the following year, *Self-Window with Reflection* (1970), Saar offers us an even more complex view of race and womanhood. In a multipanel window frame Saar renders herself as black, white, and a phrenological study; the black portrait is covered with a small window shade, which, in a nod to the performative, can be raised to reveal another image of herself as white on the verso. Saar's piece clearly anticipates feminist theory's interest in gender as performance, and complicates it by adding the layer of race.[17]

In their discussions of 1970s feminist practice in the United States and its impact on postmodernism, Norma Broude and Mary D. Garrard recognize this influence in feminist art's privileging of "non-high art forms," and questioning of standard Western categories such as "genius" and "universality"; its focus on figuration, portraiture, and decorative arts were arguments for an "expanded definition of modernism."[18] The preeminence of the female body early on has been compared, retrospectively, to the "black is beautiful" formulas of the Black Arts Movement. Yet just as there was, at least initially, no real space for lesbian imagery in the feminist art movement, neither was there much room for that of women of color.[19] But that

didn't matter, sistas had been doing it for themselves for quite some time. Indeed, we can return to the example of those nurturing home spaces of mid-century Los Angeles for African American artists, and in some cases look back even earlier.[20] It is not surprising that black women played an important role in these places, that they would oversee, run, and energize these environments. That they would translate these experiences with domestic and church-based exhibitions into later opportunities of a more formal sort and that this would result in national and international recognition for African American artists should not have been unexpected.

Saar's contemporaries—artists and cultural workers including Samella Lewis, E. J. Montgomery, and Ruth Waddy—created some of the important exhibition and publication benchmarks for African Americans in California in the 1960s and 1970s, including the magazine *Black Art* (now the *International Review of African American Art*), and the two–volume book project *Black Artists on Art* (1969). Waddy founded the artists group Arts West Associated in 1962 to press mainstream arts institutions in Southern California for greater African American representation. Montgomery, who was active in Los Angeles art networks in the 1950s and early 1960s, moved to the Bay Area in 1965 and by 1967 had founded an African American artists advocacy group there after Waddy's example, calling it Art West Associated North. In 1968 Montgomery joined the staff of the Oakland Museum, as an "ethnic art consultant," a position she held through 1974 and under the guise of which she curated eight exhibitions. Lewis, paralleling Montgomery in Northern California, was hired by the Los Angeles County Museum of Art as a coordinator of education in 1968. During the 1970s she would go on to open her own galleries in Los Angeles and in 1976 found the Museum of African American Art there. Suzanne Jackson, another artist-turned-gallerist, opened Gallery 32 in 1969. Though barely in existence for two years Jackson's featured younger artists and more political work that often had a hard time finding a venue. With "The Sapphire Show" (1970) she presented work by black women practitioners, including Betye Saar, Yvonne Cole Meo, Gloria Bohanon, and Senga Nengudi.[21]

> Imagine, if you will, a far-flung network of moles, each tirelessly burrowing underneath a cultural landscape that spans from the Los Angeles County Museum of Art to the Whitney Museum in New York. The moles may not be entirely aware of it, but after several thousand of them individually put in a decade or so of subterranean overtime, it appears that together they quite literally made an imposing mountain range out of vigorously displaced earth. Never again would anyone dare to regard

their peaks as an insignificant patch of molehills. And while excavating the buried history of women's achievements, these moles also tunneled new communications routes that would anticipate the paths of art and intellectual inquiry for years to come. The result was nothing less than a massive reconfiguration of American art.[22]

In the quotation above, moles are a metaphor for women who changed the landscape of late-twentieth-century American art. Like Samella Lewis, Ruth Waddy, and E. J. Montgomery, Betye Saar undoubtedly fits this profile. By 1975 she had had major solo shows on both coasts including one at the Whitney Museum of American Art. But we also see and feel her impact clearly in the work of younger artists who she so profoundly influenced. Suzanne Jackson was actually part of this next generation of African Americans working in Los Angeles. Many of them—for example, David Hammons, Houston Conwill, Maren Hassinger, and Senga Nengudi—followed the multimedia trajectory of Saar and other contemporary *bricoleurs*, but used such devices as part of a more conceptual, active, and performative practice. They were inspired by Saar's use of materials and the way found objects could resonate not only with past use but with collective memory representing deep time. They were captivated also by the alternate cosmologies and sense of mysticism that she inscribed in her pieces. By the early 1970s, Saar's use of window frames as organizing structures for her ideas had given way to shallow boxes and small altars. The work became more theatrical and increasingly grounded in traditional African American belief systems. This is visible in two of what she refers to as her "ancestral boxes,"[23] *Ten Mojo Secrets* and *Gris-Gris Box*, both from 1972. In each Saar uses words (mojo and gris-gris) alluding to African American ritual or conjuring practices.

In two interviews from 1979, one collected on video and the other in print, Saar converses with two younger African American artists—their reverence and respect for her is palpable. Houston Conwill's "Interview with Betye Saar" appeared in an issue of *Black Art*. He introduces Saar as a "high priestess" and her pieces as exquisite "tabernacles" for "spirits in transit," before engaging her in a conversation on the role of process and materials.[24] In Barbara McCullough's video piece, *Shopping Bag Spirits and Freeway Fetishes* (1979)—a meditation on the place of ritual in the work of contemporary African American artists—Conwill and Hammons are featured and both refer back to Saar's investigations as a way to understand the integration of spiritually encoded practice, ancestry, and memory in art.

Perhaps the most important aspect of Saar's approach to metaphysical

traditions was the idea recognized by Hammons, that "ritual" was an "action word."[25] This younger group translated that concept into performative acts and contemporary rites, even if Saar herself did not create performance art. She was, however, very active with installation. And in a sense this became a site of dialogue with artists like Hammons and Conwill, a discourse encompassing materials, metaphysics, and the desire for greater viewer engagement and participation. An example of such a creative conversation begins with an assemblage like *Mti* (1973) which starts its life as a small altar. In a later incarnation this element becomes the centerpiece of a larger site-specific installation to which the audience is invited to add personal objects. McCullough's video ends with a tête-à-tête between Saar and the filmmaker. While the other segments take place in informal settings—the street, for example—McCullough reserves a more formal, talk show style format for her discussion with Saar, conveying her significance as an artist, and an understanding of the influence she had (and has) on the Los Angeles scene and beyond.

For all the creative women in my life. Especially my mother, Hettie Jones, and sister, Lisa Jones.

NOTES

Originally published in *Betye Saar: Extending the Frozen Moment* (Ann Arbor: University of Michigan Museum of Art, 2005). The epigraph is from Faith Wilding, "The Feminist Art Programs at Fresno and Calarts, 1970–1975," in Norma Broude and Mary D. Garrard, eds., *The Power of Feminist Art* (New York: Harry N. Abrams, 1994), 32.

1. On the image of the mammy and visual art see Michael D. Harris, *Colored Pictures* (Chapel Hill: University of North Carolina Press, 2003), particularly chapter 3, "Aunt Jemima, the Fantasy Black Mammy/Servant."

2. Larry Neal, "The Black Arts Movement," in Addison Gayle, ed., *The Black Aesthetic* (New York: Anchor Books, 1972; originally published 1971), 257 (essay first published in *The Drama Review* [1968]).

3. For early Black Arts Movement visual theory see Jeff Donaldson, "Ten in Search of a Nation," *Black World* 19 (12) (1970): 80–89. Mary Schmidt Campbell, *Tradition and Conflict: Images of a Turbulent Decade* (New York: Studio Museum in Harlem, 1988), provides a wonderful overview of visual art and Black Arts Movement practice. For a California perspective see Lizzetta LeFalle Collins, *19Sixties* (Los Angeles: California Afro-American Museum, 1989).

4. Jane H. Carpenter with Betye Saar, *Betye Saar* (Petaluma, Calif.: Pomegranate, 2003), 43.

5. Robin D. G. Kelley, *Freedom Dreams: The Black Radical Imagination* (Boston: Beacon Press, 2002), 78.

6. Lawrence B. de Graff and Quintard Taylor, "Introduction: African Americans in

California History, California in African American History," Lawrence B. de Graff, Kevin Mulroy, and Quintard Taylor, eds., *Seeking El Dorado: African Americans in California History* (Seattle: University of Washington Press, 2001), 38.

7. Among the earliest as well as the longest lasting evidence of Watts as a cultural hub are the famed "Towers" that marked the site for most of the twentieth century. Created by Simon Rodia, an Italian immigrant and laborer, between 1921 and 1954, they are composed of a series of interconnected spires of steel rods and concrete embedded with shells, stones, broken glass, and all manner of refuse brought together in a mosaic-style surface. The structures, including fountains and birdbaths, reach almost one hundred feet at their highest point. After Rodia abandoned the property in the mid-1950s, the Committee for Simon Rodia's Towers was formed to protect this amazing landmark.

8. "Speaking of People," *Ebony* 6 (12) (1951): 5.

9. Curtis Tann, *African American Artists of Los Angeles: Curtis Tann* (Los Angeles: Oral History Program of the University of California, 1995), 151–52.

10. Judith Wilson, "How the Invisible Woman Got Herself on the Cultural Map: Black Women Artists in California," in Diana Burgess Fuller and Daniela Salvioni, eds., *Art / Women / California, 1950–2000* (Berkeley: University of California Press, 2002), 201–16.

11. For information on early African American creators see John Michael Vlach, *By the Work of Their Hands: Studies in Afro-American Folklife* (Charlottesville: University Press of Virginia, 1991); and *Winterthur Portfolio* 33 (4) (1998), a special issue on "African American Decorative Arts."

12. Laura Cottingham, "L.A. Womyn: The Feminist Art Movement in California, 1970–1979," in *Sunshine and Noir: Art in L.A. 1960–1997* (Humlebaek, Denmark: Louisiana Museum of Modern Art, 1997), 190.

13. Betye Saar, *African American Artists of Los Angeles: Betye Saar* (Los Angeles: Oral History Program of the University of California, 1996), 94.

14. Indeed, Saar gave birth to her third child, Tracye, in 1961. Her other daughters Lezley and Alison were born in 1953 and 1956 respectively.

15. Carolee Schneemann, *Imaging Her Erotics* (Cambridge: MIT Press, 2002).

16. See John Szwed, *Space is the Place: The Life and Times of Sun Ra* (1977), cited in Carpenter and Saar, *Betye Saar*, 18.

17. Judith Butler, *The Judith Butler Reader* (Oxford, UK: Blackwell Publishers 2004).

18. Norma Broude and Mary D. Garrard, "Introduction: Feminism and Art in the Twentieth Century," in Broude and Garrard, *The Power of Feminist Art*, 10–29.

19. Arlene Raven, "Womanhouse," in Broude and Garrard, *The Power of Feminist Art*, 63. Saar recalls organizing a show of black women artists titled "Black Mirror" for the Los Angeles alternative gallery Womanspace in 1973. The exhibition was attended primarily by African Americans (men and women) and hardly seen by any white audiences whatsoever. Saar cited in Yolanda M. Lopez and Moira Roth, "Social Protest: Racism and Sexism," in Broude and Garrard, *The Power of Feminist Art*, 152. Samella Lewis recalls that she was one of the few women of color who were active with the Woman's Building in Los Angeles in the same period. Samella Lewis,

interviewed by Richard Candida Smith in *Image and Belief* (Los Angeles: Getty Research Institute for the Arts and Humanities, 1999), 216.

20. For example, Beulah Ecton Woodard was the first African American to be given a solo show at the Los Angeles County Museum in 1935. Soon after that she founded the Los Angeles Negro Art Association, which presented a "Negro Art Exhibit" during the fall of 1937 at the Stendahl Art Galleries on Wilshire Boulevard; in the mere week the exhibition was on view, attendance reached twenty-five hundred. Though this group was short lived, perhaps due to the exigencies of the Depression, Woodard's name appears again in connection with another black collective some fifteen years later, 11 Associated. In fact, she served as the director of this cooperative gallery which had a space on South Hill Street in Los Angeles and offered one of the few "professional" opportunities for the sale and exhibition of work by African American artists. See Wilson; and Lizzetta LeFalle Collins, "Working from the Pacific Rim: Beulah Woodard and Elizabeth Catlett," in Leslie King-Hammond and Tritobia Hayes Benjamin, eds., *Three Generations of African American Women Sculptors: A Study in Paradox* (Philadelphia: Afro-American Historical and Cultural Museum, 1996), 38–45.

21. Samella Lewis, *Image and Belief*, 199–201; Suzanne Jackson, *African American Artists of Los Angeles: Suzanne Jackson* (Los Angeles: Oral History Program of the University of California, 1998), 253–54; Ruth Waddy, *African American Artists of Los Angeles: Ruth Waddy* (Los Angeles: Oral History Program of the University of California, 1993); E. J. (Evangeline Juliet) Montgomery, interview with the author, May 18, 2003.

22. Carrie Rickey, "Writing (and Righting) Wrongs: Feminist Art Publications," in Braude and Garrard, *The Power of Feminist Art*, 120.

23. Carpenter and Saar, *Betye Saar*, 25.

24. Houston Conwill, "Interview with Betye Saar," *Black Art* 3 (1) 1979: 4–15.

25. David Hammons in *Shopping Bag Spirits and Freeway Fetishes*.

Crown Jewels

Silvia Gruner, *Collar de Antigua (Antigua Necklace)*, 1995. One of nine chromogenic prints, 39.4 x 39.4 inches. Copyright Silvia Gruner.

As we look at these artifacts, we have chosen to see them from a single aspect, their fineness, their beauty; but we should remember that in isolating this dimension of them, we are moving away from the wholeness of vision of traditional culture. What would strike most traditional people as strange is not our assessing these objects as beautiful—that they would find as natural as we do; what would puzzle them is our thought that this is the only important way of assessing them—that these objects should cease to be worn and used in ordinary or ritual life, because they are works of art. And that is why, in one sense, to see these objects properly we must imagine them adorning the body.

ANTHONY APPIAH, "AN AESTHETICS FOR THE ART OF ADORNMENT IN AFRICA"

The progression [of style] is never merely from plain to ornate forms; it is from ornate to ornamentally autonomous forms. A loin-cloth apron begins as an elaborate element, and it ends as an arbitrary form which defies imagining as a real part of costume.

GEORGE KUBLER, "THE MAYA TRADITION: SCULPTURE AND PAINTING"

[Beads] are almost ubiquitous in the protohistoric and historic periods in all continents. Unfortunately, beads are notoriously difficult to use in studies of the diffusion of culture traits because of the extreme ease with which they can be used in trade and their inherent reproducibility, which often means that physicists must be called in to unmask their origin.

WILLIAM FAGG, *YORUBA BEADWORK—ART OF NIGERIA*

In necklaces, Silvia Gruner has found a form and a metaphor that allow her to move effortlessly and continuously from an intimate, personal, bodily space to a public, sculptural, universal one. Here we find an easy confluence of the artist's favorite obsessions: the physical shape and tactile presence of ancient ruins, and the possibility of reconstructing history. Like many of her pieces they reveal the inspiration of pre-Hispanic or traditional (rural) things created for ritual or domestic use. And like other works they occupy a realm where the "physical and the spiritual are continuously negotiated."[1]

The necklaces evolved out of Gruner's fascination with the catalogue or the index, and the action of recording and categorizing, which we see, for example, in the wall installation *Nature-Culture* (1993), further glorified as loving ritual in the video *Inventory* (1994). With these investigations she sought to understand how people kept track of all that they accumulated

over time, and to identify a continuity between objects and the life of those who owned them. Necklaces too presented themselves as collections of things/shards/histories. Yet they could be deconstructed and reconstructed, simply, easily, and at will.

As William Fagg reminds us, beads—and consequently the necklaces and other items of which they form a part—are some of our earliest trans-cultural travelers; their origins are equivocal, their homes, uses, meanings diverse. Dainty round or tubular glass and stone forms may immediately come to mind, but beads (and necklaces) can be made from clay, shells, wood, fish vertebrae, toucan beaks . . . and the list goes on. Gruner revels in the world cultural roots of these objects, their place in Arab, pre-Hispanic, Judeo-Christian, and African cultures. Their variable shapes and mutable roles as shields and yokes, emblems of death as well as prosperity, mark them as quintessential conceptual devices. Gruner's work too is variable, malleable, composed of sculpture and found objects in one instance, and video and photography in another; it takes on the configuration necessary to tell the story.

In the art of young Mexicans today, including Silvia Gruner, Rubén Gallo finds a "playful ambiguity and . . . disdain of didactic clarity."[2] These are certainly not simple songs of "ethnic cultural identity" one might expect from "ethnographic" subjects, or delightful, holistic messages of spiritual purity and morality from the "Other" side. The anthropological is put into play, but with the goal of revealing it as a language that constructs (and constricts) its "proper" objects of study.

In Gruner's necklace project we find a series of photographs titled *Coral and Jade*. As photographs they are neither ready to wear nor made of shell or stone. Instead strands of green and pink sausage dangle before our eyes, presented as if they are jewelry on display, the deposits of fat decorating each link echoing veins of rich ore. Is it strange that the word "precious" still comes to mind when we contemplate the importance of this as food, or later, the value of the images themselves? Are we surprised that the green-hued jade was prized more highly than gold in pre-Hispanic Mexico because it suggested the forces of life: water and vegetation?[3] What do we make of the idea that the Aztecs used the same word for "jade" as they did for "precious," or that the Maya hieroglyph for water was the same for jade?[4] Clearly, fluidity of meaning is not solely the playground of the late twentieth century.

Another photographic grouping documents a work known as *Antigua Necklace* (1995). Gruner describes this as a "waiting piece," something she made to occupy her time (mind) while awaiting materials to complete some-

thing else (in this case her amazing examination of the Holocaust, *The Birth of Venus* [1995]).[5] *Antigua Necklace* is a six-meter-long strand, strung with large red, white, and blue "beads" created from typical household washing soap found in this Guatemalan city. In shape and color the soap beads recall their pre-Hispanic clay relatives (with maybe some turquoise thrown in for good measure). If we didn't know better we might think this was an object "discovered" by the artist; that while doing a little in-depth sightseeing to pass the time, she happened upon a lost history of Maya giants. The work's title leads us further down this path: does the piece celebrate the place of its birth (Antigua, Guatemala), or does the name hint at its age (ancient)? It's hard to be sure.

The photographs record *Antigua Necklace* as installation and performative object. This is not the regal pose of the jewelry display seen in *Coral and Jade*. Instead, the drama of *Antigua Necklace* is played out against a backdrop of colonial ruins. It cascades into an abyss seeming to open in one building, or encircles the crumbling turret of another. The sexual innuendo which rests lightly within these performances only further inscribes the bodily connotations already inferred by necklace as body adornment. And like the body of any great performer it is eventually retired, and preserved at its finest on film. With no way to transport this extra, unanticipated piece back to Mexico, Gruner dismantled *Antigua Necklace*, returning it to the women of Guatemala to perform their cleansing rituals.[6]

If, in 1994, Silvia Gruner saw her work as "a place that is basically filled with tepalcates, these little pieces of clay which can be found everywhere and which you cannot reconstruct anything out of," with the necklace project she began to rethread them.[7] The result was not a return to any "original" configuration (lost long ago), but the creation of a new chain of interlocking images and traditions, at times drawn from the past, but based on her own design. Each sculptural bead, then, became a morphological clone, a small but crucial segment in this freshly created, yet somehow perpetual, stringing together of histories.

It is not surprising to learn that her fascination with necklaces arose at the time of her father's death; that upon hearing of this tragedy, the image that appeared in her mind's eye was of a strand of beads now broken.[8] Her sculptural acts were, in part, a tangible way to reconnect and reconfigure the link of family and heredity.

Like *Antigua Necklace*, all these sculptures incorporate the concept of waiting, summing up, counting. The action becomes a meditation, with each threaded bead bringing you a step closer to completion. Like the Jew-

ish funerary rite of "sitting shiva" (which the artist observed following her father's death), every one of the prescribed seven days spent in mourning is meant to be a further summation of and reflection on life. In this light, it is easy to see the connection between the rosary and the abacus. As one writer has pointed out, the rosary insured "that no prayer would be omitted. It was, therefore, truly a counting device . . ."; in parts of Asia as well, beads were used for "telling prayers."[9]

The fragment or clone is writ large in Gruner's jewelry as billboard. A different segment of one necklace is displayed over a series of huge panels. They do not necessarily form a complete piece; instead the idea is to make one see them as partial, as sections of a gigantic jewel (only visible at intervals) that surrounds the entire world. The idea is also to recognize the impossibility of an essential wholeness, and to play with that concept at the same time. (Or maybe she really has found that nation of giants.)

Both Osvaldo Sanchez and Olivier Debroise, at various moments, have spoken of Gruner's objects as fetishes.[10] For Debroise a particular piece offered a metaphor of castration, in the words of Sanchez another was an active protagonist and "cultural phallus." Through these images of the fragmented male body, each writer acknowledged the work's power as a forceful transmitter of ideas and sensations, and underlined its power as a compelling vision of the transitional. Such obsessiveness embedded in an object of passage and liminality is the marker of Silvia Gruner's production. The chain of free-floating associations that is set up is, perhaps, best described in her photography: they are not (three-dimensional) objects but picture objects, yet as photographs they are (another kind of) object. The necklaces, like her entire oeuvre, contain an array of denotations, but find their meaning in the places in between, as connectors, linking the head to the body.

Chiclet Necklace (1995), the original inspiration for the artist's project, is a found object that becomes jewelry by designation. In its other life, it is an imaginative display for chewing gum: each piece is carefully threaded onto a circular wire that is designed to be carried easily through the streets of urban Mexico.

Gruner was continuously fascinated by this item as a living archeological remnant which somehow recalled, in its careful construction and formal details, the necklaces of ancient Mexico. For her it was also a vessel of the ethnographic, an item that held traces of a particular type of economy, a method of survival, as well as an aesthetics; it resonated with issues of class and location. The artist's obsession with counting and inventory became reentwined with the economic. Each chiclet package represented another

segment of (a family's) earnings; *Chiclet Necklace* embodied a total income, and took its place, alongside North American wampum, African cowries, and the strings of shells and jade offered to Cortes, as a sign of wealth.

Before her necklaces, the artist explored hair as a material with equally complex strands of meaning and narrative, which also had a correlation to the body. Interestingly, hair could be interpolated as well as contemporary systems of Mexican commerce and trade. It was not uncommon for poor women to sell this aspect of their person to make ends meet, as wigmakers worldwide already knew. (And it was far less dangerous and painful than peddling other aspects of the self that typically could be sold.)

In the piece *Why Doesn't Anyone Talk about Mary's Cross* (1989), Gruner creates a cruciform shape from photos of a woman braiding her hair juxtaposed with lengths of the real thing. If the actual severed tress represents pain, suffering, and, as Debroise has pointed out, the metaphor of castration, the woman's caressing motions in the photographs signify love, and the pleasure of the female self and community.[11]

Adornment and fashion are often, though not exclusively, texts of beauty and enticement. As Anne Hollander has written, in the European tradition, until well into the twentieth century, women's clothing (and thus woman herself) was constructed as an extension of male fantasy. With the rising importance of female designers in the 1920s came clothes that "began to suggest how the female body actually felt to its owner."[12] Such garments conveyed "a new style of female corporeal pleasure, one more visibly expressive of what women had always liked about their own bodies . . ."[13] In this scenario, fashion and adornment—imaginative art forms that traffic in self-representation—became more inscribed with female agency, authorship, self-possession. It is this kind of feminist subjectivity that Silvia Gruner's objects evince. Works such as *Domestic Fetishes* (1992), *Middle of the Road* (1994), *Birth of Venus* (1995), and the necklace project all exist as ciphers of the universal outside of the sphere of male "regulative psychobiography";[14] each endures as a code of the "feminine buried in [tools of] work."[15]

Hair, a "vestige . . . of the living body,"[16] acted as a sign of the performative figure in Gruner's pieces. It took the place of more graphic representations of the corporeal—blood, organs, skin—that had consumed her early on and united her to the trajectory of feminist art-making practiced by others such as Carolee Schneeman and Ana Mendieta. In these preliminary pieces, Gruner used the body as a source of meaning and a means of creation. Her own person was an important subject and active instrument of art-making; at the same time the (female) body held on to a generative

function, with tools such as cameras or photocopiers seeming to work as extensions of its actions and will.[17]

While jewelry can operate as a metonym for the body, it is perhaps better cast as counterpoint or highlight. Ornament carries on a dialogue with the figure on which it is placed. As Howardena Pindell has noted:

> Placing the objects on zones of the body, the wearer is able to convey messages not only of beauty or sexual allure, but also of status, rank, age, tribal identification, and aesthetics, as well as of state of mind or a desire to placate or seek protection from the environment.[18]

Adornment has the capacity then to translate one's "inner thoughts" to the "outer body"[19] where patterns of placement and design can be read like texts. Gruner's necklaces float back and forth between both kinds of interpretation. They stand in for the corporeal, yet also seem to be in continual conversation with its absent form. Wherever they turn up, these jewels appear to have performative intentions.

These sculptures, photographs, and installations are vigorous and abundant creators of meaning, which then turn around and just as exuberantly deny any singular explanation for their existence. They are actors whose ambiguous and fluid significance is a perpetual drama, staged by the artist in galleries and specific sites all over the world. While Sanchez and Debroise have cast Gruner's objects as quintessentially male signifiers severed from distinct signification, such capacity to "dismantle Truth by referring to yet refusing to symbolize its meaning" has a powerful place in feminist practice.[20]

Women's involvement with questions of mimesis in the Western tradition has a long, if sublimated, history, from the proscriptions against female actors in the classical theater to contemporary issues of self-representation in a male-dominated society. One way to create a feminist object or act, numerous writers have argued, is by exaggerating mimetic function, producing an oversupply of copies—incessant repetitions and subversions—of the phallic model. Mimesis is thus transformed into mimicry in which the successive images are "excessive to the truth/illusion structure of mimesis," and constitute "multiple 'fake offspring.'"[21]

Silvia Gruner's artistic clones, her "asexually produced progeny,"[22] are indeed such "fake offspring." Their performative tendencies and theatrical traits can be seen as being part and parcel—as posited by Luce Irigary—of a feminist site of origination. In a subversion of Plato's allegory of the cave (i.e., a prisonlike place confining those incapable of independent, philo-

sophically enlightening thought; they rely on images/ideas of others which are projected onto the cave walls) Irigary rereads this space as womb (or *hystera*) and the original location of theater. By linking the "illusionistic theater apparatus—its mirrors, fetishes, lights, voices, the whole 'stage set-up'—to matter, earth, body," she recasts this site of production as an arena of spectacle rather than a place of "maternity and nurturance."[23] As Elin Diamond has commented on Irigary's model, "a theatricalized *hystera* necessarily de-essentializes both female anatomy and maternal experience, for if mother's womb is theater, then ideas of essence, truth, and origin become continually displaced onto questions of material relations and operations."[24]

Silvia Gruner views the art objects she constructs as transmitters of ideas and sensations. They are, as well, articles or markers of transition, created, in many instances, to take her through periods of passage and progression in her own life. They are charged with meaning, perform their purpose, and are then abandoned by the artist,[25] into the storerooms of contemporary ethnography (e.g., galleries and museums) and the ledgers of art history.

If her art-making is about transformation, the language she has used to build from has also undergone constant change: from referencing the internal body—with organs and fluids—to hair as a particle of this living framework, to the figure's surface of adornment. With this move from the interior to the exterior, Silvia Gruner has transposed her practice from art as an extension of the body to a process that is in dialogue with it. This is a migration from a space of description to the place of discussion, from the intimate and bodily to the public and sculptural. Today this path takes us to Silvia's crown jewels, but as the African American songstresses Sweet Honey in the Rock suggest, "think I'll run on and see what the end's gonna be."

For Olivier and Osvaldo.

NOTES

Originally published in *Silvia Gruner: Collares* (Mexico City: Centro de la Imagen, 1998). The epigraphs are from Anthony Appiah, "An Aesthetics for the Art of Adornment in Africa," in Marie Thérèse Brincard, ed., *Beauty by Design: The Aesthetics of African Adornment* (New York: African American Institute, 1984), 19; George Kubler, "The Maya Tradition: Sculpture and Painting," in *The Art and Architecture of Ancient America* (New York: Penguin Books, 1984, third ed.), 251; and William Fagg, *Yoruba Beadwork—Art of Nigeria* (New York: Rizzoli, 1980), 9.

1. Silvia Gruner, artist statement, 1996. This essay owes much to a conversation with the artist that took place in Mexico City on November 24, 1996. It is hereafter referred to as "SG November 1996."

2. Rubén Gallo, "The Labyrinths of Mexican Art," *Flash Art* 52 (January–February 1996): 53.

3. Chloë Sayer, *The Arts and Crafts of Mexico* (San Francisco: Chronicle Books, 1990), 53.

4. Elizabeth P. Benson, *The Maya World* (New York: Thomas Y. Crowell, 1967), 81.

5. SG November 1996.

6. *Antigua Necklace* was reconstructed for the Sydney Bienniale of 1996.

7. Silvia Gruner, artist statement, 1994.

8. SG November 1996.

9. Joan Mowat Erikson, *The Universal Bead* (New York: W.W. Norton, 1969), 78–79.

10. Osvaldo Sanchez, *Reliquias* (Buenos Aires: ICI, 1994); and Olivier Debroise, *De las formas ancestrales o uno comiéndose su propia cola* (Mexico City: Boletin de Curare, 1991).

11. Debroise, *De las formas ancestrales*; bell hooks, "Black Is a Woman's Color," *Callaloo* 12 (2) (1989): 382. See also Lisa Jones, *Bulletproof Diva: Tales of Race, Sex, and Hair* (New York: Anchor Books, 1994).

12. Anne Hollander, *Sex and Suits* (New York: Alfred A. Knopf, 1994), 134.

13. Ibid., 136.

14. Gayatri Spivak cited in Nancy K. Miller, "Changing the Subject; Authorship, Writing and the Reader," in Teresa de Lauretis, ed., *Feminist Studies, Critical Studies* (Bloomington: Indiana University Press, 1986), 107.

15. Gruner quoted in Debroise, *De las formas ancestrales*.

16. Gruner quoted in Rosario Pinelo Velázquez, "Destierro, instalación para activar la memoria," *tiempo libre*, November 12–18, 1992, 62.

17. Olivier Debroise, "Silvia Gruner," *La Jornada*, May 1990.

18. Howardena Pindell, "The Aesthetics of Texture in African Adornment," in Brincard, *Beauty by Design*, 37.

19. Ibid., 37.

20. Elin Diamond, "Mimesis, Mimicry, and the 'True-Real,'" in Lynda Hart and Peggy Phelan, eds., *Acting Out: Feminist Performances* (Ann Arbor: University of Michigan Press, 1993), 379. See also Tania Modleski, "Feminism and the Power of Interpretation: Some Critical Readings," in Teresa de Lauretis and Luce Irigary, *Speculum of the Other Woman*, trans. Gillian C. Gill (Ithaca: Cornell University Press, 1974).

21. Diamond, "Mimesis, Mimicry, and the 'True-Real,'" 371.

22. The definition of "clone" from Webster's *New Collegiate Dictionary* (1980).

23. Diamond, "Mimesis, Mimicry, and the 'True-Real,'" 371–72.

24. Ibid., 372.

25. SG November 1996.

Dawoud Bey

Portraits in the Theater of Desire

Dawoud Bey, *Brian and Paul*, 1993. Polaroid, 29 1/2 x 43 1/2 inches. Collection Walker Art Center, Minneapolis. Justin Smith Purchase Fund, 1994.

Negroes can never have impartial portraits, at the hands of white artists. It seems to us next to impossible for white men to take likenesses of black men, without most grossly exaggerating their distinctive features. And the reason is obvious. Artists, like all other white persons, have adopted a theory respecting the distinctive features of Negro physiognomy. We have heard many white persons say, that "Negroes look all alike," and that they could not distinguish between the old and the young. . . . The temptation to make the likeness of the Negro, rather than of the man, is very strong.
FREDERICK DOUGLASS, 1849

A true likeness [is] just as necessary as every other necessity in life.
ICHARD SAMUEL ROBERTS, CIRCA 1920

REPRESENTING THE SELF: MEDITATIONS ON FREDERICK DOUGLASS

In his 1849 review, Frederick Douglass lauded Wilson Armistead's book *A Tribute for the Negro* as an important if not necessary addition to any personal library because of its deft attack on the lie of stereotypes and racism. The weakest aspect of the volume for Douglass, however, was the engravings, which he felt fell sadly short of communicating the true bearing and dignity of each sitter. Speaking of his own portrait in the book, he observed wryly, "It has a much more kindly and amiable expression than is generally thought to characterize the face of a fugitive slave."[1] In remarking on these images, Douglass didn't simply take issue with a specific case, but revealed the difficulties surrounding the portrayal of African Americans. Published in London in 1848, when slavery was still very much in force in the United States (and had only been abolished fifteen years earlier in the United Kingdom), this tome of almost six hundred pages makes a case for treating black people as human beings. But, as Douglass later commented, "If our dark cheek could reveal our feelings, words would be unnecessary to the beholder."[2]

The problem of representation within the African American context might be considered an extension of the classical Western dilemma on this question. Aristotle's disbelief in the possibility of likeness ever being able to capture the essence of one's being, or the Renaissance paragone—the dispute as to whether painting or poetry was the more successful in rendering description—can seemingly be applied to this situation. The quandary that plagues African American imaging, however, has also been determined by

a history of slavery, which defined people as chattel and three-fifths human, and pseudoscience that sought biological "proof" for nonwhite "inferiority." Given these historical frameworks, black populations have not regarded representation as an impossibility but rather have fought for both just imagery and the power to illustrate the self.

Enter Dawoud Bey, photographer: a craftsman possessing the ability to describe the real, a person with the expertise to present a "true" documentation of African American life. Such an image maker can face a heavy burden. Every photograph he creates sits atop the history of the black image. And each picture is swept into the debate that has been raging in African American communities at least since the time of Frederick Douglass regarding what is an "appropriate" representation on the one hand and an "authentic" one on the other. Most visible in recent years have been the polemics surrounding hip-hop music. Critical rebukes for a lack of "positive" images stand against rappers' fascination with their own authenticity as the only legitimate purveyors of African American consciousness.

Enter Dawoud Bey, a man with a mission. Or as Greg Tate has put it,

> Before we even look at Dawoud Bey's photographs, it behooves us to understand the social contract this particular black photographer imposed on himself as a means of maintaining an ethical balance between his sense of aesthetics and his responsibility to the communities he chose to portray.[3]

Bey takes on the challenge of describing African American lives in the face of continuing racist mythologies. In doing so he creates photographic families, kinships that speak affiliation beyond blood ties, in much the same way Nan Goldin recounted the world of her extended clan in the series "The Ballad of Sexual Dependency." While Bey's photographs render a universe that is overwhelmingly populated by black people, theirs are not the only lives to be illuminated by his camera lens. His photographic project has been to capture the beauty of those who rarely find themselves illustrated in that way. Empathy, encouraged by Western tradition as a means of making images more believable, comes into play here.[4] But in Bey's program, the politics of the black image cannot be denied.

DAWOUD BEY AND THE DOCUMENTARY TRADITION

Dawoud Bey was born in Jamaica, New York, in 1953. His earliest photographic explorations evolved into a five-year project chronicling the people and streets of Harlem. "Harlem USA" (1975–1979) is a collective portrait of a place and its inhabitants in the documentary tradition of the New Deal

federal photographic projects of the 1930s and 1940s and practitioners of that period such as Walker Evans and Margaret Bourke-White. But these works also come from the personal trajectory of similar studies by photographers Roy DeCarava and James Van Der Zee. Like DeCarava, Bey has familial links to the locale, but like Van Der Zee he is an African American constructing his own official images of this renowned black metropolis.

If, in "Harlem USA," Bey has been inspired by DeCarava's take on the social landscape of urban America, this influence is certainly found in the younger photographer's focus on the ordinary details of people's daily lives. It is particularly in the way people stand commanding "their" streets, as with the gentleman in a suit, tie, and porkpie hat, surveying the terrain from his perch on the corner in *A Man at Lenox Avenue and 125th Street*. Similarities may also be seen in Bey's images of personal and intimate celebrations, like the man with a portable microphone and amplifier belting out a song in a vacant lot (*The Blues Singer*). In general, DeCarava's masterful control of the tonal range of deep blacks in the photographic palette has had important metaphoric implications, as well as technical significance, for a generation of African American photographers since the 1960s. In one such beautiful homage by Bey, *A Woman and Her Child in a Doorway*, a woman holding a toddler on her hip emerges from a darkened hall into the last vestiges of daylight that loiter in the doorway.

Bey's "Harlem USA," like his contemporary Carrie Mae Weems's early documentary series "Family Pictures and Stories" (1978–1984), marks the moment when his varied interests and approaches coalesced and the seeds of his later work were planted. Weems's piece is the first in which she uses text and commands a three-dimensional area (through sound); such textual and spatial components are integral to her more well-known later work. And it is clear from Bey's first major series that his emphasis is on the public image (particularly that of African Americans), the face people show to the world, and the style with which they present themselves.

Through most of the 1980s, Bey continued working within the stream of "street photography," traversing the byways of urban centers in North America and the Caribbean, expanding the sense of "family" that had been at the heart of his earlier work. In the northeastern cities of Syracuse, New York, Washington, D.C., and New York City, he most frequently sought out black neighborhoods and populations. In Mexico and Puerto Rico, his eye fastened on the social interactions of the market, public celebrations, and those spotted in the course of everyday existence. Bey's respect for the impeccable craftsmanship of Mexican photographer Manuel Alvarez Bravo is

evident in his own pictures taken in that country. These are characterized by careful attention to framing and formal nuance. *A Woman in Oaxaca* and her shadow quietly make their way through a small patch of light contained within an archway. A family in Mexico City gets ready to watch the festivities with homemade periscopes in *Independence Day*. The repetitious patterns that cover the outside of these viewing devices are picked up in the arabesques that decorate a sign in the background, and their vertical play draws one's eye around the composition. Photographs from Puerto Rico during this period also display a strong pictorial structure. This is especially true of works in which the figure is absent. The remnants of a dwelling command a central space in *On the Way to El Yunque*; its walls and windows and their reflections organize the picture geometrically. The perennial landscape finally dominates, however, enveloping the building's frayed extremities.

> Photographing in the black community, I'm an insider in a way that I cannot be when I'm photographing in Puerto Rico or Mexico. As a photographer, I have a curiosity that can only be satisfied by traveling to parts of the world where I am an outsider. I think it's important that we not become locked into our own communities and our own experience.[5]

In fact, from 1980 through 1981 few people appeared in any of Bey's work, as he struggled with purely formal concepts and problems. In 1982, figures began to reappear as shadows; the human form was fully reintegrated into his work by 1983. And even in photographs where the body is not present, such as *Four Shirts*, the allusion to human presence is evident.

Bey's street photography reached its apogee in the late 1980s. The works express a clear unity, where figure, shape, and the play of light and shadow all easily reside on the two-dimensional surface. *A Man and Woman Waiting for the Bus* is one such picture in which he finds pictorial drama in the spectrum of tonalities and human expressions at a modest bus stop.

Bey found himself, however, becoming more self-conscious about his position as a photographer. "There is an implicit power relationship acted out in the process of photographing people," he has noted, "particularly those on the margins of society."[6] He once described the activity of the street photographer as akin to "mugging": the artist jumps in front of a person, quickly snaps an image, and runs off to process the goods.[7] Many of his contemporaries, on reaching a similar impasse, had struck out on the conceptual road, affixing text to their images or creating environmental installations.[8] One of Bey's peers, Pat Ward Williams, described how inadequate she found straight photography:

When I first started taking photographs, especially in the documentary tradition, I was trying to fight against what I thought were the negative messages that photography had previously communicated to black people. I also realized how easy it was to fall into the same trap and become my own oppressor. A single, documentary shot is usually too little to express a broader idea about racism.[9]

Indeed, at the end of the twentieth century, more than fifty years after documentary photography was first popularized in the United States, images drawing on that tradition have the feeling of being "comprehended in advance," as Martha Rosler would say.[10] They remain bound to a convention that positions them as depictions of the powerless meant to appeal to the benevolent conscience of the powerful. The people in such photographs become doubly subjugated: first, as victims of an inequitable social structure, and second, as casualties of that same society's visual narratives.[11] As Michele Wallace and Angela Davis have both pointed out, such representations do not dispel the myths about lived experience (for instance, that "welfare queens" are living "high on the hog" off of taxpayers' dollars), but take their place comfortably alongside such myths as yet another set of generalized fictions.[12]

The roots of documentary or straight photography, in fact, can be traced back more than one hundred years to the medium's utilization within official state structures in both Europe and the United States. In late-nineteenth-century hospitals, prisons, police agencies, and health departments, photography was used as part of the apparatus of domination to document, name, and measure the people under their jurisdictions. The working class, the colonized, and the mentally ill, among others, were constructed as passive sectors of society through such images. John Tagg has noted that "Subjected to a scrutinizing gaze, forced to emit signs, yet cut off from the command of meaning, such groups were represented as, and wishfully rendered, incapable of speaking, acting, or organizing for themselves."[13] The layout of these pictures was similar to today's mug shot or police lineup: subjects were presented frontally and clearly within a restricted space to simplify and aid the act of "analysis." Photography's implication for anthropology and phrenology and their intersection with colonial rule was comparable. Such insinuation in the cornerstones of societal authority, and the camera's presence as a mechanical (and thus seemingly scientific) device, gave photography power and truth value. Five decades later, New Deal photography would trade on the idea that its images could embody equally authoritative "universal" truths. In so doing, the medium exchanged a nineteenth-

century "genetic" discourse for an "environmental" one, and, according to Tagg, "transposed the static separation of bodies and space characteristic of earlier photographic records into an ethnographic theater in which the supposed authenticity and interrelationships of gesture, behavior, and location were essential to the 'documentary' value of the representation."[14]

PORTRAITS IN THE THEATER OF DESIRE

Given the loaded history of documentary and street photography, it is not surprising that Bey felt he was taking a lot from people whose likenesses he collected and ultimately displayed as his art. He wanted to find a way to return their generosity. While he had always spent time in the places where he worked, using a few days just to get a feel for the surroundings and people before pulling out the camera, he decided to slow the process down even more. Discarding his standard 35mm equipment, Bey began working with a 4-by-5-inch view camera on a tripod—hood and all—in the street. This manner of working is more time-consuming. Not only does each piece of film require a longer exposure but the camera must be set up and the pose arranged and held while the photographer focuses the ground glass. Each of Bey's sessions (which produced at least two images) lasted anywhere from twenty to thirty minutes. Using Polaroid Positive/Negative Type 55 film, he was able to give a photograph to his model instantly and still have a usable negative to print from. Bey, then, had more interaction with his subjects. He could feel a mutual consent between himself and those whom he photographed. There was exchange; he got a negative, and people got works of art, maybe the only images of themselves they ever owned. There was even, perhaps, a sense of shared authorship, a recognition of the collaboration of artist, subject, and, ultimately, viewer, in the construction of each picture.[15]

Max Kozloff has referred to these photographs, taken between 1988 and 1991, as "formal, outdoor portraits."[16] In a sense, Bey had always made portraits, just informal ones, by isolating specific moments extracted from larger currents of human activity. And, as Kosloff argues, there is a seeming reciprocity inherent in the portrait form, which appears to frame and magnify an intimate connection between the subject and the artist; this feeling of familiarity is passed on to the viewer.[17] What Bey's portraits from 1988 on give us is a more complex look at people, particularly African Americans. With the stilled motion of both photographer and model, time is added to the equation as a compositional element. The duration of the picture-making process opens up an arena of greater descriptive possibilities. As Kozloff notes, "We are one sort of creature as we go about our errands or just hang around, and quite another when we pose for our portraits. The

interest of these pictures is in their suggestion that both states of being are hovering lightly on personal display."[18]

Bey actually had begun exploring the Polaroid process in 1986 with a series of self-portraits. Created in an sx-70 photo booth in Times Square at 3-1/2-by-3 inches these pictures were diminutive for the photographer. In each piece, Bey shows himself with a different masklike guise. The surfaces have also been altered and elaborated with layers of decoratively applied paint. While Bey's gravitation toward Polaroid material might appear to simply signify a growing interest in new technologies, the format, production, and even the imagery of the Postive/Negative pictures have links with earlier photographic practices.

Certain conventions of daguerreotypy are evoked. The "eye to eye connection with the camera" that transpired, as Vince Aletti observed, could somehow reveal the subject's interior life or soul to viewers.[19] A. D. Coleman points out the immediacy of the technique that, along with its inability to be retouched, gave it a reputation for being "truthful." Within nineteenth-century American society, Alan Trachtenberg distinguished two distinctly different roles for the daguerreotype: a public one for large images that celebrated the achievements of important figures, and a personal one for small hand-held or amulet-size pictures "which memorialized loved ones" and were "a form of sympathetic magic."[20] While drawing on all of these characteristics of daguerreotypy, Bey combines and moves to the foreground its public and private—or what Trachtenberg calls its "emulatory" and "memorial"—features in his work with Positive/Negative film.

These portraits are undeniably public. For one, they are taken outdoors. There is a command of self, a carriage and stance that is clearly reserved for the outside world. There is a certain comportment, the way each person is undoubtedly in control of his/her body, which says, "I am an individual, I am human, I exist." *A Young Woman between Carrolburg Place and Half Street* most assuredly knows who she is, with her hand on her hip, head cocked slightly to the side and jewelry flashing. Most likely she wouldn't have any problem telling you who you are and where you need to go, either. *A Young Man Resting on an Exercise Bike* peers out at us over strong arms and crossed hands; his calm appraisal is conducted through eyes that focus independently of one another but don't miss the mark. These are also intimate photographs, if simply for the proximity of each shot and the amount of time the photographer spent with those who chose to pose. A bond is created with the viewer, as we are drawn into the world of every picture by each powerful gaze.

As formal portraits, these photographs also elicit comparisons to the

heritage of studio portraiture. There is a small drop of the grandiosity of the daguerreotype gallery here, with its separate spaces for displaying, readying clients, taking pictures, and framing. After all, it's not every day we see a person with a view camera and all its trappings setting up shop on the thoroughfares of urban America. And there is an unquestionable affinity with the portrait studios found in black communities that dates back to the turn of the century.[21] Early examples of this tradition are magnificently preserved in the work of Richard Samuel Roberts, who documented the black middle class of Columbia, South Carolina, in the 1920s and 1930s, and James Van Der Zee, the official chronicler of the Harlem Renaissance.

Interestingly, the dimensions of the instant images produced by the Positive/Negative Type 55 material mirror almost exactly the postcard-size photos that were so popular during Roberts's and Van Der Zee's era.[22] But it is the aura of the studio itself that Bey has transposed into the street. Like contemporary vernacular photographers who provide a variety of clever backdrops on inner-city avenues throughout the country, the space in front of the camera lens is transformed into what Trachtenberg has termed "a theater of desire," a place where a new social self can be invented and performed.[23] Here is where we project the person we only dream of being, and the power of the imagined self supplants the narrow role that society has assigned us. The photograph becomes the "setting" rather than "the object of desire."[24] In Bey's photographs, the lived environment (replacing the text and loud colors in the painted scenarios of local practice) recedes into the background, and coveted characteristics, formerly established with props—things such as pride, beauty, and authority—become further inscribed on the body itself.

Bey's part in this process is not entirely unassuming; he doesn't just drag valuable equipment to assorted cities and wait for the next passerby to assent to a sitting. As Deborah Willis has argued of James Van Der Zee's relationship to the Harlem Renaissance, he was one of the creators of the period, not simply a recorder of its existence. Van Der Zee's shop provided a realm where the residents of this most famous black metropolis could "speak to the liveliness of the community and its capacity for renewal, its constant reinvention of itself, and its growth."[25] Through what is essentially an outdoor studio, Bey becomes the conscious architect of a similar arena in which people can envision themselves and their place in the world.

It is hardly astounding that Bey would seek a model for these Polaroid-derived works that predated the popularization of street photography, given the reputation the latter has for pathologizing poverty and racial difference. His photographic treatise on African American personae can be read as

autobiography, an important form within the African American literary tradition. The manner in which Bey maneuvered his practice at this point resonates with writer Barbara Mellix's description of this genre: "Through writing one can continually bring new selves into being, each with new responsibilities and difficulties, but also with new possibilities. Remarkable power, indeed. I write and continually give birth to myself."[26]

But what are we to make of the straight-on focus of each subject's gaze in these images? This posture presents a dilemma, at least in terms of the history of Western portraiture. Frontal poses are never used to depict persons of eminence; their concentration is elsewhere, focused on more important things than the viewing public.[27] As we have seen, such a head-on encounter with the camera is reserved for those who are regulated and indexed by society. The aversion to this type of portrayal has translated, within the European and American contexts, into a custom that considers staring uncouth.[28] Would anyone consider the direct glance of the young woman in *A Girl in a Deli Doorway* rude or brash in that way? Most certainly. In the history of the United States, African Americans have faced death for looking at the wrong person at the wrong time, whether as slaves or in the South of the twentieth century. Bey is keenly aware of this legacy and willfully becomes the vehicle through which his subjects can claim their power through the gaze.

A Girl in a Deli Doorway emerges from the store; the round face, full lips, and almond-shaped eyes gracing her solid body do not scream of a woman's presence but gently and firmly state it. Her appraisal of the situation, the photographer, and the viewer is palpable and implies her knowledge of the "narrative time" she shares with these others in the photographic space.[29] Yet, as Greg Tate points out,

> The gaze in many of these pictures seems to be secondarily toward Bey and primarily aimed at the world.[30]

These portraits are ultimately declarative, in the same sense that Henry Louis Gates Jr. characterizes the function of African American autobiography as being "in the act of declaring the existence of a surviving, enduring ethnic self."[31] Unlike August Sander's project "Portraits of the Twentieth Century," which attempted to record various "types" found in German society, Bey's subjects are not delimited by their position in the social hierarchy. In fact, their relative status within such a system remains purposefully vague. They seem instead to reveal in their own beauty and self-possession.

It is not surprising that portraiture has been used by African American

photographers over the last century as a means of registering social protest. With their formal and ideal imagery, these portrayals strove to instill race pride within the community and confront the roots of racism in the nation at large.[32] Like early textual autobiography, such visual documents embodied "the ultimate form of protest [which] was to register in print the existence of a 'black self.'"[33]

INTO THE STUDIO

In 1991, Bey had the opportunity to work with one of the Polaroid Corporation's largest cameras. Measuring 5 feet high by 3–1/2 feet wide, it produces 20-by-24-inch images on Polaroid film. The pictures arrive in a little over a minute, just like those made with its smaller, popular cousins. Built originally in 1976, the camera weighs more than two hundred pounds and is mounted on wheels to ease the activity of framing and focusing; only five exist in the world.[34]

This vast machine is quite simply a large view camera with a Polaroid back. Since Bey had worked almost exclusively with a view camera and Polaroid material beginning in 1988, the jump from the street to the studio, at this point, was not a large one. Because of the static placement of the camera in the earlier 4-by-5 works, in essence he had already begun to re-create a fixed and rarified space in the street. Perhaps the greatest obstacle for Bey with these new photographs was the so-called fear of the blank canvas. All of his pictures up to this moment were instants extracted from the flow of activity found in the streets. Deli doorways, wrought-iron gates, bus shelters, markets, and alleys in countless neighborhoods of the world served as backdrops for equally interesting faces. Now, strangely like a painter, he faced a tabula rasa, his only descriptive devices besides the people themselves a few sheets of colored paper, some lights, and an oversized camera that projected the images upside down.

But the opportunity to let go of the environment aspect of the work was a welcome one. It freed the subjects from being socially determined by the "place" of street photography. By taking the mostly African American figures out of an urban landscape, Bey performed an act that, if differing in terms of strategy, still netted similar results to that of black British photographer Ingrid Pollard. In her image/text series from 1986 entitled "Pastoral Interludes," Pollard photographed black people in the bountiful British countryside, away from the charged locale of (poverty-stricken and riot-torn) inner cities. As one of her texts declares, "It's as if the black experience is only ever lived within an urban environment."[35] In Bey's color Polaroid work, the viewer comes face to face with the people in the images. Who

they are is not already determined by where they are. There are no other elements to which the eye can escape for a reprieve from their direct gaze.

Kozloff characterizes the sitters for contemporary studio portraits as stranded or "marooned" in a sea of seamless paper. Gone, even, are the props of an earlier era, through which the sitter established an identity. More importantly for Kozloff, viewers are left without a sense of where to position themselves "socially and morally" with regard to the people within the frame.[36] Interestingly, he uses the word "maroon" as a verb to signify the isolation of the figure. The other sense of this term is as a noun meaning self-liberated slave. Maroon communities were formed in the mountains, jungles, and swamps of the Americas and the West Indies throughout three centuries of slavery by those who transgressed the slavocracy.

Bey's subjects, then, are not so much "marooned" in a passive sense but are committing "maroonage," the act of escaping, in this case from a pictorial formula that predetermined who they could be.[37] For a similar reason, Bey eagerly embraced the saturated color of the Polaroid material; its luxuriant and seductive surface was quite taboo in street photography. It finally came down to the photographer "wanting to make an unabashedly lush and romantic rendering of people who seldom receive that kind of attention."[38]

In his earliest experiments in the studio, Bey used family and friends as subjects. Taken in New York, many of these are either single photographs or emphasize a single figure. *Trajal* stands erect yet relaxed as only a dancer can, the right side of his body caressed by a warm shadow. His long, elegant hands are clasped over his chest as if in prayer. *Willie* is a portrayal of artist Willie Birch, whom Bey had previously included in a series of portraits of African American and Latino artists that spanned the 1970s and 1980s. As with all of the pictures in that cycle, this earlier work had focused on the artist in the studio, shown in conjunction with tools of the trade. In the color Polaroid piece, the signifiers of vocation disappear and Birch's thoughtful and intent stare takes center stage.

In the diptych *Tina*, Bey begins to play more with expression, letting go of the declarative face that so characterized his work with the Positive/Negative material. In the left panel, photographer Tina Barney looks away from the camera. She focuses on something distant; one arm is raised distractedly, and her body is relaxed. In the right panel, she protectively grips her body, clasps her chin, and confronts us with a steely blue glance. *Alva* is a beautiful double portrait in which Bey achieves a more subtle coexistence between separate internal and external aspects of self. Her magnificent black hair, dark blouse, and the movement of shadows frame and accentuate composer/performer Alva Rogers's powerful features. The green

background adds a feeling of serenity. The shifts in her torso and tilt of the head are delicate but explicit.

Moving on from the single subject, Bey continues exploring subtleties of character and mood, doubling both figures and panels. The use of sisters in *The James Twins* seems mischievous since we can't tell if he just photographed the same person but with a different look. In *Brian and Paul*, the black and white sitters are as clearly differentiated as their dispositions. Paul coolly appraises the viewer while Brian contemplates something unseen, splitting the composition along an axis defined by outwardly and inwardly directed panels. But the meanings of their personas are complicated. Is Brian the inwardly focused, intellectual one, or the timid white guy averting his gaze? Is Paul the aggressive black male, or an intelligent young man who looks you straight in the eye? To top it off, Brian wears his cap backwards, b-boy style, while Paul sports a chapeau more suited to the Dutch gentry of Rembrandt's paintings.

The James Twins and *Brian and Paul* also mark a new way of working with the large Polaroid camera that allowed Bey to preserve something that had by this time become integral to his practice: the concept of reciprocity.

In 1992, Jock Reynolds, director of the Addison Gallery of American Art, Andover, Massachusetts, invited Bey to participate in an artist-in-residence program at Phillips Academy, the elite prep school where the gallery is located. They were able to secure the Polaroid camera in Boston, and the photographer collaborated with students from Phillips and the local, public Lawrence High School. At each sitting, students not only posed as models but assisted in the photographic practice. Besides having the opportunity to work with an extremely rare piece of equipment, Bey involved the students in discussions and written assignments on his own work and the role images play in our society. The theater of desire was transformed into a pedagogic space. The yearning for beauty was recast through the sharing and exchange of knowledge. The contemplation of society's depictions of oneself was revolutionized by the ability to define one's own image.

Bey repeated this style of residency again in the fall of 1993 with the Museum of Contemporary Photography, Columbia College, and Providence St. Mel High School in Chicago. Working with teenagers was a way for the photographer to interact with a generation whose lives are full of visual images but who are rarely given the tools to either question or critically assess these representations or to create their own. Thus his example as an artist and his skills as a teacher could have some impact in a larger social arena.

Bey's preoccupation with teens, however, was also driven by a fascination with the youth culture's bearing on cultural history. Through his young

subjects, he records American youth culture and urban style paraded in clothing, gesture, and body language. Like photographer Coreen Simpson's "B Boys" series from the early 1980s, Bey's models use the arena of fashion and their own bodies to construct places and reflections of personal power. "My interest in young people," says Bey, "has to do with the fact that they are the arbiters of style in the community; their appearance speaks most strongly of how a community of people defines themselves at a particular historical moment."[39]

The use of multiple figures in such photographs as *Brian and Paul* points to the increasing pictorial intricacy of the color Polaroid portraits. In that piece, the discrete panels of the work are joined by Brian's hands, which extend, ever so subtly, into Paul's frame. With this breaching of the border of the self-contained photographic image, Bey moves his practice into more complex territory.

Portraits of couples, a recurring theme throughout Bey's oeuvre, become the logical containers for further investigations of duality/sameness and togetherness/separation suggested by the diptych format. Bodies, faces, and features merge across the central chemical boundary that divides the distinct sections of each work and signals its process. At the heart of these pieces composite figures are created, physical manifestations of those conjoined in love. The mechanism of the photograph's production becomes conflated with the manner in which relationships are formed. The medial form in *Nikki and Manting* is a bejeweled head to which each partner contributes an earring. In *Darshall and Mark*, the aggregate body dressed in her black-and-white stripes and his plaid is crowned with two heads reminiscent of a surrealist collage. The intimacy of companionship is addressed similarly in works such as *Hillary and Taro* and *Toussaint and Terrell*, in which the connecting element becomes a Janus-head figure.

The growth of the figure groupings also suggested the need to expand the number of photographs that comprised each distinct piece. While the triptych *Nisha, Adalisse, and Taina* presents three women inhabiting separate spaces, in *Sara, Martin David, and Tolani* the central person of the mother (author Sara Lawrence Lightfoot) is fused in both side panels with those of her children. *Toyia, Kelvin, and Erica* is an eight-panel piece in which every student is described by no less than four overlapping panels. Through this increased layering and accumulation of information across an enlarged and yet segmented photographic field, Bey achieves a fuller articulation of his subjects.

The most notable change from the single-frame pictures or even the dip-

tychs is the fragmentation of features and limbs, which creates a "flickering" activity across the surface of the work. Such movement is reminiscent of the "kinetic behavior" associated with the daguerreotype. In the earlier form, however, it was through the viewer's actions—slowly shifting handheld images, or positioning themselves in front of larger versions—that these likenesses seemed to appear.[40] Even more, this animation of the picture plane invokes cubist strategies and theories, probing the structure of the perception and observed experience, transcribing a reality in constant flux.

The disjunction of figure and form in Bey's latest Polaroid photographs shares commonalities with the cubist-inspired work of artists Chuck Close and David Hockney. Close's art develops from what Robert Storr sees as a "steady accretion of distinct bits of information."[41] Like Bey's, Close's experiments with large-scale Polaroid cameras in the late 1970s and early 1980s layered a more abstract topography and inscribed a certain painterly all-overness on the realist planes of photography. The visible chemical edges and white borders form a gridlike overlay and formalist structure. They also become a method of canceling the "hot spots" of these portraits: the genitals in Close's case, the face in Bey's.[42] In a work like *Max*, for instance, Bey manipulates the Polaroid process to create a line that bisects the visage of his father-in-law, making one more aware of the subtle movement of each shimmering half than the solidity of the whole.

Hockney's photographic and sx-70 collages, also from the early 1980s, are conscious studies of human perception. An integral aspect of these works is the way they prolong our experience of the image. Sometimes composed of more than one hundred photographic fragments, these collages invite our eyes to move languorously from section to section, tracing the careful configurations. The viewer thus becomes an active participant in reconstructing each representation.[43] Similarly, Bey slowed down the process with his Polaroid work and made his practice a site of participation.

Close and Hockney have made explorations in photography and used it as an aid in structuring their painted work, but they remain solidly painters. Because of his position as a photographer, Bey is more interested in how his recent Polaroids function as photographs. These works question the medium's distillation and simplification of the three-dimensional world. By introducing a format that attempts to document actual movement in time and space, Bey seeks to provide a chronicle that can more fully transcribe the real. Like cubist paintings, Bey's two-dimensional surfaces signal simultaneity and suggest metaphorically the present, future, and historical

experience, compressed into the faceted pictorial space. Finally, these pictures stake out a postmodernist place where the marks of time and the flow of narrative can be embodied within the usually static portrait form.[44]

The flickering fragmentation seen in Bey's latest work is the evidence of flight. These are the indices of leave-taking, as the subjects vacate the confining formula of street photography in their acts of maroonage. These are testimonies to people always "becoming," to their being forever in the midst of transformation. These disjunctions in the chemical surface of the photograph denote what Homi Bhabha sees as the tension between "signifying the people as an *a priori* historical presence, a pedagogical object; and the people constructed in the performance of narrative, its enunciatory 'present.'"[45] Bey's composite portraits stand in opposition to the concept of a stable and unchanging cultural self, and mark, as well, "the perilous journey from object to subject."[46]

CODA

If in popular culture today some hip-hop artists claim to represent the singular, genuine black self, they are answered by those who define this history as one of multiplicity and inventiveness. As Andrew Ross points out:

> The hardcore rapper's steady loyalty to ghetto realism—the appearance of being totally determined by one's social environment—finds its counterpoint in the vogue queen's "realness"—the ability to impersonate anything but that which you are.[47]

Dawoud Bey's use of abstraction and time-based qualities in his recent photographs opens up a space for a range of creative reinvention. He has found a solution to the problems of black representation and to Frederick Douglass's dilemma—how "our dark cheek could reveal" the breadth of African American personality. The only way to get a real image is to abstract it.

Douglass came to be seen as the "most representative" black man of his time. This was not because his looks identified him as a pleasing example of the race but due to the brilliance and magnitude of his writings and oratory.[48] These exemplary achievements were intellectual and cerebral in nature; they issued from but were not physically tied to the corporeal body.

In deemphasizing the exact rendering of the physical self and replacing it with an image described through allusions to time, space, thought, and history—things that effect and alter but are not an actual, material part of the body—Dawoud Bey enriches the concept of likeness. These pictures

seem to declare that we are more complex than the fleshy frames that contain us. The collaging of multiple panels suggests how limited simple single photographic depictions really are in their powers to characterize human existence. Within the faceted space of his photographs, Dawoud Bey insists that we elaborate and dream, that we contemplate the expansiveness of lives as they are lived.

NOTES

First published in the exhibition catalogue, Dawoud Bey: Portraits 1975–1995 © 1995, Walker Art Center. Kellie Jones was the exhibition curator. The exhibition traveled to Albright Knox Gallery, Buffalo, N.Y.; Chicago Cultural Center, Chicago; El Paso Museum, El Paso, Texas; Newark Museum, Jersey City Museum, and Robeson Center Gallery at State University of New Jersey Rutgers, Newark, N.J.; The Forum, St. Louis; Barbican Gallery, London. The epigraphs are from Frederick Douglass, "A Tribute for the Negro," *North Star*, April 7, 1849, in Philip S. Foner, ed., *The Life and Writings of Frederick Douglass: Early Years, 1817–1849* (New York: International, 1950), 380; Richard Samuel Roberts quoted in Thomas L. Johnson, "Richard Samuel Roberts: An Introduction," in Thomas L. Johnson and Phillip C. Dunn, *A True Likeness: The Black South of Richard Samuel Roberts, 1920–1936* (Columbia, S.C.: Bruccoli Clark, 1986), 6.

1. Douglass, "A Tribute for the Negro," 380.
2. Ibid., 382.
3. Greg Tate, "Reconstructing the Black Image: The Photographs of Dawoud Bey," in *Dawoud Bey: Recent Photographs* (New York: Ledel Gallery, 1990), unpaginated.
4. H. Perry Chapman, "Expression, Temperament, and Imagination in Rembrandt's Earliest Self-Portraits," *Art History* 12 (June 1989): 158–75.
5. Author interview with Dawoud Bey, 1994.
6. Dawoud Bey, artist statement, *Mid-Atlantic Arts Foundation, National Endowment for the Arts, Regional Fellowships, Photography and Sculpture, 1990–1991* (Baltimore: Mid-Atlantic Arts Foundation, 1991), unpaginated.
7. Vince Aletti, "Portrait in Black," *Village Voice*, 17 April 1990, 106.
8. Some of Bey's contemporaries who moved from documentary to conceptual or postmodern photography are Carrie Mae Weems, Lorna Simpson, and Pat Ward Williams. For further discussion of their transformation see Kellie Jones, "In Their Own Image," *Artforum* 29 (November 1990): 132–38.
9. Pat Ward Williams, quoted in Maurice Berger, "Speaking Out Some Distance to Go . . . ," *Art in America* 78 (September 1990): 83.
10. Martha Rosler, "In, Around, and Afterthoughts (on Documentary Photography)," in Richard Bolton, ed., *The Contest of Meaning: Critical Histories of Photography* (Cambridge: MIT Press, 1989), 322.
11. Abigail Solomon-Godeau, *Photography of the Dock* (Minneapolis: University of Minnesota Press, 1991), 176.
12. Angela Y. Davis, "Photography and Afro-American History," in Valencia Hollins Coar, ed., *A Century of Black Photographers: 1840–1960* (Providence: Museum of Art,

Rhode Island School of Design, 1983), 26; and Michele Wallace, *Invisibility Blues: From Pop to Theory* (New York: Verso, 1990), 227.

13. John Tagg, *The Burden of Representation: Essays on Photographies and Histories* (Amherst: University of Massachusetts Press, 1986), 11.

14. Ibid., 12. I am indebted to Tagg's insightful reading of "photographic histories" for the previous paragraph.

15. For a further discussion of the idea of shared authorship see Wendy Steiner, "Postmodernist Portraits," *Art Journal* 46 (fall 1987): 173–77.

16. Max Kozloff, "To Reveal without Judgement," in *Dawoud Bey: Recent Photographs* (New York: Ledel Gallery, 1990), unpaginated.

17. Max Kozloff, *Lone Visions, Crowded Frames* (Albuquerque: University of New Mexico Press, 1994), 35.

18. Kozloff, "To Reveal without Judgement."

19. Aletti, "Portrait in Black," 106.

20. Alan Trachtenberg, *Reading American Photographs: Images as History, Mathew Brady to Walker Evans* (New York: Noonday Press, 1990 [1989]), 32.

21. Deborah J. Johnson, "Black Photography: Contexts for Evolution," in Coar, *A Century of Black Photographers*, 16.

22. Bey began these works in 1988, the same year he saw and reviewed an exhibition of Roberts's photographs which appeared at the Studio Museum in Harlem from January to April. See Dawoud Bey, "Corrective Vision," *Afterimage* 16 (September 1988): 17–18.

23. Trachtenberg, *Reading American Photographs*, 38.

24. David Bate, "Photography and the Colonial Vision," *Third Text* 22 (spring 1993): 90.

25. Deborah Willis, *Van Der Zee, Photographer, 1886–1983* (New York: Harry N. Abrams, 1993), 25.

26. Barbara Mellix quoted in Henry Louis Gates Jr., "Introduction: On Bearing Witness," in Henry Louis Gates Jr., ed., *Bearing Witness: Selections from African American Autobiography in the Twentieth Century* (New York: Pantheon Books, 1991), 8.

27. See Trachtenberg, *Reading American Photographs*, 46; and Roger Cardinal, "Nadar and the Photographic Portrait in Nineteenth-Century France," in Graham Clark, ed., *The Portrait in Photography* (London: Reaktion Books, 1992), 6–24.

28. Kozloff, *Lone Visions, Crowded Frames*, 25.

29. Sheldon Nodelman quoted in Trachtenberg, *Reading American Photographs*, 54.

30. Tate, "Reconstructing the Black Image."

31. Gates, "Introduction," 4.

32. See Deborah Willis, *Black Photographers Bear Witness: 100 Years of Social Protest* (Williamstown, Mass.: Williams College Museum of Art, 1989), 8.

33. Gates, "Introduction," 3.

34. For more information on the Polaroid 20-by-24-inch camera see *20x24 Polaroid* (Washington, D.C.: National Academy of Sciences, 1982); and Susan L. Brown, "Sandi Fellman: Against the Grain," *Camera Arts*, September 1982, 64–79.

35. As Pollard's text also points out, the countryside is not always a place of respite, especially for black British people who are thought to belong elsewhere.

36. Kozloff, *Lone Visions, Crowded Frames*, 12.

37. For a discussion of maroonage as a theoretical construct, see Houston A. Baker Jr., *Modernism and the Harlem Renaissance* (Chicago: University of Chicago Press, 1987), 76–79.

38. Dawoud Bey quoted in Ted Cox, "Instant Art: Photographer Enlarges the Polaroid Snapshot into a New Art Form," *Daily Southtown*, November 19, 1993, D2.

39. Author interview with Dawoud Bey, 1994.

40. Alan Trachtenberg, "Likeness as Identity: Reflections on the Daguerrean Mystique," in Clark, *The Portrait in Photography*, 175.

41. Robert Storr, "Realism and Its Double," in Lisa Lyons and Robert Storr, *Chuck Close* (New York: Rizzoli, 1987), 18.

42. See Ken Johnson, "Photographs by Chuck Close," *Arts* 61 (May 1987): 20–23. Walker Art Center Director Kathy Halbreich first invited Chuck Close to work on the large Polaroid camera in 1979, when she was the director of the Hayden Gallery at the Massachusetts Institute of Technology in Cambridge. See Lyons and Storr, *Chuck Close*, 37.

43. For more information on Hockney's photographic practice, see Lawrence Weschler, "True to Life," in David Hockney, *Cameraworks* (New York: Alfred A. Knopf, 1984), 6–41; and Jon R. Friedman, "Everyday and Historic: The Photographs of David Hockney," *Arts* 58 (October 1983): 76–77.

44. Steiner, "Postmodernist Portraits," 175.

45. Homi K. Bhabha, "DissemiNation: Time, Narrative, and the Margins of the Modern Nation," in Homi K. Bhabha, ed., *Nation and Narration* (London: Routledge, 1990), 298–99.

46. Gates, "Introduction," 7.

47. Andrew Ross, "The Gangsta and the Diva," in Thelma Golden, *Black Male: Representations of Masculinity in Contemporary American Art* (New York: Whitney Museum of American Art, 1994), 165.

48. Henry Louis Gates Jr., "The Trope of the New Negro and the Reconstruction of the Image of the Black," *Representations* 24 (fall 1988): 129.

Pat Ward Williams

Photography and Social/Personal History

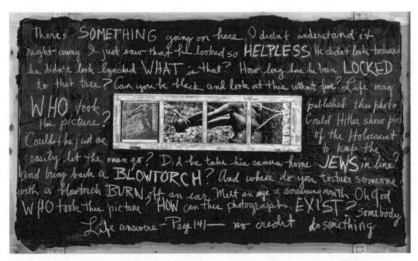

Pat Ward Williams, *Accused/Blowtorch/Padlock*, 1986. Wood, tar paper, gelatin silver prints, film positive, paper, pastel, and metal; overall 59 1/2 x 107 x 4 1/2 inches. Whitney Museum of American Art, New York. Purchase, with funds from the Audrey & Sydney Irmas Charitable Foundation. Photo credit: Sheldan Collins.

The photography of Pat Ward Williams touches on both the public and private aspects of life; many times it even conflates the two. Her work has social content, relating to the larger issues of American and human society, but the photographs can be distinctly personal, intimate, and self-conscious chronicles as well. Williams's pictures also concern both history and autobiography. As history they are systematic accounts recording events of particular significance in the larger society, and they are studies of the character and significance of those events. As autobiography they present themselves as the unique narratives of the artist's existence. Thus, history and autobiography, like the social and personal qualities of her work, also become fused.

Henry Louis Gates Jr. has pointed out the centrality of autobiography in the African American literary tradition:

> Deprived of access to literacy, the tools of citizenship, denied the rights of selfhood by law, philosophy, and pseudo-science, and denied as well the possibility, even, of possessing a collective history as a people, black Americans—commencing with the slave narratives in 1760—published their individual histories in astounding number, in a larger attempt to narrate the collective history of "the race."[1]

In this tradition, then, the part that is the individual bears witness for the whole of the group. Autobiography becomes "the act of declaring the existence of a surviving, enduring, ethnic self."[2] It is an act of remembrance, of calling on the memory that implicates the collective. This autobiographical thrust in Williams's work is also linked to concepts of reterritorialization, a way of locating oneself in the world. Reterritorialization is the movement to recapture one's history, reestablish a link with the past, and redefine self. As such, Williams's photographic pieces are texts of redemption and emancipation in that they construct and redefine the record of their maker's personal and larger societal existence.

As art, Williams's works embody mythos and become expressive of the basic truths of a people's historic experience. Writing on Chicano culture, Genaro M. Padilla interestingly has observed the "close relationship between a people's desire to determine their own political fortunes and their passion to restore their own cultural mythos."[3] Although mythos can be the pattern of meaning and valuation of a people, it is also linked to the allegory and parable of myth. And it is interesting that myth, as story, belief,

or visionary ideal, is often defined in opposition to history. Indeed, for the better part of three centuries, the Western concept of history has been regarded as superior to that of myth, which has been "made to stand in for all other approaches to the past."[4]

Until recently, the photograph was generally understood as a straight objective record, a slice of life, "something directly stenciled off the real."[5] And as this type of document, photography carried the same important weight as history. During the 1970s and 1980s, however, more photographers began to reject the medium's role as one that only described the real, or one that could only provide a simple reframing of the known world. Through techniques once labeled trick photography (such as solarization, manipulation of both negative and print, rephotography, and tableau vivant), practitioners started expanding the boundaries of the medium, which during the twentieth century had been characterized largely by a documentary approach and formalist aesthetics. In the 1970s and 1980s, then, dreams, visions, myths, and memory became valid photographic subjects.

Pat Ward Williams began working with alternate processes and combining written text with photographs in the early to middle 1980s. Like other black women photographers in both Britain and the United States, she started by making documentary images.[6] In that genre, a photograph becomes a document and a record, providing evidence and information about its subject. As photographer and critic Martha Rosler has pointed out, documentary photography is often wedded to a kind of moral stance.[7] These are images that appeal to liberal social conscience; they generally address the socially powerful with images of the powerless and entreat their charity. They seem to say to viewers, "Do something for these people because they can't do anything for themselves." Although documentary photography has created records for those rarely imaged, it remains a problematic approach. As Williams has stated:

> When I first started taking photographs, especially in the documentary tradition, I was trying to fight against what I thought were negative messages that photography had previously communicated to black people. I also realized how easy it was to fall into the same trap and become my own oppressor. A single, documentary shot is usually too little to express a broader idea about racism.[8]

Dissatisfaction with the limitations of the solitary photograph first led Williams to employ multiple images in a single work. It was her innovations with discarded window frames, however, that truly enlarged the scope of the photographer's practice. The window frames not only presented in-

credible formal possibilities as polytychs, but also were familiar objects that embodied a wealth of concepts, including before/after, in front/behind, and fantasy/reality. Williams further concretized these allusions as she moved into fully three-dimensional installations.

Construction and use of alternate processes, such as cyanotype, vandyke, and most recently the dot screen, are methods that have allowed Williams to break the rules of traditional photography. These artistic actions call into question the verity and historical truth of the photographic image. In this sense, Williams's work constitutes a response to the many immediate, exact renderings of African Americans that have depicted them as exotic, violent, or victimized. It gives primacy not just to the trained eye and the mechanical device but to the agency of the creator and the need to deconstruct an oppressive canon in order to reconstruct a truer image of the (collective) self.

Many African American artists have spoken of being discouraged in art school from using the black image.[9] They recount being asked why they continually worked with black figures (an issue that never seemed to arise for those who used white figures), and the difficulty professors had with critiquing such pieces. One artist was even told to give up the practice, since there was no market for black images.[10] Williams has related similar stories.[11] But she soon discovered, given the history of documentary photography, that the problem was not simply with the existence of the black image but also with the nature of the images she produced. What Williams conceived of as normalized images were seen as aggressive by her colleagues. She found that the exotic/violent/victimized myth was viewed as the real depiction of African Americans, and anything outside that form was considered false. As Ntozake Shange writes:

> yes/ being an afro-american writer is something to be self-conscious abt / & yes / in order to think n communicate / i haveta fix my tool to my needs / i have to take it apart to the bone / so that the malignancies / fall away / leaving us space to literally create our own image.[12]

Oh, She Got a Head Fulla Hair (1985) is one of Williams's more personal, self-referential pieces. It is not strictly autobiographical, but adds yet another offering to the growing list of "hair classics" by black women, including film by Ayoka Chenzira (*Hair Piece*, 1985), theater by Ntozake Shange (*Spell #7*, 1979), and more photography by Lorna Simpson (*ID*, 1990), and Roshini Kempadoo (*Presence*, 1990). Williams's piece was indeed inspired by a Shange poem of the same title that she saw in *Black Scholar Magazine* (the poem eventually became part of the play *Spell #7*).

Oh, She Got a Head Fulla Hair is one of the photographer's earliest works

to consider viewer participation. It consists of four silver prints depicting a black woman with long flowing hair that have been altered by handcoloring and multiple exposure and which rest on a shallow shelf. Streaming from this ledge to the floor are more than one hundred thin strips imprinted with sections of Shange's poem. The entire arrangement is affixed to a wall painted magenta. There is an air of reverence that emanates from the altarlike display, but there is also sensuality. Viewers are encouraged to read the strips, an action which amounts to stroking the hairlike tresses.[13] On one level the piece may speak to black women about decisions on "what's a girl to do with this nappy stuff," or the question of whether "to weave or not to weave." But it is also about obsession; just as the female character in the poem becomes obsessed with her hair, so the viewer must become fixated in order to read the entire text in Williams's piece. In Shange's poem, hair becomes a metaphor for abundance, generative properties, and wealth. It represents unfulfilled desire and the attainment of things denied by racism and the economic disenfranchisement of black people. But by controlling one's hair one can also symbolically control one's life. As Kobena Mercer has pointed out, hairstyling is "a popular art form articulating a variety of aesthetic 'solutions' to a range of 'problems' created by ideologies of race and racism."[14]

32 Hours in a Box . . . Still Counting (1987) is a piece that also looks at how black people attempt to "solve the problem" of racism, yet considers it in a larger historical context. This work commemorates Henry "Box" Brown's daring and imaginative escape from slavery. In 1856 he had himself shipped from Richmond, Virginia, to Philadelphia, in a box measuring not more than three feet in any direction. Upon being "delivered" to the Philadelphia Vigilance Committee (an abolitionist organization) and freedom, he went on to become a well-known abolitionist and to publish his autobiography.

With *32 Hours in a Box . . . Still Counting*, Williams moves fully into three-dimensional, freestanding work. The core element of the piece is a box of the same dimensions that Brown was mailed in. It is constructed of window frames filled with cyanotype photographs showing the figure of a black man that has been contorted to fit within the confines of this container. A single sentence wraps around the bottom of the box, compelling the viewer to circle it in order to read:

Henry Box Brown who
escaped slavery en
closed in a box 3
feet wide and 2 long.

In the last line, "2 long" refers to both the size of the box and the duration of Brown's enslavement. But this stanza also has the effect of bringing the discussion into the twentieth century. The single sentence physically connects with passages Williams has inscribed on the floor around the box describing contemporary discrimination, something that African Americans have been subjected to for "2 long." Surrounding and delimiting the floor text are four thin columns that in their placement echo the shape of the crate. On each of these is a small, framed image—a rose, a violin, a doll's eye, and a skyscraper—representing the pillars of Western society—beauty, culture, technology. Barbed wire is strung between the posts, effectively keeping the viewers away from these elements of "civilization" and giving the entire piece an air of foreboding.

Williams again delves into Philadelphia history with *MOVE?* (1988); this time, however, the incident is more contemporary. As a resident of Philadelphia and its suburbs for most of her life, the photographer can in a sense claim this history (and that of Brown's) as her own. The MOVE episode, though, has captured the imagination of a number of African American artists, including mixed-media practitioner Lorenzo Pace and documentary photographer Delcina Wilson. The event occurred in May 1985, when in an effort to evict MOVE, an outspoken group professing an alternative, communal lifestyle, from a largely black, middle-class neighborhood, Philadelphia police dropped a bomb that killed eleven members (five of whom were children) and caused a fire that destroyed two city blocks.

Here Williams constructs an information room in a black, three-walled enclosure. Adorned with photocopies, text handwritten in chalk, and schematic drawings, the partitions juxtapose the various sources of materials on MOVE. There are official documents, autopsies, and police accounts, along with a report from the Philadelphia Special Investigation Commission, which provides an authoritative perspective. But Williams has also incorporated the voice of MOVE by reproducing the group's own writings and testimonies. Handwritten in cursive script, these texts become more personal, emphasizing the group's familial relationship. The work's central element is a living-room tableau consisting of a large television, an overstuffed armchair, and an end table and lamp. Thus, from a very homey setting the viewer is encouraged to watch a videomontage made from local live television broadcasts of this surreal and horrifying event.

It is perhaps in *Not Guilty* (1991) that Williams thoroughly fuses the personal and the historical. The format of the window frame provides her with an instant film storyboard; in the manner of a number of contemporary

photographers, including John Baldessari and Mitra Tabizian, she places disjunctive images one against the other. While the piece actually contains just two stories, their conflation brings about broader interpretations. On the one hand is the narrative of a court case in which a policeman is accused of killing an African American man; on the other is a tale of the breakup of a marriage. In fact, Williams was a participant in both events simultaneously: at the time she was a witness in a murder trial, her marriage was ending. As we read the piece from left to right, images of a trial alternate with those of a distressed couple. Cartoonlike balloons of text relate to neither event but provide a third commentary.

The art of Pat Ward Williams utilizes a multiplicity of media to bring alive ideas and issues on a number of different levels. The photographer often relates her own private encounter with history—she gives it a more intimate context, making it easier to assimilate. Her work is concerned with social issues, above all how these issues impact on one's life. In adopting a more familiar tone and approach to her content, she eschews didacticism that often distances the objects and their message from the viewer. In Williams's demystification of what is personal, social, historical, and mythical, we find that these ways of looking at the world are not only interrelated but inherently political. In these works, as Michele Wallace has said, "'cultural reading' becomes an act of resistance."[15]

NOTES

Originally published in *Pat Ward Williams: Probable Cause* (Philadelphia: Moore College of Art and Design, 1992).

1. Henry Louis Gates Jr., ed., *Bearing Witness: Selections from African-American Autobiography in the Twentieth Century* (New York: Pantheon Books, 1991), 4.
2. Ibid., 4.
3. Genaro M. Padilla, "Myth and Comparative Cultural Nationalism: The Ideological Uses of Aztlan," in Rudolfo A. Anaya and Francisco Lomeli, eds., *Aztlan: Essays on the Chicano Homeland* (Albuquerque: Academia/El Norte Publications, 1989), 113.
4. Michele Wallace, *Invisibility Blues* (New York: Verso, 1990), 243.
5. Susan Sontag quoted in Max Kozloff, *The Privileged Eye* (Albuquerque: University of New Mexico Press, 1987), 227.
6. See Kellie Jones, "In Their Own Image," *Artform* 29 (November 1990): 132–39.
7. Martha Rosler, "In, Around, and Afterthoughts (on Documentary Photography)," in Richard Bolton, ed., *The Contest of Meaning: Critical Histories of Photography* (Cambridge: MIT Press, 1989), 304.
8. Pat Ward Williams interviewed by Maurice Berger in "Speaking Out: Some Distance to Go . . . ," *Art in America*, September 1990, 83.
9. Lorna Simpson, conversation with author, September 1986. See also "Interview with Joyce Scott, Winnie R. Owens-Hart, Martha Jackson-Jarvis, and Pat Ward Wil-

liams," in *Next Generation: Southern Black Aesthetic* (Winston-Salem, N.C.: South-eastern Center for Contemporary Art, 1990), 157–62.

10. Martha Jackson-Jarvis, cited in *Next Generation*, 58.

11. See interview with Pat Ward Williams, Video Data Bank (Chicago, 1990); and Pat Ward Williams interview in *Next Generation*.

12. *Three Pieces* (New York: Penguin, 1982; originally published 1981), xii.

13. In her review of this piece, Judy Collischan Van Wagner has referred to the paper strips as "human tresses." "Pat Ward Williams," *Arts Magazine*, March 1989, 85.

14. Kobena Mercer, "Black Hair/Style Politics," in Russell Ferguson, Martha Gever, Trinh T. Minh-ha, and Cornel West, eds., *Out There: Marginalization and Contemporary Cultures* (New York: New Museum of Contemporary Art, 1990), 248.

15. Wallace, *Invisibility Blues*, 244.

Interview with Howardena Pindell

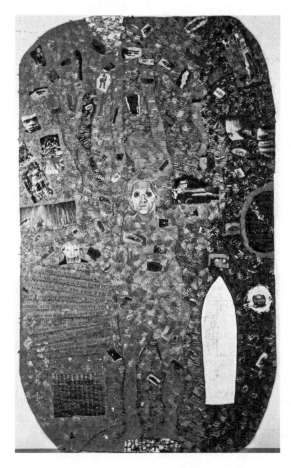

Howardena Pindell, *Autobiography: Water/ Ancestors/Middle Passage/ Family Ghosts*, 1988. Mixed media, 118 x 71 inches. Wadsworth Atheneum Museum of Art, Hartford, Conn. The Ella Gallup Sumner and Mary Caitlin Sumner Collection Fund.

I want to introduce Howardena Pindell with a quotation from the catalogue for her solo show at the Studio Museum in Harlem: "Art critics have described Howardena Pindell's work as being both innovative and unique. Praise that has come because of her extraordinary talent and hard work. Throughout her career Pindell has actively participated in all aspects of protest against discrimination in the art world. Sexism, racism, elitism and tokenism. Pindell is fundamentally a quiet, disciplined, incredibly philosophical artist. She can also easily wear the hats of curator, critic and professor of art."

I think that gives you a taste of the person we have here today. She has won numerous awards starting in 1975 with a grant from the French government to work in Paris. In 1981 she was granted a U.S.-Japan Friendship Commission Creative Artist Fellowship. In 1972 and again in 1983, she won a National Endowment for the Arts Fellowship and in 1987 a Guggenheim grant. She worked at the Museum of Modern Art for twelve years. She has been at the State University of New York, Stony Brook, for ten years and is currently a tenured professor. She was born in Philadelphia in 1943.

KELLIE JONES: I will start out by asking you about your childhood, and the early support that you got from the community, church, and family.

HOWARDENA PINDELL: My mother was forty when I was born so I was the last and the first child. My father's specialty was science and mathematics and my mother's history, although she taught third grade. I was spoiled like a typical only child. The usual stuff. Ballet lessons, music lessons. Very, very middle class. Philadelphia, at that point, was a segregated city and still is in many ways. There were a lot of gangs at the time and I remember there was a lot of conflict and tension and a sense of boundaries. You knew when you stayed in your neighborhood you were safe but there was the segregated church. You had the small black Presbyterian church packed every Sunday and then you had the white church, another Presbyterian church that felt like it was the size of Notre Dame, five blocks away. But you knew when you crossed that boundary you weren't safe. No one was there to protect you. Safety was in the community.

The first place I showed my work was in that community church. I still

see parishioners from there when I go to Philadelphia. I did feel that I had a "basic" support within the family. The art lessons really didn't start until an elementary teacher, Mrs. Oser, in the third grade told my parents they should put me in special art classes because I was talented. So as a result I started from third grade on going to Saturday classes. First the Fleisher Art Memorial which was a free program in Philadelphia, then Tyler School of Art, which was part of Temple University.

I studied ceramics and drawing, fashion design, a little advertising. A little bit of everything. But I really had very academic training.

KJ: Were your parents involved in art or was it the middle-class thing to do?

HP: I think it was the bourgeois thing to do. Everybody in the neighborhood went to dancing school or music lessons. It was a middle-class trip and almost competitive. In terms of my true interests, I preferred science. I really enjoyed chemistry, but not physics. Chemistry and geometry were my strongest subjects although my father tutored me in the beginning. I liked art but I found I was running into racist flak from some of my teachers. I went to a girls' school with all white women teachers and they were upset because I was smart and talented. I would be held back from certain kinds of classes or have my artwork hidden when there were competitions. There was one teacher who was supportive but there was also the total opposite where a teacher would be downright hostile because I was excelling over the white students. I couldn't call that sexism.

KJ: Did things change when you got to Boston University in the early '60s?

HP: Oh no! Boston was a tricky place because it was another extreme form of a segregated community. Boston University was basically a commuter school with a large boarding population from the East Coast. Boston-area black students would come in for classes and leave, rarely visible unless you took the same classes. There was a lot of tension in the city: if you went to eat in a restaurant, you didn't know whether they would serve you or not. They didn't have signs saying you could not eat there; you simply took your chances. You would encounter many tensions just navigating in the city. It was a very separate but unequal situation. I was the only black student in the school for the first two years and I think Mal Mooney came in my third year and a black woman from New York in my fourth. So there were three of us.

KJ: In the art school?

HP: Yes, in the visual arts section. I did encounter a white parent approaching the school and offering money to get rid of me because among top stu-

dents were women of color. A Chinese student and myself. Our position would fluctuate with the white men. I would be number one, she would be two or three, etc. I would be two, three, she would be one, whatever. We were at or near the top. Our school had more men than women. The students would go home and explain to their parents who were the best students and hell would break loose. Apparently a wealthy student from Shaker Heights told her parents and they came to the school and offered the school money to get rid of me specifically. I found out because one of the professors said to me, "I know you know that something is going on." People started acting very weird towards me. He said, "I want you to know a parent [he named the student, which I don't think he should have done] has offered us money, an endowment, in order to get rid of you because he didn't want his daughter to be in a school where a black student was one of the top people in the class. If you find that there are some funny things going on, I just want you to know that I'm on your side and most of the faculty support you."

So people continued to act peculiar and one of the professors actually did lower my grade. That semester I had straight A's and a C. I became very anorexic as a result that year. It was a lot of stress going to school because the students, on top of all this, were not very friendly. The faculty were surprisingly friendlier than the students. I felt very isolated. In response I joined a black sorority, Delta Sigma Theta's Iota chapter. I felt odd because I was an artist. The feeling was that I wasn't doing the "right thing" and should choose a different field. I guess that I was also different. The sorority gave me some social outlet so I didn't feel quite as outcast. But I eventually dropped the sorority too because I was not that much of a group-oriented person.

KJ: Who are some of the artists you discovered during that period or even earlier?

HP: Well, I would go back to memories of the family and the house. The artist I first saw was hanging on our wall. The painting was a Van Gogh wheat field with crows. It was one of these puffy reproductions. Fascinated by the raised surface, I would sit for hours looking at it, this puffy reproduction, running my fingers over it.

My parents, for some reason, liked museums. I don't know why, I just ended up in museums all the time when they traveled. The Philadelphia Museum was quite good. I would hang out in the Duchamp part of the collection where one could see his *Why Not Sneeze, Rose Sélavy?*, also *Bride Stripped Bare by Her Bachelors, Even*. I loved Duchamp's mind. His was the

most intriguing work I had ever seen. The rest of the place was all madonnas and everything felt academically predictable.

KJ: In college did you discover any more artists?

HP: Boston has very good museums. I used to hang out in the Egyptian collection and I liked Rembrandt and Munch, the brooding stuff. Ad Reinhardt came once to Boston University. His mind was really fascinating as his concepts stood out as "peculiar" in a very traditional environment. You learned to paint what you saw at BU but you didn't mess with the surfaces. They had to be really smooth, flawless paintings. Reinhardt . . . I didn't know what he was talking about. Then I remember going to see his work and I couldn't see it, all the close value colors. I absorbed it, was intrigued, and I started to look again at his work, trying to find the forms, trying to read the color. I started appreciating subtle color changes and value changes with Reinhardt.

KJ: You received a BFA cum laude from Boston University in 1965 and your MFA at Yale University in 1967.

HP: Oddly enough, Yale was enjoyable. There were miserable times too, but it was a good contrast to BU where I had to follow a very tight regimen about strict, traditional painting. At Yale some people were abstract expressionists and some were pop and some were involved with geometry. I felt a certain kind of freedom, visually. Also they brought in so many different people that you were exposed to the whole gamut. At BU they would bring in someone and apologize. I always felt that they were withholding information from us when I was there because they had a traditional painting agenda. When I did get accepted at Yale, some of the BU teachers just ignored me. They stopped talking to me as if I were betraying the tradition. I didn't feel as alienated at Yale. They were giving us as much information as they could and perhaps because they had a bigger budget than at BU, I don't know. They would bring in people whose work they did not like but I didn't feel that just because they didn't agree with the artist's agenda they were going to deprive me of that information. I felt like I was fed on a lot of levels, visually, intellectually.

The tension, in terms of racial stuff, was subtle. I think the dominant tension was of a sexist nature in that I went there before women were admitted on the undergraduate level. Essentially you had two hundred women and three or four thousand men or more. One would get funny comments, amusing in that you would be in class and they'd say, "Lady and gentlemen." It was not as offensive as Boston. I didn't feel in New Haven that I couldn't get a meal in a restaurant. There were, however, some subtle things

that would happen. "Friendly" people would be among my classmates but then when there would be a weekend to which parents would be invited, you would notice individuals going to the other side of the street in order to avoid you. That would be individual racism, but in terms of institutional agendas they were more outrageous toward women. All in all I remember it as a relatively happy time. I was miserable in Boston.

KJ: And some of your teachers there who were important to you?

HP: Yale had a different system. You didn't have the oppression of taking a lot of classes. They brought in a lot of visiting artists so if you didn't like one visitor there was always someone new next week. I remember Helen Frankenthaler coming to my studio and seeing that I was still figurative, not even wanting to look at the work. She said, "This kind of work was done in the Renaissance. I'm not even going to bother with this." I thought she was very closed. Richard Lindner, on the other hand, was very open and warm. He came through and spoke to everyone and tried to communicate on their level.

KJ: After you graduated from Yale in 1967 you moved to New York and got a job almost immediately at the Museum of Modern Art?

HP: You make it sound easy. No, no. Like everybody else who was graduating I applied for jobs. I don't know how many women were in the class but I think there may have been three of us out of the fifteen. I was the only black. None of the women got jobs. All the guys got jobs, even guys who weren't even graduating. I sent out five hundred letters (I actually still have the rejections). I did get a job offer from the Baldwin School in Philadelphia, a very snotty private girls' school which offered me $3,500 a year. I would have to be a kind of live-in caretaker for the students, like a live-in maid. I would have no privacy. They thought this was a good offer. So I decided that although I didn't want to be in New York, I'd come here anyway. I had a friend who had an apartment with enough room and cheap enough that I could afford to move in without a job. So I took my chances.

KJ: You didn't want to move to New York? Wasn't New York the place to be where all artists want to go?

HP: Well, the artists in the class who felt that way were really obnoxious. They were really into the art world patriarchy. They would work with the teachers who were well placed in New York. I found it a little offensive. It was almost like they weren't into their art because of their passion or love

of it, but in it to "make it." I guess all of us wanted to make it but that was their chief priority. They were patronizing about it.

Well, I walked the pavements, looking for a job. I remember feeling really terrible. I would look up at those high buildings and think, "All those people have jobs." It was really terrible. I had very little money saved. I took the test to be a welfare case worker and passed. I also got a job offer at a gallery called J. Pocker & Sons. Around the same time I had a membership at the Modern. I had gone in to use the ladies' room and I thought that since I was in the building I'd see what personnel was up to. At Yale I had worked on the Garven Collection, the current American-British Collection. I just did grunt work there and I had minored in Western art history. While I was at Yale, an art historian had encouraged me to apply for a Ford Foundation grant in museum work because I had done well in art history. I had worked also in the slide collection there as well. The Ford Foundation turned me down because I was an artist. My mentor was a British art historian named Graham Hood. He suggested that museum work might be a good idea. So I went to personnel at MOMA. It was when the museum had a more integrated staff. The head of personnel, an Asian woman who was very sympathetic, steered me to a secretarial job. I was interviewed by a black male secretary from the Caribbean. Someone had just quit and it was he who told me another job was available. A woman had literally just walked off the job that day.

Next I was interviewed by Inez Garson, who later went to the Hirshhorn Museum. She said, "We would like very much to hire you but we have to issue this job publicly and if you can stand to wait for about a month we will get in touch with you." So I held off the other jobs while my friend paid the rent and I lived very frugally. I was hired a month later. I couldn't believe it!

KJ: Does that department still exist, international?

HP: Yes, but it's called something else now. So I started working in the International and National Circulating Exhibitions Department. I was also doing quasi-registrar work which meant I got to look at the work very closely for damage. I did condition reports. One of the first people I worked with was Lucy Lippard on her Max Ernst exhibition. As a result I became involved in the (white) women's movement. That job lasted for two years and then Rene D'harancourt (some of you might know about him, the director for many years) was hit by a car and killed. After he died there was a reorganization of the museum and a new man came in, Bates Lowry. They got rid of my department and I think they were hoping that I would leave. They moved everyone else in the department to other departments but me. I guess they

didn't know what to do with this black woman who refused to leave. When they finally realized I wasn't going to budge, two people approached me to absorb me into their departments, Bill Lieberman in the Drawings and Prints Department (now at the Metropolitan), who eventually turned out to be a mentor, and Dorothy Dudley, the chief registrar. I knew I had a head for detail but I didn't know if I could deal with numbers for eight hours a day in the Registrar's Department. I chose curatorial work with Bill Lieberman. I was curatorial assistant for two years and ten years later, an associate curator in Prints and Illustrated Books.

KJ: When you decided to leave the Museum of Modern Art after twelve years, you went to SUNY at Stony Brook and eventually become a tenured professor there. How was that kind of job different from doing a curatorial job?

HP: I found the politics of the museum difficult. I was becoming more evolved politically. I would say a turning point for me was 1979, the "Nigger Drawings" episode. I found that many of the staff could not bear the sight of me because I was on the other side. That is, I was very involved in protest. As a result I realized that I could not work in that environment.

The difference between the two is that one is a corporate environment (museums are corporate, most of them) and therefore more right wing. The university, the state has positions re: affirmative action that they put in writing. They might not necessarily follow them. But instead of being in a corporate place, i.e., a museum where they always were a little embarrassed about my being an artist, I was now in the state school system where they appeared to be happy about all the things I did professionally, including my politics. Individuals in my department may be very unhappy about my exhibition record and my political stance, but the state policy is: multicultural diversity. The opposite is true in a corporate museum setting. You are to advance the interests of the corporation in the guise of a corporate cultural agenda which is basically "whites only." It's complicated because the museum may have ways of saying it is an equal opportunity employer when its practice is not to be. I am working in a better environment although individual faculty practice their version of the corporation.

KJ: You said you met Lucy Lippard early when you first started working at MOMA and you started in with the feminist movement at that time?

HP: Not right away. When I worked with her more or less daily on her Ernst show, I started hearing about feminist issues through her. I was actually

more interested at that point in the mid- to late '60s in the Artworkers Coalition. They were very active then. I remember seeing Jean Swenson with a large, plastic blue question mark sign, picketing MOMA, the picketing by AWC and antiwar protest, Mai Lai poster protests. I would go to AWC meetings but I was considered by the artists as an enemy. I didn't really get involved in the women's movement until the early '70s. That was really a direct response to taking my work to the Studio Museum. I was told by the director at the time (late '60s) that I was not doing black art because I was not using didactic images. I was not dealing with information that would be helpful to the black community. I also felt that there was bad feeling because I was a woman. I wasn't one of the boys.

So I was told to go downtown and "show with the white boys." I felt real depressed about that because I knew how I was closed out downtown. I had no recourse. So I ended up showing with multicultural groups of artists that were forming and renting spaces in Soho when it was affordable. This was when Soho was empty except for factories and folks who bought lofts for $3,000 and were living very, very secretly. I was in shows that were multi-ethnic back in the early '70s. The people who were just forming the idea for A.I.R. Gallery came to me. They approached me through a registry, ironically, at Artists Space. This was 1969 or 1970. They saw my work and invited me to be one of the founding members. That's how I started showing on a regular basis. I think I was the only black member. They have a black member now, ten, fifteen years later.

KJ: After joining A.I.R., you became more active as a feminist?

HP: I became more active as a feminist but then I got disillusioned as I came more in touch with racism in feminism and my own struggle. It has to do with clarity. Here I was in New York, trying to form myself as an artist and I'm dealing with basically white women's issues. But I identified with issues of my blackness in a racist society.

I would say I was always yanked back and forth between racism, classism, and sexism. As ideas were forming and crystallizing over the issues of race, I was turned off by the white women's movement because their attitude was, "white women first." They would sort of trot me out with this big heavy resume as their token. It was really frustrating because it was like saying to other women of color, "If you can't be Superwoman then we don't want you." It made me angry. Then came the whole issue of Artists Space in '79. Around the same time I was looking at some of the women's collectives like Heresies. They would have boards, but they were all white. I was deal-

ing with their feminism and their form of racism. It all coalesced for me in *Free, White and 21*, my videotape of 1980. I pulled back from the women's movement.

KJ: You started out with figurative work. Can you tell us about that because I don't think people know that work very well?

HP: Boston U. had a very strong figurative focus: if you couldn't paint what you saw, you were not a good painter, and if you used bright and high surface color, you were even a worse painter. My early training at Fleisher Art Memorial in Philadelphia and Tyler was all very academic, so I could do figurative work. Being solely figurative was a very limited form of expression for me. Just being able to render form was not enough. I wanted to learn about the physicality of paint. BU gave me the technical side of it but not the plastic side which I got more or less in graduate school. I also learned about color in graduate school through an Albers color course taught by S. Sillman.

KJ: And you did some soft sculpture also which I have seen pictures of in books.

HP: That was strange. I always play when I hit a hard spot in the work. If I can't go beyond it, I play. When I first came to New York I was really displaced from the figurative thing which I was still doing at Yale. Necessity caused me to change. I wasn't making very much money at the Modern, one hundred dollars a week in 1967. I could only paint at night without natural light. I found if I cut the canvas to a certain size I would have all these scraps. I figured I couldn't throw them out. I took the scraps and sewed them together. I couldn't afford clothes on my salary. I would also sew my clothes. I knew the craft of sewing. I preferred hand sewing to sewing with a machine. As a result I would make these soft sculptures out of scraps I would hand sew and stuff. One of them was a soft, portable grid. I just took canvas and I sewed it and stuffed it with foam and put it together with grommets and rings. It was about twelve by eight feet and you could fold it up into a little thing and you could carry it around. I did some other sculptural pieces as well. Also in the late '70s I started cutting the canvas and sewing it.

KJ: The pieces right after that were the stencils. You cut little paper cutter holes out of metal and sprayed through them.

HP: Actually, those were not metal. It was a very heavy oaktag. In the '60s I would use either architectural stencils or a hole punch and take strips of

paper, punch them, then glue them together into these huge constructs. Then I would surround them with plastic, I'd pin them up and spray through them and make fields of dots. This meant that I had bags of holes. I would take those and reconstitute them in those other pieces that I did later in the early '70s. The grid which was folded became a grid of sewing thread that I had used for my clothing in small, paper pieces with numbered dots.

KJ: So you switched from figuration to abstraction working mainly at night because you had a day job. Did the pieces become very monochromatic at this time because you were working without natural light?

HP: Those things just happen to have no color. The ones that you mentioned were the dots punched with the numbers, but they eventually did take on color.

KJ: You mentioned earlier that BU didn't like color. Do you think that influenced you?

HP: I think it was the color of the oaktag. I was focusing on process using the natural colors of the materials. The spray adhesive and the ink, the oaktag and the thread were their natural colors. I started doing the video drawings to change my focal length because my eyes were bothering me so badly from doing the numbering on the oaktag pieces. My eyes were getting damaged from the detailed work. The eye doctor said to concentrate on something moving in the distance. I felt that it was a good excuse to get a color TV. It was a moving image but I got bored with the poor quality of the programs. I then took clear acetate and made drawings on the acetate using the vectors and numbers I used on the oaktag pieces and put them over the TV. Since I had studied photography in graduate school and had a camera, using a tripod I took through the acetate photos of TV. The work had political implications too. It was shown in Europe more than here, where they were read as political statements about the U.S. They were first shown when P.S. 1 opened in Queens in the early 1970s. My work evaporated when it came to reviews. No one even mentioned me in the write-ups. The color punched drawings started right after that, I feel, because I was seeing the color in the TV. I made drawings in gouache and tempera and acrylic, destroying them by punching holes in them. I also used powdered pigments. The thread came back as well as the grids but I would also paint the mounts. I would draw and paint on them and sprinkle them with everything from cat hair to glitter.

KJ: You were also using canvas, all sorts of stuff?

HP: I would go through stages. I stopped painting while I was doing the number pieces. Then I started doing white paintings with embedded paper which I showed—one at the Rosa Esman Gallery. I stopped completely doing the punch-out pieces and started cutting canvas and embedding paper and using more extended surfaces.

KJ: Do you want to talk about your idea of using technology, photography, video, and then making your own video that you mentioned, *Free, White and 21*?

HP: That was really in response to the women's movement. Also in response to what had happened at Artists Space and the whole punk craze and the fact that people of color, people in poverty, were being attacked by these young white artists who thought it was cool to wear swastikas. It is happening again, now, in the late '80s. I bought a blond wig at Woolworth's. My mother had given me clothes because she would hear me complain about having no money for clothes. She would send me clothes from Sears Roebuck, which I hated. I kept bags of these things. I used some of the clothes for the tape. If you've seen the tape you see I change my clothes for each segment. Well, those were all the clothes that my mother sent me. It's just a very strange image, the image of me in a blond wig. I bought stage makeup. I put white makeup on, lipstick, and the dark glasses from my teenage years. So I had the black glasses and the blond wig. A photographer friend gave me back-drop paper . . . seamless paper in different colors. The stories I tell are all true stories from my life. They are autobiographical. The hybrid blond wig person spouts back to me, "Well, that's never happened to me. After all, I'm free, white, and 21. You really must be paranoid." These were things I'd heard year after year from babyhood on up. I was able to synthesize them into this kind of cartoon creature. At the end she pulls a white stocking over her head. I did that because . . . you know, in bank robberies people who want to disguise and hide themselves do that. In a way I think I was trying to make a political statement about how in this culture, a dominant culture which represents a tiny percent of the globe, is in a sense robbing us blind. As she is pulling this thing over her head she says, "You really must be paranoid but after all I am free, white, and 21."

In the early '80s, when I made it, it was hard to get it shown. But now it's like a cult tape and everyone wants to show it. What infuriates me is when "we" do something "everyone" scrambles around trying to find out where we got the idea from, what Euro-American we took it from. I'm just waiting to hear someone say I stole the idea from Cindy Sherman.

KJ: You mentioned when you started doing canvas again, the surfaces started getting extended. Then you were involved in a car accident where you had partial memory loss. After that, you started working with postcards, using them to jog your memory.

HP: Well, my mother had collected postcards for years and some of them I had collected from trips. I had been sent postcards over the years. The accident was in October 1979. I wasn't driving, I was sitting in the back seat of the car. I had started teaching at Stony Brook in September and the accident literally was a month later. I had insurance from the school, but I had no disability. The school was very generous and paid me a salary. I had a brain injury and memory loss. If you called me up I wouldn't recognize your voice. Even now if I meet people from my past, from my distant past, I don't have the depth of memory that I had before.

Well, the postcards function as a memory stimulant. I had a show in April coming up after the accident and I could cancel it or do it. I forced myself to finish the work because I didn't want to lose the chance to show on account of some motor problems. I didn't want to lose all my skills. I used the postcards to get my memory back and also to force myself to do work so I wouldn't lose my dexterity. I used the postcards because they reminded me of people and my past. I'd read the message and I'd think, "God, do I remember this person?" Did I pick this postcard up on a trip? I'd remember a little bit and I'd try to piece it together. It was therapeutic.

KJ: These postcard pieces shown at the Studio Museum were largely of your trips to India and Japan?

HP: Yes. When I went to Japan, the work really changed radically. I totally immersed myself in the culture. The trip itself was very difficult. I traveled for about seven months. I had been to Japan once but this was an extended stay. I had studied the language for two years but I am terrible with languages. It gave me a certain amount of mobility. I really tried to see as much of Japan as I could by not traveling as an American looking for a Howard Johnson's. When I came back (I didn't work at all in Japan except to do little figurative things), I started doing oval shapes that were conical. When I would go to the dry gardens in Kyoto I noticed there were mounds of sand that would reflect symbolically the shape of the mountain. Somehow that shape stuck with me. Mt. Fuji is one of the most beautiful mountains.

I also incorporated the maze pattern I found as a concept of fortification in Japan. I remember in Tokyo I would get very lost because the streets were not on a grid. Also the addresses are not by chronological placement

on the street. They are by chronology of building. So if you go to Camille's house, 491 means she was the 491st house built on Broadway. I felt like I was drowning in this labyrinth of information. The only way I could find my way around was if I knew very, very well the person who I was going to visit—she could give me the right cue. You could take the subway and that was fine until you would get above ground and hey, what do you do? Anyway, when I got back, that "maze" energy and the experience came out of my hands. Everything I created had a conical maze pattern.

India was very different. The internal pattern was flatter and maybe rounded at the edge. It had a snakelike or sinuous pattern within the imagery. I did not force it. The only analogy I can think of is when you listen to Indian music and it just coils in on itself. It was a natural shape which it took itself. Also the postcards were different. In India, the light was so hot that the photographs got very bleached out. So the quality of the colors was very different as opposed to the Japanese imagery where there is a lot of humidity, and very intense, lush color on the postcards.

KJ: You have traveled to many other places. Kenya, Senegal, Nigeria, Ghana, Mali, Uganda, Ivory Coast, Egypt, and also to Mexico, Brazil, Sweden, Denmark, Norway, England, and the U.S.S.R. Has traveling to these other places come out in the work as well?

HP: The only other place that seems to be in the work is Norway. It is a fantastically beautiful country. It probably also has to do with who produces good postcards. I have strong feelings about many of the places. I would love to return to Kenya and Egypt. Right now I don't want to go anywhere. I have a twelve-hour-plus roundtrip every week to Stony Brook. I'm relatively phobic about traveling. I hate flying. I have been in very strange situations in planes and they are all kind of coalescing now as I get older. I'll take the train. I find that my travel to Africa has influenced me in subtle ways, possibly because of my own ancestral family memories. My paintings were always unstretched. I loved the feeling of the flow of material. I was very aware of that in Africa. I can't think of any other place I've been to other than India where I have been aware of that. The way Kente cloth is woven and pieced together has stayed with me. The shape of the sculptural adornments also stayed with me. The African influence has remained firm.

KJ: You are currently working on the "Autobiography Series." The first painting in that series is actually called *African Buddha 1986.*

HP: The "Autobiography" paintings start in 1986 with *African Buddha.* I was very interested for years in many different religions. Since I was in Asia fre-

quently, I was very fascinated by Buddhism and Hinduism. Somehow in that painting (*African Buddha*), the shape of the painting is the shape of an adornment that I had written about for a catalogue. It was an ivory bangle of an incredibly beautiful shape. I referred to Buddha because I had been a practicing Buddhist for a while. Somehow I was trying to pull all these images from my experiences. I wanted to do autobiographical paintings because I was starting to get to the guts of my own past. It really started actually in a non-painting way in *Free, White and 21*. I guess the strongest painting of the group is called *Ancestors/Water/Middle Passage/Family Ghosts*. I deal with my family and multicultural ancestry. I deal with as many taboos as I can face putting out in public. I deal with American history as it is not told. Right now it's up at Hartford, at the Wadsworth Atheneum. I lie down on the painting and I trace my body. In a way it reminds me sadly of Ana Mendieta. I cut out my body like a tracing of her body on the roof. I started doing this after she died. I cut out the shape of myself and then I resew it back in. I also put multiple images of myself in the work. I make photo transfer images, coating magazine images to make a film. It's kind of a complex process. What the painting has are various images referring to family history. I have my cousin, a male fashion model. I include words.

Part of my ancestry is Native American (Seminole). The word Seminole and a hand holding a radioactive tablet are included because some Native Americans are dying because of being exposed to radioactivity in the uranium mines. I have also included a text from a book which was published by *The New York Times*, an abolitionist text which refers to the laws which permitted a slave owner to murder a slave who tried to prevent the master from raping his wife. If the slave moved an eyelash indicating that he disagreed, the enslaver had the right to murder the slave. This is not in our public school history books. So I've done a tremendous amount of reading to try to uncover the taboo and nonpublicized information. I tried to put the public and private history and all its pain into the painting.

KJ: And enlarging it to include all of us?

HP: Well, that brings up my book list. I've been reading a lot. I decided I was going to start to share the information because when I curated the show "Autobiography in Her Own Image" I was putting it together as I was doing my own autobiography series. I handed out some of my journal notes to the women who were in that exhibition. I also put in the catalogue a brief reading list. What started off as a tiny reading list is now huge. I also indicate on the list the names of the bookstores that can help you find a book. For example, I have just found a book I have been looking for for two years. It

was reviewed in the *Times* and of course the stores stonewalled it: *Incidents in the Life of a Slave Girl Written by Herself* published in 1987 by the Harvard University Press.

KJ: There's a real meditative aspect in your work—starting out with the hole punching and these kinds of repetitive acts that may be calming to a certain extent. Sewing is another one like that. You also state that you find a kind of meditative quality or spirituality in the work of African American artists versus the genocidal "destruction of empire" stance of recent Euro-ethnic artists, like the German artists that people are really in love with, Kiefer, Baselitz.

HP: What I notice whenever I look at work by African Americans is spirituality. It has nothing to do with the stylistic content, whether it's figurative or abstract doesn't matter. I always feel uplifted. I always feel better. When I go to the galleries and the museums, I don't feel so uplifted. I think it has to do with the spiritual content of the work. African Americans come from a spiritual cultural background and no matter what part of Africa you are from, art and life were one. Art was/is like a form of prayer. I believe that the strength of the black church is an extension of that.

On the other hand, Euro-American culture has more of a commodity base (money for money's sake!). That is, art is for sale and art for art's (profit) sake and very separate from the spiritual core of the individual. Their religious paintings reflect their patrons' status. There seemed to be a difference between black and white art students. As a black artist and art student you knew you were an artist and you were in it for life. This is not what I hear from most white students. "Well, I'll come to New York and if I don't make it in five years then I'll find another field." In other words there appears to be no depth of commitment because perhaps they feel if they are not rewarded instantly they may never be rewarded financially, so they go elsewhere. Some people say, "You get rewarded more than most people." I'd be deaf, dumb, and blind if I thought that just because I get the reward, everyone else of color is getting justly recognized.

I'm very aware of being used on the token circuit and it distresses me. When I see our people working, dedicated, and avoided by the so-called mainstream, I am infuriated. We are now going through a ten-year crest in the wave. Every ten years, the Euro-Americans come out and it's "please tell us where you've been all this time?" Suddenly we are of great interest and then the interest dips and we hear nothing. Then suddenly they get interested and it's, "Oh my God!! Where were they?" Every time the crest of the wave comes, we are there. We were there all along. We've been doing our

work, we've been plodding along. The white artists know there's a system for them. Their "crest" of the wave is about who is on top of their star system. Some white feminist artists say, "We are dedicated to the Goddess" but they are looking over their shoulders to see who is noticing and when expressionism came back they dropped the Goddess on her divine behind in favor of patriarchal neo-expressionism. I think that we have a dedication to being artists for life. It's not for how long the sweet things last because it is about spirituality. That, I think, affects the work and so when we do work it's like a form of prayer or reverence. It's an extension of our being as opposed to a trip to the bank.

I'm not saying that white artists aren't extending their being, or the spiritual, although I think racism blocks true spirituality. What I'm saying is that it's a real different ball game. I also noticed that Afro-American artists are very often involved in the extended surface. I think of Sam Gilliam. We get involved in crossover surfaces into sculpture-painting, painting-sculpture. We don't say, "Oh gee, I think I'll just do sculpture." Granted, there are white artists who also cross over sometimes by appropriating other cultures, but I think that that is also part of our rich heritage where when a sculpture is done it possibly has additional aggregates on it to empower it. There may be beads, there may be blood, there may be hair, there may be cloth, there may be shells. A very rich surface empowers the piece. I find that often Afro-American art has this aspect even if it's one material that has a sense of density of texture. Surface tension.

KJ: Do you find European art different?

HP: I find that Euro artists, the ones that are especially absorbed by their system, tend to want to emulate a machine. They seem to want to have it look like, "Look Ma, no hands." The work is manufactured, it's a fabricated thing. Somehow they feel this gives you a sense of high art because it doesn't feel like human beings did it. But if a human being has done it, it is dominant. You, as the viewer, are submissive to this huge Kiefer painting (you can also be flattened by a Serra). You are, in a Kiefer, in a Teutonic-like stage set. In other words, it feels to me like a very disempowering experience. If one says it is a message of spirit, I don't know which side the spirit is on. It's one that's very dominant, not uplifting. Artists of color deal with more spiritual subjects. For example, I was invited to be on a panel at the New York Studio School. The panel was called "The Spiritual in Art." When they invited me I said, "Oh great! Somebody is going to deal with the spiritual in art." Then they called me up and said, "We canceled it because we can't get anyone else." So I thought, "Is it my breath?" The subject was of no

interest to the rest of the panel who were Euro-Americans. There is another aspect . . . apocalypse. I find that many of the Euro artists who are absorbed in the system do work that is apocalyptic, about the end of empires or the end of the world. I suspect that is their vantage point. You know how I love statistics (my father earned a degree in statistics). When I did the report, I uncovered other kinds of statistics such as: the U.S. represents 5 percent of the world's population (and consumes 50 percent of the world's illegal drugs). That's a tiny percentage. Two-thirds to three-quarters of the world are people of color. Who's the minority? In the U.S. 20 percent of the 5 percent (world) are people of color so in the remaining 80 percent (U.S.) you have 2 percent (world) white men and 2 percent (world) white women and 13 percent of that group are poor. White Americans always seem to think that the rest of the world is the minority. What we have is global apartheid (almost the same percentage as in South Africa).

Just think of the facts and the use of language, the manipulation of language. When I've traveled all these places I was so embarrassed when I saw these white Americans going to Africa, going to Brazil, going to Asia, saying, "God, look at all these minorities!" It is just amazing how language is manipulated to give a fraudulent impression. I've done all this reading because I want to know what the reality is.

The truth will set you free but first it will make you really miserable. You are going to find out what a con the Euro-ethnics have played on the world in the name of their economic dominance and survival. I noticed this manipulation by the powers that be, who are a tiny, tiny fraction of the world's population. How many heads of corporations are in the 2 percent (world)? How many people are billionaires in that 2 percent (world)? Look how they control the media, the corporations, the boards of trustees of museums, and all. Look at your newspapers and see how the newspapers are owned by these same people who manipulate language and manipulate images (it is a form of state and corporate censorship). I love to clip stuff from the newspapers. Here is a Bloomingdale's ad. The way the ad is laid out gives a very clear message in terms of who is dominant and who is permitted to survive and who is going to be knocked out of the picture.

KJ: Can you give us an example?

HP: There are several children . . . one, a beautiful black child (female) sitting next to a young white child, maybe twelve. She is about eight. He has on what looks like a wedding ring (a subtle message to white women). And gestures as if he is going to punch her. In the back there is a small Asian male child embraced by a tall, white female child and overseeing this is this

very Teutonic, Hitler-youth-looking blond white teenager standing with his arms folded looking over the whole group. Shift the order. What would happen if you had a young black male looking dominant, surveying the whole group or a white female child with a clenched fist? Change the position of the characters and then you can see that they are messing with your mind in terms of the message (it is a form of brainwashing).

Once after I gave a lecture a white male came up to me and said he had worked in advertising for ten years and that I was absolutely right: they sit down and construct the ads to project a political message favorable to the client's political views. In other words, Bloomingdale's wants to attract a certain class and race of people that buy at Bloomingdale's to know that "we're on your side." Write to the people that do the ads. Write to Bloomingdale's and say, "Hey, here's my card, I was insulted by your advertisements. I'm not buying at your store. You hire people that send out a racist, sexist message." Read your newspapers, see the language when it talks about "terrorists" and the "freedom fighter." See who those people are. Are the "bad ones" all people of color? The immigrants who come in from Mexico are called "illegal aliens" while folks who come in from Europe are called "immigrants."

Look at the language. Empower yourselves. When you read the papers about a black male accused of a crime, it's front page news. When a white person like Boesky is accused of a crime, or those white teens in New Jersey sexually abuse a retarded girl, they are empowered with certain kinds of language. Just look at the way a newspaper gives you messages and how they empower certain attitudes and their own criminal behavior. I could go on for hours.

KJ: Let's talk about how you view activism. Everybody says, "Oh, Howardena is very active. She writes letters to everybody." But you see it as a kind of spiritual pursuit.

HP: I was raised a Christian but I'm not a Christian in a sense of going to church. I really believe that one can almost heal oneself through action and creativity. That is, if I read something that upsets me and I sit at home and I feel real bad about it and I don't do anything and don't tell you, something happens to my soul. I've absorbed all that poison and I've done nothing and not shared the information so that other people can act as well as myself. I feel it's true spirit to take your experience and share it with others. Act on your feelings for your own survival and priorities. I can't write letters all day. I have to do things to survive but I choose to pursue the things that I am passionate about. I act on them and believe me, I do feel better about myself.

I don't feel as victimized by this culture. If I gave up or felt, "Oh God, am I only one person?" Everybody can be that only one person together. It takes a little time to get things to change. It takes a focus of your energy.

You'll empower yourself through focusing and sharing it and in a sense you will become more spiritually in touch than being in a passive, religious group. I have particular views about meditation. You can become somewhat spiritual through doing passive meditation. I find that this process can be very non-empowering. Many of the religions like Buddhism tell you you cannot get angry. Your parents tell you that too. You are not supposed to feel your feelings. In Hinduism, you are not supposed to feel sad. Very dangerous stuff! If you lose your critical thought, you can do nothing for anyone, not even for yourself. If you are sitting in a lotus position blissing out, and someone pushes the button, you just could have prevented that by being active. In a way I see the New Age movement as very dangerous because a lot of people are using reincarnation dogma and channeling. You get a similar doctrine through Buddhism, Hinduism, and the New Age. If you empower yourself and use your critical thinking you don't need to bliss out to numb your anxiety because in finding the truth your pain will start to go away. I'm speaking from my own experience. You go into one of these little trips where you use meditation to shut off the signals your own body is telling you, indicating what's going on around you. Not only can you not help yourself but you cannot help your neighbor because you won't even know what you are feeling and thinking in order to figure it out.

NOTE

Interview conducted at Hatch-Billops Collection, April 2, 1989. Originally published in *Artists and Influences* 9 (1990).

Eye-Minded

Martin Puryear

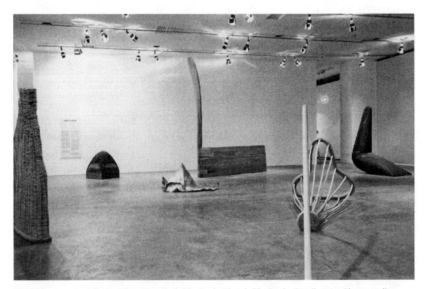

Martin Puryear, Installation View, Twentieth São Paulo Bienal, São Paulo, Brazil, 1989. Photo credit: Sarah Wells.

Encountering Martin Puryear's work one finds most of the qualities expected of sculptural objects: three-dimensional presence, an understanding of mass and volume, attention to issues of form and structure, and an innate elegance. But the pieces also evoke other less formal associations. Some seem to be part of lost animal or bird species, others approximate shelters or tools; they are possibly prehistoric, or from a contemporary culture still using traditional methods of construction; their materials and forms are found in nature but somehow also acknowledge human intervention and intellect; they often appear heavy and solid but on further inspection are actually hollow and light. Most of all, Puryear's pieces elicit a wealth of sensations — they are vaguely familiar but unknown; could possibly function but don't; embody contradiction and dichotomy. And so they allude, finally, to the conflict and tension in human existence, and are containers for life's fullness and diversity.

Martin Puryear is among those redefining the landscape of American sculpture. Having matured in the 1970s his work acknowledges minimalism and earthwork, its immediate and aesthetically disparate predecessors, embracing aspects of these styles yet moving beyond them. While using a vocabulary of seemingly minimalist reductive forms Puryear's sculpture is more inclusive and worldly in scope. Like earthwork it responds to the organic and natural world but is not wholly about the disintegration of the art object or any massive, architectonic statement etched in the terrain. With its insistence on craftsmanship it embraces the man-made, but the artist's hand and personal touch are essential; each sculpture embodies individual expression and is invested with lyrical associations distilled from human memory and experience.

While he may employ skills more identified with furniture makers, wheelwrights, coppersmiths, or shipbuilders, Martin Puryear is foremost an abstract sculptor. In his mature work dating from the mid-70s, a number of different types of sculptural language can be identified, from public projects and site-specific installations to intimately gestural wall works and larger, self-contained objects.

Shapes used for freestanding indoor sculptures are often direct and pure in a unitary sense, and have the effect of focusing our contemplation. They are more likely to manifest themselves as organic form, from the anthropomorphic suggestiveness of *Self* (1978) to the basket-like texture and sil-

houette of *The Charm of Subsistence* (1989). But the geometric is also very much a part of Puryear's vocabulary. A series of works exhibited under the title "Stereotypes and Decoys" at New York's David McKee Gallery evince the artist's admiration for the power of these reductive shapes. In *Timber's Turn* (1987) and *Sharp and Flat* (1987) the focus is on the joining of angular planes, resulting in a variety of pyramids, triangles, and rectangles; *From Somewhere near the Equator* (1987) and *Untitled* (1987) engage the circular and the spherical. But Puryear's sculpture is foremost about balance and inclusion, and so it is the exchange between the organic and geometric—or what many have referred to as the tension between "nature and culture"—that is truly at issue. For example, a sod dome seems to break through the top of a pitch pine and oak cube in *For Beckwourth* (1980). A wooden disk pierced with a square "window" provides viewers a kind of visual access to the massive bean-like body in *Maroon* (1987–1988). The artist also improvises on themes and shapes in a variety of materials, enhancing a property or the scale to extend his/our meditation. The eighteen-foot shelter-like installation *Cedar Lodge* (1977) drops to human proportions in the monolith *Self* and becomes a skeletal frame in *Bower* (1980). *Untitled* (1989) and *Lever* (1988–1989), with their sedentary bases and neck-like extensions, are further explorations of the ornithological motifs of the "Stereotypes and Decoys" series. Puryear frequently creates a dialogue between core and surface, in the process illuminating issues of volume. A piece like *Maroon* which appears heavy at first glance is actually composed of a flexible wire mesh slathered with tar. A small opening reveals its cavernous center. Oppositionals of weight and weightlessness, solid and hollow are also engaged. Line is interestingly active in his floor pieces, in the juxtaposition of various wood grains, or the movement of their sensual contours, the play of wooden slats or poles as in *Untitled* (1988), or the curving wire of *Seer* (1984).

The artist's wall "drawings" are not pictorial or illusionistic but rather utilize wood and rawhide to explore linear function; most of them in fact do have volume. The strong horizontality of helical rawhide strips in *Some Lines for Jim Beckwourth* (1978), or the irregular thrust of saplings in *Some Tales* (1977), gives one the sensation of "reading" the walls and the materials as one would a book. Created concurrently with such installations are ring-like pieces in which the circular surface is also a format for investigations of the workings of mass with color. These range from layers of polychrome in *Dream of Pairing* (1981) to a subtle tinting in *Thylacine* (1982). The circles are rarely perfect or closed. Though constructed they often end in eloquent carved details which belie their desire for completeness. In newer

pieces such as *Generation* (1988), irregular black or natural wood teardrops more than seven feet high replace delicately colored halos. Protruding even farther from the wall, their lines are more sinuous and lyrical but also elusive, appearing flat and wide or razor thin depending on viewer orientation.

Puryear's sculpture addresses formal and theoretical problems at the essence of abstract art-making but also traffics in metaphor. This suggestiveness is, for the most part, subtle and obtuse, and rarely unqualified analogy. There are a few pieces, however, that speak more openly of history. The artist has constructed a number of works in homage to Jim Beckwourth, an African American adventurer and frontiersman who lived during the first half of the nineteenth century. The use of rawhide, wood, and earth in these pieces become references to this figure's command of both nature and culture. The shape of the site-specific *Bodark Arc* (1982) recalls a bow and arrow. The work pays homage to the trees of the area—Bodark is a corruption of Bois d'Arc or bow wood—and to the original Native American inhabitants who used them.

Puryear's use of raw materials and orientation toward the biological and natural world imply to some a direct appropriation of anthropological or "primitive" sources, although the room-size *Where the Heart Is (Sleeping Mews)* is perhaps the only really recognizable derivation in this sense. Modeled on a traditional dwelling called a yurt, the piece was first constructed in New York after a fire destroyed the artist's studio, and has been installed a few times over the last dozen years. Critic Paul Krainak has said that this piece

> Allows the audience to experience an ancient, unfettered object as fresh and partially translatable, instead of remote and exotic. By his example he is saying that it's ok to imagine states of grace, but we should apply our romantic and rhapsodic analogies to things for which we have some respect and hopefully some firsthand experience because our representations will be more believable.[1]

Outright appropriation and simulation are indeed at odds with the singular character that Puryear fuses in each piece. Whatever the original object of inspiration it becomes so thoroughly integrated into the artist's vocabulary and his consciousness that we are left with a vague resemblance, an obscure referent; meaning becomes broad and implication wide. The sense of scale, the handling of technique and materials, and the art context itself subvert the signifiers of home, animal, or implement, but open the imagination.

There are two general approaches that Puryear takes to work in the public realm. He constructs sculptures similar to his studio objects, which nevertheless resonate with the history of their site. Other pieces referred to as "amenities" challenge the sculptor to create something both functional and aesthetically his own. The artist used fieldstone gathered from the surrounding area to form *Sentinel* (1982), a vertical marker echoing his earlier *Self*; the outdoor piece is a quasi-monument to the anonymous builders of that Pennsylvania locale and their enduring structures. The copper armature of *Ark* (1988) created for York College in Jamaica, New York, recalls a ship's hull in form, yet also reflects the hidden workings of the edifice in which it is located. On the other hand a work like *Knoll* (1983) considers the environment and makes a place for the viewer within it. The piece is a "constellation of objects [and] gestures,"[2] a concrete mound overlooking a lake surrounded by a semicircle of benches and an arc of trees intersecting a curving path to the place. The repetition of these simple shapes and movements in the earth is reminiscent of the gracefulness of Japanese gardens, for which Puryear has a high regard.

Though not a public amenity *Bodark Arc* also locates the viewer in the landscape. Covering 3.75 acres, it is an experiential piece leading through trees and high grass, and over a pond. Taking a more respectful and collaborative approach to nature than the colossal earthworks of the 1960s, Puryear cleared the bow and arrow shaped area with scythe and ax. At the end of the radius/arrow point is a bronze chair from which one may contemplate the vastness of nature: "At that central point, one is implicated in the artistic experience and understands how artfully contrived, how essentially unnatural this and any work of art is."[3]

In their materials, technique, and presence, the works of Martin Puryear epitomize current ideas and directions in American sculpture. His use of natural substances and handworked processes question the rarefied status of the art object and particularly eschew the industrialized heritage of minimalism, but his interest in the economy of shape, primary forms, and explorations of mass and volume link him to the formalist tradition of modernism. His experience with parts of the world as disparate as Africa, Asia, and Scandinavia has been absorbed and synthesized into a body of work that is highly individualistic. Through a personal sculptural language that is at once poetic and allusive as well as formally complex, Martin Puryear explores not only exterior physical but also interior psychological space, and reflects a new sense of wholeness and balance, a contemporary American sculpture that benefits from pluralism and internationalism.

NOTES

Originally published in Kellie Jones, curator, "Martin Puryear," Jamaica Arts Center, Twentieth São Paulo Bienal, São Paulo, Brazil, October 14–December 10, 1989.

1. Paul Krainak, "Contraprimitivism and Martin Puryear," *Art Papers* 13 (2) (1989): 38.
2. Patricia Fuller, "Martin Puryear: Public Places, Personal Visions," *Martin Puryear: Public and Personal* (Chicago: Chicago Office of Fine Arts, 1987), 38.
3. Judith Russi Kirshner, "Martin Puryear: Second Nature," *Martin Puryear: Public and Personal* (Chicago: Chicago Office of Fine Arts, 1987), 11.

Large As Life

Contemporary Photography

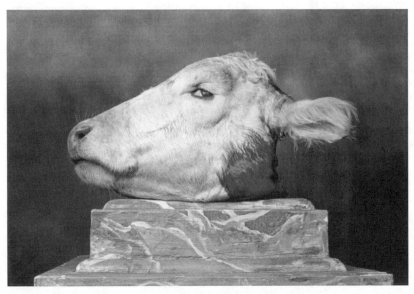

Andres Serrano, *Cabeza de Vaca*, 1984. Cibachrome. Copyright Andres Serrano. Courtesy of the artist and Yvon Lambert Paris, New York.

The exhibition "Large As Life: Contemporary Photography" is an assessment of the medium of photography as seen through the eyes of nine photographers: Albert Chong, John Kennard, Ani Rivera, Sophie Rivera, Hope Sandrow, Andres Serrano, Lorna Simpson, Kunie Sugiura, and Albert Trotman. Linking the diverse themes and styles of these artists is their concentration on large-scale photographic images. Whether in color or in black and white, no photograph in this exhibition is smaller than two by three feet.

Though the technology for making big photographs has been available since the nineteenth century, only in recent years have photographers begun to work consistently with them. The fact is that in the 1980s large images are a part of our lives. We are daily bombarded with them, on marquees, highway signs, billboards, subway and bus advertisements. "Large As Life" is also a comment on how those of us living in America receive, and are affected by, visual information in this highly technological, media-oriented culture of the 1980s.

The exhibiting photographers are of a generation brought up on the enlarged images of the movies, TV close-ups, and Disneyland's overscale fantasies. Their aesthetic has been influenced and informed by the disco/club culture, where oversized video screens parade huge fragmentary imagery. They are comfortable with the big picture. For them it is the natural form that their photographic language takes.

Often life-size and sometimes larger-than life-size, these images are at odds with our traditional concept of the photograph as a snapshot in a family album or as an eight-by-ten-inch picture on a wall. But the subjects and themes remain recognizable, there are landscapes, still lifes, and figure compositions in addition to a few abstract works.

Since 1979, John Kennard has been photographing a very special part of the American landscape: the fields on which the national pastime, baseball, is played. Taken from the grandstand, these views reveal the subtle geometry of both diamond and stadium, images often missed when one is immersed in the game. In *St. Louis, Missouri* (1979), Kennard captures the intricate play of light and shadow on turf, transforming our vision of this ordinary sports arena, and calling attention to the beautiful designs in this landscape, how the aisles of the grandstand mimic the strokes of light on the field.

Elements of landscape are also a part of the work of Albert Chong who

collects pieces of nature and brings them back to the studio, arranging the elements carefully before photographing them. Through the juxtapositions Chong creates still lifes reminiscent of shrines. *Fork, Knife and Feather* (1986), a silver print, focuses on the exquisite engraving on a pair of old utensils. There are also some rusty screws, bird feathers, the skull of a small animal, and other miscellaneous objects in the picture which suggests an ancient atmosphere. Chong creates a sense of mystery too: why are these things here and shown together? The largeness of scale draws one in and seems to envelop the viewer. Are we standing before an altar, witnessing an age-old ritual, or is this just the artist's imagination made visible?

The color cibachrome and C-print photographs of Andres Serrano satirize man's ritual/religious and intellectual preoccupations. These still lifes are pristine and elegant in mood, the lighting and placement of the objects recalling Renaissance art. The subjects, on the other hand, are bizarre. Serrano substitutes roasted pigeons for the crucified Christ and thieves in *Calvary* (1985). The birds are attached to ornate crosses and largely obscure the painted human Christs that adorn them.

Like Serrano, Albert Trotman photographs still lifes that have a distinctly unreal quality to them. Working in the thirty-by-forty-inch format with color C-prints, Trotman often paints the common objects and interiors that are his subjects before photographing them. Their strange coloring gives the pieces an eerie, surreal effect. In *Untitled* (1986), the hazy black film of paint that has been applied by the photographer to a tube of toothpaste and a toothbrush is offset by the candy-colored brightness of a red and yellow checked surface. These once familiar items have suddenly been transformed and made extremely unappealing.

Ani Rivera first became interested in photography while attending the High School of Art and Design in New York City. Later, as an apprentice, matting and framing works on paper, he was excited by images from the history of photography, including those of Man Ray and Laszlo Moholy-Nagy. In many of his recent works Rivera uses found negatives and photos; he also recycles his own older works, cutting, reassembling, and sometimes painting them before making new negatives. In this exhibition Rivera reveals the special reverence he has for Man Ray—the American artist most connected with the European art movements of Dada and Surrealism—who experimented with such photographic processes as solarizing and photograms. From the "Totentanz Series," *No 44–The Merchant* (1984) is a solarized silver gelatin print. The positive and negative areas of the image have been reversed by introducing some white light in the darkroom.

The figure is important in the work of Hope Sandrow. While she doesn't

manipulate negatives like Ani Rivera, Sandrow nevertheless creates various photographic illusions. During 1985–1986, Sandrow began to shoot in the galleries of the Metropolitan Museum of Art; through her camera, statues became interchangeable with human flesh and architecture with the blurred movement of her living models. Shown in the exhibition is an earlier work, *Every Hero Needs a Woman* (1984). In this nearly six foot high photograph, the synthesis of human and plant forms makes for a perplexing and surreal image. A woman's face emerges from behind a tree and a clump of bushes on the left. At the right we see no body, but three arms are visible. Could this be the hero's perfect woman?

Recent photographs by Lorna Simpson critique human gesture and body language. Shown in this exhibition are pieces from her "Screens Series." Each work is a three-paneled, wooden folding screen with sixty-six-by-twenty-four-inch photograph of a black woman whose face is never seen. Several of these triptychs are placed on the floor in such a way as to create a maze. Written statements in the work, as well as the images themselves, refer to the known, unknown, and hidden issues of race and gender in America. Included in the exhibition is *Screen #1* (1986), which depicts a black woman against a black background in a white dress. She is seen from the back, seated straight and proper in an ornate wrought-iron chair. Her hair has been carefully coiffed and is adorned with ornaments, including a bunch of miniature wooden watermelons and a small black doll. The legend on the piece reads "Sandy's hand was foreign to a comb."

Unlike the rest of the photographs in this show, the works of Sophie Rivera are not traditional positive images on photographic paper but are the negatives themselves. Seemingly abstract at first glance, these color cibachrome negatives actually record the juxtaposition of paint on surfaces that have been graffitied. *Tatrology* (1986) presents the red "tag" or signature of a graffiti artist. Presented in large scale, the "tag" is the normal size one would see it on the street, but by focusing on the signature itself, Rivera's negative captures and enhances color and texture.

Also a painter, Kunie Sugiura has been working with photography for twenty years. For almost half that time she has been experimenting with the photogram process—placing objects, or painting, on photographic paper and then exposing it to light. The results are unpredictable and achieve a spontaneity that is quite different from traditional camera photography. Her abstract work *Interior 3* (1986) is four feet high and refers as much to a private thought as it might to a physical interior.

The "growing up" of photography may have been the natural direction for the medium to take at this point, but photography has also been influ-

enced by a current fascination with the monumental that has marked recent painting and sculpture. According to critic Andy Grundberg, large-scale photographs of the 1980s are made with ideas of "impact and presence" in mind.[1] Writing in the early 1970s, A. D. Coleman noted a similar inclination in the photographs of those working with a large format. The size of the photographic paper itself was not as important as the size of the image on it; "amplification of content" was an affirmation of existence of both photographer and medium.[2] Large-scale photographs not only make us perceive images in a different manner but also challenge us to consider them differently. These "super" images are, as A. D. Coleman has further remarked, "extreme manifestations of our cultural consciousness."[3] In other words, photography of the 1980s, with its predilection for large scale, may be thought of as a mirror of reality in the 1980s. It reflects the ever-present media barrage, the often conflicting symbols and signals that populate our daily lives through television, radio, video, stereo, computer- and satellite-generated images. Photographs are still the immobilized slices of time: the "decisive moment" popularized by a great twentieth-century master of the medium, Henri Cartier-Bresson. But now, at least in the late twentieth-century images in this exhibition, only huge slices will do.

NOTES

Originally published in Kellie Jones, curator, "Large As Life: Contemporary Photography," Henry Street Settlement, New York, N.Y., February 13–March 29, 1987. The exhibition traveled to Jamaica Arts Center, May 2–June 13, 1987.
1. Andy Grundberg, "Big Pictures That Say Little," *New York Times*, May 8, 1983, 36.
2. A. D. Coleman, *Light Readings* (New York: Oxford University Press, 1979), 101.
3. Ibid.

Interview with David Hammons

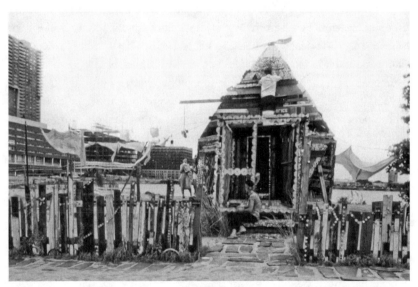

David Hammons, *Delta Spirit*, 1985. Site-specific installation, New York. Creative Time Archive, MSS 179, Art on the Beach 7, III, Binder H. The Fales Library and Special Collections, New York University.

DAVID HAMMONS: I can't stand art actually. I've never, ever liked art, ever. I never took it in school.

KELLIE JONES: Then how come you do it if you can't stand it?

DH: I was born into it. That's why I didn't even take it in school because I was born in to it. All of these liberal arts schools kicked me out, they told me I had to go to a trade school. One day I said, "well, I'm getting too old to run away from this gift," so I decided to go on and deal with it. But I've always been enraged with art because it was never that important to me. When I was in California, artists would work for years and never have a show. So showing has never been that important to me. We used to cuss people out: people who bought our work, dealers, etc., because that part of being an artist was always a joke to us.

But like someone told me: "Art is an old man's game, it's not a young man's profession." He said it was a very lonely, lonely, lonely profession. Most people can't deal with all the loneliness of it. That's what I loved about California though. These cats would be in their sixties, hadn't had a show in twenty years, didn't want a show, paint everyday, outrageous stamina. They were like poets, you know, hated everything walking, mad, evil; wouldn't talk to people because they didn't like the way they looked. Outrageously rude to anybody, they didn't care how much money that person had. Those are the kind of people I was influenced by as a young artist. Cats like Noah Purifoy and Roland Welton. When I came to New York, I didn't see any of that. Everybody was just groveling and tomming, anything, to be in the room with somebody with some money. There were no bad guys here, so I said "let me be a bad guy," or attempt to be a bad guy, or play with the bad areas and see what happens.

In Los Angeles, Senga Nengudi and I shared a studio. Her work was so conceptual and I was working in frames then. So by us sharing a studio, she got more figurative and I got more conceptual. That's when she started doing the pantyhose; those pieces are all anatomy. Before, she used to put colored water in plastic bags and sit them on pedestals. This was the '60s. No one would even speak to her because we were all doing political art. She couldn't relate. She wouldn't even show around other black artists her work was so "outrageously" abstract. Senga came to New York and still no one would deal with her because she wasn't doing "Black Art." She was living in

Harlem. So she had to leave here and go back to L.A. and regroup. Then I came in after her; I said, "I'll try it, I'll try it with my shit."

It was a totally different thing when I came here in 1974. It was a painter's town exclusively. If you weren't painting you could forget it. And I was doing body prints then and was moving into conceptual art. I had to get out of the body prints because they were doing so well. I was making money hand over fist. But I had run out of ideas, and the pieces were just becoming very ordinary, and getting very boring. I tried my best to hold on to it. It took me about two years to find something else to do.

I came here with my art in a tube. I had a whole exhibition in two tubes. I laid that on the people here and they couldn't handle it, nothing in it was for sale. This was after the body prints. This was after I had taken off for a couple of years and come up with an abstract art that wasn't salable. These things were brown paper bags with hair, barbecue bones, and grease thrown on them. But nothing was for sale. Other black artists here couldn't understand why you would do it if you couldn't sell it.

I was influenced in a way by Mel Edwards's work. He had a show at the Whitney in 1970 where he used a lot of chains and wires. That was the first abstract piece of art that I saw that had cultural value in it for black people. I couldn't believe that piece when I saw it because I didn't think you could make abstract art with a message. I saw the symbols in Mel's work. Then I met Mel's brother and we talked all day about symbols, Egypt and stuff. How a symbol, a shape has a meaning. After that, I started using the symbol of the spade; that was before I did the greasy bags. I was trying to figure out why black people were called spades, as opposed to clubs. Because I remember being called a spade once, and I didn't know what it meant; nigger I knew but spade I still don't. So I just took the shape, and started painting it. I started dealing with the spade the way Jim Dine was using the heart. I sold some of them. Stevie Wonder bought one in fact. Then I started getting shovels (spades); I got all of these shovels and made masks out of them. It was just like a chain reaction. A lot of magical things happen in art. Outrageously magical things happen when you mess around with a symbol. I was running my car over these spades and then photographing them. I was hanging them from trees. Some were made out of leather (they were skins). I would take that symbol and just do dumb stuff with it, tons of dumb ignorant corny things. But you do them, and after you do all the corny things, and all the ignorant things, then a little bit of brilliance starts happening. There's a process to get to brilliancy: you do all the corny things, and you might have to go through five hundred ideas. Any corny thought that comes into your head, do a sketch of it. You're constantly emptying the brain of the

ignorant and the dumb and the silly things and there's nothing left but the brilliant ideas. The brilliant ideas are hatched through this process. Pretty soon you get ideas that no one else could have thought of because you didn't think of them, you went through this process to get them. These thoughts are the ones that are used, the last of the hundred or five hundred, how ever many it takes. Those last thoughts are the ones that are used to make the image and the rest of them are thrown away. Hopefully you ride on that last good thought and you start thinking like that and you don't have to go through all these silly things.

It was just like a chain reaction. I started doing body prints in the shape of spades. So when I moved into using just the spade image it flowed. Then I started painting watercolors of spades. After that, I stopped using the framed format entirely; I had chains hanging off the spades. I went to Chicago to a museum and saw this piece of African art with hair on it. I couldn't believe it. Then I started using hair.

KJ: So where did you get the hair from, barber shops? People didn't want to give it up, did they? They thought you were going to do some serious magic on them using that hair.

DH: No they didn't mind it. Except there was a place in Harlem that said no they wouldn't give it to us, this Haitian place.

In L.A. I had one place that I got hair from, this one shop, because it was so hard to ask people. I'd wait until everyone left the shop. I'd sit out front until the shop closed. I would always ask this one guy. Eventually, I got used to him and he got used to me. In New York, I wouldn't get the hair. I had this friend get it for me. He was very outgoing, you know, sold you insurance and all that kind of stuff, a gallery dealer, he'd talk to anybody. He'd talk to the barber and I'd just pick up the hair.

There's so much stuff that I want to do with the hair that I didn't get a chance to do, because I just can't stay with any one thing. Plus I got really bad lice. Everyone kept telling me I was going to get lice. I shrugged it off as just a possible occupational hazard. But I did get a really bad case of head lice. Hair's like the filthiest material. It's a filter. When the wind blows through it the dirt stays on the hair. You could wash your hair every single hour and it would still be dirty. But I have information on black people's hair that no one else in the world has. It's the most unbelievable filter that I've ever run across.

I was actually going insane working with that hair so I had to stop. That's just how potent it is. You've got tons of peoples' spirits in your hands when you work with that stuff. The same with the wine bottles. A black person's

lips have touched each one of those bottles, so you have to be very, very careful. I've been working with bottles for three years and I've only exhibited them a couple of times. Most of my things I can't exhibit because the situation isn't right. The reason for that is that no one is taking the shit seriously anymore. And the rooms are almost always wrong, too much plasterboard, overlit, too shiny and too neat. Painting these rooms doesn't really help, that takes the sheen off but there's no spirit, they're still gallery spaces.

I think the worst thing about galleries is, for instance, that there's an exhibition opening from 8–10 p.m. The worst thing in the world is to say, "well I'm going to see this exhibition." The work should instead be somewhere in between your house and where you're going to see it, shouldn't be at the gallery. Because when you get there you're already prepared, your eyes are ready, your glands, your whole body is ready to receive this art. By that time, you've probably seen more art getting to the spot than you do when you get there. That's why I like doing stuff better on the street, because the art becomes just one of the objects that's in the path of your everyday existence. It's what you move through, and it doesn't have any seniority over anything else.

Everybody knows about *Higher Goals*—the telephone pole piece—up there in Harlem. If I'm on the street up there I say, "I'm the guy who put that pole up there." I'll be on 116th or 110th and Amsterdam and talk to anybody and they'll say, "You're the one who did that. Yeah, I know where that is, I know you. Brother, come here, this is the cat who did the pole, yeah." So sometimes I'll just say that to talk to somebody on the street, at three or four in the morning or something, it's like a calling card. I've been trying to put it in the Guinness book of records as the highest basketball pole in the world but I don't know who to call.

I like playing with any material and testing it out. After about a year, I understand the principles of the material. I try to be one step ahead of my audience. Some artists are predictable. You've seen their patterns over the last ten years. They're staying within these frameworks because it's financially successful. I look at these cats and this is what I never ever want to be or never ever want to do. Why should I stay safe? It takes a long time to analyze a form—whether it be metal, oil paint, whatever—it may take them their whole lifetime to analyze this material. But who gives a fuck? There are so many things to play with. And I question if what these artists are doing is art or not. I don't think it is. An artist should always be searching and searching for things. Never liking anything he finds, in a total rage with everything, never settling or sacrificing for anything. That's what I enjoy anyway.

I always try to use materials that are not easy to obtain. Like now I have all this elephant dung that I'm working with.

KJ: How did you get that?

DH: It was for a garden. Angela (Valerio) was getting some for her plants. I was there with her and saw some of this elephant manure. It was interesting. It's about the size of a coconut. So I'm painting on it now. I've been working with it since about April 1985.

KJ: You did pieces for a while that had dowels with hair and pieces of records on them. Like the piece you did for the Atlanta Airport.

DH: Those pieces were all about making sure that the black viewer had a reflection of himself in the work. White viewers have to look at someone else's culture in those pieces and see very little of themselves in it. Like looking at American Indian art or Egyptian art, you can try to fit yourself in it but it really doesn't work. And that's the beauty of looking at art from other cultures, that they're not mirror reflections of your art. But in this country, if your art doesn't reflect the status quo, well then you can forget it, financially and otherwise. I've always thought artists should concentrate on going against any kind of order, never accepting any order not even their own, but here in New York, more than anywhere else, I don't see any of that gut. Because it's so hard to live in this city. The rent is so high, your shelter and eating, those necessities are so difficult, that's what keeps the artist from being that maverick.

KJ: It's funny, though, because people always think that the starving artist is the most important one. That all that angst and starvation is what makes your art good.

DH: It does make the work good if you understand the starvation. Like Van Gogh said, he who lives in poverty and loves that poverty that he lives on will always be in the heartbeat of the universe. But you have to love the poverty, and there are very few people who love poverty; they want to get out of it. So if you are in poverty and dislike it, well then you have a real problem and it's going to reflect in the work. But if you're in poverty and enjoy it and can laugh at it, then you have no allegiance to anything and you're pretty much free.

Anyone who decides to be an artist should realize that it's a poverty trip. To go into this profession is like going into the monastery or something; it's a vow of poverty I always thought. To be an artist and not even to deal with

that poverty thing, that's a waste of time; or to be around people complaining about that. Money is going to come, you can't keep money away in a city like this. It comes but it just doesn't come as often as we want.

My key is to take as much money home as possible. Abandon any art form that costs too much. Insist that it's as cheap as possible is number one and also that it's aesthetically correct. After that anything goes. And that keeps everything interesting for me.

KJ: Would you say that your work has any political element in it? Because of not running after the status quo or being more free to do what you want and not really worrying about the money thing like so many people are doing? In other words, by abandoning running after the money, does the work become more political in a certain sense?

DH: I don't know. I don't know what my work is. I have to wait to hear that from someone.

KJ: Like who, regular people on the street?

DH: They call my art what it is. A lot of times I don't know what it is because I'm so close to it. I'm just in the process of trying to complete it. I think someone said all work is political the moment that last brushstroke is put on it. Then it's political, but before that it's alive and its being made. You don't know what it is until it's arrived, then you can make all these political decisions about it.

Sometimes I do say, "this is going to be a political piece." Like "Soweto Marketplace" that was at Kenkeleba House ("Dimensions in Dissent," December 1985). Then trying to make it is so difficult, because I want it political and I want it conceptual and I want it visually interesting. I want it gloomy, I want it hidden away from the crowd. All of these kinds of things come into play. So I'm dealing with about five different levels.

I'm learning a lot from Fellini, watching his movies over and over again. I think the movie people are much more advanced than other visual artists. They can make you cry, they can make you laugh, they can scare you. Paintings don't do that, they used to but not any more because the audience knows the game too well. But it's the artist's fault because the artist isn't researching and making the game more real. We've let filmmakers take the game from us because of our nonchalance.

If you know who you are then it's easy to make art. Most people are really concerned about their image. Artists have allowed themselves to be boxed in by saying yes all the time because they want to be seen, and they

should be saying no. I do my street art mainly to keep rooted in that, "who I am." Because the only thing that's really going on is in the street; that's where something is really happening. It isn't happening in these galleries. Lately I've been trying to meet a new kind people in this city and not the art scene. Otherwise you end up with, "Man, you shit's baaad, your shit's happening, you're the man," all this absurd praise. You start flying and thinking that your shit don't stink. I've invented a rule book for myself, that's gotten me over all of this stuff. If an artist doesn't have his own rules then he's playing with those of the art world, and you know those are stacked against you.

I have all these safety valves that I use. Like if it's on the ground, I pick it up and put it on a branch. It's still outside of me, I just found it. One artist accused me of "showing a bad image of Harlem." And I said, "I'm not showing anything. I'm just putting stuff that's on the ground onto a tree. I'm not responsible for that wine bottle getting there. All I'm doing is playing with it, activating it in some form."

Selling the shoes and other things on the street I think is my personal best; those little shoes, that's my best shot. I do it whenever I need a fix, I guess; when I know I need attention and want to make someone laugh. It's like having an opening, for me when I do that piece because I interact with the people. And I don't have to wait for these galleries. It's a way for me to show people how I see the world. I get a chance to watch people interact. It's interesting . . . if you have an item between you and other people, then they can relate to you. If you don't have an item you're enemy number one. But if you have an item between you then it cools them out and they can deal with you. It's amazing how something like a little shoe can just turn someone's head around.

KJ: Have you ever talked to people on the street—like when you had that bottle tree piece in the vacant lot next door to Studio Museum, did you ever stand around there and listen to what ordinary people said about it?

DH: I was in there one time and some people asked me what I was doing and somebody said, "He ain't got nothing better to do." And I thought, I didn't have anything else to do, that was the reason I was doing that. So they ask the questions and answer them themselves. If you're quiet or don't have anything to say, they say it all for you.

KJ: Do you think everyday people have a greater grasp of what you're doing than—

DH: Than I do.

KJ: —than you do, or than other people who are politically astute, or versed in art?

DH: They're the number one, because they're already at that place that I'm trying to get to. Sometimes I carry a whole arch of wine bottles around in the neighborhood. I walk from 125th up to 145th Street and people follow me, ask me questions, give me answers, tell me what I can do. They just give me tons of information and I don't give them any. I'm just carrying this piece around like it's a log or something. Once a woman said to me, "Mr., excuse me, but could you please tell me what that is?" I said, "What are you speaking of?" Then I said, "Oh, it's just some wine bottles." I play off it. I do this every once in a while to cleanse myself. It's putting myself out there on the street to be made fun of. I think it's important to be laughed at.

Black people, we have more problems with being made fun of then any people I've ever met. That's why it's so important for us to be cool, cool, cool. If you're not cool then you're something else and no one wants to be that other thing. But that other thing is what I'm interested in, because you have to really work at getting to that other space. Black artists, we are so conservative that it's hard to get there, you have to work at it, really, really work to be nonconservative. We've come up under this Christian, puritanical, European form of thinking and it's there, deep-rooted. It can be worked at, loosened up some, but it's very difficult. What happens with my work is like I'll be working on piece (A) but I'll do some little aside things on my way across the studio to get to piece (A) and these aside things will be more important because they are coming out of my subconscious. These aside pieces will become more interesting and haphazardly loose and piece (A), that I've been working on for months, will be real tight.

Doing the things in the street is more powerful than art I think. Because art has gotten so . . . I don't know what the fuck art is about now. It doesn't do anything. Like Malcolm X said, it's like novocaine. It used to wake you up but now it puts you to sleep. I think that art now is putting people to sleep. There's so much of it around in this town that it doesn't mean anything. That's why the artist has to be very careful what he shows and when he shows now. Because the people aren't really looking at art, they're looking at each other and each other's clothes and each other's haircuts. In other sections of the country I think they're into seriously looking at art. This is the garbage can of it all. Maybe people shouldn't look at art seriously here because there's so much.

The art audience is the worst audience in the world. It's overly educated, it's conservative, it's out to criticize not to understand, and it never has any

fun. Why should I spend my time playing to that audience? That's like going into a lion's den. So I refuse to deal with that audience and I'll play with the street audience. That audience is much more human and their opinion is from the heart. They don't have any reason to play games, there's nothing gained or lost.

KJ: The piece that was at "Art On The Beach," does it have a name?

DH: I called it *Delta Spirit* because it was about that kind of spirit that's in the South. I just love the houses in the South, the way they built them. That Negritude architecture. I really love to watch the way black people make things, houses, or magazine stands in Harlem, for instance. Just the way we use carpentry. Nothing fits, but everything works. The door closes, it keeps things from coming through. But it doesn't have that neatness about it, the way white people put things together; everything is a thirty-secondth of an inch off.

So working with the architect was fun because our shit was outrageous. You had to have an architect on this project. So I hired Jerry Barr; we did *Higher Goals* together in 1983. He came up with the structure of *Delta Spirit*, he designed it. It was very puritanical. You know he's a big time architect, all over the world. He's designed houses in Paris, Cuba, and Africa and places. So this was one of his concepts. What I had to do was take that concept and put Negritude in it, which was a porch. He wanted to buy brand new wood; he wanted to spend about one thousand dollars on wood. But I had found all this lumber in Harlem and had stacked it up in these piles on various corners. So we just went around with a truck and picked up all the lumber, took it downtown and started making the house. It was built in the shape of a hexagon, a six-sided figure, using six foot poles, everything is six feet long.

KJ: Was that your idea?

DH: No, that was all Jerry's. I don't know how to stack wood, to keep wood from falling down. That's why he was important to the project. He knew how to stack wood and he knew how to get the best out of a piece of wood. I was just going to build a lean-to, a little shed, and take all the money and go home.

KJ: Do you think by doing a piece as cheaply as possible, that puts you on the same footing with a lot of people who are just trying to survive? Like you said, these newspaper stands in Harlem, I mean obviously these people don't have, they're not going to spend three thousand dollars on wood . . .

DH: Exactly. But these stands serve the same functions and they do the same things. They're just aesthetically different.

KJ: When you were doing Delta Spirit did you go down South and look at houses, or did you make the piece from memory?

DH: It's based on memories of the South. It also had a lot to do with Simon Rhodia's *Watts Towers*. I love his work, it's one of the best. When I was in L.A., these towers just really influenced me. I would like to work on one piece for the rest of my life; just one piece, like him. As opposed to toying around with all these other little things. Just make one piece. Most artists want at least one piece to be immortalized. So one piece would do it. Because we're making one piece anyway, I guess, fragments of it.

KJ: So what ever happened to *Delta Spirit*?

DH: It's still there. Yeah, I go out there all the time.

KJ: Really, I thought it was taken down. I thought it was going to be moved to Harlem.

DH: All of that got too boring to deal with. I got tired of thinking about it. So it might be there for a couple of years. But I didn't get the five hundred dollars that they paid the artists to dismantle their work. I'm waiting for the snow because I wanted to photograph it in the winter and document it under all seasons. I just see it as a piece of public sculpture. That's the other reason why I haven't taken it down.

I would like to burn the piece. I think that would be nice visually. Videotape the burning of it. And shoot some slides. The slides would then be a piece in itself. I'm getting into that now: the slides are the art pieces and the art pieces don't exist.[1]

I have video of *Delta Spirit* now, taken in the summer (1985). It's also on this Fat Boys video; they showed it for about sixty seconds. Their managers thought it would be good to have as a stage prop.

I have no idea if there was any real connection between the Fat Boys and *Delta Spirit*. My position is that it's just irrelevant to me. I was working on the house, if someone wanted to use it, I stay away from that thing because it doesn't relate to what I was doing. But if anybody can relate to it, good. Let them weave themselves in it and through it.

The Fat Boys were like big, heifer cows who waddled out of a limousine, who are going to die within three years if they don't take care of their physical situation. These young boys, three hundred pounds each, waddling down to the house and out of breath before they get there. And everyone

else making all the money around them. So their whole thing is out to lunch.

KJ: But I wonder if a lot of people see the Fat Boys video and see that house and are affected by that image.

DH: It's not on long enough. There's a close-up and they're on the porch and they come off. You'd only know about it if you knew about the house. I told my kids in California to watch for it.

KJ: To me, that house, *Delta Spirit*, was a conglomerate of black people's living. The way they put things together. It's not exactly the way a white or European person would do it.

DH: But it transcended that and went on into another level. Its significance changed as it got more ornamented; as it got more detailed, it went universal. People started seeing it who were from places like Tibet and Viet Nam, for instance, and told us about houses they've seen like that in all corners of the world. Getting this type of feedback also affected the piece.

KJ: That's why I thought the connection with the Fat Boys might be kind of interesting. Kind of bringing it back to city kids, and maybe giving them a chance to identify with it.

DH: It was really funny working on *Delta Spirit* because the other artists were so embarrassed by us or for us. They didn't know what we were going to do. They just saw this huge junk pile and everybody wanted to get rid of the wood, they thought it was an eyesore. We were the last ones to get the structure up, and we had a ball. We never got it finished, even though we worked on it every day.

KJ: It's still not finished, and it might not ever be finished. Like you said, it's that same piece that you work on and work on, and even when you die it's not finished.

DH: The way I see it, I have two pieces of public sculpture up on the island of Manhattan now. And looking for a third.

KJ: The pieces that you are doing now with bottles, your standard wine bottle with things like crosses and the Georgia clay inside of them. Are they related at all to the Thunderbird bottle pieces that you were doing before?

DH: With these bottles I'm using now, I got the inspiration from the book *Flash of the Spirit* (by Robert Farris Thompson). On one page I saw this little juju man sitting up there with a cross in a bottle. The thing about these

bottles I love is that people have to ask how you got those things in there. It's like a trick. It's like they're saying, "how'd you do that trick?" Or I get this from people, "Oh. I know how you did it, you took the bottom off the bottle and glued it back on." And I say, "Yeah, that's how I did the trick." But visually it's hard now to mess with people because everybody is so hip on what's happening. I like when people ask how I do these things because that means they don't know. Whereas in a painting everybody knows, or everybody thinks they know "it's an extension of such and such that's coming out of Picasso, or that's a collage from the such and such school," that kind of stuff. So I'm trying to find these holes or these gaps to play in.

I just finished a piece, with a voodoo doll in the bottle. That was fun. And then there's the bottle caps. I love bottle caps. Because I can get trillions and billions and zillions of those things. Whatever you see a lot of, you can use, you can build something off of. So I want to work with them forever. I also want to come back to the hair. All of these things I want to come back to at another time. Now I'm just laying down some kind of foundation; these pieces are like visual notes, like how you put notes in your notebook. These are all notes to come back to at another time, elements to reconnect in the future. The hair, the bottle caps, the bottles they'll all represent themselves in another salad on up the road somewhere. — January 20, 1986.[2]

NOTES

Originally published in *Real Life Magazine* 16 (autumn 1986).

1. *Delta Spirit* was vandalized before Hammons could realize his concept of burning and videotaping the piece.

2. During the summer of 1986 Hammons completed another work entitled *Higher Goals* with a grant from the Public Art Fund. Situated in Brooklyn, New York, at Cadman Plaza in front of the Supreme Court building, it consists of five telephone poles embellished with bottle caps and topped by basketball hoops. *Higher Goals* was on view in Brooklyn until October 1986.

Making Multiculturalism

PART THREE

Excuse Me While I Kiss the Sky
& Then Fly and Touch Down

My sister was Jimi Hendrix, at least to me — a bony, pale, super-shy adolescent in the mid-'70s. Mind you, in the East Village at that time everyone claimed to be the second coming of Hendrix or at least his cousin, love child, or muse. But my sister, two years ahead of me in middle school, was the real stuff — colossal Afro, pouty lips, bronzed like a gladiator. In a heartbeat she could go from school-girl giggles to silent and commanding beyond her years. She stood up to FBI agents who came to Cooper Square looking for my father, but settled for harassing my mother. Early on she mastered the unimpressed monotone of those who know things and could dole out no-nonsense answers to life's most esoteric questions. ("Why does he keep calling me?" I asked once, about a do-wrong boyfriend. To which she responded in perfect-pitch monotone, "'Cause you keep picking up the phone.") My sister listened to rock and rhythm & blues like it was okay back then to mix music. (It was not.) Had black, white, and Latino friends like it was okay to mix friends. (It was not.) No one would dare ask the chick with the Hendrix Afro to take sides. How could they? It always seemed to me she was born herself, and there was no one badass enough around to argue her out of it.

Forget everything else you've heard about how she became Kellie Jones; I will let you in on the three defining elements of her young life. You don't have to thank me, it is my pleasure:

EARTH, WIND, AND FIRE RECORDS Kellie listened to Earth, Wind, and Fire albums more than anyone is humanly capable of, at high volume, for a period of at least half a decade. As her younger sister, without a record player of my own, I could only endure. (In fact, even now when I hear an Earth, Wind, and Fire

song, I don't experience it as music, but as a secret code that activates my brain waves and makes me want to retreat to bed and pull covers over my head.) Given the band's music is a hash of R&B, African, Latin American, rock, and jazz, where James Brown–style funky horns hold equal weight to the *kalimba*, the West African thumb piano, then we can only surmise where this would lead Kellie. Her world would be large, no doubt, but if you add the band's live shows complete with pyrotechnics and pyramids, magic tricks and levitating guitar gods, it was pretty clear she see would shamanism as a legitimate profession, hence her interest in fine fellows like Jean-Michel Basquiat and David Hammons.

PAPER DOLLS: Around ages nine and seven, Kellie and I created an extensive catalog of homemade paper dolls—perhaps because there were none that looked like us, perhaps because there was little money for store-bought toys. Each had an over-the-top fantasy outfit and name. These were multiculti superstars before the age of multiculti superstars; as my daughter would say, "wearing skin" of chocolate, café au lait, and cinnamon, with hair of epic proportions. It was our own version of the *casta* paintings, which documented race-mixing and caste in eighteenth-century Mexico. Kellie always insisted we write stories about these characters on the back of our drawings. "Nekkudasia–a fashion model who likes Go-Go boots too" is one foggy memory. Evidently this was Kellie's first go-around at the close reading of visual texts and interpretation of material culture as the great signifier. Was this all fun and games or was she born with a keen desire to order the universe in her own image and needed an accomplice (me)? Will we ever know?

AL LOVING'S HEXAGONS: Anne and Alicia, our girlhood running buddies in the late '60s/early '70s, were the stepdaughters of the painter Al Loving. We four girls spent many hours in Al and his wife Wyn's loft and studio on the Bowery practicing dance steps and playing make-believe. Al was in his geometric period at the time. In the stark white studio with the high ceilings and the floor covered in paint streaks, Al would stand for hours mapping out his neon 3-D hexagons and octagons. To me, these paintings always beckoned you to fall into the maze and travel to a world of your own making. The loft was our *Alice in Wonderland*. There are photographs of us four playing in the studio with Al's work in the background. The shots are blurry, rendering us just flashes of light, fairy ghosts. When I return to that time in my head, I see my sister hanging upside down (from what I don't remember), staring at a painting and me standing nearby, staring at her and wondering what she saw there. I guess this is what happened to Kellie. She was Alice. She went inside the paintings and came back to tell.

"How I Invented Multiculturalism," my essay which Kellie reproduces here, has been reprinted often as a sort of love song/manifesto of 1990s identity politics. In truth I should have called it "How I Invented Multiculturalism (after Stealing the Patent from My Sister)." After girlhood, the chick with the Hendrix Afro continued to live life ahead of the curve—designing her own major at the newly co-ed Amherst College: African American Studies/Latin American Studies/Art History. An obvious question here is how many eighteen-year-olds are self-possessed enough to conceive of their own discipline of study and then go on to make a life for themselves that seems divinely ordered by this invention? Whoever Kellie met inside those paintings laid a heavy mantle on her shoulders.

Naturally Kellie aced college with high honors and was chosen as class speaker. Burned in my mind like a fresh Polaroid is my sister at the graduation podium, Afro now replaced by cornrows accented with colored beads. There she was, schooling the blue bloods and their parents that she, as a child of the diaspora, was destined to lead, and was in fact the world's majority—connecting the dots between America, Africa, and Latin America, our shared heritage and political destiny. In the early '80s this was still a ballsy statement, even more so at an ivy-covered monument to privilege like Amherst. In the audience, I remember my mother, Hettie, the boho writer, and my grandmother Anna Lois, the social worker—one white and one black—nodding at each other with satisfaction, as if they expected this sort of thing from Kellie all along.

To me, then a college sophomore, these words felt spanking new and insurrectionist, especially when held up against the doctrines of our youth—the isolationism of black nationalism or the hedonism of the sparsely integrated hippy counterculture. Was she saying we were all connected? Was she giving us permission to be our mixed selves? Was this meant as a political dictate as well, one that moved beyond narrow race-based ideologies? A seed was planted. By my senior year in college, I had left law school ambitions behind to found a magazine called *Ritual & Dissent: A Journal of Black Arts and Letters*, which included a piece on Latin America and aspired to have a global perspective as big as my big sister's. My life keeping up with the Kellie Joneses had only begun!

You might assume these early milestones of Kellie's as a young scholar were effortless given our family back story—children of mixed marriage, of writers, and lefties. But life shuttling between the free-love East Village, our home with my mother, and the blacker-than-thou nationalist Newark of my father was not without its fissures. The multicultural One World that we went about heralding and documenting in our writing was not a neat utopia offered to us on a silver tray. It was messy, full of the same power struggles around race, gender, and class that marked the colonization of the New World from day one, and it was up to us, as my

grandmother Anna Lois instructed Kellie once, "to make it work." (My embellished translation: Take what you can use, reject what you can't, and make sure you treat all parties involved with respect.)

And clearly there was a lot to *make work*—the East Village and its race paradoxes (where Hendrix-worshiping hippies lived side by side with racist Ukrainians who threw rocks at little black girls like me and Kellie); Newark, also called New Ark, where we learned hate-whitey chants alongside race pride at Hekalu Mwalimu, my father's nationalist cultural center; but also the southern-flavored, middle-class Newark of my grandparents who, as I wrote in *Bulletproof Diva*, "loved all who presented themselves to be loved"; the Bowery and its gender- and race-morphing transvestite parades, visible from our bedroom window in the East Village; the junkie wasteland of Alphabet City, several blocks away from my mother's apartment, where druggies of all colors squandered their lives in-near perfect racial harmony; and, of course, the missing link, the largely Latino Lower East Side of our youth, known as *Loisada*.

Yet to read Kellie's introduction here, she assimilated our varied childhood influences quite effortlessly. (I guess when you're Jimi Hendrix, life makes sense.) I know in my case it was an intellectual balancing act, to say the least, which I feel I didn't get right until I wrote the essay that appears here. Hence the importance of our childhood safe spaces like our mother's place (where we could be all things, play all music, bring all friends) and, of course, the Lovings' loft (how apropos given that other famous Loving family, the Lovings of *Loving v. Virginia*, who were party to the case which legalized interracial marriage in 1967). It was a powerful example that Al and Wyn (also painter Jack Whitten and his wife, Mary), black and white, lived, loved, and made art together despite the wars of the day, something our own parents hadn't been able to do for long.

Not surprising *Loisaida* plays large in Kellie's journey as a writer and curator. At the Church of All Nations, our nursery school in the pre-gentrified East Village, Spanish was the language of the playground. We grew up taking multilingual New York, and by extension America, for granted. In college it made complete sense to find Kellie studying Spanish formally and traveling to Latin America. She was catching up on a language that was already in her bones coming of age in *Loisaida*. In her essay "Lost in Translation: Jean-Michel in the (Re)Mix," included in this section of the book, Kellie makes it her business to examine Spanish as Basquiat's mother tongue. (Also check out Kellie's dissection of the Haitian–Puerto Rican artist's strategy of occluding influences by playing primitive. Keenly multilayered scholarship, if you ask me.) Kellie and I knew something about that intimacy too. As little rainbow girls navigating the East Village, we found *Nuyorican* culture (New York Puerto Rican) to be another safe space where it appeared that folks had worked out the race thing at least to some degree. (The Young Lords, the

Latino, East Harlem–based version of the Panthers, were among my heroes grow-
ing up. Thought it was a style thing when I was kid, yet realize now they must have
embodied a community not rigidly defined by race.)

For me, learning about the "miscegenated" origins of Latin and Caribbean cul-
ture from the scholar Robert Farris Thompson in college (and I imagine for Kellie
during her tutelage with him in graduate school) was akin to being handed a libera-
tion theology. It seemed like a veil was lifted off my life and I was given permission
to flip the bird at all orthodoxies. What? As mixed-race kids we were not the taboo
love children profiled in *Jet* (Behold! Freaks of nature! The black and white twins!),
but beings who had peopled the Western hemisphere for centuries, made by the
natives, the colonizers, and the enslaved. Our birthright as citizens of the diaspora
was wide. And our mandate, to hear Kellie tell it, was to make these connections so
as to insure, in the words of Malcolm (tattooed to our brains in African Free School,
which we attended back in nationalist Newark) that all of us — black, brown, yellow,
and white — could dine at the table. Again, linking different races was still a radical
act even in the early 1980s. Best if it remained a secret that we were all related, and
that the reason for this ultimately led back to S-E-X! (And land grabs, but that's a
longer story.) After all, this fact would require too much realignment of our values
and beliefs, and would force us to reckon with being family.

Some people discover another culture that turns them on — as scholars or human
beings — and they disappear into that culture. They become, as it goes, more Jamai-
can than the *Ja-americans*, and more Rican than the *Nuyoricans*. Not Kellie. Her
relationship to Latin American culture is an intriguing one — she is neither tourist
nor native. In the essays on Latin American artists included here, she writes as a
cousin, exploring ties between lost family members, yet you always feel her re-
spect for the sanctity of the culture she explores. To borrow and recast a word from
the poet Audre Lorde, maybe she is a "sister outsider" — a lost child who was raised
elsewhere and returns a griot, a thorn in the side of the elders, opening their eyes
to possibilities beyond the village borders. Kellie's piece on artist Pepón Osorio,
"Domestic Prayer," also appears here. She begins with a concise history lesson on
origins of the diaspora so we can fully grasp the brilliance of Osorio, a black Puerto
Rican, and his labyrinth and kitsch dioramas of cultural fusion. This is classic Kellie,
giving us a road map to read the work through her lens; one that always insists that
the world family has more in common than not.

If our lives were a Tyler Perry "stage play" based on the novel *Causasia* (I'm
laughing as I write this), I would be Birdie, the younger sister who is light and is,
to some eyes, unrecognizably black, and Kellie would be Cole, the older sister who
can pass for black without a double take, unless you follow her home. Growing up,
Kellie may not have had to constantly explain her personhood the way I did — with
a calling card based on the Adrian Piper art piece as I imagined in *Bulletproof Diva*

(thanks again to Kellie for hipping me to Piper)—yet her particular journey navigating the race wars is coded in her writing.

One subtext I see in this work—perhaps speaking more as a sister than as a fellow writer, forgive me for blurring the lines—is Kellie's journey to make sense of who she is culturally and racially. (Ah—even Hendrix girl had to do it! Sorry to call you out, dude!) These are writings about works of art and how they express the personal stories and culture of those who make them, but behind them I see the road Kellie, the proverbial mixed child without a homeland, has traveled to know that she is whole. And of course find a place for all her influences: the black, brown, and white statues of saints calling out from the *botanicas* of *Loisaida*; the white skateboard kids she hung out with in the West Village; our grandfather, the southern gentleman, and weekend afternoons spent at his corner store in Newark, which he called The First and Last African Shop (though he had never been to the continent and sold primarily bowling shirts cut like dashikis); our mom, the boho Jew, and her love and respect for Native American poetry and cultural wisdom; our father, Amiri, who was to our young eyes the poet King of Afro-America; and of course, James Brown, in his long, flowing processed hair, sleek as Barbie's, urging us, to the beat, to "Say It Loud (I'm Black and I'm Proud)"—the political marching orders of the day. In the end, hip-hop might have the best line to explain how Kellie brought together such disparate worlds and made her cause the excavation of our common art history: In the words of Run-D.M.C., "It's like that, and that's the way it is."

A decade and change later, I continue to be excited by Kellie's dissertation, "Flying and Touching Down: Abstraction, Metaphor, and Social Concern," on Mexican and African American conceptual artists working from 1968 to 1983, and it remains a touchstone for my own creative process. Of course, there's the title alone (inspired by an Adrian Piper quote), which is the most concise description I've come across of the play and power abstract thinking allows. We know that the dissertation and the work that followed established Kellie as one of the leading scholars of contemporary African American and Latin American visual culture. (So, now it is clear that those journeys inside Al Loving's paintings would bring her full circle—as an adult she would be called to write about these same art pieces.) And she has done her most pioneering work linking the two cultures. In "Poets of a New Style of Speak: Cuban Artists of This Generation," also included here, Kellie gets away with comparing Cuban painter Tomas Esson's large cartoonist canvases with the music of hip-hop's "peace-loving" iconoclasts De La Soul, and recognizes that each takes on the "sacred cows of recent heritage." I guess for Hendrix girl, the diaspora is nothing but a small town where all paths converge.

Like the Spanish of *Loisaida*, abstraction was another mother tongue that surrounded my sister and me—whether at Al's studio (or Whitten's, William White's,

or the studios of other family friends) or on the walls at my mother's and father's houses. There were also those wild, joyful times we spent as kids running around gallery openings, treating the art works like our private frescos. (I remember playing red light–green light once at an opening of new work by the abstract expressionist painter Ed Clark. The adults were too buzzed on cheap white wine to notice. Yet come to think of it, even when the wine wasn't flowing they never seemed to mind much having little people dance and do magic tricks next to big people's art.) I'm sure it never occurred to us that the abstract art that filled our apartment would be bourgeois status symbols if displayed in another venue (probably because we lived in a crumbling walk-up on the Bowery). They seemed more like maps, family trees, or hieroglyphics; coded images we needed to decipher to make sense of the complicated adult world of race, love, and loss. Looking back, I think Kellie and I understood instinctually that this art was indispensible to our lives; and, as with our coterie of paper dolls, vital to the adults we would become.

No coincidence that as an art historian Kellie has emerged as a skilled translator of abstraction, recasting it as a lens indispensible for those of who have many vantage points to synthesize. Her essay on David Hammons in this section was one of the first pieces I read that saw beyond jazz as the sole trope of abstraction in black art and explored the significance of other models like hair—a medium that has been for African American women both a popular and high art form. Kellie brings together the voices of women scholars and writers and positions Hammons, the celebrated avant-gardist, as an interloper in an older creative tradition. Touché, Mr. Hammons, big man on canvas, collector of dreadlocks and shoes! You follow a largely feminine tradition! So, Kellie as Alice turns out to be on a feminist mission too.

It's still a mystery to me that Kellie, who stands on her own in every way, would chose to bracket these groundbreaking writings of hers with family voices. She writes about being in conversation with us, but in truth it is we who have been in conversation with her. She has been always four steps ahead of us—mining the New World diaspora before she turned twenty, before finding a mentor in Thompson, and before it was de rigueur in American scholarship. (Here is a snapshot of Kellie, just out of college, at a conference moderated by my father on post–Black Arts Movement visual art at Kenkeleba House, the gallery in lower Manhattan: she stood in line with scholars and artists decades her senior, and when it was her turn, didn't ask a question of the panel, but made a statement: black American artists, she warned, should familiarize themselves with the multicultural and multilingual inheritance of the diaspora, so they wouldn't be made irrelevant by their own parochialism. I remember a hush coming over the room and heads turning. Say what, little girl?)

Notice too that for this essay collection Kellie feels no need to bring in big wig

art scholars to validate her work. Clearly Hendrix girl has never required permission to speak her truths. In fact, beyond creating a forward-thinking body of critical work on contemporary art — from the new blues aesthetic to New World abstraction — Kellie's writing has been at times, by necessity, a form of activism. She championed artists the mainstream had never heard of before, as well as, when called for, critiqued the race politics of the art world. Witness the short piece here on Tim Rollins and K.O.S., which asks questions about the passive racism of the postmodernists; it was written in 1989, back before it was fashionable to lift their skirts. Yet to her credit, Kellie has never sacrificed critical thinking to the soap box. Yes, the girl with the Hendrix Afro has a long to-do list.

Did I tell you that Kellie was a painting major at Music and Art High School, the famed arts school that was once in Harlem before it moved to midtown Manhattan? A running joke we shared as kids is we didn't want to be starving artists like our parents, yet we both landed not too far from the art roost. In Kellie's writing I am aware of her eye, the eye of a painter/photographer, constantly reframing the subject, the angle telling you how to look anew; going for a close-up (an illuminating detail, a cultural fragment) or a wide shot (bringing in big history or pop references). Here's one of Kellie's "shots," this too from the Basquiat essay:

> Basquiat's canon revolves around single heroic figures: athletes, prophets, warriors, cops, musicians, kings, and the artist himself. In these images the head is often a central focus, topped by crowns, hats, and halos. In this way the intellect is emphasized, lifted up to notice, privileged over the body and the physicality that these figures — black men — commonly represent in the world. With this action the artist reveals creativity, genius, and spiritual power. Basquiat has at least four paintings that use some form of the word *cabeza* (head) in their title. In the earliest, *Cabeza* (1982), the black figure painted on a gold ground doesn't only seem to grimace through clenched teeth, but to smile. . . . *Dos Cabezas* from the same year is a double portrait of the artist with Andy Warhol. As Muñoz has pointed out, in this canvas Basquiat envisions himself as equal to his friend and mentor by painting the figures roughly the same size; here they are intellectual partners. But it is also a gesture of interculturation in which Basquiat makes Warhol speak *en español*. It is a voice of intimacy for Basquiat as well, the voice of the mother who herself was an artist, and inspired and promoted her son's creativity. As the artist has recounted, "I'd say my mother gave me all the primary things. The art came from her."

To which I say, you better work, Hendrix girl! Love the idea of Basquiat turning Warhol, the Western art demigod, into a Creole. Work those close-ups and wide shots and then bring it all back to the womb!

I was accepted by Amherst, and in the spring of my senior year of high school I

took a long bus ride up to Massachusetts to visit the college and my sister, who was a sophomore there at the time. When I got off the bus, the small welcoming party from the black student union surrounded me with smiles and someone blurted out, "Welcome to Amherst, Kellie's sister!" Needless to say, after that Amherst was not in the cards for me.

As big sisters go, Kellie has been gracious about being so smart, driven, and phenomenally talented. Others would have walked into the sunset solo. But for some reason my sister has always been intent on bringing me along. She gave me my first writing job—commissioned a performance piece for an art exhibit she was curating. This was 1985 and it was the first I had heard of "performance pieces," but my sister, as I described in *Bulletproof Diva*, was convinced I had something called a "voice" and could pull it off. From that show, I formed a performance troupe and wrote more plays. Kellie acted as a publicist and champion. Newspaper columns, books, and screenplays followed and she was always ready with encouragement. I have written about the revelation of discovering that, as a writer, I wouldn't have to tell the same stories as my writer parents, as I am neither a black man nor a white woman. And I have written about the thrill of connecting in the mid-'80s with other young black boho artists who shared the same dreams and demons. But what I haven't said out loud is that all along I have been lucky enough to write for and in conversation with a sister like Kellie: Hendrix girl, who has been making sense of our world for me since day one. Once again here she is in "Jean-Michel in the (Re) Mix":

> The excess in Basquiat's work—the parts that cannot be so easily contained in the African American context of the United States or the centuries of Western painting—reasserts itself in the context of diaspora, in the outernational culture that is at ease crossing borders and oceans. As scholar Nicholas Mirzoeff points out, it is art with a "multiple viewpoint" that exchanges "the one-point perspective of Cartesian rationalism for a forward looking, transcultural, and transitive place from *which to look and be seen*" [her emphasis]. And so the action that moves through Basquiat's painting is dialogic, it is an interactive process.

Ah, so that's the rub. Just be "your whole selves thing"—like Basquiat, like Hendrix, like Kellie—and then the world will follow suit. Now I get it!

I continue to enjoy her eye on and off the page. We keep running lists. Amazing tales, still found in *Jet* magazine, of black and white conjoined twins; hair styles of the monied, black, beautiful, and self-hating; the art world scandal sheet; notes on street fashion as walking installation art; the ongoing account of fabulous women of color everywhere and their quest for self-determination; a daily journal of the politics of race, class, and consumerism; and, last but not least, our decades-old

"The List," which catalogs the "finest" men on the planet, and now includes our husbands first, of course. Our high art rationale: it's all about the human body as sculptural form. Really.

Kellie's latest report involves a singer she heard at a Black Rock Coalition tribute concert to Curtis Mayfield at Brooklyn's BAM Café—"Dude, I'm telling you," she says to me. "This girl is Janis Joplin reincarnated as a Latina! Her voice was clean, clean! Like the high note of an electric guitar. She is an orisha or something. Eshu Elegbra as a guitar god, hiding out in the body of a woman. Screaming those notes and hitting her wah-wah pedal like she was calling down the saints."

I'm sorry you are not us. You are missing a lot.

I love to see Kellie show up at my house in Harlem, wearing as her husband calls them her "saucy kitten" thigh-high boots, a purple coat, and a zebra print scarf, looking altogether double-Hendrix—Jimi and Nona. From my place she will head up the hill to Columbia to teach a survey of Western art history. Invariably I will say, just for fun of course, "You're dressing like that?" She will look at me with eyes wide and lips pressed together in mock defiance. And then, no doubt, she will turn around slowly so I can get a better look, as if to say "This *is* the canon, baby!"

New York City | June 23, 2010

How I Invented Multiculturalism

It was easier than you think. First I arrived, fatter than an A&P chicken, just another black child in New York City born to a Jewish woman and a Negro man. Before race became my passion and my battle cry, the only thing I wanted in life was to be joined at the hip with my older sister. At the wee age of three I followed her to the Church of All Nations school on the Lower East Side. For many years I thought the entire world was a band of Latin, black, and Chinese children dancing around the maypole and singing "Que Bonita Bandera" and the few Ukrainians who served us lunch.

Picked up my first curse word, *maricón*, from Jesús, born in the Dominican Republic, which was an island, he showed me, just across the river from our playground on Avenue D. Twenty years later I moved there, but someone had changed the name to Brooklyn.

Endured my first Toni home permanent at age six to have an Afro like Angela Davis. This continued for four years, then thanks to chemical overload or natural progression, my hair napped up enough to make a 'fro on its own.

Ate potato kugel and boiled chicken with Aunt Fannie, the only Jewish relative who didn't disown my mother for marrying a black man. Eighty-year-old Aunt Fannie stayed in Flatbush through the Caribbean migration and was known to have made only one comment about her niece's interracial marriage: "How do you wash that hair?" she said, leaning over her grandnieces, still in grade school, and their enormous globes of nappiness.

Metamorphosed, in the late '60s at age seven, as a nationalist poet. Appeared in the poetry revue *In Praise of Black Women* on stage at the Negro Ensemble Company Theater wearing seventeen braids and reading, in

the style of the Last Poets, "Fried Chicken and Collard Greens Gramma." My grandmother had me recite this masterpiece for her friends the social workers and other silver-haired belles of black Newark whenever we came across the Hudson to visit.

Named my cat Huey Newton. Named my dog Ho Chi Minh.

Grew dreadlocks at Methodist summer camp in New Hampshire. The camp counselor couldn't comb my hair. Hung out on a nude beach in Nantucket another summer realizing how black people's bodies put the fear of God in some white folks. Most memorable summer: 1969. Spent two blissful months in a cabin on the Jersey shore with a household of very opinionated and well-dressed black women — my grandmother, several aunts, scores of cousins, and my sister — riding bikes six in a row and lip-synching to Aretha. The townies thought we were some lost tribe of Amazons.

Went to high school in Chinatown. The yearbook lists my two favorite books as *Wuthering Heights* and *Native Son*.

Endured chemical relaxers to slay my Afro, and curling irons in homage to Farrah Fawcett.

Gave up my cherry in Babylon, Long Island, in a trailer home owned by an Italian drug dealer. My first boyfriend was his son, a black kid with an orange Afro who sold reefer on the weekends in Washington Square Park. The kid introduced me to Jimi Hendrix and sushi. I gave him Chaka Khan and Caporel's Spanish-style fried chicken.

Took hustle lessons in the mid-'70s from a Polish DJ who grew up around Puerto Ricans and had a black Panamanian girlfriend. Became a regular at the Paradise Garage. Thought the "disco sucks" movement was a racist ploy backed by the Ku Klux Klan to keep folks of different cultures from dancing together.

Traveled to Trinidad the summer of junior year in high school at the invitation of seventeen-year-old pen pal Jenny Paul. Jenny's best friend, Wendell, was Chinese, East Indian, and African. Didn't bring back much Trini twang, though did learn how to wine like a Trini at Saturday night jump-ups in Port of Spain.

Worked in Greece as a mother's helper. Stumbled on a shrine of one of Europe's many black Madonnas on a tiny island off the coast of Crete.

Found my soul sister/best friend on an Ivy League campus in the late '70s wearing a red bandanna, booty-tight jeans, and five-inch heels. Once she cursed out the entire rugby team for advertising a "slave auction" fundraiser. "Puerto Rican" wasn't inclusive enough for Miss Two and a Half; she called herself "black Latino" or "Third World Woman."

Read Wole Soyinka, William Carlos Williams, and Gloria Anzaldua. Led

a boycott against the campus store for tracking black male customers like prison escapees.

Cofounded the We Waz Girls Together Off-Campus Collective. Threw "After the Revolution" parties with Ghanaians educated in Britain, white women in "Warhol does Mao" T-shirts, Nuyoricans in Izod polos, white guys from Chicago who spoke "black English," black women from Compton who became prison lawyers, and Cubans in deck shoes who wanted to be rich whites and, in fact, were.

Lived in a North London squat with African American rock 'n' roll expatriates and a Scottish skinhead motorcycle gang.

Returned to New York in time for the premiere of *Purple Rain*. Wondered if black women—especially browner-skinned black women—would be missing from Afro America's new media facelift as sculpted by fellows like Prince and Michael Jackson.

Refused to endure a "California curl" so my hair could bounce, as promised by a stylist, just like rainbow-baby actress Rae Dawn Chong's.

Dug Jessica Hagedorn's collection *Pet Food and Tropical Apparitions*, about a Filipino-American woman coming of age to black music and California kitsch. Discovered the multiculti in me and loved her fiercely. Knew that cultural pluralism was more than a performance piece for well-heeled art house patrons, but an everyday life led by thousands of Americans, black, yellow, brown, red, and yes, even white.

Reborn as a race woman after Howard Beach. Joined the Make Black Film movement. Made Black Movies.

Reread Zora Neale Hurston, Kafka, and Nella Larsen. Rediscovered my mentors, Thurgood Marshall, Fannie Lou Hamer, Che, and Ida B. Wells. Have plans to revamp Dr. King's Poor People's Campaign in crack capitals across the country. But first I have to write my version of *Bonfire of the Vanities*. Instead of scratching each other's eyes out, everyone does what everyone has wanted to do all along: has sex.

Eventually I'll make it to the Motherland when I raise the cash. It's been a wonderful life, really.

NOTE

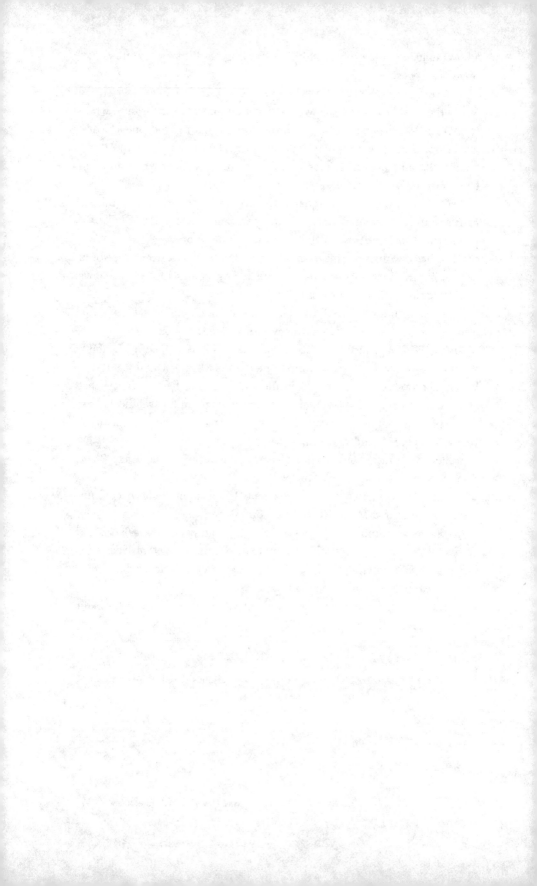

Lost in Translation

Jean-Michel in the (Re)Mix

Jean-Michel Basquiat, *Gold Griot*, 1984. Oil and oil paintstick on wood, 117 x 73 inches. The Broad Art Foundation, Santa Monica. © 2010 The Estate of Jean-Michel Basquiat / ADAGP, Paris / ARS, New York.

According to popular perception, both within the Western metropolitan psyche and in the critical strategies of postcolonial discourse, the daydream of a diasporic community is always lodged in an imaginary locale, in an elsewhere, far from the articulate inscription of native utterance. It is usually symbolically invested, and ceaselessly organized outside the principalities of any originary geography.

OKWUI ENWEZOR

PRELUDE: QUESTIONS FOR CURATORS

#1: Did you know Jean-Michel Basquiat?

On the Reverend Dr. Martin Luther King Jr. holiday I get my inspiration for this essay from a friend's five-year-old son, G, who has just learned about MLK in school. He refers to him interchangeably as Dr. King, Dr. Martin Luther King, and Martin. "And did you know, Mami, he got shot?"

#2: How well did you know Jean-Michel Basquiat?

Everyone has a Jean-Michel story. It wouldn't be a Jean-Michel show without one. Mine is this. I met him on the dance floor at a Spike Lee party at the Puck Building in '87. . . . We wuz on top of the world. Or as Ntozake said, "We wuz girlz together." We rocked and rolled in the 80s, when kolored wuz king (yit agin). But Jean-Michel wuz in another realm, in the stratosphere. . . . Anyway there I wuz on the dance floor and Fab Five Freddy introduces us. He says, "This girl's a curator" (translation: this girl's a curator and lo and behold she's kolored). But did he say I could dance?

THE ARTIST IN THE WORLD

For many years now the art of Jean-Michel Basquiat has commanded some of the highest prices of any African American artist in United States history. Like most of his African American compatriots, his work was underappreciated by United States cultural institutions during his lifetime. And also like so many others both he and his oeuvre were more palatable after his death. But the irony is that with price tags in the millions it is doubtful that the work will ever get into these same hallowed (hollowed?) halls except through the magnanimity of some private individuals.

But it is not just prices that are high, or that Basquiat has made it into the realm of famous art-star ancestors, commanding cash, recognition, and respect. The real deal is that Basquiat's aesthetic presence, his vision, his impact and effect, are, in the words of '60s R&B legends the Temptations, "so high you can't get over it, so low you can't get under it."[1] Or as anthropologist Grey Gundaker has argued about dynamic African American cultures generally, "the fruits of the relatively new enterprise of African American studies suggest that there is too much information on too many levels—and too much more to learn—to expect anything less than a wide-ranging network of connections."[2]

Indeed, there is much more to Basquiat's work and intellect than meets the eye. He was a master of seemingly exposing things—the skeleton, the infrastructure, the core language of art and life—yet at the same time he occluded origins, influences, and skill with layers of a frenetic, always-in-a-hurry style.

He is, of course, an exquisite painter as seen in the minute details that swim to the surface in works such as *Leonardo da Vinci's Greatest Hits* (1982) or the self-assured figure in *St. Joe Louis Surrounded by Snakes* (1982). But he also created engaging colorfield surfaces such as *King Pleasure* (1987). The drawings are phenomenal as well: some are spare, economical meditations, distillations of an idea into the meanderings of line; others are dense with deposits of marks and words. Basquiat's almost overwhelming wordplay points to the profound conceptualism of his project, which is also visible in his rare three-dimensional objects. A piece like *Untitled* (*Helmet*) (1981), with black hair glued to a football helmet, riffs on David Hammons's decade-long project in the same vein (check out Hammons's *Nap Tapestry* [1978]). Basquiat's *Self Portrait* (1985) reveals a surface cluttered with bottle caps that also echoes Hammons's *Higher Goals* of the same year, a take on sports as both ghetto exit strategy and unattainable dream of black manhood. This dialogue with Hammons suggests Basquiat's ease in speaking on the conceptual plane. It shows he didn't have to be, but rather chose to be a painter.

Part of Basquiat's strategy of occlusion was "playing the primitive." Selling shirts and objects in Washington Square Park. Affixing his name to urban corners, a middle-class boy from Brooklyn in the guise of graffiti artist. Like John Guare's protagonist, the gay hustler Paul, in the play *Six Degrees of Separation*, who makes his way into restricted social circles and homes by (mis)representing himself as the son of actor Sidney Poitier, Basquiat cruised into the art world on the runaway subway train of graffiti that was fueled in part by the stirrings of '80s multiculturalism. Basquiat's suc-

cess and his investment in and comments on the art world's star-making process of the art play a part in his fascination with brands and trademarks. As cultural critic José Esteban Muñoz has written, the tag "IDEAL," which appears in the late works, points at once to a nationally recognized brand name of toy maker, to the false moral value placed in consumer products, and to the artist himself, the "I" who not only "deals" in "the same consumer public sphere" but makes his way to the top of the art world heap.[3]

Basquiat and multiculturalism were the right combination in the right place at the right time. Indeed the critic Greg Tate has argued the same of Jimi Hendrix, who infused the British rock scene with new blood at a crucial moment. As Tate writes of Basquiat and crew at the turn of the 1980s, "Poised there at the historical moment when Conceptualism is about to fall before the rise of the neoprimitive upsurge . . . hiphop's train-writing graffiti cults pull into the station carrying the return of representation, figuration, expressionism, Pop-artism, the investment in canvas painting, and the idea of the masterpiece."[4] Yet interestingly, as Tate also reminds us, Basquiat arrives not with the waves of bold color that signal outlaw urban painting, hues that would later characterize his own canvases, but with spare texts sprayed in black on peeling walls; he comes to us "as a poet."[5]

There is no question that Jean-Michel Basquiat, though he sometimes chose to obscure the fact, knew how to "paint Western art," and was a formidable part of that tradition. Yet American painting, specifically, and the Western art tradition in general was only one source of Basquiat's aesthetic. As Tate writes, "Initially lumped with the graffiti artists, then the Neo-Expressionists, then the Neo-Popsters, in the end Basquiat's work evades the grasp of every camp because his originality can't be reduced to the sum of his inspirations, his associations, or his generation. . . . He has consumed his influences and overwhelmed them with his intentions."[6] Indeed Basquiat is imbricated in, and draws on, not only the story of Western mark-and-art-making but the immense history of the globe itself, *In Italian* (1983) as one painting tells us, as well as in Greek, English, Ebonics, French, and Spanish. These paintings display modernity in their very facture but also overwhelmingly in their content. They constitute a chronicle of the world in modern form, connected through waves of history and histories of power. As scholar Arjun Appadurai has pointed out, artists like Basquiat "annex the global into their own practices of the modern."[7]

To the extent that Basquiat is a New World citizen and an African American, he inherits a hybridized African culture that is a key ingredient in the cultures of the Americas. Speaking of the Cuban artist Wifredo Lam, curator Gerardo Mosquera has discussed modernism as "space to communicate

Afro-American cultural meanings."[8] A plethora of African civilizations arriving on American shores in continuous waves (as well as over them) from the seventeenth through the nineteenth centuries is carried in "religious-cultural complexes"[9] like Santería, Vodoun, Candomblé, and Shango, and I would add Hoodoo, as well as through folktales, gesture, performance, and aspects of attendant material culture production. Rather than seeing these as struggling "survivals," Mosquera speaks of African culture "on the other side of the Atlantic" as flexible, appropriative, transformational, and dynamic, leading finally to Lam and his creative dialogues with the Caribbean and African Negritude poets in the fashioning of a "neological construction of a black paradigm," or a twentieth century, modernist, diasporic culture.[10]

The cultural critic Stuart Hall sees the new world of the Americas as a "primal scene" not simply of the encounter of cultures but of displacement, migration, and as one originary site of diaspora.[11] For Hall, within this geographic and psychic space "Africa, the signified which could not be represented directly in slavery, remained and remains the unspoken unspeakable 'presence' in Caribbean culture."[12] While this may seem to be the antithesis to Mosquera (and perhaps represents the differences of the Caribbean seen from Anglophone Jamaica and Hispanic Cuba respectively), Hall's focus on the "unspoken" and "unspeakable" African life of the New World derives more from its dialectical relationship to the overdetermining European presence there, "which is endlessly speaking—and endlessly speaking us." And he asks, "how can we stage this dialogue [with Europe] so that, finally, we can place it, without terror or violence, rather than being forever placed by it?"[13]

One aspect of Basquiat's genius was his ability to "consume his influences and overwhelm them with his intentions," as Tate has noted; that is, not to be placed by European tradition but to place and reassign it, to remind us that Europe as it appears on this side of the pond is "always-already fused, syncretized," in other words, it is a version of Europe in the process of becoming American.[14] His skill was also in his energetic articulations of the "neological construction of a black paradigm," as outlined by Mosquera.

However, Basquiat's mischievous, complex, neologistic side, with regard to the fashioning of modernity and the influence and effluence of black culture, is often elided by critics and viewers—lost in translation. The establishment of a comfortably canonical body of his work obscures the places where he connects with those "religious-cultural complexes" whether as material, performative, or gestural subjects. For example, thematics such as "Negro" athletes and black jazz musicians give a place and a face to Bas-

quiat's blackness and his masculinity in the work. Certain related history paintings such as *Undiscovered Genius of the Mississippi Delta* (1983) are also fairly easily digestible forms of black culture. Through the lens of multi-culturalism, these scenes visually signify blackness, are already overdeter-mined, and as self-contained, United States black history can be assigned to "the margins of modernism,"[15] as hermetically sealed dioramas of, dare I write it, "the other." As I have argued elsewhere, art by black people is often seen as the conscience of Western humanism, a role that a work like *Natives Carrying Some Guns, Bibles, Amorites on Safari* (1982) seems to easily fulfill.[16] And as Hall suggests, *haute couture* (and luxury objects like art) can always be supplemented by the air of sophistication carried by the black transgres-sive.[17]

But even *Natives Carrying Some Guns, Bibles, Amorites on Safari* has its eye toward the global, alluding to imperialistic adventures that repeated themselves worldwide, and not just in the move from Africa to the United States. The excess in Basquiat's work—the parts that cannot be so easily contained in the African American context of the United States or the cen-turies of Western painting—reasserts itself in the context of diaspora, in the outernational culture that is at ease crossing borders and oceans. As scholar Nicholas Mirzoeff points out, it is art with a "multiple viewpoint" that ex-changes "the one-point perspective of Cartesian rationalism for a forward looking, transcultural and transitive place from *which to look and be seen*"[18] (my emphasis). And so the action that moves through Basquiat's painting is dialogic, it is an interactive process "between individuals, communities, and cultures," caught in the exchange of glances, the parrying of visuality and visibility.[19] It is this space of multiplicity and immense variability, this site of hybridity, and *mestizaje*,[20] not in the biological but the cultural sense, that has been consistently elided from Basquiat's oeuvre. It is this inheritance of the diaspora that Hall finds in the "primal" site of the Caribbean, which Basquiat inherits in his Haitian and Puerto Rican routes to Brooklyn.

SEMIOTIC IMAGINATION

One overlooked aspect of Basquiat's oeuvre that somehow cannot be con-tained by either his identification as an African American citizen of the United States or as a Western painter is the preponderance of Spanish lan-guage messages woven throughout the paintings and drawings over the entire span of his career. In my own marking of Basquiat as African Ameri-can I refer back to the wider connotations of this term as engaged by Gerardo Mosquera. In his writings Mosquera speaks of culture and peoples of the Americas (and more specifically the Caribbean) which display African cul-

tural inheritances as "Afro-American," following not from the U.S. example but from the Latin American framework of Afro-Cuban, Afro-Brazilian, and so on. Let us not forget that more than 90 percent of the African peoples who arrived in the Americas as the result of the transatlantic slave trade landed in Latin America and the Caribbean, not the United States, making the term African American even more appropriate in that context.

Like that great "political activist, bibliophile, collector, librarian, and figure of the Harlem Renaissance," Arturo Alfonso Schomburg—who at times in his life used an anglicized version of his name, Arthur A. Schomburg—Basquiat can be easily claimed by black U.S. and Puerto Rican communities.[21] And that's not even getting to the Haitian side. However, as Greg Tate reminds us about Basquiat's captivation of the art world, "it would be the Haitian boy-aristocrat with the properly French name who'd get to set their monkey-ass world on fire."[22]

Spanish is spoken by over 265 million people worldwide and more than 17 million in the United States alone.[23] In the U.S. context some commentators have viewed the Spanish language as reflecting private spaces and/or the migrant's nostaligia for home, family, the past; it is the voice of self-knowledge "in which people realize themselves in the act of speaking," a dynamic of interaction with others in "the plaza," as opposed to English, which is construed as the primary *lingua franca* of transnational commerce.[24] Spanish implies "a whole notion of conversation as pleasure, as dialogue, as intellectual inquiry, as social event, as ritual."[25] Language in this sense is not adopted for its pragmatics, to get from point A to point B in the quickest, most expedient manner, as often with English. Instead, with Spanish "there is a ludic element. There is a mystical element, there is a whole level of imagination; language for the sake of imagining, of inventing, of playing."[26] The passageway between the private realm and that of the public eye is the street: the space of code-switching (Spanish-to-English-to-Spanish-to . . .), Spanglish, or in the Chicano context the slang of *Calo*.

Other observers see Spanish as a form of communication that operates in both the private and public arenas of the United States. In the latter case print culture and, later, mass media have unified this community in the public realm. This has been the case, particularly in what is now the Southwestern United States, since the sixteenth century. Indeed, Spanish language can be seen as a discursive identity functioning as a site of cohesion apart from national origin or race. And beginning in the late twentieth century nearly half the world's migrants have been women. This is crucial for us here because it is generally "women who determine the child's mother tongue."[27]

From the vantage point of the early twenty-first century, Spanish has certainly moved beyond isolated islands (or plazas) of speakers dotting the United States. With the news in 2003 that Latinos were now the largest "minority" population of this country, Spanish language has become more and more integral to the fabric of our national life, from the shores of Hollywood and the star power of Jennifer Lopez to the Latin Grammy Awards broadcast from Miami to almost every service industry from banks to telephone companies to major store chains, where we are given the option, "Para servicio en español por favor oprima el número dos."[28] Magazines like *Business Week* have devoted special issues to the "Hispanic Nation." And even more interestingly for our purposes here, *Black Enterprise*—that organ of African American economic strivers—has made the apparent phenomenon of *black* Latinos a cover story.[29] Almost twenty years after he left us Basquiat would perhaps have been gratified to see how much his vision has been recognized as a key aspect of contemporary life.

Spanish appeared in Basquiat's work from the beginning. Robert Farris Thompson has observed that Basquiat was fluent in the language, learned from his mother, Matilde, and honed while living in Puerto Rico for several years in the mid-1970s.[30] Printed words like POLLO (chicken), CABEZA (head), and MUJER (woman) surface repeatedly in his paintings. Some, like LECHON (pork) or GUAGUA (bus), are terms identified with the Caribbean, and in the case of the latter, specifically Puerto Rico. Parts of Basquiat's lexicon connote public space and reflect his fascination with commerce, such as PESO NETO (net weight) and ORO (gold).

In *The Nile* (1983), one of Basquiat's epic paintings, the artist connects the history of the United States with that of the ancient world by using black subjects as icons or avatars of the forces of historical change. In the left panel, the word NUBA, denoting one of the earliest African cultures, floats above two masks. At the right Greece and Egypt rise to prominence in the words THEBES, HEMLOCK, PHARAOH, and MEMPHIS. The Egyptian presence is further inscribed with hieroglyphs (an eye, waves), papyrus ships, and female figures seen in three-quarter view; the word NILE is crossed out. The third presence is American. We have not only Memphis of old but Memphis, Tennessee; the sickle cell trait floats across the water both above and below an image of a sickle-like tool that is also a ship. Yet in each of the three panels, words in Spanish appear as well. One of the silhouetted females on the left is identified with MUJER, her male counterpart on the right faces forward with ESCLAVO and SLAVE on his chest, crossed out; centered at the top, the artist has named this panorama of history, blackness, and slavery EL GRAN ESPECTACULO (the grand spectacle). But the term ESPECTACULO also

reads in a mass-media, kitschy sort of way, attached to the riotous display of Spanish-language variety shows or car salathons; we are returned to commerce.[31]

> They called us graffiti but they wouldn't call him graffiti. And he gets as close to it as the word means scribble-scrabble. Unreadable. Crosses out words, doesn't spell them right, doesn't even write the damn thing right.[32]

From this fragment, it seems that fellow painter Rammelzee did not approve of his friend's way with words, perhaps connecting Basquiat's actions to the continuous elimination of black people from records both historical and contemporary.[33] In the nineteenth century, Mirzoeff tells us, diasporas were configured as troublesome bodies existing outside national boundaries and controls, excess citizenry that needed to be restricted, resettled— crossed out.[34] As a black man painting, and painting, and painting himself into view, Basquiat and his work does demonstrate an "interrogation of persistent erasure and the denial of agency,"[35] or selfhood that engulfs the subject who is black, male, Caribbean, American, Spanish-speaking artist. But Basquiat takes this trope and reverses it by visibly embracing invisibility. Robert Farris Thompson's observation that, "Jean-Michel cancels to reveal"[36] indeed reflects what the artist told him in an interview, "I cross out words so you will see them more: the fact that they are obscured makes you want to read them."[37] Basquiat's works are amazing in the scope of their form and content, as well as in their sheer numbers, making a case for a corpus that is both "transnational and translational."[38]

Many of the paintings that speak to us *en español* speak to us in more intimate terms that revolve around family, community, and food. *Arroz con Pollo* (1981), for instance, is one of Basquiat's few paintings showing the intimate interactions of a heterosexual couple, outside the worlds of masculine identity codified in sport or commerce.[39] It has a quasi-religious profile as the female figure offers her breast in sustenance to the male, a prophet crowned with a halo; the male figure in turn serves up a steaming plate of chicken. The dish, rice and chicken (which gives the painting its title), is a staple throughout Latin America, comfort food. The painting itself was made in Puerto Rico.[40]

Professor bell hooks has argued that the pain she perceives in Basquiat's work comes from the artist's concentration on the realm of masculinity to the exclusion of a counterbalancing female life-world.[41] Scholar José Esteban Muñoz, however, has critiqued this position as one which opens itself to heterosexist thinking; the communion of men should not always be seen as

a negative force. As he has written, "Representing the complicated and dire situation of black masculinity in U.S. culture is important cultural work that should not be disavowed as a limitation."[42] It should not be presumed that "female influences and inspirations" can be arrayed to fill "his lack," Muñoz continues, "assuming a spectator or critic can ever *know* what such forces might be."[43]

Basquiat's "mother tongue" is Spanish. Not necessarily in the sense that he grew up in Puerto Rico or Brooklyn speaking it exclusively but in the sense that his mother, Matilde Basquiat, was a black Puerto Rican woman. The majority of the words he uses in his art, of family, food, and community, are ones that link him back to that world of intimacy; they create a link with the Spanish-speaking world, and the realm of the mother. If we want to speculate on what might constitute some female forces in Basquiat's work it would be the continuous chatter *en español*.

Basquiat's canon revolves around single heroic figures: athletes, prophets, warriors, cops, musicians, kings, and the artist himself. In these images the head is often a central focus, topped by crowns, hats, and halos. In this way the intellect is emphasized, lifted up to notice, privileged over the body and the physicality that these figures—black men—commonly represent in the world. With this action the artist reveals creativity, genius, and spiritual power. Basquiat has at least four paintings that use some form of the word *cabeza* (head) in their title. In the earliest, *Cabeza* (1982), the black figure painted on a gold ground doesn't only seem to grimace through clenched teeth but to smile. The contrasting background offers something new, exposed stretchers and a surface crafted from a quilted blanket. *Dos Cabezas* from the same year is a double portrait of the artist with Andy Warhol. As Muñoz has pointed out, in this canvas Basquiat envisions himself as equal to his friend and mentor by painting the figures roughly the same size; here they are intellectual partners. But it is also a gesture of interculturation in which Basquiat makes Warhol speak *en español*. It is a voice of intimacy for Basquiat as well; the voice of the mother who herself was an artist, and inspired and promoted her son's creativity. As the artist has recounted, "I'd say my mother gave me all the primary things. The art came from her."[44] The language of intimacy is thus the same as that of the intellect and it is read through the accent of the mother.

CHARMED LIFE

Okwui Enwezor has taken issue with the widespread belief in contemporary art circles that the show *Magiciens de la Terre* (Centre Pompidou, Paris, 1989) is paradigmatic of today's global exhibition practice. As he com-

ments, "The discourse in 'Magiciens' was still very much dependent on an opposition within the historical tendencies of modernism in Europe—namely, its antipathy to the 'primitive' and his functional objects of ritual, and, along with this process of dissociation of the 'primitive' from the modern, its attempt to construct exotic, non-Western aesthetic systems on the margins of modernism."[45] I would certainly agree with him on this account. Yet I also find that placing the marker for "globalism" in exhibitions at this starting point also erases earlier transatlantic practices, at least on the part of African American artists, from Edmonia Lewis's Italian exhibitions and residency in the nineteenth century to the coterie of artists of the African diaspora connected to the Harlem Renaissance and Negritude movements in the early twentieth century and more recently, the 1980s investment in multiculturalism in the United States later documented in exhibitions such as *The Decade Show: Frameworks of Identity in the 1980s* (New Museum of Contemporary Art, New York, 1990), and the dialogue between black British and black American artists during that same era which was both intercultural and international in scope.

However, I believe as well that there is a place for art that celebrates spiritual and metaphysical sources, and that this type of practice shouldn't be "off limits" because of our concerns with white Western confusion about who we might be. (Robert Colescott, Kara Walker, and numerous others have jumped squarely into similar *caca* around the specter of black stereotypes for exactly this reason.) All peoples and cultures have and require a connection to the otherworldly and the divine, to make it through life or even just the day. And so it is from this premise that I argue that Jean-Michel, toward what would unfortunately mark the ending of his amazingly creative career, drew more of such signs into his art, using objects and notions that tapped historical frameworks of African spiritual systems and their power. They were charms to ward off pain and death and to fight for life and strength on a mystical plane.

Basquiat's canon of heroic masculinity revolves around the year 1982, one of his most productive. But later, as the work progressed, it is clear that the artist was painting his way out of this, or perhaps painting into new structures which could combat the isolation that Tate has characterized as the "flyboy in the buttermilk"; he was painting into a space of communion, community, and connectivity. It was a place in which Basquiat was not only a (Western) painter and (black) man; it was a realm where he could claim all that was excess to those axes of identity, where he could open himself out to the entire broad spectrum of his creativity and his soul. And he accomplished this in part by way of those "religious-cultural complexes" out-

lined by Mosquera, whose mark-making traditions are "symbolization[s] of the unity of life . . . where everything appears interconnected because all things—gods, spirits, humans, animals, plants, minerals—are charged with mystical energies and depend on and affect everything."[46]

In 1984 Basquiat created two works which link back to previous structures and yet move him simultaneously onto another plane. *Gold Griot* presents us with one of Basquiat's iconic figures, his skeleton revealed, crowned by a grinning/grimacing head that provides the major painterly focus for the image. It floats on gold-toned wooden slats that form a rectangular ground. In many ways it mirrors *Cabeza* of 1982, its black figure shimmering on a golden surface, the structure not only of the body but of the painting revealed, the smooth round head, grin/grimace, and large, all-seeing eyes. Within this formal play between these two works is the semiotic and cultural one, wherein the intellect and creativity of the Spanish mother (tongue) connect to the figure of the West African oral historian, custodian of the nation's stories, a keeper of the past who charts a vision for the future.

Gold Griot is also related to another work made the same year called *Grillo*. Formally, it seems markedly different; for one thing, *Grillo* is quite massive, three times as long as the other; in places it looms out a foot and a half from the wall. In English, we would rhyme the word "grillo" with "Brillo," as in the cleaning products made famous by Andy Warhol's boxes. In Spanish, however, the "ll" produces the sound of the letter "y." Basquiat's *Griot* and *Grillo* are therefore punning homophones; they are transliterations in which words from one language are transposed into another. Basquiat (a musician as well) has given them the same sonic sensation and assigned them similar meanings.

In both paintings we see the same smooth-headed power figure. In *Grillo*, however, the figurative element is doubled; one body sports a crown and the other a halo composed of a black wood bar topped with spiky nails. Indeed, the strips of nails adding visual interest to the canvas recall the Nkisi power figures of the Kongo peoples of which Robert Farris Thompson writes in *Flash of the Spirit* (1983). Thompson and Basquiat met in 1984 (introduced, as I was, by Fab Five Freddy). Basquiat's interest in Thompson's phenomenal work on Africa, America, and the Black Atlantic world led him to commission the scholar to write something for one of his shows at the Mary Boone Gallery, which took place in early 1985.[47] In the heavily collaged areas of *Grillo* we see references to Thompson's *Flash*, and particularly to icons of power found there: the cosmic Nsibi writing and the leopard skin power

symbols of the Niger Delta, the Rada religion of Haiti, and Yoruba gods Esu (the trickster of the crossroads) and Ogun (war).

Jumping ahead two years, we come across *Gri Gri* (1986). Again stylistically somewhat dissimilar yet taxonomically following directly from the 1984 works. Uncharacteristically, the artist limits his palette to four colors: red, black, white, and brown. The tone here is muted, almost simplistic, dark, and to some eyes just plain uninteresting. No darting linear patterns, save for the central figure's bar-like bared teeth. A single, almond-shaped eye leads us back through the genealogy of its brothers in *Cabeza, Gold Griot*, and *Grillo*. But this figure in profile has more in common with another that begins to come into view around this time. We can find it on the upper edge of a green painted panel in *Grillo*, a simple black mask-like head with eyes like ellipses. In *J's Milagro* of 1985 the eye socket is filled in with red and the figure is more clearly articulated to resemble a superhero.

A gri-gri (sometimes spelled gris-gris in the French) is a Hoodoo charm, part of African American ritual and conjuring practices often associated with New Orleans. When a revolution created the first black republic in the Western Hemisphere, in the early nineteenth century, slave owners fled Haiti with their human property for this other outpost of their culture in the Americas, reinforcing French and New World African production in architecture, foodways, and spiritual practices. Where *J's* (i.e., Jean-Michel's) *Milagro* (*Miracle*)[48] is busy, full of texture, and somewhat disjunctive, *Gri Gri* does its work quietly, without calling too much attention to itself; but its halo puts us on notice. In 1972 Betye Saar created a work called *Gris-Gris Box*. Like much of her work its energy comes from ancestors, in this case her Louisiana forbearers. It is strikingly similar to the Basquiat piece made not quite fifteen years later. Its central black figurative form has features that grimace and grin with a red mouth, and it regards the outside world through the half-lidded eyes of trance and power. In Saar's piece these powerful eyes partially ring the construction, giving us no doubt as to its intentions.

Elsewhere, I have linked Saar's *Gris-Gris Box* taxonomically to perhaps her most famous work, *The Liberation of Aunt Jemima*, also from 1972. Both share a central black female figure laden with props of power; one brings with her strong magic and the other wields strength from the barrel of a gun.[49] Similarly, Basquiat's Gri Gri reappears in other works and in other guises; and as such is what has been called a "'hyperquote,' an artifact generating multiple intertextual references."[50] It shows up again in a collaborative work with Warhol, *Untitled* (Motorbike) (1984–1985) where Muñoz

reads its appearance as signaling "the black presence that has been sys-tematically denied from this representational practice. These primitive jet-black images look only vaguely human. . . . Through such representations Basquiat ironizes the grotesque and distortive African American" images of the black body. The "smooth lines" of Warhol's silkscreen, Muñoz argues, become "a *vehicle* for Basquiat's own political and cultural practice."[51] And indeed the Gri Gri is positioned in the driver's seat of Warhol's printed motorcycle.

In 1987 Gri Gri drives itself into yet another context, that of Basquiat's cartoon culture. In *Untitled* of 1987, the black figure steers a bright red car with yellow and blue accents. Though possibly broken down, with a miss-ing tire laid to one side, the vehicle has sprouted green wings to whisk it heavenward. The hue of the wings is almost identical to that of an image proclaimed as the LONE RANGER in *To Be Titled*, of 1987, whose black mask turns him into Gri Gri. Indeed in *Untitled* of 1987, Gri Gri is transformed into a superhero traveling via Batman's Batmobile (forms of the superhero's emblem, the "Bat Signal," are found throughout Basquiat's work). In *Riddle Me This Batman* from the same year, Gri Gri shows up seemingly as an out-line, a beige tone shadow of his former self. Beneath this chimera is the word TIZOL, the name of the Puerto Rican trombonist who figured in a number of Duke Ellington's bands and brought us major compositions such as "Caravan" and "Perdido."[52]

Muñoz has applied his brilliant thesis on disidentification to the cultural work of comics. The "disidentificatory" process is a "third mode of dealing with dominant ideology, one that neither opts to assimilate within such a structure nor strictly opposes it"[53] but "works on and against dominant ide-ology."[54] Strategies of disidentification allowed two Jewish cartoonists, Jerry Siegel and Joe Schuster, to create the character Superman, a "dark-haired alien," during the 1930s at the same moment that the term *Ubermensch* (superman) was being used to denote Hitler's Aryan "master race." Like Brazilian modernist artists' philosophy of *antropófagia* (cannibalism) in the 1920s, it is a device that allows one to consume the dominant culture, re-combine its useful and powerful bits in new aesthetic formulas, and dis-card the rest. It permits young black boys like Basquiat and young Jewish ones like Shuster and Siegel to identify with Superman in their own way, shape, and form. Writing on Basquiat's *Television and Cruelty to Animals* (1983), Muñoz discusses how the artist brings Superman (as logo) into the picture to fight Nazism, displaying the artist's own knowledge of the super-hero's original if hidden task. In this relatively small painting (five by five

feet) the artist creates another epic, another *El Gran Espectaculo* (written across the bottom right) bringing in reinforcements for Superman in the figures of Batman and Popeye, the latter battling racism in both English and Spanish—POPEYE VERSUS THE NAZIS inscribed in the top right and then, further down on the left, POPEYE VERSUS LOS NAZIS. In the later works, the powers of African gods clearly become conflated with those of Western superheroes. In *Grillo*, Basquiat articulates his fascination with the Yoruba war deity, Ogun, by repeating his avatars, IRON and BLADE. On the left side of the painting, referring again to Ogun, he writes, HE IS PRESENT IN THE SPEEDING BULLET. The connection with Superman's likeness to ammunition ("faster than a speeding bullet") was not lost on the artist, and in fact, was probably an amazing discovery that allowed him to link his love for comics and his obsession with the histories of the black diaspora.[55]

EXIT, STAGE LEFT

In contrast to the protective forces of Gri Gri and other charms found in paintings toward the end of Basquiat's life, there are additional works that show (his) struggle. The difference is particularly evident in the eyes of his painted figures. The elliptical eye shape, unmistakable in pieces like *Gri Gri* and *Griot*, are half-lidded to marshal and conceal their power. In contradistinction, the villain (the Riddler) in *Riddle Me This Batman*, for example, has round eyes that are x-ed out; he is drunk or poisoned from the beverage with a triple-x label that he holds in his right hand. Similarly, in *Victor 25448* of 1987, a man with a bandaged face and the same disk-like eyes that repeat the X pattern, falls to the floor, red blood spurting everywhere, and partially covering the phrase FATAL INJURY. In *Después de un Puno* (*After a Punch*) of 1987, the figure with the unseeing eyes is large and upright, skeletal but yet somehow also formal in his looming, stovepipe-style top hat.

The curator Richard Marshall has noted several reference books that Basquiat drew inspiration from in composing the dense catalogue of symbols that made up his work. One such source was Henry Dreyfuss's *Symbol Sourcebook: An Authoritative Guide to International Graphic Symbols* (1972). Among Dreyfuss's collected lexica are "Hobo Signs," simple pictographs, "chalk or crayon signs" drawn on "fences, walls and doors, which conveyed messages such as 'dangerous neighborhood,' 'easy mark, sucker' and 'vicious dog here.'"[56] Certainly Basquiat could have considered such mark-makers forerunners of his own graffiti tagging cohort. Two of the hobo images incorporate a top hat, signifying in one instance "a gentleman lives here" and in another "these are rich people." But I would argue that

the guy in Basquiat's *Después de un Puno* is another kind of *caballero*, the regal and fatal Baron Samedi, Vodoun's keeper of cemeteries. In a photograph taken by his friend Tseng Kwong Chi in 1987, the year of *Después* and mere months before his death, Basquiat poses provocatively with a toy gun to his head in front of an unfinished painting showing the word VICTOR several times followed by various numeric combinations denoting the catalogue numbers of a discography and connecting us as well to *Victor 25448*, Basquiat's portrait of the fatally injured man. In the photograph, on a table loaded with brushes and paint, are also other things, a sculpture of seeming non-Western facture and three drums, two of them Yoruba *batas*, the famous ritual "talking drums." Again, evidence of protective avatars.

Baron Samedi appears as early as 1982 in a less skeletal, more human guise in *The Guilt of the Gold Teeth*. Yet Basquiat invoked death in some of his earliest paintings, including *Bird on Money* (1981) where the words PARA MORIR (in order to die) appear next to a drawing of Brooklyn's Green-Wood Cemetery where Basquiat would indeed be laid to rest. In *Portrait of the Artist as a Young Derelict* (1982) the word MORTE (dead, in French) and a cross are inscribed over a black boxy shape; it is surely a coffin "buried" as it is below a towering New York skyscraper.

Among Basquiat's last paintings is a six-by-eight-foot canvas that to some may seem unprepossessing. At its center is a single fox-like creature, a wily coyote caught in a whirlwind, smiling from the eye of a storm. His head is surrounded by the eyes of power, which have appeared as Egyptian hieroglyphs (*The Nile*) and the elliptical stare of Gri Gri. Above the smiling head floats the word EXU from which the piece takes its title (*Exu*, 1988). *Exu*, the Brazilian Portuguese spelling of the god also known as *Esu* and *Eleggúa*, is the Yoruba and New World African god of the crossroads; it is only through him that one can seek audience with other forces. And because he is known as a trickster, it's anyone's guess if you'll get there. Interestingly, the X in EXU is boxed in, held not within a circle of the saucer-like eyes Basquiat reserves for the beaten down, but within a box of containment. Speaking of *Eleggúa*'s elusive appearance in the paintings of Wifredo Lam, Mosquera writes, "the mutant sense of Lam's paintings, where everything seems to transform itself into another unexpected thing, could be related to the god."[57] Or not. The boxed-in X of Exu could be the containment of the forces of death (the coffin). Or not. Rewind. Remix. The circular saucer-eyes that seem nonresponsive, dead, crossed out, also riff on Kongo culture's Four Moments of the Sun, the cosmogram for the continuity of life.[58] Basquiat includes the sign repeatedly in *Grillo*; nearby wait the words ESU, EXU, and BABALAO (priest). As Muñoz movingly writes:

Basquiat understood the force of death and dying in the culture and tradition around him; his art was concerned with working through the charged relation between black male identity and death. He, like Van Der Zee, understood that the situation of the black diaspora called on a living subject to take their dying with them. They were baggage that was not to be lost or forgotten because ancestors, be they symbolic or genetically linked, were a deep source of enabling energy that death need not obstruct.[59]

Enwezor reminds us that the diaspora is a place caught, at different times and to various degrees, between "speech and its attendant untranslatability," as people and their languages, gestures, codes travel the globe from the comfort of familiar places toward the challenges that await in unknown landscapes.[60] Yet in the twenty-first century, he insists, there is no need to perpetuate the same circular debates and "paradigms of lack that have persistently enfolded the body and subjectivity of the disrecognized figure of the subalternate by asking the same old question: 'can the subaltern speak?'" or, do non-dominant bodies possess tongues and other tools for communication, and are they allowed to use them? Instead the question thrown back in the opposing court is rather, "Can the subaltern be heard?"[61] For those of us whose ears are "culturally prepared"[62] — *es pleno amor . . . y poder.*[63]

For RFT

and for

Simon and Solomon,
translating the 21st century

NOTES

Originally published in Kellie Jones, co-curator, "Basquiat," Brooklyn Museum, New York, March 11–June 5, 2005. The exhibition traveled to Museum of Contemporary Art, Los Angeles; Museum of Fine Arts, Houston. The epigraph is from Okwui Enwezor, "A Question of Place: Revisions, Reassessments, Diaspora," in Salah Hassan and Iftikhar Dadi, eds., *Unpacking Europe* (Rotterdam: Netherlands Architectural Institute, 2001): 234.

1. This line comes from the song *"Psychedelic Shack."* However, the phrase originally appeared in the spiritual "Rock My Soul in the Bosom of Abraham." Thanks to Barry Mayo for help with the Temptations reference.
2. Grey Gundaker, *Signs of Diaspora/Diaspora of Signs: Literacies, Creolization, and Vernacular Practice in African America* (New York: Oxford University Press, 1998), 8.

3. José Esteban Muñoz, "Famous and Dandy Like B. 'n' Andy: Race, Pop, and Basquiat," in Jennifer Doyle, Jonathan Flatley, and José Esteban Muñoz, eds., *Pop Out: Queer Warhol* (Durham: Duke University Press, 1996), 161.

4. Greg Tate, "Nobody Loves a Genius Child: Jean Michel Basquiat, Flyboy in the Buttermilk," *Flyboy in the Buttermilk: Essays on Contemporary America* (New York: Fireside, 1992), 236.

5. Ibid., 239.

6. Ibid., 241.

7. Arjun Appadurai, *Modernity at Large: Cultural Dimensions of Globalization* (1996), quoted in Nicholas Mirzoeff, "The Multiple Viewpoint: Diasporic Visual Cultures," in Nicholas Mirzoeff, ed., *Diaspora and Visual Culture: Representing Africans and Jews* (London: Routledge, 2000), 6.

8. Gerardo Mosquera, "Eleggúa at the (Post?)Modern Crossroads," in Arturo Lindsay, ed., *Santería Aesthetics in Contemporary Latin American Art* (Washington, D.C.: Smithsonian Institution Press, 1996), 228.

9. Ibid., 226.

10. Ibid., 227, 230.

11. Stuart Hall, "Cultural Identity and Diaspora," in Mirzoeff, *Diaspora and Visual Culture*, 30.

12. Ibid., 27.

13. Ibid., 29, 30.

14. Ibid., 30. I use the word "American" here in its most encompassing sense, to suggest the cultures of the entire Americas.

15. Okwui Enwezor quoted in "Global Tendencies," *Artforum* 42 (3) (2003): 154.

16. Kellie Jones, "(Un)Seen and Overheard: Pictures by Lorna Simpson," in Kellie Jones, Thelma Golden, and Chrissie Iles, *Lorna Simpson* (London: Phaidon Press, 2002), 77.

17. Hall, "Cultural Identity and Diaspora," 26.

18. Mirzoeff, "The Multiple Viewpoint," 6.

19. Ella Shohat and Robert Stam, "Narratavizing Visual Culture: Towards a Polycentric Aesthetics," quoted in Mirzoeff, "The Multiple Viewpoint," 6.

20. Spanish, meaning "racial mixture," as in the French, "métis," or English, "miscegenation."

21. Roberto P. Rodriguez-Morazzani, "Beyond the Rainbow: Mapping the Discourse on Puerto Ricans and 'Race,'" in Antonia Darder and Rodolfo D. Torres, eds., *The Latino Studies Reader* (Oxford: Blackwell, 1998), 145.

22. Tate, "Nobody Loves a Genius Child," 236.

23. Rosaura Sánchez, "Mapping the Spanish Language along a Multiethnic and Multilingual Border," in Darder and Torres, *The Latino Studies Reader*, 110.

24. Coco Fusco and Guillermo Gómez-Peña, "Bilingualism, Biculturalism, and Borders," in Coco Fusco, *English Is Broken Here* (New York: New Press, 1995), 151–53 (a version of this dialogue first appeared in *Third Text* in 1989).

25. Ibid., 152.

26. Ibid., 153.

27. See Sánchez, "Mapping the Spanish Language."

28. In hip-hop music, African American artists have also incorporated words in Spanish, usually slang. Puff Daddy ("All about the Benjamins") and Missy Elliott ("Work It"), for instance, have both used the term *chocha*, a reference to female genitalia. Because many radio producers don't understand these words they are often played unedited over the airwaves.

29. *Business Week*, March 15, 2004; and *Black Enterprise* 34 (February 2004).

30. Robert Farris Thompson, "Royalty, Heroism, and the Streets," in Richard Marshall, *Jean-Michel Basquiat* (New York: Whitney Museum of American Art, 1992), 29.

31. *Untitled (El Gran Espectaculo)* and *Untitled (History of Black People)* were other earlier titles for the work. The new title, *The Nile*, comes from simply checking the verso of the painting and finding Basquiat's original designation written there.

32. Rammelzee quoted in Tate, "Nobody Loves a Genius Child," 236.

33. If these were indeed Rammelzee's concerns they were not unfounded. Several years later Julian Schnabel's film *Basquiat* (1996) offered a vision of an artist who had no black/Latino community, where graffiti, hip-hop (and even punk rock), and multiculturalism did not exist. Instead "Basquiat" becomes a foil for the Schnabel character (played by Gary Oldham). The film's one redeeming quality was a stellar performance by Jeffrey Wright in the title role.

34. Mirzoeff, "The Multiple Viewpoint," 2.

35. Enwezor, "A Question of Place," 241.

36. Thompson, "Royalty, Heroism, and the Streets," 32.

37. Ibid.

38. Homi Bhabha, *The Location of Culture* (1994), quoted in Enwezor, "A Question of Place," 242.

39. Thanks to Franklin Sirmans for pointing this out.

40. Richard Marshall, "Repelling Ghosts," in Marshall, *Jean-Michel Basquiat*, 18.

41. To a certain extent, hooks's perception of pain is based on her misreading of Basquiat's frenetic expressionism as painful disarticulation of the body, which I am not quite convinced of. bell hooks, "Altars of Sacrifice: Re: Membering Basquiat," in *Art on My Mind: Visual Politics* (New York: New Press, 1995), 35–48; first published in *Art in America* 81 (June 1993).

42. Muñoz, "Famous and Dandy Like B. 'n' Andy," 175.

43. Ibid.

44. Jean-Michel Basquiat quoted in M. Franklin Sirmans, "Chronology," in Marshall, *Jean-Michel Basquiat*, 233. Gérard Basquiat also states, "His mother got him started and she pushed him. She was actually a very good artist," quoted in Sirmans, "Chronology," 233.

45. Enwezor quoted in "Global Tendencies," 154.

46. Mosquera, "Eleggúa at the (Post?)Modern Crossroads," 230.

47. Thompson, "Royalty, Heroism, and the Streets," 31–32.

48. *Milagros* are also Latin American religious folk objects and come in the form of stamped metal charms. Most often they depict body parts and are offered to saints as a request for healing.

49. See Kellie Jones, "Black West: Thoughts on Art in Los Angeles," in Lisa Gail Collins

and Margo Natalie Crawford, eds., *New Thoughts on the Black Arts Movement* (New Brunswick: Rutgers University Press, 2006).

50. Mirzoeff, "The Multiple Viewpoint," 8.

51. Muñoz, "Famous and Dandy Like B. 'n' Andy," 164.

52. Tizol's compositions in the 1930s are often seen as laying the groundwork for the explosion of Latin jazz in the 1940s. Basquiat also showed the figure of Tizol as part of the Ellington band in a drawing from a bit earlier, *Untitled (Harlem Airshaft)* (1984), the year of Tizol's death.

53. Muñoz, "Famous and Dandy Like B. 'n' Andy," 147.

54. Michel Pecheaux, *Language, Semantics, and Ideology* (1982), quoted in Muñoz, "Famous and Dandy Like B. 'n' Andy," 147.

55. Basquiat's references to Ogun come directly from Thompson's *Flash of the Spirit*, including the phrase "he is present in the speeding bullet" (53). The book was first published in 1983 with the paperback following in 1984. The painting *Grillo* is dated 1984. Basquiat, ever on the cutting edge, obviously read the book within the first year or so of its publication.

56. Marshall, "Repelling Ghosts," 23.

57. Mosquera, "Eleggúa at the (Post?)Modern Crossroads," 231.

58. See Thompson, *Flash of the Spirit*, chapter 2, "The Sign of the Four Moments of the Sun: Kongo Art and Religion in the Americas."

59. Muñoz, "Famous and Dandy Like B. 'n' Andy," 168–69.

60. Enwezor, "A Question of Place," 240.

61. Ibid., 241.

62. Robert Farris Thompson, "The Song That Named the Land: The Visionary Presence of African American Art," in Robert V. Rozelle, Alvia Wardlaw, and Maureen A. McKenna, eds., *Black Art Ancestral Legacy: The African Impulse in African American Art* (1989), quoted in Mirzoeff, "The Multiple Viewpoint," 7.

63. "It is complete love . . . and power." Thanks to William Cordova for assistance with this translation and for his encyclopedic knowledge of Basquiat in general.

In the Thick of It

David Hammons and Hair Culture in the 1970s

After a decade of success with works on paper (the popular "Body Prints"), David Hammons walked away from these framed and easily saleable objects. A growing interest in the works of Marcel Duchamp revealed the allusive and metaphoric power of everyday items. The stance of the Dada movement—at once critical, or politically charged and playful—also pointed to another way one could combine art-making with an interest in the world from which it sprang. Hammons's immersion in the southern California art scene, home to strong currents of funk and assemblage, was another impetus for the change of practice.

Since his arrival in Los Angeles in the early 1960s, a critical mass of African American artists had increasingly worked in this manner, lacing their constructions with an edge of African American cultural symbolism.[1]

Hair—that tangible crown of African American "difference"—was one such common item that Hammons submitted to this new active and all-encompassing approach to art-making, and through which his work moved more clearly into the realm of the environmental.

Kobean Mercer, Judith Wilson, and Lisa Jones have all recently jumped into and furthered the debate about the cultural and political significance of African American and African diasporic approaches to the "hair question." As Mercer has pointed out, hair is a naturally occurring organic bodily matter that is "socialized . . . constantly processed by cultural practices which thus invest it with meaning and value."[2] Or in Jones's words, "hair is never

left 'as is.' Hair exists to be worked."[3] And "working it," with all the sense of exertion, effort, and performance that the verbal root conjures, is certainly what is done; indeed, "styling" may be a tad too polite, dainty, and hands-off approximation for what is staged on and in black hair. Wilson's investigations of African approaches to the care and cultivation of hair have revealed an esteem for "abundance" and "mass and volume" as signs of "strength and fertility."[4] The idea of opulence is also paired with artifice:

> Where western culture generally condemns most forms of body adornment or alteration as vain, deceitful, grotesque, tasteless, or at best merely frivolous, Africans tend to view *failure* to supplement, transform, or otherwise improve on nature as a lapse of character or a breach of decorum.[5]

Wilson sees this passion for formal invention and innovation as another aspect of the aesthetics of abstraction, one that we easily recognize in traditional African sculpture.

Hair thus becomes an important vehicle for expression. And in African-diasporic practice, as a "popular *art form*," it is a method through which black people have been able to convey their sense of the beautiful and their creative aspirations, in the face of historical exclusion "from access to official social institutions of representation."[6]

There are dreadlocks, afros or naturals, relaxed dos, conks, close cuts, jheri curls, braids, and various styles of each and numerous stages in between. Jones's description of braided creations speaks lovingly of the art that she sees, particularly on women's heads:

> These are not simply hairdos; these are elaborate constructions, with hair piled high, woven with ornaments and shaped like fans, wedding cakes, hourglasses, and halos. Maybe they're crowns, maybe they're altars. Extensions here are used not to showcase length or "naturalness." This is hair as textile, fiber art, as nothing less than sculpture.[7]

African American hair initially appeared in David Hammons's work in a series of two-dimensional constructions for the wall. These were first shown in New York in 1975 at the Just Above Midtown Gallery under the title "Greasy Bags and Barbecue Bones." The fan-like pieces were collages that had escaped the traditional rectangular format and seemed to revel in their movement across space. Constructed from discarded brown paper bags, and lacquered erratically with common household oil, they were then embellished with tufts of hair, spare-rib bones, and glitter. Originally the hair

and the glitter provided only decorative touches. They were applied sparingly, in geometric patterns, and appeared at first glance as areas painted on each piece.

These become most visible in a sporadic series of sculptural arrangements Hammons installed along Los Angeles beaches between 1975 and 1977. An array of nappy hairballs, approximately a half inch or less in diameter, were threaded on lengths of flexible wire standing three to five feet high. The wires were curved and bent in places, and the tufts followed their lines, creating irregular dashes and dots like some newfound system of counting—an African Americanized version of Morse code, abacus, or quipus.

The artist cultivated his new gardens at the shoreline, taking advantage of the solidity of the wet sand for planting the wires, and the drama of the crashing waves on the horizon and the mirror-like reflective ground, to add to the work's potency. Hammons planted and replanted his temporary and ephemeral hair gardens in a variety of Los Angeles beach sites over the two-year period.

For his second solo New York outing at Just Above Midtown in 1976, he presented a full show of works in which black hair was the principal medium. The exhibition, titled "Dreadlock Series," was inspired by the "hairstyles of Rastafarians," a press release proclaimed. Along with indoor "sculpture gardens" of hair and wire, the gallery also presented wall "drawings" composed primarily from "the interweavings of hair and rubber bands."[8]

While today, dread—or African or Nubian—locks can be found gracing the pages of women's magazines, or the characters of daytime television, in the mid-'70s this seemingly unkempt hairstyle was the preserve of cultural rebels.

If American process works and European arte povera used all sorts of materials, from felt to hay and chalk to dirt, no one had worked with black hair in such a manner. And certainly it was not just Hammons's simple use of this fiber that made it new and different, but its positioning as an allegorical statement, and one that spoke of redemption and self-love. Hammons's exhibition of the "Dreadlock Series," during the hoopla of the Bicentennial year, was both a celebration of the incredible facets of black hair and by extension the black self, and a subtle reminder of the place of the black body as commodity in the making of the United States.

Two further solo exhibitions of hair pieces took place in 1977, in the spring at Just Above Midtown, and later that fall at the Neighborhood Art Center in Atlanta, Georgia, with the title "Nap Tapestry: Wire and Wiry

Hair." Along with free-standing gardens and rubber-band-based wall drawings, these shows also contained ersatz quilts or textiles Hammons created by stuffing hair into wire screens. There were also new floor-based sculptures of molded hair, such as *Hair Pyramids.*

Writing in the *Soho Weekly News*, John Perreault was intrigued by the works' construction and struck by the power and beauty of the New York show. At one point the critic asks, "How does one go about making abstract art and still have it come out distinctly Afro-American? Hammons's hair sculpture is his answer. It is an 'outrageous' answer but it works."[9]

Like so many artists of his generation—Jack Whitten, William T. Williams, and Sam Gilliam all come to mind—Hammons was, indeed, searching for an abstract voice—like jazz—that could be identified as distinctly African American; something that could be nonobjective in form and coded with (self-)reference, without relying on representation. In hair he seemed to have found his holy grail. As he commented in 1991, "I got to a visual object and medium that was pure [and] nonsexual, which spoke everything I wanted to say."[10]

Hammons had discovered a way to articulate "blackness" without relying on the painted or sculpted figure. His use of hair as an artistic medium allowed him to create culturally defined meaning while still working within the arena of late-twentieth-century Western form and style. However, in part because this organic matter was an actual physical piece of a human being, these works remained inscribed within the highly charged terrain of the black body. As Judith Wilson has noted, the "use of kinky hair as an ethno-cultural signified fail[ed] to dismantle the stable, biologically-determined classificatory systems" that had adversely defined black people for centuries.[11]

Hammons's quest for his own abstract visual language has brought him back again and again to the jazz paradigm. Throughout his career he has incorporated it into his work either as homage or as an actual performative element. He has counted musicians like Charlie Parker and Sun Ra as his creative mentors rather than an earlier generation of African American artists because he felt his break with that tradition was so complete.[12]

For Hammons, jazz musicians, not visual artists, are the keepers of the black avant-garde tradition. From Bessie Smith's blues to Duke Ellington's suites, from beboppers like Dizzy Gillespie to the "free jazz" of Ornette Coleman, it is a large and rich trajectory. Yet it is not only the structural intricacy of the music that Hammons admires, but the enigma of the creative being, the nattily dressed virtuoso cutting a mean figure out in the

world, the brilliance that refuses to be categorized or controlled. It is the mythology of the jazzman as transgressor; and, yes, it is almost an exclusively male club.

If Hammons has endeavored to model himself in the image of the jazz master, the material sources and reality of his installations with hair speak of other origins. He has collected hair from barbershops and even staged a performance in one where a rock with hair attached has been shaved, thus intentionally locating the site of his practice within a masculine arena. His use of dreadlocks as a motif also draws on the sphere of male culture within the Rastafarian movement.

But let's get real: who has more salons dedicated to this practice, pays more attention to these aesthetics, has more styling options and usually just more hair—WOMEN. As much as Hammons would insist on the non-gendered role of hair in his work, the manipulation of hair is largely identified with a female creative space.

Lisa Jones may sound a bit fanatic when she states, "everything I've done with my hair explains everything I've done with my life and my art. . . . Hair is the be-all and end-all."[13] But what her book and passions pay tribute to is the place of women's imagination and ingenuity. The orchestration of hair as art form becomes both the embodiment of and a shorthand for this feminist vision. For Jones, the essential, driving force of her feminism, outside of the "big political issues," springs from:

> a passion for the creative culture of women and a belief that communion with other women [is] a bread and water necessity . . . what [keeps] me interested in feminism and *identifying* is the pleasure.[14]

Hair is thus a tangible symbol of African American women's creativity and joy. As bell hooks has written:

> [G]etting our hair pressed . . . is not a sign of our longing to be white. . . . It is a sign of our desire to be women. . . . It is a rite of passage. . . . There is a deeper intimacy in the kitchen on Saturday when hair is pressed, when fish is fried, when sodas are passed around, when soul music drifts over the talk. We are women together. This is our ritual and our time.[15]

While hair culture represents inventiveness and pleasure, through it African American women are also able to realize their own sense of ceremony as well as space, by establishing a place where hair rites can be enacted.

So what are men like David Hammons doing there in the first place?

What indeed. If we look at Jones's take on an exchange between black men and black women on this topic we find that, in many instances, it is not a party to which they have been invited:

> Then the moment we'd all been waiting for; *Essence* [magazine] invited men to comment on women's hair practice. Men gave thumbs-down to weaves and drippy curls. Women wrote back telling the men to mind their business. As if today, this ain't about y'all and this ain't about The Man, this is our creative space, best you stay out.[16]

This matters little to Hammons who clearly wades right into the fray. Though he may claim jazz (and its players) as its intellectual guiding force, it is, in fact, the culture of women that provides the material underpinnings of Hammons's installation work.

Alice Walker and bell hooks both have essays which discuss their search for artistic foremothers.[17] Does the heritage of slavery and then back- (and perhaps soul-) breaking manual labor foreclose the possibility of a legacy of African American women's creativity, they ask? While the history of such cultural traditions may have been a bit more difficult to locate than the jazz-men that inspired Hammons, Walker and hooks found them nonetheless.

This inheritance of imagination came through Walker's mother, the gardener, and hooks's grandmother, the quilter. Using the tools of flowers and fabric, these women were able to create aesthetic arenas of meditation, domains in which each could "cease attending to the needs of others" and as hooks's grandmother would say, "come back to herself."[18] Walker has remarked that her mother was "involved in work her soul must have. Ordering the universe in the image of her personal conception of Beauty."[19]

Gardens and quilts. These are tropes David Hammons returns to again and again in his installations using African American hair. Particularly in the 1970s, these works are like fecund vegetation that replicates itself seemingly without end, or cloths to which pieces are continually added. They are all planting and weaving, hair sifting like dirt through the artist's fingers. As with the vivid imagery of hair culture, these sources too cast beauty as cultivation and maintenance; they are also "popular art forms," performed as daily tasks, as everyday infusions of splendor and grace.

In rejecting and then transforming the white box of the modernist exhibition space through installation, Hammons sought to create a realm that could both symbolize and, to an extent, sustain the culture of commonplace and street life. Hammons's reverence for the everyday is connected to his veneration of "folk" or "naive'" art and functional aesthetics found primarily

in the South. In many ways this is the tradition of the *bricoleur*. And doesn't this practice include the quilter who constructs a wholly new object from a fleet of scraps?

It is interesting to note as well that both the quilter and the gardener carve out real physical space—as well as the intellectual and spiritual variety—in their creative processes. Hooks recounts how her grandmother added a room for quilting and sewing to her home as soon as she was financially able. The gardens and yards of flowers definitely insinuated themselves as part of both the Walker homestead and the larger Georgia landscape. The interiors that these women created and in which they lived and worked could even be seen as forms of what we know to be installation: hooks's grandmother's chamber filled with baskets, scraps, and material in various stages of piecing; Walker's mother in the act of "cover[ing] the holes in [the] walls with sunflowers."[20] In both cases each marked space is able to signify: to attest to the inventiveness of its maker, and to impart a narrative tied to its construction.

When hooks eventually visited a "real" artist's studio, she was struck by how much that workplace had in common with the one her grandmother had built. With installation the mystical realm of the artist's studio is in effect transformed into a public space, since materially it seems to disclose the working method as well as the necessary tools. In this way it effects the decentering of the authorial role of the artist, and the parallel centralization of the position of the spectator. With this act, the place of installation (and art) is revealed as a space of constructed narrative. It is also acknowledged as a domain of intimacy, a place where not only the maker but the viewer can "come back to herself," exercise her own critical reasoning, and project her own history.

In his work from the 1970s, David Hammons clearly draws on common, everyday rituals of African American communities to create an artistic statement on and through culture. By way of installations, he fabricates sites of familiarity, and it is by evoking the cultural practices of black women—from hair to gardens to quilts—that he is able to invent spaces of experience and of intimacy.

NOTES

Originally published in *Third Text* 44 (autumn 1998): 17–24.
1. See Lizzetta LaFalle-Collins and Cecil Ferguson, *19 SIXTIES: A Cultural Awakening Re-evaluated, 1965–1975* (Los Angeles: California Afro-American Museum, 1989).
2. Kobena Mercer, "Black Hair/Style Politics," in *Welcome to the Jungle* (New York: Routledge, 1994), 100–101.

3. Lisa Jones, *Bulletproof Diva: Tales of Race, Sex, and Hair* (New York: Anchor Books, 1995, originally published 1994), 297.

4. Judith Wilson, "Beauty Rites: Towards an Anatomy of Culture in African American Women's Art," *International Review of African American Art* 11(3) (1994): 13.

5. Ibid., 13.

6. Mercer, "Black Hair/Style Politics," 100.

7. Jones, *Bulletproof Diva*, 296–97.

8. "David Hammons: Dreadlock Series," Just Above Midtown Gallery, April 6–April 26, 1976.

9. John Perreault, "David Hammons," *Soho Weekly News*, April 21, 1977, 27.

10. David Hammons and Louise Neri, "No Wonder," *Parkett* 31 (March 1992): 53.

11. Wilson, "Beauty Rites," 17.

12. Perreault, "David Hammons," 27.

13. Jones, *Bulletproof Diva*, 11.

14. Ibid., 139.

15. bell hooks, "Black Is a Woman's Color," (1989), cited in Wilson, "Beauty Rites," 15.

16. Jones, *Bulletproof Diva*, 304.

17. Alice Walker, "In Search of Our Mothers' Gardens," in *In Search of Our Mothers' Gardens* (San Diego: Harcourt, Brace, Jovanovich, 1983), 231–43; and bell hooks, "Aesthetic Inheritances: History Worked by Hand," in *Yearning* (Boston: South End Press, 1990), 115–22.

18. hooks, *Yearning*, 116.

19. Walker, "In Search of Our Mothers' Gardens," 241.

20. Ibid., 242.

Domestic Prayer

Pepón Osorio, *La cama* (*The Bed*), 1987. Mixed-media installation, dimensions variable (bed: 75 x 57.5 x 81.5 inches). Collection of El Museo del Barrio. Courtesy Ronald Feldman Fine Arts, New York. Photo credit: Tony Velez.

Critics writing on both modern and postmodern Western existence have continually identified fragmentation, layering of meaning and/or combinations of meaning(s) as the experience of twentieth-century life. However, it seems like some of us living in the Americas and Caribbean have about a four hundred year jump on this game.

For the past five centuries people of Amerindian, European, African, and Asian heritages have come together, not always under the best circumstances, and have created New World culture. Hardly a monolithic entity, it changes from region to locality, and is qualified by language, environment, and degree of segregation of one element from another. The Americas and the Caribbean are therefore perhaps best characterized as areas that possess a variety of living, breathing, changing cultural traditions that spring from the same four roots. Maybe we can call this creole—signifying mixture, hybrid, *mestizaje*, the conjunction of three or more linguistic, cultural, or visual traditions. One thing is certain, American cultures are heterogeneous, eclectic, and pluralistic.

If the modern and the contemporary in culture and art are identified by a multifaceted and multilingual nature, then Pepón Osorio epitomizes the twentieth-century artist. As a black Puerto Rican living in the United States, he attempts through his work to synthesize his many traditions and in a way that speaks to the differences and similarities among us all.

Working with three-dimensional objects and room-size environments, Osorio activates popular symbols and everyday commodities in unexpected ways. Through these he analyzes the legacies and customs he grew up with, reformulating them in his own manner. Osorio uses his art to make public, if subtle, statements about the dialectics and opposing forces in the world around him: "high" versus "low" culture, black versus white skin, and the specter of assimilation. In Osorio's work, what Amalia Mesa-Bains has termed "cultural reclamation" becomes a strong component of both impetus and method. The act of looking for, searching out, and piecing together aspects of lost or hidden legacies becomes at once a motivating force in the making of the work and the technique by which it is made.

Orosio's pieces are flamboyant. His favorite materials seem to be plastic trinkets, anything that can be found on the discount store sale rack. His artwork is encrusted with them, as if each surface had been dipped in barrels from a toy store. The profusion of knickknacks and playthings make these

works comical and fun. Because there is a lot to look at, one must approach the pieces again and again to see and then understand what is going on beneath the surface. As in life, the appearance of exuberance and lightheartedness often masks a deeper seriousness, even melancholy, or political intent.

The artist is concerned primarily with the domestic, the seemingly uneventful private facets of human life. By embellishing these ordinary objects and scenarios, he not only calls attention to the mundane but employs the familiar as metaphor. Physically, Osorio's work has a striking affinity with the religious altars that appear throughout the Americas in numerous homes, whether Brazilian, Puerto Rican, Mexican, Haitian, or African American. In each we can find diminutive saints and figurines, artificial flowers, shiny accessories, and photographs. Like these domestic reliquaries, the artist's pieces also "serve as a point of connection and mediation between distinct domains, the terrestrial and celestial, the material and the spiritual, the personal and the communal."[1] But rather than arranging the devotional items on a table or shelf, he attached them, profusely, to common articles found in the home, such as beds, spoons, bicycles, and clocks.

Among the plastic palm trees and miniature sombreros, the latex rhinestones and other gaudy baubles, the tassels, loud fabrics, and gold detailing, numerous ethnic stereotypes have also been set loose. However, Osorio is intent on giving these a new twist and reshaping interpretation. Exaggeration is one method: his artworks drip and ooze with symbols of the typecast Latino. But while he ridicules these images through excess, in another way he also embraces them. The cliché is revealed as the mask, the disguise that conceals not just life's disappointments but histories of domination and subjugation. The portrait of the happy-go-lucky *jíbaro*, like that of the African American contented slave, becomes part of the narrative of survival. Osorio's precious commodities are tacky signs of prosperity in miniature. His abundance parodies a world where people of color often lack the basics of health care, education, and money. In place of denial and poverty, the artist invents a universe where more is indeed more, as opposed to the contemporary "less is more," and more is better.

Osorio also critiques a Puerto Rican society that venerates the elitist models of its Spanish roots at the expense of popular and other, particularly African, traditions. In *El Chandelier* (1988), for instance, the majestic, European identified lighting fixture is weighed down with signs of these missing elements from the cultural story. Dominoes, black babies, and palm trees are attached to a lamp already over-saturated with mass-produced jewels. A profusion of frills and lace embodies the European in *María Cristina Martinez Olmedo, DOB, 3.27.89* (1989). Here the purity and delicacy signaled

by yards of fabric covering a bassinet are contrasted with the sickly black child it contains. The tubes, wires, and instruments attached to the doll imply control and helplessness, yet the piece is also a searing comment on the black and Latino infant mortality rate in the United States. The artist also reflects on racial issues in pieces like *La Cama* (*The Bed*, 1987), where he reverses the concept of tokenism and "minority" status by including a single white doll in crowds of black ones, thus more accurately portraying the world population as it truly exists.

Like altars, Pepón Osorio's artworks are sites of transcendence and healing. In the midst of the chaos of guns, knives, skeletons, gold, glitter, and other aspects that vie for attention in and on his sculptures and installations, there is always a proliferation of babies, the new generation that will restore balance to the world. In uniting disparate visions of Puerto Rican life, the artist attempts to reconstruct an equilibrium.

NOTES

Originally published in *Con To' Los Hierros: A Retrospective of the Work of Pepón Osorio* (New York: El Museo del Barrio, 1991).

1. Tomas Ybarra-Fausto, "Cultural Context," in *Ceremony of Memory* (Santa Fe: Center for Contemporary Art of Santa Fe, 1988), 9.

Critical Curators

Interview with Kellie Jones

Glenn Ligon, *Profile Series "A Sharp Dresser,"* 1990–1991. Oilstick and gesso on canvas. Courtesy Regen Projects, Los Angeles, Calif. Photo credit: Stanley Gainsforth.

POLIESTER: How did you get started as a curator?

KELLIE JONES: Like most other curators I first worked in the museum setting as an intern. My earliest internship was at the Studio Museum in Harlem (SMH). The summer before my senior year in college (1980) I worked at SMH for the education and curatorial departments. Mostly I did research on an exhibition of the work of painter Ed Clark, compiling a chronology of the artist's life, which was my first published writing on an artist. After graduating from Amherst College (with an interdisciplinary degree in black studies, Latin American studies, and fine arts) I returned to SMH in September 1981 as a National Endowment for the Arts Intern. Under this program I worked for a number of weeks in each department (finance, public relations, design, etc.) and then chose an area of interest in which to concentrate: curatorial. That internship was over after nine months and I was promoted to curatorial assistant with primary responsibility for overseeing the art collection at the Adam Clayton Powell State Office Building which SMH administers.

P: What shows have you worked on?

KJ: At SMH I worked primarily on shows of African American artists, exhibitions of Charles White, Roy DeCarava, and James Van der Zee among them. I also had the opportunity to work with younger artists who came through the Artist-in-Residence Program there such as Tyrone Mitchell, David Hammons, Alison Saar, Candida Alvarez, Jorge Rodriguez, and Charles Abramson.

After SMH I worked for the Broida Museum, a space that never actually opened, though I was employed there for two and a half years. Located in SoHo it was a "mainstream" museum of contemporary art. Even though it was disbanded a few months before the proposed opening date, I still had the opportunity during my tenure there to work with artists such as Bruce Nauman, Susan Rothenberg, and Eric Fischl and with curators and writers like Robert Storr and Joan Simon. This experience opened up another side of the art world to me, or rather made it more accessible since one is always aware of what the "mainstream" is doing.

Following Broida I tried to find employment in "mainstream" museums and galleries in New York. Though I had five years of experience by this

time, my efforts were stymied basically by art world racism; I couldn't even get an entry-level position. I did land a job in Queens at the Jamaica Arts Center which in retrospect was probably the best thing that could have happened. It was there as visual arts director that I was able to consistently work on my own exhibition ideas over a three-year period. Some of the shows I organized there were: "Deja Vu: Haitian Influence in Contemporary American Art," "Abstract Expressionism: The Missing Link" (which presented African American artists connected with the New York School), "US/UK Photography Exchange," and "Works from the Isamu Noguchi Garden Museum." Beginning in 1986 I also organized exhibitions as a guest curator for other institutions such as the Longwood Art Project (Bronx), Artists Space (New York), the Caribbean Cultural Center (New York), Soho 20 Gallery (New York), and Camerawork (London). In 1989 I was the commissioner (curator) to Brazil's Twentieth São Paulo Bienal, one of the oldest of major international arts exhibitions. My show of sculptor Martin Puryear won the grand prize for the best individual exhibition.

Most of my career as a curator has focused on presenting art by African American, Latin American, Asian American, and Native American practitioners, or those who we now call "artists of color" in the United States. I am concerned not just with explaining or showing this art to "mainstream"/white institutions, curators, and audiences, but exposing communities of color to the work of their own (and other) artists. Writing is important to me as well. A large part of why artists of color are unknown is because written documentation of their work has not been a priority.

P: What are some of your most recent shows, and what do you have planned for the future?

KJ: "Interrogating Identity" is a show I co-organized with Tom Sokolowski in New York University's Grey Art Gallery; it opened in New York in March 1991 and is still touring. The show looks at issues of identity among artists of color in three English-speaking areas of the world: Canada, Great Britain, and the United States. In May of this year I presented a mixed media installation by British photographer Ingrid Pollard sponsored by En Foco, Inc., at Art in General in New York. In the next year I have two shows planned. "Malcolm X: Man, Ideal, Icon" will open at Walker Art Center on December 13. Through fine art, commissioned works, elements of popular culture, and excerpts of his own speeches, the exhibition will explore the life and philosophies of Malcolm X while also providing artists with the opportunity to present their own visions of this important African American leader. In February "In the Ring" will open at Snug Harbor Cultural Center in

Staten Island. This exhibition uses boxing as a motif to explore societal and domestic violence and struggle.

P: How do you organize your shows: by theme, nationality, geography, race, gender, medium, etc.?

KJ: I have used all of these categories as organizing themes for exhibitions, and they are all valuable at one time or another. It just depends on what catches your interest at a particular time. I don't think there's one singular way that curators should organize shows. Sometimes there may be an interest in looking at German photography or African American abstract expressionist painting. As a type of category these two are the same, though perhaps in the past looking at a group of European artists has been considered more valid. Sometimes you want to look at what's happening in sculpture or painting during a specific period. But I do think it's important when a curator is working with a theme, "Painting in the '90s," for instance, that she/he tries to balance the show demographically, by ethnicity, and gender. To do this not just for the sake of doing it but because that makes the show more representative of what's happening out there.

P: What are you doing in terms of exhibition organizing that no one else is?

KJ: I don't think what I do is necessarily unique. There are other curators out there doing similar things. However, the approach I usually take is not widespread or by any means a dominant mode used by curators. What I try to do is be inclusive in my selection of artists. That is, I try to represent different viewpoints and bring them into a national or international dialogue. For example, "Malcolm X: Man, Ideal, Icon," includes white, African American, and Latino artists, men and women, and collaborations, as well as a variety of media. I think it is important to have shows that are integrated in terms of artists and perspectives. Artists of color are getting tired of only being represented in the "black," "Latino," or "Asian" show. They have just as much to say about color, line, and form; their work is not always about ethnicity. Besides, as most of us now know, white men aren't the only ones who make art.

P: Who are some of the best curators in the world today? What galleries, museums, or alternative spaces are presenting the most interesting exhibitions these days?

KJ: Since I haven't had much of an opportunity lately to jet around the world seeing exhibitions, I don't know if I can really make a worldwide assessment. Many of the curators and spaces I admire most are based in New

York because that's where I've had most of my experience. Thelma Golden at the Whitney Museum at Philip Morris has been doing some very interesting projects over the last year. Holly Block of Art in General has consistently had an extremely inclusive program. Carlos Gutiérrez Solana, the new director of Artists Space, is someone whose vision I've respected over the years. Robert Storr at the Museum of Modern Art is bringing a fresh outlook to that place, and he's also a wonderful writer. Ivo Mesquita is an independent curator in São Paulo, Brazil, who is bringing contemporary critical perspective to art in Latin America. Mari-Carmen Ramírez of the Archer M. Huntington Gallery at the University of Texas, Austin, is also doing exciting work with Latin American artists. Independent scholar, curator, and artist Margo Machida is raising interesting issues around the work of Asian American artists. Other spaces that I think present interesting programs because of the culturally and formally diverse artists they show are Exit Art and Washington Projects for the Arts (Washington, D.C.).

P: What are some of the most interesting new art movements these days? How are they changing traditional concepts of organizing an art exhibition?

KJ: I don't think we're seeing what one would call clearly defined movements these days, not like neo-geometry, or neo-expressionism, etc. There is a lot of interest in three-dimensional installation, and this is done by artists working in all media. I think artists are turning to this format because it allows them to experiment without being restricted to a certain medium. Installation changes the curatorial process because for the most part you are not borrowing objects for a show but hiring an artist to create a piece (often a new and onetime thing) on site. You are often dealing with materials not necessarily recognized as art materials. For instance, the recent collaborative work by Ann Hamilton and David Ireland that was shown at Walker Art Center used flour, literally tons and tons of it. What I find interesting about site-specific installations is that they tend to be very topical and suggest human issues that people are dealing with in their lives right now. And that's what I want to do as a curator, speak to people, present art that can touch people, that can make them think about what's going on in the world, or in their own homes. Fred Wilson is an artist who uses this form particularly well. In his recent show at the Baltimore Historical Society in Maryland, *Mining the Museum*, he uses pieces from the permanent collection of that institution. By juxtaposing them in unorthodox ways he creates a critique of slavery and race relations in the U.S. It's fascinating what recontextualizing can do. Coco Fusco and Guillermo Gómez-Peña will create *Year of the White Bear* at the Walker Art Center in September. This piece will

also use archival materials to support an alternative view of Columbus's "discovery" of America. Photography and media-based art are some areas that I also think show a lot of interesting change. The idea of photographs juxtaposed with text or objects is hardly new, but I think the practitioners and the ideas are different these days. Women of color are doing a lot with this format and are exposing issues that heretofore have not been in the forefront of artistic practice. In this country Lorna Simpson and Carrie Mae Weems are among those working this way, in England, Ingrid Pollard and Zarina Bhimji. These artists have also experimented with installation formats using photography. This gives exhibitions of photography a new visual interest. One thing I like about the medium is that it can be shipped very cheaply so that it's quite accessible to smaller art centers and a variety of audiences. It's also a more contemporary process that people identify with.

Don't get me wrong, though, there is still interesting painting and sculpture out there, too.

P: How has the art world changed over the last five or ten years, specifically in relation to your projects?

KJ: On the one hand, it seems as if some sectors in the art world have become more open to art by people of color. Some major institutions in the U.S. have opened up in this way, for instance the Walker Art Center, San Diego Museum of Contemporary Art, Whitney Museum of American Art, and the High Museum of Art to name a few. For the most part I believe this is due to the fact that these places in particular have younger directors. They're of a generation that came of age in the 1960s when things were being questioned radically and often violently. Thus the people in these top positions who can help institutions start to change have the potential to do the right thing, if you will. Yet there are some people in power who are of the same generation who still hold on to the supremacy of a white male–dominated structure. If there is evidence of things changing, they are changing slowly. And even one person in power can't really do it alone.

With regard to African American artists, this type of thing has happened a number of times in the last century. During the Harlem Renaissance of the 1920s and 1930s there was a strong interest in work by these practitioners. In the early 1940s, as well, one can find documentation of gallery and museum shows highlighting African American artists. In the late 1960s and early 1970s as a result of action and protest, African American artists (and those of Latin American descent as well) were given the resources to found their own institutions (Studio Museum in Harlem and El Museo del Barrio in New York are two examples). With such organizations run by

people of color in their own interest, these groups no longer had to rely on the benevolence of "mainstream" or predominantly white institutions to exhibit work.

P: Do you feel the art world is becoming increasingly international and multicultural? Is this an important aspect of your work?

KJ: I think there is a gesture to be more international and not just so focused on Europe. However, again I think it will take a number of years on this track before it will become a truly institution-wide way of thinking. Let's see what happens by the end of the century. It has been going on somewhat in Europe, with *Magiciens de la Terre* at the Centre Pompidou in Paris; *The Other Story*, at the Hayward Gallery in London; and with the recent *Documenta* in Kassel. These are baby steps. We are somewhat more ahead in this country but it is still not enough, especially when you look at growing U.S. demographics. When museums are showing works that deal exclusively with European culture in cities that are populated by more than 50 percent people of color, whose cultures and ethnic backgrounds range from Vietnam to Guatemala and Jamaica to Ghana, I think there is something wrong. There is an investment in maintaining some notion of European/ white supremacy; there is some investment in making the majority of the people feel that their culture or they themselves don't measure up. In this way a kind of self-hate and confusion are engendered that keep people from challenging the status quo. Perhaps this is a strong statement but in some ways it is very true. In the museum world it may not be as deliberate as in the business world for instance. But culture is also used as a prop of social/ political power. And there is an ingrained belief in the majority of "mainstream" or "general" cultural institutions in this country that European aesthetics and forms are better. People really believe this. You can see it come into play in arguments about "quality." These organizations and those who run them are now somewhat ready to accept cultural or ethnic diversity; aesthetic diversity, though, is another thing. It's still hard to accept that a piece of art might not be following conventions you like or understand, that it still might be good or of a quality based on other criteria. This type of difference is hard to integrate into a museum that has a specific "vision" that it takes pride in. More than that, though, it's hard to accept that a European aesthetic is just one of many "different" forms.

P: What's lacking in the art world?

KJ: I think the thing that's still lacking is a strong commitment to hiring and training people of color. This goes on in institutions run by people of color

who have an investment in seeing people from their own ethnic groups carry on their tradition. But with regard to internships and staffing in most other institutions, there hasn't been that type of commitment. Most of the people of color working in your larger institutions are guards and clerical support staff. It is rarer to find people of color making executive or managerial decisions or learning these skills through internships. This is where major change is still sorely needed. Diversity in the workplace is another step to integrating a multicultural agenda into the art world.

NOTE

Originally published in *Poliester* 3, fall 1992.

Poets of a New Style of Speak

Cuban Artists of This Generation

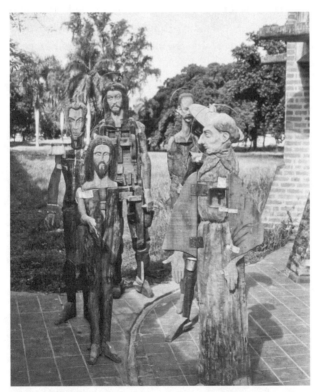

Alejandro Aguilera, *En el Mar de America* (*On the Sea of America*) 1989. Mixed-media installation, dimensions variable. Photo credit: Luis Camnitzer.

[If] the first time you didn't quite understand our new style of speak, don't worry, we can fix that right now.

DE LA SOUL, "PLUG TUNIN"

Who would think that contemporary Cuban artists and African American rap musicians have anything in common? Besides youth. One group is a product of a revolution, has lived "the dream," can see its benefits, and won't abandon it. The other is playing at living the American dream (at least the successful ones) while being caught in a web of racial (masking political and economic) disenfranchisement (no, they still can't catch a cab in New York or buy a condominium in certain neighborhoods).

But both the young Cubans and African Americans are uniquely positioned as prescient and searing critics of their time. Irreverent and comical, they take on the sacred cows of recent heritage. Maybe they use crude and offensive language or images, or make disturbing allusions that have more in common with reality than fantasy. Indeed, at one time or another, both rappers and artists have been censored.

With members aged in their twenties, each group has developed extremely rapidly; a work may be considered old that was made only three months earlier. In the Cuban case, this swift growth is a result of a free, popular, and complex education which benefited individuals from parts of society that prior to the Revolution were not privy to such training. They have given a voice to the grass roots that had been silenced for years.

In contrast, an underground system of production and distribution fueled the development of African American rappers. Demo tapes were made in basements, apartments, or cheap studios, a few thousand copies pressed into records and sold from the trunks of cars at clubs and concerts. Even as rap grew more popular, it was still largely controlled by independent labels and producers, and disdained by a mainstream music industry that saw this art form as both a threat and a passing fad. (That is, of course, until recently.)

While Glexis Novoa goes from his "romantic phase"—adopting (and critiquing) the gestural brushwork of abstract expressionism—to his "practical phase"—deconstructing the language of billboards and socialist realist portraiture—in a matter of months, the hippest rappers are discarding the

poise of crass consumerism (frolicking with big gold chains, fancy cars, and women in jacuzzis) for a more political stance; as rapper KRS-One says, "the new fad is intelligence."

These young Cuban artists and African American rap musicians work for their own audience, for themselves, for the people that they come from. At the same time their aim is to break through traditional codes and distinctions, to expand their art forms and audience. The Cuban artists are not out to dismantle their system but to poke and prod at the stifling rhetoric and bureaucratic lethargy that pervade their institutions. In the same way, African American rappers and young artists are blurring the distinctions between what Henry Louis Gates Jr. has referred to as "public" and "private" culture. According to Gates,

> There was material that was exclusively the province of the black oral tradition, but now people have decided to cross the line. People like Keenan Ivory Wayans and Spike Lee and Eddie Murphy, along with the rappers, they're saying all the things that we couldn't say even in the 1960s about our own excesses, things we could only whisper in dark rooms. They're saying we're going to explode all these sacred cows. It's fascinating, and it's upsetting everybody—not just white people but black people. But it's a liberating moment.[1]

What links these visual artists and rappers in particular is their relationship to an oral tradition (as Lazaro Saavedra has said, "Today we paint the same things that formerly were not painted but spoken"); group and generational dynamics; and seeing themselves (especially the Cubans) as the political vanguard.

The work of each group is at once humorous and iconoclastic. Both rap songs and physical objects combine jokes, advice, tales, social statements, political criticisms, and baroque hyperbole in formally sophisticated pieces. It is surprising, at times offensive, and not at all what one expects of "art."

> When I came to New York . . . [black artists were] just groveling and tomming, anything, to be in the room with somebody with some money. There were no bad guys here, so I said "let me be a bad guy," or attempt to be a bad guy, or play with the bad areas and see what happens. (David Hammons)[2]

"Playing with the bad areas" has no real relation to the American "bad painting" of the early 1980s, which was a purely formalist reaction. Instead, these newer Cuban and African American artists are concerned with "recti-

fication," or revisionism, and with forms which explore flaws in their respective cultures. They follow their own rules, and are not bound by "positive" imagery. Reginald Hudlin is not concerned with his films "being good public relations for the race." His noncommercially released *Reggie's World of Soul* is a send-up of television news shows, and traffics in stereotypes while attempting to demystify them. Similarly, Robert Townsend's commercially successful *Hollywood Shuffle* is a film that confronts cultural myths in various vignettes in which African American actors self-consciously play their supposedly "natural" roles, learning to talk, walk, and act as others have imagined black people should.

Such films have much in common with works by Marta María Pérez Bravo and Carlos Rodríguez Cárdenas. In a series of serigraphs (originally photographs) titled "Para Concebir" (In Order to Conceive), Pérez Bravo investigates Cuban superstitions surrounding conception. Each image illustrates the saying which is written across it, in a manner reminiscent of scientific or anthropological dissection and labeling, yet somehow with an ironic twist. In *No matar ni ver matar animales* (*Don't Kill Animals or See Them Killed*), a woman is poised with a large knife above her pregnant belly. The small and delicate oil paintings in Cárdenas's series "Feliz encuentro entre arte, política y sexo" (Happy Encounter between Art, Politics and Sex) inject satire and innuendo into illustrations of Communist Party slogans. In *Ahorrar para crecer* (*Saving Means Growth*), a tiny man looking quite chagrined is confronted by an amazon of a woman.

> When you're faced with a stereotype, you can disavow it or you can embrace it and exaggerate it to the nth degree. (Henry Louis Gates Jr.)[3]

In an article in the *New York Times*,[4] Gates defends the rap group 2 Live Crew, recently banned in Florida for their obscenity. He contends that those persecuting the band have no understanding of black cultural codes, their history of double meaning, allegory, or "heavy-handed parody" known as "signifying" or "playing the dozens" whereby subjects are exploded with exaggeration. He concludes by saying that those who would condemn the group should first "become literate in the vernacular traditions of African Americans."

In an event that had similar repercussions but very different circumstances, painter Tomás Esson voluntarily dismantled an exhibition of his work after a number of pieces were found to be offensive.[5] At issue once again was comprehension, the fact that members of the bureaucratic structure controlling the event could not relate to the paintings. One controversial work titled *Mi homenaje a Ché* (*My Homage to Ché*) (1987–1988) de-

picted Esson's fairly grotesque, signature biomorphic forms copulating in front of a portrait of Ché. While some found this a denigration of a major hero of the Revolution, Esson insisted the painting was a comment on hypocrisy and the double standard of some government functionaries.

Both Cuban and African American artists see their projects as a means of improving their respective situations. There is a reevaluation of the idea of nationalism. Cubanía (Cubanism) for these younger Cubans has come to mean the rejection of the stylistic hegemony of the "international art world" and the working toward communicating and educating within their own national boundaries. For African Americans this same concept is manifest in a renewed interest in 1960s and 1970s Black Nationalism and activists, African American history, and things African — a phenomenon recently coined as Afrocentrism. Yet none of those ideas are bought wholesale by the artists, but instead are subjected to their own newly defined and emerging critique. Nationalism becomes just one of the many elements (albeit an important one) that goes into the making of a new aesthetic/new art.

As art forms, rap music and the new Cuban art physically approximate what has come to be known as postmodernism: they appropriate and combine elements from a variety of sources. In rap, vocalists rhyme over a collage of sound bites produced by a disc jockey interweaving (mixing) and distorting existing records. Contemporary Cuban art can contain magazine clippings, cartoons, accomplished painting or drawing, text, and found objects, all in a single piece, and make it work. However, this syncretic thrust has more historical underpinnings for these two groups than any grounding in contemporary art per se. For centuries Cuba, and Latin America generally, has created a living culture from Amerindian, African, Asian, and European sources incorporating the diverse heritage of those who have lived, worked, settled, and even exploited the land. As Luis Camnitzer points out, eclecticism and pluralism are terms that perhaps better describe the reality of Latin American and Cuban art and culture, free from a singular, omnipotent "aesthetic dogma." The appellation "African American" in itself expresses what Greg Tate has called the "multicultural tradition" of that people and culture, a New World hybrid. Unlike postmodernism, which sees the death of "art" in such juxtapositions and recycling, in the Cuban and African American contexts it is a tradition connected with survival and life. As Stuart Hall has written:

> Now that, in the postmodern age, you all feel so dispersed, I become centered. What I've thought of as dispersed and fragmented comes, paradoxically, to be *the* representative modern experience![6]

In looking at the work of these Cuban artists, there is much that is immediately familiar and recognizable to any U.S. audience. Yet the context of the isolated images and a thorough understanding of the meaning and intent is certainly more obscure to North Americans, as outsiders to the material and intellectual culture of Cuba (made even more estranged by the years of the United States government–enforced blockade). While it is perhaps unfair to compare the pieces by the nine artists on view in this exhibition with the work of U.S.-based or other artists, for us, the uninitiated, it is a place to start.

For Marta María Pérez Bravo, the female body—her own body—is a form that can fully express artistic and social concerns and personal feelings. Perhaps Pérez's investigations are similar to those of United States feminist artists of the 1970s who produced objects and performances connected with their own bodies. But the works in this exhibition demonstrate that Pérez Bravo's art is also grounded in Cuban myth. While the series "Para Concebir" (In Order to Conceive) explores the lore surrounding conception, the other photographs presented here consider the particular significance of the birth of twins, a belief that can be traced to Africa. It is interesting to compare this aspect of Pérez Bravo's work to that of photographer Carrie Mae Weems, who uses African American folklore and traditional beliefs as the basis of her work because of its ability to speak more directly to deeper issues. In "Para Concebir" Pérez Bravo's torso fills the page but her face is never seen, in a striking formal similarity to the archetypal (black) women found in the photographs of Lorna Simpson. Conversely, Pérez Bravo's other photographs focus only on her head, where two small plastic dolls gambol in a variety of tableaux.

One of the rare traditional sculptors in Cuba, Alejandro Aguilera combines carving and construction in his work of found wood. *En el mar de América (On the Sea of America)* is a collection of six nearly life-size saints/saviors of Cuba/Latin America. The artist brings together the mythical and the actual—Simón Bolívar, José Martí, Father Bartolome de las Casas, Don Quixote, Jesus, and Ché—suspending them over a pool of water. The inclusion of religious figures, the halos over each statue, and the configuration of the work itself, add to its altar-like feeling. In that sense, this piece mirrors the concerns of a number of contemporary United States artists working with the altar format, such as Amalia Mesa-Bains, Betye Saar, and Juan Boza. The body of each saint/savior is an assemblage of wood scraps accented with metal joinery, while their faces (and at times arms) are chiseled and sculpted. The robe of the priest de las Casas becomes a termite-eaten

tree trunk. A compartment has been hollowed out for his heart where instead rests a cross; this figure in particular is related to pieces by contemporary sculptor Alison Saar, whose traditional or folk art–inspired characters often have similar elements embedded in them that are symbolic of an interior life.

Ana Albertina Delgado's paintings are fairly large and lushly painted. They are dreamlike scenarios in which the straightforward representational and the cartoon-like get to mingle. In some, expanses of flat or swirling color contain masked or smaller painted symbols, as in *Los Polvos* (Past Flings). The edge of one canvas, entitled *Dentro del Labio* (*A Mouthful*), becomes a profile, with a possibly pre-Columbian Venus-like form hovering where an ear would be. The breadth of the facial image and the incorporation of the meaningful sign is a feminine counterpart to the mammoth self-portraits of Puerto Rican painter Arnaldo Roche, which explore the diverse identities of that island.

Tomás Esson has developed a strong style that combines opulent painting with the cartoonish and the grotesque. His recent works are large polytychs that cover entire walls with a bestiary of alternating national and primordial symbols. His primary protagonist is "talisman," an indeterminate, horned turd that often takes on anthropomorphic form as a metaphor for the workings of society. Part comic book character and part scatological antihero, talisman becomes a witness to human inconsistencies and shortcomings. Other flora and fauna, of amorphous species but endowed with pronounced genitalia, populate Esson's paintings; they combine pigs, bears, cows, bulls, snakes, and birds, or maybe an assembly of green peppers, entrails, and heart valves. Esson's bizarre hybrids could be the offspring of cartoonist R. Crumb and Francis Bacon, or graffiti artist Kenny Scharf and expressionist painter Luis Cruz Azaceta, but the luxuriant surfaces and exuberant obscenity are very much his own.

Esson's interest in the power of sexuality, vulgarity, and wordplay is in some ways very close to that of the Long Island rap group De La Soul. One of the first widely popular, iconoclastic groups in this genre, De La Soul rejected the macho image of the gold-chain-toting womanizer for the peace-loving homeboy (often mistaken for a hippie) who speaks "from the soul." Esson's frequent deployment of the erotic as motif brings to mind De La Soul's development of an alternative language or "new style of speak," of which a mainstay is the renaming of sex acts and organs. The title of Esson's piece *SPOULAKK* presents viewers with a word game whose end result involves them in vulgarity, while De La Soul's similar foray into acronyms pro-

vides them in one case with their pacifist emblem, the daisy.[7] Additionally, the rap group's odes to excrement, body odor, dandruff, and bad breath on other cuts confirm a certain artistic kinship with Esson and generally with Cuban artists of this generation.

If Tomás Esson's work pushes the more salacious aspects of art, Segundo Planes goes for the existential. Planes is the resident poet of this generation, both in terms of written text that appears in his work and the physical presence of the objects themselves. His are the most minimal and intimate drawings of the group presented in this exhibition. Planes takes viewers on a journey through the land of fantasy, imagination, and dreams, pulling them into the middle of his own stream of consciousness soup in a manner sometime compared with that of artist Jon Borofsky. "Jamas podran salir de esta oscuridad, solamente como cerdos" (They will never be able to leave this darkness, only as pigs) declares one piece; "La arana que se convirtio en cuatro manchas de esperanza" (The scratch that became four stains of hope) states another. Because they respond to, reflect, and are part of the larger Cuban society, Planes's musings are perhaps not as esoteric as they seem. Perhaps his work is a reflection, albeit a lyrical one, of a part of the national sensibility. As one drawing affirms, "Dibujo totalmente emotivo, esa es la idea" (Totally emotive drawing, that is the idea).

The work of Glexis Novoa critiques both the world of art and the way it can be used for cultural stratification and indoctrination. His recent pieces are part of what the artist calls his "*etapa práctica*" (practical phase). By characterizing his output in terms of "*etapas*" (connoting "phases," or "periods" or "epochs"), rather than as series or progressive stylistic shifts, Novoa criticizes the bombast and grandiloquence that surrounds art history. Indeed, paintings in the "practical phase" are extremely heraldic, and are reminiscent of wall-sized coats of arms or huge military medals. In the work, formal portraits are interspersed with large panels of unidentified script which bears a resemblance to Cyrillic, the alphabet in which Russian is written. While presenting itself as something very official, this piece is actually a monumental testament against stagnation of the status quo, whether in art or society.

While not using the billboard format that bespeaks authority, Carlos Rodríguez Cárdenas also analyzes the language that governs Cuban life. In fact, the small scale of his paintings and their stylized figures present the antithesis of the omnipotent and omnipresent slogan. Each piece is meticulously painted, the fairly bright colors and flat surfaces seemingly an homage to naif or folk painting. Each work begins with a well-known phrase, which Cárdenas illustrates with images that give the words a com-

pletely different meaning. The artist does not empty the familiar signifier of content, but instead replaces it with an alternative interpretation, and in doing so questions the official rhetoric that pervades any—but in this case particularly Cuban—society.

Lázaro Saavedra's work is not so strictly bound in its images and sources to the national wellspring. Instead, any object or form is used—whether local or international—as long as it can be transformed to serve the artist's needs. In addition to styles that cover the gamut of Western art, Saavedra has also drawn on prehistoric painting and Egyptian art as well as cartoons and other non-art inspirations. He communicates through humor, as a more direct and unmediated approach. Much of his satire focuses on the making of art, and text incorporated into the pieces often critiques the work itself. One piece on canvas board features a small, thickly painted square from which rises a cartoon-style word balloon reading "Mírame. Interrógame. Recrea tu vista en mi. Soy la textura." (Look at me. Question me. Re-create your vision in me. I am the texture.) In other works, diminutive generic cartoonish figures comment on the action taking place on the picture plane, and act as liaisons between the work of art and the viewer.

Ciro Quintana, like Saavedra, integrates elements of disparate origin into an all-encompassing whole. Like certain African sculpture that has been "primed" with diverse libations, it is the additive aspect of Quintana's work that gives it power. His exquisite drawings of anything from hammers to glacial mountains to comic book characters are combined with metallic paint, collaged magazine clippings, and (sometimes) three-dimensional objects. In this way Quintana layers meaning, creating a variety of simultaneous dialogues with the community, the nation, and the (art) world. These works are baroquely kitsch; everything seems to have cartooney beads of sweat popping off it. The written commentary runs continuously, and self-consciously, throughout the pieces in what Luis Camnitzer has characterized as "chatter"; in a wry take on postmodernism, Quintana has renamed this contemporary style "Postjodernismo," after the Spanish profane term *joder*, loosely translated as "to screw."

Not simply critics of the culture of which they are a part, the new Cuban and African American artists are also instruments of change. Because of the segments of the society that they come from, they have an interest in expanding the audience for "fine arts" to include a larger part of themselves. While the arenas of film and rap music, in the African American case, are indeed channels that have the potential to address larger populations, the Cuban visual artists endeavor to find alternatives to the peculiarly specialized art world and gallery scene. This has been accomplished through group

actions and performances, taking on projects in more isolated towns, and participating in both the organization of and critical writing about exhibitions.

> What we should ask ourselves is whether it would be possible to revolutionize art or if it is doomed to continue becoming more and more complex as a highly specialized activity, sharing its work with "mass culture" as is now the case; or whether it would be possible to revolutionize the people so that they can appreciate art; or whether they will revolutionize us, the "cultured." (Gerardo Mosquera)[8]

The new Cuban art's concern with topicality and development of discourse, above presentation and permanence, is perhaps its greatest strength. Its openness to both vernacular and refined sources, and their easy integration into works that can be understood on a variety of levels by a multiplicity of people, is a goal that many artists and others share. (Perhaps this is the beginning of what Mosquera means by the people revolutionizing the "cultured.") Unlike those of us living in places sans belief and sans direction, where alienation, nihilism, and death are the buzzwords of our late-twentieth-century lives, this generation of Cuban artists has a confidence in the progressive social function of art which stems from their support of the Revolution itself and the benefits they have experienced from that system.

The idea that making art can be socially useful is certainly not new, just out of fashion these days in the Western world. As Robert Storr has said,

> things addressed to or accommodating the "spirit" are only considered "useless" in societies such as ours which take a narrowly materialist account of experience and need.[9]

The frankness, vulgarity, and crudeness that characterizes much of the thematic concerns of these Cuban artists is a way of cutting through the hypocrisy and bureaucracy, of calling out the pretenders, and revitalizing the notion of progress. By discussing these things through art, other more physical confrontations may be averted. These possibilities and potentials are also evident in African American rap music, as the title of a recent article by music critic Jon Pareles announces: "Rap: Slick, Violent, Nasty and, Maybe, Hopeful."

NOTES

Originally published in *The Nearest Edge of the World, Art and Cuba Now* (Brookline, Mass.: Polarities, Inc., 1990).

1. Henry Louis Gates Jr. quoted in Jon Pareles, "Rap: Slick, Violent, Nasty and, Maybe, Hopeful," *New York Times*, June 17, 1990, section 4, 1.
2. David Hammons interviewed by Kellie Jones, *Real Life* 16 (autumn 1986): 2.
3. Henry Louis Gates Jr. quoted in Pareles, "Rap," 1.
4. Henry Louis Gates Jr., "2 Live Crew Decoded," *New York Times*, June 19, 1990. A23.
5. A discussion of this incident is found in Luis Camnitzer, New Art of Cuba (Austin: University of Texas Press, 1994), 309–14.
6. Stuart Hall, "Minimal Selves," ICA *Documents 6: Identity* (London: Institute of Contemporary Art, 1987), 44.
7. The pronunciation of the letters in Esson's title become "ese peo uele a kaka," a version in sound meaning "that fart smells like shit." De La Soul's acronym and identifying motif, DAISY, is formed from the colloquial phrase "Da Inner Sound Y'all."
8. Gerardo Mosquera, "New Cuban Art: Identity and Popular Culture," *Art Criticism* 6 (1) (1989): 62.
9. Robert Storr, "Martin Puryear: The Hand's Proportion," in Kellie Jones, *Martin Puryear* (New York: Jamaica Arts Center, 1989), 33.

In Their Own Image

.... Searching for sea-shells: waves lap my wellington boots, carrying
lost souls of brothers & sisters released over the ship side...........

Ingrid Pollard, from the "Pastoral Interludes Series," 1984. Hand-tinted photograph with text, 16 x 20 inches. Courtesy the artist.

Somewhere in the interstices between the much maligned mutability of "pluralism" and the marginalized trajectory of "difference" is the common ground where most artists work. It is baffling to consider that in most art-historical texts, a handful of practitioners represents the industry and ideas of fifty years, while hundreds go unaccounted for—until such time, of course, as they serve the purposes of the commercial or cultural power structure. History, after all, tends to be written by winners. As Lowery Stokes Sims has pointed out, the fictional "other" is little more than a cathartic symbol, and "difference" a detour sign deflecting us from issues of power and control of a narrowly defined, nonrepresentative (art) world.[1] If today there is a "reworking of existing cultural frames of reference,"[2] it is a movement occasioned by the need to redefine a skewed perspective that has somehow cast more than two-thirds of the world's people—and their culture—as "minority."

Taking a look at the recent history of photography and text art, it should not be surprising to find women of color who are involved with this medium, though most books, articles, and general documentation might lead you to believe that only white males have created anything of lasting value.[3] Indeed, it is with individually identifying these black women practitioners rather than abstractly acknowledging their existence that problems arise, that the record has to be set straight. In exploring the work of the Americans Lorna Simpson, Clarissa Sligh, Pat Ward Williams, and Carrie Mae Weems and the Britons Zarina Bhimji, Roshini Kempadoo, Ingrid Pollard, and Mitra Tabrizian, one recognizes not only constructive strategies familiar in contemporary photography, but also the international dialogue their works have with each other, and the extent to which they expand the parameters of photography and text. These are women whose work is, with a few exceptions, well known in black and, to some extent, academic artwork circles, but whose recognition within the larger art community is still minimal although growing.[4]

The eight artists discussed here all began combining text with photography during the early to mid-1980s. Most had done documentary work and adopted the photography/text format as a method to both delimit and expand the implicit meanings in standard "straight" photography. On the one hand, joining words to the photograph could clarify the reception of the single image, grounding ideology and meaning and leaving less chance

for misinterpretation. This approach, of course, also mirrors the way photographs usually circulate in the world: in magazines, newspapers, and advertising, and on television an image is always accompanied by a verbal cue. On the other hand, adding text can also expand the meaning of the single image. Furthermore, the addition of a textual element changes the traditional relationship between the photographer and the subject, forcing the practitioner in some way to explain her voyeurism. At the same time these works challenge the viewer's customary response. A "typical" family portrait layered with script is no longer seen as a regular family photograph but must be read in a different way, relative to a specific situation; an image of a woman sitting alone in a bucolic field, for example, becomes not a figure of meditation or contemplation but one signifying isolation and danger as directed by the caption below. Implication expands, creating layers and levels of intent; words do not have to allude to pictures nor pictures to words, but can signify ideas outside this framework. These photographers were also drawn to the intrinsic social, almost didactic, function of the format. Because the act of reading expands the time one actually spends with any given work, photography and text do more to engage the viewer as reader/participant.

Of course, shared language and concerns also connect the work of these British and American photographers to that of other women artists. There is an interest in making visible women's lives and in revealing the range of their experiences as a valid starting point for art-making. In some cases, the commodification and objectification of women may be addressed. In others, strident texts appropriate a "male" voice, critiquing the foundations of authority, much like the work of Barbara Kruger. The female image might be used as archetype—the visualization of an exemplar or transcendent idea—that becomes a vehicle for the investigation of many issues and an instrument not limited to/by discussions of gender. As with Jenny Holzer's multimedia incursions, the photography and text of these British and American women may be said to be "the realization of the 'new' female voice, speaking for women but not exclusively to women; it forces the issue, to be sure, of initiating a feminist practice within the male-dominated culture but not containing it within 'issues' that can be conveniently labeled (and thus dismissed) as feminist."[5]

Indeed, the work of these artists also speaks to issues of cultural or racial identity. As women of African, Asian, or Caribbean descent living or born in the United States and Britain, they draw on a variety of worldviews and ethoses. It is often a fragmented existence, described by W. E. B. DuBois at the turn of the century as one lived behind a veil, a life *in* but not en-

tirely *of* the dominant/modern culture. Yet it is interesting that the post-modern condition of the decentered (Western) individual sans "master narrative" has much in common with the quandary in which people of color find themselves in the West. As Stuart Hall has noted, "Now that, in the postmodern age, you all feel so dispersed, I become centered. What I've thought of as dispersed and fragmented comes, paradoxically, to be *the* representative modern experience!"[6] The work of these artists thus extends and supplements our understanding of Western culture and cultural practices.

So while the techniques and formal methods used by the photographers here are recognizable, there is something—image, language, reference—by which they make them their own. Self-expression cannot be culled from a "limitless replication of existing models,"[7] à la Cindy Sherman, for few exist. And simply recontextualizing found images (as does Sherrie Levine or Richard Prince) will often not get through to an audience including people of color, who have a hard time getting past stereotypes and slurs that still sting from habitual (and current) use. As Angela Davis and Michele Wallace have both pointed out, exposing myth as fabrication does not dispel the myth; the "revelation" simply takes its place next to the fiction as another version of this fiction.[8]

All of these photographers are concerned with identity and its re-creation to some extent, but Kempadoo, Tabrizian, and Simpson in particular confront this issue in both personal and larger cultural terms. Kempadoo speaks about it from a very intimate place. A group of four untitled pieces from 1989 alludes formally and contextually to the reality of the multiple self through the juxtaposition of older black and white family snapshots with more recent color photographs she took herself. Kempadoo's "self" is composed of a mixture of races—she claims a mixed East Indian, West Indian, Amerindian, and European heritage, but also identifies herself as a black woman—and is one that finds "home"—the site where identity is nurtured—in not one but a variety of places. The pieces are generally composed as triptychs, with two photographic images accompanied by a single panel of text. The words become the mediator between Caribbean and British locales, between the family universe and that of the world. Kempadoo explores ideas of fragmentation and dislocation, attempting through her photographs to build a new identity that might be wholly inclusive.

One piece from the series juxtaposes a photograph of a brown couple in an affectionate pose, who sit on the prow of a boat and overlook a beautiful tropical landscape, with a vintage picture of what appears to be the woman

from the first shot, now laughing and seated on a very English heath. The work's text reads:

> I wonder if it is possible to position
> myself from both
> HERE and THERE?
> No one experience
> no one history
> but from this an identity
> in constant change

The work neither attempts to explain the images nor the photographer's definitive stance but plays with ambivalence and fluctuations in meaning. In a series of black and white self-portraits from 1990, Kempadoo focuses on identity as masquerade. One untitled work presents, for instance, a triple exposure of the artist dressed in African, Western, and Asian garb, accompanied by the text "Who do they expect me to be today?" In this and other photographs, the essential character or substance that identity is assumed to be is shown as fluid, easily interchanged from one situation—or picture—to the next. Identity becomes a disguise, the subtle changes one makes in different company, the various personae one adopts in different circumstances.

Tabrizian's photographs employ the language and structure of film. Using this familiar and popular visual form she deconstructs "standard" or "given" definitions of sexuality and race, calling into question the power relations that structure our identity and existence. In a black and white series of works from 1985–1986 entitled "Correct Distance," Tabrizian focuses on women as enigma, re-presenting the femme fatale of '40s and '50s films noirs. At once mysterious, charming, and seductive, the femme fatale was up to no good and spelled trouble for any man captured by her spell. Tabrizian twists this stereotypical reading of the ultrafeminine evil temptress and succeeds in offering an alternate and positive vision of these women who appropriate femininity as power.

"The Blues" (1986–1987), a series of photographs Tabrizian made in collaboration with Andy Golding, uses the scale and poses of movie posters, as well as the inflammatory declarative style of their text. Spare interiors bathed in blue light call attention to the melodramatic action of their subjects. *Her Way*, a detail from one of three triptychs in the series, reveals a bathroom interior with a black woman lying on the floor, dead; the words "See my blood is the same colour as yours" are scrawled on a mirror that

also reflects the face of a white man; overlaid text on the lower right provides additional commentary: "He was a man who had all the answers until she started asking the questions." Such staged scenarios declare the "fabricated nature of the photographic image"[9] and the folly of cultural and social categorization. Installed in a gridlike formation, "The Blues" is also reminiscent of a movie storyboard, and recalls the disjunctive, nonchronological narrative found in John Baldessari's work, although Baldessari's interest in the banality of our lives is almost diametrically opposed to Tabrizian's controversial investigations of racial issues and difference. And race is engaged in this work in subtle and various ways. While the staging of each frame seems to be based on the conversations of contemporary espionage films, almost every image has an interracial cast of characters and a text that explores themes of assimilation, acculturation, and difference. The exploration of these constructs extends to Tabrizian's appropriation, as a unifying motif, of the African American musical form of the blues. Her use of this musical metaphor is indeed significant, for as James H. Cone has noted, the blues can offer a "perspective on the incongruity of life and the attempt to achieve meaning in a situation fraught with contradictions."[10]

Inherent in Simpson's work is a critique of the formulas of "straight" photography, its prescribed voyeurism, and the patented responses to social disaster or beauty it expects from viewers. Simpson's pieces begin with gesture. They isolate a movement and analyze the sentiment or attitude that that motion or stance suggests. In the triptych *Necklines* (1989), for example, alternate views of a black woman's neck appear in panels up to five feet high, overwhelming us with their smooth and sensuous curves; but in small plastic plaques below the photographs, words implying the sexual ("necking," "neckline") are interspersed with those alluding to violence ("neckless," "breakneck") problematizing the reading of the images as simply beautiful.

In Simpson's fragmented photographic processions, her generic women are never presented as whole. Instead, the figures insist on their completeness through synecdoche—in which the part becomes a proxy for the total entity. On a formal level these works share similarities with both Eadweard Muybridge's and Vito Acconci's photo pieces recording isolated body movements. But whereas Muybridge's works are purely documents of motion, and Acconci's texts read as bland operational instructions, Simpson forcefully inserts the woman's—and particularly the black woman's—voice and experience. In *Five Day Forecast* (1988), a sequence of five torsos with folded arms is accompanied by two tiers of plastic plaques. The plaques positioned above the images designate the days of the work week (Monday, Tuesday,

etc.), those below supply an alliterated variety of ways women are misinterpreted in the professional (with inferences to the larger) world. This lower level of text also puns on the honorific for an unmarried woman, "Miss," so that the five women pictured have alternate identities as "misconstrue" or "misinformation," and so on.

Simpson has a wonderful feel for language, and she finds inspiration everywhere, in children's rhymes and the sophisticated innuendo of the blues, as well as in the conceptual art-language gymnastics of such artists as Joseph Kosuth and Lawrence Weiner. But her work also confronts us over and over again with the black female body as beautiful in itself and worthy of contemplation.[11]

Weems is also interested in language, not so much in its properties of definition per se but as cultural signifier. Trained as a folklorist as well as an artist, Weems has found the implications and subtlety of folklore more interesting than text used didactically; for her, it's an unmediated form of communication that has the ability to speak more directly to deeper issues. A series from the mid-'80s entitled "Ain't Jokin" employs jokes as a way to explore how such humorous narratives are used to legitimate the negative treatment of designated groups in a society. There are sexual jokes that allow sexist comments to slip by "in the spirit of fun"; there are ethnic jokes whose protagonists may be easily substituted—Polish, African American, Jewish—depending on the company you're in; and as the saying goes, "There is truth in jest." Weems seems effortlessly to combine the directorial mode of staged photographs with a more documentary/photojournalistic style in her various limited-edition books (produced over the last decade) and multi-panel pieces. While earlier photographs focused on an explosive condemnation of race relations and were addressed to changing the minds of whites, newer pieces are concerned with communicating with a black audience.

In her recent book *Then What? Photographs and Folklore* (Buffalo: CEPA Gallery, 1990), Weems looks at traditional beliefs to show the power and beauty of African American culture and, offering new readings of old folktales, considers the function of folklore as a way African Americans have learned to live life in America. For example, one belief has it that if a hat is placed on a bed someone will go to jail. But across Weems's photograph of this scenario runs the text: "Girl evidently the man plans on staying cause when I got home from work yesterday his hat was on my bed." On the page facing this image is a stanza from a blues song: "Some got six months, some got a solid year, but me and my buddy we got lifetime here." While in this case the blues verse might convey the original meaning of the hat/bed con-

junction, it might just as well be a comment on the durability of personal relationships as raised by the phototext. Through the language of African American folk wisdom, culture, and the blues, Weems attempts to locate her own voice, in a present-day extension and reinterpretation of tradition. Like Baldessari's "blasted allegories," her texts are "'exploded,' pieces and bits of meaning floating in the air, their transient syntax providing new ideas."[12] By questioning what is remembered, the photographer changes contemporary understanding.

Kempadoo, Sligh, and Pollard have all incorporated family snapshots into their work; Kempadoo uses them to piece together a persona, Pollard to rectify history, and Sligh to weave narratives and fables of her/a family. Sligh's interest in recording her own reality (as distinct from that supplied by the media or by the white, male megalomaniacal power structure of Wall Street, where she worked as a financial analyst for ten years) first led her from documentary work to her family photos. But in these as well she found only fictive poses that did not convey her history as she remembered it. By collaging and marking the images, wrapping them in her own incantations, she reinvents herself in her own image. Using cyanotype and kallitype processes, Sligh preserves the old look of her family photographs while her practice of *cliché-verre* and other forms of directorial manipulation insist on the works' contemporaneity. Handwritten repetition of words further integrates language into the image.

Most recently Sligh has moved into installation with the piece *Mississippi Is America* (1990), dedicated to the civil-rights martyrs James Earl Chaney, Andrew Goodman, and Michael Henry Schwerner. Here the photographer used "rediscovered" FBI photos of the three culled from back issues of *Time*. Three seven-foot strips of these portraits hang from a billboard-scale panel bearing the work's title, which itself is hung from the ceiling. On the floor underneath is detritus from a car accident—a smashed fender and headlights—and torn fragments of a poem about the incidents surrounding the murder of these three activists that Sligh composed in the style of a civil-rights freedom song. For Sligh this piece is just as personal as her earlier photographs because she lived through and was very much affected by the civil-rights era. Through three-dimensional installation, the photographer feels she further clarifies her intentions for the viewer: to provide a larger and more powerful context within which to consider the murders as signals of America's persistent (under)current of racial hostility.

Combining personal photographs (family pictures and vacation shots) with traditional views of the English countryside, Pollard questions and reconstructs the concept of "Britishness." Hand-coloring emphasizes the

lushness and seduction of the photographs and is applied equally to the landscape and the black people who populate it, conflating ideas of so-called natural beauty. In *Pastorale Interludes* (1986), these images provide alternatives to representations of black Britons as rioting ne'er-do-wells. But they also query the "metaphor of individual freedom and transcendence"[13] that the English countryside represents by alluding to the violence and isolation faced by people of color living there. "It's as if the Black experience is only lived within an urban environment," declares Pollard's text.

In later works the narrative voice is replaced by the language of tourism. "The Seaside Series" (1989) is modeled on the intimate format of the postcard; the photographs must be viewed quite closely to pick out the camouflaged black figure. In this work Pollard questions the location of the "other" and contrasts actual physical similarity or material likeness with perceived or socially constructed difference. Through text Pollard further elaborates on this comparison, pointing up the fictive uniformity of travel brochures and postcards directed to a "British"—read white—audience with the reality of a black British presence. *Oceans Apart* (1989) is an attempt to see her contemporary image making through the eyes of history, particularly that of the slave trade and Britain's imperialist legacy. Unpopulated photos of crashing waves and craggy shores take on an ominous quality when paired with vintage shots of a black family enjoying themselves at the beach. Ordinary messages from postcards echo with the pain of separation ("missing you," "wish you were here," "keep safe till I see you again") as we begin to consider them in the context of the dislocations of slavery. Also included in this sequential work are more contemporary (though somehow ageless) images of black people enjoying the seaside, contrasting with the unpictured horrors of history. Framing the piece are two color lithographs that layer historical imagery: maps charting the Atlantic Triangle (the slave-trading route between Africa, the West Indies, and England), colonial family crests, old Scottish currency with portraits of slaves, colonial ships, and "happy-go-lucky" "immigrant" laborers.

Like Pollard, Bhimji and Ward Williams fuse personal and collective history. Through installation and other alternate photographic processes, they attempt to further direct the viewers' reading/experience of their work. For Bhimji the movement of her photography into space is a way to connect with the larger reality of life itself by including the viewer's presence as an element of the work's "performance." Large, at times grainy photographs hung from the ceiling position us as children in an adult world. Bhimji activates the floor with spices, rose petals, and delicate muslin cloth that has been violated by burning. Many of her texts are abstracted from diaries kept

over the years, but the words connect with the broader issues of migration, displacement, and identity. (*TOUCHING YOU*)—Discovering the history of my ancestors makes my blood purr (1989) takes the form of an unspoken conversation between mother and daughter, divided by generations and differing perceptions of "self" and "home." How does one locate the self as an Asian born in Uganda and living in England for decades? As writer and director Hanif Kureishi has said, "'My Country' isn't a notion that comes easily. It is still difficult to answer the question, where do you come from?"[14] Graphs included in the piece detail patterns of migration for Asians since the 1940s. Vaguely defined objects connected with "Indianness" (e.g., a buddha's head, a doll clothed in traditional dress) float in and out of view. This piece, like many of Bhimji's, is, in the artist's words, "based on memory, dreams, conversations from East African Indian and English backgrounds. I wanted to use them as metaphors, since I am concerned with not imitating the world, but recreating it."[15]

How can we rely on memory with no extant documents to support our claim to existence? If, in the images given, we are pictured as exotic, violent, or victims, then what? Ward Williams sees herself not only as a re-creator but as an active part of the chronicle. "I had to DIG for my history but in doing so gained the ability not only to redefine [it], but also to see my role as a participant."[16] Her three-dimensional pieces commemorating Philadelphia's MOVE tragedy or Henry "Box" Brown might be seen as political because they don't conform to either "popular" images or to those of broad historical currency. But these, too, are stories, part of the individual tales that reveal the larger issues of a society. For Ward Williams, nonsilver and physically and conceptually constructed photographs better convey her ideative stance. Her installations further define meaning by creating an environment within which the photograph may be seen, thus communicating more of the photographer's intent—the difference between Ward Williams creating a piece on lynching using "found" imagery (*Accused/Blowtorch/Padlock*, 1986) and a member of the KKK finding the same image and tacking it up on his wall. The impetus for much of Ward Williams's text comes from "word-bites"—snatches of language culled from books and magazines, overheard or remembered from family sayings—that she expands on or bounces off.

Michele Wallace has pointed out that women of color fall outside the constructs of Western binary logic.[17] In a society predicated upon such oppositions as black/white, male/female, and "universal"/"other," women of color remain excluded from the either/or formula in which the polarities to white

male are occupied by black (as in male) and female (as in white). In the schema of Western discourse, then, women of color inhabit a space of complete invisibility and negation that Wallace refers to as "the 'other' of the 'other.'"[18]

Much of the photography and text work discussed in this essay has to do with "making ourselves visible," redefining the image/position of the woman/person of color within the larger discourse. It engages aspects of what the Border Arts Workshop in San Diego has termed "reterritorialization," a way of locating oneself in the world.[19] Reterritorialization includes recapturing one's (combined and various) history, much of which has been dismissed as an insignificant footnote to the dominant culture. These objects then become texts of redemption and emancipation. Not simply adaptations of Western codes, they construct and (re)define the record of their makers' own existence, challenging as well meanings and definitions once thought to be fixed.

NOTES

Originally published in *Artforum* 29 (November 1990): 133–38. © Artforum, November 1990, "In Their Own Image" by Kellie Jones.

1. Lowery Stokes Sims, "The Mirror the Other: The Politics of Esthetics," *Artforum* 28 (7) (March 1990): 111–15.

2. Gilane Tawadros, LUMO '89: The Boundaries of Photography, exhibition catalogue (Jyväskylä, Finland: Alvar Aalto Museo, 1989), n.p.

3. Throughout this essay I at times use the phrase "people/women of color" interchangeably with "black people/women." This is because in Britain "black" has broader racial implications—encompassing peoples of African, Afro-Caribbean, and Asian descent—and is closer in significance to what we mean by "people of color" in the United States. Currently, however, there is much debate in Britain as to the essentialist (inherent, cultural) connotations of the use of the term versus its importance in signifying a shared political oppression. That discussion, however, falls outside the purview of this essay and will have to be taken up in a later work.

4. Lorna Simpson is certainly the most well known of the eight in the United States, having had numerous solo shows over the last three years, most recently at the Museum of Modern Art in New York. She also appeared in this year's *Aperto 90* exhibition at the Venice Biennale.

5. William Olander, "Re-coding the Codes: Jenny Holzer/Barbara Kruger/Richard Prince," in *Holzer, Kruger, Prince*, exhibition catalogue (Charlotte: Knight Gallery, 1984).

6. Stuart Hall, "Minimal Selves," ICA *Documents 6: Identity* (London: Institute of Contemporary Art, 1987), 44.

7. Lisa Phillips, "Art and Media Culture," in *Image World: Art and Media Culture*, exhibition catalogue (New York: Whitney Museum of American Art, 1989), 67. The two

basic acceptable personae for women of color in the West are the mammy/maid and the prostitute. Betye Saar and Carrie Mae Weems are among the artists who have successfully appropriated these debased models.

8. Angela Y. Davis, "Underexposed: Photography and Afro-American History," in *Women, Culture and Politics* (London: Women's Press, 1990), 224–225; and Michele Wallace, "Variations on Negation and the Heresy of Black Feminist Creativity," *Heresies* 24 (1989): 69–75.

9. Tawadros, *LUMO '89*.

10. James H. Cone, *The Spirituals and the Blues: An Interpretation* (New York: Seabury Press, 1972), 116.

11. I would like to thank Lowery Stokes Sims for reemphasizing how Lorna Simpson's work connects with images of beauty, making a place for the recognition of black beauty on its own terms. See Sims, "The Mirror the Other," 115.

12. John Baldessari quoted in *John Baldessari*, exhibition catalogue (Eindhoven: Van Abbemuseum, 1981), 49.

13. Gilane Tawadros, "Other Britains, Other Britons," in *Aperture: British Photography: Towards a Bigger Picture* 113 (winter 1988): 41.

14. Hanif Kureishi, "The Rainbow Sign" (extract), in *Fabled Territories: New Asian Photography in Britain*, exhibition catalogue (Leeds: Leeds City Gallery, 1989), 9.

15. Zarina Bhimji, quoted in *Employed Image*, exhibition catalogue (Manchester: Corner House Gallery, 1987).

16. Pat Ward Williams, cited in Kellie Jones, "Towards a Visible/Visual History," in *Constructed Images: New Photography*, exhibition catalogue (New York: New York Public Library Astor Lenox and Tilden Foundations/The Schomburg Center for Research in Black Culture, 1989), 9.

17. Wallace, "Variations on Negation," 69.

18. Ibid.

19. Coco Fusco, "The Border Arts Workshop/Taller de Arte Fronterizo: Interview with Guillermo Gómez-Peña and Emily Hicks," *Third Text* 7 (summer 1989): 66.

Tim Rollins and K.O.S.

What's Wrong with This Picture?

Looking at the most recent resume of Tim Rollins and Kids of Survival (K.O.S.) I was struck particularly by the first page, which begins: "Tim Rollins + K.O.S. born Pittsfield Maine, 1955; Education: M.A. New York University B.F.A. School of Visual Arts." This obviously represents information on Rollins alone, while the collaboration with K.O.S., a changing group which some fifty kids have passed through, began in 1982. Nowhere in the eleven-page resume are any of the names of K.O.S. mentioned. Some of their names may appear in the numerous articles or catalogues about them, or quotes by them may be cited, but we never know anything about K.O.S. except that they're from the South Bronx.

The collaboration has been a vehicle for Rollins, the ticket for inclusion of his work in exhibitions and collections of some of the more prestigious museums and galleries on the resume. Rollins himself admitted in an interview with *The New York Times*, "Without this, I'd just be another boring conceptual artist." But while the artist's work with K.O.S. may smack of careerism in some respects, his dedication to reaching kids shut out by the educational system (and eventually by society) is not something to be taken lightly.

Rollins maintains that teaching has become his art, and his conflation of the two is interesting. The emphasis within the group is not just on making paintings but on the process of creation and education in the process. Researching current politics and reading George Orwell's *Animal Farm* as preparation for a work is something these kids may never have done other-

wise, but Rollins's reliance on Eurocentric literary classics for collective projects with people of color seems almost neocolonialist in 1989, especially to those of us pushing for a multicultural agenda. His strategy, à la educator Paulo Freire, to use the dominant culture to one's own ends and therefore subvert it, is something we on the margin should and must master. This program also helps assimilation into the society that has rejected these kids; they, too, will now be able to talk about their fabulous European trips and the novels they've read.

But the literary works of Zora Neale Hurston, Langston Hughes, and Octavio Paz are works of enduring excellence also. K.O.S., as the inheritors of these traditions, as well as members of the "dominant culture" should know about them. They should know about Wifredo Lam as well as Marcel Duchamp, and Henry O. Tanner as well as Mathias Grunewald. They should visit El Museo del Barrio and the Studio Museum in Harlem as well as the Museum of Modern Art. They should collaborate with kids in Harlem and Howard Beach along with those in Roxbury, Massachusetts, and Derry, Ireland. As Tim Rollins + K.O.S. travel the world visiting museums, galleries, and other artists, I hope they connect with other artists of color.

K.O.S. member George Garces was quoted in a recent British catalogue as saying, "I want to be an artist, and when I'm good enough to be an artist, a real artist, then I'll know." But will the art world know and accept him as a colleague when he is no longer a kid in the collective, when he is no longer an art world mascot? Richie Cruz, Annette Rosado, Carlos Rivera, Nelson Montes, Nelson Savinon, George Garces, and other K.O.S. members are not surviving simply due to Tim Rollins, although he has made a valuable impact on their lives. You can bet there's some family and community (and a history of it) involved. Through K.O.S. and Tim Rollins let's hope the art world can begin to think about the multicultural society in which we live.

NOTE

Originally published in *Parkett* 20 (1989), reprinted with permission of Parkett Publishers, Zurich/New York.

Blues to the Future

In the winter of 1986–1987 I heard rumblings about the citing of a supposed "new" Black Aesthetic. Culture-mongers began to discuss this new life form. What were its identifying marks? Was it the same aesthetic, in hibernation since the '70s, well preserved, complete with dashiki, Afro, and raised fist? And how did hip-hop, high-top sneakers, and high-top fades fit in?

In "Cult-Nats Meet Freaky-Deke," an article in the December 1986 *Village Voice Literary Supplement,* Greg Tate offered a few ideas on "the return of the Black Aesthetic." His basic premise was that the Black Cultural Nationalist movement of the '60s provided African Americans with an atmosphere of cultural confidence "where anything black could be considered an aesthetic object of contemplation." With that as a "given," the next generation of artists were free to be more cosmopolitan and international, to take inspiration from other sources outside their own experience. Trey Ellis is another young writer who began to take note of this changing aesthetic, its openness to cross-fertilization with other cultures (particularly those with which it empathizes), its acceptance of a broader range of information and stimuli, resistance to ghettoization, defiance of the strictures of figurative or overtly political art. Ellis: "We no longer need to deny or suppress any part of our complicated and sometimes contradictory cultural baggage to please either white people or black."[1]

Cultural Nationalism helped African Americans, as Paul Carter Harrison says, "define themselves culturally inside of American life." Looking at the larger picture, and in retrospect, it also had a revitalizing effect on

American art in general. Since the '70s there has been a growing interest in content as well as form in contemporary art. During the last two decades we have seen the floodgates open to neo-expressionism and neo-figuration as well as performance and installation art, where neat categories of media and form are no longer applicable. And as Michael Brenson points out in his *New York Times* article "Black Artists: A Place in the Sun," America's fascination with current German art and its ability to face a "painful history" has been a recurrent theme in African American art. Consider the work of many African American artists in the '60s: Benny Andrews and Faith Ringgold, for example, who raised political issues but also used canvas and fabric and made us look at these materials in a new way. Or Dana Chandler, whose figurative paintings and constructions were "loud" in terms of color and the way they screamed on black persecution; or Chandler's contemporary, Mel Edwards, whose use of barbed wire, chains, axes, and various tools linked with black oppression were welded together in abstract compositions.

To make art that in some way speaks to the injustices in their lives, African American visual artists have historically been concerned with content. Maybe this is the reason it is hard to find those who were solely abstractionists before two decades ago: they had no use for the self-(read: *non*)referential posture of formalist art, and continually strove to model an aesthetic on their unique musical heritage which was formally sophisticated yet evocative of sensation, feeling, and meaning.

If the blues offer a "perspective on the incongruity of life and the attempt to achieve meaning in a situation fraught with contradictions,"[2] then the blues aesthetic speaks still to the postmodern 1980s–1990s. It addresses a human situation which is more and more about dislocation and fragmentation in a world ruled by media and high-speed technology; it appeals to the decentered individual. And don't think this is some new age primitivist revisionism; no, I'm talking about a consummate aesthetic. In fact, think again about how African American aesthetics rule popular culture, think of Eddie Murphy, RunDMC, Arsenio Hall, Bobby Brown, and the likes of George Michael, the Beastie Boys, and Soul II Soul, who go along the scale from appropriators to appreciators when it comes to African American art forms. And this is just today; if you want to go back a bit we can talk about Josephine Baker, Nat King Cole, James Brown, and on the other side Janis Joplin and Elvis Presley. Then think of those African American artists who are strutting other kinds of stuff: Anthony Davis with an operatic Malcolm X; the plays of George Wolfe and August Wilson that refuse to pander to audiences (black or white); Tracy Chapman's socially conscious folk music; Joyce Scott's outrageous performances concerning big, black

women; Martin Puryear's abstract sculptures that are at once poetic and allusive as well as formally complex.

While creating fresh forms, these arbiters of the blues/(new) black aesthetic are also pushing to expand minds and to guard against elitism. There is faith that folk can understand and appreciate color, texture, presence, and metaphor as well as raised fists, a black image, or Cultural Nationalist stances. There is respect for people's aesthetic incarnate. As artist David Hammons (who always brings his work into the street so folks will tell him what the piece is about) explains, "They [referring to "the folk"] ask the questions, and answer them themselves."

NOTES

Originally published in *The Blues Aesthetic: Black Culture and Modernism* (Washington, D.C.: Washington Project for the Arts, 1989).
1. Written in 1987, this article was recently published as "The New Black Aesthetic," in *Before Columbus Review* 1 (1989): 5, 20.
2. James H. Cone, *The Spirituals and the Blues* (New York: Seabury Press, 1972), 116.

Abstract Truths

———

PART FOUR

Them There Eyes:
On Connections and the Visual

Through the thick gathering at a book signing I glanced on *la femme petite* with a robust burst of curls defying the crush of a hip-hop-style, apple hat (or so we called them in Chitown). A couple of seconds later—lost in the excited buzz of the crowd. The room, full of jazz-heads, jazzratis, and jazz-love, was there to celebrate the music's interdisciplinary attraction with the new publication *Uptown Conversation: The New Jazz Studies* (2004). Great—curls and myself were introduced to each other, and up close, drawn into the twinkle and spark of the eyes, the ease of uptown conversation, it finally dawned on me: oh, she's one of *those* Joneses.

With time, and in minding those eyes closer still, I learned that she does what those Joneses are known to do: think hard, write clearly, speak with conviction, and of specific interest to me, a historian of music, listen deeply, widely, and with intent. As the saying goes, what you see is what you get. And in K.J.'s specific case, you are shown things with the understanding of few others I've known.

At the time of our meeting, she was wrapping up an exhibition on Jean-Michel Basquiat, the icon of the 1980s—an era that also produced her favorite "get up and dance" music—and completing the checklist for *Energy/Experimentation: Black Artists and Abstraction, 1964–1980*, the time period that produced her beloved "sit down and listen music." When shortly after meeting, K.J. invited me to contribute a music essay to the catalogue for the *Energy* show, it gave me an opportunity to think about the relationship between musicology and art history, of the congruence and dissonance in visual and musical production, and about the connections between perceptions of eye and ear.

It has, and continues to be, a fruitful trip. *Energy* allowed my first exposure to "the studio visit" as I escorted K.J. through storage spaces of the Whitney and the

work spaces of artists like Ed Clark and Jack Whitten. It was in the latter's work space that he said to me, "if you don't experiment, you die," as he casually finished a piece of fried fish before revealing a stunning tribute to pianist Bud Powell, among other works. Thus began my plunge into "the visual," or eye school—learning how to see things. In her world, black visual culture, language, music, and community coexisted in a "what other way is possible?" fashion. "Didn't everyone," she remembers thinking as a very fresh freshman in college, "grow up around artists?" Well, no. But it has advantages, as I have witnessed when listening to K.J., Mom-Hettie, and Sis-Lisa casually chop it up about art—music, the visual, writing. These (usually) uptown conversations reveal the powerful connections existing among artistic communities, the public, and the critics; indeed, the constant flow of "archive" exchanged among them underscores the importance of "the story" behind it all. It's the family gossip, in fact.

The writings in this part also reveal more of the advantages of connections, although they might be somewhat cloaked in the expected mode of distancing that an "acceptable" critical stance is purported to demand. These essays are, nonetheless, richly rewarding as they show how "the eyes" have it.

The lessons are numerous. As a commenter on music cultures, I find the essays allow me, first, to think about the links among the creation, dissemination, reception, and institutionalization of visual and musical works. One encounters in her work formal explanations embedded in a language culture that can be likened to the discipline of music theory, the branch of music study dedicated to explaining the syntax and structural principles of sound organization. The congruence of musical and visual modes becomes clear, especially when artists make the connections clear in explications of their creative processes or when musicians are part of those artists' broader artistic collectives.

To speak of these broader collectives, however, is to move one out of the formal organization of works and into what might be called the "extravisual," or the social world in which the art becomes meaningful. Indeed, a theme running throughout most of the part is the various impacts and articulations of the Black Arts Movement aesthetic, one that stressed "a changing same" across historical expressive culture. Named by K.J.'s father, Amiri Baraka, the movement points to the practical and often audacious functions of art—even fine visual art—for its practitioners and their public.

There is always, in K.J.'s eyes, a direct connection between the art object and the life lived. Although that is not to say that an object should be simply reduced to illustrating history: objects *are* history—living, breathing, and animated discourses in and of themselves. As her writing shows us, they can never serve as a backdrop to history's truth claim, functioning like the musical score under a film's dialogue, necessary but unnoticed. She teaches us that the art object may be the

only reliable index of "truth" between the "what happened" and "the what is said to have happened." Through K.J.'s pen, the object, indeed, speaks.

From various articulations of abstraction to assemblage to performance art and beyond, black artists are shown here to have cleared an experimental space from which to speak, not only through language of protest but also in the spirit of affirmation and celebration. As we learn, history, culture, power, and geography inform these artists' compelling works in specific ways as they demanded that institutions such as the Whitney Museum provide a nontokenized platform for themselves, one complete with an adequate scholarly and critical apparatus to engage the art at hand. In each case study, what KJ brings into sharp relief are the relationships existing between structural factors in society and the aesthetic practices of artists at any given historical moment or geographic location. A strong current of what might be called "intervisuality"—the formal similarities between art works—abounds among some of these artists such as David Hammons and Betye Saar. And we are led to see in such examples the cross influences that form communities, alliances, to experience the lively conversations that occurred across time, canvas, and performance spaces.

As Norman Lewis, Sam Gilliam, and others proved, figuration did not solely represent the black aesthetic or sensibility. John Coltrane, Ornette Coleman, Olly Wilson, and other avant-garde musicians demonstrated the same thing: that "black" musical figurations need not be linked only to isometric rhythmic conceptions and the distress of blues culture to the Western tonal system. K.J.'s archive of artistic habitus together with the interpretive acumen she brings to bear on history and art objects achieves similar cultural work. Through them we are allowed to reimagine the importance of visual objects in the project of contemporary African American history. To become eye-minded is to take seriously this world of visual bounty that has been tucked away in storage spaces, the exhibition catalogue, the long-closed gallery, the lost sculpture, or the forgotten interview. In them there eyes they live on.

Brooklyn, N.Y. | February 15, 2009

—

Free Jazz and the Price of Black Musical Abstraction

If you don't experiment, you'll die.
JACK WHITTEN, 2005

Free jazz, the development in American music that shook jazz's traditional relationship to popular song form, controlled improvisation, blues tonality, and rhythmic regularity, rose simultaneously with other social upheavals during the 1960s. Even bebop, a musical turn in jazz that transformed the genre into an "art," or America's classical music, seemed like a tame venture in comparison to the New Thing, as free jazz was called. The lightning-fast melodic, rhythmic, and harmonic inventions of Charlie Parker, Dizzy Gillespie, Bud Powell, and others became key signs of an Afro-Modernism at mid-century linked to numerous social, economic, and political developments. Among these changes was a massive migration of southern blacks north and westward, a demographic shift that created an atmosphere for advances in education, economics, and culture. Although these shifts formed the foundation for the civil rights victories of the 1950s and early 1960s, the free jazz movement remains linked to Black Power, a similar revolutionary push for African American freedom.

The influence of the Black Power movement was considerable. It represented "the dominant ideological framework through which many young, poor, and middle-class blacks made sense of their lives and articulated a political vision for their futures."[1] The Black Power era—roughly from the mid-1960s to the mid-1970s—symbolized for many a new social order, a new radicalism. This social movement was not, however, a unified, static affair. Numerous political currents and agendas formed this new expres-

sion of "blackness": violence was advocated by some, peaceful resistance by others; a wide variety of new organizations appeared, each influenced by a wide range of philosophies; leftist-leaning ideologues clashed with black middle-class sensibilities; black feminism critiqued the overwhelmingly male centricity of the movement; and international concerns about black and Latin folk around the globe resisted a solely African American focus of the freedom struggle. What emerged was a highly politicized and quite diverse blackness that reclaimed, and in some instances reformed, black history, transformed its present, and informed Afro-America's future. And it all took place under the slogan "Black Power."

During the 1960s, the northern and western cities to which previous generations of southern black migrants had fled during the 1940s began to collapse around them. As the capital base of these urban spaces rapidly progressed toward a stifling post-industrialism that would mark the 1970s, they imploded in riots, joblessness, and structural decay. It became clear that the land of promise had not, in fact, kept its word. African Americans responded to black hopelessness with Black Power—an expression that, as we have learned, meant many things to many people.

Out of this multifarious, conflicted blackness exploded an array of cultural expressions in poetry, visual arts, theater, and music and their criticism. Dubbed the Black Arts Movement, its concerns formed a complex of radical spiritual, ideological, and political priorities. One never gets the sense that it was ever a "culture for culture's sake" project. It had a razor's edge, and it cut to the bone. Although the masses of working-class African Americans sought pleasure in the activities of the mainstream culture industry, such as rock and R&B, musical works that white Americans adored as well, many writers, musicians, and artists believed that free jazz formed the perfect soundtrack for Black Power. In their minds, a social revolution required a musical one as well.

And a musical revolution it was. What began as heady experiments among a smattering of musicians in more prosperous and socially stable times slowly gathered force and became a creative storm. But like Black Power, free jazz represented a particularly wide range of musicians and stylistic developments.

Jazz historians often trace the origins of free jazz to a long line of subtle innovations that date back as early as Duke Ellington's experiments with colorful timbres and long-form composition in the 1930s. During the 1940s and 1950s, in the long shadow of the bebop era, Lennie Tristano, Thelonious Monk, Miles Davis, and Charles Mingus all stood out among their peers for their unorthodox approaches to jazz composition and improvisation. Many

trace the foundations of free jazz to divergent musical precursors that displayed what might be called an experimental impulse.

Beginning in the late 1950s, the jazz idiom took its most dramatic departure from its time-honored conventions. Ornette Coleman, John Coltrane, Cecil Taylor, Albert Ayler, the Association for the Advancement of Creative Musicians (AACM), and Eric Dolphy all emerged as leaders of the New Thing, indeed, a thing so brutally new that in the ears of many it threatened the "natural" organic development of the genre. In other words, people wondered if free jazz was jazz at all, or even music for that matter. If bebop exaggerated melodic contour, harmonic extension, and rhythmic disjuncture to the brink of abstraction, certainly free jazz broke through the genre's common-practice sound barrier, wreaking musical havoc, building controversial careers, mystifying old-school critics, and attracting reverent converts.[2]

On the formal level, free jazz comprised a number of sweeping experiments in sound organization that broke with the past. Because the music was more collectively improvised than either swing or bebop, the division of labor between soloist and accompaniment was often obscured. Each competed for the listeners' attention because the music did not include a single emotional focal point, as is the case with, say, a pop singer backed by an orchestra or even a bebop soloist center stage in the soundscape of a virtuoso jazz trio. The New Thing's introduction of unconventional timbral approaches pushed the envelope of what was expected in African American music in general and jazz specifically. Popular song-form harmonic patterns were shunned in favor of open structures that denied listeners familiar landmarks and placed new demands on musicians. Two other significant breaks with past styles could be felt in tonality and rhythm. Exploitation of the tonal system marked bebop as singular; the flatted fifth together with abundant ninth, eleventh, and thirteenth scale degrees made it a harmonically rich modernism. Free jazz took this tendency and pushed it further out, almost completely liberating the genre from the restrictions of functional harmony. Finally, free jazz tended to move through time unevenly, undermining the sense of swing that perhaps represented jazz's most distinctive feature.

Did free jazz—this radical experiment in sound—merely reflect the politically charged moment, or did it fuel it? Both. Evidence suggests, however, that because both sides of the equation, the musical and the social, were eclectic and diverse, drawing one-to-one homologies between the art and the times can be imprecise at best. Yet we can say this much: the political commitments of musicians such as Archie Shepp and writers such as

Amiri Baraka (a.k.a. LeRoi Jones) made the connections unavoidable. At the same time, we must always think about agency. Artists, no matter how political, are rarely motivated by a singular idea. Rather, they are usually responding to a variety of factors. The forces of the culture industry and the search for an individual, immediately recognizable voice within a set field of musical parameters (i.e., the formal qualities of free jazz) have, for example, always provided inspiration for creativity.

Qualifications aside, the free jazz movement represents the most insistent consummation of social, cultural, and identity politics in jazz's history. There was undeniable cross-fertilization of performance rhetoric. During the 1960s, Amiri Baraka's recitation style was heavily influenced by Albert Ayler's cultivated saxophone yelps. Charlie Mingus and Sun Ra both experimented with poetry, and Archie Shepp was both a playwright and poet. Music was a central preoccupation, as the poets were often accompanied by jazz and R&B. The mutual influence among black artists of all stripes could also be seen in their similar attempts to control the modes of production of their work. Coltrane, for example, spearheaded efforts to start a record label and booking agency, and Baraka founded the Black Arts Repertory Theater/School, sponsored concerts for prominent free jazz artists, and claimed that the cultural politics of identity should be central to jazz criticism. Such efforts demonstrated how these artists formed an unprecedented community of social and cultural activism.[3]

Free jazz's musical conventions can claim two streams of influence. There existed during the 1960s a huge investment in the claim that by rejecting many of the melodic, harmonic, rhythmic, and even timbral tenets of common-practice Western art music, the New Thing was returning black music to its African roots. The spirit behind this idea was a well-traveled one. In fact, scholars and cultural critics of the African American experience have long sought to find continuities among the lives of black people throughout the African diaspora, especially as they manifest in cultural expressions such as music, literature, cuisine, religion, visual arts, and dance.

The forced migration of Africans throughout the Atlantic world spawned myriad cultural forms, which, though displaced and transformed, share a core set of distinctive and unifying attributes that link them to the (black) Old World. Art historian Robert Farris Thompson called it a "flash of the spirit." The term describes for him "*visual* and *philosophic* streams of creativity and imagination, running parallel to the massive musical and choreographic modalities that connect black persons of the western hemisphere, as well as the millions of European and Asian people attracted to and performing their styles, to Mother Africa. . . . The rise, development, and achieve-

ment of Yoruba, Kongo, Fon, Mande, and Ejagham art and philosophy fused with new elements overseas, shaping and defining the black Atlantic visual traditions."[4] Religious scholar Albert Raboteau sees this continuity in religion as well, despite efforts to remove the cultural memory of slaves: "In the New World slave control was based on the eradication of all forms of African culture because of their power to unify the slaves and thus enable them to resist or rebel. Nevertheless, African beliefs and customs persisted and were transmitted by slaves to their descendants. Shaped and modified by a new environment, elements of African folklore, music, language, and religion were transplanted in the New World."[5] These notions were adopted by free jazz artists to tie their musical works to both historic Africa and the struggles of black people around the globe. As early as 1964, Marion Brown insisted, for example, that because many black musical forms were passed down from generation to generation orally, he could discern African tribal musics in the riffs and runs of contemporary black music such as jazz and R&B, an idea that many others began to champion.[6]

The push to locate continuity with the African past was central to Black Power rhetoric, and for its architects, black music underscored this coherence poignantly. This strain of thinking has been so influential in Black Nationalist rhetoric that blues and jazz have continued to provide engaging metaphors, models, and themes for a host of studies aimed at elucidating black cultural production and even larger issues in American culture, especially literature.[7]

Indeed, exploration of the dynamic relationship between black Old and New World practices traditionally has been regarded as a valuable way to explain the power and especially the *difference* in black music-making. Historically, this subject has attracted considerable attention: from the antebellum writings of American journalists, missionaries, foreign travelers, and schoolteachers to the twentieth-century work of critics and scholars.[8] Conflicting notions about African American music's African-ness (blackness) or its hybridity (Afro/Euro-ness) fuel this continuing debate. The Black Arts Movement championed the idea that black musical creativity was the result of its engagement of African ways of "musiking," ways that revealed themselves in a range of techniques, styles, and repertoires. The musical styles born of this seemingly endless capacity to codify the stuff of Others into something with a black difference, to cross-pollinate real and imagined boundaries, have proceeded throughout the years without reflecting the conflict expressed in the discourse *about* these musical texts.

At the same time, however, one cannot dismiss as irrelevant the strain of experimentation in Western art music that also discarded the tonal sys-

tem and other familiar qualities of "classical music." Musicologist Susan McClary has brilliantly identified the economy of prestige within which avant-garde composers such as Roger Sessions, Arnold Schoenberg, Milton Babbitt, and Pierre Boulez worked. Difficulty, audience alienation, disdain of the popular, and dismissal of signification grounded in social meaning—the meaning that makes music compelling to most listeners—were worn like badges of honor and consigned their work to a condition she calls "terminal prestige." While classical musics have long functioned as repositories for aristocratic and then middle-class sensibilities, desires, struggles, and fulfillment, they have become invested (particularly the classical avant-garde) in denying the idea that the most prestigious forms of instrumental music signify social meaning.[9]

The formal qualities of this "Western" avant-garde and the jazz avant-garde discussed here may strike many casual listeners as possessing a number of similarities. But a comparison of the claims that each group made about itself is instructive. As the literary scholar Henry Louis Gates Jr. once argued: "Anyone who analyzes black literature must do so as a comparativist, by definition, because our canonical texts have complex double formal antecedents, the Western and the black."[10] The same is obviously true of black music.

If the Western avant-garde (so called for my purposes here) subscribed to what McClary called the "difficulty-for-the-sake-of-difficulty"[11] attitude, free jazz was assigned more politically charged meanings. Don't get me wrong. Jazz has over the last fifty or so years actively sought upward mobility on the cultural hierarchies ladder, and has done so with challenging music. Critics and musicians have fought for the legitimacy of the genre, working to change its status to a bona fide art, replete with anxieties about popular culture. But as we learned above, the difficulty of free jazz was invested with a social function. Furthermore, because the composers of the Western avant-garde were subsidized by prestigious university and college music departments, they could afford to shun commercialism outside of their protected circle. Jazz musicians, on the other hand, have always had to cultivate careers within the culture industry, competing for their share of the pie to survive. Indeed, the economy of prestige was quite different for free jazz musicians.

Both, however, were masculinist discourses. Male musicians formed the core of each, with seemingly little room for the creative work of women. If female musicians had made inroads into the ranks of early jazz, swing, and bebop, free jazz was categorically a boys club. As I noted above, the black feminist agenda that emerged in the 1960s and 1970s was not considered

central to the thrust of Black Power, and according to some, this undermined the scope and potential of the project. Thus, the free jazz movement reflected this lacuna. Yet at the same time, musicologist David Ake has recently drawn attention to, and complicated, the view of free jazz as simply masculinist. Ornette Coleman, he argues, provided a new paradigm for black male jazz musicians by expanding what were acceptable representations of masculinity in jazz. Coleman achieved this in his non-teleological compositions, his preppy, non-slick demeanor in cover art photographs, his vegetarianism, and his non-womanizing reputation, which all challenged the conventional codes of jazz masculinity in the late 1960s.[12]

Cornel West has recently argued that the Black Power era revealed a crack in what was once considered a monolithic equal rights struggle. As an emergent black middle class grew apart from the black working class and the working poor, the resulting stratification within Afro-America threatened traditional alliances. This stratification, of course, could be seen in the jazz world, as musicians with diverse educational and social backgrounds began to constitute the community to a greater degree than they had before. Musical diversity followed. No longer could one assume that, say, jazz and R&B or even gospel were the musics of the black working class exclusively. As free jazz showed us especially, the rich diversity of experiences spawned experimentation. And as Jack Whitten reminds us in the epigraph above, there is much at stake both artistically and socially if one ceases to experiment.

But free jazz musicians paid a price for their experiments. Although their connections to the freedom struggle were clear, there is little indication that the black masses fully embraced the form as their own, as their flag, so to speak. By challenging the arbiters of taste in both Western music and the bebop old guard, free jazz musicians pushed the envelope and themselves out of the cherished circle of common-practice jazz. But the price of not freeing jazz would have been more costly, indeed. Jazz could have died.

NOTES

Originally published in Kellie Jones, curator, "Energy/Experimentation: Black Artists and Abstraction, 1964–1980," the Studio Museum in Harlem, New York, April 5–July 2, 2006. The epigraph is from Jack Whitten, conversation with author, 2005.

1. Eddie S. Glaude Jr., "Black Power Revisited," *Is It Nation Time? Contemporary Essays on Black Power and Black Nationalism* (Chicago: University of Chicago Press, 2002), 1.
2. For varied treatments of this music and its history, see David G. Such, *Avant Garde Jazz Musicians Performing "Out There"* (Iowa City: University of Iowa Press, 1993); Ekkehard Jost, *Free Jazz* (New York: Da Capo Press, 1994 [1974]); David Litweiler,

The Freedom Principle: Jazz after 1958 (New York: Da Capo Press, 1990 [1984]); Salim Washington, "'All the Things You Could Be by Now': Charles Mingus Presents Charles Mingus and the Limits of Avant-Garde Jazz," in Robert G. O'Meally, Brent Hayes Edwards, and Farah Jasmine Griffin, eds., *Uptown Conversations: The New Jazz Studies* (New York: Columbia University Press, 2004), 27–49; LeRoi Jones, *Black Music* (New York: William Morrow, 1967); Robin D. G. Kelley, "Dig They Freedom: Meditations of History and the Black Avant-Garde," *Lenox Avenue: A Journal of Interartistic Activity* 3 (1997): 13–27; Frank Kovsky, *Black Nationalism and the Revolution in Music* (New York: Pathfinder, 1970); George Lewis, "Experimental Music in Black and White: The AACM in New York, 1970–1985," in O'Meally, Edwards, and Griffin, *Uptown Conversation*, 50–101; and Ronald M. Radano, *New Musical Figurations: Anthony Braxton's Cultural Critique* (Chicago: University of Chicago Press, 1993).

3. Lorenzo Thomas, "Ascension: Music and the Black Arts Movement," in Krin Gabbard, ed., *Jazz among the Discourses* (Durham: Duke University Press, 1995), 256–75.

4. Robert Farris Thompson, *Flash of the Spirit: African and Afro-American Art and Philosophy* (New York: Vintage Books, 1983), xiii–xiv.

5. Albert J. Raboteau, *Slave Religion: The "Invisible Institution" in the Antebellum South* (New York: Oxford University Press, 1978), 4.

6. Thomas, "Ascension," 262.

7. See, for example, Houston A. Baker Jr., *Blues, Ideology, and Afro-American Literature: A Vernacular Theory* (Chicago: University of Chicago, 1984); Houston A. Baker Jr., "Critical Change and Blues Continuity: An Essay on the Criticism of Larry Neal," in *Afro-American Poetics: Revisions of Harlem and the Black Aesthetic* (Madison: University of Wisconsin Press, 1981), 140–59; Craig Hansen Werner, *Playing the Changes: From Afro-Modernism to the Jazz Impulse* (Urbana: University of Illinois Press, 1994); Richard J. Powell, ed., *The Blues Aesthetic: Black Culture and Modernism* (Washington, D.C.: Washington Project for the Arts, 1989); Amiri Baraka, "'The Blues Aesthetic and the Black Aesthetic': Aesthetics as the Continuing Political History of a Culture," *Black Music Research Journal* 11 (fall 1991): 101–9; J. Martin Favor, "'Ain't Nothin' Like the Real Thing Baby': Trey Ellis's Search for New Black Voices," *Callaloo* 16 (summer 1993): 694–705; Greg Tate, "Cult Nats Meet Freaky-Deke: The Return of the Black Aesthetic," *Village Voice Literary Supplement*, December 1986, 7; George Lipsitz, "Listening to Learn and Learning to Listen: Popular Culture, Cultural Theory, and American Studies," *American Quarterly* 42 (December 1990): 615–36; Portia Maultsby, "Africanisms in African-American Music," in Joseph E. Holloway, ed., *Africanisms in American Culture* (Bloomington: Indiana University Press, 1990); and Portia Maultsby, "Africanisms Retained in the Spiritual Tradition," in Daniel Heartz and Bonnie Wade, eds., *International Musicological Society: Berkeley 1977* (Basel: Bärenreiter, 1981), 75–82.

8. For comprehensive bibliographic treatment of this material, see Eileen Southern and Josephine Wright, eds., *African-American Traditions in Song, Sermon, Tale, and Dance, 1600s–1920: An Annotated Bibliography of Literature, Collections, and Artworks* (New York: Greenwood Press, 1990). Also see Dena Epstein, "Slave Music in the

United States Before 1860 (Part I)," *Notes* 20 second series (spring 1963): 195–212; Dena Epstein, "A White Origin for the Black Spiritual? An Invalid Theory and How It Grew," *American Music* 1 (summer 1983): 53–59; Dena Epstein, "African Music in British and French America," *Musical Quarterly* 59 (January 1973): 61–91; Dena Epstein, "Documenting the History of Black Folk Music in the United States: A Librarian's Odyssey," *Fontis Artis Musicae* 23 (1976): 151–57; Dena Epstein, *Sinful Tunes and Spirituals: Black Folk Music to the Civil War* (Urbana: University of Illinois Press, 1977).

9. Susan McClary, "Terminal Prestige: The Case of Avant-Garde Composition," *Cultural Critique* 12 (spring 1989): 57–81.

10. Henry Louis Gates Jr., *The Signifying Monkey: A Theory of African-American Literary Criticism* (New York: Oxford University Press, 1988), xxiv.

11. McClary, "Terminal Prestige," 64.

12. David Ake, *Jazz Cultures* (Berkeley: University of California Press, 2002), 62–82.

To the Max

Energy and Experimentation

Al Loving, *Rational Irrationalism*, 1969. Synthetic polymer on canvas; Diptych: 82 x 96 1/2 inches; two panels, each: 82 x 48 1/4 inches. Purchase, with funds from the Robert C. Scull Fund for Young Artists not in the Collection. Photograph Copyright © 1998, Whitney Museum of American Art, New York. Courtesy Mara Kearney Loving. Photo credit: Sheldan C. Collins.

Figurative art doesn't represent blackness any more than a non-narrative media-oriented kind of painting, like what I do.

SAM GILLIAM

The period from the 1950s through the 1970s were a heady, if now almost mythic, time of struggle for African American civil rights, African independence, and youth and antiwar movements worldwide. In the history of art by African Americans, the time is known for the cultural production of the Black Arts Movement, whose images of resistance and African heritage have become icons of the era. Simultaneously, these artists protested for inclusion in American society.

Certainly less discussed is the strong voice of abstraction that developed among black artists around this time in both painting and sculpture, a voice created by a critical mass of practitioners committed to experimentation with structure and materials. Flush with the scientific idealism of 1960s, they wrestled with new technologies, including light- and electronic-based works and explorations of recently invented acrylic paint. Their painted works were frontal, holistic, and engaged, to an extent, with geometry or primary forms in the manner of other contemporary trends, including post-painterly abstraction and systemic painting. They moved from the planar into considerations of "objecthood" that signaled minimalism. Most of them did not fall wholly into one camp or style, but rather their works were hybrids formed in unique, individual languages of abstraction, at once iconic and emotional, optical, and vibrant.

"Energy/Experimentation: Black Artists and Abstraction, 1964–1980" focuses on a core group of artists who continued to stay true to these strategies over time. They also exhibit what Mary Schmidt Campbell has identified as a certain "aesthetic collegiality"[1] characterized by similar experiments with opticality, materials, space, tools, and surfaces.

MAINSTREAM CONNECTIONS

As segregation was successfully challenged and legally abolished in the 1950s and 1960s, an entire generation of African Americans was able to attend art school. Not only did they receive the skills and credentials neces-

sary to survive as artists, but the social process itself integrated them into the mainstream art world. Many of the practitioners featured in "Energy/ Experimentation" received bachelor's and master's degrees in art from renowned institutions such as Cooper Union, the Art Institute of Chicago, and the Pratt Institute. Barbara Chase-Riboud (MFA, 1960), Howardena Pindell (MFA, 1967), and William T. Williams (MFA, 1968) all attended Yale University School of Art, along with Robert Mangold (MFA, 1963) and Brice Marden (MFA, 1963), and it is interesting to consider the shared legacy of color and geometric vision they may have inherited from Yale's influential teacher there, Josef Albers.

These artists were also employed in mainstream institutions. Jack Whitten and Williams were professors at Cooper Union and Brooklyn College, respectively. Pindell worked for a decade at the Museum of Modern Art (1967–1977), rising to the position of associate curator of prints and illustrated books. There she met Lucy Lippard; Mangold, Robert Ryman, Sol LeWitt, and Dan Flavin were employed there as well, mostly as guards. These African American artists were also among the first residents of SoHo and helped transform it into an artists' neighborhood. Al Loving lived in a loft on the Bowery in the same building as Kenneth Noland; Joe Overstreet, Haywood Bill Rivers, Daniel LaRue Johnson, Pindell, Whitten, and Williams were neighbors.

They participated in Whitney annuals and biennials, biennials at the Corcoran, and numerous other museum and gallery shows, as well as the plethora of culturally specific exhibitions in mainstream and newly minted alternative venues. Loving and Alma Thomas were the first African American man and woman to have solo shows at the Whitney Museum of American Art.[2] The Studio Museum in Harlem figures centrally in this narrative as well.

In the Black Nationalist atmosphere of this period, many of these artists were rejected by more militant practitioners and institutions that believed figuration was a more useful way to combat centuries of derogatory imagery centered on people of African descent. Abstraction was characterized as "white art in blackface," but without the subjects and artifacts of colonialism—the people and art of the Americas, Africa, and Oceania— where would Picasso (or Matisse, etc.) or their heirs really be? As we shall see, it is fascinating how black abstractionists of the 1960s and 1970s negotiated such dogmatism and rejection. They were committed to equality, but they were equally committed to their right to aesthetic experimentation.

EXPERIMENTATION
Antecedents

Haywood Bill Rivers, Edward Clark, and Alma Thomas were among the first artists in "Energy/Experimentation" to test abstract languages. Thomas was a junior high school teacher for decades and created art in her kitchen before being "discovered" by the mainstream in the 1960s. Rivers and Clark found inspiration and support in France in the 1940s and 1950s, respectively. Both were creating fully nonobjective canvases by the 1950s. Returning from Paris and settling in New York in the 1950s, Clark shifted from the more static geometry of cubism to the gestures of American action painting. His hunger for action took him right off the canvas and onto what was arguably one of the first shaped canvases of the period.[3]

Creative antecedents were also vernacular. The incorporation of sewing into the work of Al Loving, Sam Gilliam, and Joe Overstreet at this time evoked family traditions of quilting and tailoring. These were functional arts that African Americans had used to earn a living and keep their creative juices flowing at the same time.[4] In this way Alma Thomas saw herself surrounded by creativity from an early age, from her mother's use of color as an expert seamstress to her extended family's planting and working of southern soil.[5] For William T. Williams, it was the patterns of raked yards the artist created in childhood visits to North Carolina under the watchful and aesthetically keen eye of his grandmother.

The categories of experimentation that I discuss below are useful but random to a certain degree. All of the artists in "Energy/Experimentation" can fit in almost any area. Changing notions of what constituted the art object led these artists toward hybrid forms that pointed out tensions between painting and sculpture, and challenged the strict delineation of the two.

Opticality

"Opticality" is a term linked to this era and the American art criticism of Clement Greenberg and Michael Fried. It implies aesthetic perception and the intersection of color, composition, and materials to create visual dynamism. In Loving's cubes and Williams's early geometric paintings, we note the use of masking tape and acrylic paint to create sharp line and eliminate painterly gesture, as was seen in the contemporary work of Frank Stella and Kenneth Noland. Thomas substituted the organizational structure of hard-edge with painterly layering that evokes the grid. Daniel LaRue Johnson's sculpture emphasizes the tension between the solid form and its painted surface.

Al Loving's polyhedrons and cubes provided a basis for his early art language. A single cubic word could be combined variably with others to create phrases and sentences, declarations in paint about space and color. Color could be organizational as well. In retrospect, these hues also represent the era; in the painterly day-glo oranges and pinks of the large work *Septehedron 34* (1969) we now see the youth and spirit of the 1960s. At the same time, Loving's geometric profile is "polished and tasteful."[6]

A confluence of events in the early 1970s led Loving to change aesthetic gears. He began to think more about the quilt as creative form. His work as a dancer with the Batya Zamir Dance Company further attuned him to space and environment. Another event was more extreme—a laborer completing one of Loving's large public commissions in Detroit was fatally injured. Horrified, Loving decamped to Newfoundland, Canada, cut up all his geometric paintings, learned how to sew, and began piecing them back together.

Such antiformalist works as *Untitled* (c. 1975) are diametrically opposed to the hard-edge painting that initially won him recognition in New York. He used standard-issue cotton duck, but worked with other fabrics as well, such as velvet, which brought sensuous texture to his surfaces. Each canvas strip also became a painting in and of itself. This explosion of the flat illusionistic object released the artist onto a trajectory of ebullient and continuous experimentation. Romare Bearden provided additional inspiration for this dislocation of painting. His cutting and reassembling of his abstract expressionist pieces led to the collages for which he became well known. This made Loving realize that his disassembling of the cubes was a form of collage and a way to make paintings work in real space. He also came to understand the limits of the category of "painter." As he recalled, "that aspect of me doesn't paint but makes things. But I'm not a sculptor."[7]

In the early work of William T. Williams, color became structure, "geometric labyrinths"[8] and planes of intersecting hues. Williams said of these paintings that he was interested in bringing an "irrationalism" to the formalism of the day as a vehicle for emotion and expression. As he has noted, "I was caught between two issues: an interest in Colorfield painting and an interest in expressionism, and in trying to reconcile the two."[9] Because of his geometric motion and emotion, his works certainly were not experienced in the same manner as typical color-field paintings, but people were still drawn to his handling of color. Williams also found the complexity he sought in his paintings in the jazz stylings of the moment. The dynamic geometries in *Trane* (1969) visualize the sounds of John Coltrane's saxophone. Williams sought out jazz for formal inspiration, but also for its "reassertion

of cultural identity."[10] To drive home his point, at the opening of his solo show at SoHo's Reese Paley Gallery in 1971, Williams showed the paintings along with "the musical accompaniment of blaring radios."[11]

Linked with the Washington Color School, both Alma Thomas and Sam Gilliam found support for their work in that city in the 1960s. While the majority of the artists in "Energy/Experimentation" were in their thirties during this period, Alma Thomas was in her seventies. Nevertheless, she was clear that regardless of age, she and her work were part of the current "day in time."[12] While her art may have been inspired by the natural world, she said, "I leave behind me all those artists who sit out in the sun to paint. I leave them back in the horse and buggy time when everything moved slowly. I get on with the new."[13]

Thomas found a nonobjective language that honored the flat picture plane that had captivated Western modernism. While there is no depth to her paintings, there are layers. Her painted strokes began primarily as gatherings of horizontal lines, thin bands of color, as in *Air View of Spring Nursery* (1966). These blocks of color at times obliterate the canvas field but still evoke an underlying grid. Thomas's excitement for the natural world set her apart from figures such as Noland and Morris Louis. Yet when she translated circular beds of flowers throughout the city into circular imagery, it could invoke comparisons with both Noland and Jasper Johns. She also chose the eccentricities of the brush over the staining of canvas and the sharp, clean lines favored by her peers.

Daniel LaRue Johnson was born in Los Angeles, and began his formal art training there in the late 1950s. By the 1960s he lived a peripatetic life-style, going back and forth between, primarily, Los Angeles and New York. In the second half of the 1960s his interests in various media came together in highly polished polychrome wood sculpture linked, due to its decorative sheen, to the "finish fetish" of Los Angeles art. An exquisite and complex composition such as *Homage to Rene D'Harnoncourt* (1968) focuses on the horizontal thrust of sculptural forms with a variety of intersecting planes that seem to float above the floor. Shown in the exhibition "In Honor of Dr. Martin Luther King, Jr." at the Museum of Modern Art in 1968, John-son's piece seems from our perspective to have a satiric edge, as it is an homage not to the slain civil rights leader but to a director of the museum. Within months of the exhibition's opening, however, D'Harnoncourt re-tired and then met with an untimely death soon after. D'Harnoncourt's interests in Mexican and Native American art could be seen, in one sense, as paving the way for a more complex notion of modernism and contempo-rary culture, and one that might more fully include black artists.

Materials

While Fred Eversley and Tom Lloyd worked with materials considered part of the cutting edge—plastic resin for Eversley, electronics and light for Lloyd—Sam Gilliam took the more traditional notion of painting into another realm. For these artists, the investment in action, and the changing notion of what materials could be considered "art" and how they were used, provided the basis for their continuing explorations.

Fred Eversley, a former aerospace engineer turned artist, began creating cast-plastic resin sculpture in Southern California in 1968. His ideas fitted comfortably into the stylistic trends of the era known as the "L.A. Look"— including hard-edge painting, minimalist sculpture, and pop art visions— which critic Peter Plagens called "cool, semitechnological, industrially pretty art."[14] It was identified with new techniques and materials, such as resins, glass, plastic, metal, and industrial pigments, in works by artists such as Larry Bell, Judy Chicago, and Craig Kauffman. The style favored primary forms over decorative surfaces, the inspiration of West Coast aerospace technology over East Coast industrialism. Eversley's sculpture addresses opticality, perception, mathematical formulas, and kineticism. While pieces such as *Untitled* (1970) and *Untitled* (1971) are solid geometrical structures, they use kaleidoscopic properties to conjure the movement of bodies in space and reflect viewers' shifting emotional profiles.

Like Eversley, Tom Lloyd used materials that visibly incorporated new technologies. If Dan Flavin's light works create atmosphere and Keith Sonnier's use neon as expressionistic gesture, Lloyd's pieces reflect the movement and pacing of the city—street and traffic lights, automobile signals, and theater marquees. Their programmed and changing hues also seem to insert an emotive flair. Large sculptural geometry is further complicated by the form of the lights themselves: circular lenses that refract and fracture light and color; add line, pattern, and shape; and alter the holistic sense of each piece. *Moussakoo* (1968), a wall work more than six square feet in size and made up of interconnected hexagons, is among Lloyd's most complex pieces in this medium and mirrors Al Loving's investigations of this shape during the same period. Loving's paintings suggest an easy seriality and interchangeability, while Lloyd's floating light plays belie the connectedness of electronics and wiring that precludes actual physical movement. Instead the light and color offer evanescent motion.

Though he was working with hard-edge abstraction as early as 1964, in 1968 Sam Gilliam's experiments with staining and folding canvas exploded into the draped works for which he is perhaps best known: huge skeins that

pushed the notion of the Washington Color School into new dimensions. Such works made us rethink what painting might be, what it looked like, how it worked or lived in the world. Yet at no time did Gilliam himself see these as forms of sculpture; instead he considered them "suspended paintings."[15] The painted surface is still the key and the voluminous folds of canvas highlight and emphasize luminous color. By moving the painting off the stretcher bars and into space, the artist acknowledged the "properties inherent to canvas itself . . . allowing the canvas to be exactly what it really is—a flexible, drapeable piece of cloth," and let this provide the structure for his imagery.[16] Yet as has been suggested, the installation of the suspended paintings was not random. Gilliam had specific notions about the way he saw the works engaging with space that can be usefully compared to the felt works of Robert Morris or the synthetic skeins of Eve Hesse, which also date from this moment.[17]

Gilliam's investigations of monumental drapes were accompanied by explorations on a smaller scale. Works such as *Gram* (1973), included in "Energy/Experimentation," demonstrate the importance of circular shapes evolving from the larger cascading pieces. The tondo form became an extension of investigations that problematized the traditional rectangle of modern painting. *Toward a Red* (1975), though completed only two years after *Gram*, shows Gilliam putting paintings back on stretcher bars and in a rectangular format. Where the draped works demonstrated exuberant staining, the surface of *Toward a Red* is thick with encrusted layers of paint, and though more traditional in shape, is formed by joined collaged strips of canvas of varying sizes. It can be usefully compared with Al Loving's *Untitled* (c. 1975), which uses a similar structure of pieced canvas sections, although in this case they are dyed and released from the stretcher.

Space

The notion of space as a sculptural equation is demonstrated in works by Melvin Edwards and Barbara Chase-Riboud, but their approaches take us in other directions, with pieces that may be suspended from the ceiling or lie on the floor. In contrast to Edwards and Chase-Riboud, who manipulated metals, Joe Overstreet transferred the workings of mass and volume to billowy canvases stretched with rope and experienced in three dimensions.

Joe Overstreet left the Bay Area in 1958 for New York, where he received good responses to his work over the next decade. In 1969, he showed intensely hued hard-edge and shaped canvases in a solo exhibition at the Studio Museum in Harlem.[18] Overstreet received praise in *The New York Times* and a stellar review in *Arts Magazine*, where his colleague Frank Bowl-

ing declared, "This show is a triumph!"[19] He lauded Overstreet's emotional color and edgy sense of shape, and wrote, approvingly, that "the wall is not dealt with formally, but with utter distrust."[20] These shaped canvases, with titles such as *Tribal Chieftain* (c. 1969) and *He and She* (1969), are results of a period of study of "African systems of design, mythology, and philosophy," distilled to make a "statement as a black man in the West."[21] If ethnically specific institutions such as the Studio Museum in Harlem began to move away from works of nonobjective abstraction around this time, it seems odd that such works by Overstreet would find approval. But his interest in African design systems, particularly the sense of frontality and confrontation of the mask form, made the works acceptable under the new dispensation.[22]

Rather than find Overstreet's invocation of African symbology situational or opportunistic, we can relate it back to his home base in the Bay Area. There he was mentored by Sargent Johnson, a Harlem Renaissance–era artist who not only was an ardent proponent of Alain Locke's theories, but also, like most West Coast artists, had an open approach to a multiplicity of cultural sources.[23] Overstreet returned to the Bay Area from 1970 to 1973 to teach at California State University, Hayward. During this period he developed the "Flight Patterns Series" and related works, which saw canvases removed from the stretchers. *Saint Expedite A* (1971) is a beautiful example. He transferred the geometry he worked with previously to more flexible formats that indeed bear out Bowling's earlier observation of Overstreet's "distrust" of the wall. These pieces take shape through taut ropes that attach to the floor, ceiling, and wall at strategic points. The hues in *Saint Expedite A*—in acrylic paint applied to the ground with a wire brush— appear to be red, black, and green, an invocation of the colors of black liberation, a way perhaps to link this work to the social concerns of the day.[24] In the "Flight Pattern Series," the flexibility of installation and the attention to the canvas as fabric and as a sewn form are attributes Overstreet shared with Loving and Gilliam. But while Gilliam and Loving both referred back to quiltmaking as an impetus for that process, Overstreet was captivated by nomadic shelters, home spaces that can be easily assembled and disassembled to provide shelter on the road and when in flight.[25]

Before arriving in New York in 1967, Melvin Edwards was a rising star in Southern California, garnering major attention there by the age of 30. *Lifted X* (1965), included in "Energy/Experimentation," was made for his first solo museum show at the Santa Barbara Museum that same year, and is an homage to the then recently assassinated Malcolm X. Similar to the "Lynch Fragments" series for which he is perhaps most well known, *The Lifted X* contains a strong vertical mass of welded fragments which seems

to hold together only tentatively, forming compositional chiaroscuro in the interstices of the welded steel. In *The Lifted X*, however, this central form rests on a cool rectilineal base.

The sense of ritual and eroticism that Mary Schmidt Campbell read in the "Lynch Fragments" is not yet quite visible in *The Lifted X* or *Cotton Hangup* (1966).[26] Both seem more experimental. The latter is hung from the ceiling and anticipates more environmental works such as *Curtain for William and Peter* (1969). That work is composed of barbwire and chains, which cascade from the ceiling to the floor, and had its debut at the Studio Museum in Harlem in 1969 in the exhibition "X to the 4th Power," curated by William T. Williams, before being included in Edwards's solo show at the Whitney Museum the following year. However, as early as 1968, Edwards was experimenting with large-scale geometries that were sometimes painted. These were shown at his one-man show at the Walker Art Center in 1968 and appeared in a public work, *Double Circles* (1968, installed 1970), in Harlem at 142nd Street and Lenox Avenue.

Barbara Chase-Riboud has spent the last four decades living and working in Europe, but her art is still intricately involved with the issues faced by this generation of artists and the tensions between abstraction, politics, and race. She also continues to be concerned with themes of the African diaspora. A sculptor and an erudite draftsman, she is also a poet and award-winning novelist.[27] At times her various projects intersect into one continuous study, as we see with the piece *Bathers* (1972), which is also the subject of a poem. The sculpture is a floor work of undulating elegance. It covers nine feet by twelve feet of floor space but rises a mere six inches off the ground. Silk and synthetic fiber appear to erupt from the places where the sixteen aluminum sections join, and ooze and flow more flagrantly at certain points. A useful comparison can be made here to the decidedly more minimal work of Carl Andre, which radically offered up sculpture not only as flat piece barely rising from the floor, but also crafted from mundane materials such as firebrick and steel. We can also think about Chase-Riboud's oeuvre as valorizing materials considered craft (fabric, yarns, etc.), part of the changing notions of the art object in this era, and particularly linked to a feminist practice. In this light, French art historian Françoise Nora related Chase-Riboud's work to that of contemporaries, such as Magdalena Abakanowicz and Nancy Graves, in an orientation toward, and revitalization of, fiber.[28]

Chase-Riboud used the lost wax process to cast unique metal elements in her sculpture from the 1970s. An ancient method, it is associated with

the exquisite bronzes of fifteenth- and sixteenth-century Benin. Correlation to African creative traditions can also be seen in the way Chase-Riboud approached her vertically oriented pieces from the period, such as the "Malcolm X Series." Here we find parallels to West African masquerades, which join wooden mask superstructures with fabric, raffia, and other materials draping the body, and are then put into performance. Yet Chase-Riboud has also been adamant about the fully global inspirations for her work and the need for an equally expansive contextualization.[29]

Tools

New approaches to painting required new types of implements. Jack Whitten and Ed Clark were among those who developed different ways of applying paint to the canvas ground. Their inventiveness was not just in the workings of the flat surface, but in the methods and tools used to intercede in it. These interventions were also about process, where the actions constituting the creation of the work are made/left visible. As Whitten noted, "the painting is more about the journey than the destination."[30]

Although an admirer of abstract expressionism and color-field painting, Jack Whitten considered his own works as a further development: fields of painted matter that he related to the "sheets of sound" created by jazz musicians and the active surfaces of photography in process. As he explained:

> I had a conversation with John Coltrane, in 1965, at the Club Coronet in Brooklyn. He was playing with Eric Dolphy and for about two weeks straight I was going out there every night to hear him. Coltrane told me how he equated his sound to sheets: the sound you hear in his music comes at you in waves. When they say 'Training in,' it's about the sound coming in in waves. He catches it when it comes by, and he'll grab at as much of it as he needs, or can grasp. I think that, in plastic terms, translating from sound, I was sensing sheets, waves of light. A sheet of light passing, that's how I was seeing light. That's why I refer to these paintings as energy fields. I often thought of them as two poles that create a magnetic field in which light is trapped. That's the energy.[31]

Paintings of the 1970s, such as *Khee I* (1978), from the artist's "Greek Alphabet Series," thrust horizontally in thick vibrating bands, with incisions in pale hues interrupting the flowing movement of gray, black, and white tones. The working of the surface is elaborate and refined, hinting at the illusionism that was painting's stock-in-trade. Whitten worked in the area of tension between the actual painted planes and the pictorial space. The

surfaces he created are also tactile, made by layering and cutting back into thick strata of acrylic. Whitten's experiments make the physical nature of painting palpable.

What distinguished Whitten from his peers, however, was his invention of processes and tools for painting. In 1970 he made a decision to let go of the brush and remove the marks of the hand from the canvas. He created a floor-based platform on which to paint and a variety of objects with which to manipulate or intercede in the liquid surface. The first of these were, tellingly, an Afro-comb and a saw, which he pulled through wet acrylic. The former was a sign of African American identity and the latter of manual labor and the construction trade in which Whitten worked when he arrived in New York in 1960. These two items inspired an array of inventions, often immense things made of metal, rubber, or wood, that the artist pulled across profuse layers of paint. "This technique [was] a physical way of getting light into the painted surface without relying on the mixture of color."[32]

Edward Clark's mature work is a testament to gesture and action. The traditional paintbrush, however, was replaced by a push broom in the 1960s to capture not only the motion of the hand and arm, but also to involve the power of the body. With the body behind it, the push broom offered speed. As the size of the paintings grew, Clark added a track-like device to keep the broom steady. Clark's voice developed with the intersection of gesture and color. He began to create oval paintings in Paris between 1966 and 1969 as a way to incorporate perception by mimicking the shape of the eye. This form is also a continuation of Clark's shaped paintings of the 1950s. By the early 1970s, the ellipse or oval had evolved into a "bounding shape"[33] contained within the canvas rectangle and which interceded into the strong horizontals formed by the push broom, as we see in Untitled (1977) from the "Yucatan Series." During the period covered by "Energy/Experimentation," Clark created groups of paintings influenced by travel and memory. Paler hues—white, wisps of faintest blue, some beige into a whisper of pink— dominate the "Yucatan Series," while the "Ife Series" concentrates on terracotta and umbers, for instance, in ruminations on place and culture.

Surface

An involvement with surface in painting is demonstrated in the works of Haywood Bill Rivers, Frank Bowling, and Howardena Pindell. Bowling's experimentation with processes of staining in the late 1960s and early 1970s was incrementally replaced with an increased emphasis on layering of painted material. Rivers began creating thick paintings in the 1950s and this became his signature. Unlike the others, Pindell's canvases were largely

monochromatic, making the buildup of surface materials almost invisible despite their loaded density.

Haywood Bill Rivers is the oldest artist represented in "Energy/Experimentation," although he and Ed Clark are of the same generation. Through his example we understand how African Americans marshaled their creativity, whether they were trained formally or not, and regardless of whether anybody cared to recognize what they did as fine art. Born in the small rural town of Morven, North Carolina, Rivers made his way to New York and the Art Students League in 1946. Rivers's earliest work follows the naïf vein of Horace Pippin and owes much to his interest in the work of Jacob Lawrence. Interestingly, one of his mentors at the Art Students League was Morris Kantor, who would turn out to be one of Al Loving's professors in graduate school at the University of Michigan in Ann Arbor some twenty years later.[34]

Rivers developed his fully abstract voice by the 1950s, when he was living in Paris. At that time he developed his heavily impastoed canvases, some of which were so thick that "they could not be rolled for shipment to the United States."[35] Rivers was inspired and captivated by abstract expressionism, a movement in which he felt he could participate, and that had national and international impact.[36] *Eclipse #1* (1970) demonstrates the language that the New York art world came to know him by in the 1970s. It is driven by a unique color sensibility and characteristic geometry, and, interestingly, still bears the frontality found in his figurative "naïf" canvases of the 1940s. Rivers, too, thought of his practice in relationship to the traditions of quilting, vernacular and functional creativity. He also saw them as issuing, to a certain extent, from the natural world, as seen in his repeated petal images based on the bountiful daisies of North Carolina. However, the circular forms that reappear in his canvases were inspired by the Moorish architecture of Spain, where he spent time in the 1960s.

Arriving in New York from London in the mid-1960s, Frank Bowling, originally a citizen of Guyana, visually and intellectually confronted the notion of "American-type painting." *Bartica Born III* (1969) demonstrates Bowling's investigation of large stained color-fields. Yet his larger "American" autobiography is also present here in the painting's Guyanese title and furthered in his incorporation of maps and photo silkscreens.[37]

As Kobena Mercer has noted, maps in the works of other artists in the 1960s, Jasper Johns and Alighiero Boetti among them, become vehicles for the exploration of a changing sense of geography. Bowling's figure and actions were part of the global effort to "decentre the planisphere," or the perspective of the globe from the Western eye.[38] But the maps become increasingly vestigial as color takes control. At times juicy and luminous, these

paintings also offer, according to Mercer, an "aquatic mood" that relates to the Afro-Atlantic Middle Passage.[39]

While he is discussed here in the context of surfaces, Bowling invented his own tools as well. He built a low platform equipped with a gutter to accommodate the running water and paint of his staining process, and also created canted stretchers to allow paint to course down the center in forms both sensorial and dimensional. In later paintings, such as *Barticaflats Even Time* (1980), our attention is drawn to the thick layering and slubs on the active surface.

Around 1970, Howardena Pindell began to adapt various "systems" to work out aesthetic problems in paper and paint, such as hole-punched templates through which she applied color to a surface. The circular remains of these stencils, as well as fragments of discarded works, were then reapplied to paintings and drawings, sometimes numbered but "out of sequence" and sometimes bearers of delicate color. Underlying this play of surface is a grid, maybe formed of graph paper and later made more three-dimensional with monofilament or thread. Large paintings from the period are light, almost translucent, and seem to merge with the wall, some with barely flickering dots that are iridescent and poetic.

In the practice of Howardena Pindell we begin to see the stakes of painting, and art in general, change as we move toward 1980. Increasingly concerned with the lack of content, and later with the abscence of specifically *political* content, in her own work, Pindell began to make surfaces that reflect changing notions of what the picture plane should hold. We see this in the greater incorporation of color, and the sexy fun of shimmery substances—"sequins, confetti, and glitter, like minimalist paintings seen through the eyes of a Vegas couturier," as Carrie Rickey mused.[40] In these later large paintings, Pindell belatedly took up the craft of sewing—often used to mark feminist practice earlier in the 1970s—to create soft grids from strips of canvas that were then sewn back together but "so loosely bound that the paint-stiffened threads become airy, organic grids."[41] *Feast Day of Iemanja II, December 31, 1980* evidences such developments in the artist's work. The titular link to the African diaspora (in this case in the reference to the Afro-Brazilian religion of Candomblé) is something we have seen in other works in "Energy/Experimentation." But here it is feminized with allusions to the goddess of the sea and of procreation, its sensuous beauty compounded by the addition of perfumed scent. These shifts on Pindell's part moved the work toward what would become postmodern practice in the 1980s—a focus on overt investigations of identity and the return, in painting as well as in sculpture, of the figure.

While she realized the importance of political activism early in her professional career, Pindell did not incorporate that into her painting before 1980. As works of process, Pindell's paintings and drawings from the 1970s could be seen as meditations. However, in 1980 she forecasted a shift: "I do work that tends to be very beautiful, very physical. There's texture, there's color, even smell. . . . People who see my work now find it very soothing. I want to start confronting people with having to change their attitudes. It's not because I feel I *should* do that; I feel that I physically *must* do that work, or I'll get ill from not doing it!"[42] The evolution in Pindell's paintings—the embrace of figures, lush applications of color and text, and indeed the autobiographical turn, seen in such works as *Autobiography: Scapegoat* (1990) in the collection of the the Studio Museum in Harlem—began with the video performance work *Free White and 21* (1980), a paean to art/real world racism. In the twelve-minute video, Pindell plays all roles. One person is a black woman/artist recounting vignettes of discriminatory encounters taken from Pindell's life. Another figure is a white racist, a caricature of a "lady"—Pindell in a blonde wig and white face. The third character is a liminal entity who wraps and unwraps her head in white gauze, which is eerily close to the white canvas strips from which Pindell had been creating her paintings up to that moment.

ENERGY

"Energy" in the title of this exhibition inflects the "Experimentation" of these artists. Much of it is found in explorations of new materials and technologies, including new formulas of acrylic paint, light, electronics, and photography and a translation of photographic thinking.

Corporate Technology

Some of this exploration was imbricated with certain kinds of corporate support. Tom Lloyd created his *Electronic Refractions* in consultation with Al Sussman, a scientist working for the electronics giant RCA (Radio Corporation of America). William T. Williams had a relationship with Lenny Bocour, owner of Bocour Artist Colors (maker of the first acrylic paints), that not only allowed him access to the latest products, but also enabled him to comment on and perfect these materials for his own use. Jack Whitten's fellowship with the Xerox Corporation in the mid-1970s gave him access to flat-plate photocopy equipment. He also created works on paper using dry carbon pigment, or toner. Whitten also had a relationship with Bocour, and traded paintings for large quantities of paint. Fred Eversley's location in Southern California and experience as an engineer made him a perfect

candidate for the infamous "Art and Technology" institute at the Los Angeles County Museum of Art, which culminated in an exhibition in 1971. The program matched artists with corporations producing new and specialized materials. Eversley was paired with Ampex Corporation, a maker of audio and visual recording and data technologies, to create a project with heat-sensitive liquid crystals in a full-spectrum, light-filled environment.

Photographic Thinking

Jack Whitten was interested in photography's growing preeminence and the technology's imbrication in contemporary vision; as he wrote on his studio wall during this period, "The image is photographic; therefore I must photograph my thoughts."[43] This was not a nod to figuration but his way of considering the painted surface as something developed and activated by process. Whitten's use of the generic term "developer" for all his invented tools was another link to photographic thinking and method. The close tones, shimmer, and keen articulation of his surfaces also draw comparisons to new media, such as television and video.

Howardena Pindell's experiments with minimalist-driven aesthetics signaled both the contemporary and future time. Her sardonic use of numerical systems, grid structures, and discarded materials was seen as having "succeeded in making art out of the detritus of the computer age," unlike assemblage, which was experienced through the lens of nostalgia.[44] In the second half of the 1970s, Pindell's explorations of translucence in the painted ground began to move her further toward technology. In her "video drawings" the artist replaced raw canvas with acetate, which she decorated with diagrammatic pen and ink sketches. She then positioned these acetate gels over a television screen and photographed them at slow speeds so the video image became blurred while the solid ink drawing remained constant. One gets a sense of the works as new hybrid objects, even though they were technically photographs.

Afro-Futurism

Scholar Alondra Nelson and others have identified certain types of cultural production under the rubric Afro-Futurism, which describes art forms that engage the futuristic, science fiction, and technology, but are tethered to histories of the African diaspora. During the period covered by "Energy/Experimentation," we see this in the speculative fiction of writer Ishmael Reed and the musical innovations of avant-garde jazz musician Sun Ra.[45] Art historian Françoise Nora has spoken of Barbara Chase-Riboud's *Bathers* in this

context. Its floor orientation, along with the conjunction of metal and fiber, gives the piece the quality of something unknown, evoking "a poetic science fiction of the past," similar to the otherworldly black slab in the film *2001: A Space Odyssey* (1968).[46]

Also during this period, Alma Thomas created a series of phenomenal paintings inspired by United States space exploration. Thomas was captivated by it all: craft and men, orbiting and landing on the moon, the material of the lunar surface, pictures of other planets—as in *Mars Dust* (1972)—and Earth as seen from the cosmos. Thomas's daubs of color also captured the grainy texture of the televised image and the screens that mediated much of her space imagery.[47] Yet she imagined seeing her visions of earthbound flora from "way up there on the moon"[48] or "planes that are airborne"[49] as well, even before having flown commercially, which signaled her progressive, forward-looking vision or Afro-Futuristic thinking.[50]

Abstract Art and Protest

Undeniably, aspects of the power and energy manifest in the work on view are also drawn from the era's climate of protest and social change. The artists in "Energy/Experimentation" wanted to be acknowledged for the "artistic merit of their creations, rather than for the social content of their works."[51] However, they also often attempted to make the social ferment of the time present in the work as pictorial and spatial energy, and through themes or titles. The social connotations of this body of work also appeared in its environmental and public aspects; many of the pieces were crafted with the idea of encompassing the viewer, which came from a desire to share this vision, to have people connect with this energy. Some artists were also strategically involved in actual protest. For most, being an artist and a person of color at this time also meant being an activist or an organizer on some level, if only to bring one's vision into the world.

One watershed was the protest against the exhibition "Contemporary Black Artists in America" at the Whitney Museum in 1971. Although the show was originally an initiative of the Black Emergency Cultural Coalition in conjunction with the museum, objections built as the methods of organization and scholarship came into question. At least sixteen artists withdrew from the show to protest the museum's shoddy and haphazard approach to these artists, their work, and their history. A letter stating some of their positions appeared in *Artforum*, and was signed by John Dowell, Melvin Edwards, Sam Gilliam, Richard Hunt, Daniel LaRue Johnson, Joe Overstreet, and William T. Williams—all abstract artists.[52]

Protest Actions

William T. Williams used a proposal for bringing artists into local communities, a concept he developed as a graduate student at Yale University, to create a template for the Studio Museum in Harlem's famed Artists-in-Residence program, which, in fact, gave the institution its name. The museum was seen as a location for living artists. The idea was to take artists, and perhaps particularly African American artists, and put them back into community settings to inspire other kinds of thinking among youth of the inner city. Another goal was to bring art into the urban landscape. In a way, this mirrored what some black artists groups, such as Weusi in New York, the Organization of Black American Culture (OBAC) in Chicago, or the Black Arts Council in Los Angeles, were doing at the time. These efforts included holding exhibitions in community centers and banks, on fences and walls, and in other nontraditional locations to attract equally nontraditional audiences. Williams's plan placed both the art world and the artists themselves in the urban community setting, thus taking art out of the realm of elitist culture and putting visual aesthetics within the reach of everyday people.

Williams, along with Melvin Edwards, Billy Rose, and Guy Ciarcia, formed the Smokehouse group, and between 1968 and 1970 created murals for outdoor sites in Harlem. There was this sense then that art in outdoor locales could energize a place and a people and be a catalyst for change. The group's renovation of a small park in Sylvan Court (on 123rd Street in East Harlem) is a good example. After they had worked on the walls, more life seemed to flow into the park—the Parks Department updated seating areas and people from the area began to return to this site, which had previously been abandoned to addicts and the like. Unlike OBAC's famous *Wall of Respect* (1967) in Chicago, which featured figurative renderings of past and present heroes of the African diaspora, Smokehouse murals were always abstract. The artists nevertheless sought community input at the conceptual stage and at completion, creating a sense of ownership and investment by the neighborhood.[53] The idea was not to preach from walls through politicized or didactic messages, but to bring resources and a sense of the possibilities for transformation.

Tom Lloyd appears in the historical record as more of an activist because of his connection to the founding of the Studio Museum in Harlem, along with his demands for accessibility to art by urban communities, as well as his protests for the diversification of museum exhibitions and collections. Lloyd's series of light pieces, the "Electronic Refractions," opened the Studio Museum to the public on September 26, 1968.

In the beginning the Studio Museum in Harlem focused its energies in three major areas: a schedule of exhibitions, filmmaking for young people, and the Artist-in-Residence program. Such activities marked the museum as incredibly progressive for the time, particularly in the support of African American artists that had been sorely lacking since the end of the Federal Art Project of the Works Progress Administration (WPA). The filmmaking component also seems quite radical in retrospect, as it involved inner-city residents not only in the creation of art works but also in the manipulation of technology.

When it opened on "upper Fifth Avenue" in the fall of 1968, the Studio Museum in Harlem extended "Museum Mile" up to 126th Street. But as Grace Glueck commented almost a year later, there was ambivalence toward what was viewed as the encroachment of the dominant culture into the spiritual home of the black world.[54] In that first year, questioning of the museum's leadership and aesthetic profile by community residents and "militants" led to early changes, a backlash against what some saw as the Museum of Modern Art transplanted to the inner city.[55] Even Lloyd's opening show was viewed as "irrelevant."[56] While The New York Times reported that a mishap by a drunk was responsible for damage to one of Lloyd's pieces on opening night, in a recent interview William T. Williams confirmed a black historical urban legend that had ascribed the damage to the ire of the some of the crowd, a stance subsequently borne out by the museum's move away from nonobjective abstraction.[57]

Lloyd continued with his own radical activities to force United States cultural institutions to recognize and support the contributions of black people to the visual arts. Between 1969 and 1970 he was a major force in the interracial Art Workers Coalition, which specifically targeted the Museum of Modern Art, insisting the museum become more open to the work of a diversity of contemporary artists and audiences. From 1970 on, Lloyd's art activism turned to his home borough of Queens. After setting up the Community Artists Cultural Survey Committee to assess and identify the cultural needs and wants of non-elite art audiences in the New York area, he founded the Store Front Museum/Paul Robeson Theater in the neighborhood of Jamaica in 1971. The same year he joined the board of the newly formed Queens Museum. Until 1986, he was director of the Store Front Museum, which he viewed as a place to support creativity far removed from Manhattan's elite halls of culture.[58]

Activism became an ever-important force for Melvin Edwards. In California he was active in protests against housing discrimination. He also worked directly with Mark di Suvero in 1966 in the construction of the Los

Angeles Peace Tower, a monumental work that used a steel structure as a framework for hundreds of two-foot square paintings contributed by an array of international artists protesting the war in Vietnam.[59]

Edwards's radical thinking was also reflected in several artist's statements of the period. One appeared in conjunction with his solo show at the Whitney Museum in 1970.[60] Another missive, "Notes on Black Art," written in 1971, gained wider circulation in 1978 when it was published in the catalogue for his solo show at the Studio Museum in Harlem. It is fascinating to review the definition of the term "black art" given by someone working three-dimensionally and always abstractly, especially in light of the push for didacticism and figurative representation that was heralded as the authentic role of the black visual.

Edwards defined "black art" as "works made by black people that are in some way functional in dealing with our lives here in America."[61] For Edwards, "the work can either take the form of giving and using ideas, subjects & symbols for radical change, or the works can be of such large physical scale, and in the right places, as to make real change. It should always be known that these works are our methods of changing things."[62] It is interesting that Edwards's definition left room for abstraction by defining content as "subjects & symbols"—linking two perhaps diametrically opposed camps through an ampersand. The "large physical scale" he mentioned also reflected his own investigations of public art and monumental sculpture at that moment, including the work with the Smokehouse group.

Some types of activism were more situational and pressed the point about black creativity and the existence of black abstractionists through a certain type of visibility, through participation in group exhibitions of black artists, and at the level of content. Activism by Al Loving, Fred Eversley, and Daniel LaRue Johnson can be viewed in this light.

When Al Loving landed in New York in early 1969, protests against the "Harlem on My Mind" exhibition at the Metropolitan Museum of Art were in full swing. He arrived at the museum to see the show and instead joined the picket line, where he met numerous black artists—many included in "Energy/Experimentation."[63] Coming from Detroit, Loving had been exposed to "black art" by street artists or through work on display during conferences held by the radical Reverend Cleage. As Loving recalls, "There were paintings of people in struggle, people in chains, slaves, romantic pictures of Africa, and so on."[64] Even before arriving in New York he began to question this notion of "black art," which seemed to be at odds with all that he had been learning about aesthetics in his BFA training: "Was art supposed to be propaganda for the Civil Rights Movement?"[65] He made a deci-

sion to keep his commitment to radical politics out of what he created on canvas.

During the 1960s and 1970s, the figurative and didactic demands of the Black Arts Movement intersected with mainstream society's putative requirement that creative culture by black people "be heavily sociological in content."[66] Nevertheless, Fred Eversley's cast-resin sculptures were included in many shows of black artists during this time, as were Tom Lloyd's light works.

Throughout the 1970s, Daniel LaRue Johnson dedicated himself to the completion of a public monument to Ralph J. Bunche, a winner of the Nobel Peace Prize and a United Nations undersecretary-general who died in 1971. Finally dedicated in 1980, *Peace Form One*, a fifty-foot stainless steel obelisk, was located at 47th Street and First Avenue in a small park outside the United Nations complex in New York.

The youngest artist in "Energy/Experimentation," Howardena Pindell most exemplifies the problematizing of a monolithic black identity at the end of the 1970s and the rise of black feminist thinking, which was also epitomized by the rising prominence of authors such as Toni Morrison, Alice Walker, and Ntozake Shange. Additionally, Pindell's practice demonstrated the changing nature of art, the move toward the greater visibility of content, figuration, density of the painted surface, and, finally, the decentering of Western master narratives in favor of a more global sense of art and culture. Pindell's travels to Africa, Asia, and South America got her thinking about using models other than Western ones as paradigms for the art-making process. Even before that, however, her interaction with feminist circles demonstrated her broader thinking on black identity.

Pindell was among the founding members of the feminist SoHo co-op gallery A.I.R. in 1972.[67] Such galleries were part of the alternative space movement, found parallels with ethnically specific spaces such as the Studio Museum in Harlem, and were created to provide exhibition opportunities for a cadre of artists, in this case women, who were denied exposure in the larger mainstream art world. The feminist sector first showed the greatest support for Pindell's work. Yet after several years of active participation and exhibition with A.I.R., Pindell resigned because of the continuing specter of racism within feminist ranks. Her video performance *Free White and 21* is an allegorical meditation on some of these experiences.[68]

Pindell's activism continued in the late 1970s with participation in the Committee against Racism in the Arts, formed in response to the exhibition *The Nigger Drawings* at New York's Artists Space in 1979. Using public funds, this alternative space mounted a show of charcoal drawings by

a white male artist under the pseudonym "Donald," who chose the racial slur as the title of the series and sparked controversy in the art world.[69] In the 1980s, Pindell took this energy and expanded it into several projects that focused specifically on racism in the realm of culture. Her documentation of discriminatory practices first appeared as the article "Art World Racism: A Documentation" in the *New Art Examiner* in 1989. She revisited the project in the 1990s and it was published in an expanded version in a book of Pindell's writings, *The Heart of the Question: The Writings and Paintings of Howardena Pindell.*[70]

In the example of Haywood Bill Rivers we see how the energy of protest set the artist's career flowing. When he left North Carolina at sixteen, his first stop was Baltimore. Like many budding black artists of his generation, he was initially accepted to art school, at the Maryland Institute College of Art (MICA), only to be rejected when he arrived at the school to begin his study. The National Association for the Advancement of Colored People (NAACP) was then brought in to argue Rivers's case. Though he did not win admittance to MICA, the state government gave him a scholarship to study anywhere outside its boundaries. Rivers chose to come to New York and work at the Art Students League in 1946. By the end of the 1940s he had joined Knoedler Gallery, exhibited at the Carnegie International of 1949, and ironically had a solo show at the Baltimore Museum, which also purchased several pieces.[71]

Rivers's experience was evidence of the way things had been for African American artists in previous periods, particularly those who were too young to have participated in the WPA. The 1960s and 1970s were a testament not only to the new social status that black people were demanding of this country and the world, but also to how this energy translated into new kinds of opportunities for creative culture.

If Romare Bearden proved to be a mentor to others during the period covered by "Energy/Experimentation," Haywood Bill Rivers filled a similar role. Jack Whitten has recounted Rivers's importance to younger black artists in New York at that time, and the artist's Bowery loft was an important meeting place even in the early 1960s. As Whitten recalls:

> The one thing that Bill impressed upon me was that there were ideas in art to work with. . . . Today formalism has become a political key word and it is wrong that it has become that. Every painting has a degree of formalism in it. You can't do a painting without thinking of formalist tenets in some way. [And then there is] the connection of painting as a larger, universal means, the connection of painting as a possibility of

showing world view, world vision. . . . Bill Rivers was the one who set up that sort of atmosphere. Because of his painting, his involvement with painting, his lifestyle, he enabled me to become acquainted with these sorts of ideas.[72]

Joe Overstreet's contribution to the political and social energy of the period was significant and lasting. Shortly after his return to New York in 1974 after three years in the Bay Area, he opened Kenkeleba House Gallery on the Lower East Side with his partner, Corrine Jennings. The two made a commitment to offer exhibitions for artists of color and others who were underserved by the visual arts institutions of the day. Kenkeleba House, whose name was inspired by an African medicinal plant,[73] was a significant part of the culture of alternative spaces that grew in the 1970s and 1980s in New York that offered opportunities not only for artists, but also for curators and writers to develop and ply their craft.[74] In addition to gallery space, Overstreet and Jennings made studios and living spaces available in the building on East Second Street.

Texts of Protest

Rather than engage in physical protest activities, some artists made their radical thinking known through published criticism, statements, and interviews.

In addition to being a painter, Frank Bowling was a contributing critic to various art magazines during the late 1960s and early 1970s. He penned a number of significant articles in which he attempted to unpack notions of that troublesome term "black art." His ruminations on material aspects of black life, struggle, jazz, and, importantly, a global framework for black experience were key contributions to artistic dialogues of the era.[75]

Part of Alma Thomas's allure for the art world was her apparent profile as an older, untrained folk artist and proper Negro lady. Because she was of a different generation than the majority of artists emerging in the 1960s, her approaches to social issues and to notions of art and race were different, though I would argue not necessarily less radical. In fact, her views clearly reflect the tenor of the Harlem Renaissance of the 1920s and its emphasis on presenting black cultural accomplishment as the key to ending racism.

Responding to the critic Eleanor Munro's query, "Do you think of yourself as a black artist?" Thomas replied, "No, I do not. I am a painter. I am an American. I've been here for at least three or four generations. When I was in the South, that was segregated. When I came to Washington, that was segregated. And New York, that was segregated. But I always thought

the reason was ignorance. I thought myself superior and kept on going. Culture is sensitivity to beauty. And a cultured person is the highest stage of the human being. If everyone were cultured we would have no wars or disturbance. There would be peace in the world."[76]

In interview after interview Thomas reiterated, if subtly, the role racism and segregation played in organizing her life choices. Born with speech and hearing impediments that perhaps drove her toward an inner creative life, she also cast her physical challenges as an apocryphal tale of white supremacy; as she mused, "My mother always thought [my handicaps] were because before I was born, a lynch party came up the hill near our house with ropes and dogs looking for someone," and the fear that the incident created caused Thomas's disabilities.[77] As a child she moved with her family from Columbus, Georgia, to Washington, D.C., because "there was nowhere I could continue my education. . . . At least Washington's libraries were open to Negroes, whereas Columbus excluded us from its library."[78] Indeed, she went on, "there was only one library in Columbus and the only way to go in there as a Negro would be with a mop and bucket to wash and scrub something."[79]

Like Alma Thomas, Ed Clark was of a different generation than the majority of artists gathered in "Energy/Experimentation." In an interview with Judith Wilson in 1985 he admitted to not being so comfortable with the notion of a segregated "black art." He felt that artists should have the opportunity to be with and learn from each other, and he was equally uneasy with the way grouping artists by race automatically shifted interest from the creative work to politics. However, he also admitted that while he was uncomfortable with such notions, the focus brought to the work of black artists during the 1960s and 1970s affected him positively in other ways, leading to greater visibility and sales.

Clark lived in Paris from 1951 to 1956, moved to New York for a decade, and then returned to Paris between 1966 and 1969. While back in Paris in the 1960s he made some of his most caustic political commentary regarding the situation of black artists in the United States. In a statement for L'Art Vivant, a publication of the Galerie Maeght, on the occasion of the opening of the Studio Museum in Harlem in 1968, and in an interview the following year in L'Express, Clark was vocal about the dearth of opportunities for black artists in the United States and the lack of encouragement and support, a lack that leads to a curtailment of possibilities and prospects.[80]

The naming of works became another way to connect with black social struggles of the time. We see this in the series of canvases that Sam Gilliam made in response to the death of Martin Luther King Jr. and the subsequent

riots in Washington, D.C.[81] Another example is *Three Panels for Mr. Robeson* (1975), large-scale drapes shown at the Thirty-fourth Corcoran Biennial.[82] He referred to these works as "heraldic," not typical works of protest art but meditations, as Barbara Chase-Riboud has noted of her "Malcolm X Series." While Gilliam has spoken of the baroque gestures of his suspended paintings, he has also addressed their relationship to African masquerade forms. Such connections can be seen in the implied movement of Gilliam's work and its links to dance. Other pieces from the 1970s by the Washington, D.C.–based artist in which yards of material entwine wooden beams and embrace solid sawhorses bring to mind the interaction between wood and fabric in the masquerade models. Mary Schmidt Campbell continued the analogy to African form in the early 1980s by linking Gilliam's folding and staining processes to that of African textiles.[83]

Like his peers gathered here, Gilliam's commitment to aesthetic and material experimentation clearly did not prevent him from social engagement on some level, and like them too, though fascinated with what the entire universe had to offer, he never stepped away from being a black man in the world. In an interview in *Art News* in 1973, answering the proverbial question regarding "black art," Gilliam mused, "I think there has to be a black art because there is a white art. . . . Being black is a very important point of tension and self-discovery. To have a sense of self-acceptance we blacks have to throw off the dichotomy that has been forced on us by the white experience."[84] In a compelling reversal of the pejorative connotations some saw in the term, Gilliam further noted:

> Even just the phrase *black art* is the best thing that has happened for the condition of black artists in America. It really calls attention to the number of major galleries in New York and museums around the world that had not shown, were not showing, were not *willing* to show any work by any black artist. Yet everyone has not come aboard, you *know* that. And there's that same kind of tokenism as before. . . . But there is nothing to suggest in the history of men that we would ever arrive at utopia.[85]

In the works of Barbara Chase-Riboud from this era we find some of the most pointed meditations on beauty. For Chase-Riboud, this was a major function of life and there was a need for the important and expansive possibilities signaled by the notion of the beautiful in conjunction with that of blackness. In a moment when contemporary art in the United States was captivated by conceptualism, minimalism, process, and things that generally celebrated the nonaesthetic object or antiform, Chase-Riboud's focus on the aesthetic and the beautiful can be seen as diametrically opposed.

Lyricism and romanticism in her work were identified by critics as having French sources, but I would argue that in another sense these aspects of her work epitomized the complexities of black artists' tendentious relationship to Western cultural canons.

In light of the negative and problematic reception of her first solo show at a commercial gallery in New York in 1970, it is not surprising that Chase-Riboud would never again make the United States her home, especially when her expatriate existence seemed to allow her talents to flourish. Her eloquent response to the situation appeared several months after the exhibition closed, in the second issue of the new black women's magazine, *Essence*. Getting right to the point, Chase-Riboud acknowledged that critics—Hilton Kramer, the chief art critic for *The New York Times* being a "typical" example—completely "misinterpreted" her work because she was black and a woman. Rather than setting out to make protest work with her exhibition "Four Monuments to Malcolm X," the artist was "trying to express the ideas of a man who, more than any single individual, has affected the way Black people think of themselves. My aims were philosophical and moral." Chase-Riboud recognized that in "America today political art is necessary to the Black community," and even agreed that abstract art might be "out of place in a revolutionary situation." Yet she concluded, "My work may be too abstract or too sophisticated for revolutionary needs. I don't know. But it's too late for me to turn back."[86] She encouraged young African American artists to travel, see the world as she had, and break the confines of American existence and knowledge.

Jack Whitten described his semi-figurative work of the 1960s as a way to manage "the pressure of being a black in America. And keep in mind I'm not talking about some kind of intellectual choice here. This was psychological necessity. It's just there, and you have to work with it. You work with it or it works with you."[87] Later Whitten found that this reflexive urge need not cast itself as figurative, but could be manifested through experimentation with materials and modes of perception and thought.

Whitten participated in scant few exhibitions featuring solely black artists in the 1960s and 1970s and he still managed to show and sell his work.[88] As with Gilliam, this was not a rejection of the reality of his life as a black person, rather he saw himself as part of a larger world picture. Equally his identity as a person and a painter was quite specific. "For me being black has something to do with the making of the image. But it is also important that I am from the South, that I worked in the construction trade, that I am living in New York."[89]

Whitten's (and Overstreet's and others') strong connection to Rivers's artistic example was perhaps due to their shared rural southern roots; Whitten was originally from Alabama and Overstreet from Mississippi. As Whitten once commented, "you know what attracted me to painting in the first place and to art? Being in the South, where you're black and the white people own everything and you're always in the back, and you can't do anything until they say, 'You do this, you do that.' [Art instead represented] an amazing kind of freedom."[90] The creative act demonstrated the possibility of inventing worlds that one wanted, making them function and look the way one wanted, and the ability to own one's mind, one's thoughts, and make them matter, make them count in the world.

Afro-American Abstraction

In the spring of 1980 April Kingsley curated "Afro-American Abstraction" for New York's P.S.1 Institute for Art and Urban Resources. Like "Energy/ Experimentation," the exhibition was interested in combating the invisibility of black artists working nonobjectively but also wanted to provide a broader historical context for this work. More than half of the artists included here participated in the earlier show.[91] Unlike 1960s and 1970s exhibitions of "black art," this one was thematically coherent, bringing together abstract art by African American artists and its relationship to African aesthetics. In a sense this emphasis gave us a view of what was to come in the 1980s with the focus on identity-based work. The show was well received, though critics were skeptical about the one-to-one relationship between the nonobjective work on view and traditional African art. Even Kingsley herself noted, "I became convinced that the pluralism of the 70s and the growing need for humanistic content and mythic and ritual significance in art offered optimum connections for Afro-American artists," hinting at a more expansive reading of the contextualization of this work.[92]

The artists in *Afro-American Abstraction* and in "Energy/Experimentation" worked in ways contemporary to their time. They were a part of the ongoing development of American abstraction; their aesthetics were inflected by minimalism but also, as the era progressed, embraced a more expansive array of art languages, identified by Kingsley as "pluralism of the 70s," and named postminimalism by others.[93] This trend intervened in the cool impersonality associated with formalist abstraction and minimalism, rethinking ideas of content, emotion, expression, and the eruption of conceptualism and performance. Postminimalism offered important space for black artists because it allowed for the emergence of their positionality on

a multiplicity of levels in terms of context and content. Previously, "race" was always spun as something "extra" and additional, particularly to formalist art-making; it was somehow unquantifiable in an abstract context even though these ideas had always been there. Speaking in 1973 of what black artists brought to the formalist table, Chase-Riboud coined the term "maximal," a notion certainly counterposed to minimalism and one that would be taken up briefly by mainstream criticism around 1980 to identify what would become known as postmodernism.[94]

Maximalism

"Maximal art," in Chase-Riboud's view, brought something extra to the table. As she commented, "I think our civilization is minimal enough without underlining it. Sculpture as a created object in space should enrich, not reflect, and should be beautiful. Beauty is function."[95]

The "maximal" on one hand described art that incorporated something that "functioned" in life, in the larger social world, even (or perhaps especially) on a metaphysical level, as both Chase-Riboud and Melvin Edwards insisted.[96] Other experiences, thoughts and notions of blackness, diaspora, labor, culture, and emotions were brought to and invested in contemporary art practice, which seemed to be uncontainable within the forms and language of post-painterly abstraction and minimalism. Concepts of beauty operated in this way for Chase-Riboud, and also for Alma Thomas and Al Loving, whose search for and recording of the beautiful was the energy that fueled the work. The "maximal" was exemplified in William T. Williams's and Loving's alternate takes on geometricism—emotional in the former case and portraiture in the latter ("even a box can be a self-portrait," Loving noted).[97] It could be seen in Bowling's stain paintings that channeled the African diaspora, for example, or in the sonic/visual dialogue so many of the artists had with avant-garde jazz in terms of compositional complexity and meditations on cultural identity. Finally, it could be seen in the way these artists refused to avoid race, their participation in some way in the social struggles of the time, and their insistence that all this could exist with, and in, their nonobjective work.

"Maximalism" also offered an explanation for a more heterogeneous sense of practice, such as Chase-Riboud's gathering of sources worldwide for her creative work as a sculptor, poet, and novelist. Fred Eversley was trained as an electrical engineer and it was his family business; over the years he continued to work on and off as a consultant in the field. Eversley's presence begs a question: does his multiple positions as black person, engineer, and artist, whose work represented the intersection of aesthetics and

scientific properties, modulate our thinking about the place and importance of this work?

This idea of heterogeneity also provided space for notions of the African diaspora. It was not necessarily a direct link with Africa, as Kingsley attempted to argue, but a connection to how African culture impacted the world. Chase-Riboud's projects ponder sites all over the globe—thus her admonition for young artists of color to study and embrace global aesthetics. Edwards also recounted the importance of creative inspiration from Guyana, Cuba, Ghana, and Egypt during this period. We see it in Pindell's series on Iemanja, an Afro-Brazilian goddess. And this notion even erupts in Chase-Riboud's, Clark's, and Rivers's relationships to Paris, an outpost of the African diaspora at least since the New Negro and Negritude movements of the 1920s and 1930s. Similarly, Frank Bowling's recurring invocation of "experience," and particularly that which that took into account the global reaches of black culture, in his criticism in the 1960s and 1970s, articulated the same concept. These were the beginnings of a discourse that would challenge the monologic viewpoint of Western art history at the end of the twentieth century and into the new millennium.

NOTES

Originally published in Kellie Jones, curator, "Energy/Experimentation: Black Artists and Abstraction, 1964–1980," the Studio Museum in Harlem, New York, April 5–July 2, 2006. The epigraph is from *Since the Harlem Renaissance: 50 Years of Afro-American Art* (Lewisburg, Penn.: Center Gallery at Bucknell University, 1984), 21.

1. For more information on the shared camaraderie and exhibitions of Gilliam, Melvin Edwards, and William T. Williams, see Mary Schmidt Campbell, "Sam Gilliam: Journey toward Red, Black, and 'D,'" in *Red and Black to "D": Paintings by Sam Gilliam* (New York: Studio Museum in Harlem, 1982), 9; and Jonathan Binstock, *Sam Gilliam* (Washington, D.C.: Corcoran Gallery of Art, 2005).

2. Al Loving's show that opened in December 1969 would be the first of twelve exhibitions Whitney would do with black artists over the next six years. Almost all of them were curated by then Associate Curator Marcia Tucker, who would go on to found the New Museum of Contemporary Art in 1977. Alma Thomas's show opened in April 1972. See Kellie Jones, "It's Not Enough to Say 'Black is Beautiful': Abstraction at the Whitney, 1969–1974," in Kobena Mercer, ed., *Discrepant Abstractions* (Cambridge: MIT Press, 2006), 154–81.

3. Rivers's thick canvases and Clark's shaped paintings have also been ascribed to the reuse of materials due to lack of funds. See Kellie Jones, *Abstract Expressionism: The Missing Link* (brochure) (New York: Jamaica Arts Center, 1989).

4. Judith Wilson, "How the Invisible Woman Got Herself on the Cultural Map," in Diana Burgess Fuller and Daniela Salvioni, eds., *Art/Women/California: Parallels and Intersections, 1950–2000* (San Jose: San Jose Museum of Art, 2002), 201–16.

5. Eleanor Munro, "The Late Springtime of Alma Thomas," *The Washington Post Magazine*, April 15, 1979, 18–24. On the garden as vernacular creativity, see the title essay in Alice Walker, *In Search of Our Mothers' Gardens* (San Diego: Harcourt Brace, 1983).

6. Walter Robinson, "Al Loving at William Zierler," *Art in America*, September–October 1973, 110.

7. *Since the Harlem Renaissance*, 33.

8. David C. Driskell, ". . . An Unending Visual Odyssey," in *William T. Williams* (Winston-Salem, N.C.: Southeastern Center for Contemporary Art, 1985), 43.

9. *Since the Harlem Renaissance*, 47.

10. Ibid.

11. April Kingsley, "From Explosion to Implosion: The Ten Year Transition of William T. Williams," *Arts* 55 (February 1981): 154.

12. Munro, "The Late Springtime of Alma Thomas," 24.

13. Ibid.

14. Peter Plagens, *Sunshine Muse: Art on the West Coast, 1945–1970* (New York: Praeger, 1974), 120.

15. Walter Hopps and Nina Felshin Osnos, "Three Washington Artists: Gilliam, Krebs, McGowin," *Art International*, May 1970, 32.

16. Hopps and Osnos, "Three Washington Artists," 33.

17. Jay Kloner argues that Gilliam devised three basic "modes of presentation: hanging close to the wall, extending out from the wall but retaining a proximity, and projecting into the space of a room." See Jay Kloner, "Sam Gilliam: Recent Black Paintings," *Arts Magazine*, February 1978, 150–53. Also see Hopps and Osnos, "Three Washington Artists," 34; and Binstock, *Sam Gilliam*, 62–63.

18. Overstreet's solo show at the Studio Museum was paired with another of sculpture by Ben Jones.

19. John Canaday, "Art: Scanning America of the 19th Century," *New York Times*, November 1, 1969, 29; Frank Bowling, "Joe Overstreet," *Arts Magazine*, December 1969, 55.

20. Bowling, "Joe Overstreet," 55.

21. Edward S. Spriggs, *Ben Jones and Joe Overstreet* (New York: Studio Museum in Harlem, 1969).

22. Overstreet talks about conceiving these works as types of portraits after the example of African masks. See Spriggs, *Ben Jones and Joe Overstreet*.

23. Judith Wilson and Lizetta LeFalle Collins, *Sargent Johnson: African American Modernist* (San Francisco: San Francisco Museum of Modern Art, 1998).

24. While the colors of the piece appear to be red, black, and green, Overstreet referred to the deepest tone as a very deep purple when I visited. Personal communication, February 24, 2006.

25. *Joe Overstreet: Works from 1957 to 1993* (Trenton: New Jersey State Museum, 1996). It is interesting to think of these pieces as being made by Overstreet in the Bay Area. It was a place that he came to know as home, but only after his family had crisscrossed the country during his childhood years and finally settled in Berkeley in

1946. Overstreet also sailed with the Merchant Marine between 1951 and 1958; the proficiency with rope in these pieces may owe something to this experience.

26. Mary Schmidt Campbell, "Introduction," in *Melvin Edwards, Sculptor* (New York: Studio Museum in Harlem, 1978), 3–10.

27. Chase-Riboud's writings such as *Sally Hemmings* (1979) and *The President's Daughter* (1994) brought to life Thomas Jefferson's black mistress long before the DNA tests confirmed that the president was involved in the same type of liaison that formed the making of America. Many of her works also foreground women's history such as her meditations on Cleopatra in poetry, *Portrait of a Nude Woman as Cleopatra* (1988), and a suite of impressive sculptural objects made between the 1970s and 1990s, including *Le Manteau (The Cape)* (1973) in the collection of the Sudio Museum in Harlem. Chase-Riboud's most recent novel, *Hottentot Venus* (2003), was preceded by the sculpture *Sarah Baartman/Africa Rising* (1996). See Lisa Jones, "A Most Dangerous Woman," *Village Voice*, February 3–9, 1999.

28. Françoise Nora, "From Another Country," *Art News*, March 1972, 28–29, 62.

29. Eleanor Munro, *The Originals: American Women Artists* (New York: Macmillan, 1979), 370–76.

30. *Since the Harlem Renaissance*, 44.

31. Henry Geldzahler, "Jack Whitten: Ten Years, 1970–1980," in *Jack Whitten: Ten Years, 1970–1980* (New York: Studio Museum in Harlem, 1983), 8. Geldzahler also makes a link between Whitten's ideas and those of Sam Gilliam around this time. He quotes Mary Schimdt Campbell on the artist: "Gilliam's cascades of color are not unlike Coltrane's sheets of sound." Campbell, "Sam Gilliam," 9. Whitten himself played tenor saxophone in college. *Since the Harlem Renaissance*: 45.

32. Kellie Jones, "Chronology," in *Jack Whitten: Ten Years, 1970–1980*, 15.

33. Corrine Robins, "Edward Clark," *Arts*, October 1975, 8.

34. Janey Washburn, "Bill Hayward [*sic*] Rivers, Painter, April 21, 1985," *Artists and Influence*, 1986, 99.

35. Ann Gibson, "Two Worlds: African-American Abstraction in New York at Mid-Century," in *The Search for Freedom: African American Abstract Painting, 1945–1975* (New York: Kenkeleba Gallery, 1991), 20.

36. Washburn, "Bill Hayward Rivers," 96.

37. John Tancock, "Frank Bowling at the Center for Inter-American Relations," *Arts Magazine* 48 (December 1973): 58.

38. Kobena Mercer, "Frank Bowling's Map Paintings," in Gilane Tawadros and Sarah Campbell, eds., *Fault Lines: Contemporary African Art and Shifting Landscapes* (London: Institute of International Visual Arts, 2003), 141.

39. Ibid., 146–47.

40. Carrie Ricky, "Howardena Pindell," *Village Voice*, April 23, 1980, 79.

41. Judith Wilson, "Private Commentary Goes Public," *Village Voice*, April 15, 1981, 84.

42. Judith Wilson, "Howardena Pindell Makes Art That Winks at You," *Ms. Magazine*, May 1980, 70.

43. *Since the Harlem Renaissance*, 44.

44. Donald Miller, "Three-Woman Art Show," *Pittsburgh Post-Gazette*, May 13, 1975.

45. For a definition of Afro-Futurism, see "Afrofuturism Special Issue," ed. Alondra Nelson, *Social Text* 71 (summer 2002).

46. Barbara Chase-Riboud and Françoise Nora, "Dialogue: Another Country," in *Chase-Riboud* (Berkeley: University Art Museum, 1973), n.p.

47. Thanks to my colleague Alondra Nelson for calling my attention to this. Personal communication, March 2005.

48. David C. Driskell, "Foreword," in *Alma W. Thomas: Recent Paintings, October 10–November 12, 1971* (Nashville: Carl Van Vechten Gallery of the Fine Arts, Fisk University, 1971), unpaginated.

49. David L. Shirey, "At 77, She's Made It to the Whitney," *New York Times*, May 4, 1972, 52.

50. Munro, "The Late Springtime of Alma Thomas," 24.

51. Henri Ghent, "Notes to the Young Black Artist: Revolution or Evolution," *Art International*, June 20, 1971, 33.

52. However, the majority of artists chosen for that show remained, including Al Loving, Frank Bowling, Alma Thomas, and Barbara Chase-Riboud. "Politics," *Artforum* 9 (May 1971), 12; Grace Glueck, "15 of 75 Black Artists Leave as Whitney Exhibition Opens," *New York Times*, April 6, 1971, 50. Romare Bearden pulled his work from the show after it had already been installed. For a further discussion of this exhibition, see Kellie Jones, "It's Not Enough to Say 'Black Is Beautiful.'"

53. Local teenagers were hired to complete ground-level painting. After a while, these same groups made their own nonrepresentational murals or rechristened fire hydrants in similar hues. In other instances, paint vanished from projects and was used by people to transform their own living spaces. Michael Oren, "The Smokehouse Painters, 1968–1970," *Black American Literature Forum* 24 (3) (1990): 512, 516.

54. Grace Glueck, "Less Downtown Uptown," *New York Times*, July 20, 1969, D19–20.

55. The museum's first director, Charles Inniss, resigned after six months and resumed his career in the corporate world. The museum's board, initially composed of heavy hitters from the mainstream art world, was "white-weighted" and strong in people identified with the Museum of Modern Art, including Kynaston McShine, then an associate curator there. A newly constructed board a few months later included James Hinton of Harlem Audiovisual Productions and Charles Hobson, writer-producer with WABC-TV's *Like It Is*, an early African American television talk show hosted by Gil Noble. It is interesting to see how some of this initial black representation on the museum board came from the media rather than the art world. The focus on film that was an aspect of the museum's profile represented at once the lack of black people in administrative positions in the art world and how media was seen as the cutting edge at that moment. Glueck, "Less Downtown Uptown," D19.

56. Ibid.

57. Grace Glueck, "Harlem Initiates First Art Museum," *New York Times*, September 25, 1968: 40; and Binstock, *Sam Gilliam*, 62–63.

58. *Store Front Museum/Paul Robeson Theater: A Community Museum in the Inner City, 10th Anniversary Publication* (New York: Store Front Museum, 1981).

59. Francis Frascina, *Art, Politics, and Dissent* (New York: St. Martin's Press, 1999). In

2006 the Whitney Museum of American Art is revisiting the Peace Tower structure as part of the biennial exhibition.

60. For a discussion of this statement and the show, see Kellie Jones, "It's Not Enough to Say 'Black Is Beautiful.'"

61. Melvin Edwards, "Notes on Black Art," in *Melvin Edwards, Sculptor* (New York: Studio Museum in Harlem, 1978), 20.

62. Ibid., 20.

63. These protests were organized by the Black Emergency Cultural Coalition.

64. *Since the Harlem Renaissance*, 30.

65. Ibid., 30.

66. Ghent, "Notes to the Young Black Artist," 33.

67. It appears that Pindell also was the one who named the co-op. A.I.R. stood for "artists in residence," but was also a pun on Jane Eyre, the Charlotte Brontë heroine. See Wilson, "Howardena Pindell Makes Art," 69.

68. Howardena Pindell, "Free White and 21," in *The Heart of the Question: The Writings and Paintings of Howardena Pindell* (New York: Midmarch Arts Press, 1997), 65–69.

69. Richard Goldstein, "Darky Chic," *Village Voice*, March 31, 1980, 34; and Wilson, "Howardena Pindell Makes Art," 70. It is interesting to think about the "Nigger Drawings" in conjunction with contemporaneous "investigations" of blackface by white artists, including early photographs by Cindy Sherman, Eleanor Antin's performances as Antinova, a black Russian ballerina, and the Wooster Group's theater piece *Route 1 & 9*.

70. Howardena Pindell, "Art World Racism: A Documentation," *New Art Examiner* 16 (17) (March 1989): 32–36; and Pindell, *The Heart of the Question*.

71. Kellie Jones, *Abstract Expressionism*.

72. Jack Whitten quoted in Washburn, "Bill Hayward Rivers," 102.

73. *Joe Overstreet*, 22.

74. Julie Ault, ed., *Alternative New York, 1965–1985* (Minneapolis: University of Minnesota Press, 2002).

75. The six articles were "Discussion on Black Art," *Arts Magazine* 43 (April 1969): 16, 18, 20; "Discussion on Black Art II," *Arts Magazine* 43 (May 1969): 20–23; "Black Art III," *Arts Magazine* 44 (December 1969–January 1970): 20, 22; "The Rupture: Ancestor Worship, Revival, Confusion, or Disguise," *Arts Magazine* 44 (summer 1970): 31–34; "Silence: People Die Crying When They Should Love," *Arts Magazine* 45 (September 1970): 31–32; and "It's Not Enough To Say 'Black Is Beautiful,'" *Art News*, April 1971, 53–55, 82–84. Also see Kellie Jones, "It's Not Enough to Say 'Black Is Beautiful.'"

76. Munro, "The Late Springtime of Alma Thomas," 24.

77. Ibid., 23.

78. H. E. Mahal, "Interviews: Four Afro-American Artists," *Art Gallery*, April 1970, 36–37.

79. Munro, "The Late Springtime of Alma Thomas," 23.

80. Excerpts from these two statements can be found in Anita Feldman, "A Complex Identity: Edward Clark, 'Noir de Grand Talent,'" in *Edward Clark* (New York: Studio Museum in Harlem, 1980).

81. One canvas from this series, *April 4, 1969*, is in the collection of the Studio Museum in Harlem.

82. The piece was also influenced by his wife's, Dorothy Gilliam's, work on a biography of Robeson. See Campbell, "Sam Gilliam," 6, 9.

83. LeGrace Benson, "Sam Gilliam: Certain Attitudes," *Artforum*, September 1970, 58; and Campbell, "Sam Gilliam," 6.

84. Donald Miller, "Hanging Loose: An Interview with Sam Gilliam," *Art News*, January 1973, 43.

85. Ibid., 43.

86. "People—Barbara Chase-Riboud," *Essence* 1 (2) (1970): 62, 71. Chase-Riboud also received at least one positive review of her 1970 Bertha Schaefer exhibition. Hilton Kramer's comments also generated some interesting letters in support of the artist's work. See M. L., "Barbara Chase-Riboud," *Art News*, March 1970, 12; Henri Ghent and Alvin Smith, "Art Mailbag," *New York Times*, April 19, 1970, 22. Some of the problematic reviews Chase-Riboud responded to included Hilton Kramer, "Black Experience and Modernist Art," *New York Times*, February 14, 1970, 23; and Gerrit Henry, "New York," *Art International*, May 1972, 54.

87. *Since the Harlem Renaissance*, 43.

88. Whitten did participate in the exhibition "In Honor of Dr. Martin Luther King, Jr." at the Museum of Modern Art in 1968.

89. *Since the Harlem Renaissance*, 46.

90. Beryl J. Wright, *Jack Whitten* (Newark: Newark Museum, 1990), 12–13.

91. Included were Clark, Edwards, Gilliam, Loving, Pindell, Whitten, and Williams. Chase-Riboud appeared at P.S.1 but was not a part of the exhibition tour, which took place between 1982 and 1984.

92. April Kingsley, *Afro American Abstraction* (San Francisco: Art Museum Association, 1982).

93. Robert Pincus-Witten, *Postminimalism* (New York: Out of London Press, 1977).

94. Robert Pincus-Witten, *Entries (Maximalism)* (New York: Out of London Press, 1983).

95. Chase-Riboud and Nora, "Dialogue."

96. Edwards, "Notes on Black Art."

97. Bowling, "It's Not Enough to Say 'Black Is Beautiful,'" 83.

It's Not Enough to Say "Black is Beautiful"

Abstraction at the Whitney, 1969–1974

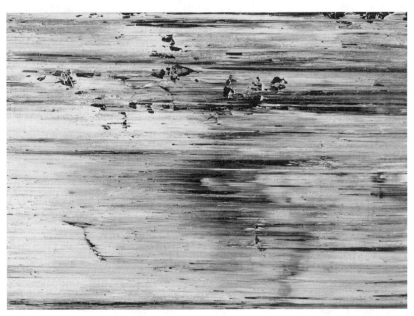

Jack Whitten, *Prime Mover*, 1974. Acrylic on canvas, 54 1/4 x 75 1/4 inches. Courtesy Alexander Gray Associates, New York.

The 1960s gave rise to a range of art forms, including pop, minimalism, post-painterly abstraction, conceptualism, and process art, but for many American artists who acted as citizens another important factor was protest.

During the beginning of this era, artists' groups such as Artists and Writers' Protest, Kamoinge Workshop, and Spiral—all based in New York—and Arts West Associated, which was founded in Los Angeles, became involved with civil rights, disarmament, and anti-war issues, participating in letter-writing campaigns, interventions in newspapers, and protest marches and pursuing a focus on integration into museums and other mainstream art world settings. At the end of the decade, some of this activism began to bear fruit. In 1968, for instance, the Studio Museum in Harlem was founded as a space to support African American artists who had been largely shut out of exhibition and commercial opportunities since the decline of the Works Progress Administration (WPA) era of the 1930s and 1940s. By the 1960s, however, the decentralization of culture (bringing art to the people—as community art centers had done during the WPA period) was just one aspect of the equation. Young artists and artists of color demanded entry into museums and insisted that public institutions supported by taxpayer dollars be more responsive to the diversity of contemporary cultures in the United States.

By 1968 a few overtures were being made in New York. The Brooklyn Museum opened its Community Gallery—offering greater local access—within a week of the launch of the Studio Museum in Harlem. The Museum of Modern Art (MOMA) announced the exhibition "In Honor of Martin Luther King, Jr." just months after the civil rights leader's death. With Jacqueline Kennedy as honorary patron, the show was a fund-raising benefit for the Southern Christian Leadership Conference (SCLC).[1] In a demonstration of its own growing accessibility, the Metropolitan Museum of Art (MMA) previewed the upcoming exhibition "Harlem on My Mind" before a (select) public audience in June 1968, six months prior to the show's official opening in January 1969.

But these first steps, like a baby's, were quite wobbly and initially unsuccessful. MOMA's exhibition on Martin Luther King Jr. did not actually include any black artists until objections were raised, and even then the artists were only exhibited in a small and separate room.[2] Benny Andrews remembered the preview of the Metropolitan's "Harlem on My Mind" ex-

hibition as a problematic experience: it was clear that no thought had been given to scholarly content or the inclusion of real live African American artists.[3] Harlem, the spiritual and psychological metonym for so much modern American culture, had simply become an avatar for all that was black. At a November 1968 press conference, the Harlem Cultural Council publicly withdrew its support for "Harlem on My Mind," stating: "We disagree with the lack of Negro scholarly participation and the projected use of photographs in place of original art works in the show."[4]

By 1969 several pressure groups had formed around New York's key art institutions. The Art Workers Coalition (AWC) focused its energy on promulgating change at the Museum of Modern Art. An integrated group, it insisted on more input into MOMA from living artists, greater access for New York's diverse communities and increased representation of black and Latino artists in the museum's exhibitions and collections.[5] The Black Emergency Cultural Coalition (BECC) was formed to take on the Metropolitan Museum of Art in January 1969, with protests and picket lines in front of the museum directed against "Harlem on My Mind." Among the protesters were Romare Bearden, Norman Lewis, and Roy DeCarava: older artists who knew the history of black artists in the United States and were not foreign to activism.[6]

In the spring of 1969, a more formalized BECC turned its attention to the Whitney Museum of American Art. Representatives met with Whitney Director John I. H. Baur in April and May and put forward a list of demands which included: 1) a major group show of black artists organized by a black curator, 2) increased representation of black artists in the Whitney Annuals, 3) a commitment to hire black curatorial staff, 4) to mount a minimum of five solo shows a year for younger artists in the lobby gallery, and 5) to purchase more work by black artists.[7] Negotiations between the Whitney and the BECC seemed amiable and continued into the fall of 1969. The major sticking point, however, seemed to be the insistence on black curatorial input and scholarship; the Whitney appeared to want no part of this, even though it became an increasingly important rallying point for the BECC. As Andrews acknowledged at the time, "With the great number of black art exhibitions taking place across the country, it is no longer necessary for the BECC to demand that black art work be shown or for black art exhibitions to take place; instead we have moved into the area of the employment of black expertise."[8]

Across the country museums were indeed beginning to employ black curators in various positions, albeit in minuscule numbers. Samella Lewis was hired as a consultant in the Education Department at the Los Angeles

County Museum of Art in 1968 and E. J. Montgomery was brought in as an "ethnic art consultant" at the Oakland Museum. By 1970 Edmund B. Gaither was the director of the Museum of the National Center of Afro-American Artists while also holding the position of adjunct curator at the Museum of Fine Arts, Boston. In New York, Lowery Stokes Sims began at the Metropolitan Museum of Art in the Community Programs Department in 1972 and moved on to a curatorial position in the Twentieth Century Art Department in 1975. Among curators of a similar generation, Kynaston McShine had begun working at MOMA as early as 1959 and was among the first board members of the Studio Museum in Harlem. Perhaps most interestingly, the inaugural curator of the Community Gallery of the Brooklyn Museum when it opened in 1968 was Henri Ghent, who only months later joined up with the BECC, becoming co-director with Ed Taylor and Benny Andrews, standing on picket lines in front of one "sister" institution and making demands on another.

AFRICAN AMERICAN ARTISTS AND THE WHITNEY MUSEUM

The BECC's actions resulted in an immediate response from the Whitney. Between 1969 and 1975 the Whitney Museum of American Art presented twelve exhibitions featuring black artists—eleven solo and one group.[9] Of that total number, six were one-person shows by artists working abstractly. The Whitney's commitment to artists of African descent at this moment is quite stunning because it was historically unprecedented. It was, however, certainly the result of the climate of black arts activism. As the institution was devoted specifically to American art and one that had itself come into existence to combat the invisibility that such work faced in relation to the European tradition, black artists' quarrel with the Whitney Museum seemed particularly well founded.

The Whitney Museum of American Art opened its doors to the public in 1931. It was the brainchild of Gertrude Vanderbilt Whitney, an heiress, patron, and academic artist who began showing the work of other Americans in her studio as early as 1907. Whitney championed new art for a modern city and was particularly supportive of artists connected to Robert Henri and the Ashcan school. In 1918 she formalized her exhibition program with the Whitney Studio Club, and initiated plans for a museum when the Metropolitan Museum of Art rejected her gift of hundreds of works by American artists in 1929. Although more identified with the modern American realism of the Ashcan school, the Whitney Museum was the first to support American abstract painting with the exhibition "Abstract Painting in America" in 1935; Stuart Davis, a painter thoroughly committed to abstrac-

tion, was also very much part of the Whitney profile. In the post–World War II period, the Whitney Museum eagerly embraced the abstract expressionists as did the Museum of Modern Art and the Guggenheim Museum of Art, though these latter institutions, also formed in the first part of the twentieth century, had always been more specifically identified with nonobjective or abstract art.[10]

Against this historical backdrop, the Whitney's relationship to African American artists was negligible at worst, strange at best, and ultimately conformed to the way people were treated in a segregated society. Much that was happening with black artists in New York in the twentieth century continued to take place in Harlem. However, a few artists received some support and made it into the Whitney Museum collection, including Richmond Barthe and Nancy Elizabeth Prophet in the 1930s. Beuford Delaney, an artist whose work moved between abstraction and figuration, was shown in an exhibition of native artists titled "Four Sunday Painters" (1930). It was one of the last to be held at the Whitney Studio Club Galleries before the institution officially became a museum. Although several works of Delaney's were purchased, the artist himself

> was offered a longer-lasting source of income. The museum would need a guard. . . . Besides his salary, he would receive free studio and living space in the basement. Delaney worked at the Whitney for about three years. Depending on what was required, his duties were those of a guard, gallery attendant, telephone operator, and caretaker.[11]

By the 1960s, although the majority of black artists had not received much exposure in the mainstream museum context, the Whitney Museum presented the work of black abstractionists of a younger generation. These exhibitions were curated by two in-house curators, Robert Doty and Marcia Tucker (the latter of whom would subsequently leave to start the New Museum of Contemporary Art in 1977). Although most of the artists selected had some experience on the national gallery scene, it is compelling to think about how they were selected given the controversial discussions of "black art" and "quality" that were swirling around the New York art world at that moment.

Each exhibition was accompanied by a small four-page brochure. Every one of the six shows garnered at least one review and it is revealing to examine the critical response. How did critics respond to the co-mingling of protest, race, and aesthetics in the exhibitions and in the works themselves? How do the positions taken by the critics compare to the dialogue created by the artists and the Whitney within the brochure? What can these exchanges

tell us about the changing nature of the art scene at this moment, and the relationship of black artists to the discourse on abstraction and American art? In the generation before these artists came into view discussions surrounding abstraction had moved from Europe to the United States with the success of abstract expressionist painting. Championed by critics such as Clement Greenberg, the gestural qualities of painterly abstraction moved toward hard-edge, frequently incorporating staining techniques, and by 1964 Greenberg nominated this trend as "post-painterly abstraction." During the 1960s Greenberg's formalist ideas were advanced by Michael Fried, who wrote about the artists emerging in the moment of post-painterly abstraction, Morris Louis, Jules Olitski, Frank Stella, and Anthony Caro in sculpture, among them. Yet as both Greenberg and Fried noted, something significant had changed in 1960, which they identified as an important shift within modern painting itself.[12]

In 1969 Alvin Loving became the first African American artist to have a solo show at the Whitney Museum of American Art. This was indeed intriguing since the Museum of Modern Art, some twenty blocks downtown, had presented its first show of a single African American artist some thirty years prior. The self-taught Tennessee native William Edmondson debuted at MOMA in 1937, two years after "African Negro Sculpture" (1935). Edmondson's show can be seen as part of a larger continuum of self-taught and "primitivist" exhibitions that were counterpoints to the vision of Western art as advanced, and yet which were also integral to definitions of the modernist canon.[13] In 1944, MOMA and the Phillips Gallery in Washington, D.C., shared the purchase of the entire "Migration of the Negro" series by painter Jacob Lawrence. However, MOMA's next solo show by a black artist did not take place until 1971, when Romare Bearden and Richard Hunt were both given separate solo exhibitions, and Sam Gilliam received a show in MOMA's "Project" space, all these unmistakably mounted in response to protests of the period.[14]

Alvin Loving: Paintings—December 19, 1969–January 25, 1970

At the time of his Whitney debut, Al Loving was thirty-four, fresh from the Midwest, where he obtained his BFA from the University of Illinois and his MFA from the University of Michigan. Working in a hard-edge style, Loving's paintings of shaped canvases in modular and geometric compositions represented his mature art grammar. The canvases were sometimes interchangeable and played with ideas of illusionism.

In the brochure for his show, Loving offers a philosophical commentary that seems to set the bar for the publications in this series. He describes

both the formal elements of the work and its place in the contemporary world. For Loving, color creates a sense of drama. Although he would later define his use of color as intuitive, a review of his career reveals that it plays a defining role in much of his compositional structure.[15] The shaping of the canvas grew out of the internal logic of the geometry that he used, with the cube regarded as the building block of the intellect. Time was also built into his paintings in the repetition of form. With his statement "Composition = the position of a reality," Loving moves his viewers into another realm where his principles of composition worked in an analogous way to the "indexical present" that conceptualist Adrian Piper was beginning to articulate during the same late 1960s period. In Loving's discourse, "reality" was the contemporaneous moment in both art practice and in the social world. "I'm no longer interested in 'new' ideas," he wrote; "what is relevant to the artist today is what contemporary events will mean to the state of reality twenty-five years from now."[16] Alluding to how the activism of the time would result in a better future, his words poetically collapse the painterly and social moment.

Loving's painting *Rational Irrationalism* (1969) was subsequently purchased by the Whitney, with resources from the collector Robert Scull, who donated "funds for artists not in the collection," possibly in response to the BECC demand for more acquisitions of work by black artists.

Of all the Whitney shows of black artists working abstractly, Loving received the most reviews in the mainstream art press: a grand total of three. *Arts Magazine* (February 1970) was the only publication to mention that his was the first in a series of exhibitions by "fine Negro artists of this country."[17] The article emphasizes that it is the paintings and not "race" that are important and thus alludes to, but does not directly address, the activism of African American artists as part of the exhibition context. While the majority of the shows were held in the small lobby gallery, the Loving exhibition, as the *Arts Magazine* review observed, appeared "in the museum's second floor auditorium," still a relatively marginal space within the Whitney.[18]

Writing in *Art International* (April 1970), Carter Ratcliff was impressed by Loving's paintings, even if one senses a hint of disbelief and perhaps bemusement in his writing style. Given ongoing debates, in the press and among the artists themselves, about the nature, goals, and quality of "black art"—and the fact that the majority of professional black artists were almost unknown to this generation of critics—it was perhaps shocking for Ratcliff to discover works this accomplished by an artist of such credentials. Although the critic is relieved to see that Loving's modular paintings are not simply collections of interchangeable polyhedral forms, and that color is not

merely decorative but part of the geometric reasoning of the work, he ulti-
mately opts for a fairly neutral position that finds the predominant metal-
lic hues to be "very efficient, and the source of precise assured paintings."[19]
In *Studio International* (April 1970), Dore Ashton, an early chronicler of
the New York school, actually discusses how Loving engages the history of
modernist painting: "By taking the complex problems of painterly illusion
and coming at them from various points of view, Loving subtly controverts
the principle of the module."[20] Next to Ratcliff's assessment, Ashton's is a
fairly strong endorsement as it positions a black artist inside the tradition
of Western modernism. While neither Ratcliff nor Ashton mention the race
of the artist, *Studio International* manages to ease this information into its
review with an image of Loving standing in front of one of his unfinished
paintings.

Melvin Edwards: Works — March 2–29, 1970

Coming a mere two months after Al Loving's exhibition, Melvin Edwards
became the first African American sculptor to have works presented in a
solo show at the Whitney. In contrast to the hard-edge precision of Loving's
paintings, Edwards's sculpture appeared more fluid and dematerialized.
Taking the form of a room-size installation composed of chains and barbed
wire, the "works" that Edwards presented at the Whitney, like many of the
artist's pieces generally, incorporated disparate objects that were tied to
the history of labor. Melvin Edwards's strategies were also connected with
the "industrialism" of minimalism, the reevaluation of material in action
that informed process art, and the "art as idea" of conceptualism. His work
was not illustrated in the accompanying brochure, perhaps due to its site-
specific nature. However, most of its constitutive elements had been shown
at the Studio Museum in Harlem in "X to the 4th Power" (1969), an exhi-
bition curated by William T. Williams, the creative mind behind the Studio
Museum in Harlem's signature Artist-in-Residence program. The title of
one component of Edwards's Whitney installation, *Curtain for William and
Peter* (1969–1970), a thirty-foot long sheer drape of barbed wire edged with
links of heavy-gauge chain, is a dedication to Williams and to Peter Bradley,
two African American painters also working abstractly. In the room's cor-
ners, Edwards created two pyramids of barbed wire (one of which was in-
verted) that climbed the walls from floor to ceiling.

In his brochure statement Edwards, like Loving, speaks elliptically about
politics, by creating an ambivalent narrative around the associations of the
highly charged materials in play. He speaks of their brutalist connotations
and of "linear geometry having its purity complicated because one chooses

to exploit the flexibility of the wire." Nevertheless it is easy enough to read between the lines of his fairly poetic statement,

How long is a chain? How long is a change?
How heavy is a chain? How heavy is a change?

The artist continues:

B.wire has a long history in war both as obstacle and enclosure. B.wire has a long history in agricultural life both as obstacle and as enclosure. Wire like most linear materials has a history both as obstacle and enclosure but barbwire has the added capacity of painfully dynamic and aggressive resistance if contacted unintelligently.[21]

The works shown at the Whitney were made during the time that Edwards had laid aside his more obviously politically directed, though still nonobjective, works, namely the "Lynch Fragment" series. Comprised of welded sculptural abstractions that are forged from items such as tools, knives, hooks, and machine parts, elements connoting both labor and violence, the various titles of the "Lynch Fragments" adopted themes of African diaspora heritage and brutality against the black body, themes continued, however, in Edwards's Whitney show.

Given the 1970 installation's greater interface with languages of dematerialization and process art, and Edwards's engagement in a dialogue on changing notions of what sculpture and painting could be, it is perhaps surprising to see that his show garnered only one review. Indeed, it is significant to note that Edwards's involvement with current practices earned him castigation instead. The artist's use of these materials was new, yet for many critics it was not "new enough." In *Artforum* (May 1970), Robert Pincus-Witten found the work "modish" in its rejection of the floor and in its sense of sculpture as the antithesis of the "vertical monolith"; the barbed wire curtain is just too expressive. While Edwards "negotiates a supposed gap between geometrical minimalism and antiform," this had already been achieved by Robert Morris, in Pincus-Witten's view. More damningly, Pincus-Witten criticized the Whitney for even exhibiting Edwards, and "for obviously sponsoring the career of a young artist over those of the many artists who are responsible for having brought that style into being — Hesse, Andre, Flavin, Rosenquist, to name but a few."[22]

These comments seem to be a way of sidestepping a direct attack on a black artist, while subtly engaging with the racial politics of the Whitney initiative. Couched in Pincus-Witten's review is a deafening alarm against the intersection of "race," art, and the museum, for Edwards was neither all that

young (he was thirty-four at the time of the show) nor did his work present an imitation of the white artists cited. Edwards had arrived in New York from Southern California in 1967, where his work was highly successful. By the time he reached the East Coast he had already had solo exhibitions at the Santa Barbara Museum and at the Walker Art Center in Minneapolis; he had also been included in group shows at the Los Angeles County Museum of Art and the La Jolla Museum of Art. Pincus-Witten clearly did not consider Edwards's discussion of his own motivations, which integrated his artistic practice with political thought, and made his sculpture quite different from those of the other practitioners mentioned.

Fred Eversley: Recent Sculpture — May 18–June 7, 1970

Born in Brooklyn, Eversley started his professional life as an engineer. He moved to Southern California to take up a position in the aerospace field, living at Venice beach, whose bohemian culture inspired him to become an artist. Unlike the other abstractionists who showed at the Whitney during this period, Eversley had no real formal art training, but his work nevertheless reflected a style that came to be known as the "L.A. Look." A seemingly more decorative approach to minimalism that appeared to take its cues from the surfaces of hot rods and surfboards, the polished formalism of the "L.A. Look" was practiced by artists like Larry Bell, Craig Kaufman, and Judy Chicago.

Eversley's work had appeared in important shows in Southern California such as *California Artists* (1971) and *Art and Technology* (1970), both held at the Los Angeles County Museum of Art and curated by Maurice Tuchman. The latter show grew out of a program of the same name, which matched artists with corporations that were producing new and specialized materials. Eversley also appeared in numerous group shows featuring the work of black artists including "Dimensions in Black" at the La Jolla Museum of Art and "Two Generations of Black Artists" at the California State College at Los Angeles, both in 1970.

Composed of cast polyester resin in solid and singular geometric shapes, Eversley's early sculptures were concerned with transparency, kineticism, optical properties, and mathematical tautology.[23] In his Whitney brochure he describes the creation of his pieces, which were meticulously composed by a method of layering that used only three colors of resin—amber, violet, and blue. Depending on the amount of pigment used and density of each progression, every sculpture took on a strikingly distinct appearance. Moving in and among the works one is struck by their kaleidoscopic spectrum of

light and color and their translucent presence and beauty. Unlike Edwards or Loving, Eversley's statement is among the least political of the cohort, perhaps bespeaking his California location. Instead the artist viewed his sculptures as amusing "toys" which were kinetic without relying on mechanization; rather the pieces "constantly change in relationship to ambient light, viewing angle, environment, and the spectator's frame of mind."[24]

While Eversley's Whitney show received no coverage in the mainstream art press, it did get reviewed. Writing in *New York Magazine* (June 1970), John Gruen linked the work to "décor" rather than art, an unfavorable assessment that nevertheless reflected the outlook of numerous East Coast critics when faced with much California work.[25] Eversley's exhibition received another mention, in the calendar section of *The Los Angeles Times* (June 1970), which was informational rather than a critical assessment. The journalist Henry J. Seldis would later pen an extensive piece, also for *The Los Angeles Times*, on Eversley's 1976 one-man show at the Santa Barbara Museum. It would seem that the context in which Eversely's work became newsworthy—local boy makes good!—may have reinforced the perception that California work was largely anathema to the critical milieu of the East Coast.[26]

CHANGING DEBATES ON "BLACK ART"

Along with protests for access to exhibition opportunities within American art institutions, as well as the fight for alternative exhibition spaces, the period in which the Whitney's initiative took place was marked by critical debates surrounding aesthetics. Artists of African descent all over the world had been producing work throughout the modern era, and even in the United States this activity was centuries old, but it was largely unacknowledged and therefore passed under the mainstream art world radar. During the Harlem Renaissance of the 1920s and 1930s, the notion of black practice had been raised both in the United States and worldwide, as the outpouring of newly urban cultures of the African diaspora made themselves known. Harlem, the largest and perhaps most advanced center of black cultural expression, was nominated the spiritual home of the movement and Africa its wellspring of creativity. The development and control of aesthetics was seen as a way to gain acceptance, visibility, and respect; it held the power to overcome discrimination, racism, and perhaps even violence. The Harlem Renaissance was imbricated in the vogue for things Negro, with Western artists and audiences captivated by the formal qualities of African art and fascinated by performative traditions throughout the dias-

pora. It also marked a historic turning point as black culture was embraced as a way of banishing putrefying Western academic thought and the specter of the world at war. As a result, all things black were "modern."

In the second half of the twentieth century, however, social changes made the terms of debate quite different and the call for alternative artistic frameworks came from *within* black cultures themselves, which were militant in seeking political freedom all over the world. Art became more closely integrated with this global push for independence and the question of black artistic practices took on a more charged meaning. There was a reevaluation of culture as a fundamental component of the black quest for self-determination. What should a radical black aesthetic look like, how should it function? Segregation, a liability, a "Negro problem," became a potent focal point, but how was this difference translated into cultural practice? Was there something called "black art"?

Early in the twentieth century, the term "black art" had connoted the visual (primarily sculptural) traditions of African art, but increasingly the term became more fluidly attached to the creative practices of the African diaspora as a whole. After the critic and philosopher Alain Locke declared in 1925 that African art held the key to a classic black tradition, what was the next step for African American artists, and how would this manifest itself?[27] Against the background of the civil rights and Black Power movements throughout the 1960s and 1970s, this question appeared in publication after publication, from *Negro Digest* (later *Black World*) to arts magazines such as *Art in America* and *Art Gallery* to newspapers like *The New York Times*. Artists and critics sought to discover, understand, and define something *else* that would distinguish the forms and practices called black art. Could black art be about color and form in the way that jazz, in its tonality, timbre, and syncopation, signalled something distinctly American and aesthetically enveloped in black culture, style, nuance, and meaning?[28] Or was black art about a political stance, did it require social realism, with black figures, and radical messages? In which case, where or how did abstraction fit in?[29]

Increasingly, the demands of the BECC and other pressure groups were not just addressed to boosting the number of exhibitions featuring black artists, but for proper scholarship and criticism. The withdrawal or refusal of scholarly engagement, like the void of sustained critical consideration, meant that activists soon realized that poorly conceived exhibitions were just as bad as not showing at all. Artists' careers foundered and disappeared if they were not written about, discussed, and cultivated. Where were the

writers, curators, scholars, then, who could do for black artists what Clement Greenberg and others had done for American painters at mid-century?

Into this fray waded Frank Bowling. A painter originally from Guyana, trained and living in London, he had made his way to New York in 1966. His solo exhibition at the Terry Dintenfass Gallery in January of that year won acclaim for pictures of physically exuberant, convulsive figures after the style of Bacon.[30] As Bowling himself noted at the time, his confrontation with "American painting" was instructive, for United States abstraction pushed his work in new directions and enabled him to give his painting a different kind of muscle.[31]

Bowling's swift move into the New York scene signalled the internationalism and cosmopolitanism of the city itself, demonstrating why it had become the blueprint for international blackness in the modern age, from the Harlem Renaissance and even earlier.[32] His involvement in the New York art world also indicates why it becomes important to use the broader term "black" rather than the specificity of "African American" in the recapitulation of this moment. Furthermore, Bowling was not just an artist but also a critic: such multiple roles were the tradition in a field that had been in the process of inventing itself over decades. Indeed it was a luxury for people to have only one part to play in the unfolding scenario of a developing black art criticism. Seen in this light, I would suggest that equal to his confrontation with "American painting," it was his critical engagement with debates surrounding black art and culture that shaped Bowling as an intellectual and as an artist.

In the late 1960s and early 1970s Bowling was a contributing critic to *Arts Magazine*, where he wrote primarily on painting while also addressing aesthetics more generally. Between 1969 and 1971, however, he penned six articles in which he tried to unpack notions of black art. These articles are compelling: they are not only gauges of the cultural climate but also reveal an artist of color battling with various definitions, attempting to put his concerns into perspective. Casting a jaundiced eye at black art, Bowling sees it as kitsch; he pronounces all-black group shows as "barrel-scrapping" fiascos that privilege quantity over quality; he holds fledgling institutions (like the Studio Museum in Harlem) up for scrutiny, and he even takes on individuals, some of whom were his friends, others of whom had fought hard so that artists such as Bowling could gain greater institutional access and visibility. Bowling's acerbic wit assuredly earned him enemies. On the other hand, however, in his more expansive moments, Bowling meditated on concepts of black experience; mused on black visual analogues to jazz;

focused on patterns of resistance, struggle, and what he called black "anarchism" as one of the defining characteristics of black life; and finally, and most importantly in this context, considered notions of black life in global terms by highlighting the international aspects of the African diaspora.[33]

Bowling was enamored of Greenberg's criticism, which he declaimed in many a review. Greenberg's collection *Art and Culture*, first published in 1961, became available in paperback in 1965, so there was easy access to his important writings. It was perhaps Greenberg's keen analysis of modern and contemporary art coupled with his socialist political leanings that engaged Bowling's attention and respect as he thought about how to craft a critical voice, one that would do justice to himself as a critic and provide the equal balance with which to speak about black artistic practice. While Bowling's show at the Whitney marked the midway point of the museum's initiative—Alma Thomas and Jack Whitten would follow over the next three years—his role as a vocal commentator on the art of the time also provides a larger context for all of the Whitney shows and the growing debates about black art.

Frank Bowling: November 4–December 6, 1971

By exhibiting the work of Frank Bowling in 1971, the Whitney Museum made a certain commitment (albeit convenient) to a larger concept of "American" art that included practitioners from South America such as Bowling. The show itself seems to mark the completion of the artist's map paintings, which he was engaged with between 1967 and 1971 while living in New York. As Kobena Mercer has outlined, these works signal a transition between figuration and abstraction. More importantly, they evoke a disavowal of the monocular system of vision, which insists that an accomplished artist must work in a singular mode. Mercer and Ann Gibson have both revealed how black artists working with abstraction in the post-1945 period used nonobjective and representational mark-making to address emotional and political concerns.[34]

Somehow Bowling managed to fit six large paintings, each nine feet high and ranging in length from seven to twenty-two feet, into the Whitney's main floor gallery. His brochure text featured an interview between the artist and Robert Doty, the curator of the exhibition "Contemporary Black Artists in America" which had taken place earlier that year and which proved to be highly controversial. Bowling discussed his early years as a painter in the contexts of Guyana and England, his iconography and use of color as both personal and expressive, and the importance of keeping a sense of ambiguity in his painting. He also confirmed that he did not believe "in the

idea of black art," thereby articulating a position that would seem to put him at odds with the collective protests and sacrifices that had brought him into the space of the museum. He appeared to cast out all those who had made his current success at the Whitney happen, a peculiar position for Bowling to take at that moment. On the other hand, when challenged by Doty to see the map, or rather Bowling's particular take on cartography, as a microcosm, Bowling replied instead that "black experience is universal," an allusion to and acknowledgment of the African diaspora. Indeed, thinking of Bowling as an American in this larger hemispheric sense—having travelled via Guyana and England to New York—jibes with Mercer's reading of the paintings as capturing an "Atlanticist vision," mapping and re-visioning a postcolonial history by virtue of the ways in which their size, surface, and tone evoke, at times, the sorrowful, oceanic expanses of the Middle Passage.[35]

Both reviewers of Bowling's solo exhibition were impressed by his technique and commented on the stained, soaked, painted, and scumbled "fields" of his richly mottled and vibrantly hued canvases. But they were equally captivated by his eccentric maps where "much of the world at large is missing" and is replaced instead by select "dark, hidden continents," as one writer in *Art News* (December 1971) put it.[36] Writing in *Arts Magazine* (December 1971), for which Bowling was also a contributor, Marcia Hafif waxed eloquently about his process and individual paintings, giving over an entire page, which was certainly rare for a review of a black artist at the time. But while Hafif suggested that the maps as shapes "save the viewer from being overwhelmed by the seductive mass of color," in the end she regarded them as flawed vehicles, in that they are too descriptive of what she clearly did not want to see. Hafif concludes:

> But couldn't unknown shapes of the same intensity carry out that work? And don't the horizontal division, as in landscape, and the quality of color, suggest Africa and South America and the rest of the personal view of the world? These would be stronger paintings if they relied solely on the visual possibilities present within them instead of trying to deal simultaneously with the literary element of the map.[37]

Alma W. Thomas: April 25–May 28, 1972

Alma Thomas's work was contemporary with the other abstract artists featured at the Whitney and she shared an interest in similar pictorial issues such as the play of color, the use of canvas as an all-over field, and the rejection of representational illusionism. However, while most of the other art-

ists were in their thirties, Thomas was seventy-seven at the time of her solo exhibition. She was not, however, a naïve artist. Thomas had received the first ever BS in art from Howard University in 1924, an MA from Columbia University in 1934, and had done postgraduate study in the 1950s at American University in Washington, D.C. She spent much of her adult life as a junior high school art teacher and it was after her retirement in 1960 that her artistic career took off.

Thomas's exhibition was extensive, with nineteen acrylic paintings, six of them on paper, dated from 1966 to 1972. The artist described her primary formal concerns as color, light, rhythm, and pattern, and she placed particular emphasis on how her measured strokes of color contrasted with the white canvas ground. Thomas's oeuvre has been linked with the Washington color school—some of the artists first identified with the stylistic trends of post-painterly abstraction—although she came to her artistic voice outside the formation and support network of that group. Additionally, Thomas revelled in the eccentricities of the brush and her excitement at the natural world set her apart from the color-field staining of painters associated with Washington, D.C.–based painters such as Kenneth Noland and Morris Louis. "I do not use masking tape," she pointed out, even though with that statement she nevertheless put herself on a par with such artists as Gene Davis or Al Loving, who did.[38]

The only color image to illustrate a brochure in the series of Whitney shows was of Thomas's *Wind Dancing with Spring Flowers* (1970). Known for her themes drawn from nature, Thomas also favored the cosmos. However, the artist's view of the heavenly was not metaphysical but based on contemporary space travel. Indeed Thomas was fascinated with modern technology: "I was born at the end of [the] 19th century, horse and buggy days, and experienced the phenomenal changes of the 20th century machine and space age," she remarked. Considering how color television brought space exploration into the home, her interest in broken horizontal lines can be seen as reproducing the graininess of the television screen. Even when her daubs of color take on other patterns, their quirky edges recall the flickering sensation that evokes the pulse of electronic media.[39]

As the first black woman artist to have a solo show at the Whitney, Thomas was quoted in a *New York Times* article (May 1972), where she marvelled, "Who would have ever dreamed somebody like me would make it to the Whitney in New York? I'm a 77-year-old Negro woman after all, who was born in Columbus, Georgia."[40] Recalling her development as an artist, and her early exposure to great works in museums, Thomas brought her interviewer back to the reality of segregation: "One of the things we couldn't do

was go into museums, let alone think of hanging our pictures there."[41] Like Beauford Delaney's experience as a janitor in the first days of the Whitney Museum, Thomas also reminds us that most often, "the only way to get in there as a Negro would be with a mop and bucket to wash and scrub something."[42] Given the extraordinary curiosity about her in the general press, it seems significant that the art press was uninterested. The sole review of Thomas's Whitney show, in *Art News* (summer 1972), is barely three sentences long. Hers are "vibrant primitivist abstractions [which] pulsate with an air of celebration."[43] Despite the fact that she had a master's degree, and that her works visually held their own with any of the color-field painters of the day, the mere mention of "primitivism" reduced her abstractions to simplistic mosaics of color.

Jack Whitten: August 20–September 22, 1974

Psychoanalytic paintings of protest with looping surrealistic and expressionistic figures defined Jack Whitten's painterly content in the 1960s. By 1970 he had jettisoned this way of working and moved to the purely nonobjective. Although an admirer of abstract expressionism, Whitten considered his own works as a further development, producing fields of painted matter that could be related to the "sheets of sound" created by jazz artists of the time (such as John Coltrane),[44] and the active surfaces of photography in process. Whitten's was the last of the Whitney solo shows by black abstractionists during this period. Excerpts of an earlier interview with David Shapiro served as the brochure's text and offered a space for Whitten to describe his method in detail. By 1974 he was creating paintings on the floor. He placed the canvas on a wooden platform, poured acrylic paint and gel medium on to it, then pulled a homemade, rake-like tool over the entire thing in one motion and the painting was finished. Wire and other objects placed directly under the canvas created pulls and slubs, breaking the smooth contours of the rake's lines. The language Whitten uses to describe these paintings is photographic: his tool is a "developer," and the painted space is a frame that freezes action and traps an image.[45]

Certainly Whitten had been thinking about links between painting and photography since the mid-1960s when he initiated his first series of pieces that were limited to tones of black, white, and grey. His growing awareness of photography's intercession in and authority over perception led him to write on his studio wall that "the image is photographic; therefore I must photograph my thoughts."[46] Eventually disregarding figurative imagery altogether, Whitten moved his notion of a painterly snapshot toward process art, but the link to the photographic, and by extension television and video,

remains in the play of his two-dimensional surfaces. The artist extended this line of thinking in further experiments with photostatic processes and photocopier toner, the result of a grant from the Xerox Corporation in the mid-1970s where he was given open access to a flat-plate copier. Such connections to corporate support paralleled the "Art and Technology" program at the Los Angeles County Museum of Art and were indicative of the associations being forged among artists, corporations, and new materials during the 1970s.

What remains fascinating about Whitten's commentary is his clarity about the variegated sources of his work, spanning the spaces between high and low, avant-garde and kitsch. He relates his floor-based orientation, not particularly to Pollock (although he would certainly acknowledge the precedent), but to the exacting work of tile-setters, skilled artisans in the construction trade in which he worked when he first came to New York in 1960. Whitten's raking process was also an act of drawing: "The whole painting is line. The whole painting is *one* line, let's face it," he said. For Whitten, however, the line-as-form was also the line-as-demarcation, that is, a fixture of geography and class. In one statement he declares, "Do you know that Crete is the edge of the Western World? That's where we in the West draw the line. Right across those waters is Africa," and in another he states, "Soho—the whole thing turns into a flea market."[47]

Whitten's command of process, his lyrical surfaces, and his painterly imagination captivated both of his reviewers. In *Art News* (November 1974), Peter Frank noted how Whitten changed the stakes of illusionism; the artist was not interested in creating depth but rather motion through contrasts of "light and shadow" on the canvas surface.[48] Like Hafif on Bowling in *Arts Magazine*, Peter Schjeldahl gave over most of an entire page in *Art in America* (November 1974) to a discussion of Whitten's Whitney show. For Schjeldahl, the artist's ambiguous planes create a sense of speed and the insertion of fissures reveal underpainting in the form of layers of color rather than depth. Whitten's is "a sophisticated, songful style that brightens the view of abstract painting's immediate future," *but this is because* "the critical side-issues of the '60s—and side-issues they nearly always were, finally, when it came to painting—have receded, leaving the field to the sensibilities and smarts of a gifted, no-nonsense generation of painters."[49] One might argue that for Whitten these so-called side-issues were crucial; they guided his interests and were actively present as part of the experiential context of his paintings. Indeed, Whitten's captivation with photography—widely regarded as the stepchild of the fine arts, a medium that from the outset was linked with practices of enslavement (to the index) and with domination (in

the documentation of imperial endeavor)—far from being a side issue addressed the changed status of painting in the contemporary world of visual communications.[50]

"Contemporary Black Artists in America," April 6–May 16, 1971

All twelve exhibitions at the Whitney Museum of American Art between 1969 and 1975 were groundbreaking. After thirty years without a commitment to exhibiting a substantial body of work by a single African American artist, the Whitney Museum seemed dedicated to changing its dismal record by offering eleven solos and one group show in an extremely condensed period of six years. The fact that more than half of these single-person shows featured the work of abstract artists reflected a key current in American art of the period, but it also suggests a commitment to a broader notion of black art during the 1960s and 1970s.

In a 1984 interview, however, when Benny Andrews recalled his work with the Black Emergency Cultural Coalition, and the demands it made upon the Whitney, which resulted in this historical initiative, he stated that

> we had no success. The Whitney Museum of American Art today is pretty much what it was then. If the Whitney wanted to call itself the Museum of American Art, then we felt they were obligated to be much more responsive to the cultural output of black artists in this country. . . . Oh, yes, people like Mel Edwards, Al Loving, Alma Thomas, and Betye Saar had one-person shows there, but they were in the little lobby gallery. But that space is basically for students and people just starting out. When you know that, the concept of a one-person show certainly gets qualified.[51]

In Andrews's view, only Jacob Lawrence had received a "proper" solo exhibition at the Whitney for this was the one show by an African American artist to take place on the upper floors of the museum.

Indeed, such underlying tensions informed the group show of black artists that the Whitney had pledged to hold as part of its original negotiation with the BECC in 1968. "Contemporary Black Artists in America" took place in 1971, effectively marking the midway point in the six years of exhibition programming highlighting black artists. Featuring a mix of the representational and nonrepresentational, with approximately eighty-four works by fifty-eight artists, it coincided with a solo show of the figurative painter Malcolm Bailey in the lobby gallery. While the combined effect gave the Whitney the appearance of a substantial commitment to work of black artists, the dissatisfaction of the BECC was manifest when the group began planning its protests a good six months before the opening.[52]

Unlike the smaller solo brochures, the catalogue for "Contemporary Black Artists in America" was fairly substantial at approximately sixty pages. Of the six abstractionists discussed above, four were represented in this group show: Loving, Eversley, Bowling, and Thomas. In his brief introductory essay, curator Robert Doty draws on impressive sources from Romare Bearden to Richard Wright. He discusses the parameters of art by African Americans by evoking Alain Locke's theories, the Black Panthers' need for didacticism, and a nod to abstract modes articulated by the abstract sculptor Barbara Chase-Riboud, who stated that "nobody should attempt to limit artists in their response to the world."[53] Doty concludes that African Americans in the twentieth century have relied on figuration to record the exigencies of black peoples' daily lives. While Doty insists that these communities require such visible expressions of blackness, one might add that white institutions also require such evidence as a way to attest to their own humanism and liberal values. Indeed, as social movements became more militant in the mid-1960s, the U.S. witnessed an explosion of "black art shows" in mainstream as well as alternative venues as a way to demonstrate that white curators and decision makers were "down with the program."[54]

"Contemporary Black Artists in America" received dismal reviews.[55] It seemed to fit into a pattern of exhibitions of this kind, later identified by art historian Mary Schmidt Campbell as

> often expeditiously organized, poorly planned, and virtually non-curated. Works of poor quality and artists of questionable merit were often included. Scholarship is minimal. Critical essays in the catalogues are often perfunctory or nonexistent. Political expediency created exhibition opportunities but also became an excuse for the abrogation of curatorial and scholarly standards.[56]

Such abandonment of critical and intellectual responsibility was very much evident in the mainstream press reaction to "black art shows" in the late 1960s. Critics had no common language for what they were seeing, scholarship was scarce, and even then seemed to be rarely considered or consulted. Instead audiences and readers were left with assertions about the "weaknesses of Black art,"[57] with the view that black artists were merely "decorative . . . imitator[s],"[58] whose approach was retardaire,[59] and with the opinion that such artists were not creating anything "black" since they possessed no "backgrounds in tribal art."[60] Although chided for a reliance on the figurative, the work of black artists was most often seen as successful where images of black rage abounded.[61]

Discussions of the Whitney's 1971 group show conform to this profile:

they were almost non-reviews, overshadowed by the constant return to the problematics of the politics that were also seemingly on display.[62] Sixteen artists ended up withdrawing from the exhibition, including Romare Bearden, who pulled his work after the show was already up. After two years of negotiations to bring this exhibition into existence, the BECC spearheaded a boycott on the grounds that the show was not held during the prime of the season, and that black art experts, with knowledge of the work and its history, were being shunned, ill used, and disrespected by the museum. After putting the exhibition into place, the BECC withdrew its support, much to the consternation and disgust of artists who continued to participate. An alternative show, "Rebuttal to the Whitney Museum," was held simultaneously at the black-owned Acts of Art Gallery on Charles Street in the West Village.[63] Al Loving stayed in the Whitney exhibition but commented to *Time Magazine*,

> The black community is completely split up over this. . . . I'm black, I'm an artist, and I can't deal with all the circumstances of America's illness. I don't want to hide my art. The first mistake was going to a white institution and asking for something.[64]

During the second month that "Contemporary Black Artists in America" was on view, a letter appeared in *Artforum* (May 1971) that offered a severe critique of its premises. The letter was signed by seven artists, all of whom worked nonobjectively, and all of whom had withdrawn their work from the exhibition. They included John Dowell, Melvin Edwards, Sam Gilliam, Richard Hunt, Daniel LaRue Johnson, Joe Overstreet, and William T. Williams. They alluded to the recent social pressure that brought the show into existence and acknowledged the Whitney's precedent in attempting to redress the problems of art world racism and exclusion. However, they found the exhibition reactionary in many aspects, and described it as an "anti-curated . . . survey" that in its poor, ahistorical approach exemplified "the worst form of tokenism." The artists continued, "We cannot endorse non-creative intentions and procedures; therefore we refuse, withdraw, and withhold our work from the Whitney Museum of American Art's Survey of Black Art."[65]

Indeed, as Bowling noted in the brochure for his exhibition that took place later in 1971, withdrawal had become one very visible means for black artists to register their disagreement with institutional actions and real world events. Adrian Piper had pulled her piece from a show of conceptual art at the New York Cultural Center in 1970 to protest the invasion of Cambodia; and at earlier moments, Robert Morris and Marcel Duchamp took

similar actions. Of the artists who withdrew from the Whitney's 1971 exhibition, none were subsequently presented in the series of solo exhibitions, for Melvin Edwards's exhibition had already taken place a year before the statement was issued.

The same month that "Contemporary Black Artists in America" opened to the public, Frank Bowling published what would be his last article on that troublesome and elusive subject of "black art." Entitled "It's Not Enough to Say 'Black is Beautiful,'" it appeared as a feature-length article in *Art News*. Over the course of two years, between 1969 and 1971, as he wrestled with this topic, Bowling had often invoked some of his fellow travellers on the road of nonobjective language—Melvin Edwards, Al Loving, Daniel LaRue Johnson, Jack Whitten, and William T. Williams—as well as referring to his own prodigious output.[66] However, what became evident by April 1971 is that Bowling had finally found a language with which to speak about that key phenomenon: the black artist working at the end of the twentieth century. In fact, it is significant that he is able to make his strongest arguments on questions of aesthetics, intellect, and skill through reflections on artists working abstractly.

By virtue of his own example as an international citizen, a black artist from South America living in England and then the United States, Bowling argued from the very first for a view of "black experience, which is global."[67] In article after article he grapples with the example of jazz as a distinctly black art form, rejects social realism as the only method of expression viable for black artists, and searches for language, a terminology, with which to define himself. Is there a visual manifestation that is comparable to jazz, that expresses an aesthetic that has what he calls that "niggerish" quality, something brash, strong, visible, and unique?[68] In his 1971 article, Bowling argues that blackness has been shaped as a "talisman" in Western society, but that in the context of the 1960s and 1970s scene of black consciousness, the need for such a figure, which would act as a body to stand up against discrimination, prejudice, violence, has obscured the role of art. For Bowling, such needs for black images are best left to electronic media like television. Rather than providing representations of black experience, black art, in Bowling's view, channels the legacy of a globally diasporic heritage.

By 1971 Bowling finds the words that he is looking for, and finds them through the emergent discipline of black studies. In 1969, the volume *Black Studies in the University* appeared, a book-length version of a symposium held at Yale University. Among the numerous essays making the case for the scholarly investigation of black cultures as a discipline was Robert Farris Thompson's groundbreaking text, "African Influence in the Art of the

United States."[69] Taking his knowledge of West and Central African creative traditions into account, Thompson used them to read black material cultures as semiotic formations and performative gestures in the Americas: he reframed the discourse not as anthropology but as art and art history.

Bowling is clearly energized by Thompson and quotes him in "It's Not Enough to Say 'Black Is Beautiful,'" particularly in his references to traditions in Surinam, a culture similar to Bowling's own Guyana. Moreover, Bowling was aware of Thompson's article almost a year earlier when he used a section as an epigraph for the fourth of his six articles, "The Rupture: Ancestor Worship, Revival, Confusion, or Disguise" (1970). Through Thompson's vocabulary, Bowling was able to construct a pragmatics of black diasporic art-making that acknowledged its encounter with and history within Western traditions, but which also affirmed its ties to traditions, knowledge, understanding, and aesthetics from elsewhere. In particular, Bowling places an emphasis on the aspect of disguise, double entendre, the ability to repeat with a difference, through which a black aesthetic often reveals itself. In speaking of Melvin Edwards's works at the Whitney Museum, he actually uses the term "signify," when he describes the sculptor's linear geometries in barbed wire and chains as "signifying" on minimalism and antiform. A generation later, the analysis of such activity was more fully unpacked in the literary theory of Henry Louis Gates Jr., which regarded "signifying" as a distinctive feature of African American literary expression.[70]

Bowling's commitment to formalist art criticism may have reflected aspects of the artist's training such that he felt a continuing need to define the works of his black contemporaries, as well as his own, as operating inside the Western tradition. However, like the standard museological and critical frameworks of the period, there was no real expertise being brought to the table that could provide an avenue to conceptualize how black artists were at once part of, and still working in ways different from, Western canonical modes. As Ann Gibson has argued regarding Norman Lewis, artists of the abstract expressionist generation may have felt comfortable with him as a person but not necessarily as an artist committed to the forms and processes of abstract art-making as they were; many took the view that Lewis should, instead, be "painting lynchings."[71] We find a similar conundrum in Clement Greenberg's involvement in an integrated show of abstract artists called "the de luxe show" (1971). Held in an abandoned movie theater in Houston's black Fifth Ward, the exhibition was organized by Peter Bradley with the support of the powerful de Menil family. Greenberg counted black artists such as Bowling and Bradley among his social circle and yet the framework of his formalist criticism allowed no room for integrating issues of "race,"

culture, or identity into an intellectually rigorous model of art criticism.[72] It seems that even by the early 1970s the art world was still not prepared for the sophistication that black abstract artists offered.

As we have seen, the series of shows by abstract artists at the Whitney Museum between 1969 and 1974 presented a generation of black practitioners whose complex approaches to abstraction involved serious and intense formal experimentation. While some works floated between representation and pure nonobjectivity (Bowling), others addressed protest (Loving, Edwards), or engaged with the technologies of the time (Thomas, Eversley), and some bodies of work spoke to the global context of the black diaspora (Whitten, Bowling). However, there was little art language at the time that allowed all of this "other" information to be seamlessly incorporated into the art-historical record. By virtue of his status as a non–United States artist and as one who knew the diaspora and some of its traditions first hand, Frank Bowling saw and revealed this impasse. Bowling's recurring invocation of "experience" within the pages of his own version of formalist criticism articulated the beginnings of a discourse that would challenge the monologic viewpoint of Western art history.

Indeed, Bowling's 1971 article "It's Not Enough to Say 'Black is Beautiful'" marks a turning point precisely because it moves toward an intellectual meeting point between the formalist criticism of Clement Greenberg and the model of visual and semiotic analysis put forward by Robert Farris Thompson. When Bowling wrote that the bold color and geometries in the paintings of William T. Williams were not so much commenting on Frank Stella and abstract expressionism, but were confrontations with the history of modernism itself—and with the legacies of constructivism and Bauhaus in particular[73]—we can see the broad scope of his outlook on art and culture. Bowling's awareness of disguise, double entendre, and repetition-with-a-critical difference as aspects of black diaspora culture (notions that James Scott would later refer to as "hidden transcripts")[74] can also be read into Al Loving's comment that "even a box can be a self-portrait."[75] On the one hand, this comment relates to twentieth-century modernism's history of nonobjective practice. But on the other hand, we can also find allusions in this comment to African American history, especially the story of Henry "Box" Brown who, in the 1840s, climbed into a box in Virginia and mailed himself to Philadelphia and to freedom via the postal service.[76] Although Bowling's tone was boisterous, obstreperous, controversial, and at times bombastic, perhaps this was the only way out of the impasse. His texts signal an art writing that had come to be sited within a broader understanding of the world. Ultimately, the concept of "experience"—a wide-ranging,

global, diasporic experience—provided the locus where an active and ever-changing aesthetics could reside.

NOTES

Originally published in Kobena Mercer, ed., *Discrepant Abstraction* (Cambridge: MIT Press, 2006).

1. "Mrs. JFK Leads Benefit Art Exhibit Sponsors," *Amsterdam News*, October 12, 1968, 8.
2. Lucy R. Lippard, "Dreams, Demands, and Desires: The Black, Antiwar, and Women's Movements," in Mary Schmidt Campbell, *Tradition and Conflict* (New York: Studio Museum in Harlem, 1985), 78.
3. Benny Andrews, "The B.E.C.C.—Black Emergency Cultural Coalition," *Arts Magazine* 44 (summer 1970): 18–20.
4. Benny Andrews, "Benny Andrews Journal: A Black Artist's View of Artistic and Political Activism, 1963–1973," in Campbell, *Tradition and Conflict*, 69. The show did include the work of black photographers, such as Lloyd Yearwood, Reginald McGhee, Gordon Parks, and James Van Der Zee. Ironically, the latter, who was then unknown to art or photo history, received a renaissance and new scholarly interest in his work (Deborah Willis, personal communication, November 2005). See also Deborah Willis, *Van Der Zee: Photographer, 1886–1983* (New York: Harry N. Abrams, 1993).
5. For more on the politicization of art culture in the United States during this period see Beth Ann Handler, "The Art of Activism: Artists and Writers Protest, the Art Workers' Coalition, and the New York Art Strike Protest the Vietnam War," dissertation, Yale University, 2001; and Francis Frascina, *Art, Politics, and Dissent: Aspects of the Art Left in Sixties America* (New York: St. Martin's Press, 1999). Among important black leaders and participants in the Art Workers Coalition were Tom Lloyd, a maker of electronic light sculpture, and Faith Ringgold, a painter who had yet to move into her signature work with quilts (see Faith Ringgold, *We Flew over the Bridge: Memoirs of Faith Ringgold* [Boston: Little Brown, 1995]).
6. Lewis and Bearden had both been part of the artists' group Spiral at the beginning of the 1960s; DeCarava had figured importantly in the parallel photographic collective Kamoinge Workshop. Andrews, "The B.E.C.C.," 19; Andrews, "Benny Andrews Journal," 70; Courtney J. Martin, "Approaching Spiral from the Center: The Spiral Group 1963–1966," unpublished manuscript, 2004. See also Lippard, "Dreams, Demands, and Desires," 78.
7. Andrews, "The B.E.C.C.," 19; Andrews, "Benny Andrews Journal," 70.
8. Andrews, "The B.E.C.C.," 20.
9. The exhibitions at the Whitney were as follows:

 "Alvin Loving: Paintings," December 19, 1969–January 25, 1970
 "Melvin Edwards: Works," March 2–29, 1970
 "Fred Eversley: Recent Sculpture," May 18–June 7, 1970
 "Marvin Harden," January 5–February 4, 1971
 "Malcolm Bailey," March 16–April 25, 1971

"Contemporary Black Artists in America," April 6–May 16, 1971

"Frank Bowling," November 4–December 6, 1971

"Alma W. Thomas," April 25–May 28, 1972

"Jacob Lawrence," May 16–July 7, 1974

"Jack Whitten," August 20–September 22, 1974

"Betye Saar," March 20–April 20, 1975

"Minnie Evans," July 3—August 3, 1975

10. The Guggenheim Museum in particular was begun as an institution championing the abstract over the representational. Inspired by the art and theories of Wassily Kandinsky, the museum's first director, Hilla Rebay, coined the term "non-objective" to describe this concept of "pure" visual creation. The museum began its life in 1939 as the Museum of Non-Objective Painting (see Nathaniel Burt, *Palaces for the People, A Social History of the American Art Museum* [Boston: Little Brown, 1977], 340).

11. Avis Berman, *Rebels on Eighth Street* (New York: Atheneum, 1990), 279. Although Delaney was identified in this exhibition (and periodically throughout his career) as a self-taught artist, as Ann Gibson has pointed out, "Delaney had arrived in New York [in 1929] with more formal training than most would-be artists," having studied in Boston at the Copley Society, the South Boston School of Art, and the Lowell Institute. Ann Gibson, "Gay and Black in Greenwich Village: Beauford Delaney's Idylls of Integration," in Patricia Sue Canterbury, *Beauford Delaney: From New York to Paris* (Minneapolis: Minneapolis Institute of Arts, 2004), 12.

12. Clement Greenberg. *Post Painterly Abstraction* (Los Angeles: Los Angeles County Museum of Art, 1964); and Michael Fried, "Art and Objecthood" (1967), in *Art and Objecthood* (Chicago: University of Chicago Press, 1998), 160.

13. These shows included "American Sources of Modern Art (Aztec, Mayan, Incan)" (1933), "Prehistoric Rock Pictures in Europe and Africa" (1937), "Masters of Popular Painting: Modern Primitives of Europe and America" (1938), "Indian Art of the United States" (1941), and "Religious Folk Art of the Southwest" (1943). See Russell Lynes, *Good Old Modern: An Intimate Portrait of the Museum of Modern Art* (New York: Atheneum, 1973); and Josef Helfenstein, "From the Sidewalk to the Marketplace: Traylor, Edmondson, and the Modern Impulse," in Josef Helfenstein and Roxanne Stanulis, eds., *Bill Traylor, William Edmondson and the Modernist Impulse* (Urbana-Champaign, Ill.: Krannert Art Museum, 2004), 45–67.

14. These shows were "Romare Bearden: The Prevalence of Ritual," "The Sculpture of Richard Hunt," and "Projects: Sam Gilliam," all of which appeared in 1971 (Lynes, *Good Old Modern*, 468–69). Indeed Faith Ringgold recounts meetings she and Tom Lloyd had with the MOMA director John Hightower to put Bearden's show in place (Ringgold, *We Flew over the Bridge*, 171–72).

15. See Al Loving interviewed in Joseph Jacobs, in *Since the Harlem Renaissance: 50 Years of Afro-American Art* (Lewisburg, Penn.: Center Gallery at Bucknell University, 1984), 30–33.

16. Al Loving, artist statement in *Al Loving: Paintings*, December 19, 1969–January 25, 1970, Whitney Museum of American Art, unpaginated.

17. George Perret, "Al Loving," *Arts Magazine* 44 (February 1970), 57.

18. Ibid. The lobby gallery still exists in the Whitney Museum today; the second floor auditorium is possibly now the video gallery.

19. Carter Ratcliff, "New York Letter," *Art International*, April 14, 1970, 71.

20. Dore Ashton, "New York Commentary," *Studio International* 179 (April 1970): 187.

21. Melvin Edwards, artist statement in *Melvin Edwards: Works*, March 2–29, 1970, Whitney Museum of American Art, unpaginated.

22. Robert Pincus-Witten, "Melvin Edwards," *Artforum*, May 1970, 77.

23. Frederick J. Eversley, "Statement of the Artist," in *Frederick Eversley*, Santa Barbara Museum of Art, 1976.

24. Fred Eversley, artist statement in *Fred Eversley: Recent Sculpture*, May 18–June 7, 1970, Whitney Museum of American Art, unpaginated.

25. John Gruen, "All That Smoke," *New York*, June 8, 1970, 59; and Carter Ratcliff, "New York Letter," *Art International*, January 20, 1971, 28–29.

26. Henry J. Seldis, "Eversley Show in New York," *Los Angeles Times*, calendar, June 8, 1970: E10; and Henry J. Seldis, "Optical Magic Turns Us Inward as We Look Out," *Los Angeles Times*, calendar, May 23, 1976, 76.

27. Alain Locke, "The Legacy of the Ancestral Arts" (1925), in Alain Locke, ed., *The New Negro* (New York: Atheneum, 1992), 254–67.

28. Thanks to Guthrie P. Ramsey Jr. for our many dialogues on the relationship of music and art. See Guthrie P. Ramsey Jr., *Race Music: Black Cultures from Bebop to Hip-Hop* (Berkeley: University of California Press, 2003).

29. Among the articles to appear on the topic of black art were Grace Glueck, "Negroes' Art Is What's In Just Now," *New York Times*, February 27, 1969, D34; "Black Art: What Is It?," *The Art Gallery*, April 1970, 32–35; Jeff Donaldson, "Ten in Search of a Nation," *Black World* 19 (12) (1970), 80–89; Barbara Rose, "Black Art in America," *Art in America* 58 (September 1970), 54–67; Elsa Honig Fine, "Mainstream, Blackstream and the Black Art Movement," *Art Journal* 30 (4) (1971), 374–75.

30. Elizabeth Baker, "Frank Bowling," *Art News*, January 1966, 11.

31. Frank Bowling and Bill Thomson, "A Conversation between Two Painters," *Art International* vol. 20, December 10, 1976, 61–67.

32. On black cultures in New York as early as the seventeenth century see W. T. Lhamon Jr., *Raising Cain: Blackface Performance from Jim Crow to Hip Hop* (Cambridge: Harvard University Press, 1998); and the exhibition "Slavery in New York," which appeared at the New York Historical Society, October 7, 2005–March 6, 2006, slaveryinnewyork.org (accessed January 2, 2006).

33. The six articles were "Discussion on Black Art," *Arts Magazine* 43 (April 1969): 16, 18, 20; "Discussion on Black Art II," *Arts Magazine* 43 (May 1969): 20–23; "Black Art III," *Arts Magazine* 44 (December 1969–January 1970): 20, 22; "The Rupture: Ancestor Worship, Revival, Confusion, or Disguise," *Arts Magazine* 44 (summer 1970): 31–34; "Silence: People Die Crying When They Should Love," *Arts Magazine* 45 (September 1970): 31–32; and "It's Not Enough To Say 'Black Is Beautiful,'" *Art News*, April 1971, 53–55, 82–84.

34. Kobena Mercer, "Frank Bowling's Map Paintings," in Gilane Tawadros, ed., *Fault Lines: Contemporary African Art and Shifting Landscapes* (London: Institute of Inter-

national Visual Arts, 2003); and Ann Gibson, "Recasting the Canon: Norman Lewis and Jackson Pollock," *Artforum* 22 (May 1984), 64–70.

35. All quotes taken from Frank Bowling interviewed by Robert Doty, in *Frank Bowling*, November 4–December 6, 1971, Whitney Museum of American Art, unpaginated.

36. Gerrit Henry, "Frank Bowling," *Art News*, December 1971, 13.

37. Marcia Hafif, "Frank Bowling," *Arts Magazine* 46 (December 1971), 58.

38. Alma W. Thomas, artist statement in *Alma W. Thomas*, April 25–May 28, 1972, Whitney Museum of American Art, unpaginated; and Lowery Stokes Sims, "Stroke, Style, Technique, Culture, and Politics," in *Stroke! Beauford Delaney, Norman Lewis, and Alma Thomas* (New York: Michael Rosenfeld Gallery, 2005), 4–11.

39. Thanks to my colleague Alondra Nelson for calling my attention to this (personal communication, March 2005). See Alondra Nelson, ed., "Afrofuturism," special issue of *Social Text* 71 (summer, 2002).

40. Alma Thomas quoted in David L. Shirey, "At 77, She's Made It to the Whitney," *New York Times*, May 4, 1972, 52.

41. Ibid.

42. Alma Thomas quoted in Eleanor Munro, "The Late Springtime of Alma Thomas," *The Washington Post Magazine*, April 15, 1979, 23.

43. Phyllis Derfner, "Alma W. Thomas," *Art News*, summer 1972, 59. Reviews in the general press included James R. Mellow, "Expert Abstractions by Alma Thomas," *New York Times*, April 29, 1972, 27; and Paul Richards, "First Solo Show at 77," *Washington Post, Times Herald*, April 28, 1972, B1+B5.

44. See Jack Whitten's statement in Henry Geldzahler, "Jack Whitten: Ten Years, 1970–1980," in *Jack Whitten: Ten Years, 1970–1980* (New York: Studio Museum in Harlem, 1983), 8. Geldzahler also makes a link between Whitten's ideas and those of Sam Gilliam at around this time. He quotes Mary Schimdt Campbell on the artist: "Gilliam's cascades of color are not unlike Coltrane's sheets of sound" (see "Sam Gilliam: Journey toward Red, Black and D," in *Red and Black to "D": Paintings by Sam Gilliam* [New York: Studio Museum in Harlem, 1982], 9). Whitten himself played tenor saxophone in college. Whitten interviewed in Jacobs, *Since the Harlem Renaissance*, 45. The concept of "sheets of sound" is often used to refer to John Coltrane's sound within the realm of jazz criticism and music history (see, for instance, Frank Tirro, *Jazz: A History* [New York: W.W. Norton, 1977], 352). Thanks to Guthrie P. Ramsey Jr. for this reference.

45. Jack Whitten interviewed by David Shapiro, in *Jack Whitten*, August 20–September 22, 1974, Whitney Museum of American Art, unpaginated.

46. See Whitten interviewed in Jacobs, *Since the Harlem Renaissance*, 44.

47. Whitten interviewed by Shapiro, *Jack Whitten*.

48. Peter Frank, "Jack Whitten," *Art News*, November 1974, 114–15.

49. Peter Schjeldahl, "Jack Whitten at the Whitney," *Art in America* 62 (November 1974): 120.

50. See Alan Trachtenberg, ed., *Classic Essays on Photography* (New Haven, Conn.: Leete's Island Books, 1981).

51. See Benny Andrews interviewed in Jacobs, *Since the Harlem Renaissance*, 12.

52. Benny Andrews mentions that protest activities began to be planned in October

1970 with actions outside of the Whitney taking place as early as January 1971 (Andrews, "Benny Andrews Journal," 72). On January 4, 1971, Charles Alston, another artist who had come of age in the 1930s, and who was one of the first black supervisors of a WPA project, wrote to Robert Doty, the show's curator, offering extensive reasons why he declined to participate in "Contemporary Black Artists in America." This letter has been published in *Charles Alston: Artist and Teacher* (New York: Kenkeleba Gallery, 1990), 27. Thanks to my colleague, the wonderful poet Elizabeth Alexander, for pointing this resource out to me.

53. Barbara Chase-Riboud quoted in "People: Barbara Chase Riboud," *Essence* (1970), cited in Robert Doty, *Contemporary Black Artists in America* (New York: Whitney Museum of American Art, 1971), 11.

54. Benny Andrews remembers that from 1966 onward his work with black figures became hugely popular; see Andrews interviewed in Jacobs, *Since the Harlem Renaissance*, 11; see also Glueck, "Negroes' Art," D34.

55. John Canaday, "Black Artists on View in 2 Exhibitions," *New York Times*, April 7, 1971, 52; and Lawrence Alloway, "Art," *The Nation*, May 10, 1971, 604–5.

56. Campbell, *Tradition and Conflict*, 56.

57. Alloway, "Art," 604–605.

58. Canaday, "Black Artists on View," 52.

59. Rose, "Black Art in America," 54–67.

60. John I. H. Baur quoted in Grace Glueck, "Black Show under Fire at the Whitney," *New York Times*, January 31, 1971, D25.

61. Canaday, "Black Artists on View," 52.

62. Glueck, "Black Show under Fire at the Whitney," D25; Grace Glueck, "15 of 75 Black Artists Leave as Whitney Exhibition Opens," *New York Times*, April 6, 1971, 50; and Grace Glueck, "In a Black Bind," *Time*, April 12, 1971, 64.

63. Acts of Art Gallery was run by Nigel Jackson. Romare Bearden, Richard Hunt, and Sam Gilliam had simultaneous solos at the Museum of Modern Art; William T. Williams was showing at the Reese Paley Gallery at this moment.

64. Al Loving quoted in Glueck, "In a Black Bind," 64.

65. "Politics," *Artforum* 9 (9) (1971), 12.

66. See Frank Bowling, "The Rupture: Ancestor Worship, Revival, Confusion, or Disguise," *Arts Magazine* 44 (summer 1970): 31–34. While critical of shows of "black art," Bowling was also known to participate in them as an artist, thus offering his own work and position as a critic up for analysis. This article includes a review of the exhibition "Afro-American Artists: New York and Boston," Boston Museum of Fine Arts, May 19 – June 23, 1970, in which Bowling took part.

67. Bowling, "Discussion on Black Art," 20.

68. Bowling, "Discussion on Black Art II," 23.

69. Robert Farris Thompson, "African Influence in the Art of the United States," in Armstead L. Robinson, Craig G. Foster, and Donald H. Ogilvie, eds., *Black Studies in the University* (New Haven, Conn.: Yale University Press, 1969).

70. Henry Louis Gates Jr., *The Signifying Monkey* (New York: Oxford University Press, 1988).

71. Joan Murray quoted in Gibson, "Recasting the Canon," 69.

72. "The de luxe show," Houston, the Menil Foundation, August 15–September 12, 1971. Nineteen artists participated in the show including: Peter Bradley, Anthony Caro, Ed Clark, Craig Kauffman, Alvin Loving, Kenneth Noland, Jules Olitski, Larry Poons, William T. Williams, and James Wolfe. The catalogue included a text by poet Steve Cannon and separate interviews with Bradley and Greenberg. This is a fascinating moment that begs to be unpacked further.

73. An ongoing dialogue with his teacher at Yale University, Josef Albers.

74. James C. Scott, *Domination and the Arts of Resistance: Hidden Transcripts* (New Haven: Yale University Press, 1990).

75. Al Loving quoted in Bowling, "It's Not Enough To Say 'Black Is Beautiful,'" 83.

76. Henry Box Brown, *Narrative of Henry Box Brown, Who Escaped from Slavery Enclosed in a Box 3 Feet Long and 2 Wide, Written from a Statement of Facts Made by Himself, with Remarks upon the Remedy for Slavery by Charles Stearns* (Boston: Brown & Stearns, 1849). I find a strong parallel here with African American artists who can only enter the "white box" of a modern art museum in order to clean it.

Black West

Thoughts on Art in Los Angeles

Senga Nengudi, *R.S.V.P. V*, 1976. Mixed media, dimensions variable. Collection of the Studio Museum in Harlem, New York.

BLACK SPACE/BLACK PLACE

Generally periodized between 1965 and 1976, the Black Arts Movement has been primarily theorized as literary though like its most recognized forerunner, the Harlem Renaissance, it encompassed visual arts, music, theater, and all the arts. Among its hallmarks were social and political engagement; a view that art had the ability to encourage change in the world and in the viewer; separatism—a belief in a self-contained "black aesthetic" walled off from white culture; forms that were populist, that could be easily distributed and understood by audiences (broadsides, pamphlets, one-act plays, concerts, representational painting, posters, etc.).

The Black Arts Movement championed the aesthetic pleasures of blackness and focused on reception by black audiences. It was art with African American specificity, that reflected "the special character and imperatives of black experience."[1] Again as in the Harlem Renaissance the wellspring of African American creativity was found in vernacular form, the creativity of "the folk" who by the 1960s were recognized as the urban working class and underclass rather than inhabitants of the rural South. There was also the ancestral legacy of Africa that became ever more palpable in the ongoing independence struggles of the period. A premium was placed on orality and performativity. Literary forms, like poetry, that could be "built around anthems, chants, and political slogans"[2] were favored. Black speech and music were privileged. Music could be popular, social, sacred, and entertaining; in music one could see more clearly the African American cultural connections to Africa; music was egalitarian and participatory, it did not "stress roles of performer and audience but rather of mutual participation in an aesthetic activity."[3] As David Lionel Smith has theorized, the result of transposing the literary into a musical form was theater.[4]

In the realm of visual art perhaps the most defining voice of the movement was the collective AfriCobra from Chicago which, in 1970, offered some guidelines for art-making through a set of aesthetic principles; these included representational imagery, fragmented planes combined with organic form (called free symmetry and rhythm), bright colors (augmented by "shine"), and embedded words which clarified message and content. Thematically the works should define the past—through a consideration of African heritage; identify the present—in contemporary black heroes; and offer

direction for the future—with images of the black family. As Africobra was overwhelmingly composed of painters, these tenets, not surprisingly, seem more focused on qualities of two-dimensional art. Mary Schmidt Campbell has also identified other works which dismantled "icons of racism" (including the American flag) and thus fulfilled their role as "weapons" of the black cultural revolution.[5]

The founding of Broadside Press in Detroit, the Association for the Advancement of Creative Musicians (AACM) in Chicago, and the Black Arts Repertory Theater (BARTS) in Harlem all in 1965 make it the watershed year for the start of the Black Arts Movement. Mirroring these cultural signposts were even more visible social ones, the assassination of Malcolm X and the rebellions in Watts. In roughly the same epoch—1965–1966—we also see the initiation of activism by the US Organization[6] in Los Angeles and the Black Panther Party for Self-Defense in Oakland. These groups would prove to be the most influential Black Nationalist organizations in the coming period. Both emerged from a "militant intellectual culture" that presaged the call for black studies nationwide, and were connected to the Afro-American Association, which had branches possibly as early as 1962 at the University of California, Los Angeles (UCLA), headed by Ron Everett (later Karenga) and in the Bay Area centered around the University of California, Berkeley, and Merritt College in Oakland which had Huey Newton as one of its members.[7]

While the Black Panthers and US shared the goal of African American empowerment, the approaches were different; the Black Panthers called for immediate armed struggle to this end, while US championed a revolution in black cultural life and thought as a precursor to radical material transformation. Both US and the Panthers took the strict view that art must be "a tool for liberation,"[8] that it "must expose the enemy, praise the people, and support the revolution."[9] Or to use Karenga's famous three criteria, it must be "functional, collective, and committing."[10] Though based in Los Angeles, Karenga's program of Black Cultural Nationalism became more widespread among artists because of its adoption by the poet and playwright Amiri Baraka (the former LeRoi Jones), one of the most influential voices of the time who in fact gave the Black Arts Movement its name.[11] While more has been written about activities on the East Coast and in the Midwest, indeed much of the ideological force behind the Black Arts Movement came from California.[12]

In writing about practices in the 1960s and 1970s and site-specific art in particular, Miwon Kwon has spoken of art that ceded to its environment, placed itself in the context of the world, and became enamored of a pub-

lic role which penetrated social frameworks and concerned itself with con-temporary life and issues (rather than solely with internal dynamics).[13] All of these qualities could be found in the precepts and artworks of the Black Arts Movement. Considered more broadly, such ideas—a concern with the social/political landscape, and individuals' relationship to the polis and the larger world—were what many African Americans, artists and nonartists, were grappling with during this era. Like the practices Kwon names these people insinuated themselves into the environment in a quest to claim and hold space. The Watts rebellions, the activities of us, the Black Panthers, the Black Arts Movement, and other social, political, and cultural formations of African Americans in the 1960s were all about opening a larger arena for black culture and life, insisting on its visibility, its place as human and equal, and its viable contribution to the existence and history of the United States.

Kwon has identified the concept of "site" as simultaneously "phenome-nological, social/institutional, and discursive."[14] While the first two itera-tions are fairly self-explanatory, site in its discursive sense threads itself through all types of spaces, concrete and ethereal, as well as those of mem-ory. Kwon's formulations share similarities with poststructuralists such as Henri Lefebvre who outlines a theory of space that is at once mental, physi-cal, and social, defined through "knowledge and action," outlined through a collection of social practices, and that is a social product;[15] or Michel Fou-cault's heterotopia that is more trace, "the habitus of social practices."[16] In the example of the Watts rebellions we see this marking and claim of terri-tory through violence. Yet the same action of defining and asserting one's place in the world is also found in the Black Panthers' championing of self-defense, communications, and social programs, in the development by us of new cultural traditions such as Kwanzaa, and the poems, theater, music, and art gathered under the rubric of the Black Arts Movement.

In Los Angeles, artists and other social actors delineated space and place in a rapidly changing and increasingly globalized society. The city's fortunes shifted as it went from being one of the world's largest areas of growth in the immediate postwar period to a scarred map of urban deindustrializa-tion in the 1960s and 1970s, demonstrating signs of crisis and conflict as it devolved into a militarized enterprise zone for world capital.[17] Many of the African Americans artists discussed here (and/or their parents) had mi-grated to California from the South and the Midwest seeking opportunity and a less restrictive life. Like Saskia Sassen's classic protagonists that fuel globalized urban economies, they were "new city users" staking their claim

through imaginative cultural forms and identities.[18] It was this energy that artists in Los Angeles would transform into a visual language for their time.

ODE TO WATTS

After 1910 Los Angeles became the center of California's black population and a vibrant cultural mecca.[19] A lively music scene grew up along Central Avenue as well as in Watts into the 1950s. At mid-century visual artists— like William Pajaud, Curtis Tann, Betye Saar, Camille Billops, and even Charles White—began to create informal networks, producing exhibitions in churches and homes. White had relocated to Los Angeles in 1956 bringing with him a practice inspired by social realism and progressive politics. A younger generation of artists, those more fully a part of the Black Arts Movement, connected directly with White's activist voice when he began teaching at Otis Art Institute in 1965.[20]

Around 1962 Ruth Waddy started a more formal artist organization called Art West Associated. Formed in dialogue with the civil rights movement, Waddy's intention was a civic activism that would create more opportunity for African American artists. Some of those involved with the group included Dale and Alonzo Davis—who in a few years time would start Brockman Gallery—and Chestyn Everett, elder brother of Ron Karenga. It was Chestyn who Karenga first stayed with when he arrived in Los Angeles from rural Maryland in 1958 upon his graduation from high school.[21]

Other influential figures in the evolution from 1950s types of art practices to those that more fully embodied the goals of the Black Arts Movement included Melvin Edwards and Jayne Cortez. Edwards had a meteoric rise in the burgeoning mainstream Los Angeles art scene before he was thirty. His growing political consciousness led him to make his first "Lynch Fragments" there in the mid-1960s using the welding technique that would become his signature. At that same moment Cortez was creating works that can be referred to as performance pieces, combining literature, jazz, visual art, and politics (in 1963 she worked with the Student Non-Violent Coordinating Committee in Mississippi and with founding a branch in Los Angeles). I would argue that she is one of the figures who first embodies what is understood as the aesthetics of the Black Arts Movement with its base in oral poetry and verse and its connection to political struggle and black communities.[22]

As many have noted, the rebellions in Watts during August 1965 changed things: changed people's expectations and the way they looked at the world; changed artists' approach to their craft, and their materials, and led them to

question what art might be and do. The Watts rebellions galvanized people to write about these experiences, sing and play about them, create objects about them. To take what had happened and turn it into something else called art. In the post-1965 era there was an outpouring of creativity from African Americans in Los Angeles in all areas. Given that poetry was one of the key expressive forms of the Black Arts Movement, it is not surprising that Los Angeles became home to numerous writers in the late 1960s.

Immediately after the rebellions, screenwriter Budd Schulberg began a writers' workshop as a way to bridge the divide between white and black Los Angeles. Known as the Watts Writers Workshop, it eventually published an anthology under the title *From the Ashes: Voices of Watts*.[23] Quincy Troupe was already a published poet by the time he arrived in Los Angeles in the mid-1960s.[24] His earliest book-length work was the edited collection *Watts Poets: A Book of New Poetry and Essays* (1968), which included some of the Watts Writers collective (Ojenke and Emory Evans) as well as others such as K. Curtis Lyle, Eric Priestly, and Stanley Crouch; another contributor was Elaine Brown who was a singer and songwriter before dedicating her energies to the Black Panthers.[25] These artists and others like Wanda Coleman and Kamau Daaood performed their poetry at places such as the Watts Happening Coffee Shop—a former furniture showroom that was transformed into a performance space after the rebellions. Another regular there was Horace Tapscott, a pianist and leader of the Pan Afrikan People's Arkestra begun in 1961 to preserve and perform black music for the benefit of African American communities; Jayne Cortez figured among the group's early collaborators.[26]

The Watts Summer Festival became one of the most well-known cultural institutions in the community. Among its founders was Ron Karenga, head of the recently formed US Organization, which, with its cultural nationalist profile, was thus identified with the event from the outset.[27] Starting with its own members US set out to educate African Americans about African history, language, and traditions, and through its program "construct a new black culture."[28] US members (known as "advocates") wore African-inspired attire, and took African (Swahili) names. Indeed, a key aspect of Karenga's program was the creation of rituals that focused on contemporary milestones in African American life. These were acknowledgments of "status elevation" and "status reversal" which sought to replace an apparently bankrupt black cultural inheritance.[29] The institutionalization of the Kwanzaa celebrated in December is the most visibly lasting part of the US legacy. Other events included Dhabihu (sacrifice)—commemorating

Malcolm X's sacrifice of life for African Americans; held February 22, 1966, it also marked the first public appearance of us.[30] Uhuru (freedom) Day—celebrated on August 11—marked the Watts rebellions.

Begun a year after the rebellions, the Watts Summer Festival embodied ideas of rebirth and celebration as well as commemoration. While some law enforcement officials rejected it because of the seeming tribute to acts of violence and uprising against the state, the Los Angeles County Commission on Human Relations fostered the idea of an "anti-riot coalition" and the event as a way to curtail future hostilities and activism.[31] Featuring an array of African and African American cultural displays including art, crafts, and music, the Watts Summer Festival was held from 1966 through the mid-1980s. Its heyday, however, was from 1966 to 1973, the high point of the Black Arts Movement.

Over the years the Watts Summer Festival always hosted exhibitions of visual art, placing focus on supporting community artists who often made work specifically for the venue. This tradition was perhaps related to how art had initially appeared there, in an exhibition called "66 Signs of Neon," comprised of work created from the material evidence of the Watts uprising.

Among the earliest as well as the longest lasting evidence of Watts as a cultural hub are the famed "Towers" that marked the site for most of the twentieth century. Created by Simon Rodia, an Italian immigrant and laborer, between 1921 and 1954, they are composed of a series of interconnected spires of steel rods and concrete embedded with shells, stones, broken glass, and all manner of refuse brought together in a mosaic-style surface. The structures, including fountains and birdbaths, reach almost one hundred feet at their highest point. After Rodia abandoned the property in the mid-1950s, the Committee for Simon Rodia's Towers was formed to protect this amazing landmark.[32]

In 1964 Noah Purifoy was hired by the committee to look after the towers and the small school that was run there and is credited as the founding director of Watts Towers Arts Center. The '60s saw the beginning of the renaissance of the site as a home for classes in visual and performing arts primarily for youth, as well as exhibitions, and concerts. It also became a place where artists found employment.

While Purifoy records some of his own earliest work as collage, he was eventually drawn to assemblage because of the accessibility and availability of materials; it was made from discarded things. In his eyes such junk was democratic: it didn't discriminate against those with less advantage (or ac-

cess to art materials) because it was free. Assemblage also had its relation-
ship to narratives of poverty; in a way it reflected communities ravaged by
a social system that cared little for them.[33]

Though he received his BFA from Chouinard Art Institute some years be-
fore, Purifoy contends that it was the rebellions at Watts in 1965 "that made
me an artist."[34] He experienced them from the "back door" of the center, the
destruction, the looting. He and Judson Powell, another artist on the center
staff, "while the debris was still smoldering, . . . ventured into the rubble like
other junkers of the community, digging and searching, but unlike others,
obsessed without quite knowing why. By September, working during lunch
time and after teaching hours, we had collected three tons of charred wood
and fire-moulded debris."[35] A year later this detritus had been transformed
into the exhibition "66 Signs of Neon," part of the first Watts Summer Fes-
tival. The show was composed of sixty-six assemblages created by various
artists. In the catalogue for the exhibition one gets a sense of how Purifoy's
philosophy affected the show's overall concept where "creativity is the only
way left for a person to find himself in this materialistic world," where junk
creates order from disorder and "beauty from ugliness."[36] In the reworking
of charred remnants of society was found the transformative power of art,
its ability to affect change in the individual and the psyche.

Examples of Purifoy's own work created in the aftermath of the rebel-
lions include *Sir Watts* (c. 1966, now lost), which graced the frontispiece of
the catalogue for "66 Signs of Neon." As its title seems to suggest, the piece
is modeled after medieval armor. What we see, however, is only a partial
torso molded out of metal, with abbreviated arms and head. Where a face
might be a small purse of metal mesh was affixed, which was sometimes
opened and gaping as a hungry mouth. The belly was a series of wooden
drawers, while the chest cavity was covered with a scarred piece of glass re-
vealing a complicated agglomeration of small personal objects (hairpins,
a fork, buttons). The heart was an open hole through which poured hun-
dreds of tangled safety pins, dripping down the front of the sculpture. Again
the image of violence, of the warrior—the knight as a sign for "people in
battle"[37]—was turned into a figure simply in want of love and care.

For some artists, including Noah Purifoy, Betye Saar, John Riddle, and
John Outterbridge, assemblage was a clear metaphor for the process of
change—the transformation of psyche and social existence—required of art
in the rhetoric of the Black Arts Movement, art that "advance[d] social con-
sciousness and promote[d] black development."[38] While numerous times
he thought of abandoning such parameters for art-making John Riddle real-

ized that the world was such, that politics was such that "there's always, every day, some resource" when one was working in a socially based mode.[39]

A Los Angeles native, Riddle began to meet a community of African American artists around the time of the Watts rebellions, some while poking through the post-rebellion rubble. While he had been drawn to assemblage before that time, August 1965 as well as Noah Purifoy's influence put a new spin on things, made him think hard about "what the purpose of art should be."[40] *Ghetto Merchant* (c.1966) was created from physical remnants of the rebellions and most probably shown in the "66 Signs of Neon" exhibition. Anthropomorphic in sensibility, it incorporates a burnt-up cash register as its core element, its wiry keys a skeletal torso. This is topped by an "empty" head formed from the negative space in a metal fragment and held up by spindly steel legs, an apt metaphor for a figure that preyed on the Watts community.

John Outterbridge, who arrived in Los Angeles from Chicago in 1963, saw the beginnings of the Black Arts Movement as a visionary time for artists because it took into consideration "how art and culture could effectively participate to help build a community, break existing moulds and create an interest in social change. . . . Artists were challenged to think among themselves in new ways."[41] For Outterbridge art with social commentary evolved naturally from the climate of the times. It was indeed part of the aesthetic of assemblage, "how you use whatever is available to you, and what is available to you is not mere material but the material and the essence of the political climate, the material in the debris of social issues."[42] Catalyzed by the times, Outterbridge came to think of himself as an "activist-artist" whose "studio was everywhere."[43]

Outterbridge worked typically in series, and his "Rag Man" group (1970–1976) was inspired by a figure from his youth in the South and Midwest who would come by to collect cast-off clothes for reuse and resale. By alluding to an African American vernacular method here, Outterbridge makes a subtle comparison between black tradition and assemblage as a fine art practice, creating a dialogue between high and low forms, and showing how African American creativity, in fact, even predated this modernist mode of art-making.

Born in Watts, Betye Saar began her career as an artist in the 1950s making fine crafts and jewelry. By 1960 she had turned to printmaking and early on developed a number of thematic threads and art-making strategies that she has continued to explore; among these are the centrality of images of women, alternative spiritual practices and cosmologies, and the collision

of textures. Beginning in 1966 the prints became meshed with found win-
dow frames which provided a new kind of support but also set up a fresh
narrative structure, which like a film storyboard allowed the action of the
picture plane to unfold incrementally, as in *Mystic Window for Leo* (1966).

As has been argued elsewhere, the mystical arena evoked by Saar and
others like Sun Ra during this period represented a surrogate space of lib-
eration, and for Saar one that pointed back to the self.[44] *Black Girl's Window*
(1969) seems to be a turning point in this regard where we see Saar re-
embrace the black body and make the connection between the black female
form and her surrogate, the lion (emblem of Saar's zodiac sign, Leo). As the
window frame device gave way to shallow boxes and small altars, the work
became at once more theatrical and increasingly grounded in traditional
African American belief systems.[45] In two of what she refers to as her "an-
cestral boxes"[46] — *Ten Mojo Secrets* (1972) and *Gris-Gris Box* (1972) — Saar
uses words ("mojo" and "gris-gris") alluding to African American ritual or
conjuring practices often identified with Louisiana, homeland of her pater-
nal grandparents. A small altar like *Mti* (1973) takes its title from the Swahili
word for wood, engaging in this way with a lexicon of the Black Arts Move-
ment. However, it is perhaps the link between *Gris-Gris Box* and what is
arguably Saar's most famous work, *The Liberation of Aunt Jemima* (1972),
made the same year, that we see how the personal — in the form of an active
yet private spirituality — indeed becomes political, how the mystical repre-
sents the will to power. In both works the central figure is a black woman in
a headscarf, linking her iconographically to the stereotypical mammy. Yet
each is laden with props of power, guns in the latter and strong magic in the
former.

Engagement with the idea of exploding stereotypes was a trope of visual
arts practice clearly connected to Black Arts Movement theory. It allowed
artists to create figurative, representational work which was recognizable
and thus available "to the masses" yet at the same time demonstrated art's
role as weapon by enacting the destruction of negative imagery. Other art-
ists creating work in this vein included Murray DePillars, Jeff Donaldson,
and Joe Overstreet. As Carpenter and Saar argue, however, Saar was the
first to integrate *actual* historical objects, so-called black collectibles into
her pieces.[47] By incorporating them Saar sought to consume their power,
to enact physical and artistic cannibalization and thus drain their negative
magic.

In the 1950s Watts was perceived as "the bottom of the social and eco-
nomic ladder"; Eldridge Cleaver, who grew up in Los Angeles at that time,
observed that to say someone was from Watts was a put-down, a way of say-

ing that person was uncool.[48] After 1965 the reverse was true; having any connection with Watts was seen as a badge of honor as it came to connote a new course for black identity, one which embodied power, strength, and uncompromising behavior. Indeed Watts seemed to epitomize site in the discursive sense as outlined by Kwon. It denoted a tangible place, a symbol, and a way of thinking; it was (re)constructed and (re)born through violence, assemblage, language, as well as physical and institutional structure.

SHOWING OUT

If the Black Arts Movement embodied a search for a black aesthetic, it also sought out alternative institutional structures that could nurture and support these new art forms. Historically, the majority of African American artists were certainly not welcomed with open arms, if at all, within mainstream museums and galleries in Los Angeles or the rest of the country. In the post–World War II period we begin to see a slow shift in African American relations to art world structure, a trend which picked up momentum in the 1960s. We can consider these changes in terms of different types of activity, actions which were more "integrationist" in focus (i.e., penetrating preexisting institutions) paired with those creating autochthonous formations (i.e., new galleries, periodicals, etc.).

This advance began with African Americans' growing attendance in BFA and MFA programs, fueled by the disintegrating barriers to de jure segregation as well as the G.I. Bill. Riddle, Purifoy, and Outterbridge were all veterans of the Korean War who used their educational benefits to attend art school. Each of them also ended up working in new institutional settings that supported the work of African American artists. Riddle moved to Atlanta in the mid-1970s, becoming the head of the Neighborhood Arts Center, which gave David Hammons one of his first solo shows. Outterbridge assumed the directorship of the Watts Towers Arts Center in 1975, the year that it officially became a municipal art space. Purifoy, the first director of Watts Towers between 1964 and 1966, eventually joined the newly created California Arts Council, where he remained an arts administrator for eleven years.

Around 1969 several nonmunicipal, independent establishments were also formed. Brockman Gallery, Gallery 32, and The Gallery were all venues run by and largely for African American artists. While Brockman Gallery had the longest life span of the three—1967–1990—the other two enterprises were very active in the first half of the '70s. At their core these were spaces run by artists for artists.

Besides creating or managing sites for the display (and sale) of art or

places where people could perform or just congregate, another institutionally directed aspect of Black Arts Movement activity was agitating and protesting against public organizations that refused to admit, exhibit, or hire African Americans yet benefited from the tax dollars of these same citizens. One Los Angeles group that concerned itself with such issues was the Black Art Council.

Like Art West Associated before it and the Black Emergency Cultural Coalition in New York, the Black Art Council served in part as a watchdog organization, the thorn in the side of mainstream art institutions demanding that they be more fully representative of the city which they served.[49] Cecil Fergerson, one of the Black Art Council's founding members, had begun working at the Los Angeles County Museum (LACMA) as a janitor in 1948. By the mid-'60s he had risen through the ranks to the position of preparator. With the climate of social change alive in the United States and the rising prominence of the Black Arts Movement and growing consciousness about the importance of culture, Fergerson and Black Art Council (BAC) co-founder Claude Booker "both realized how important arts were to people. Up until that point, I just looked at art as a [nice club] for the rich. Because you have no point of reference—right?—being black. No black museums. No black people in the collection."[50]

During the first half of the '70s continuous lobbying of LACMA by the BAC brought about three major exhibitions focused on African American artists.[51] "Three Graphic Artists" (1971) featured works on paper by Charles White, David Hammons, and Timothy Washington.[52] It was from this exhibition that LACMA purchased Hammons's seminal *Injustice Case* (1970). The next year the museum presented "Los Angeles, 1972: A Panorama of Black Artists," a group show of contemporary art curated by African American art historian Carroll Greene.

The last very visible project that LACMA undertook in the '70s involving African American artists was the large historical exhibition "Two Centuries of Black American Art" (1976). It provided much needed historical context to the contemporary art scene, reminding the world that African-descended peoples in the United States had been around hundreds of years and in that time had been creative, and that amazingly, given their circumstance for much of that time, had made some beautiful things, including art. Curated by renowned professor, artist, and curator David Driskell, the show traveled extensively and was a huge success. The exhibition catalogue often served as a key text in courses on African American artists that were beginning to be taught at this time.

While much of the focus of the Black Art Council was on correcting

the oversights of the Los Angeles County Museum of Art, the group also involved itself in other projects in the larger community. Fergerson and Booker, preparators at LACMA and the real driving force behind the BAC, lent their installation skills to the visual arts portion of the Watts Summer Festival between 1970 and 1975. Black Student Unions at colleges and universities in the area also engaged the services of the Black Art Council to create a black visual presence on campus. The group helped out hanging shows at emerging black-owned galleries such as Gallery 32 as well. The gallery in turn opened its space for the organization's meetings and at least once for a fund-raising exhibition.[53]

A year after a cross-country road trip led them to experience the United States and "see artists of color, that they were out there, that they were doing it, they were making a significant statement," Alonzo and Dale Davis opened the Brockman Gallery.[54] Named for their maternal grandmother, who had been a slave, the Davises dedicated Brockman primarily to the work of African American artists. The gallery was located on the Westside of Los Angeles in its wealthiest black enclave, a bid to attract that clientele.

The Davises opened their gallery in 1967 with shows of their own work. Early on Brockman represented Timothy Washington and David Hammons. Brockman was in fact the place where Hammons first showed the now classic *Injustice Case* (1970) in its original guise as a mixed-media installation: a body print bordered by an actual American flag and enclosed in a lighted, glass, museum display case along with a gavel (this larger container was later destroyed). Elizabeth Catlett had her first United States solo show in many years at Brockman. In addition to exhibitions of works by African Americans, Brockman also organized group shows that were more integrated including work by Chicano, Japanese, and white artists.

The Davis brothers had always envisioned Brockman Gallery as a commercial venture. Yet they were also very active in the community helping with other exhibitions and programs. To handle their growing community-focused activities they set up Brockman Productions in 1973, a nonprofit entity that was eligible for public funding. By 1976 Alonzo was able to quit all the other jobs he held to keep the gallery afloat and concentrate his energies on running these enterprises.[55] Brockman expanded its reach to outdoor exhibitions, mural projects, and concerts, as well as a film festival; it was able to support more artists than ever before because commercial viability was not so much of an issue.

Suzanne Jackson was a professional dancer before moving to Los Angeles in 1967. She initially supported herself working concurrently for the Los Angeles Unified School District as an elementary school art instructor,

and at Watts Towers Arts Center teaching dance and visual art. She was a model for other classes at Watts Towers and for Charles White's courses at Otis Art Institute. She sat in as a student on some of White's sessions as well which was how she first met other artists such as David Hammons, Dan Concholar, Alonzo Davis, and Timothy Washington. Searching for a new studio space in the vicinity of both Otis and Chouinard Jackson found a beautiful place on Lafayette Park and was encouraged by friends to turn it into a gallery. And so Gallery 32 was born.[56]

Though barely in operation for two years Gallery 32 was visible, progressive, and full of energy. It was not necessarily a "black gallery" though its proprietor and the majority of the artists who showed there were. There was a healthy competition between Brockman Gallery and Gallery 32, though they often shared opening weekends (Brockman debuting new shows on Friday and Gallery 32 on Saturday), and some artists (Hammons, Washington, Concholar). However, Brockman was known for exhibiting more established practitioners while Gallery 32 specialized in a younger, more eclectic and in some ways more political group.

Jackson considered her effort more alternative, a space for artists who weren't really showing elsewhere; it was not a serious effort at a commercially viable venture. Elizabeth Leigh-Taylor's exhibition focused on the Greek resistance (1969); "The Sapphire Show" (1970) presented black women artists including Betye Saar, Yvonne Cole Meo, Gloria Bohanon, and Senga Nengudi. The invitation for John Stinson's exhibition of photographs—showing him standing in the doorway of his mail truck—drew crowds of politicos as well as everyday folk.[57] But arguably the best attended of all Gallery 32 shows was a 1969 solo by Emory Douglas, minister of culture of the Black Panther Party and principal illustrator of the *Black Panther* newspaper. By 1970 Jackson had closed Gallery 32 and moved on. Like many artists during this period she was harassed and seen as subversive; the gallery as a meeting place, as a place to debate the artist's relevance to the black community, came under scrutiny, particularly one with a higher political profile such as hers.[58]

Samella Lewis arrived in Southern California in 1966, as a forty-four-year-old artist and academic, with a PhD from Ohio State University and fifteen years of teaching under her belt. She initially took a position at California State University, Long Beach, but by 1968 she had joined the Los Angeles County Museum of Art as coordinator of education. This position was the result of agitation by forces such as Art West Associated and the Black Arts Council seeking greater visibility for African Americans in this large municipal art center which their tax dollars went to fund but which

provided them with little access and even less inspiration. It was Lewis's own disenchantment with the institution, combined with the social energy of the time, that led her to develop her own groundbreaking projects which would distinguish her as a major force in African American art in the twentieth century. The amazing projects—three books, a magazine, two galleries, and a museum—all came to fruition in the decade between 1969 and 1978 and flowered in the California landscape.

The first of the two-volume *Black Artists on Art* was published in 1969 and hatched somewhat earlier by Lewis, Ruth Waddy, and E. J. Montgomery in the latter's Bay Area living room.[59] It featured introductory texts by Lewis and Waddy reflecting the rhetoric of the Black Arts Movement, attesting to the unique vision of African American artists and the need for the mainstream to expand notions of aesthetic beauty. Each artist was also represented by a brief statement and at least one image. Many of the contributors, not surprisingly, were from California, and, in effect, the book reproduces those networks of African American artists stretching from the 1950s to the contemporary moment. In Lewis's eyes the publication legitimized the work of these practitioners, demonstrating that they were worthy of exhibitions, jobs, and general support by the larger culture. A second volume of *Black Artists on Art* appeared in 1971. Both were self-published. Together they highlighted the work of almost 150 contemporary African American artists, an amazing number given Lewis's resources and the one or two figures often showcased in mainstream contexts (even today). As a way to keep the ideas in the books updated, Lewis along with Val Spaulding and Jan Jemison began the magazine *Black Art*. This first periodical devoted to African American and African diaspora artists would later change its name to *International Review of African American Art*.

The first half of the '70s found Samella Lewis putting her mark on Los Angeles as a curator; however she did so through sheer force of will and in spaces that she herself created. Lewis first opened The Gallery on Redondo Boulevard near Olympic, later moving it to Pico Boulevard.[60] In addition to organizing shows for The Gallery, in 1976 Lewis founded the Museum of African American Art. For a while both gallery and museum shared the same building. Eventually Lewis relinquished the gallery space to focus on the museum. In its third year of existence, the Museum of African American Art moved to its current space in the May Company Department store. Mary Jane Hewitt eventually joined Lewis in this endeavor.[61]

All during this period Lewis continued to work full-time in academia. She was hired as a professor of art history and humanities by Scripps College in 1970. Scripps was part of the Claremont University Center (CUC)—a con-

sortium of colleges—which provided support for several of Lewis's projects, particularly the museum and the magazine. She also worked with CUC's Black Studies program mentoring students and giving lectures on African American art. In 1978 Lewis transformed these lectures into a book, *Art: African American*. This survey joined only two others, James Porter's *Modern Negro Art* (1943) and Cedric Dover's *American Negro Art* (1960). Until the mid-'90s this book was the standard academic text to introduce new students of all ages to the field of African American artists and their histories.[62]

Institutional structures of the Black Arts Movement related to the visual arts revitalized and revalidated African American art history at the same time as they supported contemporary practitioners. It was perhaps the younger generation of artists active in this era that would benefit most from the embrace of black aesthetics and organizational support and who would also take these forms to the next level and to their endpoint.

SHOWING UP

The path opened up by assemblage and other multimedia art forms in the post–World War II visual landscape led away from traditional practices of painting and sculpture. These styles instead placed value on the recycling of everyday objects of human facture in new juxtapositions which retained echoes of their use, recontextualized, and often reinscribed in the mirror of metaphor. Such strategies found a comfortable home with Los Angeles artists working within Black Arts Movement rubric such as Noah Purifoy, John Otterbridge, John Riddle, and Betye Saar. These artists (and others) engaged with bits and pieces of their environment, in particular the remnants of the Watts rebellions, through which they could refer to African American culture and life without relying on simplistic painted representations of the black figure. David Hammons, Houston Conwill, Maren Hassinger, and Senga Nengudi followed the trajectory of these and other contemporary bricoleurs. Yet they were of a slightly younger generation that employed such devices as part of a more conceptual, active, and participatory practice.

Conceptual art privileged ideas. Art was a "metaphysical vehicle for an idea intended,"[63] it was human thought made visible. No longer defined by its physical attributes, art dematerialized into "the melted down . . . status of evidence,"[64] remains, concepts, words. Conceptualism like Black Arts Movement forms emphasized audience, the reception of and interaction with aesthetics. Art was not just to be seen but experienced. Eventually these methods would separate from autonomous form altogether and live as performance. If, as David Lionel Smith has suggested, the Black Arts Movement's flow of poetry into music created theater, then we can also see the

gestures of theater and material culture combining to produce performance art. Post–World War II temporal aesthetics led away from the specter of world annihilation (in wartime destruction, nuclear menace, and cold war countermoves), *and* formalism's impasse (art solely concerned with the status of itself), back to a reaffirmation of human existence.[65] In African American communities, threats to the physical and social body continued into the 1960s and 1970s (as they had for hundreds of years), making such practices in some ways even more appropriate. Performance could also be "placed" anywhere, dispersed quite effortlessly into the flow of everyday life, as "spectacle or political act,"[66] and offered unmediated connection to the viewer, again qualities favored by the Black Arts Movement.

Of the younger group of Los Angeles artists it is perhaps through the work of David Hammons that we can most clearly chart the evolving visual aesthetics of the Black Arts Movement, and the move from more didactic formulas to those that rely to a greater extent on abstraction, dematerialized practices, and performance. Hammons arrived in Los Angeles from Illinois in 1963 at the age of twenty. He attended art classes at various institutions throughout the city but in particular sought out Charles White at Otis Art Institute.[67] White's influence on Hammons can be seen in his early choice of the graphic medium as well as in the works' political content. In pieces such as *Black Boy's Window* (1968), and *Injustice Case* (1970), the commentary on African American exclusion from opportunity (in the first instance) and persecution by the American system (in the second) is clear. They classically embody Black Arts Movement style in their figurative presentation and commentary on United States racism. Hammons is also clearly working within the California assemblage aesthetic. In *Black Boy's Window* Hammons applies a photo silkscreen process to a discarded window frame using the bar-like structure of panes to suggest jail-like connotations. The piece also demonstrates the influence of Betye Saar, who had begun creating similar constructions in 1966. However, there is a dialogue between the two artists as well. Saar made her *Black Girl's Window* (1969) the year after Hammons's piece appeared; her *Self-Window with Reflection* (1970), like *Black Boy's Window*, also included a functional window shade in a nod to the performative.

It was the development of the printing process in Hammons's early works that was most fascinating. He used himself as the printable "plate," oiling his body, leaning or lying on a piece of paper or board, then sprinkling the grease-infused areas with powdered pigment. Silkscreened embellishments were often added to these emblematic indexes, but it was clear that the fulcrum of signification revolved around the performative body. The

body prints share similarities with the *Anthropometries* of Yves Klein.[68] But rather than using the female form as a titillating paintbrush, Hammons was the dynamic agent, collapsing the position of auteur with those of signifier *and* signified.

With his "Spade Series" (c.1971–1974) Hammons moved more fully into a multimedia and performance practice. Of equal interest was the artist's manipulation of language. Hammons took a derogatory term for African Americans—"spade"—and reversed and opened up meaning. In showing the spade in so many permutations, he attempted to deconstruct the image and divest it of its power, again a classic trope of Black Arts Movement practice and one also employed by Saar at the same moment.

In a vintage 1970s photo, Hammons poses with *3 Spades* (1971), a body print showing a black man (the artist "in print") holding two familiar (if enlarged) emblems taken from a deck of playing cards. The conflation between symbol, slur, and human being reveals an approach to speech and use of taboo language clearly influenced by Black Arts Movement poetics. In sculptural pieces such as *Laughing Magic* and *Bird* (both 1973), Hammons takes a more celebratory stance, again locating his method stylistically within Black Arts Movement commemoration of black heroes and heritage. Each pays homage to respective African and African American legacies, one through the use of the mask form, the other as a quiet monument to the musical genius of alto saxophonist Charlie "Bird" Parker.

In his interaction with "spade" objects Hammons created some of his earliest performance works. Interestingly, using the spade as a performative device lent a more violent edge to his concept. Shapes cut from cardboard or leather are props used by the artist, but they also become stand-ins for black bodies. One piece from this period, *Spade Covered with Sand* or *Buried Spade* (no date), has been referred to by Hammons as an "earth work"; the action is as the title suggests: Hammons digs a hole and entombs the form in the ground.[69] Documentation of *Murder Mystery* (1972, also known as *Spade Run Over by a Volkswagen*) shows a cardboard spade "crushed" under the wheel of a Volkswagen Beetle, painted blood pouring forth. Another performance consisted of Hammons hanging leather spade forms from trees. Given the violent repression of African Americans agitating against injustice—both historical and contemporary, some witnessed and experienced firsthand by the artist—it would not be a stretch to see Hammons's spade performances as his own coded response to the climate of the times, in the same vein as Melvin Edwards's "Lynch Fragments" (and perhaps even as a homage to them). It wasn't merely formal exploration that led Hammons to hang these pieces (which he dubbed "skins") from trees.[70]

After meeting at Howard University where they both were art students, Houston and Kinshasha Conwill moved to Los Angeles in the early '70s to attend graduate school at the University of Southern California (USC).[71] There Houston created an artistic vocabulary for objects and performances that referenced both African and African American visual and ritual heritage. Performances often took place within a different solo exhibition of objects. These included the shows "JuJu Funk" (1975) at the Lindhurst Gallery of USC, "JuJu" (1976) at the Pearl C. Woods Gallery, and "JuJu III" (1976) at The Gallery, the space on Pico Boulevard run by Samella Lewis. Hybrid painted/sculpted elements hung from the walls and were laid out on the floor, but in each installation the focus was drawn to "the ceremonial space at the center of the room."[72]

The action revolved around a central sculptural tableau: a narrow strip of red carpet connecting a stool and a pail that were both elaborately adorned. Perched on the stool during the performance, Houston's painted body became a medium, calling his forbearers with an evocative litany. This base held the seated energy of the African ancestors, in much the same way stools do in the Akan traditions of Ghana.[73] The pail became a "gutbucket"— antebellum container of "the food remains given slaves," sign of "the base level of emotion or experience," and inspiration for that down home blues.[74] Here allusion to African American foodways celebrated heritage but also vernacular practice, the creation of delicacies (such as chitterlings) from discards, yet another approach to and comment on the practice of assemblage. These live works were often collaborations with artists like Kinshasha and Hammons as well as musicians. Other significant performances by Houston in this period included *Warrior Chants, Love Songs and New Spirituals* (with poets Kamau Daaood, Charles Dickson, and Ojenke) performed at the Watts Towers Art Center in 1979, and *Getup*, written by Senga Nengudi in 1980.

Both Senga Nengudi and Maren Hassinger came to performance from dance, though they were discouraged by their respective colleges from majoring in it on the undergraduate level. To a great extent this rejection had to do with what was (is?) perceived as the correct body type for the discipline, a formula that didn't include black women.[75] Hassinger, a Los Angeles native, was a neighbor of Alonzo and Dale Davis growing up on the Westside of Los Angeles. In graduate school at UCLA in the early 1970s she discovered what would become a pivotal medium for her: wire rope. In her hands, this material came to embody the changing landscape of American sculpture from minimal to postminimal: it was a synthetic substance that, with subtle intervention, could echo organic form. These solid and indus-

trial, yet process-driven sculptures become the "initiators of activity" lending themselves to the temporality of performance.[76] Though she showed at Brockman Gallery and was a certainly a part of this group of younger artists in Los Angeles experimenting with dematerialized practices and performance, Hassinger's work seemed the least concerned with rhetorics of African American or African aesthetics. However, in retrospect she did feel there was a connection:

> One thing I think I have discovered along the way, after years of feeling compelled to do things and many of those years doing them in collaboration with Senga [Nengudi] and Ulysses [Jenkins] and Frank Parker, and then recently looking at slides from African performances and masquerades and reading . . . I realized that in Africa. . . . time-based movements are not separated from the static work in the same way. . . . You know, it's the flip side of one coin. And I really do think that it's the impulse that moves through all of our work. . . . [This gives a context to] my impulse to take the sculpture and expand it so that the idea exists in time and includes movement and includes people, sound and voices, and things.[77]

Like Conwill's, one of Hassinger's first performances took place within one of her gallery installations.[78] *High Noon* (1976), performed at the Arco Center for Visual Art in Los Angeles, extended sculptural notions into time and motion. Another early performance took place on Easter Sunday, 1977, at David Hammons's Slauson Avenue studio. This time Hassinger was not performing among her own works, but those of Hammons certainly provided an environment for the action.[79] An ensemble of performers (including Senga Nengudi) is linked through the interchange of objects, in this case actual wood saplings. Like *High Noon*, the title of the piece, *Ten Minutes*, is blandly descriptive in the mode of classic, language-driven conceptualism. The spareness of the branches, the performers' light colored and soft clothing, and their simple actions, capture the minimalist edge that Hassinger's sculptures tread as well. A third work, *Diaries (Part 1 of Lives)* (1978), was performed at the Vanguard Gallery, a newly opened alternative space in downtown Los Angeles, and finds corollaries in the anthropomorphic connotations of her major sculptures from that year, *Walking* and *Whirling*.

While studying at California State University, Los Angeles, Senga Nengudi worked both at Pasadena Art Museum and Watts Towers Arts Center drawing inspiration from mainstream sources as well as others that privileged black creativity.[80] As David Hammons recalls, Nengudi was rejected for the most part by the then burgeoning West Coast Black Arts Movement

due to her nonrepresentational tendencies. Speaking of the *Water Compositions*, he observed, "she used to put colored water in plastic bags and sit them on pedestals. This was the Sixties. No one would even speak to her because we were all doing political art. She couldn't relate. She wouldn't even show around other Black artists her work was so 'outrageously' abstract. Senga came to New York and still no one would deal with her because she wasn't doing 'Black Art.'"[81]

Yet in New York Nengudi did create what would become her signature works, free-form sculptures constructed primarily of panty hose and sand. Their "skin-like forms . . . stretched and pulled linear extensions and appendages,"[82] were tied and knotted, shaped, twisted, and suspended from walls and ceilings. Their very material and anthropomorphic form certainly suggested the body in motion. However, their pliant nature was not just part of an anti-sculptural, environmental orientation, or feminist bearing. They were supposed to be interacted with: caressed, fondled, and stroked by the artist as well as viewers. It was through participatory three-dimensional works that movement and finally performance (re)entered her work as an important creative force.

Some of Nengudi's early forays into performance were done in the company of other artists who formed the core of Studio Z. This loose group came together at Hammons's studio on Slauson Avenue—sometimes weekly—to engage in spontaneous actions; these might be performed in the streets of Los Angeles as well. Studio Z had a changing membership (if one could call it that), including at various times Franklin Parker, Houston Conwill, Ulysses Jenkins, and RoHo along with Hassinger, Hammons, and Nengudi. Hammons's space, a huge old dance hall with a wooden floor, was a perfect place to work out ideas.[83]

Nengudi's first full-length work of performance took place in March 1978. *Ceremony for Freeway Fets* was a public art project supported by a CETA grant and sponsored by Brockman Gallery along with Cal Trans (the Los Angeles transportation system).[84] The one-time event took place under a section of the freeway near the Convention Center. A small orchestra composed of students and artists played saxophone, flute, drums, and other less traditional instruments. Nearly everyone was equipped with a form of Nengudi's sculpture, from Franklin Parker's knotted and twisted headdress, to RoHo's full mask. Nengudi, Hassinger, and Hammons provided the work's major movement and most elaborate costume.

Ceremony for Freeway Fets shares certain aesthetic conventions with West African masquerade. For instance, there is the crew of masked performers, some in full-body gear. Nengudi's version of her wearable sculpture cul-

minates in a crown that appears to be placed on top of the head, calling to mind the elaborate wooden superstructures found in Nigerian Gelede masquerades, among others. In some African productions, the actual faces of performers are covered with mesh or folds of fabric, comparable in affect to Hammons's panty-hose-clad headpiece sans eyeholes. The object that spins in Nengudi's hand finds a comfortable analogy in the flywhisks and other items often carried by African masqueraders. This feel or sensibility of West African performance is certainly intentional on Nengudi's part and again is in line with aesthetics of the Black Arts Movement if perhaps belatedly.[85] In her mind she created an African environment:

> I really liked the space because there were little tiny palm trees and a lot of dirt. It wasn't as extreme as it is now, but even at that time there were a lot of transients who slept there; so there were little campfires and stuff. For me, it had the feel of what I imagined an African village to be. Because it was under the freeway it was kind of cloistered in a sense. You could have this rural atmosphere in the midst of an urban setting.[86]

As Kinshasha Conwill moved away from formal art-making practices in the mid-'70s she became more involved with performative acts, particularly those connected with her husband's objects. She performed dances with elaborate costumes and makeup, sometimes singing, slicing a knife through the air in a cleansing ritual, or offering gifts to the audience.[87] But she also engaged in more quotidian actions linked to Black Arts Movement practice. Like so many others she changed the way she presented herself in everyday life, donning traditional African-style dress—with geles (head wraps) and long skirts; she made her own clothes. She adorned her hair with braids, beads, and feathers. Kinshasha has also described these activities as her own visceral reaction to California's multimedia sensibility.[88] Other artists saw personal adornment as a site of aesthetic play as well. Hammons was known to walk the streets with half his head or beard shaved (which also resulted in him being stopped often by police).[89] It was in California that Karen transformed into Kinshasha. Just as Sue Irons became Senga Nengudi in the moment that her work more openly embraced African modes. Just as Ron Everett became Ron Karenga and LeRoi Jones became Amiri Baraka. Or as Sonny Blount became Sun Ra or Yvette Richards became Chaka Khan. Or even earlier as Malcolm Little became Malcolm X, pointing to the Nation of Islam as a force in such naming and sartorial modes, the role of these practices as aspects of self-determination, and the organization's ideological impact on the Black Arts Movement. Yet we can point to a source for such actions a century before with newly liberated African

Americans, like Frederick Douglass and Sojourner Truth, choosing names *and* new identities for themselves.

Expanding simple notions of what "black art" could be artists such as Hammons, the Conwills, Hassinger, and Nengudi took ideas such as affirmations of African American cultural identity, celebrations of African heritage, and notions of art's availability to audiences to their endpoint. In moving away from figurative representations in two dimensions, through dematerialized practices and performance, ultimately and ironically they were led back to the black body as form.

MIGRATION AND IMAGINATION

Most observers locate the ending of the Black Arts Movement in the mid-1970s. Kalamu ya Salaam, whose BLKARTSOUTH theater represented a southern branch of the movement, dates its demise to 1974, with the decimation of black activist groups such as the Black Panthers and US (through government-sponsored infiltration and assassination), the rejection of race-based organizing for that driven by Marxist philosophy, and the cooptation and commercialization of black aesthetics (in Blaxploitation films, for instance).[90]

Another endpoint is often seen in the outpouring of black women's writing and the growing prominence of figures like Toni Morrison and Alice Walker. One milestone in this regard is the opening of Ntozake Shange's *for colored girls who have considered suicide when the rainbow is enuf* on Broadway in 1976. Called a "choreopoem" by its creator, *for colored girls* explored the lives of African American women through a combination of performance and spoken word. Yet the language, writing, and even Shange's name demonstrated roots in the Black Arts Movement. As Shange herself would later comment, "I am a daughter of the black arts movement (even though they didn't know they were going to have a girl!)."[91] To an extent women's voices had been heard during the period, in the writings of Sonia Sanchez and Nikki Giovanni, and anthologies like *The Black Woman* (1970), and *Soulscript* (1970), edited by Toni Cade Bambara and June Jordan respectively, and in the political activities of Kathleen Cleaver, Elaine Brown, and Angela Davis, among many others.[92]

Yet even as the growing visibility of women became the flashpoint for disintegration of the Black Arts Movement, male voices of the time, some of them located, interestingly, in California, such as Ismael Reed and Quincy Troupe, rebelled against its "prescriptive and narrowly political nature."[93] In a sense the movement imploded with the weight of it own "masculine bias, homophobia, anti-Semitism, violent imagery, [and] simplistic racial di-

chotomies."[94] But the lessons about the profound beauty *and* complexity of black culture were never lost, and moved forward into the future.

In a sense African American artists working in Los Angeles also provided an alternative to the standard formulas of the Black Arts Movement. Their take on black heroes, affirmations of cultural identity, and links with the African past followed different routes. Their visions were not particularly two-dimensional or graphic, colorful, or solely representational. This multimedia aesthetic also emerged from a California tradition which embraced the materiality of craft, and its notions of functionality may have issued to an extent from this trajectory as well as Black Arts Movement tenets. It also remains to be seen what kind of influence the work of Chestyn Everett, and his involvement with Art West Associated and other art-driven activities, may have had on his brother Ron Karenga in the 1950s and 1960s.

By the late 1970s, Hammons, Hassinger, Edwards, and the Conwills had all departed Los Angeles for New York. Nengudi had also developed her mature aesthetic there in the early 1970s. Indeed, another important aspect to consider in the work of these Southern California–based artists is what role migration might have played in the development of visual aesthetics? Many of the practitioners featured here migrated from the South or the Midwest or were children of others who had relocated to the area. As mentioned earlier, during and following World War II an increasing number of African Americans moved to California drawn by the promise of work in the growing war and aeronautics industries. While many artists made their way to the state during these decades (Bruce Nauman, Edward Kienholz, and Edward Ruscha among them), migration holds a special place in the African American cultural imagination.

Scholar Farah Jasmine Griffin sees migration as *the* key text of modern African American life.[95] The majority of black people lived in the South until well into the twentieth century, their travel restricted by Jim Crow laws even as late as the 1950s. The "Great Migration" between the two World Wars radically altered the African American demographics of the United States. More importantly, migration held a significant place in the black creative mind, and was a major theme in a variety of cultural forms from literature to music and painting. Were these same themes discernable in the production of African American artists working more abstractly in Los Angeles during the 1960s and 1970s? How might we see migration reenacted in notions of place and space that came to be signified by the "dematerialization" of the art object?

This brings us back to Kwon's notion of the discursive role of site, one

not necessarily tied to a fixed or physical locale, a sense of site being generated in and through a variety of places, tangible and intangible. In the context of 1960s and 1970s African America, we can discern site's relationship to notions of claim, land, territory, culture, spirituality, and imagination, particularly in the Los Angeles example of Watts. If the migration narrative is the voice of modern African America, and above all explores issues of urbanism, is its endpoint found in the deindustrialized landscape that then produces postmodern culture? And can that postmodern phase be defined in the trajectory that runs from assemblage to hip-hop? We should also consider how the changing realities of material and lived experience of African Americans, vernacular, popular culture, *and* fine art contribute to our understanding of major art movements such as assemblage or pop. Indeed, what impact *did* these artists based in Los Angeles and their wide-ranging use of media have on the vitality of the postminimalist landscape of the 1970s? And later how did their presence on the East Coast affect the expanding discourse of multiculturalism in the 1980s art scene? While these questions remain largely unanswered here, we know that African American culture has played a major role worldwide in the late twentieth century. And many of its routes lead us back to the Black Arts.

In celebration of E. J. Montgomery and in memory of Ruth Waddy

NOTES

Interviews with Alonzo Davis, Cecil Fergerson, John Outterbridge, Noah Purifoy, and John Riddle conducted by the UCLA Oral History Program, Department of Special Collections, Charles E. Young Research Library, are used with permission of the Regents of the University of California. Originally published in Lisa Gail Collins and Margo Crawford, eds., *New Thoughts on the Black Arts Movement* (New Brunswick: Rutgers University Press, 2006).

1. Hoyt Fuller, "Towards a Black Aesthetic," in Addison Gayle, ed., *The Black Aesthetic* (New York: Anchor Books, 1972; originally published 1971), 8 (first published in *The Critic*, 1968).
2. Kalamu ya Salaam, "The Black Arts Movement," in William L. Andrews, Frances Smith Foster, and Trudier Harris, eds., *The Oxford Companion to African American Literature* (New York: Oxford University Press, 1997), 71. See also Elizabeth J. West, "Black Nationalism," in Andrews, Foster, and Harris, eds., *The Oxford Companion to African American Literature*, 75–79.
3. David Lionel Smith, "The Black Arts Movement and Its Critics," *American Literary History* 3 (1) (1991), 99.
4. Ibid.
5. AfriCobra (African Commune of Bad Relevant Artists) grew out of the multidisciplinary artists collective OBAC (Organization of Black American Culture), which was

responsible for the well-known public mural *Wall of Respect* (1967). Early members of AfriCobra were Jeff Donaldson, Jae Jarrell, Wadsworth Jarrell, Barbara J. Jones, Gerald Williams, Napoleon Henderson, Nelson Stevens, Sherman Beck, Omar Lama, Howard Mallory Jr., and Carolyn Lawrence. See Jeff Donaldson, "Ten in Search of a Nation," *Black World* 19 (12) (1970), 80–89. Mary Schmidt Campbell, *Tradition and Conflict: Images of a Turbulent Decade* (New York: Studio Museum in Harlem, 1988), provides a wonderful overview of visual art and Black Arts Movement practice. However, her study focuses mostly on the East Coast. For a more profound discussion of West Coast aesthetics and the Black Arts Movement see Lizzetta LeFalle Collins, *19Sixties* (Los Angeles: California Afro-American Museum, 1989).

6. Although numerous sources have written that US stood for "United Slaves" new scholarship by Scot Brown has confirmed that the name signifies "us Blacks as opposed to 'them' whites." Scot Brown, "The US Organization, Black Power Vanguard Politics, and the United Front Ideal: Los Angeles and Beyond," *The Black Scholar* 31 (3–4) (2001), 21.

7. Robin D. G. Kelley, *Freedom Dreams: The Black Radical Imagination* (Boston: Beacon Press, 2002), 74–75. United States scholar Scot Brown dates Everett/Karenga's involvement with the Afro-American Association to 1963; Brown, "The US Organization," 23.

8. Emory Douglas, "On Revolutionary Art" (1970), quoted in Erika Doss, "'Revolutionary Art Is a Tool for Liberation': Emory Douglas and Protest Aesthetics at the *Black Panther*," in Kathleen Cleaver and George Katsiaficas, eds., *Liberation, Imagination, and the Black Panther Party: A New Look at the Panthers and Their Legacy* (New York: Routledge, 2001), 175 (originally published in *New Political Science*, 1999).

9. Ron Karenga, "Black Cultural Nationalism," in Gayle, *The Black Aesthetic*, 32 (first published in *Black World*, 1968).

10. Ibid. David Lionel Smith has pointed out that these views really reveal Marxist-Leninist roots on both accounts. David Lionel Smith, "Black Arts Movement," in J. Salzman, David Lionel Smith, and Cornel West, eds., *Encyclopedia of African American Culture and History*, vol. 5 (New York: Macmillan Library Reference, 1996), 327.

11. See Kalamu ya Salaam cited in note 2 and Larry Neal, "The Black Arts Movement," in Gayle, *The Black Aesthetic* (first published in *The Drama Review*, 1968).

12. Elijah Muhammad's Chicago-based Nation of Islam provided another strong philosophical cornerstone, as did the Revolutionary Action Movement out of Cleveland. See Salaam cited in note 2; Kelley, *Freedom Dreams*, chapter 3.

13. Miwon Kwon, "One Place after Another: Notes on Site Specificity," *October* 80 (spring 1997): 85–110.

14. Ibid, 95.

15. Henri Lefebvre, *The Production of Space*, trans. Donald Nicholson-Smith (Oxford: Blackwell, 1995, originally published 1974), 11.

16. For an illuminating discussion of Foucault's concept of heterotopia see Edward Soja, "History: Geography: Modernity," in Simon During, ed., *The Cultural Studies Reader* (New York: Routledge, 1993), 143.

17. See Edward Soja, Rebecca Morales, and Goetz Wolff, "Urban Restructuring: An

Analysis of Social and Spatial Change in Los Angeles," *Economic Geography* 59 (2) (1983): 195–230; and Mike Davis, *City of Quartz* (London: Verso, 1990).

18. Saskia Sassen, "Whose City Is It? Globalization and the Formation of New Claims," in Okwui Enwezor, ed., *Trade Routes: History and Geography, 2nd Johannesburg Biennale, 1997* (Johannesburg: Greater Johannesburg Metropolitan Council, 1997), 61 (first published in *Public Culture*, 1996).

19. At mid-century there was a meteoric increase in African American residents as migrants came to Los Angeles lured by the employment opportunities of the war industry. By 1943 about 10,000 African Americans per month were arriving in the city; in 1940 the African American population of Los Angeles was 124,306, and by 1950 it was 462,172. Statistics taken from Lawrence B. de Graff and Quintard Taylor, "Introduction: African Americans in California History, California in African American History," in Lawrence B. de Graff, Kevin Mulroy, and Quintard Taylor, *Seeking El Dorado: African Americans in California History* (Seattle: University of Washington Press, 2001), 27–28.

20. White's students during this period included David Hammons, Suzanne Jackson, Alonzo Davis, Dan Concholar, and Timothy Washington. For more on African American artists in Los Angeles during the 1950s see William Pajaud, *African American Artists of Los Angeles: William Pajaud* (Los Angeles: Oral History Program of the University of California, 1993); Curtis Tann, *African American Artists of Los Angeles: Curtis Tann* (Los Angeles: Oral History Program of the University of California, 1995); Betye Saar, *African American Artists of Los Angeles: Betye Saar* (Los Angeles: Oral History Program of the University of California, 1996); and Andrea Barnwell, *Charles White* (Petaluma, Calif.: Pomegranate, 2002).

21. Brown, "The US Organization," 22. See also John Riddle, *African American Artists of Los Angeles: John Riddle* (Los Angeles: Oral History Program of the University of California, 2000), 15; and Ruth Waddy, *African American Artists of Los Angeles: Ruth Waddy* (Los Angeles: Oral History Program of the University of California, 1993).

22. See Lucinda H. Gedeon, ed., *Melvin Edwards Sculpture: A Thirty Year Retrospective, 1963–1993* (Purchase, N.Y.: Neuberger Museum of Art, State University of New York at Purchase, 1993); and Jayne Cortez, "Jayne Cortez, in Her Own Words," in *Watts, Art and Social Change in Los Angeles, 1965–2002* (Milwaukee: Haggerty Museum of Art, Marquette University, 2002), unpaginated.

23. Budd Schulberg, ed., *From the Ashes: Voices of Watts* (New York: New American Library, 1967). This volume was preceded by a special issue of the *Antioch Review*, Budd Schulberg, ed., "Watts Writers Workshop," *Antioch Review* 27 (3) (1967): 274–416.

24. Troupe's poems appeared in *Paris Match* in 1964. Horace Coleman, "Quincy Thomas Troupe, Jr.," in Trudier Harris and Thadious M. Davis, eds., *Afro-American Poets since 1955* (Detroit: Gale Research, 1985), 335.

25. Quincy Troupe, ed., *Watts Poets: A Book of New Poetry and Essays* (Los Angeles: House of Respect, 1968).

26. The word "ark" was employed by Tapscott for its biblical connotations, to suggest the gathering together and preserving of the world's black musics. Sun Ra—who was the first to form an "arkestra" dedicated to avant-garde black music in 1953— was also a positive example. The founding members of the Pan Afrikan People's

Arkestra included Linda Hill, Lester Robertson, David Bryant, Alan Hines, Jimmy Woods, and Guido Sinclair along with Tapscott. A list of many of the members of the Arkestra and the larger organization, Union of God's Musicians and Artists Ascension (UGMAA), appears in Horace Tapscott, *Songs of the Unsung*, ed. Steven Isoardi (Durham: Duke University Press, 2001), 217–20.

27. Bruce M. Tyler, "The Rise and Decline of the Watts Summer Festival, 1965 to 1986," *American Studies* 31 (2) (1990): 63.

28. Brown, "The US Organization," 21.

29. Victor W. Turner, *The Ritual Process: Structure and Anti-Structure* (1969), quoted in Tyler, "The Rise and Decline of the Watts Summer Festival," 63.

30. At the time Malcolm X was still seen as a traitor by the Nation of Islam and thus this commemoration was seen as a challenge to the older organization. Brown, "The US Organization," 24.

31. Despite their opposition, both the Los Angeles Police Department and the Fire Department had recruitment booths at the festival as did many government agencies. Tyler, "The Rise and Decline of the Watts Summer Festival," 62, 64–65.

32. See the website of wattstowers.net.

33. Part of Purifoy's interest as well was how art related to the life of the mind. Inspired by his readings in psychology and philosophy as well as his earlier profession as a social worker, Purifoy saw art as a tool of psychotherapy, as way to reintegrate the mind and body. It is interesting how Purifoy's practice mirrors that of Lygia Clark of Brazil whose object making led her to a psychotherapy practice during roughly the same period. See Lygia Clark and Yves-Alain Bois, "Nostalgia of the Body," *October* 69 (summer 1994): 85–109.

34. Noah Purifoy, *African American Artists of Los Angeles: Noah Purifoy* (Los Angeles: Oral History Program of the University of California, 1992), 42.

35. Noah Purifoy as told to Ted Michel, "The Art of Communication as Creative Act," in *Junk Art: "66 Signs of Neon"* (Los Angeles: 66 Signs of Neon, c. 1966).

36. Ibid. As evidenced by the catalogue, the artists involved in the project were a multiracial group including Frank Anthony, Debby Brewer, David Mann, Max Neufeldt, Judson Powell, Noah Purifoy, Leon Saulter, Arthur Secunda, Ruth Saturensky, and Gordon Wagner. There were additional collaborators on the catalogue. Purifoy mentions that the show toured until 1969. The pieces (and artists) were substituted when something was sold or fell apart so the exhibition was always changing. Purifoy, *African American Artists of Los Angeles: Noah Purifoy*, 90–92. Although not noted in the catalogue or in Purifoy's recollection in his oral history, John Riddle claims he took part in the exhibition as well. Riddle, *African American Artists of Los Angeles: John Riddle*, 117.

37. Samella Lewis, *African American Art and Artists* (Berkeley: University of California Press, 2003 [1990]), 198.

38. Riddle, *African American Artists of Los Angeles: John Riddle*, 123.

39. Ibid., 124.

40. Elaine Woo, "Obituaries—John Riddle, Jr.: Artist and Curator," *Los Angeles Times*, March 9, 2002, B17.

41. Outterbridge quoted in Curtis L. Carter, "Watts: The Hub of the Universe: Art and

Social Change," in *Watts, Art and Social Change in Los Angeles, 1965–2002* (Milwaukee: Haggerty Museum of Art, Marquette University, 2002), 10.

42. John Outterbridge, *African American Artists of Los Angeles: John Outterbridge* (Los Angeles: Oral History Program of the University of California, 1993), 362.

43. Outterbridge, *African American Artists of Los Angeles: John Outterbridge*, 243.

44. John Szwed, *Space Is the Place: The Life and Times of Sun Ra* (1977), cited in Jane H. Carpenter with Betye Saar, *Betye Saar* (Petaluma, Calif.: Pomegranate, 2003), 18.

45. Although she had focused on interior design in college, this growing tendency toward the theatrical in Saar's art can be linked to her employment as a costume designer for theater productions at the Inner City Cultural Center in Los Angeles. Carpenter and Saar, *Betye Saar*, 33.

46. Ibid., 25.

47. Ibid., 43.

48. Gerald Horne, "Black Fire: 'Riot' and 'Revolt' in Los Angeles, 1965 and 1992," in de Graff, Mulroy, and Taylor, *Seeking El Dorado*, 382. Horne cites Eldridge Cleaver, *Soul on Ice* (1968).

49. Other African American artists groups that formed during this period include Kamoinge Workshop (1961), Spiral (1963), Weusi (1967), Women Students and Artists for Black Liberation (1970), Where We At (1971), all in New York; and Organization of Black Culture (1967) in Chicago.

50. Cecil Fergerson, *African American Artists of Los Angeles: Cecil Fergerson* (Los Angeles: Oral History Program of the University of California, 1996), 140.

51. In an interesting parallel, protests by the Black Emergency Cultural Coalition in New York resulted in a number of solo exhibitions as well as a group show by African Americans at the Whitney Museum of American Art in New York during this same period.

52. Curated by Ebria Feinblatt, head of the Department of Prints and Drawings, and the departmental assistant Joseph E. Young, this was the only one of the shows that relied on in-house curators; it later traveled to the Santa Barbara Museum of Art.

53. Suzanne Jackson, *African American Artists of Los Angeles: Suzanne Jackson* (Los Angeles: Oral History Program of the University of California, 1998), 253–54.

54. Alonzo Davis, *African American Artists of Los Angeles: Alonzo Davis* (Los Angeles: Oral History Program of the University of California, 1994), 133.

55. At the time Brockman Gallery opened in 1966 Alonzo was a teacher at Crenshaw High School. After leaving that position in 1970 and before being able to work full-time at Brockman in 1976 he taught as an adjunct at various colleges and universities including Mount Saint Antonio College, Pasadena City College, UCLA, California State University at Northridge, and Otis Art Institute.

56. The gallery took its name from the apartment suite number 32; Jackson was inspired by the precedent of Alfred Stieglitz's modernist gallery 291. Jackson, *African American Artists of Los Angeles: Suzanne Jackson*, 253.

57. Ibid., 256–57.

58. She was harassed on tax issues and even jailed for parking violations. Ibid., 150–53, 134.

59. E. J. Montgomery, who had been active in Los Angeles art networks in the 1950s

and early 1960s, moved to the Bay Area in 1965. By 1967 she had founded an African American artists advocacy group there after Waddy's example, calling it Art West Associated North. Paralleling Lewis's hire at LACMA, Montgomery joined the staff of the Oakland Museum in 1968, as an "ethnic art consultant," a position she held through 1974 and under the guise of which she curated eight exhibitions. Samella Lewis, interviewed by Richard Candida Smith in *Image and Belief* (Los Angeles: Getty Research Institute for the Arts and Humanities, 1999), 199–201; and E. J. Montgomery, interview with the author, May 18, 2003.

60. Lewis states that upon moving to Pico Boulevard The Gallery changed its name to Gallery Tanner. However, Kinshasha Conwill recalls the name as The Gallery even on Pico Boulevard. Kinshasha Conwill, *African American Artists of Los Angeles: Kinshasha Conwill* (Los Angeles: Oral History Program of the University of California, 1996), 62. Further archival research will uncover more detailed information about these galleries and the exhibitions and other activities that took place there.

61. A significant early gift was a collection of more than fifty works by early modernist painter Palmer Hayden, donated by his widow. After a decade Lewis and Hewitt relinquished all control of the museum.

62. *Art: African American* was first published in 1978 by Harcourt, Brace and Jovanovich. A second edition was published by the University of California Press in 1990 under the title *African American Art and Artists*; this version was updated in 2003. Interestingly, though Lewis provided the field with its major contemporary text, she has never taught African American art. Instead her teaching has focused on Asian, Native American, and African art. Lewis interviewed by Candida Smith in *Image and Belief*, 204.

63. John Chandler and Lucy R. Lippard, "The Dematerialization of Art," *Art International*, February 20, 1968, 34–35.

64. Judith Wilson, "In Memory of the News of Ourselves: The Art of Adrian Piper," *Third Text* 16–17 (autumn–winter 1991), 39.

65. See Kristine Stiles, "Between Water and Stone, Fluxus Performance: A Metaphysics of Acts," in Elizabeth Armstrong and Joan Rothfuss, eds., *In the Spirit of Fluxus* (Minneapolis: Walker Art Center, 1993), 92.

66. Rita Eder, "Razón y sin razón del arte efímero: algunos ejemplares latinoamericanos," *Plural* 8 (90) (second epoch) (1979), 28 (translation mine).

67. Joseph E. Young, "Three Graphic Artists," in *Three Graphic Artists: Charles White, David Hammons, Timothy Washington* (Los Angeles: Los Angeles County Museum of Art, 1971), 7.

68. Hammons learned this technique at Chouinard Art Institute. He never actually took this class but witnessed the demonstration as he passed by the room. David Hammons, personal communication, December 10, 1996.

69. Hammons, personal communication.

70. See David Hammons interviewed by Kellie Jones, *Real Life Magazine* 16 (autumn 1986), 4.

71. Houston received his MFA in 1976. Kinshasha received an MBA in arts management in 1980.

72. Judith Wilson, "Creating a Necessary Space: The Art of Houston Conwill, 1975–1983," *International Review of African American Art* 6 (1) (1984), 50.

73. Ceremonial stools are part of every aspect of traditional life among Akan peoples, including ceremonies marking puberty, death, birth, and marriage. They become objects through which ancestors are venerated. Most visibly the stool is a symbol of state power; political leaders' rise and fall are marked by the terms "enstooled" and "destooled" respectively. See Herbert M. Cole and Doran H. Ross, *The Arts of Ghana* (Los Angeles: Museum of Cultural History, University of California, 1977).

74. Linda Goode Bryant and Marcy S. Philips, *Contextures* (New York: Just Above Midtown, 1978), 64.

75. Senga Nengudi, telephone interview with the author, June 3, 1996; and Maren Hassinger, telephone interview with the author, May 29, 1996. Bill T. Jones touches on this issue in "You Don't Have to Be Thin to Dance," *New York Times*, July 19, 1997, A19.

76. Maren Hassinger quoted in "Maren Hassinger," *International Review of African American Art* 6 (1) (1984), 40. This sense of process work as an initiatory practice is raised by Sandy Ballatore, "Hassinger and Mahan: Works in Transition," *Artweek*, (September 4, 1976), 4.

77. Hassinger, telephone interview.

78. Hassinger quoted in "Maren Hassinger," 40.

79. In the upper right-hand corner of a photograph documenting the action, we see a work from Hammons's series called "Greasy Bags and Barbecue Bones," a set of "collages" composed of oil-stained brown paper bags with spareribs (licked clean), hair, and glitter. Hanging from the wall on the upper left is a Persian carpet, clearly the seeds of his *Flying Carpet* (1990) planted years before. Thanks to Maren Hassinger for pointing these works out to me. See the catalogue *Maren Hassinger, 1972–1991*, Hillwood Art Museum, Long Island University/C. W. Post Campus, Brookville, N.Y., 1991.

80. Nengudi completed both her BA and MA at California State University, Los Angeles, finishing in 1971.

81. Hammons interviewed by Jones, 2.

82. Goode-Bryant and Philips, *Contextures*, 45.

83. Nengudi, telephone interview. Maren Hassinger has pointed out that a version of Studio Z performed together until 1986. Between 1982 and 1983 the group met at the studio of Ulysses Jenkins on Vermont Avenue and included Rudy Perez and May Sun. Though the initial place where Studio Z gathered was David Hammons's studio, during that period he was back and forth between New York and Los Angeles and performed with the group rarely; Hassinger, telephone interview. This was also confirmed by David Hammons, personal communication.

84. CETA stood for the Comprehensive Employment and Training Act. In effect from 1974 to 1983, this job-training program used federal block grants for locally targeted programs, which were often aimed at underemployed populations (such as artists). Most programs with creative sections focused on utilizing their artist-employees as "resources," tapping their painting, graphic, writing, and theatrical skills for a broad

range of publicly directed activities. Suzanne Jackson—artist and former proprietor of Gallery 32—coordinated Brockman's CETA projects for a while. "Professional Artist Employment Program Gets Underway at Brockman Gallery Productions," *Black Art* 2 (1) (1977), 68. On CETA see Grace A. Franklin and Randall B. Ripley, *C.E.T.A. Politics and Policy 1973–1982* (Knoxville: University of Tennessee Press, 1984); and Steven C. Dubin, "Artistic Production and Social Control," *Social Forces* 64 (3) (1986), 667–88.

The term "Fets" was short for Fetishes. Fetish is a word that comes with a lot of baggage, especially when applied to the African context. Within a colonial framework it was used in a disparaging manner to identify African religious articles. Certainly the confluence with psychoanalytic meaning—as an object that elicits erotic desire—is not simply fortuitous.

85. Henry Drewal and Margaret Thompson Drewal, *Gelede, Art and Female Power: The Yoruba* (Bloomington: Indiana University Press, 1990); and Robert Farris Thompson, *Flash of the Spirit* (New York: Random House, 1983).

86. Nengudi, telephone interview.

87. Kinshasha Conwill, *African American Artists of Los Angeles: Kinshasha Conwill*, 62–65; Melinda Wortz, "Meditations on Death," *ArtNews*, November 1978, 154, 159; Suzanne Muchnic, "JuJu Ritual—Cycles of Life" *Artweek*, February 25, 1978, 4. Even though Kinshasha speaks of winding down her own art-making practice during this time, she is interviewed about it in Barbara McCullough's film *Shopping Bag Spirits*, which was released in 1979. The couple also collaborated on a mural for St. Augustine Church in Houston's hometown of Louisville, Kentucky, in 1974.

88. Kinshasha Conwill, *African American Artists of Los Angeles: Kinshasha Conwill*, 75–77.

89. Jackson, *African American Artists of Los Angeles: Suzanne Jackson*, 153.

90. Salaam, 74.

91. Ntozake Shange cited in Alan Read, ed., *The Fact of Blackness: Frantz Fanon and Visual Representation* (Seattle: Bay Press, 1996), 159.

92. Elizabeth Alexander has brilliantly argued this same point. She demonstrates that many of the black female literary figures that supposedly "emerge" after 1970 were, in fact, writing and publishing in the 1950s and 1960s including Paule Marshall, Audre Lorde, Adrienne Kennedy, Lucille Clifton, and Alice Walker. Elizabeth Alexander, *The Black Interior* (St. Paul, Minn.: Graywolf Press, 2004), 61–65.

93. William J. Harris, "Black Aesthetic," in Andrews, Foster, and Harris, *The Oxford Companion to African American Literature*, 69.

94. Harryette Mullen, "The Black Arts Movement," in Valerie Smith, ed., *African American Writers*, vol. 1, second edition (New York: Charles Scribner's Sons, 2001), 57.

95. Farah Jasmine Griffin, *"Who Set You Flowin'?" The African American Migration Narrative* (New York: Oxford University Press, 1995).

Brothers and Sisters

Houston Conwill, *Juju*, 1975–1978 (detail). Mixed-media installation, dimensions variable. Courtesy the artist. Photo credit: Stanley Gainsforth.

"Ritual is an action word," declares David Hammons as he moves methodically between one unassuming pile of rubble and another, physically articulating a performance that is true to his word; back and forth he paces, trying to hide the long cord of the otherwise well-hidden microphone that snakes subtly behind him. Hammons addresses interviewer and director Barbara McCullough in the latter's compelling film *Shopping Bag Spirits and Freeway Fetishes* (1979). Conceived as a meditation on African American art and ritual, McCullough's film looks at the production of poets and musicians but dedicates most of the film to visual artists. In his ruminations, Hammons refers again and again to the work of Betye Saar. While Saar never took the leap into performance art, her amazing juxtapositions of objects and traditions and spiritual systems seemed to suggest it.

On film Hammons focuses on Saar's evocative *Spirit Catcher* (1976–1977). Created from various natural fibrous elements—rattan, basketry, gourds, wood, and rope—it is a small tower, similar in ways to other more familiar ones: the biblical Tower of Babel, Vladimir Tatlin's *Monument to the Third International* (1919–1920), and those created by Simon Rodia in the Watts section of Los Angeles in the middle of the twentieth century. Saar has said her piece was based on an object from the South Pacific, though she overlaid it with items from Nigeria, Mexico, and Haiti.[1] The original model was meant to attract positive life forces and screen out unwanted energy. The open network and intersecting verdant forms of *Spirit Catcher* re-created the sense of such powers flowing through the sculpture. This represented a shift from the solid containers—boxes and window frames—which had previously ordered her compositions. The idea of movement in, around, and through the piece, and the notion of art activated by events in the world, also suggested the performative. For many younger artists, such as Hammons, Houston Conwill, Senga Nengudi, and Maren Hassinger, multimedia and dematerialized sculptural practices led them to the welcoming shores of performance art in the 1970s. In *Shopping Bag Spirits and Freeway Fetishes*, Houston Conwill also invokes Saar's oeuvre as a crucial example of the type of practice he is striving for. The same year that the film was released Conwill interviewed Saar for the journal *Black Art*, founded by another impressive woman and tireless cultural worker in the Los Angeles scene, Samella Lewis.[2] In Conwill's introduction he addresses Saar as a "high priestess" and calls her works nothing less than magnificent "tabernacles" for the spirit.

Conwill and Hammons's elevation of Saar to the status of important artistic forbearer is telling on a number of levels. By the late 1970s Saar was perhaps the most well-known African American artist of that era working in a style that had its roots in California assemblage; yet her work had taken off in a direction that was seemingly more dispersed and freewheeling as well as somehow materially in touch with a larger world. She had also had important solo museum shows on both East and West Coasts, including at the Whitney Museum of American Art and the San Francisco Museum of Modern Art. Saar's works embodied a move from art created under the rubric of the Black Arts Movement and its adherence to Black Nationalist parameters—evocation of heroes, families, and African heritage—cast for the most part as patriarchal privilege, and a dematerialized practice that incorporated feminist concerns, and paralleled writings by the likes of Toni Cade Bambara and Ntozake Shange. As Paul Gilroy has noted, after 1969, as the violent backlash against Black Power took its toll in human lives, direct discussions of this kind of activism in music were replaced by the notion of searching for an African spiritual home.[3] Saar's interest in sacred systems reflects this same shift.

Betye Saar's dialogue with David Hammons in particular seems to begin in the 1960s. A pair of works—Hammons's *Black Boy's Window* (1968), and Saar's *Black Girl's Window* (1969)—tell the tale. In Hammons's piece the conjunction of a window frame and one of Hammons's body prints take us to the space of separate but equal, or even to jail, as the bar-like structure of the window grill placed over the figurative element accentuates both exclusion and containment. The boy's hands are raised, either banging for entry or held high in a posture of surrender ("no, I don't have a gun"). Saar's work also uses a window frame to organize compositional structure. Though hers was made the year after Hammons's, she had begun using this element as early as 1966. *Black Girl's Window*, however, represents the reinscription of the recognizable black self after its disappearance for a number of years. Saar's girl also holds her hands against an invisible windowpane seeming to peer out, perhaps "into her future."[4] Her palms are inscribed with mystical symbols some of which are reiterated in smaller panes above. Saar's piece is more otherworldly and elusive, a meditation on black biography and autobiography that is not as forthright and didactic as Hammons's take. Her assemblage is delicately polychromed while his emphasizes the contrasting black white of the print, and the bars and weathered wooden surface of the window.

Hammons's *Black Boy's Window* also retained a window shade with a pull as if one could just as easily shut out what was going on with African

America in 1968. The implied motion pointed as well toward the artist's performance practice that would develop later. In 1970 Saar also created a piece that incorporated a similar window treatment. *Self Window with Reflection* (1970) offers four portraits of herself. Here she also limits her palette to black, white, and gray as if this restricted range of tones allowed one to focus more clearly on the subject of race. The figure in deep black mirrors that of *Black Girl's Window*. In the later work, however, that persona is covered up by the shade; lifting this element reveals another image of the artist outlined in pencil which thus allows the figure to read as white. Saar's multiple portraits also allude to performance, but one explored through the theoretical constructs of feminist theory.

The dialogue between Saar and Hammons here is quite clear, from their titles, to the central figurative/autobiographical form, and the found frame. Both are mixed-media assemblages. Yet Saar makes more use of painting and collage while Hammons's two-dimensional component is a print. The process he used for such graphics is now well known: he coated his body with grease, presses up against board or paper, then applied pigment to the oil-saturated area, creating a positive image. Such body prints represent Hammons's first mature art language. They were quite popular and sold well. Figurative and usually carrying clear political messages, they fit in easily with the push for didacticism and black self-reflection prescribed by the climate of the Black Arts Movement. These works in two dimensions grew out of Hammons's training in advertising art as well as his studies with Charles White. By the early '60s, White was one of a handful of well-known African American artists, like Jacob Lawrence and Elizabeth Catlett, who had made their marks in the 1930s and 1940s with social realist styles and themes that revolved around black history and politics.

Most of White's work was on paper, large sensual drawings and lyrical prints that caressed the contours and details of black bodies as had seemingly never been done before. Though originally from Chicago, White spent much of his career in New York before moving to Southern California in 1956. From 1965 into the late 1970s he taught drawing at the Otis Art Institute where young artists like Hammons, Suzanne Jackson, Dan Concholar, Alonzo Davis, and later Kerry James Marshall studied with him. Hammons's graphic bent and his keenly articulated figures clearly show White's influence. Yet he also incorporated assemblage early on, often as frame, as in *Black Boy's Window* or *Injustice Case* (1970). But as the work moved into the 1970s dematerialized practices like those articulated by Betye Saar took hold.

In 1973 Saar and Hammons traveled together to the annual meeting of

the National Conference of Artists (NCA), a professional organization of African American creators first organized in 1959. The conference was held in Chicago and while there Hammons and Saar visited the famous Field Museum. In their meanderings they happened upon an amazing hunter's shirt from Cameroon. Upon closer inspection the textured beauty of the garment was created by small hairballs that were sewn in place. As a result of this encounter Hammons ended up working with black hair for the rest of the decade. Saar's work began to focus on the altar form, becoming larger and concerned with more fully conceptualized and experienced three-dimensional form.[5]

At the Field Museum Saar and Hammons looked at a wide variety of things from many places, not only African objects. Though this was her first trip out of Los Angeles, for some time Saar had been fascinated by and engaged with Asian and Oceanic cultures as well as alternative Western metaphysical practices such as palmistry. And this was another compelling reason younger artists were drawn to Saar's work, because her interest in spiritual and mystical realms always brought them in contact with customs from all parts of the world. If the rhetoric of the Black Arts Movement made the focus on things African American and African constricting at a certain point, Saar's example bespoke a larger sphere of influence that at the same time did not forget or displace African-descended cultures.

As I have written elsewhere, Hammons's strategies of incorporating black hair into his artworks in the 1970s mostly appropriated forms associated with women's popular aesthetics, from the dominance of female salon culture, living verdant gardens, to quilts and woven textiles.[6] During this period Hammons "planted" temporary and ephemeral hair gardens in outdoor locales in the damp sand along the shores of Southern California beaches. They were saltwater grasses, somehow hybrid cattails familiar yet out of place, too close to the water's edge, strangely shaped yet seeming to bend in the cool ocean breeze. But these "gardens" also took root inside. These appear not just on the West Coast but in the Southwest and the East as if the spores had flown throughout the country, making an apparent reverse migration along the routes black people had traveled earlier in the century. Between 1975 and 1977, we find documentation of Hammons's indoor projects for hair gardens. At his Slauson Avenue studio in South Central Los Angeles circa 1975, one sprouts in the corner perhaps issuing from debris having landed there. Like the beach gardens these pieces emanate from below, seeming to grow upwards out of the wood of the floorboards. The following year, that of the U.S. bicentennial, the Just Above Midtown Gallery in New York announced its second solo show by Hammons called

the "Dreadlock Series."[7] In addition to hair gardens Hammons also presented wall drawings. Rather than threading hairballs on dowels as he did to create the floor-based, free-standing pieces, here he strung them on rubber bands, which were stretched along the walls and affixed at various points.

The proprietor of Just Above Midtown Gallery was the savvy and energetic Lynda Goode-Bryant. A former employee of both the Metropolitan Museum of Art and the Studio Museum in Harlem, Goode-Bryant created this new venue to provide an alternative for African American artists whose work was pushing boundaries and not necessarily welcome in strictly Black Nationalist settings. Intent on becoming a practicing artist herself at a young age, she changed her mind after being exposed to the work of David Hammons in a course taught by curator Edmund "Barry" Gaither at her alma mater, Spelman College.[8] She eventually met Hammons and a cadre of Los Angeles folks at the 1973 NCA Conference in Chicago. The following year Goode-Bryant opened Just Above Midtown Gallery to great fanfare on West Fifty-seventh Street, New York's elite gallery row. She launched her space with the exhibition "Synthesis" which along with Hammons included the Los Angeles–based artists Dan Concholar, Suzanne Jackson, Alonzo Davis, and RoHo.

Just Above Midtown (later Just Above Midtown/Downtown, affectionately known as JAM) operated in various locations through 1986. Similar to Alonzo and Dale Davis's Brockman Gallery in Los Angeles, JAM began as a commercial venture and later changed to nonprofit status after it became clear that a black audience was not necessarily running to support the gallery through purchases. In any case, the nontraditional multimedia work favored by Goode-Bryant was not easily salable. It was JAM that introduced the work of the black West Coast to New York on a large scale and in a consistent manner, allowing these aesthetics to infiltrate the East.[9]

Linda Goode-Bryant and JAM presented solo shows by Hammons in 1975, 1976, and 1977. In each he incrementally developed his language with black hair. In the 1975 New York exhibition, the substance primarily played a decorative role as subtle accents adorning Hammons's "greasy bag art" even though by that time he was already creating the gardens in Los Angeles. The function hair plays in these works is akin to its task in the Cameroonian hunter's shirt that Hammons had encountered two years earlier. Like similar vestments for hunting and war in West and Central Africa, such additions of hair, bone, claws, or leather amulets containing medicines or koranic texts are meant to empower and protect the wearer.[10] With Hammons's 1976 show, hair "sculpture gardens"[11] bloomed on the floors and

walls of the gallery. The following year the artist had two solo exhibitions, one at JAM and the other in Atlanta, Georgia.

Hammons was invited to Atlanta by John Riddle, director of the Neighborhood Art Center and a veteran of the Los Angeles art scene. Like a number of African American artists working on the West Coast during that era, including Betye Saar, John Outterbridge, and Noah Purifoy, Riddle worked with assemblage and like many of his colleagues his practice was further inspired by the rebellion in Watts, both in the attitude taken toward the creation and dissemination of art itself as well as its very materiality. Riddle too worked with materials found in the remnants of the rebellion.[12] The relationship between Hammons and Riddle and their families was a close one; Hammons's daughter was even named Carmen in homage to Riddle's wife.

Riddle arrived in Atlanta in 1974 and took up the helm of the Neighborhood Art Center shortly thereafter. His move into the role of administrator and curator parallels a similar direction on the part of a number of artists in Los Angeles: Outterbridge accepted the leadership role at the Watts Tower Arts Center and Purifoy was named to the California Arts Council during this same period. On the one hand, these positions represented growing governmental support of the arts in this moment, a revival of the Arts Centers movement supported under the WPA; on the other hand it was indicative of the burgeoning alternative space movement.[13] It also more broadly reflects the will of artists in the modern United States to create their own places to show when traditional venues would not support them; examples include Alfred Steiglitz's 291 begun in New York in 1905, the Ferus Gallery in Los Angeles started by Walter Hopps and Ed Kienholz in the late 1950s, and a host of independent African American–run spaces including JAM, Brockman Gallery, and others which appeared in the 1960s and 1970s.

David Hammons titled his Atlanta exhibition "Nap Tapestry: Wire and Wiry Hair." In an image advertising the show we see how he has pushed his experiments with hair even further. Hammons stands in the middle of his creation; pieces shoot from the floor and dance along the wall behind him. Dowels and rubber bands have been replaced with wire allowing for greater articulation of the linear form in rounded curves, sharp angles, or delicate curlicues. We also recognize in the show's title the linguistic element which has been ever present and important to Hammons from the beginning. The conflation of "wire"—a flexible though hard metal substance—and "wiry hair"—a textured physical attribute of the black body—emphasizes the dissonance between these two positions as well as their similarities. It also

underscores Hammons's insistence on viewing black hair as an amazing sculptural material and finding in that a celebration of black life.[14] Such concepts, of course, black women have known for centuries.

What Hammons had also developed by 1977 was "Nap Tapestry," textile-like wall pieces formed by embedding hair in wire mesh screens. Their geometric surfaces approximated weaving and evoked African American quilt culture. These works also suggested the creativity of women and Western associations with craft and decorative arts generally. Indeed the incorporation of such "non-high art forms"[15] was part of the feminist art movement, accelerating art's dematerialization and making space for mixed media installations like Hammons's.

Betye Saar's example seemed to open the door to this type of art-making for Hammons and his West Coast colleagues. In her practice they saw the expansiveness of mixing media, broader connections to tradition, heritage, and spirit in an African American context. But perhaps even more importantly at that moment they could envision through Saar's work the concept of diaspora. Rather than a one-to-one relationship between black people in the United States and those in Africa, a window opened to peoples all over the globe, and metaphysical practices worldwide. Through Saar, one could acknowledge the tangibility of an international black culture, and African Americans' place in it. If feminist art and the example of Betye Saar provide an important point of departure for Hammons's mixed media work in the 1970s, so too did the art of the 1960s in general in styles such as conceptualism and process. As society's status quo was questioned so were traditional forms of art that represented the pinnacle of its culture. But at least since 1965 the example of the Watts rebellion had also had African American artists thinking about issues of materiality, practice, and meaning.

In 1978 Linda Goode-Bryant and Marcy S. Philips published *Contextures*, a breakthrough volume that is one of the first and continues to be one of the only books to attempt sustained discussion of African American abstract art-making. Reflecting the current creative climate (and Goode-Bryant and JAM's curatorial concentration), the publication focuses primarily on artists working in mixed-media installation. These practitioners utilized "remains"—things imbued with the marks of past actions and use—to fashion "contextural" sites, places of identification and memory.[16] Perhaps half of those featured developed their mature aesthetic in Los Angeles, including Houston Conwill, Melvin Edwards, Fred Eversley, David Hammons, Maren Hassinger, Suzanne Jackson, Senga Nengudi, and Betye Saar. It was this spirit and practice that Hammons would carry with him into the decades to come and into the next millennium.

NOTES

This essay is dedicated to my very own brothers and sisters, children of the 1960s and 1970s: Lisa Jones, Maria Jones, Dominique DiPrima, Vera Wilson, Wanda Wilson, Obalaji Baraka, Ras Jua Baraka, Amiri Baraka Jr., Ahi Baraka. And especially to our sister Shani Baraka. Gone too soon. May she rest in peace. Originally published in *Back to Black: Art, Cinema, and the Racial Imaginary* (London: Whitechapel Art Gallery, 2005).

1. Betye Saar in *Shopping Bag Spirits and Freeway Fetishes* (1979).
2. Houston Conwill, "Interview with Betye Saar," *Black Art* 3 (1) (1979): 4–15. This journal is still in existence and is now known as the *International Review of African American Art*.
3. Paul Gilroy, *Ain't No Black in the Union Jack* (London: Hutchinson, 1987), 178.
4. Jane H. Carpenter with Betye Saar, *Betye Saar* (Petaluma, Calif.: Pomegranate Communications, 2003), 20.
5. Betye Saar, *African American Artists of Los Angeles: Betye Saar* (Los Angeles: Oral History Program of the University of California, 1996).
6. Kellie Jones, "In the Thick of It: David Hammons and Hair Culture in the 1970s," *Third Text* 44 (autumn 1998), 17–24.
7. "David Hammons: Dreadlock Series," press release, Just Above Midtown Gallery, April 6–April 26, 1976.
8. Goode-Bryant had also received her MA from the City University of New York. Edmund "Barry" Gaither was the founding director of the Museum of the National Center of Afro-American Artists in Boston, another institution created to support African American artists during this period. Linda Goode-Bryant interviewed by Tony Whitfield, *Artist and Influence* 13 (1994), 13–27.
9. In addition to showing Hammons's work, JAM also presented solo shows by the following artists from Los Angeles: Senga Nengudi in 1977 and 1981; Houston Conwill in 1978 and 1983; and Maren Hassinger in 1980.
10. See Suzanne Preston Blier, *The Royal Arts of Africa* (New York: Harry N. Abrams, 1998), 130–31; and Roy Sieber, *African Textiles and Decorative Arts* (New York: Museum of Modern Art, 1972), 40–53.
11. "David Hammons: Dreadlock Series."
12. For more on African Americans and art-making during this period in Los Angeles see *19SIXTIES* (Los Angeles: California Afro-American Museum, 1989); and Kellie Jones, "Black West: Thoughts on Art in Los Angeles," in Margo Crawford and Lisa Gail Collins, eds., *New Thoughts on the Black Arts Movement* (New Brunswick: Rutgers University Press, 2005), 43–74.
13. For more on the alternative space movement see Julie Ault, ed., *Alternative Art New York, 1965–1985* (Minneapolis: University of Minnesota Press, 2002).
14. David Hammons interviewed by Kellie Jones, *Real Life* 16 (autumn 1986), 2–9.
15. Norma Broude and Mary D. Garrard, "Introduction: Feminism and Art in the Twentieth Century," in Norma Broude and Mary D. Garrard, eds., *The Power of Feminist Art* (New York: Harry N. Abrams, 1994), 10.
16. Linda Goode-Bryant and Marcy S. Philips, *Contextures* (New York: Just Above Midtown, 1978).

Bill T. Jones

Bill T. Jones and Arne Zane performing *Secret Pastures*, Walker Art Center auditorium, 1985. Courtesy Walker Art Center, Minneapolis.

In a recent article, Bill T. Jones considered classical ballet's adoration of the sylph as the veneration of a delicate body type that is excruciating for a dancer to achieve precisely because it is otherworldly. His own vision, on the other hand, was one of a more "earthy, casual, and familiar art," one in which dance "acts as a microcosm of society" filled with all sorts of peoples who inhabit all kinds of bodies. Those with a strong grasp of his own choreography were "sometimes ample in body, with large spirits, lively imaginations, who brought great verve and meaning to the stage."[1] In this description of the body in dance, Bill T. Jones subtly lays out the ever-shifting foundation of his own practice: the pull between purity and honesty, the collision of form and context.

In the beginning there was gesture, technique, the impact of contact improvisation, leveraged bodies, thrusting, moving, balancing in counterweight. Any body could move with (against?) any body. And so it was that a tall "athletic" black person and a short "muscular" white one came together: Bill T. Jones and Arnie Zane. They formed a partnership, creating a style based on spare constructivist moves, distillations of the lessons of modernism as it flowed through Martha Graham, Merce Cunningham, Yvonne Rainer, and on to Bill and Arnie. But also in the contact of their improvisation, they brought same-sex partnering to dance, they kissed, hugged, held, supported, propelled, and pushed each other away.

And in the beginning there was also verse and narrative, Bill and Arnie dancing to their own everyday dialogues and personal poetry, then to the admonitions of Jenny Holzer's *Truisms* (1977–1979), and later Bill alone creating movement to the words of Toni Morrison, Dylan Thomas, Kurt Schwitters's *Ursonate* (1932), and the prayers of his own mother. The text also brought with it its context, the testimony, the history of those making the dance. Or as Bill has brought out over and over again, the "we" in who we are. Who's talking? Whose truth?

In 1982 the Bill T. Jones/Arnie Zane Dance Company was born. What had started as a dialogue between two people blossomed into a collective built on a shared vocabulary of choreographic form. And yes, it was made with all sorts of peoples inhabiting all kinds of bodies, and filled with language and theatricality, grace and visualization. Even in the early duet *Blauvelt Mountain* (1980)—with its wall of 157 cinder blocks—visual icons had been there. Visual arts offered itself as both a primer and a system, the

organization of creative language (Arnie was a scholar of art history and a photographer). Then Robert Longo came and brought some meditations on architecture and physicality, Gretchen Bender added a steel edifice and kinetic video, and Keith Haring brought his own flamboyant painting to the set but also inscribed it on the body itself.

However, in the midst of all this exuberance and energy, growing visibility and success, touring the world, developing a discourse in dance that cast an eye toward the past but hungrily consumed the future, the guardians of modernism told them (again and again) that this type of drama, this type of production, was unacceptable. The "social" was not allowed, neither was the "political"—only purity, only form, no context to implicate "us." Iconoclasm may be the hallmark of modernism, but it's not done in that way. Let us show you.

And then, after seventeen years of moving together (sometimes in unison), the body of the short muscular half of their foundation, Arnie Zane, succumbed to AIDS. Bill himself was diagnosed as HIV-positive. In 1988, Arnie's fleshy frame had fled, but not his spirit. Infused by their collective animation, ignited by a choreographic vernacular that Bill and Arnie together had developed, Bill continued making works that would stun our sensibilities, creating gestures that would move our souls.

Refusing to be fettered by what he has called "the silver mask of modernism," Bill T. Jones has encouraged us to see and to understand, to look at undulating hips and see the traditions of popular movement and/or those of the African diaspora, not "inappropriate" form. To honor the truth of race, of sexuality, of loss, of history, of spirituality, of human endurance.

In a 1993 interview Bill T. Jones was asked how he, the child of farmworkers—whose labor and lack of formal education rang out with the vestiges of the African American's enforced servitude—became an "artist," a practitioner of concert dance, a resident choreographer of the Lyon Opera Ballet in France, a MacArthur Foundation "genius." "It seems paradoxical to say that my life, with all of its conflicts, prepared me more than anything for the world of art," he replied. Shuttling between the idioms and values of the rural black South and the white world of upstate New York, where he was raised and educated, gave him the skill of being able to speak in multiple, metaphoric languages. "I always assumed that the world was a place of struggle that had to be negotiated."[2]

In human perseverance, there is faith, the willingness to meet and overcome obstacles, whatever their guise. The strong, robust, and impeccable body of the dancer comfortably speaks of the ideal, the transcendent. Yet it can also be possessed by the spirit of our pain, shortcomings, and mortality.

In mirroring through form the questions and the possibilities of our society, the choreography of Bill T. Jones can "transport us to exquisite realms, but also give us back to ourselves."[3]

NOTES

First published in the exhibition catalogue *Art Performs Life: Cunningham/Monk/Jones* © 1998 (Minneapolis: Walker Art Center, 1998), June 28–September 20, 1998. Kellie Jones was co-curator of the exhibition.

1. Bill T. Jones, "You Don't Have to be Thin to Dance," *New York Times*, July 19, 1997, A19.
2. Eric K. Washington, "Sculpture in Flight: A Conversation with Bill T. Jones," *Transition* 62 (1993): 190–91.
3. Jones, "You Don't Have to be Thin to Dance," A19.

Abstract Expressionism

The Missing Link

Romare Bearden, *North of the River*, 1962. Canvas collage with oil, watercolor, ink, and graphite on canvas; 132.1 x 106.7 inches. Collection of The Studio Museum in Harlem, New York, Museum Purchase 1993. Art © Romare Bearden Foundation/ Licensed by VAGA, New York. Image courtesy the Romare Bearden Foundation.

The late 1940s through the 1950s are often characterized as the zenith years of American art. Irving Sandler's description of the period as "the triumph of American painting" recalls both this country's ascendancy in the Western art world and the creation of its own stylistically unique modernist art. Abstract expressionism is the familiar term by which we've come to know this loosely knit movement.

With the fall of Paris to the Nazis in 1940 the center of Western art moved to New York along with its artist (particularly surrealist) émigrés. Certain of their techniques and concerns, especially use of automatic writing and reliance on the unconscious, influenced the developing American school which also found inspiration in the "eternal symbols"[1] of myth, as the essence of human culture, and the traditions of Third World people. The search for an American nonobjective visual language included recognition of the spiritual basis and formally abstract concepts of traditions such as the African and Native American, as "authentic aesthetic accomplishments that flourished without benefit of European history."[2] The importance of African art in particular held special resonance for African American artists, of course, and in the interviews for this exhibition it is a point to which each of them returned.

Not necessarily stylistically uniform, mature (about 1948) abstract expressionism encompassed two general directions, gesture and color-field, and numerous variations on these themes. Gesture—as in the paintings of Jackson Pollock and Willem deKooning—was exemplified by dynamic, impulsive, painterly marks. Color-field artists, notably Barnett Newman, Ad Reinhardt, and Mark Rothko, created expanses of color which evoked an environment of the sublime. All abstract expressionists insisted on the flatness and two-dimensionality of the painted surface, though their actions seemed to extend beyond the large picture edge. Of the artists in this exhibition Romare Bearden, Norman Lewis, Thomas Sills, and Haywood Bill Rivers can be seen in terms of color-field tendencies, while Paul Keene, Ed Clark, Merton Simpson, Hale Woodruff, and John Rhoden are identified with gesture.

Abstract expressionist artists, though described as a group or school, could not agree on what bound them together. Yet there was a camaraderie, an American artistic milieu that developed (particularly in New York) where discussions and explorations of abstract process led to the develop-

ment of something new. Many came out of the federal art program of the Works Project Administration (WPA), which supported a budding American artistic community by providing time and money for artists such as Pollock, Rothko, Reinhardt, and Norman Lewis to work and experiment. Like many of the artists in the WPA, Norman Lewis was a member of the Artists Union as well. He also showed with American Abstract Artists, a group whose aims were to foster appreciation for abstract art generally and also specifically to support its American practitioners. Until the beginning of the 1950s, when he arrived at his mature style, Lewis experimented with figuration, geometric abstraction, and a calligraphic automatism. His development parallels that of nascent abstract expressionists who, prior to 1948, "worked in more or less linear and quasi figurative manners."[3]

During the '40s and '50s, Norman Lewis's paintings were shown in a number of important national and international exhibitions. Two of these were shows organized by the Carnegie Institute in Pittsburgh, a survey in the fall of 1944 called "Painting in the United States" and the Carnegie International of 1955 for which the artist's entry *Migrating Birds* (1953) won the popularity prize. His work was included in "American Artists Paint the City" organized by the Art Institute of Chicago as the United States entry for the Venice Biennial of 1956; Pollock, Mark Tobey, and Jacob Lawrence (the only other African American) were also among the thirty-five artists who participated. Of the few museum exhibitions during the period dedicated to post–World War II American abstraction, Lewis was shown in two, "Abstract Painting and Sculpture in America" at the Museum of Modern Art (1951) and "Nature in Abstraction" at the Whitney (1958).

Lewis joined Willard Gallery in 1946 which also represented painters Mark Tobey and Morris Graves and sculptors Richard Lippold and David Smith. Between 1949 and 1964 his eight solo shows there were all reviewed in one or more major publications, and a review of a 1954 group show at the Willard could easily have described Lewis's work alone: "An evanescent twilight mood prevails, where muted colors, fragile and vanishing lines create an atmosphere of hushed and mysterious reverie."[4]

Romare Bearden is primarily known for the exquisite collages he created (especially those on African American life) during the last twenty-five years of his career. Yet prior to "finding his voice" in collage, as a painter Bearden had experimented for more than two decades with methods from social realism to the purely nonobjective. Though he was not a participant in the WPA, he was part of other '30s groups such as the Harlem Artists Guild and "306." In 1945 his work was "discovered" by Caresse Crosby, a patron of Salvador Dali and the owner of G Place Gallery in Washington, D.C. Crosby

introduced his work to New York dealer Samuel Kootz, who gave Bearden a show in his newly opened gallery in 1945; that exhibition, Bearden's first solo in a commercial gallery in New York, was a near sellout.[5]

Largely working in watercolor, by the late '40s the artist had developed a style which while it acknowledged cubism was actually, as Lowery Sims has pointed out, a unique blend of arabesque line and washes of color that could (and did at times) each stand on its own.[6] From 1945 to 1948 Bearden had three solo exhibitions and participated in most group shows at Kootz. He was included in the exhibition "Abstract and Surrealist American Art" at the Art Institute of Chicago in 1948 and the Whitney annuals of 1945 and 1950. During that period Bearden, along with fellow Kootz Gallery artists William Baziotes, Byron Browne, Adolph Gottlieb, Carl Holty, and Robert Motherwell, were among the "most talked about, exhibited modernists in America."[7]

Under the auspices of the G.I. Bill, Bearden spent a year in Europe in 1950, mostly in Paris, where he met artists such as Wifredo Lam, Georges Braque, Constantin Brancusi, and Jean Helion. Back in New York his paintings became increasingly nonobjective. He was, perhaps, provoked by the younger Parisian artists (his contemporaries) who he felt had "been in the cooking school too long. . . . It's time for the barbarians to invade and introduce new blood."[8]

Particularly during the late '50s Bearden's paintings eschew figurative references. Oil paint replaces water-based media. In works on canvas, the paint is stained on in large areas, and these irregular sections of color order the surface. Additional splattering gives the paintings a topographical feel; they appear to be maps of uncharted territories or lost planets. These are not the large aggressive gestures that we have come to know as abstract expressionist but are more modestly scaled and delicate; they share the quiet insistence of the paintings of Lewis and Tobey and the techniques also explored by Helen Frankenthaler and Morris Louis during this period. When Hale Woodruff (1900–1980, b. Cairo, Illinois) moved from Atlanta to New York in the mid-'40s, it was with the idea of participating in "the exciting new developments in American art."[9] Unlike Romare Bearden or the younger generation of African American artists that included Ed Clark, Haywood Bill Rivers, and Paul Keene, Woodruff had been to Paris in the '20s and had already made his peace with the European heritage of American painting. His residence in Greenwich Village and tenure at New York University placed him truly in the center of budding abstract expressionist activity. In the fall of 1949 Woodruff along with fellow NYU professors Tony Smith and Robert Inglehard rented a studio and gallery for their students at 35

East Eighth Street. Studio 35, as it was known, inhabited the former site of Subjects of the Artist, an alternative school begun by Baziotes, Mother-well, Rothko, and sculptor David Hare which had closed after a year. Both ventures had in common an open lecture series held on Friday evenings, a focal point for new and stimulating ideas by artists and intellectuals of "ad-vanced" art. In the famous final sessions at Studio 35 in April 1950, thirty-five artists including Lewis, Motherwell, and Reinhardt came together in an attempt to define their "movement."

Woodruff worked both figuratively and abstractly from the time he ar-rived in New York until the late '50s. His Atlanta University murals (in the planning since 1945 but completed in 1950) make use of some stylized fig-ures and the pictogram format, where the painted surface is divided into compartments of symbols or organic shapes. Other artists such as Adolph Gottlieb were also working with pictograms in New York at that time. Yet *Blue Intrusion* from 1958 is a completely nonobjective piece, where the art-ist's own restless brushwork explodes all over the canvas. Woodruff's in-volvement with mythical themes in such works as *Leda and the Swan* and *Europa and the Bull* ties him to other contemporary investigations. Like Lewis and Bearden, he also was represented on prestigious Fifty-seventh Street during the '50s, with three solo shows at the Bertha Schaefer Gallery.

European surrealist Max Ernst may have found that New York's "café life was lacking"[10] when he arrived in 1940, but by the '50s places such as the Waldorf Cafeteria, Cedar Tavern, The Club, Studio 35, Rienzi's, and the Five Spot had become almost standard meeting places for artists in Green-wich Village. The Village was also where many artists lived or had studios, and by the mid-'50s artist-run galleries had begun to appear downtown as well. In this way an art world focused on American art began to develop in New York.

Thomas Sills has lived in the Village for more than three decades. Though he had always had a creative streak he was never allowed to develop it while growing up in the South. He began painting in 1952 (at age thirty-eight) shortly after marrying ceramic artist Jeanne Reynal. Sills jumped into ab-stract expressionist technique with both feet, using housepainters' brushes and more often velvet or rags to apply paint to canvas and working with automobile or industrial enamel. During this time his home was frequented by American and European contemporary artists and he received encour-agement from deKooning (also a Village resident) and Enrico Donati, as well as Newman, who also showed at Betty Parsons Gallery—as did Sills—but he was not directly influenced by these artists' work. The structure of his paintings begins with the application of color which solidifies into sinu-

ous and biomorphic shapes; a similar working process was also used by artists such as Baziotes and James Brooks. The juxtaposition of high keyed colors in his paintings is reminiscent of the "push pull" dynamic championed by and seen in the work of Hans Hoffman. Though Hoffman's well-known art school was nearby, Sills's artist friends admonished him not to attend, insisting that he could be more creative if self-taught. Sills had four solo exhibitions at the Betty Parsons Gallery between 1955 and 1961. Parsons along with Kootz and Willard was among the first galleries to support this new American abstraction.

Merton Simpson came to New York to study art in 1949. He enrolled at Cooper Union where he worked with Baziotes and Motherwell but he received an associate's degree from NYU (1951) where he studied with Woodruff. Also important to his development was an apprenticeship in Herbert Benvey's frame shop where he met Pollock and deKooning as well as Franz Kline and Max Weber. After serving in the Korean War he was included in the Guggenheim's "Younger American Painters" exhibition in 1954. This led to numerous solo shows at such midtown and Madison Avenue galleries as Barone, Bertha Schaefer, and Krasner. Simpson's work of this period is heavily laden with painted and collaged layers which collide in forceful diagonals or shimmer as celestial orbs. His titles often refer to natural phenomena such as *Sky Party* or *Sea Poem*, which is also included in this exhibition, but it is the feeling of the experience rather than a visual documentation that Simpson evokes.

The cooperative galleries that opened in the '50s were outlets for a younger generation who began working with abstraction during that decade. These artist-run spaces were somewhat more democratic and open to a variety of artists than the traditional commercial galleries. Area, Brata, Camino, and Phoenix were all co-ops that had African American members or showed work by these artists. Ed Clark was a charter member of the Brata Gallery, which also showed the work of Ronald Bladen, George Sugarman, and Al Held. Clark, a student at the Art Institute of Chicago, came to New York in 1956 after five years in Paris. In Europe he had developed a very personal style based on color relationships and free-form geometry; in New York the movement of color replaced the stasis of geometry as the ordering principle of his canvases. He began working on the floor in 1953 and was one of the few African Americans of the period to paint on a large scale. Clark experimented with shaped paintings in the '50s; it was as if his brushstrokes were "moving with such force that they could not be contained within the boundaries of the stretcher and consequently, lunged beyond."[11]

While the other three artists included in this exhibition were working ab-

stractly during this time, their links to New York were not as strong. Nevertheless, their work explored such typical abstract expressionist concerns as myth, gesture, field, and materials.

Between 1947 and 1961 John Rhoden won many of the most prestigious awards granted to artists and scholars in this country including the Rosenwald, Fulbright, Rockefeller, and Guggenheim and also the Prix de Rome. He traveled throughout Scandinavia, the Soviet Union, Africa, and Asia on his grants or for the State Department during much of the '50s. In New York during the latter part of the decade his abstract language blossomed. His sculptures from that period, such as *Spirit Regarding Order* (1958), are similar in expression to those of David Hare; they illustrate the syncretism of imaginary yet disparate elements into visually dynamic three-dimensional works.

Like Bearden and Clark, Paul Keene went to Paris from 1949 to 1951 under the auspices of the G.I. Bill. In 1952 he was awarded a John Hay Whitney Fellowship, which took him to Haiti for a year, after which time his work became increasingly abstract. His staccato gestures are somewhat similar to the paintings of Clyfford Still but fill the entire picture surface. The genesis of Keene's imagery in Haitian myth confirms his link to abstract expressionist interest in both mythology and Third World cultures. There is also an affinity with Lam's New World surrealism, though Keene's work is not as figurative. A resident of Pennsylvania, Keene often drove to New York on weekends and visited Bearden, whom he'd met in France. He exhibited in New York at the Roko Gallery, which over the years had shown a number of African American artists.

As a young man Haywood Bill Rivers was barred from studying at the Maryland Institute College of Art on purely racial grounds. Though his suit for admission was unsuccessful, the state of Maryland agreed to provide him with a full scholarship to any other art school in the country. Rivers arrived in New York in 1946 to study at the Art Students League. His early paintings had affinities with the naïf style of Horace Pippin and were somewhat similar in structure and color to the work of Jacob Lawrence. Rivers received many accolades for these pieces: he was awarded a Rosenwald fellowship, joined the Knoedler Gallery and was selected for the Carnegie International of 1949, and, ironically, Maryland's Baltimore Museum gave him a solo show and purchased some work. In 1949 he left for France, where he met Keene and Sam Francis and, along with Robert Rosenwald, organized Galerie Huit, which showed the work of American artists including Keene, Held, and Jules Olitski. Rivers received a John Hay Whitney Fellowship in 1952 and returned to New York in 1954, frequenting the co-op

galleries on Tenth Street and the Cedar Bar, where, he has recounted, artists told "shaggy dog stories," until the critic Harold Rosenberg walked in when they would "freeze up."[12] Rivers's work moved toward figurative abstraction as early as 1950. During the decade from 1950 to 1960 his paintings became increasingly more expressionistic and heavily impastoed. He often worked on pieces for a number of years, delicately balancing form and color.

The artists gathered for this exhibition were among the first African Americans to explore the visual language of nonobjective art and it is evident that they shared elements of style and community with the mainstream. Lewis, Sills, and deKooning all used industrial paint at one point. Clark's and Sill's use of unconventional tools (brooms and cloth respectively) links them to Pollock's pouring and dripping techniques; all as well worked on the floor. DeKooning relied on the figure and Pollock returned to it in the '50s, giving a context for Woodruff's constant battle with it during that time. But their aesthetic was also affected by other, perhaps more personal, influences.

Both Rivers and Sills insist on the role of their southern roots. For Sills, memories of the flourishing land provide him with ideas for color while Rivers has always been fascinated with the structure of African American quilts and in his later geometrical work the analogy is more direct. African art has had a particularly strong impact on Simpson and Woodruff. Bearden's concern with "trying to humanize the structure of abstract painting"[13] led to a body of nonobjective work of very meditative quality.

Despite what notice they received, African American artists of this period still suffered from lack of extensive exposure and critique as well as gallery and financial support. Lack of funds accounted for Bearden's thick surfaces (he painted and repainted the same canvas) and Clark's shaped experiments (extending his canvases with paper and wood). It explains the few large canvases. In the 1940s and 1950s African Americans still lived, legally, with segregation. As white artists had turned from social and political ideas of the '30s to existential exegesis in the '50s, for African Americans the specter of humanist concerns in the form of the civil rights movement was growing louder and clearer. The "push toward existentialist anxiety and alienation"[14] was not necessarily the direction they wanted to take. Their abstract work, though, can be seen as a product of its time encompassing mainstream concerns as well as ideas about color, structure, and content that were gleaned from their own heritage and reality. They laid the foundation for a younger generation of artists who in the '60s and '70s extended this dialogue with abstraction.

NOTES

Originally published in Kellie Jones, curator, "Abstract Expressionism: The Missing Link," Jamaica Arts Center, Jamaica, N.Y., January 12–February 25, 1989.

1. Adolph Gottlieb and Mark Rothko cited in Irving Sandler, *The Triumph of American Painting: A History of Abstract Expressionism* (New York: Harper and Row, 1971), 29.

2. Barnett Newman cited in Sandler, *The Triumph of American Painting*, 69.

3. Sandler, *The Triumph of American Painting*, 2.

4. Robert Rosenblum, "The Willard Group," *Art Digest*, June 1, 1954, 20–21.

5. *Art Digest*, October 15, 1945, 14.

6. Lowery Sims, "Romare Bearden: An Artist's Odyssey," in *Romare Bearden: Origins and Progressions*, exhibition catalogue (Detroit: Detroit Institute of Arts, 1986), 13 (September 6–December 16, 1986).

7. April J. Paul, "Introduction à la Peinture Moderne Americain: Six Young Painters of the Samuel Kootz Gallery," *Arts Magazine*, February 1986, 65.

8. Romare Bearden cited in Sims, "Romare Bearden," 17.

9. Mary Schmidt Campbell, "Hale Woodruff: 50 Years in His Art," in *Hale Woodruff: 50 Years of His Art*, exhibition catalogue (New York: Studio Museum in Harlem, 1979), 33.

10. Max Ernst cited in Sandler, *The Triumph of American Painting*, 211.

11. Edward Clark, exhibition announcement, 141 Prince Street Gallery, New York, 1972.

12. Bill Rivers, interviewed by John Mandelsohn and Dona Nelson, *Issue: A Journal for Artists* 5 (fall 1985), 14.

13. Romare Bearden, "The Journal of Romare Bearden," in *Romare Bearden: Origins and Progressions*, 29.

14. Paul, "Introduction a la Peinture Moderne Americain," 68.

Norman Lewis

The Black Paintings

Norman Lewis, *America the Beautiful*, 1960. Oil on canvas, 50 x 64 inches, signed. Credit Line: Private Collection; Courtesy of Michael Rosenfeld Gallery, LLC, New York.

Norman Wilfred Lewis was born in Harlem in 1909. Primarily self-taught, he came along at a time when the arts were beginning to flourish in the United States. The '20s saw the Harlem Renaissance, when black writers and artists were searching for ways to express a uniquely African American spirit. During the '30s, the Works Projects Administration (WPA) subsidized artists to work in their own studios, as well as to teach art classes and set up community art programs. Lewis's growth as an artist was nurtured by this environment, though his introduction to the world of art was quite unintentional; one day in 1933, out for a walk, he happened on the studio of sculptor Augusta Savage. This black woman had recently returned to New York from studying in Europe at Paris's La Grande Chaumière and in Belgium and Germany with the intent of starting an art school in Harlem. From then on, Lewis spent many hours painting and drawing in Savage's 143rd Street studio.

Savage eventually received funds from the WPA to expand her project. By 1937 the school had moved from 125th Street and Lenox Avenue and had become part of the Harlem Community Art Center, which at its peak had fifteen hundred students and was a model for federally sponsored art centers around the country. Through the WPA, Lewis began teaching there; he was to teach, intermittently, over the next forty-odd years, encouraging hundreds of people to pursue careers in art.

Norman Lewis inspired people not just through teaching but by setting an example. In a career that spanned almost fifty years, he showed in exhibitions at the Metropolitan Museum of Art, Corcoran Gallery, Carnegie International, Whitney Museum of American Art, and internationally in France, Ghana, Italy, and Brazil. His work was collected by public institutions such as the Museum of Modern Art and the Chicago Art Institute, and private corporations including Time Life Corporation, IBM, and Manufacturer's Hanover Trust.

There are numerous contexts in which to discuss Norman Lewis's extensive oeuvre. The retrospective approach considers the artist's full development and takes an overview of an entire career. In-depth examinations of different themes or periods in the artist's work bring to light the specifics of the various stages of artistic growth. The current exhibition, "Norman Lewis: The Black Paintings," focuses on a rarely discussed but important

continuum in Lewis's work: his use of the color black both as a dominant compositional element in his abstract paintings and as a social comment.

To retrace the evolution of Lewis's art and social concerns, it is necessary to return to Harlem in the mid-'30s, the site of numerous artists' organizations in which he was quite active. Between 1935 and 1937 the studios of painter Charles Alston, sculptor Henry "Mike" Bannarn, and dancer Ad Bates at 306 West 141st Street were gathering places for artists and intellectuals; Ralph Ellison, Joseph Cotton, and Orson Welles were among those who frequented this informal and interracial salon. Many of the black visual artists who frequented "306" were also members of the more formal Harlem Artists Guild. The guild initially came together in 1935 to lobby for the creation of an art center in Harlem; through its efforts, the Harlem Community Art Center was formed. The Art Center provided an exhibition venue for guild members and other artists; such exhibitions were often traveled by the WPA to community art centers nationwide, giving these artists national exposure. Norman Lewis was the treasurer of the Harlem Artist Guild which, like the WPA itself, disbanded shortly after the United States entered World War II. Other guild members included Joseph and Beauford Delaney, Aaron Douglas, Bob Blackburn, and Augusta Savage to name a few.

Lewis was just as much a part of the art scene downtown. He was a member of the politically active Artists' Union, formed in 1934 to lobby for the continuance of progressive federal art projects. This organization not only concerned itself with the problems of artists but of other labor groups as well. American Abstract Artists was another organization; its purpose was to expose and promote abstract art in the United States, which is accomplished through annual exhibitions. Though he was never an actual member, Lewis was invited to exhibit with this group from time to time. Norman Lewis marched on many picket lines in those days, along with artists such as David Smith, Ad Reinhardt, and Mark Rothko.

Social realism characterized the art of the '30s and early '40s in the United States. Against the backdrop of the Depression and the government-sponsored art of the Mexican Muralists, American artists set out to discover their own national identity. For many artists, this often meant the outright rejection of European modernist abstract styles. For others, the time demanded a questioning and searching that was broader in scope; experimentation was not limited to considerations of solely one style or, for that matter, culture.

Like many of his contemporaries, Jackson Pollock for instance, Norman Lewis oscillated between representational and purely abstract styles for a

number of years. As late as 1944, he uses a variant of social realism in his painting *Four Figures*. However, while the figures are recognizable, each is expressed by a system of sinuous lines reminiscent of surrealist automatic writing; his growing interest in modern abstract technique is evident.

Lewis eventually gave up a purely social realist documentary style in his art, though he remained committed to political causes all his life. Even in his mature, abstract work, he retains references to the observed world, a tendency prevalent in the work of many American artists who matured in the post–World War II era. Indeed, Lewis was very much a part of the vanguard of artists of this period, those who subsequently came to be known as the New York School.

In 1946, he joined the Willard Gallery, which also showed the work of David Smith, Mark Tobey, and Morris Graves among others. By the early '50s, he was working in his mature style, subtle and atmospheric, characterized by the use of dry brush, thinness of paint, and soft-edged (at times indistinguishable) brushstrokes. The paintings evoke and suggest rather than delineate; forms and planes dissolve and reappear as dense or dispersed clusters of color. In the catalogue to his 1951 one-man exhibition at the Willard Gallery, Joan Murray says of Lewis's work, "Colors and lines merge to produce essences of moods, places, fantasies and fears, the gloom of the city, perhaps, or the chill black and white of winter, but transcending the particular with the unity and simplicity that make private experiences communicable."

Norman Lewis won the popularity prize at the 1955 Carnegie International Exhibition for his piece *Migrating Birds* (1953). The following year, in 1956, he was one of two blacks (the other was Jacob Lawrence) who were among the thirty-five artists represented in the United States Pavilion at the Venice Biennale. The piece he exhibited, *Cathedral* (1950), was later purchased by the Art Institute of Chicago. During this period, Lewis's work was included in major exhibitions at the Museum of Modern Art "Abstract Painting and Sculpture in America" in 1951 and the Whitney Museum of American Art "Nature in Abstraction" in 1958. Between 1949 and 1964, he also had eight one-man shows at the Willard Gallery.

A month before the historic March on Washington in 1963, a group of black artists in New York formed SPIRAL, as their response to civil rights activity in the South. The SPIRAL Group included Norman Lewis, Charles Alston, Emma Amos, Romare Bearden, Reginald Gammon, Al Hollingsworth, Hale Woodruff, and others. They met once a week at their various studios and for a while in a space they collectively rented at 147 Christopher Street in Greenwich Village.

SPIRAL was basically a discussion group, providing an outlet for these artists to talk about their common problems as black artists in America. In an era of growing cultural self-awareness among black Americans, SPIRAL was also trying to discover if there were any formal qualities in art, as there were with jazz, that were identifiable as African-American or "black." But there were almost as many styles and approaches as there were members in the group. Even the symbol of the organization, the Archimedian spiral which moves outward from a starting point to embrace all directions, testified to the members' wide-ranging points of view and stylistic concerns. There could be no singular, categorical definition of "black art."

For artists involved in SPIRAL, the experience proved to be stimulating and beneficial in many ways. Discussion led to a variety of exhibitions during the three years of the organization's existence. For one of them at the SPIRAL Gallery on Christopher Street during May and June 1965, the artists agreed to limit their palettes to black and white both as an esthetic exercise and as a political statement. Norman Lewis presented the now famous *Processional* (1965), a tribute to Martin Luther King Jr.'s march from Selma to Montgomery, Alabama.

Processional is one of over fifty paintings Norman Lewis painted between 1944 and 1977 in which the color black is predominant. This exhibition includes ten of these works dating from 1960 to 1977. In some of the pieces, the color black takes on symbolic political meaning; in others, Lewis explores the emotional and technical complexities of pure color.

Black is a strong element in the linear play that may be called automatist in works dating from the '40s, when Lewis is beginning to work more consistently in an abstract style. In *Shapes in Space* (1948), for example, red and white organic forms float on a black background. Lewis has then scratched back through the painted layers to the primed canvas, overlaying and ordering the composition with an almost rectilinear scrawl. Lewis's explorations in black of the 1950s and 1960s can be compared with those of his contemporaries, Clyfford Still, Franz Kline, Willem deKooning, and his close friend Ad Reinhardt. Like Reinhardt, Lewis experimented with the tonal nuances of black and other colors. Compositions such as *America the Beautiful* (1960) and *Klu Klux* (1963) share the fluid, gestural yet consciously controlled brushstrokes of black and white works by Kline and deKooning.

But while Lewis's use of black reflected the contemporary idioms and concerns of his time, it also allowed him to make pertinent political and social associations in a powerful way. In *America the Beautiful*, for example, white figural forms become hooded and robed specters carrying crosses, symbolizing the evil and terror of the Ku Klux Klan. *American Totem* (1960)

is another painting which comments on the racial situation in the United States. In this piece the symbol of the "land of liberty" is a vertical pole-like mass composed of white skulls or masks. Lewis creates a stark contrast between the open work of the totem pole and the black ground which envelopes it.

A more calligraphic style often expresses Lewis's lifelong affinity with music, especially jazz. In a composition like *Blue and Boogie* (1974), he allows the interplay between blue and black to convey mood, the ambiance of the music that had fired and sustained as well as chronicled the life of black Americans. A lyrical rhythm activates solid geometric and linear elements in *Untitled* (1977); these orange, black, and white painted shapes dance in a dense, snaking, spiraling pattern. The black ground is hazy and sheer; in some areas, Lewis creates filmy gray tones by allowing portions of white canvas to show through the painted surface.

Black is a color rarely associated with nature. Lewis used black, though, to create a series of pastoral canvases inspired by a trip to Crete in 1973. Each painting describes a sensory experience of natural phenomena, distilled and rearticulated by the artist. *No. 17* (1973) of the series alludes to the Cretan landscape with dense and linear brushwork which moves horizontally across the painting's surface. In *No. 8, Eye of the Storm* (1973), a storm's calm center is evoked by a mass of blue tones which do not quite fill the black canvas; an ovid of white lines circle the blue form, suggesting the whirling motion of the storm. *No. 4* (1973) is a minimalist work, the black painted surface of the canvas interrupted only by an ultramarine rectangle and finely incised perpendicular lines flanked by small circles. *Ighia Galini* (1974) is named for the town in Crete where Lewis stayed. Here wavelike white shapes have been created by rubbing into the black paint with a dry brush; a horizontal patch of blue recalls the village's craggy shoreline.

The pieces inspired by Lewis's Cretan sojourn can be compared to Monet's numerous approaches to Rouen Cathedral. In Monet's series (c. 1892) each work is painted at a different time of the day and chronicles the effects of changing light on the cathedral. Each painting is unique. For Monet, light and time play important roles in the forming of these images. But in both Monet's and Lewis's works, it is the artist's sensation of these changing elements and his ability to translate his perception of the view that make each painting distinctive.

During the last decade of his life, Norman Lewis continued the tradition of passing on knowledge and inspiration that he had begun in the '30s. He taught on Fifty-seventh Street at the Art Students League (1972–1977) and in Harlem with HARYOU-ACT (1965–1971). Lewis himself was not surprised

at the talent he found in Harlem, understanding firsthand what a difference encouragement and resources could make.

He took this idea of encouraging and promoting minority artists one step further when in 1969, together with Romare Bearden and Ernest Crichlow, he formed the Cinque Gallery. First located on Lafayette Street in a space donated by the Public Theater, later in the Lincoln Center area, and presently housed on West Seventy-second Street in Manhattan, the Cinque Gallery's mandate has always been to show the work of ethnic minority artists under the age of thirty.

As with so many artists, it was only toward the end of Norman Lewis's career that he began to receive the accolades due him. He received awards from the American Academy of Arts and Letters and the National Institute of Arts and Letters in 1970 and 1971 respectively. In 1972, he received an individual artist's fellowship from the National Endowment for the Arts and in 1975 the much coveted Guggenheim Fellowship. At the age of sixty-seven, in 1976, Lewis had his first retrospective (the only one he would see during his lifetime) at the Graduate Center of the City University of New York.

When Norman Lewis died in 1979, he left a legacy of artists and others who had been touched by his sagacity. He was someone who had lived through the growing pains of the United States in the twentieth century: World War I, the Jazz Age/Harlem Renaissance, the Depression, World War II, the civil rights movement, the Vietnam War, the Black Power and women's rights movements. Throughout it all, Lewis was always very much involved with both black artists' groups and the mainstream art world. His life experiences had given him a keen sense of morality and a definitive political stance. And he remained just as much committed to the separation of his political and social views from his aesthetic vision and what he was trying to do with his art. In his black paintings, Lewis at times used the color black as a metaphor for people of African descent. Yet the paintings are first and foremost compelling works of art and have a life outside that of pure social allusion.

Lewis had come to terms with his political sentiments and his aesthetic concerns as early as 1949. In a statement from that year he says: "For many years, I, too, struggled single-mindedly to express social conflict through my painting. However, gradually I came to realize that certain things are true: the development of one's aesthetic abilities suffers from such emphasis; the content of truly creative work must be inherently aesthetic or the work becomes merely another form of illustration; therefore, the goal of the artist must be aesthetic development, and in a universal sense, to make in

his own way some contribution to culture. Further, I realized that my own greatest effectiveness would not come by painting racial difficulties but by excelling as an artist first of all."

NOTE

Originally published in *Norman Lewis, 1909–1979*, Robeson Center Gallery (Newark: State University of New Jersey, Rutgers, 1985).

INDEX

Abakanowicz, Magdalena, 372
About, Nicholas, 62
Abramson, Charles, 12, 30n30, 310
"Abstract and Surrealist American Art" exhibition, 476
abstract expressionism, 375, 401–2, 419, 473*f*, 474–80; color-field tendencies in, 474; gesture tendencies in, 474; myth and symbology in, 474, 477, 479
abstraction, 21–22, 268–70, 398; in African art, 37–40, 69*f*, 70–77, 378–79; in the Black Arts Movement, 364–91, 407–10, 442–49, 466; creative antecedents of, 366; Edwards's definition of, 382; experimental materials of, 369–70; heterogeneity of practices in, 391; linguistic component of, 88–93; of Lorna Simpson, 81–117; mainstream contexts of, 364–65; maximalism in, 390–91; opticality in, 366–68; painting surfaces in, 374–77; photographic experiments in, 378; pluralist trends in, 389–90; privileging of ideas (conceptualism) in, 442–43; protest and social activism in, 379–89, 394n52; technological experiments in, 377–78; tools and methods used in, 373–74; of Tracey Rose, 69*f*, 70–77; uses of space and shape in, 370–73; at the Whitney Museum, 398–421
"Abstract Painting and Sculpture in America" exhibition, 475, 486
"Abstract Painting in America" exhibition, 400

Acconci, Vito, 334
Accused/Blowtorch/Padlock (Williams), 207*f*, 212
Acts of Art Gallery, 417, 425n63
Adam Clayton Powell State Office Building, 310
Adkins, Terry, 12, 30n30
African art, 474; colonial-based primitivism in, 70, 72, 402; conceptual forms of, 37–40, 69*f*, 70–77; "township" art in, 76
African Arts journal, 70
African Buddha 1986 (Pindell), 229
African diaspora, 15, 19, 466; conceptual art of, 37–40; cultural links of, 356–58, 418–20; designation of "black" in, 31n38; focus on oppression of, 39–40; heterogeneity in, 391, 410; hidden transcripts in culture of, 420; hybridized culture of, 280–81, 293; maps representing, 375–76; oral tradition in, 9, 91–92, 319; songs of signification in, 38
African Free School, 267
"African Influence in the Art of the United States" (Thompson), 418–19
"African Negro Sculpture" exhibition, 402
AfriCobra collective, Chicago, 428–29, 452n5
Africus Institute for Contemporary Art, 49
Afrikaans, 66n9
"Afro-American Abstraction" exhibition, 149, 389–90, 396n91
Afro-American Association, 429, 452n7
Afro-Futurism, 378–79

Autobiography: Scapegoat (Pindell), 377

Autobiography: Water/Ancestors/Middle Passage/Family Ghosts (Pindell), 215*f*, 229

"Autobiography in Her Own Image" exhibition, 229–30

"Autobiography Series" (Pindell), 215*f*, 229

Avant Garde Walk a Venezia (L. Simpson), 121n55

Avgikos, Jan, 74, 105

Ayler, Albert, 355, 356

Azaceta, Luis Cruz, 323

Baartman, Saartjie, 16, 39–40, 43–63; appearance in conceptual art of, 75, 95; displayed body of, 44–48, 51–61; legacy in South Africa of, 62–63; presumed consent of, 47, 52, 54, 66n9; repatriation of remains of, 58, 62–63, 66n12, 66nn15–16, 119n34; South African women's views on, 49–61; stage names of, 46, 65n6

Babbitt, Milton, 358

Bacon, Francis, 323

Bailey, Beezy, 64–65n3

Bailey, David A., 14, 30–31nn35–36

Bailey, Malcolm, 415, 421n9

Baker, Josephine, 344

Baldessari, John, 90, 213, 334, 336

"The Ballad of Sexual Dependency" (Goldin), 189

Baltimore Museum of Art, 384, 479

BAM. *See* Black Arts Movement

Bambara, Toni Cade, 461

Bannarn, Henry "Mike," 485

Baraka, Amina, 28n16

Baraka, Amiri, 4, 8, 268, 350; on American culture, 19; Black Cultural Nationalism of, 7, 265, 356, 429; on contemporary art, 37–40; multicultural politics of, 28n12; recitation style of, 356; writing of, 18, 22–23, 41

Baraka, Ras, 28n16

Barlett, Jennifer, 4

Barney, Tina, 198

Barr, Jerry, 256

Barthe, Richmond, 401

Bartica Born III (Bowling), 375

Barticaflats Even Time (Bowling), 376

Baselitz, Georg, 230

basketball, 150–51

Basquiat, Jean-Michel, 11, 21, 29n27, 277*f*; cartoon work of, 290–91; collaborations with Warhol of, 286, 288–90; diasporic viewpoint of, 271, 282–83; fame of, 278–82;

heroic figures of, 270, 286–87, 290–91; IDEAL tag of, 280; late works of, 291–93; multicultural viewpoint of, 278–82, 294n14; pop art and graffiti of, 279–80; primitive work of, 266; religious and cultural connectivity of, 287–92, 295n48, 296n55; Spanish as language of intimacy for, 266, 282–86, 295n41

Basquiat, Matilde, 284, 286

"Basquiat" exhibition, 11, 29n27

Basquiat film, 295n33

Bates, Ad, 485

Bathers (Chase-Riboud), 372–73, 378–79

Batya Zamir Dance Company, 367

Baur, John I. H., 399

Baziotes, William, 476–78

"B. D. Woman's Blues" (Bogan), 120n44

beads, 177*f*, 178–84

Bearden, Romare, 416; abstract expressionist work of, 148, 367, 473*f*, 474–76, 480; as mentor, 384; MOMA exhibition of, 402, 422n14, 425n63; social activism of, 394n52, 399, 417, 421n6, 486, 489; work with the nude of, 121n58

Beastie Boys, 344

bebop, 353, 355, 358

Beck, Sherman, 452n5

Beckwourth, James, 237, 238

Bedia, José, 140

The Bed (L. Simpson), 102–3

Bell, Larry, 369, 406

Belmore, Rebecca, 31n38

Bender, Gretchen, 471

Bentley, Gladys, 96–97, 120n44

Benvey, Herbert, 478

Bertha Schaefer Gallery, 477

Betty Parsons Gallery, 477–78

"Between Memory and History: Les Lieux de Memoire" (Nora), 33n63

Beuys, Joseph, 102

Bey, Dawoud, 14, 15, 20, 187*f*, 189–203; autobiographical work of, 196–97; composite figure groupings in, 199–202; on describing African American lives, 160; documentary tradition of, 189–93, 203n8; exhibitions of, 30n35; formal portraiture of, 193–97; Polaroid self-portraiture of, 194; recording of youth culture by, 199–200; street as studio for, 195, 204n22; studio-based color Polaroids of, 187*f*, 197–202, 204n35

"Beyond Visual Pleasures: (Oguibe), 64n3

Bhabha, Homi, 115–16, 122n79, 202

Soul II Soul, 344

South Africa: the black female body in, 45–47, 51–62, 64n3; Castle of Good Hope, Cape Town, 45; "colored" identity in, 57–58, 72–74; contemporary art in, 70–77; museums of, 59; the necklace in, 90; original inhabitants of, 46, 57, 59, 62, 65n7; repatriation of Saartjie Baartman to, 58, 62–63, 119n34; Robben Island prison of, 15–16, 79n25; Second Johannesburg Biennale of, 47–48; security and surveillance in, 74–77; sexual violence and rape in, 58–63, 67n21, 131; traditional practices of women in, 129, 131; Truth and Reconciliation Commission of, 58; women in government in, 130–31

South Africa Museum, 59

Southern California. *See* Los Angeles

Southern Christian Leadership Conference (SCLC), 398

"Soweto Marketplace" (Hammons), 253

Soyinka, Wole, 274

Spade Covered with Sand (Hammons), 444

"Spade" series (Hammons), 147–48, 151, 249–50, 444

Span I (Rose), 73

Span II (Rose), 69f, 73–74

Spanish language, 266, 282–86, 294n28

Spectrum Women's Photography Festival, 31n36

Spell #7 (Shange), 210–11

Spillers, Hortense, 83–84

SPIRAL Group, 398, 421n6, 455n49, 486–87

Spirit Catcher (Saar), 460

Spirit Regarding Order (Rhoden), 479

spoken communication, 9, 91–92, 319

SPOULAKK (Esson), 323–24, 327n7

Spring Chicken (Hammons), 153

St. Joe Louis Surrounded by Snakes (Basquiat), 279

St. Louis, Missouri (Kennard), 242

Stack of Diaries (L. Simpson), 100

Standing in the Water (L. Simpson), 100–101, 121n53, 121n55

Stearns, Charles, 426n76

Steiglitz, Alfred, 465

Stella, Frank, 366, 402, 420

"Stereotypes and Decoys" (Puryear), 237

sterilization, 94–95, 119n35

Stevens, Nelson, 452n5

Still, Clyfford, 479, 487

Stinson, John, 440

Store Front Museum/Paul Robeson Theater, 381

Storr, Robert, 13, 201, 310, 313, 326

straight photography, 191–92, 209, 330–31, 334

Stuckey, Charles, 13

Studio 35, 476–77

Studio Museum in Harlem, 254, 310, 342, 365; Artists-in-Residence program, 380, 381, 404; commitment to living artists at, 12; Edward's exhibition at, 382; "Electronic Refractions" exhibition at, 380–81; "Energy/Experimentation" exhibition at, 5; founding of, 380–81, 386, 394n55, 398, 400; "In the Tropics" exhibition at, 12–13; Overstreet's exhibition at, 370–71, 392n18; permanent collection of, 377, 393n27, 396n81; "X to the 4th Power" exhibition at, 372, 404

Studio Z, 447, 457n80

Subjects of the Artist school, 477

Sugarman, George, 478

Sugiura, Kunie, 242, 244

Suit (L. Simpson), 96–98, 100

Sulter, Maud, 14

Sun, May, 457n80

Sundaram, Vivan, 9

Sun Ra, 170, 300, 356, 378, 436, 453n26

Sunseri, Don, 4, 161

Superman, 290–91

surveillance, 74–77, 103

Sussman, Al, 377

Swann Galleries, 1

Sweet Honey in the Rock, 184

Swenson, Jean, 223

Sylvan Court murals, 380

Symbol Sourcebook (Dreyfuss), 291

"Synthesis" exhibition, 464

systemic painting, 364

Tabrizian, Mitra, 213, 330, 332–34

Tagg, John, 192–93

Tann, Curtis, 169, 431

Tanner, Henry O., 342

Tapscott, Horace, 432, 453n26

Tate, Greg, 14–15, 99–100; on African American culture, 321; on Basquiat, 281, 283, 287; on Bey's portraiture, 189, 196; on Hendrix's fame, 280

Tatlin, Vladimir, 460

Tatlin spiral, 138–39

Tatrology (S. Rivera), 244

Taylor, Cecil, 355

KELLIE JONES is an associate professor in the Department of Art History and Archae-
ology at Columbia University. She is the author of several books and exhibition cata-
logues including *Energy/Experimentation: Black Artists and Abstraction, 1964–1980*
(2006), *Basquiat* (2005), and *Lorna Simpson* (2002).

AMIRI BARAKA is the author of over forty books of essays, poems, drama, and music
history and criticism. His recent book, *Digging: The Afro-American Soul of American Clas-
sical Music* (2009) is the winner of an American Book Award.

HETTIE JONES is an award-winning poet who has written over twenty books includ-
ing *How I Became Hettie Jones* (1990), a memoir of the Beat scene. She teaches in the
Graduate Writing Program of New School University and at the 92Y Poetry Center in
New York.

LISA JONES is a screenwriter and journalist. A former columnist at the *Village Voice*, she
is the author of *Bulletproof Diva: Tales of Race, Sex, and Hair* (1994).

GUTHRIE P. RAMSEY JR., the Edmund J. and Louise W. Kahn Term Professor of Music
at the University of Pennsylvania, is a music historian and pianist. He is the author of
the book *Race Music: Black Cultures from BeBop to Hip-Hop* (2003) and the CD *Y the Q?*
(2007) with his band Dr. Guy's MusiQology.

Library of Congress Cataloging-in-Publication Data
Jones, Kellie, 1959–
Eyeminded : living and writing contemporary art / Kellie Jones ;
with contributions by Amiri Baraka . . . [et al.].
p. cm.
Includes bibliographical references and index.
ISBN 978-0-8223-4861-0 (cloth : alk. paper)
ISBN 978-0-8223-4873-3 (pbk. : alk. paper)
1. Art, Modern—21st century. 2. Art, American—20th century.
3. African American art. 4. African American artists. I. Baraka,
Imamu Amiri, 1934– II. Title.
N6538.N5J664 2011
709.04—dc22 2010049724